The Later Centuries

THE LATER MING AND LEADING CH'ING MASTERS

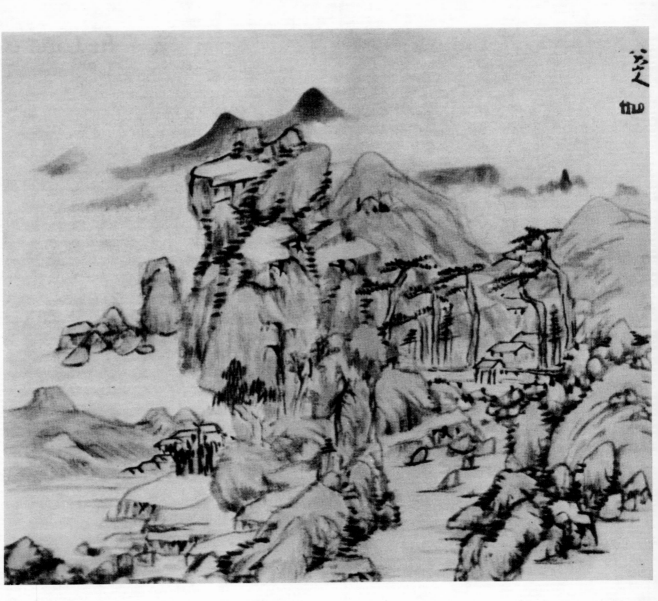

A Rocky River-bank with Pine-trees and Cottages.
Album-leaf by Pa-ta shan-jên. From a publication by Jurakusha, Tōkyō.

OSVALD SIRÉN

CHINESE PAINTING

VOLUME V

Hacker Art Books Inc., New York, 1973

First Published 1956, 1958
by Lund, Humphries and Company, Ltd. London
Reissued 1973 by Hacker Art Books, Inc.
New York, New York 10019

Library of Congress Catalogue Card Number A57-1105
ISBN 0-87817-130-4

Printed in the United States of America

TABLE OF CONTENTS

THEORY AND PRACTICE OF THE LATER MING PAINTERS

 I. Tung Ch'i-ch'ang 1

 II. Mo Shih-lung and Ch'ên Chi-ju 10

 III. The Hua-t'ing and Su-sung Schools: Ku Chêng-i, Sun K'o-hung, Chao Tso, Shên Shih-ch'ung 17

VARIOUS CENTRES OF LANDSCAPE-PAINTING

 I. Introduction 25

 II. The Suchou Painters. Epigons of the Wu School: Li Shih-ta, Shêng Mao-hua, Wang Ch'i, Chang Hung, Shao Mi, Pien Wên-yü, Yün Hsiang 26

 III. Painters from Hangchou; the last of the Chê school and theorists: Kuan Chiu-ssŭ, Lan Ying, Hsiang Shêng-mo, Li Jih-hua and Ku Ning-yuan 35

 IV. The Intimists from Ch'ia-ting: Ch'êng Chia-sui and Li Liu-fang 45

 V. Virtuosi from Fukien and Painter-patriots in Nanking:
 i. Chang Jui-t'u, Wu Pin and Wang Chien-chang
 ii. Huang Tao-chou, Ni Yüan-lu and Yang Wên-tsung 47

 VI. Traditionalists from the Northern Provinces: Mi Wan-chung, Wang To, and Tai Ming-shuo 54

FIGURE-PAINTERS

 I. Traditionalists and Archaistic Painters 59

 II. Portraitists and Illustrators 66

PAINTERS OF EPIDENDRUM, FLOWERS, TREES AND BAMBOO

 I: Wang Wei-lieh, Hu Ching, Ch'ên Chia-yên, Ma Shou-chêng, Hsüeh Wu, Chao Wên-shu, Kuei Chang-shih, Chao Pei and others 70

 II. Artists working for the *Shih-chu-chai shu-hua-p'u* 75

THE ADVENT OF THE MANCHUS 79

COURT-PAINTERS IN THE SHUN-CHIH AND K'ANG-HSI EPOCHS .. 84

INFLUENCES FROM EUROPEAN PAINTING 88

PAINTERS SURVIVING FROM THE MING PERIOD, THE TWO OLDER
WANG AND CONTEMPORARIES
 I. Wang Shih-min 95
 II. Wang Chien 104
 III. Some Contemporaries of the Two Older Wang 109

THE PAINTERS OF ANHUI 114

PAINTERS IN KIANGSU AND KIANGSI 123

THE EIGHT MASTERS OF NANKING 128

THE GREAT MONK PAINTERS
 I. Fang I-chih, Fu Shan and Chang Fêng 138
 II. K'un-ts'an 142
 III. Pa-ta shan-jên 149
 IV. Tao-chi 156

THE FOUR GREAT MASTERS OF THE K'ANG-HSI REIGN (1662–1722)
 I. Wang Hui 173
 II. Wu Li 184
 III. Yün Shou-p'ing 192
 IV. Wang Yüan-ch'i 200

FOLLOWERS OF THE LOU-TUNG SCHOOL AND OTHER FAMOUS LAND-
SCAPISTS AT THE BEGINNING OF THE CHIEN-LUNG ERA
 Huang Ting, Wang Yü, T'ang-tai, Chang Tsung-ts'ang, Fang Shih-shu, Tung Pang-ta,
 Chien Wei-ch'êng, Kao Ch'i-p'ei, Li Shih-cho and others 212

WESTERNERS AND PAINTERS OF FLOWERS AND ANIMALS AT COURT
IN THE CH'IEN-LUNG ERA
 Castiglione, Shên Ch'üan, Chiang T'ing-hsi, Tsou I-kuei, Ch'ien Tsai, Chin Ting-piao, T'ing
 Kuan-p'êng and others 225

THE INDEPENDENT MASTERS IN YANGCHOU AND ELSEWHERE IN THE
CH'IEN-LUNG REIGN
 Kao Fêng-han, Chin Nung, Chêng Hsieh, Wang Shih-shên, Li Fang-yin, Li Shan, Huang
 Shên, Hua Yen, Lo P'ing and others 235

INDEX TO CHINESE NAMES AND TERMS for Vols. IV, V 251

INDEX TO JAPANESE NAMES AND TERMS for Vols. IV, V 276

INDEX TO WESTERN NAMES AND TERMS for Vols. IV, V 278

Theory and Practice of the Later Ming Painters

I

Tung Ch'i-ch'ang

THE TRADITIONAL method of dividing the history of Chinese art in accordance with the dynastic periods may at times appear somewhat scholastic or misleading to critical students of the problems involved, because there is seldom, if ever, a direct or exact correspondence between the rise and fall of the dynasties and the upward and downward movements – *i.e.* progress and decline – of artistic creation during the same time. Yet the dynastic names are commonly used in both cases, which easily gives cause for the conclusion that there is a correspondence between the political and the artistic development apart from their contemporaneousness.

Such conclusions are in some instances justified by the course of the historical events and the kind or quality of the artistic productions, but it is by no means a general rule; it is rather exceptional to find the same succession of progress and decline in the artistic activities as in the ups and downs of the fortunes of the respective dynasties. The inward and outward events (if we may call them so) do not very often follow the same rhythm; the time periods of their rising and falling movements are different; spiritual achievements usually require longer preparation than political conquests or defeats.

In our presentation of the development of painting in the Ming period we have had occasion to observe how some of the powerful early rulers made special efforts to stimulate artistic activities, and painting in particular, as means for enhancing the glory and grandeur of their new dynasty. The best painters from every part of the country were invited to the capital and entrusted with imperial orders. The production that ensued was very rich and some of it was of good quality, because most of the artists drawn into the service of the court were highly trained professionals, but even when doing their best few of them expressed any new ideas or opened up new roads for the art of painting. Their main endeavours were directed towards re-asserting traditional, not to say classic, ideals of yore, which in times of national glory had formed the essentials of official painting.

This official renaissance, if we may so call it, won the support of a number of prominent painters who, as previously told, formed a group or current that became known as the Chê school. The limits of this are difficult to fix, because it included many local and individual variations, yet the above-noted historical orientation is evident in all their works and also in the rather sweeping decorative designs, often rendered somewhat superficially but with impressive technical dexterity.

The artistic merits and defects of this kind of painting need not be further discussed at this place; it is mentioned here mainly because of its affiliations with the dynastic and political ambitions of the Ming rulers; it seemed to answer in particular to their aesthetic needs and outlook and may as such be remembered as a typical manifestation of the Ming genius. Yet it was not the sole current of painting of which this may be said, nor did it last for more than about half the time of the dynastic rule. Before the end of the fifteenth century, other currents which sprang from deeper sources of spiritual inspiration

brought fresh waters to the fields of painting, causing a new artistic outgrowth, which had no connexion whatsoever with political or dynastic endeavours, but nevertheless was an equally significant exposition of the Ming genius in painting.

The lives and works of the leading personalities of this new, independent movement have been described in some of the preceding chapters; we have seen that they were not professional painters (like most of the members of the Chê school), but scholars and poets, masters of the brush, skilled in painting as they were in writing, and thus able to express in pictorial form the poetry of nature and the rhythm of life. Their works marked the highest level ever reached by men of the brush in the Ming period. Their names and schools have consequently become identified with historical and artistic conceptions indicated by such expressions as Ming art or Ming style. They represented this art at the time of its most brilliant florescence and greatest range.

The high standard set by Shên Chou and Wên Chêng-ming could, however, not be maintained by their pupils and followers for any length of time. These did what they could, reproducing more or less faithfully the ideas, viewpoints and patterns of their great predecessors, but they did not add very much in the way of new individual interpretations or reactions to the standard compositions. It was a heritage which gradually tended to crystallize in formal repetitions or trickle away into the shifting sands of artistry. It is true that there were exceptions to the rule, for instance, men of fresh individual talent like Hsü Wei, who did not follow the well-beaten track, but their influence was not sufficient to stop the downward movement by which Ming painting was resolving itself into a somewhat monotonous exposition of traditional skill. Yet before the sixteenth century had reached its close, a new spirit or counter movement made itself felt in the field of painting, a fresh influx of new ideas which to begin with found more theoretical than practical expression, but nevertheless initiated new views on the evolution of painting and directed attention towards problems which had been unknown to the preceding generation.

This new quasi-theoretical movement which became manifest while the Ming dynasty was staggering to a fall, was headed by scholars, philosophers and amateurs who, at least in part, served in the government, though apparently they were more interested in problems of art than in the need to strengthen a tottering dynasty. Neither Tung Ch'i-ch'ang, nor Mo Shih-lung nor Ch'ên Chi-ju seem to have been much concerned with the political troubles of the day or to have felt that there could be any connexion between the development in the political field and the evolution of painting; they were certainly staunch traditionalists to judge from their aesthetic and philosophical attitude. Yet they opened up roads for the development of painting which led over into the new era and period named after the succeeding Ch'ing dynasty and, though typical scholars of the Ming period, were spiritually and aesthetically in closer harmony with the following dynastic period. They thus prepared the ground for the highly individualistic, not to say antischolarly, movement which drew its strength from the intense emotional reactions aroused by the crumbling away of the Ming rule and the conquest of the Middle Kingdom by the Manchus. This movement which, owing to its highly individualistic character, can hardly be called a school or a definite group, was also introduced by artists born and trained in the Ming period and in some cases, such as Pa-ta Shan-jên and Shih-t'ao, closely related by blood-ties with the fallen dynasty. In other words, they were men of pure Ming extraction, who used every occasion to manifest their attachment to the Ming house, yet they worked in styles and patterns which have little, if any, connexion with Ming art. Chronologically they still stand with one foot in the Ming period, but aesthetically they belong to the first great section of Manchu rule and consequently will only be discussed in a later chapter. Still the movement that they represented

should be remembered at this place as one more illustration of the lack of correspondence between the dynastic periods of Chinese history and the stylistic divisions or temporary ups and downs in the continuous evolution of painting.

As we have now reached the stage where an account of the last section of painting in the Ming period is necessary, it may be of interest to take note of how one of the best informed art critics of the time, Ku Ning-yüan, represented the development that led up to this stage. He wrote as follows:[1] "At the end of the Yüan and the beginning of the present dynasty the flourishing of painting was quite exhausted, but in the Ch'êng-hua, Hung-chih and Chia-ching reigns (i.e. 1465–1505) it was again revived in my home country (Suchou), and a whole series of famous masters appeared who made this district a leading centre of art. Towards the end of the Wan-li reign, painting again began to decay, but fortunately Tung Ch'i-ch'ang arose in Yün-chien (Sung-chiang), and his talents and eminence in Tao and art again spread glory over the peaks and gave fresh impetus to the spirit. He was indeed a man who opened up new paths. Unfortunately the students of art did not search for his real intentions, but simply copied his outward forms (skin). Consequently they became merely shadows of shadows, and after these shadows followed still other shadows in accordance with them. The traditions of the two places (Suchou and Sung-chiang) lost their impetus like strong arrows at the end of their flight. Now that I am going to record the opinions of the present day, I will briefly indicate the relative positions of the artists, thereby glorifying the path of painting, but I will not allow myself any criticism."

These general remarks are followed by the classification of certain leading painters (and some little known men) of the Ming period, which gives some idea as to how and why these artists were particularly appreciated. The first class is called: Famous Gentleman-painters (Shih-ta-fu) and Professional Artists (Tsung-chiang) and comprises the following names: Shên Chou, Wên Chêng-ming, T'ang Yin,

Chou Yung, Liu Chüeh and Ch'iu Ying. The second class is called: The Genius (Spirit) of the Intermediate Period of Florescence, and contains only one name: Tung Ch'i-ch'ang. The third class is called: Famous Painters with Literary Culture (Wên shih-ming chia) and contains twelve names: Ch'ên Tao-fu, Lu Chih, Wên Chia, Mo Shih-lung, Wên Po-jên, Wang Ku-hsiang, Yo Tai, Sun K'o-hung, T'an Chih-i, Chang Yüan-chü, Chang Ling and Ch'ien Ku, i.e. painters who practically all belonged to the circle of Wên Chêng-ming and T'ang Yin. The fourth class is called simply: Famous Painters, and contains the names Chou Ch'ên, Hou Mou-kung, Ch'ên Ts'an and Chou Chih-mien. The fifth class is devoted to later men and called Present-day Painters with Literary Culture, i.e. Li Liu-fang, Chung Hsing, Ch'ên Yüan-su, Chu Lu and Ku Ch'ing-ên. The sixth and last class contains two lady painters, Wên Shu and Han Mao.

The men who brought the art of painting to a point of culmination at the beginning of the sixteenth century are all placed in the first class, but immediately after them, as a resuscitator of painting from a state of relative decay, comes Tung Ch'i-ch'ang. The later classes contain the names of artists who reached a certain celebrity by reason of their literary culture or their professional skill without being creative personalities of the first order. Practically all those painters have been mentioned in previous chapters, and we may thus proceed to what Ku Ning-yüan calls the Intermediate Period of Florescence and its leading genius, Tung Ch'i-ch'ang.

* * *

The main centre of art during this period was no longer Suchou, but the neighbouring town of Sung-chiang (formerly known as Hua-t'ing or Yün-chien). Here the old Wu school branched off into local divisions which were called after this place the Hua-t'ing and the Yün-chien schools, a third one was the Su-sung school, whose name indicates that

[1] Cf. Shu Hua-p'u, vol.58, p.18.

it was a school combining the Suchou and Sung-chiang traditions of style. But the differences between these schools were not very important; they were all continuations of the Wu school, though adjusted to varying individual temperaments.

The records about Tung Ch'i-ch'ang are extensive, owing to the fact that he was not simply an artist and a writer, but also a high official who time and again held prominent posts in the government and cut a considerable figure in the social and political life of the period. The most complete account of his career is contained in the *Ming-shih*, but more detailed information about his personal life and artistic occupations are reported in *Wu-shêng shih shih*:

"Tung Ch'i-ch'ang, *tzŭ* Hsüan-tsai, *hao* Ssŭ-po, came from Hua-t'ing. In the years 1588-1589 he passed the state examinations as number one, and had an opportunity to study the books in the palace. With two companions, T'ao Wang-ling and Yüan Chung-t'ao, he devoted himself to Ch'an Buddhism. He looked down on personal fame, official positions and literary accomplishments as the heron looks down on worms in the soil. Consequently the high officials of the time looked askance at him, and he was sent away from the capital to serve in the provinces. He became chief examiner in Hunan and Hupei, but after some time he retired from this office and settled in his home province, where he lived for eighteen years. His fame increased continuously, and people came from every quarter to ask for his compositions. Even emperors, high officials, district magistrates, and provincial governors applied to him for help in writing letters and farewell messages, which he could do better than anybody else. When tablets were to be erected at Taoist or Buddhist temples, it was thought that Tung was the only one who could do them properly. Even the smallest fragments of his writings were considered a hundred times more valuable than those of other contemporary writers.

"He was an old friend of his fellow-townsman Ch'ên Chi-ju, and whenever he made a fine com-position he showed it to Ch'ên, and they enjoyed it together. His noble spirit shone brightly during two dynasties.

"He served as vice-president in the Bureau of Imperial Historiographers. Then he was proposed as vice-president of the Board of Civil Office (*Li Pu*), but he refused. Nor did he accept the position of a director of the crown prince's household. He again asked leave and returned to the South. Shortly afterwards the eunuch Wei Chung-hsien usurped the imperial power, which made the officials very uneasy, as they had to concentrate on pleasing him, and they felt great admiration for Tung, who had been wise enough to leave in time. In the Ch'ung-chêng reign he was appointed president of the Board of Rites.

"Still, when approaching the age of 80, he could read by lamplight books with characters no larger than a fly's head, and write equally small characters. This was possible because he held the creative power of nature in his hand and was nourished by the mists and clouds. Thus his spirit never grew weak.

"As a calligrapher he copied every kind of writing, but he was most prominent in writing the small *k'ai-shu*, though he did this only reluctantly. He preferred to write the *hsing-shu*, or rough running characters, which he did quite hastily and without much care, simply to satisfy the demand. But his most harmonious writings were equal to those of the Chin and Wei periods.

"In painting he imitated Tung Yüan, Chü-jan, Chao Po-chü, Chao Mêng-fu, Huang Kung-wang, Wang Mêng and Ni Tsan. He studied the Six Principles in great detail, brought peaks together and blended the rivers (in his works). His brush harmonized with the spirit of things and thus he reached the very essence of 'life-breath and movement' (*ch'i-yün shêng-tung*). Consequently it may be said that everything in his paintings, whether clouds, peaks or stones, was made as by the power of Heaven, his brushwork being quite unrestrained like the working of nature. He said of himself: 'If

my works are compared with those of Wên Chêng-ming, certain merits and faults may be observed in each of us. Wên, the Han-lin scholar, was very refined and skilful, and his works were highly finished. I could not equal him in this respect, but in regard to originality (quaintness) and rich beauty, I have passed a step farther'."

It may not be necessary here to dwell in greater detail on Tung Ch'i-ch'ang's various official occupations as they are recorded in the *Ming Shih*,[1] but the following points from this source may be worth noting: "He emerged after Mo Shih-lung and started as a follower of Mi Fei; his paintings were based on studies of the Sung and Yüan masters interwoven with his own ideas. They were free and full of life-movement, almost beyond human powers. As a critic of art he was highly appreciated and his opinions were much sought after by collectors. He was by nature a kind and easy-going man, a student of Ch'an, who, when at leisure, practised meditation and never used vulgar language. He died at the age of 83,[2] and one of the imperial princes gave him the posthumous title: 'Wên Min' (Genius of Literature)."

Judging by the records about Tung Ch'i-ch'ang's life and his activity as a painter, critic, writer and official, it seems evident that his great influence in matters of art was the result of his general aesthetic culture, his connoisseurship and well-balanced character rather than of his accomplishment as a painter. He was no doubt an impressive scholar of the old type, but further developed and moulded through the practice of Ch'an. His learning and experience in the field of art and literature were comprehensive, but he was not hampered by a blind enthusiasm for the past. Quite the contrary, although he knew the old masters of calligraphy and painting better than most of his contemporaries and had a deep admiration for many of them, he remained surprisingly free and spontaneous in his own works. Whatever he wrote or painted reflected the rhythm of his own mind and hand, and he was a true master of the brush.

It should also be remembered that his writings were known to more people than his paintings, which to no small extent were done as records of his studies or as illustrations to essays or poems which he copied from writers of old, or as gifts to friends; so that much of what Tung Ch'i-ch'ang did as a painter is accompanied by poems or calligraphic specimens which are just as important as the paintings.

Seldom, indeed, have the two arts supplemented each other more harmoniously than in the case of Tung Ch'i-ch'ang; the fluent rhythm of his calligraphic specimens is sometimes evident also in the brushwork of his paintings. Tung Ch'i-ch'ang was a true expressionist, in the proper sense of the word. Among his many observations on painting and calligraphy the following seems particularly significant: "Painting and calligraphy both have their special characteristics. Calligraphy should be fresh (spontaneous), but painting should be ripe; indeed, calligraphy must be fresh (spontaneous) even after it is ripe, whereas the ripeness in painting must lead beyond ripeness" (the writer feels his way, the painter waits for the unifying flash of inspiration) – which seems to imply that the quality of spontaneity (which cannot be acquired by practice) should dominate in calligraphy, whereas a thorough preparation, which can no longer be observed as such, is necessary for good paintings.

In turning to the numerous paintings which bear the name of Tung Ch'i-ch'ang, we are confronted with a material that hardly lends itself to regular stylistic analysis. Their formal criteria are not of the kind that can easily be translated into descriptive terms, their intrinsic artistic merits are often more evasive than obvious, and their pictorial significance a matter of suggestion rather than the result of elaborate design or detailed execution.

Most of his pictures known to us in original or reproduction are paraphrases or free renderings of

[1] Vol.228, p.8.

[2] According to Western reckoning he was 81 years old at his death; b.1555, d.1636.

compositions or concepts of the old masters which only to a minor degree reveal the individual style and temperament of the transmitter. The main endeavour of Tung Ch'i-ch'ang was not, as a rule, to express his own ideas, but to give his interpretation of those predecessors' works which seemed to him most valuable and fitting as models. For this purpose sketchy records on album-leaves or other paintings of small size were quite satisfactory, and consequently it is not surprising to find that a large portion of Tung Ch'i-ch'ang's painted work consists of such minor pictures, executed mainly in ink, sometimes with the addition of light colours.

Like all the great masters, Tung Ch'i-ch'ang no doubt passed through a stylistic evolution during his long life, but it is hardly possible to follow this step by step in his still preserved works, because only a few of them are dated by inscriptions. These range from 1592 to 1634, *i.e.* over a period of more than forty years, but the differences in pictorial style between the earlier and the later among the dated specimens are not very marked. The general tendency to be observed in these pictures seems to be a gradual increase in the fluency and freedom of the brushwork; the pictures from the earlier years are, at least in some instances, done in a more detailed and painstaking manner than the pictures from his later years, which generally are rather free transpositions of earlier patterns or simply creations in the spirit or vein of certain old masters. Tung Ch'i-ch'ang's main attention was never directed to formal likeness; what he sought to render was the expressional significance of the works. And as he did it quite spontaneously after he had assimilated the essentials of the models, his best transpositions are alive with their own vital rhythm.

The masters whom he imitated most frequently may here be recalled as signposts along the path of his evolution. Foremost among them should be named Tung Yüan, whose fundamental importance for Tung Ch'i-ch'ang is proved not only by the fact that he is mentioned more frequently than any other old master in the inscriptions on Tung's paintings, but also by the predominating stylistic characteristics of many of his works. Tung Pei-yüan was, in fact, from the stylistic point of view, the ancestral chief or guide of Tung Ch'i-ch'ang as a painter. Among other early masters who served repeatedly as his models may be mentioned Chang Sêng-yu of the sixth century, Yang Shêng of the seventh and Wang Wei of the eighth, but more important to him than these was Li Ch'êng who, according to his own words, headed a special school or current of style parallel to that of Tung Yüan. Other painters of the North Sung period whom he studied and recorded were Kuo Chung-shu (Pl.262), Yen Wên-kuei, Chao Ta-nien and Li Lung-mien, and particularly the two Mi, father and son, who were considered as the closest followers of Tung Yüan. The Yüan masters who carried on the same stylistic tradition, *i.e.* Huang Kung-wang and Kao K'o-kung, are also mentioned on many of his paintings, but his favourite among the Yüan painters was, however, Ni Tsan. He has bestowed on Huang and Ni, as we shall find, words of the utmost admiration. But other Yüan painters such as Chao Mêng-fu, Ts'ao Ch'ih-po and Wang Mêng are also mentioned by Tung as inspiring models. They were all faithful followers of the Southern School, *i.e.* the ideal style as defined by Tung Ch'i-ch'ang.

In order to realize how he estimated and imitated these and some other painters of former times, one can hardly do better than pay some attention to one or several of the albums in which Tung united sets of ten or more studies after various old masters. In the album published (1928) by the Chung Hua Book Co. in Shanghai, the paintings dated between 1621 and 1624 are marked as imitations after Yen Wên-kuei, Li Lung-mien, Chao Ta-nien, Li Ch'êng, Chao Mêng-fu, Ni Tsan, Wang Mêng and three others, but to recognize these masters in the transcriptions would in most cases be very difficult if their names were not mentioned in the inscriptions. In spite of Tung's obvious efforts to modify his manner of painting the respective parts such as rocks and mountains, trees and grass, crevices and

wrinkles, in accordance with his models, and to be faithful to the designs, it is not the characteristics of the old masters which prevail, but those of their interpreter.

According to the previously quoted statement in the Ming History, Tung Ch'i-ch'ang "started as a follower of Mi Fei", but this statement is not confirmed by his still existing dated works. None of the pictures with dated inscriptions of the last decade of the sixteenth or of the first of the seventeenth century is executed in the characteristic manner of Mi Fei; their stylistic correspondence with Tung Yüan, or his imitators of the Yüan period, such as Huang Kung-wang or Wu Chên, is far more obvious. This is clearly exemplified by the two pictures dated 1592 and 1597 respectively. The former, which is in a private collection in Japan,[1] was, according to the inscription, painted on the occasion of the painter's visit to Yang Shan, and represents a river view between pine-trees and terraced rocks of the type that is best known from Huang Kung-wang's works (Pl.261A).

The other picture (formerly in a private collection in Shanghai), which is known to us through a reproduction in *Chung-kuo ming-hua chi*, looks almost like a written document because all the empty space is here covered with inscriptions, two of which are from the artist (dated 1597), while all the rest are poems by the emperor Ch'ien-lung, who seems to have had a very high opinion of this picture. It represents a view over a river valley, or canyon, framed by some steep and deeply-folded rocks which rise on both sides like the side-wings of a stage setting. The foreground is marked by some spare pine-trees on a rocky ledge. The composition is unusual and perhaps not perfectly balanced, yet remarkable of its kind. It may have been inspired by some work by Tung Yüan, but this has not stifled the painter's individual efforts to find a new solution of old problems.

In most of the pictures which have dated inscriptions from the two first decades of the seventeenth century the decisive influence is derived from Huang Kung-wang; they remind us of Tung Ch'i-ch'ang's own statement about his early studies and gradual change of models: "In my youth I studied the landscapes of Huang Kung-wang; in later years I abandoned him and worked according to the Sung masters. Now I imitate him again occasionally, but cannot come up to him."

This statement, which was made towards the end of Tung Ch'i-ch'ang's life, conveys no doubt a good hint regarding the alternative importance of the Sung and Yüan masters for the artist, though the influences are rather subtle and intermittent and can consequently not be exposed or analysed in detail without a display of much more material than we have at our disposal. But a few typical examples with dated inscriptions may serve to illustrate the general line of development in Tung Ch'i-ch'ang's landscape-paintings.

One of the best examples of the large hanging-scrolls from the beginning of the century is the picture in the Ku-kung collection which is dated 1612 (Pl.263A). It represents a view of a river winding between steep rocks and screened by a row of thin trees at the lower edge. The most original and dominating feature of the composition is, however, a tall rock rising from a low spit in the river which with its twisting and tumbled folds gives the impression of a vast flame. It is structural and yet not devoid of a vital rhythm and may be said to form the tongue on the balance of this composition of mountains and trees.

No less remarkable for its structural quality is the tall picture in Mr. H. C. Wêng's rich collection of Tung Ch'i-ch'ang's works which is dated 1617 and represents the Ch'ing-pien mountain. The design, which consists of curving sharply cut mountains rising from a tranquil river, is grand, dominated by this sweeping rhythm in which all the minor details are absorbed. The painter used a relatively dry brush and by this the structural beauty has been more definitely expressed than in most of Tung's paintings, which as a rule are more remarkable for their

[1] *Cf.* Ōmura, *Bunjin Gasen*, I. 4.

easy flow and natural charm than for firmness and accentuating energy in the brushwork. Pictures of this quality and kind may be said to foretell Wang Yüan-ch'i's masterly landscapes (Pl.263B).

I do not know any other picture by Tung Ch'i-ch'ang that could be placed on a level with this; yet there are several interesting examples by the master in the same collection which, however, can be mentioned here only in passing, since no photographs of them are available. One is the handscroll known as A Hermit's Abode by the Ching-hsi River. The streams running down from the mountain here form the warp of the composition and the trees and the buildings give the pattern of the woof. This is likewise a monochrome ink-painting done with a so-called dry brush, by which the structure and the contrasting elements of the design are accentuated. It is dated 1611 and accompanied by a colophon and poems written by the artist two years later.

Another example in the Wêng collection represents Pine-trees and Pavilions in Autumn Colours in accordance with the manner of Ni Tsan. It is signed and dated 1621 and marked with the seals of Wang Hui, who once was the owner of the picture. The composition is rather unusual as it consists of two separate portions, i.e. the large pine-trees below and the mountains above.

The two other pictures in the same collection said to be inspired by Ni Tsan's art are rather different; the earlier one (dated 1599) is a short handscroll painted with "dry brush" on paper in a rather thin manner, while the later (undated) picture is a hanging-scroll of satin on which the picture is done in a bolder style. The motifs may have been inspired by Ni Tsan's river views, but they have very little in common, nor would they be mentioned as "in the manner of Ni Tsan" if this was not indicated in the inscriptions on the pictures. They illustrate the fact pointed out before, that the "manners" or "models" indicated in Tung Ch'i-ch'ang's inscriptions must not be taken literally, they are more like suggestive hints about thoughts or memories that occupied the mind of the painter while he was doing certain

pictures. This also becomes evident from the way in which Huang Kung-wang and Mi Fei are mentioned in the inscriptions on some pictures in the same collection, such as Tung's version of a section from Huang's famous *Fu-ch'un shan-chü t'u*, which is a rather sloppy performance though provided with a long colophon dated 1626.

Several other pictures dated in the same or the previous year give a better idea of Tung's manner at the time of his richest production. Beginning with those which have inscriptions of 1624, I would mention the *Hsi-shan mu-hsi-t'u* in Hui-hua kuan and the so-called View of the Shang-lin Park, formerly in the P'ang Yüan-chi collection. To these should be added the mountain view in Mr. W. Hochstadter's collection which is dated 1625 (Pl.265B) and the landscape dated 1626 which is reproduced on Pl.74 in Liu Hai-su's compendium. The two last-named pictures, which are rather closely related, give the best idea of Tung Ch'i-ch'ang's ability to combine structural design with pictorial charm. The usual motif of a stream winding between rocky mountains is beautifully developed in these pictures, which have more open space than most of Tung's landscapes and tonal values produced in the interplay of peaks and clouds. The brushwork is delicate, yet firm and very effective in bringing out the cubic values of the terraced cliffs. In these pictures there is a happy balance of all the best elements in Tung Ch'i-ch'ang's artistic repertoire, but it is only by looking at them in comparison with a number of other somewhat similar pictures commonly considered as his works, that one can realize their superior quality.

The firm and functional brushwork in the above-mentioned paintings no doubt offers the best criterion in any classification of the master's own personal creations, a quality which is more difficult to detect in the other kind of paintings, executed with soft washes in so-called Mi style, though also provided with Tung Ch'i-ch'ang's inscriptions and signatures (Pl.264B).

Among the numerous examples of this kind of

paintings should be mentioned: A handscroll in the C. T. Loo collection, New York, representing the Scenery of Hsiao and Hsiang after Mi Yu-jên, dated 1616; a hanging-scroll in the Chang Ta-ch'ien collection representing grassy hills enveloped in clouds, and the larger picture in the Boston Museum representing a pointed mountain cone rising through successive layers of mist above the usual river and rocky ledge with a clump of trees in the foreground (Pl.261B). It would be easy to quote a number of other pictures, particularly among the album-leaves, executed in a similar manner, but to discuss them without access to the actual pictures seems futile because the reproductions are often misleading with their exaggerated contrasts of black and white and consequent lack of those subtle intermediate tones which serve to suggest an atmosphere or the reverberation of a life-breath. And yet it was just in suggestions of the kind that Tung Ch'i-ch'ang sometimes revealed his poetic temperament and mastery of brush and ink.

The best examples of this particular phase of Tung Ch'i-ch'ang's pictorial mastery known to me in the original are the five large (double) album-leaves in the collection of King Gustaf VI Adolphus. The album may originally have included a larger number of leaves but the five which remain are united within a cover with the title Hsiang-kuang mo hsi (i.e. Tung Ch'i-ch'ang Plays with Ink). Each leaf has a short inscription, signed by the master, by which he indicates the model or current of style which he followed in doing the respective pictures. Even though the inscriptions are not to be taken literally, they should be quoted here because of their historical interest:

1. Terraced Rocks by a River; a man in a boat. "Conforming to I-fêng lao jên's (i.e. Huang Kung-wang's) brushwork" (Pl.266A).
2. River Landscape; a man in a boat near the bank and an old willow-tree. "Imitating Chao Ta-nien's picture: A Boat Returning on the Willow stream."
3. A Wide Bay; small buildings and leafy trees on a rocky shore. "The brushwork of Ching and Kuan

(i.e. Ching Hao and Kuan T'ung) is full of life. I follow them without necessarily imitating them."
4. River View with flat Rocks and small Houses shaded by Trees. "Imitating the brushwork of Tung Pei-yüan, who was of my family" (Pl.266B).
5. Snow over a Stream and Distant Mountains. "Imitating Mei Tao-jên's (i.e. Wu Chên's) picture Snow, over Streams."

The most interesting remark that occurs in these inscriptions by Tung Ch'i-ch'ang is no doubt the statement that he follows certain old masters without necessarily imitating them, an attitude which probably served to characterize most of his studies after old masters. He has not copied them but absorbed them in his own creative consciousness, giving fresh life to their thoughts through this faculty of absorption and exceptional command of the brush.

In pictures of this kind Tung Ch'i-ch'ang has given free scope to his brush and indulged in a kind of individual p'o mo manner (splash-ink), which appealed to him when "playing with the ink", though he also realized its dangers and limitations, as appears from the following remark: "The painting of cloudy mountains did not begin with Mi Fei; such things were already done in the T'ang period by Wang Hsia, who used the p'o mo manner. Tung Yüan loved to paint landscapes enveloped in mist, but Mi Fei painted effects of dissolving clouds and mist. It was only through Mi's picture White Clouds over Hsiao and Hsiang that I learned the secrets of ink-play (mo-hsi). I painted my picture of Ch'u Shan in this manner."

This note of appreciation in which he declares his dependence on Mi is, however, conditioned by other pronouncements which show that Tung was fully aware of the dangers of following the Mi school blindly, for instance: "Wang Wei was the originator (of this school), he was a great reformer like Wang Hsi-chih, but Mi Fei marked the highest perfection in the use of ink as a means of artistic expression and therefore also the danger point which could only be followed by decline. Very few painters could maintain his level."

Another time he writes: "Usually I do not follow Mi's manner of painting because I fear to fall into superficiality. It amuses me now to imitate it, but I dare not leave out the ideas of Tung Yüan and Chü-jan." – After all, Tung Yüan remained the principal standby, the classic ideal for Tung Ch'i-ch'ang, even though other artists served him as models from time to time; he loved to represent himself as a faithful follower of Tung Yüan artistically, and also as a descendant of the same family and thus a worthy and able continuator of the same stylistic tradition. But this had been sifted through such important intermediary creations as the works of Huang Kung-wang and friends.

Tung Ch'i-ch'ang knew perfectly well himself that the great Yüan masters were all in one way or another followers of Tung Yüan. After pointing out the differences between the Li Ch'êng and the Tung Yüan current he wrote: "The four great schools of Huang Kung-wang, Ni Tsan, Wu Chên and Wang Mêng were all derived from Tung Yüan and Chü-jan. They became very famous and were foremost within the seas." Each of these masters has been extolled by him individually, if only by his trying to follow them in his own way, i.e. not as a copyist but as an interpreter of equal standing, in accordance with his words: "Those who study the old masters and do not introduce some changes are as if closed in by a fence. If one imitates the models too closely one is often farther removed from them." Tung has certainly not offended against this rule; on the contrary he took great liberties in transmitting what he considered to be the essential spirit and ideas of certain old masters. No one will deny that the main interest of Tung's imitative paintings does not depend on the merits and characteristics of the originals, but on the individual manner in which Tung interpreted them.

II

Mo Shih-lung and Ch'ên Chi-ju

TUNG CH'I-CH'ANG's theoretical ideas and pronouncements were largely formed under influence from his two fellow citizens Mo Shih-lung and Ch'ên Chi-ju. The three men were close friends and much of what they wrote was evidently the result of mutual discussions. They were all "gentleman-painters" and representatives of the wên-jên-hua, i.e. scholarly dilettanti who could use painting just as well as writing for self-expression. They formed their lives to parallel their aesthetic ideas; neither Mo Shih-lung nor Ch'ên Chi-ju accepted any official appointments, but lived as private gentleman in the quiet surroundings of Sung-chiang (Hua-t'ing), spending their time in literary and philosophical studies, playing with brush and ink.

Comparatively little of their painted work has been preserved, and it does not seem to have been of outstanding importance, but to judge by the biographical accounts of these men and their own writings, they must have exercised a far-reaching influence on the evolution of painting. Mo Shih-lung was the oldest (though his year of birth is not definitely known), Ch'ên Chi-ju was three years younger than Tung and one of his closest friends. Intellectually they all belonged to the same set, and as Tung Ch'i-ch'ang incorporated into his theoretical writings many of the thoughts which had first been expressed by Mo Shih-lung and (to a lesser extent) also by Ch'ên Chi-ju, it seems necessary to add some information regarding these men before proceeding to a discussion of the aesthetic attitude of Tung and his friends. Their biographies are most fully related in Wu-shêng shih shih by Chiang Shao-shu, who may even have known them personally.

"Mo Shih-lung, *tzŭ* Yün-ch'ing, later used the *tzŭ* as his name and took another *tzŭ*, T'ing-han; his *hao* was Hou-ming, and also Ch'iu-shui (active *c*.1567–1583). He came from Hua-t'ing and was the eldest son of a provincial governor. At the age of 8 already he was a good student, who could grasp at once several columns, remembering them all. At the age of 10 he was a good writer; his overflowing literary accomplishments made him known as the 'boy sage'. At the age of 14 he attained the *hsiu-ts'ai* degree, and his fame became great among the students in the district school. He proceeded with the studies of a *hsiu-ts'ai*, but they did not answer to his inclinations, he preferred to occupy himself with poetry and literature, and to practise calligraphy and painting. In his poetry he followed the T'ang poets, and was able to finish a poem in a few moments. He did it (as was said in the old stories) 'while taking eight steps, or while leaning on a running horse'. In his classical prose writings he followed the style of the former Han dynasty, or that of Liu Ts'ung-yüan,[1] and in this he also gained great fame. As a calligrapher he used every style of writing, but his particular models were Chung Yu,[2] Wang Hsi-chih and Mi Fei. In his painting he followed Huang Kung-wang, studying his art very closely and executing his copies with the greatest care. He never handled the brush in a reckless fashion, and it was truly said of him that he used ten days for painting a mountain and five days for doing a watercourse. As soon as he had completed a picture people came to buy it. His fame as an artist was not less than that of T'ang Yin and Shên Chou."

The rest of this somewhat euphemistic biography may here be left out, since it does not contain any information of particular interest to us.

Mo Shih-lung's fame was based on his scholarship rather than on his skill as a painter, a fact which still holds good. The writings of his which have come down to us are, relatively speaking, more important than his paintings, few of which have survived and become known through reproduc-

tions; none of them are of outstanding importance. The most elaborate, but also the most traditional, is the picture in the Ku-kung collection called The Thatched Hut on the Eastern Hill[3] (Pl.268), which is done in ink and light colours with a care that may be said to illustrate the traditional statement according to which Mo Shih-lung used several days for painting a mountain or a stream. The composition is centred round the scholar's pavilion in a mountain valley filled with woolly mist. The most surprising thing about the picture is perhaps the fact that it is so different from Tung Ch'i-ch'ang's landscapes, being painted in a more detailed academic fashion and thus technically as well as stylistically more akin to the works of Sung masters like Liu Sung-nien than to the products of the Yüan or early Ming period. But in other examples Mo Shih-lung follows rather closely in the footsteps of Ni Tsan and even Wang Mêng, using his brush and ink more impressionistically.[4]

He was evidently less of an original painter than a learned connoisseur, whose knowledge of the old masters was stronger than his individual creative faculty. But his theoretical ideas in matters of art were nevertheless more original than those of the other men of the same circle, as will appear from a glance at his critical pronouncements. But before we give quotations from his writings some biographical information should be inserted regarding the third personality, who together with Tung Ch'i-ch'ang and Mo Shih-lung formed the leading aesthetic council of the time, *i.e.* Ch'ên Chi-ju, *tzŭ* Chung-ch'un, *hao* Mei-kung (b.1558, d.1639).

He was a typical scholar, collector and gentleman-painter who devoted himself not only to artistic occupations (calligraphy and painting) and to literary and philosophical studies (particularly Ch'an Buddhism), but also to gardening, chess-playing and tea-drinking in a more or less ceremonial

[1] One of the best writers of T'ang period, b.773, d.819.

[2] The great calligrapher, famous for his *li-shu* style, d.230.

[3] *K.-k. shu-hua chi*, vol.VII.

[4] *Bunjin Gasen*, I. 10, Dubosc Cat. No.38, and *Sōgen*, p.159.

fashion. And to judge from his mode of life, and from his numerous houses and pavilions for study as well as for the reception of congenial friends, he must have possessed the material means to satisfy his desires and to carry out his aesthetic ideas in actual life. Ch'ên Chi-ju is described in *Wu-shêng shih shih* as follows:

"He was a good student already as a child, and when he grew up he acquired great skill in poetry and literary writing. Towards the end of his life he devoted himself to the study of Taoism as well as Buddhism. At the age of 21 he passed the *hsiu-ts'ai* examination, but at 28 he gave up the official career. He built himself a straw-covered hut on the south side of the 'small' K'un shan, and there he used to sit, burning incense among tall bamboos and white clouds, thus 'opening his heart'. After he had renounced the *hsiu-ts'ai* career he never took any interest whatsoever in public affairs, except such things as drought and floods, or other national calamities which affected the people. Even when no other wealthy people of the district took it up, he helped the stricken very liberally, not minding any trouble. His penetrating faculty of judgement often aroused the anger of the officials, and they tried to obstruct his ideas. . . .

"Towards the end of his life he acquired new ground at Tung-shê, and there he built a larger house. By it he planted pine-trees and firs, and furthermore, on one side, a hundred old plum-trees, all of very rare species. Behind the house he built a pavilion called Ch'ing-wei t'ing, and transplanted there four writhing dragon pines from an old tomb-site and said 'They stand like a picture by an old master placed in front of the pavilion. I only regret that there is no splashing waterfall between the pines and the blue sky.'

"In the year 1614 he bought an old site from the Kao family, and there he made some trees into a gateway which led to a small gallery. Over it he placed a tablet with the inscription: 'Fisherman and Woodcutter' (*i.e.* hermit), and on the two sides a pair of tablets with the inscriptions 'A Fisherman

Angling in a Cave', and 'A Humming Woodcutter Seated on Leaves', inscriptions which were truly significant.

"He furthermore built a small hut on the To-lo-p'o (slope), amidst green bamboos, blue junipers, tall *wu-t'ung* trees, and large willows which offered shade from the sun. He used to come here with his friends, bringing along a bamboo stove and a cane table, to enjoy the cool air and pass the time playing chess. To the north of this was the so-called 'Herb Collectors' Pavilion', where the monks of the mountains and the hermits in grass-clothes with bamboo staves used to gather. When all these people were walking about there, the place looked just like one of Chao Po-chü's pictures of hermits.

"His style of writing was half-way between Su Tung-p'o's and Mi Fei's. Sometimes he painted landscapes, strange stones, plum-trees and bamboos, all quite original." (The biography ends with the mention of eight different men who at various times recommended Ch'ên Chi-ju for official service, an honour which he never accepted.)

Ch'ên Chi-ju preferred to live as an independent gentleman who expressed his artistic personality in everyday life and in the arrangement of his gardens and various habitations even more than in his paintings or writings. Most of his preserved works are small paintings of bamboos and plum-blossoms of little importance as works of art.[1] One of the larger landscape compositions is, according to the inscription, a direct imitation after Chü-jan.[2] The others seem more or less faithful renderings of paintings by Yüan masters, particularly Huang Kung-wang and Kao K'o-kung. His picture of Bodhidharma crossing the Yangtse on a reed, a motif which he may have chosen because of his interest in Ch'an Buddhism, can hardly be said to convey any deeper inspiration[3] (Pl.267A).

[1] Four minor albums containing such pictures have been published by the Chung Hua and the Shên Chou companies in Shanghai, 1919, 1920, 1920 and 1931.

[2] *Shimbi*, vol.19, and in *Tōyō*, vol.XI.

[3] *Shina Nanga*, III, 10.

Ch'ên Chi-ju has, however, also given expression to his ideas as an artist, a connoisseur and a collector in some theoretical notes and short treatises from which a few remarks may be quoted. The shortest is the so-called *Shu hua chin-t'ang*. It consists of remarks on "Good Ways of Enjoying" (pictures), "Destructive Conditions" (for pictures), "Correct Adornments" (of pictures), and "Calamities" (which may befall pictures). In the first category he defines twenty different situations in which pictures may be properly enjoyed, such as: "A party of connoisseurs, a Buddhist temple. . . . In the seasons of tea, of bamboo shoots, and of oranges; in the midst of mountains and streams; . . . when burning incense and cultivating Buddha; when the country is at peace, . . . When surrounded by rare stones and sacrificial tripods and vases," etc.

Among the twenty-eight "Destructive Conditions" may be mentioned: "The season of yellow plums" (humid season), Below a lamp, After drinking, . . . Too many collectors' seals, Colophons written carelessly, A hurried visitor at one's side, A room where the water is dripping in, Rain and of parching winds, The picture taken away while one is looking at it . . . Pretended connoisseurship, Sneezing rats, Servants standing about", etc.

Among the "Correct Adornments" he enumerates various kinds of precious rollers made of tortoise-shell, agate, enamel, polished gold, white jade, rhinoceros horn, and *kuan-yao* pottery; furthermore proper kinds of covers, ribbons, labels, boxes, etc., imperial seals, colophons by famous scholars, etc. And among the "Calamities" which may befall pictures, Ch'ên Chi-ju mentions for instance: "To fall into the hands of a ruffian, to be pawned, to be given to haughty people, to be cut up for making garments and stockings, . . . to be exchanged for wine and food," etc.

These aphoristic observations take us right into the collector's home, reflecting as they do his attitude of reverence towards the masterpieces of old; precious things to be preserved and adorned with the utmost care and taste and to be enjoyed only when the outward conditions are propitious and the onlookers in the right mood. The same principles still hold good in regard to Far Eastern painting, though they are nowadays applied with less zeal in China than in Japan.

Ch'ên Chi-ju also wrote many colophons (particularly on pictures by Tung Ch'i-ch'ang) and appreciations of pictures by old masters as well as remarks on aesthetic principles and the evolution of painting, and some of these writings have been preserved in the treatises called *Ni ku-lu* and *Shu-hua shih*,[1] of which the latter is mainly a short résumé of the former with certain additions. The contents are quite miscellaneous, consisting largely of observations on specimens of calligraphy and painting which the author has seen or possessed, and also of historical and aesthetic notes, inspired in part by Mo Shih-lung's short treatise *Hua-shuo*, which must have been known to Ch'ên Chi-ju, even though he never indicates this source of inspiration.[2] Ch'ên Chi-ju's publications are thus in the nature of personal notebooks in which he recorded sayings by others as well as his own thought. The importance attached to Mo Shih-lung's writings is furthermore proved by the fact that many of them are also incorporated in Tung Ch'i-ch'ang's treatises *Hua-yen* and *Hua ch'an-shih sui-pi*, which were edited after the death of Tung.[3] These treatises are also rather unsystematic and made up of a mixture of personal observations and ideas borrowed from earlier writers, particularly Mo Shih-lung. The fact that Mo was the oldest of the three friends and passed away at a comparatively early age, makes it evident that priority must be accorded to him. He seems to have been the most original thinker and the one who first formulated certain aesthetic and historical

[1] Both reprinted in *Mei-shu ts'ung-shu*, part II, section 1, last volume.

[2] Mo Shih-lung's *Hua-shuo* is included in *Pao-yen t'ang-pi chi*, which was edited by Ch'ên Chi-ju.

[3] Tung Ch'i-ch'ang's *Hua-yen* is included in *Hua-hsüeh hsin-yin*; the same material with certain additions is found in *Hua Ch'an-shih sui-pi*.

ideas regarding the aim and evolution of painting, which then gained a wider circulation and more general acceptance through the works and writings not only of Tung Ch'i-ch'ang and Ch'ên Chi-ju, but also through later painter-critics such as Li Jih-hua and Ku Ning-yüan. In presenting some extracts from this common material we will therefore principally confine ourselves to Mo Shih-lung's *Hua-shuo*, supplementing it with some quotations from Tung Ch'i-ch'ang's *Hua-yen*.

The question which seems to have occupied Mo Shih-lung and Tung Ch'i-ch'ang more than any other in the field of aesthetic speculation, was the one concerning what they called the Northern and the Southern school of painting. It had to them a far-reaching historical background and implied a classification of practically all painters, past and present, according to certain theoretical principles which also lead to a definition of what they called the gentleman's, or scholar's and high official's (*shih-ta-fu*) painting, or sometimes, the literary school of painting (*wên-jên-hua*). As this classification has remained a fundamental feature of Chinese art-history up to the present day, it seems appropriate to give some information about its meaning and origin.

The theory was perhaps, after all, based less on historical studies of painting than on the great interest of these men in Ch'an Buddhism. It was constructed as a parallel to the division which had taken place in the evolution of this Buddhist school; the painters were classified, as far as possible, in accordance with this. It was first formulated by Mo Shih-lung, as pointed out by Tung Ch'i-ch'ang in a colophon(?) in which he speaks about the mutual admiration of Ku Chêng-i and Mo Shih-lung: "When Mo Shih-lung appeared, the division between the Northern and Southern school was started. On a small landscape by Ku Chêng-i he wrote that he considered it divine and extra-ordinary, and Ku Chêng-i expressed to me the greatest admiration for Mo Shih-lung's pictures. They praised each other continuously in poems and prose-writings." Tung Ch'i-ch'ang copied textually Mo Shih-lung's definitions as follows:

"In Ch'an Buddhism there is a Southern and a Northern School, which first separated in the T'ang period; in painting a similar division into a Southern and a Northern school was brought about in about the same period. But the men (who represented these schools) did not come from the South and the North (respectively). The Northern school took its origin from Li Ssŭ-hsün, father and son, who used colours in their landscapes; their manner was transmitted in the Sung period by Chao Kan,[1] Chao Po-chü, Chao Po-su down to Ma Yüan, Hsia Kuei and others. The Southern school started with Mo-ch'i (Wang Wei), who used light washes of ink instead of fine lines (hookings and cuttings), and this was continued by Chang Tsao, Ching Hao, Kuan T'ung, Tung Yüan, Chü-jan, Kuo Chung-shu and the two Mi, father and son, down to the four great masters of the Yüan period. It was just as in Ch'an Buddhism; after the time of the Sixth Patriarch, the Ma-chü, Yün-mên and Lin-chi (schools) developed as flourishing offshoots (of the Southern school), while the Northern School was declining. Very important is the saying by Mo-ch'i, according to which clouds, peaks, and stones should be formed as by the power of Heaven; then, if the brushwork is free and bold, the picture may rank as a creation of nature. Tung-p'o praised Wu Tao-tzŭ's and Mo-ch'i's wall-paintings and said that as to Mo-ch'i, there could be no word of disparagement. That is certainly right."

Wang Wei (Mo-ch'i) was, according to these men, the great precursor, and Tung Ch'i-ch'ang spent no little time in looking for works by him, which he then studied for whole days and months and wrote about extensively. One or two paragraphs may be quoted in which he further characterizes Wang Wei's poetic art as the origin of the "literary men's paintings" (*wên-jên hua*).

"It is commonly said that the painters before Mo-ch'i were not lacking in skill, but could not

[1] A painter of the South T'ang period.

transmit the spirit of a landscape (the emotions evoked by it). They had not yet reached that point. Mo-ch'i started the use of wrinkles (*ts'un-fa*) and of ink-washes. It was just as when Wang Hsi-chih changed the style of Chung Yu by writing characters like the lifting *fêng* and the flying *luan*; they seemed strange, but they were really correct. The painters who followed after Mo-ch'i all expressed some ideas of their own, as for instance Wang Hsia and Li Ssŭ-hsün. The former used to splash and sprinkle the ink, the latter painted gracefully in colour. As the art of expressing much by little (the use of short cuts, *i.e. hsi-ching*) had already been established, it was not difficult to follow suit."

Even as a painter Wang Wei was primarily a poet; he was no longer tied by traditional rules, and worked in a freer fashion aiming at a closer representation of nature, but at the same time he was employing painting as a complement to poetry. He was the first typical poet-painter of the gentleman-class. This is further expressed by Tung Ch'i-ch'ang in other notes:

"The literary man's painting started with Mo-ch'i; then followed Tung Yüan, Chü-jan, Li Ch'êng and Fan K'uan, who were all his faithful successors. Li Lung-mien, Wang Chin-ch'ing, Mi Fei and his son Hu-êrh, all learned from Tung and Chü, and this tradition was continued by the four great masters of the Yüan period, Huang Kung-wang, Wang Mêng, Ni Tsan and Wu Chên in an unbroken line. During our present dynasty Wên Chêng-ming and Shên Chou were the distant transmitters of the same tradition. As to Ma Yüan and Hsia Kuei, Li T'ang and Liu Sung-nien, they all belonged to the school of general Li, and we should not study them."

The above statements are interesting as confirmations of the essential identity of the Southern School and the *wên-jên hua*, and also of the fact that this current of style was continued in the Ming period by the leading masters in Suchou, who were all men of literary culture or poet-painters and not professional artists. The ideals of these men are further discussed in several sayings by Mo Shih-lung and Tung Ch'i-ch'ang; the former for instance wrote:

"The Tao of painting is to hold the universe in your hand. There will then be nothing before your eyes which is not replete with life, and therefore such painters often live to a ripe old age. But those who work in the fine and finicky manner (*k'o-hua*) make themselves the servants of nature and shorten the length of their lives; it does not increase their life-force. Huang Kung-wang, Shên Chou and Wên Chêng-ming lived to be over 80 years old. Ch'iu Ying lived to 50, Chao Mêng-fu lived to a little over 60; they did not belong to the same class, yet they were both men of common routine who did not use painting as a means of expression, nor did they get any happiness out of it. The one who first combined painting as a means of expression with pleasure was Huang Kung-wang – it was he who opened the door", *i.e.* to the later gentleman-painters, including the writer and his friends.

In discussing some of the old painters like Chao Ta-nien, Mo Shih-lung is not very consistent in his appreciations. Once he praises Chao Ta-nien for painting far-extending views similar to those of Wang Wei, and says that "he was certainly the gentleman-painter of Sung", but another time he repeats the traditional criticism referring to Chao Ta-nien's lack of sufficient experience, "he did not walk ten thousand miles, nor did he read ten thousand books, how could he then be a real ancestor of painting? That is precisely what we ought to do instead of looking to common painters."

In other words, painters should combine real scholarship with extensive studies of nature, and in spite of their attachment to a certain tradition and their close studies of old masters, these scholarly painters were by no means indifferent to observations of nature. Mo Shih-lung and Tung Ch'i-ch'ang equally insist on this point in various utterances, as for instance the following, which is found in the writings of both:

"Painters usually take the old masters as their

models, but it is better still to take Heaven and Earth as teachers. Every morning one should observe the changing effects of clouds – in old paintings they look like mountains – and go out among real mountains. When one sees strange trees, one should study them from all four sides. The trees have one side which is suitable and another which is not suitable for a picture; they may be effective from the front, or from the back. If one observes them thoroughly one will transmit their spirit naturally, but for this transmission the form is necessary. The form, the mind, and the hand must all support each other, though unconsciously (forgetting each other). That is the proper way of expressing the spirit. How could there then be any trees which are not suitable if properly introduced into a picture?"

Even to these men close communion with nature was a fundamental condition for great art, but the proper study of the old masters was essential for a formal development of their style. Their endeavour was not to imitate or copy slavishly the models of old, but to grasp their essentials, or what they called "the spirit of the old masters", and to transmit it in their own way. The following observations by Mo Shih-lung (also included in Tung Ch'i-ch'ang's writings) are in this respect significant:

"As I once said, the style of Wang Hsi-chih and his son was no longer continued during the Ch'i and Liang dynasties. At the beginning of the T'ang dynasty Yü Shih-nan and Ch'u Sui-liang again completely changed the manner of writing; they were different from, yet like (the two Wang). Wang Hsi-chih and his son seemed reborn in them. These words are not so easily understood, because however easy it may be to make a close copy, it is difficult to transmit the spirit. Chü-jan studied (Tung) Pei-yüan, Yüan-chang (Mi Fei) studied Pei-yüan, Huang Kung-wang studied Pei-yüan, and Ni Tsan studied Pei-yüan, they all followed the same model; yet they were not like one another. But when ordinary people make faithful copies, they do not transmit anything to posterity."

Tung Ch'i-ch'ang's own remarks, in which he says that cringing copyists are enclosed by a fence, have already been quoted and need not be repeated, but it may be of interest to recall what he means by "the spirit of the old masters", or "the spirit of art", that animating breath which according to him cannot be communicated by ordinary copyists. He links it up with the traditional concept of ch'i-yün, the resonance or reverberation of the life-breath, a force or quality latent in the painter, which has to be developed by spiritual and formal training so as to become the guiding and sustaining factor in his creative activity. He wrote:

"The reverberation of the life-breath cannot be acquired by study but is inborn in the painter. It is the gift of Heaven, yet some of it may be learned. If one has studied ten thousand volumes and walked ten thousand miles and has freed one's mind from all dust and dirt, beautiful landscapes will take form within one quite naturally and become established. The outlines produced by the work of the hand will transmit the spirit of the landscape."

If the above quotation points to the importance of a wide culture and profound study of a general nature – which according to Tung implied the practice of Ch'an – in another connexion he defines certain elements of the formal expression which he considers particularly important: "The methods of doing the wrinkles and the deepest secrets in art cannot be taught. Among the Six Principles of painting ch'i-yün is the result of something inborn (in the painter). The more skill that is applied, the farther ch'i-yün recedes."

The same concept is also expressed by Ch'ên Chi-ju in one of his short notes in Ni-ku-lu. He speaks there about certain elements in calligraphy which cannot be acquired by study, and adds: "They are like ch'i-yün in painting, which must be inborn. The Ch'an Buddhists call this (gift) wisdom without a teacher. It cannot be forced."

But in order to make it recognizable in painting it had to be transposed by the painters into visible shapes, a problem often discussed by Chinese

writers, as we have had occasion to observe in several of the preceding chapters.

In the above quotation Tung Ch'i-ch'ang mentioned the *ts'un fa* (the method of making wrinkles) as one of the deepest secrets in art, as something that cannot be taught, and it is also evident from other remarks by him and by Mo Shih-lung that they attached the greatest importance to this element in the technique of the painter. One of the reasons for this may have been that the "wrinkles" were perhaps the most subtle strings on the painter's instrument, strings which he could make reverberate with his life-breath or reflect his temperament. They were formal elements through which imprints of his thoughts were transmitted by the brush. This could never be fully explained, only suggested in words:

"Men of former times said: 'One must have brush and ink.' Many people do not understand the significance of these two words, brush and ink. But how could there be pictures without brush and ink? If pictures are executed simply with lines and without wrinkles, they are said to be made without brush, whereas pictures which have wrinkles but no variations of tone (light and heavy) and no distinction between the back and the front of the objects, or between the light and the dark (parts) (modelling?), are said to be done without ink."

Through a previous quotation we have also learned that Wang Wei's position as the founder of the Southern School and the *wên-jên hua* was, according to Tung Ch'i-ch'ang, closely connected with the fact that he introduced the method of using wrinkles, which evidently became a means of transmitting the "spirit" of nature; and this was further developed by his followers such as Tung Yüan, Chü-jan and others. Each of the great painters had his own mannerism in brushwork, his own kind of *ts'un fa*, designated by various descriptive terms. Ch'ên Chi-ju enumerates several of them, but it hardly seems necessary to repeat them here; it may, however, be recalled that the same author also emphasizes the importance of the brush and the ink, which contain "the strength, the skill, the spirit, the courage, the study and the knowledge of the painter". These technical means and their proper use, which constituted the central problem of the painter's art, have been the subject of endless discussions, but it may be doubted whether their intrinsic characteristics have ever been made clearer or more comprehensible through descriptive definitions, because they are not intellectual concepts but elements in visual symbols, the meaning of which must be grasped through mental or imaginative perceptions innate in the seeing eye.

III

The Hua-t'ing and Su-Sung schools:
Ku Chêng-i, Sun K'o-hung, Chao Tso and Shên Shih-ch'ung

KU CHÊNG-I, who is traditionally considered as the founder of the Hua-t'ing school, was probably a little older than Mo Shih-lung and Tung Ch'i-ch'ang. His close friendship with them is brought out in several colophons; and he served for a while as the teacher of Tung, who considered him a prominent representative of the Southern school.

The following notice is included in *Wu-shêng shih shih*: "Ku Chêng-i, *tzŭ* Chung-fang, *hao* T'ing-lin, from Sung-chiang, served as secretary in the Chung Shu (Central Board). As a painter he first followed Ma Wên-pi,[1] then Mei Tao-jên and Huang Tzŭ-

[1] Ma Yüan, *tzŭ* Wên-pi, was a painter active in the Hung Wu period who also followed the Southern school.

chiu and grasped the innermost secrets of their art. President Tung Ssŭ-po often took Chung-fang's pictures as models. When he went to the capital, crowds of scholars and officials from every quarter came to ask for his pictures, and when they obtained the masterpieces of his brush they treasured them like precious jades." His personality and circle of friends are further described in *Sung-chiang chih*[1] as follows: "Ku Chêng-i followed Huang Kung-wang in painting and had many paintings by famous masters in his home. He was a good friend of Sung Hsü from Chia-hsing and of Sun K'o-hung in Hua-t'ing. He searched deeply for the aims of the art of painting and founded a school of his own. Later in life he lived by the Cho-chin river. There he made a small garden with many trees; it was a quiet and pure place where he ended his life."

Mo Shih-lung confirms in particular the studious character of his friend: "Ku Chung-fang was very fond of the brushwork of the four great masters of the preceding dynasty and collected many fine works by them. Whenever he had time he unrolled these pictures, and in copying them he grasped their very essence and came, indeed, very close to the originals."

Four of his pictures in the Ku-kung collection are known to us in reproduction and, besides these, five album-leaves with landscape-studies were on exhibition in Hui-hua kuan in 1954. None of them is distinguished by a clearly marked individual style, but they reveal suppleness and skill in transmitting impressions of the Yüan masters. Most interesting in this respect is the little picture of some bare trees and young bamboos after Ni Tsan; seven of the painter's friends wrote poems or colophons on it besides himself, the best known among the writers being Sun K'o-hung and Tung Ch'i-ch'ang.[2] The latter wrote: "In this picture Chung-fang has really grasped the bare trees of Li Ch'êng. They are superior to those of Ni Tsan" – an opinion which may be said to reflect more friendship than truth. The painter's admiration for Ni Tsan is more simply expressed in his own poem: "White stones in the shade of slender bamboos; cold springs which bubble softly. Ni Tsan often did things like this. His thoughts were lofty as the azure sky."

There is a somewhat larger picture representing deeply creviced mountains overgrown with twisted pines and shady trees among which a solitary wanderer is seeking the coolness of the mountain air, in which the artist has followed in the footsteps of Wang Mêng (Pl.269). It seems remarkable by its structural quality.[3] In the inscription he gives expression to his friendship with Tung Ch'i-ch'ang as follows: "For many years I copied real works by the great masters of the Sung and Yüan periods. I learned to some extent to grasp their marrow and their spirit. Ssŭ-po (Tung Ch'i-ch'ang) followed my directions, but now he has surpassed me. Whoever sees my picture will admit the truth of that."

Ku Chêng-i's tall composition called Streams and Mountains in Clear Autumn, dated 1575,[4] is a no less important picture from a stylistic point of view. The compositional elements are traditional and the general lines of the design remind us of works by other followers of Huang Kung-wang and Wang Mêng, but the mountains and cliffs are somewhat unusual, because they are not pointed or rounded at the top but truncated in square shapes, a feature which is considered particularly characteristic of the Hua-t'ing school (Pl.270). In the *Hua shih-hui yao* his style is described as follows: "In Chêng-i's pictures most of the mountains have square tops. They consist of layer upon layer and peak after peak. Trees are used only sparingly; but the effect is natural, deep and beautiful. Such is the Hua-t'ing school."

The description fits the last-mentioned picture, which may thus be taken as a typical example of this local school, but the square mountain tops are not to be seen in the two other works ascribed to the same painter.

[1] Quoted in *Sung-Yüan i-lai*.
[2] *K.-k. shu-hua chi*, vol.VII.
[3] *Ibid.* vol.XLIV.
[4] *K.-k. shu-hua chi*, vol.V.

Of the two painters Sung Hsü (1523–c.1605) and Sun K'o-hung (1532–1610), mentioned in the biography of Ku Chêng-i as his particular friends, the former really belonged to an earlier generation. His style seems to have been formed through studies of Shên Chou's art, as appears from the examples mentioned in a preceding chapter.

Sun K'o-hung, on the other hand, has sometimes been placed in a later period,[1] but he was also contemporary with Ku Chêng-i, his friend and fellow-citizen. His *tzŭ* was Yün-chih, his *hao* Hsüeh-chü, and he served for some time as governor of Hupeh. When he retired he built himself a beautiful house in a suburb of Hua-t'ing, where he displayed his collection of strange stones, sacrificial vessels, writings, and paintings. The objects and furniture in the house were kept as bright as mirrors. When people came to call on him, he ordered his servants to entertain the guests with music and songs of the kind performed on the stage, as well as with dancing and pantomimes. He became known as a generous and wide-hearted man, whose house was open to artists and artisans of every kind. We are told that he often said smilingly: "Every place at my table is always occupied and the cups are never empty." His original and generous way of life and his artistic home are furthermore described in *Wu-shêng shih shih* as follows:

"In order to create an impression of coolness he decorated the walls of his room with pictures of pine-trees, cedars, breaking waves, and rushing streams, and when there were no guests he spent his time in copying old pictures and writings. If at the time some disturbing influences from the outside world or some family matter reached him, he put his hands to his ears and stared at the people in an angry fashion.

"He started with flower and bird-painting in which he followed Hsü Hsi and Chao Ch'ang, but in later years he followed Ma Yüan in painting water, and the two Mi, father and son, in painting cloudy mountains. People came from far and near in great numbers to ask for his pictures, and several

painters made a living from imitations after them. Consequently less than ten per cent (of the works attributed to him) are genuine."

These notes are to some extent illustrated by a very entertaining series of twenty small pictures, mounted in the form of a scroll (in the Ku-kung collection) known as *Hsiao-hsien ch'ing-k'o t'u*. They represent scenes from the leisurely life of a scholar, his occupations in the house and in the garden, such as Receiving Guests (Pl.271A), Boiling Tea Water, Examining Pictures, Practising Calligraphy, Burning Incense, Admiring the Rising Moon, Drinking Wine, Sitting up through the Night in Conversation with a Monk (Pl.272B), Worshipping Buddha, Listening to the Rain, Enjoying Bamboo (Pl.272A), Watering Flowers (Pl.271B), Excursion to the Mountains, etc., *i.e.* a number of very simple but intimate and telling scenes from the garden and pavilions of a well-to-do gentleman who occupied himself only with such things as were prescribed by tradition for a true scholar. The artistic value of the pictures is definitely inferior to their historical interest, which is increased by their descriptive titles.

Sun K'o-hung was hardly a leading painter, his artistic talent being less developed than his faculty of making life enjoyable to himself and his friends; but he was not only a well-to-do scholar, trained in the management of the brush, but also a keen observer of nature who found pleasure in representing the actual surroundings of his country home.

The figure-paintings ascribed to him in Japanese collections seem rather doubtful and hardly worth further consideration,[2] whereas some of the flower studies signed by Sun K'o-hung should be remembered. The little picture in the Ku-kung collection,[3] representing a bouquet of Flowers of the Fifth Month, is distinguished by the sensitive rendering of the various flowers, whereas the large picture in

[1] *Cf.* Waley's *Index*, p.83, and *Tōyō*, XII, where one of his works is reproduced among those of the late Ch'ing period.

[2] *Cf. Tōsō*, p.333. Han-shan and Shih-tê; also *Shina Nanga*, I, 22. Kuanyin with the Fish Basket.

[3] *K.-k. shu-hua chi*, vol.XXI.

Japan which represents an overhanging rock with a plum-tree and some bamboo-shoots is a more decorative design.[1]

The only landscape of some importance by Sun K'o-hung known to me is in the C. T. Loo collection and was included in the Toronto Exhibition 1956.[2] It is called A Monastery among Mists and represents a deep gulley between steep hills with small buildings among the trees on the slopes. The hills are largely veiled by the light mist; only the dark tall pine-trees detach themselves from their white surroundings. They form pillared rows at both sides of the pathway that leads to the temple gate, and contribute as such to the rising rhythm of this well-unified design.

The most gifted among the painters of the Hua-t'ing group was no doubt Chao Tso, tzŭ Wên-tu. He was probably a few years younger than the man mentioned above, though still a close friend of Tung Ch'i-ch'ang and usually classified as the founder of the so-called Su-Sung school which, according to the name, was a combination of certain elements of style derived from the Suchou and the Sung-chiang painters. To describe these in detail without passing in review a number of works from both quarters is hardly possible, but generally speaking it may be said that Chao Tso's landscapes are distinguished by a pictorial, not to say colouristic, quality seldom found in the works of the contemporaries mentioned above. His relative independence and originality as a painter are evidenced by the fact that he is traditionally considered as the representative of a special school, which, however, had very few followers.

In the Sung-chiang chih we are told that "he studied under Sung Hsü together with Sung Mou-chin, but whereas Sung Mou-chin painted in a loose and sprinkling fashion, Chao Tso never worked carelessly. His model was Tung Yüan, but he combined this model with ideas derived from Huang Kung-wang and Ni Tsan. The spiritual reverberation (shên-yün) was quite unrestrained in his works and they were highly treasured among scholars."[3]

Chao Tso has also left some observations on the general principles and technique of landscape-painting, but before we quote from them we should pay attention to some of his pictures. He seems to have worked with great ease and must have produced quantities of paintings both under his own name and under that of Tung Ch'i-ch'ang, because he was quite capable of excellent imitations. Their dates range from 1609 to 1629 and most of them are painted with light washes of colour in addition to ink. But he has also painted with ink only, as may be seen in the picture in the former Abe collection (in the Ōsaka Museum), which in some respects is his masterpiece. One of his early works (dated 1611), called Autumn Mountains and Red Trees,[4] is, according to the inscription, a version of a picture by Yang Shêng, the famous master of the eighth century, who was particularly appreciated for his snowscapes executed in colour, mostly in adherence to Chang Sêng-yu's "boneless manner". It seems as if this early type of coloured landscapes had been of some importance for the formation of Chao Tso's style. He followed methods somewhat similar to those of the old masters, though in a more modern and fluent transposition, working with a broader brush and lighter washes of colour. The influence may be traced in several of his most effective landscapes.

As an example of this free transformation of the old coloured landscapes into impressionistically executed large compositions may be mentioned the picture in the National Museum in Stockholm which represents An Autumn Morning, with wisps of mist circling round wooded mountains (Pl.273). Some small cottages are placed in a valley at the foot of the mountains and in one of them may be seen a man seated in silent contemplation. Farther away among the trees on the terrace appear the roof of a temple and its pagoda. The large trees on the river-

[1] Tōyō, vol.XII, also in Later Chinese Painting, pl.122.

[2] Cat. No.29. Inscription by Ch'ên Chi-ju.

[3] Quoted in Sung-Yüan i-lai.

[4] K.-k. shu-hua chi, vol.XVII.

bank in the foreground are dropping their leaves and turning to autumn colours; a faint rosy tone prevails as if the sun were trying to break through the misty atmosphere. The brushwork is easy and light, yet not without strength in the drawing of the trees and the crevices of the mountains. It is akin to Tung Ch'i-ch'ang's manner, though of a more decoratively pictorial kind. It is dated 1615, *i.e.* in the same year as the so-called Thatched Hut by a River in the Ku-kung collection,[1] which represents a somewhat similar though more traditional design. The river valley at the foot of the mountain range is here covered with dense mist, only the large leafy trees at the bottom and the mountain peaks at the top detach themselves from the soft covering blanket. Other details are lost in the moisty atmosphere, which seems to be almost opaque.

A more attractive example of Chao Tso's pictorial expressionism is, however, the above-mentioned picture in the former Abe collection which, according to an inscription by Ch'ên Chi-ju, represents a scholar who has come to visit a monk in his thatched cottage in a bamboo grove (Chu-yüan) at the foot of The Temple of the Crane Forest (Ho-lin ssŭ). It is painted in ink not only with great ease, but the scene is full of the atmosphere of a warm summer day and makes us feel the deep harmony of the motif. It reveals Chao Tso's individual talent as an expressionist who could transmit a situation with a few reducing strokes of the brush (Pl.274).

When he worked in a somewhat more elaborate and detailed manner based on studies of Sung and Yüan masters he sometimes sacrificed pictorial beauty for the intricacies of minor structural details, as may be seen in the highly finished mountain landscape in the Ku-kung collection.[2] In the long handscrolls belonging to the Kurokawa Institute in Ashiya and to Mr. James Cahill in Washington, he has developed continuous landscape designs, which are remarkable for their structural unity just as much as for the fresh naturalistic effect.

Chao Tso was also a member of the artistic circle which gathered round Tung Ch'i-ch'ang, and his observations on landscape-painting may have ripened as fruits of discussions with his older friend. They are reported in a short treatise called *Hua-yu lu*[3] and in *Wu-shêng shih shih* in connexion with the notes on his close friendship and co-operation with Tung Ch'i-ch'ang: "The two gentlemen were, indeed, companions in the realm of art like the ancient states of Lu and Wei; some of Tung's pictures were painted by Chao Tso, and although he was not like the guard at the side of the throne[4] (*i.e.* a superior), yet his pictures could pass as substitutes (it was like buying a Wang and getting a Yang). In his discussion on painting he says among other things: "In painting large landscapes the principal thing is (structural) strength (*shih*). A mountain which has strength may be twisting and winding, high or low, but its life-veins are continuous." (This demand for structure and strength is also applied to paintings of trees, stones and mountains in which, furthermore, the veins and wrinkles are of decisive importance.) "The manner of making the wrinkles, of drawing the outlines (hooks and cuts), of dividing and combining, is all in (dependent on) the structural veins. As to bridges, villages, towers, temples, boats, carriages, figures, and houses, the impressions they convey of formal strength depend on how they are placed, how they are partly hidden or introduced as accessories.

"You should first work with a dry brush and scrutinize every part carefully to make sure that no further changes are needed, then you may spread the ink and the whole thing will become interesting. In painting far-away trees, you should make them indistinct; ornamental trees should stand close together, so that they connect and intertwine, partly hidden and partly visible. Light mist, distant shores,

[1] *K.-k. shu-hua chi*, vol.IX.

[2] *K.-k. shu-hua chi*, vol.XIV.

[3] Quoted in *Sung-Yüan i-lai*.

[4] Reference to a story of Ts'ao Ts'ao (155–220) who once stood as a guard by his own throne on which he had placed a subordinate minister, because he was afraid that his ugly appearance would make an unfavourable impression on some envoys from the Hsiung-nu.

scattered stones, hidden streams, young bamboos, luxuriant grass, and such things, should simply be added according to your ideas. Mist around the peaks and clouds in the valleys should serve to reflect light on the mountains all round (front and back, right and left) and should be rendered in such a way that from the point where they issue to the point where they recede, whether broken up or continuous, it corresponds to the structure of the mountains. Watercourses, roads and paths should be partly visible and partly invisible; you should make them winding and connect them with the veins of the mountains.

"To sum up; if your manner of composing is not based on careful thought, but simply consists of filling up holes, it will be like a patched gown. How could it then arouse the admiration of other people? Thus, the most important point in regard to the composition (the spreading of the view) is to lay hold of (structural) strength. Then, when one looks at it, the picture will seem as if filled with one breath of life, and if one examines it more closely, one will find that the spirit and the veins are in harmony, and that it is the work of a great man . . ."

The painters who gathered around Tung Ch'i-ch'ang and Chao Tso in Sung-chiang can hardly be said to have been of leading importance, even though they are characterized in superlative (not to say stereotyped) terms in *Wu-shêng shih shih*; their fame is of local origin and their works are little known. The oldest among them was probably Sung Mou-chin, *tzŭ* Ming-chih. He is said to have studied Chao Po-chü, Wu Chên and Huang Kung-wang; "his brush was elegant, his ink rich, his hills and valleys fresh and luxuriant. The most famous painters of the time like president Tung Ssŭ-po (Ch'i-ch'ang) and the provincial examiner Tsou Ti-kuang praised his pictures highly. He held an equal place with Chao Tso." The two pictures of his which are reproduced in an album devoted to the Sung-chiang school are not distinguished by any outstanding qualities;[1] one of them represents a garden with magnolia trees and high rockeries, the other some small cottages under overhanging cliffs, and both are painted in a more traditional style than that of Tung Ch'i-ch'ang or Chao Tso.

Wu Chên, *tzŭ* Chên-chih and Yüan-chen, *hao* Chu-yü, is said to have followed in particular Huang Kung-wang. Chiang Shao-shu writes of him (in *Wu shêng shih shih*): "I once saw his copy of Huang's picture Floating Vapours over a Warm Sky, and some others; their wrinkles and washes of colour were overflowingly rich. He aroused the resonance (*yün*) which is beyond brush and ink. They were really the works of a scholar. The painters of Yün-chien since the time of president Tung Ssŭ-po, who was the standard-bearer of the literary men (*wên-jên*), were all exalted scholars, aiming at excessive refinement, but the things they have left behind (*i.e.* their works) are hardly more than skin deep; but Chu-yü may be said to have transmitted the real Yün-chien school." His pictures are nowadays quite rare, only four of them are known in reproductions; they reveal a sensitive but rather fluctuating temperament influenced not only by the Yüan masters, but also by academic traditions of the Sung period, as may be seen in the picture of Autumn Mountains in Mist in the Seikadō collection, which is marked as an imitation after Hsia Kuei.[2]

Shên Shih-ch'ung, *tzŭ* Tzŭ-chü, who also came from Sung-chiang, according to the *Ming-hua lu*, followed Sung Mou-chin and Chao Tso, but like these two painters and a few less prominent, he imitated Tung Ch'i-ch'ang in particular. We are furthermore told that "his brush-manner was pure and exuberant, very firm and yet freely flowing; his style and (vital) resonance were both excellent." The same characterization is more or less repeated in *Wu-shêng shih shih*, where it is said that he painted "luxuriant hills and valleys with wrinkles and washes of colour, overflowingly rich. He was the principle transmitter of the Yün-chien school."

[1] *Sung-chiang p'ai ming-hua chi*, published in 1924 by the Shên Chou Co., Shanghai.

[2] *Cf. Kokka* 370.

This is no doubt correct in so far as none of the other Sung-chiang painters imitated the head of the school more assiduously. Shên Shih-ch'ung might almost be called the double of Tung Ch'i-ch'ang, because he absorbed the style of the master so successfully that many of his paintings have been accepted as works by Tung Ch'i-ch'ang, particularly when also provided with Tung's authentic signature. An explanation of this surprising fact, which has contributed to the confusion regarding Tung Ch'i-ch'ang's pictorial *œuvre*, may be found in the following anecdote quoted by Sun Ta-kung from *Sung-chiang chih*:[1]

"Ch'ên Chi-ju once sent a letter to Shên Shih-ch'ung as follows: 'Tzŭ-chü, my old friend, I am sending you herewith a scroll of white paper together with the brush-fee of three ounces (?). Would you be so kind as to paint a landscape for a large hall and have it ready for tomorrow? But do not write your signature on it, because I want our friend Tung Ssŭ-po to put his name on it!' " – a demand which president Tung presumably could not refuse to his friend Ch'ên Chi-ju, since he had often done the same thing, thus increasing, by affixing his highly appreciated signature, the value of pictures done by friends. This practice, which may seem surprising to us, was by no means a novelty introduced by Tung and his friends; it was a good old tradition, particularly recorded also in the biographies of other famous masters, as for instance Shên Chou. But the result of it has indeed contributed to the overloading of the *œuvre* of masters, no less benevolent than famous, and to making them responsible for paintings which simply constitute a dead weight in their artistic legacy.

If we look for paintings which for stylistic reasons may be considered as works by Shên Shih-ch'ung, though provided with the signature of Tung Ch'i-ch'ang, we find one of the most prominent examples in the Ku-kung collection, *viz.* the large landscape representing old trees and soft hills along a river, which according to the inscription is inspired by a T'ang poem and called "Frost-bitten Trees in Autumn"[2] (Pl.275). The design is beautifully unified in a large rising curve and the brushwork is easy and free, but somewhat thicker and more inky than in Tung Ch'i-ch'ang's own works, which as a rule have a more structural quality. We agree with the modern Chinese experts who consider the picture as a work by Shên Shih-ch'ung rather than by Tung Ch'i-ch'ang. As a stylistic support for this opinion may be recalled the section of a handscroll (in a Japanese collection) by Shên Shih-ch'ung, in which the mountains are shaded and wrinkled in the same manner as in the picture under discussion.[3]

Other examples of a similar kind could easily be picked out among the pictures ascribed to Tung Ch'i-ch'ang (and often inspired by him); as a rule they show more skill than refinement, a more obvious or striking decorative effect than Tung's personal works, but it seems useless to enter into such a discussion here without the support of a sufficient number of reproductions.

Among the pictures signed by Shên Shih-ch'ung himself may be recalled the large landscape in the Ku-kung collection known as The Study in Fragrant Nature,[4] which is dated 1623 and painted with light colours in the vaporous manner which was characteristic of the Yün-chien school. The handscroll in the Boston Museum, which represents landscapes in Four Seasons, is signed and dated ten years later (1633), and executed with an easily flowing brush and effective use of light coloured washes to suggest wisps of mist and faint lines of an evening sky. The painter has certainly understood how to utilize the impulses received from Tung Ch'i-ch'ang and to infuse new breath into traditional designs by pictorial means. He was not one of the leading creative masters, but a very accomplished painter who should be remembered not only

[1] *Chung-kuo hua-shih jên-ming ta-tzŭ tien*, p.146.

[2] *K.-k. shu-hua chi*, vol.XXI.

[3] *Cf. Sōgen*, p.189.

[4] *K.-k. shu-hua chi*, vol.VIII.

as an imitator of Tung Ch'i-ch'ang but also because of his way of transmitting the shifting moods of landscape in pictorial values.

The success of the minor men was, indeed, to no small extent dependent on their ability to imitate the leading masters, and among these none was more influential at the time than Tung Ch'i-ch'ang.

His personality was dominant not only at his home in Sung-chiang (Hua-t'ing) but all over the country. The principles which he advocated in theory as well as in practice were accepted by most of the painters active during the last four decades of the Ming period, as we shall have occasion to notice in the following chapters.

Various Centres of Landscape-painting

I

Introduction

THE TWO well-known currents of style, named after the Chê and the Wu school, which formed fundamental features in the development of painting during the heyday of the Ming dynasty had lost most of their distinctive qualities and practically ceased to function as main arteries in the field of painting about the middle of the sixteenth century. The reason for this was, however, by no means a general decline or decrease in the production of painting, quite the contrary; it may rather be described as the consequence of the lavish, not to say exuberant, growth in the practice of pictorial art which reached its culmination at the very end of the Ming period. It may indeed be said that the old currents were nourished by so many new tributaries that they were brought to overflow their banks and to split into a number of streamlets which in turn spread over wider areas and absorbed or mixed with new elements of style.

Through this process, which was gaining in strength towards the end of the seventeenth century, the general pattern or map of the pictorial development was gradually enriched and complicated in a way that makes it more difficult than hitherto for the historian to present a systematic survey of the whole material. It cannot be condensed simply under two or three general headlines, based on leading currents of style or on the dominant position of a few outstanding personalities who gave the impetus to new schools of lasting importance. Such distinct schools dominated by leading masters as constituted the main arteries in the development of painting during the earlier part of the Ming dynasty,

no longer existed, with the sole exception of Tung Ch'i-ch'ang's and the Sung-chiang school, which, however, did not have very definite stylistic limits, even though (in a general way) it stood for the renewal of scholarly painting after the models of the Yüan masters.

There is no other personality among the many gifted and skilful painters at the beginning of the seventeenth century who could be placed in a line with Tung Ch'i-ch'ang as a leader in art; no one else who represented the same degree of aesthetic culture and authority. His outstanding importance was to some extent described in a previous chapter, and it will no doubt become clear from our discussion of his contemporaries and immediate followers that his position was unique and based on something more than any of the other painters could offer.

Owing to the importance of Tung Ch'i-ch'ang, Sung-chiang became for a while, during the last years of the Ming reign, a very prominent centre of pictorial activity, from which influences radiated to various parts of the country, but it was a relatively small country town and could never compete with Suchou or Hangchou as a home of artistic culture. Suchou still retained its privileged position as the favourite resort of scholars and artists; the large number of prominent painters who at the time were active there formed a kind of aftermath to the old Wu school, even though they embodied important individual differences of style (as will be shown below).

Hangchou had not harboured the same abundance

of artistic activity during the sixteenth century as Suchou, but owing to its historical prominence and its well-recognized fame as the birthplace of the old Chê school, it still retained a kind of afterglow of the academic glory of the South Sung period. The stylistic traditions which were kept alive in Hangchou reached further back in time than those of the Wu school (mainly derived from the Yüan painters), and they were so intimately connected with the surrounding landscape, the West Lake, the bamboo-groves and the pine-woods framing the mountain paths formed by nature into pictorial compositions that they could not but impress successive generations of sensitive painters and impose on them their grand and vigorous style. Lan Ying, for instance, who is often called "the last representative of the Chê school", was not simply a traditionalist, but also a keen student of actual nature who could render the intimate charm of some bamboo-shoots or plum-blossoms in spontaneous and convincing sketches.

The special importance attached by the Chinese historians to the currents of style or schools named above should not make us overlook the fact that there existed at the time other local centres of painting which included artists who are recorded in literature without being attached to any particular school. They cannot be named here, particularly when no signed works by them have been seen by the author. But a few representatives from various parts of the country will be mentioned to illustrate the growing diffusion of landscape-painting and to some extent local tendencies of style. They are often noticeable among painters who worked at the same place or provincial centre, and are thus serviceable in our endeavour to obtain a general view. But to follow out this kind of systematic grouping and division would require far more space and illustrations than are permissible in the present publication, and we must consequently leave out a number of interesting artists active at the end of the Ming period who under more favourable conditions would have found their places in the present survey. Some of them are, however, mentioned in the Lists with references to reproductions in Chinese or Japanese publications.

II

The Suchou Painters. Epigons of the Wu School:
Li Shih-ta, Ch'ên Lo, Shêng Mao-hua, Wang Ch'i, Chang Hung,
Shao Mi, Pien Wên-yü and Yün Hsiang

WHEN WE again turn to Suchou, the old centre of the school or trend of painting named after the Wu district, we must not expect to find the place in the same state of artistic florescence in which we left it shortly after the middle of the sixteenth century, when Wên Chêng-ming's immediate followers were still carrying on aesthetic discussions and applying pictorial principles which they had inherited from the patriarch, who for a long generation had been the genius and protagonist of the whole movement or school of Wu. Now, right at the end of the sixteenth century or shortly after,

Suchou was no longer the place where the most progressive young talents gathered under the leadership of an experienced teacher, because the most famous among the actual leaders in art was no longer to be found in Suchou, but in the neighbouring town of Sung-chiang, the little home town of Tung Ch'i-ch'ang. His position there was somewhat similar to that of Wên Chêng-ming in Suchou during the preceding generation though hardly equally important, because Sung-chiang was never comparable to Suchou as a place of artistic culture. Yet it was for a while the centre of the most

progressive efforts in painting, as was explained in a previous chapter.

The contemporary Suchou painters were generally of a more conservative bent, more firmly rooted in the fertile soil of the old Wu current. But this did not prevent them from being individually progressive and following paths of their own. Only a few of them can here be illustrated, but they should suffice to make us realize that there was no lack of genuine talents in Suchou at the time, though none of them rose to the position of a leader in art.

The oldest among these Suchou painters was probably Li Shih-ta, who may have been born as early as 1570 (or before) because his earliest dated picture is of the year 1605 and the last is dated 1620; yet he also signs himself as seventy-three years old in an undated inscription. The biographical information about Li Shih-ta is very meagre; he held no official position but "lived as a hermit by the new city wall", according to the *Wu-hsien chih*, and he is described as a man "with green pupils of the eyes, slender wrists, and a body like that of an Immortal",[1] a characterization which no doubt signifies a perfect Taoist.

But he was also a philosopher on art and is said to have composed an essay which is no longer preserved, except in extracts such as the following enumeration[2] of the "five principal merits and five cardinal faults in landscape-painting", to wit: Vigour (*ts'ang*), Spontaneity (*i*), Originality (*ch'i*), Completeness (*yüan*) and Harmonious resonance (*yün*.)

The weak points are opposites to the strong points and defined as follows: Timidity (*nun*), Stiffness (*pan*), Carving (or meticulous execution) (*k'o*), Incompleteness (*shêng*) and Unbalanced emotions (*ch'ih*).

These statements are said to contain the "most profound principles in painting", which, however, ultimately must depend on how they are interpreted and applied by the brush of the painter.

Li Shih-ta is as a painter a somewhat uneven and uncommon master. Judging by his large landscapes

(in Japanese collections) we are tempted to call him a traditionalist rooted in early Sung art, but when these pictures are studied closer some of them reveal very intimate illustrative details, and also, at least in one instance, imaginative elements of a kind that are quite unusual before Shih-t'ao. If we may base some conclusions regarding the development of his pictorial style on his dated pictures, it may be said that he started as a rather common follower of the Sung masters, and became towards the end of his life a more independent and imaginative creative master.

The early stage is illustrated by the Mountain Landscape after Rain (in the Ōtsuki collection), which is dated 1608 and painted in a kind of Mi Fei manner, with heavy mist circling round the peaks, but without much atmosphere or tonal quality. The design is here dependent on models of a well-known classic type. When Li Shih-ta represented a similar motif in later years he gave it an entirely new interpretation, as may be seen in the picture dated 1618, in the Seikadō collection (Pl.277). The whole thing seems to be transformed into a vision of wild rocks and a bottomless river of white mist. The foreground is marked by a broad mountain terrace crowned by a pavilion where two men are seated in conversation. Beyond the pavilion is a gorge filled with wisps of woolly mist from which another mountain wall rises like a broad tower into the region of the clouds. The composition makes the impression of a cross-section of overwhelmingly grand mountain scenery, visioned rather than viewed by the two men in the pavilion. The imaginative tone is also strengthened by the somewhat flossy pictorial manner and the rich ink-tones which vary from deep black into transparent white.

But this picture is something of an exception; most of Li Shih-ta's landscape-paintings are more remarkable for realistic exactitude than for visionary glimpses of infinity, and when they are completed with figures they become entertaining illustrations.

[1] Quoted in *Sung Yüan i-lai*.

[2] Reported in *Wu-shêng shih shih*, IV, p.17.

Among the best examples of this kind of paintings may be mentioned two of the large compositions in the Ku-kung collection, one called Listening to the Wind in the Pine-trees (Pl.276), the other Rain-storm in the Valley.[1]

The first, which is dated 1616, represents a low sandy beach with four monumental pine-trees growing on it. A man in a white robe is seated on the ground sunk in thought and apparently listening to the soughing of the wind in the trees, while four servant-boys, likewise in white, are occupied in collecting herbs and preparing some food or drugs on a small stove. The wide horizontal extension of the undulating ground forms an effective contrast to the pillar-like trees; the composition has a structural character which reminds us of Western rather than of traditional landscape-paintings in China.

The other picture (dated 1618) represents a party of men, riding on mules, who are approaching a little inn in a mountain valley just as a storm is beginning to shake the trees and clouds are gather-ing round the mountain slopes. The men have opened their umbrellas and the carriers are hustling over the bridge. The scene is entertaining as an illustration, somewhat in the same way as Chou Ch'ên's paintings, but it gives very little of the actual outburst of a storm. There is another varia-tion of the same motif, rendered apparently with more suggestion of cloudy atmosphere (though less well preserved), in the Seikadō collection. The design and the figures are quite alike in the two pictures, but the landscapes show some differences.[2]

Another Suchou painter who followed a similar path was Ch'ên Lo, *tzŭ* Shu-lo, *hao* Po-shih. His original name was Tsan, but later on he was called Ch'ên Lo and Ch'êng-chiang; on his pictures he signs himself Tao-ch'u Lo. "He painted landscapes after the manners of Chao Po-chü, Chao Mêng-fu, and Wên Chêng-ming – deep forests, curving paths, and winding streams – in a very careful manner, and followed closely in the footsteps of the old masters." His pictures being executed in a noble traditional style, they were much appreciated by

officials who visited Suchou. In his old age he lived on Tiger Hill and passed his time composing and chanting poems.[3]

He is represented by two characteristic pictures in the Ku-kung collection, executed in a somewhat stiff but very neat manner.[4] The one which is dated 1636 represents Bamboos and Bare Willows by a Stream; it is painted in colours not unlike certain works by Chao Mêng-fu and the Northern Sung masters, while the other, which has a date that probably should be read 1614, is a more faithful imitation after Wên Chêng-ming. It was painted, according to the inscription, on the suggestion of a friend who was a collector of ink-stones. This gentleman desired to have the opportunity of wash-ing his old and precious ink-stones in a clear mountain stream, and as he apparently had no chance of doing so in reality, he asked the painter to represent such a scene, which he furthermore described in a poem (Pl.270B). The poem, which is copied on the picture, runs as follows: "A hundred paths of water rushing down in rapids. Proudly he brings the ink-stones to the rocky bank. The flowers of ink mix in friendly fashion with the lustral waves. He watches them in the shade of the pines, keeping his hands in his sleeves" – a descrip-tion exactly illustrated in the picture. The pine-trees stand tall and imposing in front of the scholar's study, which is surrounded by a bamboo fence and tucked away among rocks and leafy trees. It transmits something of the delight and quiet enjoy-ment of a true *wên jên*.

Shêng Mao-hua (or: yeh), *tzŭ* Nien-an, *hao* Yen-an, was active in Suchou up to the very end of the Ming dynasty and he, too, seems to have freely com-bined elements borrowed from the Sung academi-cians with more modern forms of pictorial realism.

[1] *K.-k. shu-hua chi*, vol.XXVIII and vol.XXI. The first-named was included in the London exhibition 1935.

[2] *Nanju*, vol.13.

[3] Cf. *Wu-shêng shih shih* and *Wu-hsien chih*, the latter quoted in *Sung Yüan i-lai*.

[4] *K.-k. shu-hua chi*, vols.XXIV and XXXIX.

According to *Wu-shêng shih shih*, he represented "misty forests and open plains, painted figures with great skill in a refined style; conceived his ideas before he took up the brush, and expressed perfectly the spirit of a scholar". The characterization applies quite well to such of his pictures as the one in the Seikadō collection (dated 1626), which represents two old scholars in a pavilion examining scrolls which are being brought to them by servant-boys, thus celebrating New Year's day with an artistic enjoyment.[1] The trees round the pavilion are bare, the mountains behind enveloped in mist, the air is grey and cold, suggestive of a winter day when the sun is hidden behind a haze.

In other pictures the main interest is not concentrated on the figures but on the landscapes of rocky and scraggy old pines as may be seen in the very effective composition representing Three Scholars Viewing a Waterfall, which formed part of the Yamamoto collection. The poetic inscription is dated 1633 (Pl.278).

A more elaborate picture, formerly in private possession in Peking, was published by Dr. G. Ecke in *Monumenta Serica* 1938. It is dated 1634 and represents a number of scholars in long white gowns who are gathered in a bamboo grove at the foot of grassy mountains. The men form two groups; some of them are around a low table where they seem to have been playing a game, while the others are standing in a glade and listening to a speaker. They are evidently deeply impressed, as if they were receiving an initiation into nature's secrets. The whole representation is steeped in an air of quiet solemnity; these men have not gathered for pleasure in the bamboo-grove, but to take part in some kind of ceremony, a situation which is suggested by the way in which the white figures are placed and rendered, as well as by their pictorial combination with the broadly treated masses of green bamboos and grassy hills which form the setting of the scene. Shêng Mao-hua's sensitiveness to the shifting moods of nature and his faculty of rendering them in the actual brushwork may also be observed in the small picture in the Sumitomo collection, which represents A Rainstorm on a River at the foot of a city wall. The violent rain slashing diagonally across the picture is whipping the willows on the river-bank and preventing the fisherman's boat from reaching the shore. The momentum of the outburst has been well caught by the painter's brush.

In other minor landscapes, such as the album-leaves reproduced in *A Pageant of Chinese Painting*, Pl.680, 681, and the beautiful handscroll in Mr. Hochstadter's collection representing mountains and trees enveloped in soft woolly clouds, Shêng Mao-hua employs a more fluent brushwork, which has a softer pictorial quality than we find in his larger compositions (Pl.279). He was evidently a gifted but somewhat eclectic painter, who modified his manner according to the characteristics of the subjects.

Wang Ch'i, *tzǔ* Li-jo, was less well known, though evidently more original as a painter. He came of an old Suchou family and was the grandson of Wang Chih-têng, the author of *Wu-chün tan ch'ing chih*, the chronicle of the Suchou painters previously mentioned. The characterization of the painter in *Ming-hua lu* is short, but quite to the point: "He painted landscapes, trees, and stones in a dotted manner (thus obtaining their likeness), and was quite wonderful for his extraordinary simplicity, far surpassing the other painters of the time."

There are at least two of his paintings in the Ku-kung collection, one representing Chrysanthemums by a Rockery,[2] which is dated 1626, the other called Autumn Trees by a Bridge, and dated 1606.[3] Three or four sparse trees dominate the composition, which also includes a thatched pavilion and two lonely wanderers who are passing over the bridge. A mountain top marks the background, but a somewhat misty grey atmosphere softens the forms and emphasizes the empty spaces. The picture conveys an impression of silence and solitude and seems

[1] *Nanju*, vol.22.

[2] *K.-k. shu-hua chi*, vol.XVI.

[3] *K.-k. shu-hua chi*, vol.V.

indeed to be an intimate expression of the painter's soul: "a man of shy and timid nature who preferred to keep his door shut and amuse himself with painting".

Related to Wang Ch'i through the very quiet and subdued tone of his art, was Wên Ts'ung-chien, *tzǔ* Yen-k'o, *hao* Chên-yen lao-jên (1574–1648), the great-grandson of Wên Chêng-ming (grandson of Wên Chia). He continued the family tradition not only in his painting, but also in his life, being a scholar and a highly virtuous man who was looked upon as a model by his fellow-citizens. His ideal in art was, of course, Ni Tsan, as may be seen in the very sensitive painting called Low Hills by a Wide River, dated 1614 (in the former Abe collection), in which some bare trees are set off in faint silhouette against a grey atmosphere over quiet water.[1] The composition is more traditional than Wang Ch'i's Autumn Trees by a Bridge, but rendered in the same tone of meditative quietness. Wên Ts'ung-chien also represented Buddhist subjects occasionally, as may be seen in a small picture in the Ku-kung collection, representing an abbot or teacher in a chair attended by some minor figures placed in front of him.[2] It may be added that Wên Ts'ung-chien's daughter, Wên Shu, who married a man called Chao Ling-chün (1595–1634), was also a gifted painter, though of a very delicate feminine type. She painted mainly flowers and insects in a kind of *hsieh i* manner with slight individual expression.[3] Other members of the same family continued the tradition into the eighteenth century, but none of these later Wên painters can be said to have approached the level of their ancestors. They are noted in the records because of the family fame rather than for what they accomplished individually as painters.

Chang Hung, *tzǔ* Chün-tu, *hao* Hao-chien was a more original and interesting personality, one of the few, at this time, who tried to go their own ways as painters. He may have been born about 1580, because he is said to have been an octogenarian in 1660, but his main production belongs to the end of the Ming period.[4] Chang Kêng mentions him in

Kuo-chao hua-chêng lu (I, p.6) and says that he painted "landscapes which were vigorous and exuberantly beautiful, but also with far reaching effects of loneliness and desolation. The students in Wu all looked up to him as a teacher." He mentions, furthermore, two pictures by Chang Hung, one representing A Fisherman playing the Flute on a River, and another of Evergreen Pines and Cypresses; and to this he adds the remark: "He was not inferior to the Yüan painters of the *miao* (i.e. wonderful or third) class."

Chang Hung's rich production, which in recent years has aroused more and more interest among students, includes paintings of rather varying importance, as may be observed in our list of his works. He did many fan-paintings but also pictures which reach more than ten feet in height. It would require too much space to describe a larger number of these pictures in detail; we can mention briefly only a few of them, and select for the purpose such as may serve to illustrate the painter's remarkable interest in colouristic problems, his attempts to render the *plein air* effects of various seasons and hours of the day. Colour was to him a more essential means of expression than to most of his contemporaries, though he, too, used it sparingly, *i.e.* to suggest rather than to depict in detail definite sights or impressions of nature. The colour is in most of his pictures subject to the design, yet it is not a superficial addition, but has a definite expressional value. He uses it to accentuate the seasonal aspects and the tones of shifting light. But it should also be remembered that he sometimes obtains the colouristic effects less by the use of colour than by a fluttering or flossy brushwork which produces the appearance of scintillating

[1] Ōmura, I, 10.

[2] *K.-k. shu-hua chi*, vol.III, dated 1643.

[3] *Cf.* paintings by Chao Wên-shu reproduced in *K.-k. shu-hua chi*, vols.II and XV.

[4] The earliest dateable work by Chang Hung seems to be the ink-painting representing Pu-tai (reproduced in *Ku-kung shu-hua chi*, vol.XXIV) which has an inscription by Wang Chih-têng who died in 1612. It is surprising as a work by Chang Hung and shows no connexion with his landscapes.

light. This can be observed, for instance, in a picture (in the Ku-kung collection)[1] of some scraggy trees and a thatched pavilion at the foot of a waterfall. The water that rushes down over a steep mountain wall is partly lost in white mist which forms a diffuse background to the dark trees in front of it, and the rocks below, which are painted in a *pointillist* manner, remind us of French paintings of the late nineteenth century (Pl.280).

The following examples of Chang Hung's way of representing various seasonal aspects may here be recorded: 1. The Shih-hsieh Mountain, dated 1613;[2] a typical summer scene with rows of pine-trees and many small buildings along a path which leads up to a pass. Light-green and bluish colours. 2. Summer Landscape before rain, dated 1626 (Kenninji, Kyōto);[3] related to the preceding picture by its design, though the atmosphere is more vaporous, the mountains partly enveloped in mist. 3. A Mountain Temple in Snow above a Stream; the ground is partly covered with snow, but there are clumps of large trees on the river-bank and around the temple which form a deep green contrast to the white snow. The picture is dated in the same year as the previous one (*i.e.* 1626)[4] and likewise executed in a careful *kung pi* manner (with no undue insistance on the outlines). Technically, it may be noted as an example of Chang Hung's connexion with the Wên Chêng-ming tradition, though he follows this current with a great deal of individual freedom.

The same may be said with regard to the very large mountain landscape in the Ku-kung collection (10 ft 6 in. × 3 ft 1 in.), which was executed 1634.[5] The enormous size of the picture has indeed necessitated a somewhat broader brushwork, yet the connexion with some of Shên Chou's later works and Wên Chêng-ming's transmissions of the same style is quite obvious, though somewhat disguised by a more conspicuous colouring than was common in the old Wu school.

Chang Hung's special merit as interpreter of the colouristic beauty of actual landscapes may also be observed in the very remarkable picture lately acquired by the Boston Museum, which is called Wind in the Pine-trees on Mount Kou-chü, a sharply-rising mountain cone in Kiangsu, also known as Mao shan (Pl.281). The road follows a rivulet through a deep gully and with twists and twirls continues through the mist to the very summit. The lower regions of the mountains are covered with verdant grass and rows of dark pine-trees. The view is luminous, the green carpets over the mountain sides sparkling with life, the air is filled with the freshness of spring, and the brook at the bottom is purling gaily, re-echoing the life of the peaks until it reaches the cottages and temple pavilions in the valley. The painter has evidently contemplated this scene not only with his eyes, but also with his heart, and experienced a happy inspiration which has given speed to his brush and lucidity to his colours.

Chang Hung has occasionally also tried to render more subtle effects of moonlight, dawn or evening dusk, in his paintings. There is a short scroll in the Ku-kung collection called Wanderers by Night,[6] representing a river valley in moonlight, veiled by transparent mist, and another picture in the collection of King Gustaf VI Adolf, dated 1650, which represents part of a small mountain lake with pavilions on poles and a man approaching over a mud-bridge, while mountains in the background "vomit the moon", to quote the painter's inscription on this attempt at a moonlit lake view. The idea of this venture is worth noticing as a sign of the painter's interest in the pictorial problems of shifting light, even though it must be admitted that he did not possess the technical means of solving such problems (Pl.282B). In this respect he was still an experimenter.

[1] *K.-k. shu hua chi*, vol.XXX; dated 1629.

[2] *K.-k. shu-hua chi*, vol.XL.

[3] *Cf. Nanju*, vol.7.

[4] *K.-k. shu-hua chi*, vol.XIII.

[5] *Ibid.* vol.XXVII.

[6] *Cf.* Nanking Exhibition catalogue, No.238.

Chang Hung seems to have been one of the relatively rare masters who considered nature as his main teacher and who followed his own observations more closely than the traditions of schools or manners. He approached new problems of light and colour which other contemporaries hardly noticed, and he was apparently also particularly interested in depicting life and movement. One of the most telling examples of his fresh and unhampered realism is the handscroll in the H. C. Wêng collection representing Grazing Buffaloes, in which a large number of these humorously grotesque animals are rendered in varied situations on the watery shores of a small river (Pl.283).

The album-leaf in the Ku-kung collection is another vivid example of Chang Hung's entertaining realism. In this he has illustrated a Boat Race with all the minute details and decorations that no doubt belonged to the events and impressed the onlookers. The interest of the artist seems to have been equally divided between the animation of the men in the richly decorated dragon-shaped boats, the crowds of onlookers on the quay, at the foot of a pagoda, and the buffaloes grazing tranquilly with their herd-boys on the foreground shore.

Shao Mi, *tzŭ* Sêng-mi, *hao* Kua-ch'ou, was practically of the same age as Chang Hung; his dated works range between 1626 and 1662, but the two painters do not seem to have had any personal or artistic relations. Their temperaments and ideals were quite different; while Chang Hung was something of a colourist and *plein air* painter, Shao Mi was of a more introspective nature, following the dictates of his imagination rather than his observation of nature.

Wu Wei-yeh introduced him in the poem *Nine Friends in Painting* with the following words: "All his life he has been blamed for his impractical ways; his servants curse him stealthily; his wife and children are in distress. He is thin like a yellow crane, yet free as a sea-gull!" Chang Kêng speaks about him in similar terms in *Kuo-ch'ao hua chêng lu* (I. 1), calling him "a pure spirit and a very thin but warped man

who did not like to meet vulgar people". His manner of painting is said to have been like his personality, *viz.* excessively delicate and emaciated, producing effects of calm and loneliness, a bent of temperament which, however, also found expression in a rather exaggerated opinion of his own works: "whenever he made a picture, he was proud of it".

His production was evidently not so rich and easy-flowing as that of Chang Hung; his preserved paintings are relatively few and some are of minor size, such as album-leaves and fan-paintings, nor do they present a strongly marked individual manner, but they reveal a very sensitive artistic temperament which was akin to that of old Ni Tsan, though less vigorous. This may be observed in the charming little picture (in a Japanese collection) which represents some dry trees and bamboos by a rock, and also in some sections of the very long handscroll (in the Abe collection, Ōsaka Museum), called Distant Waters and Cloudy Mountains.[1] The picture, which may be considered as Shao Mi's masterpiece, is dated 1640 and reveals some influence from Ni Tsan as well as from Mi Fei.

It opens with views over waters widening between rocky banks where some bare scattered trees have taken root; then it changes into a mountainous region where the ridges reach up to the very edge of the picture, covering the field of vision. But the mountains recede again into layers of mist that cover the background, while a strip of a low shore-line with a humble fishing-village becomes visible in the foreground. The whole thing is painted as if seen at a distance from above, but the light is clear and the view open over a wide bay where a number of tiny fishing-boats are gliding towards port on the evening breeze. All the changing forms of the design, the scattered trees, the cavernous cliffs, the distant mountains, the sandy shores with houses, the bridges and the boats are perfectly realized, but they are only passing elements in a vision, which as a whole may be called an evocation of evening calm

[1] *Sōraikan*, I, 42. Cf. *Later Chinese Painting*. pl.142.

and limitless space. As a work of art, from a stylistic point of view, it reflects Sung-Yüan traditions in a minor mood.

Several of Shao Mi's paintings represent single branches of bamboo or of old plum-trees in blossom, *i.e.* typical motifs of so-called gentleman painting, rendered with refinement but only slight individual accents. These are more perceptible in some of his landscape-paintings such as the one in the collection of King Gustaf VI Adolf, which represents a misty mountain stream spanned by a bridge, where a man is approaching as he walks towards a small pavilion under the pine-trees on the opposite bank. Another man is visible here, and according to the inscription he is "washing the cups", to receive his friend, while "the soughing of the wind is audible like human speech". The picture was done to amuse an old gentleman, Wei-ch'i, by his friend Shao Mi in the spring of 1633 (Pl.282A). The artistic distinction of this picture depends on the soft silvery grey tone no less than on the rhythmic design in which rocks and rushing water form a succession of steps leading into the infinite.

The imaginative, not to say mystic, note of Shao Mi's genius has found still more striking expression in an album of landscape-studies in the collection of M. J. P. Dubosc (dated 1638). These studies, which represent fantastically split and creviced mountains are, if we may believe the words of the painter, meant to illustrate the road to Ling Ching, the divine scene (or, spiritual dwelling place) "where the Immortals hide" and to which he often came in his dreams. The way to their abode is indeed elevating, not to say awe-inspiring (Pl.284A); it winds along past mountain walls, on poles and palisades, partly across and partly above the clouds, but the place where they finally abut can hardly be said to represent very uncommon or extraordinary scenery. It looks like a section of a broad river or a small lake in the mountains, with pavilions and zig-zag galleries built across and some scraggy pine-trees lining the path along the banks (Pl.284B). There are some old men enjoying the fresh mountain air, but the place is more like an idyllic health-resort than any soul-inspiring paradise.

On the last page of this album the artist has made some notes referring to the proper practice of painting, from which the following may be quoted: "To take the old masters as your teachers is certainly good, but in order to make further progress it is necessary to take Heaven and Earth as teachers. I often returned to the mountains and observed the changing clouds and mist in the mornings, and also the singular trees and springs. In gathering it all on the plain silk I sometimes went forward and sometimes backward; such are the pleasant diversions of hermits. – I painted this album after drinking wine by lamplight; it is not worth examining by critical eyes."

It may indeed be admitted that these album-leaves are not among the painter's most carefully planned and finished works, yet they are exceptionally interesting as illustrations to his imaginary journeys to the abodes of the Immortals – the final aim or endeavour of a creative activity which was not satisfied with dwelling simply on the material appearances of this common world.

Pien Wên-yü, *tzŭ* Jun-fu, *hao* Fou-po, is also commonly named among *The Nine Friends in Painting*, but he must have been somewhat younger than Shao Mi, his artistic activity being equally divided between the Ming and the Ch'ing periods; the first dated picture is of the year 1622, while the last is dated 1669. In our List he is placed among the Ch'ing painters, yet it must be admitted that he is artistically more closely connected with the Ming tradition, particularly as a friend and pupil of Tung Ch'i-ch'ang. According to *T'ung-yin lun hua*[1] "he used to discuss the Six Principles of Painting with Tung Ch'i-ch'ang, and consequently their brush and ink-work was similar. He never had any fixed abode and always carried his incense-burner and tea-cup with him" (*i.e.* the most necessary outfit of a scholar). The same author gives, furthermore, the following characterization of his art: "His

[1] Part I, vol.2, p.2.

brushwork was subtle and graceful, altogether free and expressive, of a kind that could wash away all vulgar feelings and awaken continual interest in the beholder. Li Liu-fang used his brush in too bold a manner, his fault was coarseness; Pien Wên-yü used the ink in too loose a manner, his fault was weakness (insipidity). Those who understand the faults of these two men may learn by them and profit by it. Those who study the Six Principles should not ignore my words."

If we had to choose between the faults of the two painters, as mentioned above, we should prefer those of Li Liu-fang. His paintings may be lacking in refinement, but they show the imprint of a definite artistic temperament, whereas Pien Wên-yü's works are often so timid that they leave us indifferent or wondering why the artist has been accorded a place among the leading painters of the period. The best example is perhaps the small picture in the Abe collection (Ōsaka Museum) dated 1623, called The Quiet Study, with cottages in a bamboo grove shaded by large trees at the foot of wooded hills, an idyllic scene painted in the fluent and easy manner of Tung Ch'i-ch'ang[1] (Pl.285A). More significant as an expression of the painter's in-dividual temperament is the little picture in the Sogawa collection (in Takamatsu) called Old Pines and Crying Cranes.[2] It is likewise an autumn scene with scattered trees and mountain silhouettes, drab and grey in tone, but the cranes – one perched in a pine-tree, the other descending from the air – im-part to the scenery a kind of animation, though without human appeal.

Considering the main purpose of the present volume, which is to give a condensed general account of the leading masters and principles of painting at the end of the Ming period, and also the strict limitation of illustrations ·to which we are subjected, it is neither possible nor desirable to dwell here on all the painters whose names may be found on pictures of the period. A somewhat rigorous selection is necessary, but this is by no means easy in view of the rapid growth of amateur skill in the art

of painting at the time. Here we can only add one of the Wu painters, or Suchou men, whose name occurs on several interesting pictures.

Yün Hsiang, whose original name was Tao-sheng, used the tzŭ Pên-ch'u and the hao Hsiang-shan wêng, was born in 1586 and died 1655. He was a scholarly gentleman, well known as a painter and a poet, and esteemed as an upright and loyal character. At the very end of the Ming period he was appointed to a secretarial post in the Grand Council, but did not accept the appointment, he preferred to live as a gentleman artist in the south and to "ramble in Ch'i and Lu".

According to T'ung-yin lun-hua (I. vol.2, p.2) "he was unrestrained and spontaneous in his brushwork and could render the structural character and strength of a landscape. In his early years he worked with rich ink and great strength, following Tung Yüan and Chü-jan quite closely. In later years he spared the ink like gold and his paintings opened up far-reaching views, his ideas then being the same as those of Ni Tsan and Huang Kung-wang."

This characterization of Yün Hsiang's artistic ideals and manner of painting applies quite well to the large picture signed by the artist in King Gustaf VI Adolf's collection. It is a river view with typical Ni Tsan elements such as the spare trees on the rocky ledge in the foreground and the low open pavilion on the promontory further away, though the strati-fied rock with overhanging top which covers a large section of the upper part is of a bolder type than in any picture by Ni Tsan and it might even be con-sidered too prominent or obtrusive for the rest of the picture. But the neat linear manner of execution, the light ink-washes and soft greyish tone of the whole picture reaffirm the painter's intimate acquaintance with Ni Tsan's art and his endeavour to utilize this in a picture which, in spite of close adherence to the famous model, retains a character of its own. This is also conveyed by the inscription in which the painter tells us that he did this picture to amuse or

[1] Sōraikan, I, p.37.

[2] Nanju, vol.18.

satisfy his old friend Tzŭ Hsüan who had asked for something like a work by old Ni Yün-lin (Pl.285B).

It may be noted that there are other pictures by Yün Hsiang in which he has copied Ni Tsan more literally without any such diversions or additions as were noted above. The best example of a faithful Ni Tsan imitation is the River View with three spare trees and a low pavilion in the Ku-kung collection, which is dated 1654. But Ni Tsan was by no means the only Yüan painter who served as a model for Yün Hsiang. Wang Mêng and Huang Kung-wang have evidently also had some guiding and inspiring influence on him, as may be seen in the large mountain landscapes reproduced in the Nanking Exhibition cat., pl.248, and in *Sōgen*, pp.239, 240. These, as well as a few other examples mentioned in our List of the master's work, make us realize that Yün Hsiang, like most of these late-born Wu painters, was a highly talented, subtle master, who, in spite of his close attachment to certain predecessors of the Yüan period, remained a distinct artistic personality.

III

Painters from Hangchou; the last of the Chê school and theorists:
Kuan Chiu-ssŭ, Lan Ying, Hsiang Shêng-mo, Li Jih-hua and Ku Ning-yüan

THE PAINTERS who at the end of the Ming period were active in Hangchou or neighbouring districts of Chekiang, did not form a very homogeneous group. Some of them, like Ko Chêng-ch'i, Li Jih-hua, and Ku Ning-yüan, were essentially gentleman-painters who in their paintings as well as in their writings revealed the decisive influence of Tung Ch'i-ch'ang, while others such as Kuan Chiu-ssŭ and Lan Ying were more closely attached to the old traditions of style rooted in their home province. It may well be admitted that the traces of the former Chê school are not very obvious in their works, yet some of the Chekiang painters were more catholic in their artistic orientation than their contemporaries in Suchou and Sung-chiang, and in closer touch with the academic tradition surviving from the South Sung period. Their individual independence is, however, in most cases more marked than their adherence to some definite school tradition.

Kuan Chiu-ssŭ, or Kuan Ssŭ, was probably the oldest among these Chekiang painters. He became best known under the former appellation and also under other *tzŭ*, such as Chung-t'ung and Ho-ssŭ, and the *hao* Hsü-po. According to *Ming-hua lu* he painted landscapes in the manner of Kuan T'ung and Ching Hao, and besides these masters he also studied Huang Kung-wang and Ni Tsan. But "it was through his own genius that he created the most beautiful and original things, transforming them completely, according to his own manner." Kuan Chiu-ssŭ's studies of the North Sung masters are most evident in his early works, such as the two pictures in the Ku-kung collection: Listening to a Stream in Autumn Mountains, and Hermits and Cranes, dated respectively 1600 and 1622.[1] They are both executed with colours on silk in a very elaborate manner with close definition of every detail, such as the wrinkles of the mountains and the leaves of the trees. Nothing could be more unlike the products of the *literati* painters, yet, as pointed out in *T'u-hui pao-chien hsü-tsuan*[2], "in later years he painted mountains and stones in a free and sketchy manner, with groves of trees divided and scattered, adding on the leaves quite loosely, making the figures sylph-like, the boats and buildings simple and beautiful. Such paintings of his are a joy to the eye."

[1] *K.-k. shu-hua chi*, vols.XXVIII and XXI.

[2] Quoted in *Shu Hua-p'u*, vol.57.

The remarks are well sustained and illustrated by the pictures in the Nezu and Seikadō collections in Tōkyō, both dated 1630.[1] The former represents A River in the Mountains after Rain, with mist filling the valley and trees like wet plumes emerging through woolly air; the other, which is called Travellers in Moonlight, is particularly interesting owing to the suggestive rendering of the atmosphere of a cold moonlit autumn night when things are veiled by a slight mist (Pl.286A). The travellers are resting in a small inn consisting of some thatched huts; the donkeys are grazing outside, the trees are bare and tall, stretching upwards as if reaching towards the moon; the mountains in the far distance appear dimly like faint shadows. The silence is deep; one can almost hear the munching of the donkeys and feel the wet air dripping from the trees. It is something the painter has seen with his own eyes and realized in his mind, i.e. an actual experience, which is also confirmed by the poem written on the picture:

"We rode abreast through the cold,
 With moonlight flooding the mountains;
 And deep in the mountains we came to an inn,
 Not closed as yet.
 There in the light from a lamp we wrote
 Scraps of poems.
 Then we went out to look at the mist, and the
 trees in the night.

The third year of Ch'ung Chêng (1630), ninth month after full moon, imitating Li-hsi Kuan Ssŭ."
The painter who, according to this inscription, served as a model for Kuan Chiu-ssŭ was probably Li T'ang, tzŭ Hsi-ku, though the name is arbitrarily concracted and the model is freely transformed according to Kuan Chiu-ssŭ's own genius.

Lan Ying, who came from Ch'ien-t'ang, was a little younger but no less independent in his choice of models and in the general course of his creative work. He used the tzŭ T'ien-shu, and several hao: Chieh-sou and Shih-t'ou-t'o. His fame with posterity is considerable, though often modified by the remark that he was the last representative of the Chê school, "which was not particularly appreciated by connoisseurs". An unprejudiced study of his works gives us no reason to classify him below any of his contemporaries, on the contrary, he was at times a brilliant expressionist, as may be seen in his album-leaves, whereas his more finished paintings are often somewhat indifferent imitations, after masters of old times. He was more of a professional artist than the literati painters and this, combined with the fact that he was a Hangchou man, seems to have been more important for the classification of Lan Ying than the stylistic characteristics of most of his works, which are derived from the Yüan masters rather than from Tai Chin or other representatives of the former Chê school. His artistic development is described in Wu-shêng shih shih as follows: "Lan Ying in his early years painted landscapes in a beautifully rich (moist) manner. He copied the old masters of T'ang, Sung and Yüan periods (with such care that) every stroke of his brush was in accordance with the old models, and he studied Huang Kung-wang in particular, thus following the same method as calligraphers who start by practising k'ai-shu writing and then introduce their own transformations. In later years his brushwork became more vigorous. . . . He lived to be over eighty and had many pupils." (His year of birth is not known, but his activity must have extended beyond 1660.)

Later writers like Chang Kêng indicate his historical position more definitely: "His large pictures were particularly good. . . The Chê school of painting started with Tai Chin and ended with Lan Ying; hence it is not very highly appreciated by connoisseurs."[2] A similar though still more explicit and exaggerated characterization of Lan Ying is given in T'ung-yin lun hua[3]: "He was a bold and strange old man like the high mountains in spirit and appearance, and his fame was great at the time. His artistic achievements were profound, but his trees and mountains showed all the mannerism

[1] Tōsō, pp.339, 340; also in Kokka, 299, and Nanju, 1.

[2] In Kuo-ch'ao hua-chêng lu, I, 1.

[3] Part II, vol.1, p.16.

(crudeness) of professional men. If he had given to his work more gentleness and ease, he would not have been inferior to Shên Chou and Wên Chêng-ming."

The majority of Lan Ying's large pictures still existing are free interpretations of works by famous masters of the Sung and Yüan dynasties, and occasionally of even earlier painters such as Chang Sêng-yu of the Liang dynasty. The models are, as we shall find, of highly varying character, and it may well be admitted that Lan Ying has rendered them with more faithfulness and closer adherence to the respective styles of the originals than we usually find in imitations by late Ming painters, a fact which bears witness to his skill and suppleness as a painter rather than to a definite individual style. The earliest example, with a dated inscription of the year 1620, is called Lofty Pines on the Po-yo Mountain (formerly in the Yamamoto collection), and although no earlier painter's name is mentioned it seems evident that Lan Ying here has followed a model of the North Sung period.[1]

More significant as a document of Lan Ying's evolution as a painter is the long scroll in the Fuller Art Museum in Seattle representing mountain ridges, partly wooded and partly bare, along a winding river, a picture which, according to the inscription, was painted in 1624 "in the study of a friend, in the combined manners of Tung Yuan, Huang Kung-wang, Wang Mêng and Wu Chên, and was completed in ten days", which sounds as if his intention had been to make a synthesis of the leading masters of the Southern school, a kind of programmatic display of their strong points. Yet the picture also proves the statement, quoted above, that he studied Huang Kung-wang in particular, because the influence from this master is quite obvious in the rendering of the bare mountain slopes and the distant trees[2] (Pl.287).

The same date is found on the large picture (in the former Yamamoto collection) of Cloudy Mountains with trees and waterfalls which, according to the inscription, was painted after a model by Tung Yuan.[3] The brushwork is broader and the ink quite deep. A rather different manner may be observed in the picture dated three years later (1627) in the Boston Museum, which represents A Lofty Peak on Sung-shan. The design reminds us of some of Wang Mêng's landscapes, but the brushwork is of a more finicky kind, it seems as if the painter had not been quite able to do justice to the monumental design. In another picture he has imitated Wang Mêng's brushwork more successfully, though the model was not an original by the Yüan master but, according to the inscription, a rendering of Wang Mêng's composition by Tung Ch'i-ch'ang.[4]

Other great masters of the Southern school transmitted in imitations by Lan Ying, are Mi Fei and Wu Chên. The former (in Prince Sanjō's collection) (Pl.286B) represents pine-trees and tall mountain peaks rising through clouds, a typical motif which the artist seems to have chosen because it fitted the occasion, as explained in the inscription:[5] "The rain of yesterday has ceased, the morning mist is clearing. A picture by Mi Fei imitated by Lan Ying." Wu Chên is named on several pictures by Lan Ying; the earliest and perhaps most beautiful among these is the tall mountain, rising high above some buildings and trees, which is dated 1629.[6] The fantastic transformation of the mountain ridge is typical of Lan Ying, whereas the dotting of the leafage of the trees and the delicate shades of ink, fading in the misty atmosphere until they gradually disappear, are reminiscences from Wu Chên. Lan Ying's admiration for Wu Chên is expressed in his inscription on a somewhat similar picture in the National Museum in Stockholm, dated 1644. He wrote there: "Wu Chên followed Chü-jan. Mist and clouds form endless illusions in this picture; when people unroll and enjoy it they will suddenly feel its

[1] Ōmura, I, 12.
[2] Tōsō, p.385.
[3] Tōsō, p.386.
[4] Kokka, p.303. Iwasaki collection; dated 1638.
[5] Kokka, p.232.
[6] Nanju, vol.25. Formerly Kuwana collection, 1629.

depth. I used his noble ideas, but I could not render his forms exactly."

But masters of a more traditional classic type, like Ching Hao, Kuo Hsi and Chao Mêng-fu, also served as models for Lan Ying, as witnessed by the beautiful scroll in the collection of Dr. Moriya in Kyōto, which is dated 1636 (Pl.288). His faculty as interpreter of the old masters is most strikingly evidenced in his copies after Chang Sêng-yu, the famous master of the beginning of the sixth century, who was generally admired as one of the earliest landscape painters in China. But it may not be necessary to describe these imitations here in detail; they are all mentioned in our List of Lan Ying's works.[1]

It is surprising to find that Lan Ying at the same time also painted imitations of the Yüan masters like Kao K'o-kung and Fang Ts'ung-i in a free *p'o mo* style. The most telling examples of this kind form parts of an album, dated 1642, in the Saitō collection.[2] Some of the leaves contain explanatory inscriptions at the side of the pictures, as for instance, "Kao Yen-ching painted a picture called Cloudy Forest on a Clearing Autumn Day; I have here imitated his manner" – with obvious success: The mountains and trees appearing through the mist are dissolved into a few splashes of ink and red colour. Again: "Kao K'o-kung started by following Tung and Chü-jan, but in later years he combined them with Mi Fei. This picture shows influences from both Tung and Mi." The influence of the latter predominates; the picture is executed in a very splashy manner. Then follows a picture by Fang Fang-hu, called Strange Peaks and White Clouds, also in a broad style, and finally more structural compositions after Ni Tsan, Chao Mêng-fu, Wang Mêng and Ts'ao Chih-po, painted with more sparing ink and a firm brush, yet easily and spontaneously, the endeavour of the painter being to transmit the spirit of these old masters, as explained in the note on the last picture: "Among the followers of Ni Tsan in the Yüan period Ts'ao Chih-po was the one who grasped his spirit. I wonder if I

have rendered the spirit of Ts'ao Chih-po in this picture?" Indeed, few renderings of the Yüan master are more suggestive of his noble and melancholy spirit than this little picture of some meagre trees on some elevated ground by a river in a misty autumn light which tends to etherealize the forms.

Lan Ying's faculty of *Einlebung* into the art of the old masters was evidently quite exceptional; he was in this respect far more supple and penetrating than Tung Ch'i-ch'ang. He possessed the art of actually tuning his mind to be in harmony with the inspiring ideas of the models, of grasping their intentions as well as their manners of painting. He was perhaps not a very original genius, but once in a while his supreme mastery of the brush and ink also served him splendidly in original creations, for instance, the little picture of Bamboo Shoots after a Spring Shower (in the Shinozaki collection),[3] which is painted with almost the same *elan* that we shall find in the works of Pa-ta Shan-jên or Shih-t'ao, retaining in the very brush-strokes and light washes the smell of wet soil and a suggestion of the awakening life of spring (Pl.289).

Several other works by Lan Ying might still be mentioned to illustrate his versatile character and faculty of absorbing influences from various sources, but they would hardly change the general picture. Lan Ying does not fit into any of the well-established schools or groups (or at most into several of them). He holds a place of his own, separate from his contemporaries, but characteristic of the increasing tendency to reproduce or recreate the old masters in works which reflect their spirit rather than their formal manner of painting.

Hsiang Shêng-mo, *tzŭ* K'ung-chang, *hao* I-an and Hsü-shan-ch'iao (1597–1658), from Chia-hsing in Chekiang, is usually classified as a landscape-painter, but might with equal reason be placed among the flower-painters. He was the grandson of the great collector and amateur painter Hsiang Yüan-pien,

[1] Cf. *Chung-kuo*, p.36, and *Nanju*, vol.17.

[2] *Tōan*, No.34, pp.1–8.

[3] *Tōsō*, p.387.

and had thus, no doubt, from early years an opportunity to familiarize himself with the styles of the old masters and the principles of the painter's art. Chang Kêng offers the following information about his art and personality in *Kuo-ch'ao hua-chêng lu*: "At first he studied the works of Wên Chêng-ming, but later on extended his studies to the Sung masters and was also inspired by the painters of the Yüan period. His paintings of flowers, grass, pines, bamboos, trees, and rockeries were most wonderful. Once Tung Ch'i-ch'ang wrote a colophon in an album of pictures by him in which he said: 'These pictures by K'ung-chang are altogether most excellent. The trees, stones, buildings, flowers, grass and figures are as good as the works of the Sung masters. The landscapes, furthermore, contain the life-breath of the Yüan painters. Thus it may be said that they reveal the spirit of the scholar as well as the painter's art (skill). Hsiang Mo-lin's great exertions as an amateur of the arts and a connoisseur found their recompense after a hundred years (*sic*!) in a worthy grandson.'" In *Ming-hua lu* is repeated Tung Ch'i-ch'ang's verdict that he possessed the spirit of a scholar as well as that of a professional man.

His art, as we know it from a large number of landscapes and minor pictures representing single trees or branches of trees with blossoms and fruits, does not reflect a very strongly-marked creative personality, but it bears the impress of individual refinement and sensitiveness. The earliest dated works of his are landscapes, which show more or less definite influences from Wên Chêng-ming's late works. The compositions have an idyllic tone and they are painted with a relatively strong brush and firm outlines, as may be seen in the two pictures of the year 1632,[1] and also in the landscape of the year 1640 in the Ku-kung collection, which is traditional in design.[2] More interesting as a composition is the horizontal scroll (belonging to Chang Ying-hua) in which the painter has recorded impressions gathered during a journey to Fukien, though the execution seems somewhat dry and closely dependent on models of the Sung period.[3] It is dated

1655 and may thus be taken as an indication that Hsiang Shêng-mo even in his later years followed the beaten track when painting works of an elaborate kind.

His own particular genius and mastery of the brush are more evident in some of the minor and less formal pictures, be they simple landscapes or single trees or branches. Quite charming in its tone of evening calm and hazy atmosphere is the picture in the Ku-kung collection which represents a view over a marshy river-bank with flocks of wild geese descending from the air[4] (Pl.290). One may find here some connexion with Sung masters like Chao Ling-jang, but the painter has utilized the simple component elements according to his own fashion – high reeds ranged along low promontories and flocks of birds winging through the air – to create an impression of distance and light vapour which is quite unusual. Empty space itself has here been rendered expressive.

The refinement of his art, his light, yet firm brushwork, may also be observed in the picture in the National Museum in Stockholm, representing some branches of a flowering peach-tree reaching out over a stream where two big fish are seen feeding in the water. The inscription explains the charm of the motif: "In the third month of spring, flowers furnish food for fish, and when they come to catch the flowers they break the bright mirror on which the perfumes float. When the wind touches the willows, the flowers fall. The fish are frightened and, turning round, make the water swirl" (Pl.291).

Branches of peach-trees in blossom, or loaded with fruit, seem to have been a favourite motif of the painter; he has treated it several times and always with a marked refinement that successfully suggests the fragrance of the blossoms and the soft hues of the fruits.[5] Such motifs suited his brush far better

[1] *Shina Nanga*, II, 8, and III, 3.
[2] *K.-k. shu-hua chi*, vol.XV.
[3] *Tōsō*, p.332.
[4] *K.-k. shu-hua chi*, vol.XVI.
[5] *K.-k. shu-hua chi*, vol.XV, and *Ku-kung*, vol.XXII.

than the bare trees and energetic bamboos which he also represented in some minor paintings.[1] Hsiang Shêng-mo's artistic instrument did not have many strings or a very deep resonance, but it was pure and sensitive, he could render a tree or a branch with a touch of poetry and individual expression, and he was most successful when he made the least display of his skill and learning.

The other Chekiang painters were more definitely *dilettanti*, less accomplished from the technical point of view, but more or less interesting as exponents of the artistic attitude which was dominant in the Chia-ting and Sung-chiang schools. They painted merely as a pastime when not occupied with official duties or literary work. Ko Chêng-ch'i, *tzŭ* Wu-ch'i, *hao* Chieh-k'an, who passed his *chin-shih* degree in 1628, may be mentioned as an example; two or three pictures by him are known in Japanese collections, but as none of them rise above the ordinary level of minor *literati* paintings, they may be passed over here without further comment.

Li Jih-hua, *tzŭ* Chün-shih, *hao* Chiu-i, from Chia-hsing, was a more important personality who deserves to be recorded among "leading masters and principles", though less for his pictures than for his critical writings about paintings, which are well known through a number of publications mentioned below. He was a typical gentleman-scholar, well read and prominent as a poet and calligrapher; painting was to him only supplementary to his accomplishments in the other arts. After he had passed the usual examinations with success he held various official posts and rose to the vice-presidency of the Board of War, but remained always a hermit at heart, indifferent to the honours attached to his positions. In a poem which he wrote on a picture he said: "The picture is finished but I have no intention of parting with it. When the tea-water is boiling and the incense is burning, I will take it out again and look at it myself." In other words, whatever he did as a painter was done simply for his own pleasure.

Four pictures of his, dated between 1624 and 1631, are known from Japanese collections; one of them represents Orchids and Bamboos, the others are landscapes, and they are all executed in a very careful, not to say refined manner. The most attractive among them is the handscroll, formerly in the Tomioka collection, in which he has rendered changing views along a broad river, bordered in places by undulating hills and at other places by low flat banks with small hamlets, pavilions and connecting bridges, all neatly rendered with an accuracy of detail that does not disturb the unifying silvery tone of the sensitive brushwork. The same swift and light touch endows his small paintings of *lan-hua* and bamboo with a breath of life.

Li Jih-hua's discussions of the painter's methods and ideals form a kind of parallel to Tung Ch'i-ch'ang's writings, but they are quite independent and scattered without much order in several collections such as *Liu-yen chai-pi-chi, Chu-lan hua-ying* (mostly poetic colophons), and *Tzŭ-t'ao hsien-tsa chui* (also quoted as *Wei-shui hsien-jih chi*), which contains his daily notes from 1589 to 1616. The ideas of the writer are thus expressed without any consecutive order or attempt to give a systematic presentation of different topics, but in the following we have tried to group certain quotations with a view to their subject-matter.[2]

His description of the painter's creative activity may serve as introduction: "To paint is like the rising into space of vapours and clouds which, as they gather round cliffs and drift over wide expanses, produce an interplay of shadows and lights. It should not be fixed beforehand. The essential point is not to lose the effect of naturalness, which makes it harmonious. The practice of writing is like washing stones; when the sand on the surface and the foul mud have been completely removed, the cavities come out and their beautiful colours are

[1] *K.-k. shu-hua chi*, vol.XLIII. There is also a tall landscape composition dominated by a large tree in the Saitō collection. *Tōan*, p.35.

[2] Important extracts from all these collections are reprinted in *P'ei-wên-chai shu-hua p'u*, vol.XVI.

revealed. In both arts one should at the very start establish an ideal, and then, as a practice, exercise one's power of observation to the utmost. Only thus may one enter on the right way."

Another time he writes with regard to pictures by old masters: "Not a single brush-stroke was done thoughtlessly. In their paintings of forests in successive layers, of winding and turning paths, of peaks, and slopes, either single or double, cloud effects were introduced to close or to open up views, and the windings of the rivers were represented by means of intersecting promontories both near and far. The effect of their vaporous ink is diffused and unfathomably deep and rich, but if one looks at their pictures with close attention, one can see that everything is clearly set forth, even the minutest details are properly rendered. Thus, the more firmly the scenery and the ground are established, the freer flows the expression of life. Such pictures may contain a great many things without being crowded, or only a few things without being scattered and thin; the brushwork may be thick without being muddy and dirty, or light without being empty or unreal. These have what may be called spiritual emptiness, or the mystery of emptiness, for everything that appears or disappears in them is animated by the creative power of nature, whereas pictures in which every leaf is carved separately and every object represented according to its outward form, will show no difference from the exertions of varnishers and masons."

The proper way of studying and practising painting is described as follows: "I often discussed the fact that students of painting must be skilled in writing in order to know how to use the brush. But students of calligraphy must first acquire knowledge of ancient as well as of modern writings. If they want to become erudite scholars who grasp old as well as modern examples, they must be loyal, faithful, sincere and respectful. When the roots and stems are not firmly planted, the branches and leaves will not be properly attached. Such sayings have often been pronounced by Su Shih, Huang T'ing-chien, and Mi Fei. You may look them up in their writings."

The same fundamental ideas as to the necessity of a high character and a proper attitude of mind for the creation of pure and significant paintings are emphasized in other remarks:

"Chiang Po-shih said in talking about calligraphy: 'The important point is that the man should be of high character'. Wên Chêng-ming wrote on a picture of his representing a mountain, after Mi: 'If the man is not of high character he cannot use the ink properly'. From this one may realize that the least drop of ink which falls on the paper is no small matter.

"The artist must keep his mind open and free from all matters of the world, then the effects of vapours and clouds and the beauty of the colours will come out naturally in accordance with the life-giving spirit of heaven and earth, and the most wonderful things will take shape under the brush. But if worldly thoughts are stirring in his mind and not completely eliminated, he will – in spite of daily contemplation of hills and valleys and incessant copying of wonderful pictures – arrive at something which can hardly be distinguished from the laborious works of artisans."

The right psychological preparation or attitude is the first condition for the artist's success, but he must also understand how to manage the brush, how to make it a supple and responsive instrument of the mind: "In painting one must understand how to take and how to yield. To take means to give the formal likeness by catching it with the brush. This, in practical use, is a matter of determination and firmness, yet it implies proper and elegant interruptions and continuations of the strokes. If the brush is moved in a continuously straight fashion, it will lead to the fault of stiffness, and the work will seem tied up. To yield means that the idea is carried on even though the brush-strokes are interrupted, as for instance, when mountains are indicated simply by outlines, or trees are drawn without separate branches. It is all in between what is and what is not there.

"The prefect Ch'ên told me that Huang Tzŭ-chiu spent whole days among wild mountains and rugged cliffs, seated in a thicket of trees or in bamboo groves quite lost in his thoughts. No one could guess what he was doing. At other times he went to the estuary of the Mao river and sat in contemplation of the rapid current and the roaring waves; even when storms were raging and sea-monsters wailed and cried, he remained undisturbed. Ah, this was how Ta-ch'ih's brushwork became so profound and melancholy that its power of transformation competed with the creative powers of nature.

"When rambling in the mountains one should always have paper and ink at hand so as to be able to make sketches of the strange trees and queer stones that one may come across, like the poet Li Ho, who stored his stock of phrases in a brocade bag."

Among Li Jih-hua's remarks of a more technical nature the following, which relate to the proper way of starting a composition, may be quoted: "The first thing in painting is generally to spread the view (arrange the composition), but this should only be done in a sketchy fashion. Then, by moving the brush, one should make the clouds, the streams, the trees, and stones, the houses and the figures, one by one, each according to its nature. Thus it may be said that the ideas are born where the brush arrives – like the fisherman who entered the peach-garden and gradually came upon beautiful places, which he at the beginning never expected."[1]

The art of painting was indeed, according to Li Jih-hua, no easy sport with brush and ink, but a most exacting creative activity which demanded an intense concentration of all the spiritual and mental faculties of the artist. It should be a revelation of his heart and mind. It could be done only when the whole personality was perfectly attuned, when the character of the man was detached from worldly concerns and his mind clear and open to inspiring thought. Then the work would flow easily and freely like the welling-up of a clear spring, and the picture would reflect in symbols the rhythm and life-breath of the things that filled his mind.

Such were the ideals, but how many artists have ever been able to express themselves fully in their works? Like all the writers of the Ming period, Li Jih-hua points to the great masters of olden times as the ideals, because, as he says, "they worked by natural inspiration without any (apparent) effort ... like the Buddha who spoke quite freely, yet never contrary to truth and reason. Both Heaven and men listened to him with fear, and nobody had any criticism to offer." To this he adds as final comprehensive advice:

"In painting one need not seek for the strange, nor be tied by the rules. The point of greatest importance is to carry in the heart what one is going to express, then it will be right."

★ ★ ★

Ideas of a similar nature were also expressed by another painter-critic who was possibly a little younger than Li Jih-hua, though we have no definite dates regarding his activity, except the inscription on a picture of the year 1636, namely, Ku Ning-yüan, *hao* Ch'ing-hsia. He came from an old Suchou family of officials, but, as far as we know, he never served in any government position. He preferred to remain in old Suchou, his native town, where he could devote himself freely to writing about painting and to the formation of an important collection of antiquities. All the great scholars of the time were his friends, and he often received them in his study by the Flower Stream in the North City. His models in painting were Tung Yüan and Chü-jan, but he also studied Ching Hao and Kuan T'ung. His paintings were much appreciated, though apparently of rather moderate artistic importance, as is illustrated by three small landscapes known to us in reproduction. The one in the Ku-kung collection is a free imitation after Chao Mêng-fu, representing two thatched pavilions in a grove of leafy trees in front of some conventional

[1] Quoted from *Chu-lan-hua ying* in *Hua ta-yao lu*.

hills;[1] the others are likewise typical examples of the literary men's painting. Their artistic importance is pre-eminently a matter of the very neat and pure brushwork, but they do not convey any marked individual characteristics.

Ku Ning-yüan's importance in the history of Chinese painting is mainly based on his activity as a connoisseur and critic along much the same lines as Mo Shih-lung's and Ch'ên Chi-ju's critical discussions. The treatise in which he epitomized his ideas about painting is quite short but clearly written and informative in regard to the painter's technical activity, as well as to the aesthetic principles of his art and it is as a whole a characteristic expression of the ideals of the so-called Southern School. The text is divided into seven short sections under the following headings: I. To Cultivate Inspiration, II. Resonance of the Life-breath, III. Brush and Ink, IV. Naïveté and Simplicity, V. Dry and Moist (Ink), VI. Directing the Strength, VII. Painting Water. The ideas cover a wide ground, though expressed in a rather scanty form and convey the impression of a well-informed and relatively independent art-critic. We have limited our translation to the six first chapters:

I. "When inspiration does not come and the wrist refuses to move, one should merely follow the flow of the feelings and desist if one is impressed by nothing. But if one observes dry and decaying stubs, stones, pools of water, and spare trees, as they are left by nature, which are completely different from things fashioned by men, and with deep feelings and clear eyes seek for their hidden meaning, spontaneous ideas will be expressed in the pictures. This is like the method of (the poet who) picked phrases from a brocade bag."[2]

II. "Among the Six Principles of Painting the first is Resonance of the Life-breath and Movement of Life (*Ch'i-yün shêng-tung*). If there is Resonance of the Life-breath, there is also Movement of Life. The Resonance of the Life-breath may be either within or outside the scenery. It may be grasped in the seasonal aspects, in the cold and in the warm (season), in the clear sky and in the rain, in darkness or brightness; it does not consist in piling up ink."

III. "If one uses astringent ink for the groundwork and then proceeds to cover and soak the whole thing with dots, there will be neither ink nor brush. If one makes the groundwork by piling up the ink in layers without washing or spreading it out, there will be no ink and no brushwork. One should first settle the sinews and the bones and then gradually add on flesh with a firm and bold movement of the wrist, yet aiming at ease and lightness, then there will be ink as well as brushwork. Such is the general way (plan), but the most gifted masters and eminent scholars have let the brush soak and the ink drip; yet even the beards and the eyebrows in their pictures are distinct. They had no need of pasting on the skin and joining the bones."

IV. "In painting one should strive for that naïveté which is beyond (the reach of) maturity; after maturity one can no more return to naïveté. It is important, however, to distinguish between excessive maturity and proper maturity, because proper maturity can still include naïveté. Workmanship (skill) does not equal simplicity; when once one is all skill one cannot return to simplicity. If one does not strive for skill, but starts with ideas, then although the result may appear simple, it also implies skill, and although it is skilled, it remains also simple. Only the Yüan painters possessed naïveté as well as simplicity.

"When students have already entered upon their career they are tied by rules of painting; whereas fine gentlemen and well-born ladies express their natural reactions with the brush in the manner of young children, fearing that people who look at their work may criticize it. Although everything (in their work) may not be quite like reality, it possesses something which famous men are unable to give, *i.e.* naïveté and simplicity. But this kind of naïveté and simplicity is not the same thing as the first

[1] *K.-k. shu-hua chi*, vol.XXVIII.

[2] Referring to the poet Li Ho of the T'ang period, also mentioned by Li Jih-hua. *Cf.* Giles, *Biogr. Dict.*, 1132.

efforts of students; because the primaeval breath of painting is contained in these qualities like the flower in the bud, still undisclosed. It may be described as a sketch (a tentative beginning) corresponding to the first outlining of chaos.

"The Yüan painters worked with the brush in a naïve manner and expressed simple ideas; they did it deliberately, attaching deep significance to it, for they were capable of concealing their technicality, as they were afraid of becoming famous through their paintings, and in that way (*i.e.* through their fame) risking their lives. Only Chao Mêng-fu, who was a high official at the time, made a free display of his talents. He competed boldly with the famous masters of the T'ang and Sung periods without the least hesitation. Nevertheless, in his official career, his supreme artistic skill became an embarrassment to him.

"What is then to be obtained through naïveté and simplicity? Naïveté is the absence of a rough air, it is culture and therefore it may be called the brushwork of the scholar. Simplicity is the absence of an artificial air; it is refinement and consequently the quality of really refined people."

V. "If the ink is too dry, it has no life-breath, but if one is simply bent upon the resonance of the life-breath, it will become excessive and overflowing. If the ink is too moist, there will be no refinement and order. But if one is simply bent on refinement and order, the result will be 'carved' painting (*k'o-hua*). The very secret of the Six Principles should be sought first and last in the handling of the ink."

VI. "If one wants the main strength to move towards the left, one must first pay attention to the right side, and if one wants it to move towards the right, one must first pay attention to the left. If one starts from above, the strength is tending downwards; but if one starts from below, the strength is rising. It will not do simply to follow the feelings from the starting point. If there are no roots, how can (the tree) grow. There is a reason for all things being what they are. Those who observe things widely and think carefully will grasp this by themselves."

The importance of writers like Li Jih-hua and Ku Ning-yüan lies mainly in their faculty to throw some new light on the old problems regarding the creative activity of painters, its nature and principles. The discussion regarding these had been renewed time and again, ever since the days of Hsieh Ho; there had been many attempts to explain the essentials of the painter's art, but few indeed as concise and penetrating as the expositions of the subject by the two above-mentioned critics at the end of the Ming period. They did not introduce any new ideas or points of view, but they lay more stress than most of their predecessors on the essential freedom and spontaneity of the artist's work, and its function as an expression for the life-breath of the creative painter.

It should be noted that when Ku Ning-yüan emphasizes the importance of naïveté and simplicity, his demands do not concern simply the brushwork, but have also reference to the psychological attitude of the painter. By way of illustration he points to the great landscape-painters of the Yüan period, who worked spontaneously and suppressed every show of technical skill. To him they were painters of the highest class, because they had mastered all the traditional rules, without being trammelled by them, and had thus reached a stage of simplicity and naturalness which is superior to brilliant skill and excessive maturity. When these qualities are perfectly realized, they culminate, according to Ku Ning-yüan, in "the brushwork of a scholar" and reveal the quality of superior refinement, *i.e.* ideals which had been attained by the great poet-painters of the Sung period and the landscapists of the Yüan epoch, who were afraid of profaning art by exhibiting too much skill or by accumulating a too glaring personal fame.

IV

The Intimists from Chia-ting: Chêng Chia-sui and Li Liu-fang

THE PAINTERS active in Chia-ting, a little town not far from Shanghai, were more closely related to the Sung-chiang school. It became customary to speak of the "Four Masters of Chia-ting", two of them being poets and two painters, *i.e.* Ch'êng Chia-sui and Li Liu-fang, both highly gifted representatives of the Southern school, though not properly speaking of the *literati* class.

Ch'êng Chia-sui, *tzŭ* Mêng-yang, *hao* Sung-yüan, was born in 1565 in Anhui, but moved to Chia-ting and lived there until 1643. He was classified by Wu Wei-yeh among *The Nine Friends in Painting*. According to the *Wu-shêng shih-shih*, "in his landscapes he followed Ni Tsan and Huang Kung-wang, but was also skilled in painting flowers and birds. His brush and ink were rich and 'moist'. Many people came to offer him money for his pictures, but Chia-sui was always held back by hesitation and kept on brushing and rubbing his pictures. It took him a year to finish a single one. He was also skilled in music, and an amateur of old writings, paintings and antiquities. In his youth he prepared himself for the official career, but did not pass the examinations. Then he went in for military training, but did not succeed, and so he changed over to literary studies with the idea of becoming a poet. At thirty he wrote perfect poems. He was a close friend of Li Liu-fang in poetry and art, and a very kind man who never spoke harshly of anyone . . ."

Ch'êng Chia-sui's fame with posterity is, however, based mainly on his paintings; the short poems which he has added on some of them are of slight importance. His favourite model of the Yüan period was evidently Ni Tsan, who is often mentioned in his inscriptions, but he also followed occasionally Ts'ao Chih-po's more strongly accentuating manner of painting dry trees and split rocks. On a picture which used to form part of the Kikuchi collection in Tōkyō[1] he expresses his admiration for Ni Tsan as follows: "Yün-lin has not been seen for three hundred years, and who has after him transformed a mortal man into an Immortal? But in the cold and far expanses with distant peaks reflected in the river (which he painted), one may still find the elixir of immortality" (dated 1642).

The very large picture after Ts'ao Chih-po in the Ku-kung collection,[2] and the most important, is the tall landscape called Piled-up Rocks by a River in Autumn, which is a more elaborate but hardly more successful performance than the imitations after Ni Tsan. The rocks and trees are painted with great care and definition of detail, but are lacking in structure, which makes us recall the tradition that Ch'êng Chia-sui "rubbed and brushed" his pictures for a long time before he parted with them. Such large compositions are, however, rather exceptional in the *œuvre* of Ch'êng Chia-sui; most of his pictures are of smaller size, which indeed corresponded better to his talent and style.

According to a terminology nowadays often used in the classification of painters, Ch'êng Chia-sui might be called an *"intimist"*, a descriptive name or epithet which may be said to indicate the fundamental quality or significance of his best paintings. And it may also be admitted that the epithet would fit almost equally well several of the other artists who were placed by Wu Wei-yeh (1609–1676) in the group called *The Nine Friends in Painting* (though not all of them). The typical "intimists" among them were Li Liu-fang, Shao Mi, Wang Chien, Pien Wên-yü and Yang Wên-tsung, whereas Tung Ch'i-ch'ang and Wang Shih-min (who also are counted among the "Friends") reached beyond the limits of a strictly "intimist" art. The grouping of all these painters under a common title was

[1] *Cf. Ōmura*, I, 7, and *Chung-kuo*, p.43.

[2] *Cf. K.-k. shu-hua chi*, vol.II. The picture is nearly two metres tall.

apparently proposed for personal rather than stylistic reasons; they came from different places and absorbed various local currents of style, yet they were all *literary* men, poets and writers just as much as painters, and distinguished by their very intimate approach to nature, their sensitiveness and search for the spiritual undertone of its phenomena. The range of their artistic endeavours is not very wide, but their small pictures have often a truly intimate appeal, as may be observed in the albums published in China and Japan, which contain selected specimens by *The Nine Friends in Painting*.[1]

Ch'êng Chia-sui is represented in the Hakubundo album (published 1921) by a study of some leafless trees and a pavilion on a rocky ledge at the foot of a cliff. Nothing could be simpler than this combination of rugged trees and split rocks, yet they have a meaning of their own, due to the artistic penetration and very sensitive tonal modulations in the brushwork (Pl.293).

Another remarkable example of the painter's faculty to absorb the tone or spirit of a landscape and to suggest it by the atmosphere and the design of apparently very simple paintings, is to be seen in the National Museum in Stockholm. It is a long handscroll (dated 1635), evidently based on actual observations of nature, in which the painter has unrolled continuous views along a winding river bordered in places by rocky banks or, at other places, by low sandy shores grown with rows of pillar-like pines or cedars which spread their wide foliage like green umbrellas over light-coloured sand-dunes. The yellowish shades which prevail in the open country suggest the faint afterglow of a cool spring evening, when the willows still are leafless and the solemn pine-trees with their darker tones dominate the scene like endless rows of pillars in nature's cathedral (Pl.292). Such was the "intimist's" way of approaching a not too common motif.

★ ★ ★

Li Liu-fang, *tzǔ* Ch'ang-hêng, *hao* T'an-yüan, was also essentially an "intimist", though he worked in a somewhat broader pictorial style and became particularly known as a writer. He is said to have been born in 1575 in Anhui, but passed most of his life in Chia-ting, reaching the *chü-jen* degree in 1606. Further efforts to pass the higher state examinations did not bring success; consequently he gave up his official career and retired to the little town in the south where he led the carefree life of a Bohemian poet and painter, and died in 1629. According to *Lieh-ch'ao shih chi*,[2] "he was by nature a lover of beautiful landscapes, and later in life he often made excursions to the West Lake (in Hangchou). There he used to drink wine and write poetry, and then he brushed and painted in a free manner, the ink flowing abundantly. The monks from the mountains and the boatmen of the lake came to chat with him, talking gently and bringing with them paper or silk on which they asked him to paint. He never refused their requests. He studied the Yüan masters and particularly liked Wu Chên", an attachment which was decisive for the development of his pictorial style.

Most of the fairly numerous works by Li Liu-fang still to be seen are minor things, studies of rugged trees and stones on the borders of quiet waters, more or less like improvisations done on the spur of the moment.[3] The best of them, with their spontaneous freshness and intimacy, are appealing, though not comparable to similar studies by his great predecessors, Wu Chên and Ni Tsan (Pl.295). Li Liu-fang's "silent poems" reflect a louder tone; the oppositions of light and shade are stronger and the atmosphere heavier. In a short poem on one of his pictures in the manner of Ni Tsan he makes the following confession: "I always like the scattered trees and distant mountains as represented in the works of Ni Yün-lin. I am a hermit who has built his cottage south of the town, where I can paint the

[1] The album published 1925 by the Yu Chêng Co., Shanghai, is called *Hua-chung chiu-yu*, while the other album published by the Hakubundō Co., Ōsaka, 1921, is called *Hua-chung chiu-yu ts'ê*.

[2] Quoted in *Shu-hua p'u*, vol.58.

[3] *Cf. Ōmura*, I, 7, and *Shina Nanga*, II, 3.

winds of spring and all the winding streams. In the spring of 1628 I painted this picture and copied an old poem of mine."[1]

In his larger compositions Li Liu-fang appears as a rule less interesting because, like so many of these gifted but not particularly strong painters, he is not quite master of structural design. They are often dependent on earlier models, for instance pictures by Chü-jan, Wu Chên, or Ni Tsan, and although the manner of painting may be remarkably free and light, these larger works seldom have the beauty and significance of the minor things. As an illustration of this we may refer to the picture formerly in the Kuwana collection in Kyōto, which is dated 1626 and represents a man seated under two large pine-trees looking at a waterfall. According to the painter's inscription it is a free rendering of a picture by Wu Chên, and as such quite impressive and beautifully balanced. But the younger painter seems to have lost something of the structural quality that no doubt distinguished the Yüan painting and also the deeper accents in the brushwork.[2]

Li Liu-fang was not exclusively a skilful painter and not pre-eminently interested in the formal beauty of his models. He was no less of a poet and perhaps also a musician (at least *in nuce*). He did not submit very strictly to compositional rules but "played with the ink" according to the inspiration of the moment, trying to transmit the creative ideas or life-breath of certain old masters rather than their formal patterns. In this respect he followed very closely in the footsteps of Tung Ch'i-ch'ang, though with less virtuosity. Consequently he found the best and most intimate expression for his creative genius when musing for himself over certain typical or traditional motifs of landscape-painting, which he tried to recast or renew according to the mood of the moment or the thoughts at the back of it. This may be observed for instance in the very attractive six album-leaves in the Boston Museum (dated 1618), in which he has given free renderings of illustrations to T'ang poems, transformed in accordance with his own poetic genius into what might be called lyrical improvisations in black and white[3] (Pl.294).

[1] *Tōsō*, p.362.

[2] *Cf. Nanju*, vol.8. Other large pictures by Li Liu-fang are reproduced in *Shina Nanga*, I, 14, and in *Nanshu*, p.14.

[3] Li Liu-fang and Ch'êng Chia-sui, who both were active in Chia-ting, are usually mentioned as members of the group called *The Nine Friends in Painting*. Other members of the group will occupy us in connexion with painters from different places in accordance with our endeavour to adhere to a geographical distribution of the artistic activities at the end of the Ming period.

<div style="text-align:center">

V

Virtuosi from Fukien and Painter-patriots in Nanking:

i. Chang Jui-t'u, Wu Pin and Wang Chien-chang

ii. Huang Tao-chou, Ni Yüan-lu and Yang Wên-ts'ung

</div>

THE LEADING masters of the Fukien group were of a different nature and followed other stylistic traditions than the painters of Suchou and Sung-chiang. They were brilliant technicians and successful officials, but perhaps not philosophers or men of literary culture to the same extent as their colleagues in Hangchou and Suchou. Several of them took an active part in the political events connected with the fall of the Ming dynasty; their practical ability as leaders of men and administrators seems to have been no less appreciated than their skill as painters and calligraphers.

Chang Jui-t'u, *tzŭ* Ch'ang-kung, *hao* Êrh-shui and Po-hao-an, has for patriotic reasons been thrust into the background in China; he is not represented in the former imperial collections and it is rare to find works by him reproduced in Chinese publications. The national prejudice against the man seems

to have formed a barrier to a just and sympathetic appreciation of his art in China, whereas the situation has been quite different in Japan, where he has been the subject of much admiration which recently has found enthusiastic expression.[1]

He was born in Ch'üan-chou (presumably about 1575), and after he had become a *chin-shih*, in 1607, he took part in the special palace examination, at which he received the third place in the first class. In 1627 he was appointed to the position of a Grand Secretary, one of the highest offices in the government, which is said to have been a consequence of his friendship with the unprincipled eunuch Wei Chung-hsien, who at the time had usurped practically the whole of the imperial power. But as the rule of the eunuch ended suddenly with the death of the emperor Hsi Tsung, when Wei Chung-hsien hanged himself, all the officials created by him were convicted and sentenced to various penalties.[2] Chang Jui-t'u was condemned to exile, but bought himself free and was allowed to return to his home in the south, where he devoted himself henceforth to calligraphy and painting. "His style of writing was free and original, by far surpassing the writings of Chung Yu and Wang Hsi-chih. He opened up a new path (in calligraphy) and was like a descendant of Huai-su.[3] His landscape-paintings were vigorous and strongly built (with strong bones). . . . He was said to be related to the planet Mercury (*Shui hsing*), and a scroll with his writing or painting hung in the house was considered a protection against calamity by fire."

Chang Jui-t'u's individual genius has found the most appealing expressions in minor paintings or sketches on album-leaves in which he has noted down fugitive impressions of open waters with rocky islands, mountains rising through low mist, or promontories with a few trees, *i.e.* records of actual observations rendered with a swift and sensitive brush. The best examples of such paintings are found in two albums, one in Japanese[4] and the other in Chinese[5] possession. Among the eight pictures in the former should be noted in particular

the views of A Cone-shaped Rock Island crowned by a Pagoda, and of A Misty River Valley on a Moonlit Night. The latter picture has the following explanatory inscription: "Above the moon is shining and one hears the monks reciting (in the temple on the hill); below the trees are clustered (in the mist) and a wanderer is seen." This album is dated 1625 (Pl.297).

In his larger pictures such as hanging-scrolls of normal size, Chang Jui-t'u follows quite different principles of representation; their main interest or artistic expression does not depend on the transmission of impressions of actual nature or on the suggestiveness of tone and atmosphere, but on the decorative stylization of the motifs which is carried out very effectively with a strong and firm brush. The compositions consist mainly of fantastically shaped rocks divided by deep gullies where mountain torrents disappear into misty caves, while the tall pine-trees stand out like pillars in the foreground. The motifs are far removed from the common world, but the designs are convincingly structural and mostly dominated by a vertical rhythm as emphasized by the mast-like trees and the water cascades which seem to be falling right down from the clouds (Pl.296A and B).

At least a dozen of such mountain views with convoluted rocks, rushing cascades and a few thin trees are known from Japanese collections, as may be noticed in our list of Chang Jui-t'u's works. It may not be necessary to mention them here in detail, because they are all fundamentally akin, the compositional elements being the same and also the

[1] *Cf.* Y. Yonezawa, *Painting in the Ming dynasty* (1956). The painter is here placed on a level with Tung Ch'i-ch'ang, if not above him, and it is stated that "he must be recognized as one of the most outstanding of the Ming".

[2] Biographical information *re* Chang Jui-t'u in *Jên-ming ta tz'ŭ-tien*, and *re* Wei Chung-hsien in Giles, *Biogr. Dict.*, 2270, and Hummel, *Eminent Chinese*, vol.II, p.847.

[3] A Buddhist priest of the seventh century. *Cf.* Giles, *Biogr. Dict.*, 833.

[4] *Cf. Sekai Bijutsu Zenshū*, 20, pl.26, **27**.

[5] *Nanking Exhibition Cat.*, pl.208. Also a small album in **K.** Sumitomo collection.

dominating verticalism of the designs. The most famous is the picture in the Seikadō collection of the year 1631. Another smaller picture of a similar type, dated 1635, is in Mr. Ernest Erikson's collection in Stockholm. – The horizontal scrolls are quite few, the best one belongs to the Sumitomo collection in Ōiso. It is specially notable because of its composition, which is not of the usual continuous kind, but divided into a number of sections (accompanied by poems) which are all dominated by the sharply-rising rhythm of precipitous mountain walls. Chang Jui-t'u was not afraid of repeating himself; the descriptive lines that he added on the great picture in the Seikadō collection might just as well be applied to several of his paintings: "Steep peaks rising into clouds tinted in gold and colours; tall pines scattered along a stream are playing their organ tunes".

Wu Pin, *tzŭ* Wên-chung, was a somewhat older man, likewise born in P'u-t'ien, who also had close connexions with the court. He served in the Wan-li period as a secretary in the Central Board (*Chung-shu*) in Nanking, and was active as a painter between 1585 and 1621, his works consisting of Buddhist paintings as well as landscapes. – "Besides being a great man in the field of art, he was also a man of moral courage. Once in the *T'ien-ch'i* period (1621–1627) he saw a public announcement in the capital referring to Wei Chung-hsien's usurpation of power, and as he criticized it openly he was arrested by the police and thrown into prison. In consequence he lost his official position. He was a man 'of the pure current'. As a painter he may be placed on a level with Ting Yün-p'êng."[1] This juxtaposition may well be correct with regard to Wu Pin's Buddhist pictures, but it is not supported by his landscapes, which represent a rather different type of art. This is to some extent confirmed by the following remark, likewise in *Wu-shêng shih shih*: "His compositions were dense (crowded), their colouring brilliant and beautiful; his workmanship was finer than the cutting of jade."

There are at least two tall landscapes by Wu Pin

which should be remembered as illustrations of this rather peculiar descriptive remark, one in the Ku-kung collection, dated 1609,[2] the other in the Hashimoto collection in Takatsuki, dated 1615.[3] They are both very tall, measuring 9 and 10 ft respectively, and filled to the last square inch with peaks and gorges, fantastically shaped, cracks and crevices which are sharply cut like jade carvings. Nature is here transformed into purely decorative patterns which remind us of silk embroideries or stone engravings rather than of ordinary paintings. They are both essentially of the same kind and executed with the same brilliant virtuosity in a very neat, not to say polished kind of *kung pi* technique, but in the larger picture in the Hashimoto collection (Pl.298) there are clumps of leafy trees on the slopes which contribute to a more pictorial effect than the severe and cold impression of the other pictures, in which the peaks and ridges may be said to possess the sharpness of jade-cuttings. The decorative designs are, however, in both cases dominated by the same kind of excessive verticalism which we noticed in Chang Jui-t'u's large compositions, and which also is to be observed in the works of other Fukien painters.

Wu Pin's artistic fame is based on his figure-paintings with Buddhist subjects no less than on his landscapes, but as far as may be judged by the examples in the Ku-kung collection, they are more curious than individually expressive. In these he follows models of Sung or pre-Sung times, but translates them in a manner by which their archaistic features are grossly exaggerated. (*Cf.* the picture of a Buddhist saint in *K.-k. shu-hua chi*, vol. XXIX.)

Wang Chien-chang, *tzŭ* Chung-ch'u, *hao* Yen-t'ien, also lived in Ch'üan-chou, and was a friend of Chang Jui-t'u, but he never held any official position and seems to be practically forgotten by his countrymen. His name is not mentioned in the historical records known to us, and no work of any

[1] *Wu-shêng shih shih*, IV, 14.
[2] *K.-k. shu-hua chi*, vol.XXXIV.
[3] *Nanju*, 23.

consequence has been identified in China. But a whole series of important pictures by the master have found their way to Japan, some as early as in the seventeenth century, some in recent times, through the acquisition by the Hashimoto family of the Lien Ch'üan collection from Hangchou. The collection was an heirloom of the Lien family, which had inherited it from its original owner, a man called Kung Pên-ang, who lived in the Ch'ien-lung period and was a descendant of a close friend of Wang Chien-chang. It consists mainly of fans said to number over 1000 in all, painted by 800 prominent artists of the late Ming and early Ch'ing periods, but includes also a number of larger scroll paintings. Wang Chien-chang is here represented by twenty-four fan-paintings (in two volumes), five horizontal scrolls[1], and two larger hanging pictures. A selection of these pictures was published in 1914 in a folio volume (by Shimbi Shoin) under the title *Shoman Ryūdo Gekiseki* (Selected Pictures from the Small Willow Pavilion) with a preface by Tuan Fang (dated 1911) in which he offers some information about the collection and points out that Wang Chien-chang, who holds such a prominent place in it, is practically forgotten in his homeland. Judging by the dated inscriptions on his paintings, his artistic activity must have covered the second quarter of the seventeenth century.

The majority of Wang Chien-chang's large landscapes seems to have been executed for decorative purposes in a somewhat heavy or coarse manner, in some cases with addition of colour and on gold-sprinkled ground. The most important example of this kind of painting is the one called Viewing the Waterfall on Lu-shan. Two men are standing on a bridge at the lower edge of the picture contemplating the cascades falling over the successive terraces in the folds of the huge mountain. The picture, which measures 9½ ft in height, is said to have served as a wall decoration in a pavilion belonging to the Kung family, which explains the strong emphasis on the linear pattern and also the use of colour and gold-ground.

Other large landscapes of his are done mainly in ink and not so strongly conventionalized, yet they are all built up of deeply folded and bulging mountain terraces and rushing waters combined with clumps of luxuriant trees, which altogether produce an impression of inaccessible places where there is no space to move or air to breathe. This may be observed for instance in the picture of the Yü-hua mountain in the Viscount Yamanouchi's collection (*Nanju*, vol.7). The famous picture known as Sunrise on the River (in the Seikadō collection) (Pl.299) is more open and appealing in design, yet of the same class as the preceding picture, but the title may seem surprising, because the sun is visible only as a tiny spot high up in the sky. The river is reduced to some splashing cascades washing the stones in the foreground, where a clump of large pines forms the dominating motif.

In addition to the above landscapes should also be mentioned a short handscroll (reproduced in *Shoman*) which illustrates a different side of Wang Chien-chang's artistic genius. It is called Floating on the Willow Stream in Spring, and is painted with a fluent brush and light washes in a free *hsieh-i* manner. The whole thing is transparently airy, the wide stretch of water and the misty shore beyond are rendered with thin washes which have retained the moist atmosphere of a spring morning on a small river in the south. Similar fugitive impressions rendered with a light brush may also be observed in some of the fan-paintings by Wang Chien-chang, formerly in the Hashimoto collection and partly reproduced in *Shoman* (Pl.300A).

In the preface to the *Shoman*-album we are also told that Wang Chien-chang's "favourite subjects were Buddhist figures, and in painting such subjects he considered himself not inferior to Li Lung-mien of Sung." The statement may be noted as a record of the painter's attachment to the Sung tradition and also of the wide range of his individual talent. It is illustrated by two characteristic paintings, *viz.* a

[1] Two sections of a scroll are reproduced in *Shimbi*, vol.16, and in *Kokka*, 336.

short handscroll depicting the Sixteen Arhats (dated 1631),[1] (Pl.300B) and a hanging scroll representing the Island of the Immortals.[2] They are both executed in a kind of *kung-pi* technique, the former with ink only, the latter with some addition of colour, which together with the fantastic design which is composed mainly of sharply outlined rocks rising out of turbulent waves, reminds us of Wu Pin's extraordinary landscapes. If the latter could be compared to cuttings in jade these luminous rocks in the midst of the grey sea are more like icebergs, inaccessible to ordinary human beings. It is surprising to find that the painter who did the imposingly rich and exuberant composition described above could also do a picture in this rather frozen style (*Cf.* Pl.308A).

<p style="text-align:center">★　★　★</p>

More than one of the prominent painters from Fukien active at the beginning of the seventeenth century, became involved in the political events which finally led to the fall of the Ming dynasty. Connexions of the kind were noticed in the biographical accounts of Chang Jui-t'u and Wu Pin, but they became still more important in the life of Huang Tao-chou, the painter whose fame in history is to no small extent based on the fact that he became a political martyr. The correspondence between the lives and characters of the painters and their artistic accomplishments is a theme to which Chinese historians often return, emphasizing the viewpoint that if they acted like heroes in the politica! arena and in practical life, they also expressed a noble spirit in their art (and *vice versa*); their artistic merits received added lustre from their sterling loyalty because their creative genius could not but reflect their fundamental character.

Huang Tao-chou, *tzŭ* Yu-yüan and Ch'ih-jo, *hao* Shih-chai, is a characteristic example of the above-mentioned estimate and he is as such usually combined with Ni Yüan-lu and Yang Wên-tsung, two other stout patriots who did not come from Fukien,

but like Huang passed most of their lives in Nanking, and thus may be recorded here in connexion with him. The three form a group attached to the Fukien centre through Huang, though mainly rooted in Nanking.

Huang was born 1585 in Chang-chou (Fukien), passed his *chin-shih* examination in 1622 in the company of Ni Yüan-lu (from Chekiang), who became his life-long companion. His official career, which started brilliantly, was evidently checked at various intervals through his outspoken criticisms of the actual political conditions.[3] He served in the Ch'ung-chêng period as vice-president of one of the Boards, but was deprived of office; later on he was called in again to serve, but was shortly afterwards exiled. Finally, when Prince Fu rallied the supporters of the Mings to a temporary government in Nanking, he was made president of the Board of Rites; and after the fall of Nanking he was appointed to the supreme position of a Grand Secretary by Prince T'ang, who established his government in Fuchou. He led an army against the Manchus in Chekiang, but lost the battle and was captured by the enemy. He was thrown into prison in Nanking and there he tranquillized his heart by reading *Shu-ching* and *I-ching*. On the eve of his execution he drank plenty of wine, rose early the next morning and told his servant that he had promised a man some specimens of his writings and paintings, whereupon he wrote a long scroll and painted two landscapes with large pine-trees. When these were finished, he went out and knelt before the executioner, who cut off his head. He was given the posthumous title, Chung Tuan, Loyal and Upright.

The favourite motifs of Huang Tao-chou's paintings are pine-trees, symbols of manly strength and endurance. He must have loved them beyond anything else and searched for the most beautiful

[1] *Nanju*, vol.11.

[2] *Tōsō*, p.381. (Sinozaki collection, Tōkyō.)

[3] Huang Tao-chou's biography is related in *Ming-shih*, vol.255, and in *Jên Ming ta tz'ŭ-tien*, besides abbreviated accounts in *Wu-shêng shih shih* and Painters' Dictionary.

specimens of pines with something of the same assiduity as other painters applied in their search for the different varieties of bamboos and plum-trees. The best examples of his pines are two paintings in the former Abe collection, one representing a single old pine bending and stretching its partly naked branches over the boulder at its side (dated 1737),[1] the other a selection of various kinds of pine-trees arranged successively on a horizontal scroll, each with explanatory notes. According to the text the first is a tree growing by the Pao Kuo temple in the South city of Peking, the second a pine by the Altar of Heaven in Nanking; then follow several pines and rocks from the Pao Shan island in T'ai Hu, and finally some steep rocks and tall pines from Huang Shan in Anhui. The picture has thus a documentary interest besides being a beautiful display of arboreal motifs rendered with insistence on their structural character[2] (Pl.301).

His larger and more finished compositions are less significant and the more he elaborates them, the more he seems to lose the strong expressionistic quality of the more sketchy paintings. This is illustrated by the landscapes reproduced in *Sōgen* (p.168) and *Tōsō* (p.366) respectively; the former being painted in a rather blotty but very expressive manner, whereas the latter seems to be a more finished product of ordinary type.

Huang Tao-chou's art and personality are well characterized in *T'ung-yin lun hua* in the following terms: "His manner of painting was of a very superior kind; he was melancholy by nature, but easily aroused and animated by moral courage (or a scholarly spirit). The hanging-scrolls, album-leaves, screens and handscroll by him which I have seen are mostly written in *hsing* and *ts'ao shu*; the brush-manner is intricate and exceedingly wonderful. He grasped the very spirit of the two Wang (*viz.* Wang Hsi-chih and Wang Hsien-chih). As to the paintings by the master, they are deep and boundless, filled with movement and overflowing with vitality. Truly his painting was an overflow of his writing."

Ni Yüan-lu, *tzŭ* Yü-ju, *hao* Hung-pao, was born in 1593, in Shao-hsing (Chekiang). Although eight years younger than Huang Tao-chou, he passed the *chin-shih* examination in the same year as his older friend and became a member of the Han-lin Academy. Owing to his prominent official position and patriotic services he is recorded in the Ming History as well as in *Wu-shêng shih shih* (IV.27), which reads as follows: "He was a highly esteemed poet and prose writer, and his calligraphy in *hsing-shu* and *ts'ao-shu* was extraordinary like brocade patterns. As a painter he excelled in representing ornamental stones (*i.e.* garden rocks), which he did with washes of watery ink; they looked as if they were soaked in moisture and had the air of old things. These were also an overflow of his literary culture."[3]

This description of his literary accomplishment is completed in *Ming-shih* with biographical information, according to which he experienced several ups and downs in his official career. The first time he was checked and deposed was after criticizing the eunuch Wei Chung-hsien; some time afterwards he was appointed director of the Confucian temple in Peking, but was slandered by others and again lost his position. When he learned that the capital was besieged by the rebels he hastened to Peking, at the risk of his life, and was then made president of the Board of Revenue. But this position he evidently held only for a month or two; when Li Tzŭ-ch'êng entered Peking he committed suicide by hanging himself. Prince Fu conferred upon him the posthumous title: Wên Chêng.

Ni Yüan-lu is nowadays esteemed no less highly than Huang Tao-chou, and his works are not very common. He, too, had a preference for pine-trees beside garden rockeries, and he painted them with admirable ease and strength, as may be seen in a picture representing three tall trees, of which two are intertwined, and a little man seated at their

[1] Ōmura, *Bunjin Gasen*, I, 7.

[2] *Sōraikan*, I, 39.

[3] Cf. *Ming-shih*, vol.265, and *Jên-ming ta tz'ŭ-tien*.

roots.[1] The design is more interesting than in Huang's paintings, but the brushwork may not be of the same decidedly expressionistic quality. In the larger picture in the Seikadō collection, known as Sailing Boats on the River by a Mountain,[2] pine-trees stand on rocks in the foreground and mountains rise steeply on one side, while the rest of the picture is filled by the view over the quiet water which extends into infinity (Pl.302A). The motif is thus not unlike that of certain pictures by Wên Chêng-ming and his followers, though rendered in a colder tone than by the old Suchou painters. Ni Yüan-lu's brush emphasized the strength of the trees and the structure of the mountains rather than the pictorial atmosphere of the scenery.

Ni Yüan-lu's structural and yet very free brush-work may also be observed in his flower-paintings, particularly when combined with richly flowing deep ink. The best among these, such as the hand-scroll in the Freer Gallery, are done with brilliant dash and, at the same time, marvellous control of the running brush and the flowing ink[3] (Pl.303). The manner may lead our thoughts to some of Hsü Wei's most successful flower-paintings, but the flowers by the younger master are painted with a softer touch, more sensitive variations in tone and a more gliding rhythm; this may be followed all through the scroll in spite of the wide intervals between the single flowers, all of which are accompanied by poems. Each flower has enough space to expand and light to breathe.

Ni Yüan-lu must have been deeply attached to the picturesque rock-gardens which at his time had attained their full development, particularly in the south. He represented the ornamental rockeries with the same care and sympathy as he bestowed on magnolias, roses and chrysanthemums. The most impressive example of his love of stones is the picture in the former Abe collection (Ōsaka Museum) which represents a magnificent T'ai-hu rock partly overgrown with moss. Its structural beauty is rendered in a fashion that makes us realize why such stones could arouse the enthusiasm of

painters; it possesses the imaginative appeal of Chinese writing, and harmonizes consequently with the inscription that fills the upper part of the picture. The artist tells there how he painted this stone in 1636 on the eve of his nephew's departure from Tientsin to Ching-hai. They had been drinking wine together; and then he grasped the brush and did this strangely expressive thing "in the manners of Mi Fei and Ni Tsan" – the two most admired gentleman-painters of the Sung and Yüan periods whose widely diverging individual styles we should hardly expect to see combined in one picture. Nor is this claim of the artist substantiated by the work. He may have had these great predecessors in mind, but "he expressed – here as elsewhere – his own loyal spirit with his brush, and consequently surpassed other painters" – a statement by one of his biographers which leaves a wide field for interpretation.

Yang Wên-ts'ung, tzǔ Lung-yu, is usually placed in a group with Huang Tao-chou and Ni Yüan-lu, a co-ordination which, however, is caused by national or patriotic reasons rather than by correspondence of style and origin. He was born 1597 in Kueichou, one of the south-western provinces, but passed most of his life in Nanking and other places in Kiangsu. At the time of the Ming debacle he was serving as a magistrate in Nanking and was appointed by Prince Fu to organize the military defence of the city. When defeated he, like Huang Tao-chou, fled to Fukien, where Prince T'ang collected the last forces of the patriots and set up his independent government. There Yang Wên-ts'ung led an army against the Manchus, but was again defeated and captured by the enemy.

As a painter he was more closely related to Tung Ch'i-ch'ang than Huang and Ni, no doubt as a

[1] The picture is dated 1632 and reproduced in *Shina Nanga*, III, 10, without indication of owner.

[2] *Nanju*, vol.13, and *Tōsō*, p.368.

[3] Another handscroll by the master representing a number of detached flowers is in the collection of Prof. Chêng Tê-k'un in Cambridge.

consequence of his studies during early years in Sung-chiang, "yet he did not adhere to the principles of the Yün-chien school", to quote the *T'ung-yin lun hua*, where his personality and art are described in rather eulogistic terms: "His nature was free and unrestrained; his manner of painting was like wind blowing and clouds unrolling; his genius was different from that of ordinary (painters). I have seen several minor (one foot square) pictures by him, they were all quite spontaneous (begun and finished in one moment). He did not follow any (stereotyped) 'short cuts' in his paintings, but filled them with effects of ease and tranquillity. They were perfect expressions of his scholarly spirit."

Yang Wên-tsung seems to have been too much of a genius by nature to stick to any definite style. His best paintings are indeed spontaneous expressions of a sensitive temperament, mostly album-leaves, fans or minor paintings of bamboo or epidendrums.[1] His larger works are less interesting, if we may judge by the mountain landscape of 1638, which is made up of bulging humps and misty gorges into a crowded composition in the Wang Mêng style. The picture can hardly be called very attractive, but it is highly praised by Chinese critics, who have provided it with long inscriptions.[2] Yang Wên-tsung's mastery of the brush is more evident in the twelve small landscapes which make up the album known as *Lung-yu mo miao* (dated the same year),[3] *i.e.* a series of spontaneous records after the manners of certain old masters such as Kuan T'ung, Ma Yüan, Chiang Kuan-tao, Huang Kung-wang, Wu Chên and Ni Tsan. It would, however, be a mistake to look for close imitations of the brush-work of these masters in the sketches (Pl.304). The artist has evidently been more interested in recreating or transforming the motifs that he borrowed from some old masters than in imitating their formal styles or manners of expression. All the pictures in this album, whether inspired by earlier works, or expressive of the artist's own fleeting thoughts, are painted with a brush that seems to distribute light and shade as freely and easily as sailing clouds or rays of light playing in the leafage of the trees. It matters little what they represent, be it a man walking through an autumn wood, a lonely philosopher contemplating a waterfall, a fisherman "homeward bound in wind and rain", rugged cliffs rising over a mountain stream, or some friendly cottages in the shade of wu-t'ung trees, they all contain a resonance of silent poetry rendered by a very sensitive brush.

[1] Cf. *Shoman*, pl.25, and the bamboo and epidendrum pictures in *Shên-chou*, vol.I and *Ku-kung*, vol.XII.

[2] *Chung-kuo ming-hua*, vol.8, and *Shina Nanga*, I, 13.

[3] The album was published by the Hakubundō Co., 1920.

VI

Traditionalists from the Northern Provinces: Mi Wan-chung, Wang To and Tai Ming-shuo

THE LANDSCAPE-PAINTERS mentioned in the preceding pages and grouped with a view to their places of origin and their stylistic associations, were all men of the south. They were active at the well-known art-centres in Kiangsu, Chekiang and Fukien, and more or less attached to the natural surroundings in which they grew up and to certain traditions of style which were deeply rooted at some of these centres of pictorial activity. The importance of this may not always be recognizable at the first glance, but it becomes clearer in the same measure as we understand or sense the *genius loci* of the various local schools. When we have grasped this it seems self-evident that for instance a landscape by one of the Fukien painters could not have been done in Suchou or *vice versa*.

This very rich and locally differentiated florescence of landscape-painting which at the end of the Ming period had spread over large sections of the southern provinces, was not matched by anything of a corresponding nature and importance north of the River. Judging by the historical records and pictures known to us, the painters active in the northern part of China who devoted themselves to landscape-painting were relatively few and not of outstanding importance. The most prominent among the northern artists were, as a matter of fact, not specialists of landscape-painting, but figure-painters, more or less professional men who supplied the demand for illustrative figure-paintings of a profane as well as quasi-religious kind. We shall return to some of them in the next chapter, but must first mention two or three of the non-professional or scholarly painters who followed somewhat the same paths of activity as the literary or gentleman painters in the south, though with quite different ideals of style and workmanship. They were, as said above, quite few, nor of the same artistic importance as the leading masters in the south, yet historically interesting because they formed a kind of stylistic counter-current to the general flow of landscape-painting which was conducted by the leading masters in the south. This becomes evident not only through some of their characteristic works, but also through critical remarks by certain northern painters about the painters and the stylistic ideas or models which were highly esteemed by the southerners. These remarks are not very extensive, yet quite explicit in their depreciation of current forms of expressionistic landscape-painting which through the activities of Tung Ch'i-ch'ang (in writing and painting) and his immediate followers had won the day and spread their influence far and wide. The northerners had no use for expressionistic picture-writing; they preferred models of a more traditional type which embodied the principles of the great masters of the North Sung or pre-Sung times. By their training and occupation they belonged to the class of scholars

and officials, no less skilled in painting than in calligraphy, yet quite detached from the romantic attitude towards nature and art that constituted an inexhaustible source of inspiration for the Sung-chiang and Suchou painters.

The oldest and most prominent among these northern traditionalists was Mi Wan-chung, *tzŭ* Chung-chao, *hao* Yü-shih. He came from An-hua in Shensi, and was probably born before 1575, because he passed the *chin-shih* examination in 1595 and died 1628, when he had been "famous for forty years", during which he had served in several prominent positions such as provincial governor and vice-president of the Board of War. He prided himself on being a descendant of the same Mi family as the great Sung painter, and like Mi Fu (Mi Fei) he amassed an important collection of ink-stones and became particularly famous for his *hsing-shu* and *ts'ao-shu* style. He was, as a matter of fact, recognized as one of the four greatest calligraphers of this period, the others being Tung Ch'i-ch'ang, Chang Jui-t'u and Hsing T'ung.

He is characterized in *T'ung-yin lun hua* as a very distinguished man of great refinement; in fact, it became customary to place him on a level with Tung Ch'i-ch'ang and to speak of Tung from the south, and Mi from the north. The writer tells, furthermore, that he had seen a large scroll which Mi Wan-chung had painted in imitation after old Mi. "It possessed boundless strength and vitality, and was filled with floating mist and clouds, yet painted in strict conformity with the rules. The effect of his startlingly free brushwork was luxuriant, it overflowed the white paper and was a source of inexhaustible fascination."

Another somewhat different eulogistic description of Mi Wan-chung's artistic activities, and his landscape-painting in particular, is included in *Wu-shêng shih shih*, where it is said that he used to practise with brush and ink at random and thus developed a very refined manner. According to his own view this was due to the inspiration of Heaven. "He collected many strangely shaped

stones according to the same fashion as Mi Fu (Hsiang-yang). The painters of the North Sung and previous age served as his models; he imitated them assiduously with great skill. His compositions were stupendously profound in thought. He never did any petty trifles. He used to discuss matters with Wu Pin, who was a secretary in the Chung-shu, and consequently their manners became somewhat similar."

It is hardly possible to obtain a correct idea about a painter like Mi Wan-chung through reproductions of his works, because they are mostly of very large size (reaching a height of 3 or 3½ m) and filled to the brim with carefully selected and executed details of rocky humps, rushing streams, clumps of trees, buildings in the folds and clouds around the peaks. The general designs of these imposing pictures are more or less the same as those known from the works of the great landscapists of the tenth and eleventh centuries, such as Kuan T'ung, Hsü Tao-ning, Yen Wên-kuei and others, and also from the more or less successful imitations made all through the centuries down to the end of the Ming period. They were the links in a tradition which was kept unbroken not only by generations of scholars and academicians, but also by hosts of ordinary professional painters.

Mi Wan-chung adopted these principles with certain modifications which reflect his studies not only of the Sung and pre-Sung models, but also of Yüan painters like Wu Chên and Wang Mêng, and Ming classics of Shên Chou's type. The two examples of his art here reproduced are both imposingly lofty and elaborate, yet derived from originals of rather different types. The very tall picture (3½ m high) in Chinese possession, which represents a famous mountain view at Yang-so in Kuangsi, reminds us of some early Shên Chou compositions, (Pl.305A), whereas the other picture (in a Japanese collection) leads our thoughts more directly to Wu Chên or Wang Mêng, but also reveals the painter's faculty of suggesting a soft misty atmosphere (Pl.305B). The same is true of the large mountain landscape in the National Museum in Tōkyō, in which reminiscences of Wang Mêng mingle with those of Mi Fu in a way which lends support to the statement in *Wu-shêng shih shih* that in consequence of their mutual friendship the manners of Mi Wan-chung and Wu Pin showed some correspondence.

Mi Wan-chung was not exclusively a landscape-painter; he was also well known for his flower and bamboo-paintings, which formed a counterpart to his calligraphy and offered the best opportunity for a display of his excellent brushmanship. The best among these are painted in a rather fluent manner with rich ink, as may be seen in the picture from the Horikawa collection, which represents Bamboos and Chrysanthemums by a Rockery with strikingly vivid and effective pictorial accents. Yet it is not an "expressionistic" sketch of the kind that was produced by the younger flower-painters from Suchou and Sung-chiang, but reminds us rather of corresponding things from the beginning of the sixteenth century, thus offering a perfect illustration to the statement in *Ming-hua lu* that "he followed Ch'ên Tao-fu in his paintings of flowers and grass" (Pl.306).

Wang To, *tzŭ* Chio-ssŭ, who came from Mêng-ching in Honan, was at least twenty years younger than Mi Wan-chung, but as a painter and an official he followed the same path as the older colleague. He became a *chin-shih* in 1622, and acquired great reputation as a literary writer and a Hanlin official. When the defeated Ming dynasty set up its last government in Nanking 1646, Wang To was summoned to take part in it and made president of one of the Boards. He died 1652. The old chroniclers dwell particularly on his noble character and imposing appearance, with a beautiful beard that inspired veneration. He was a great student of history and particularly prominent as a calligraphist, writing *hsing-shu* and *ts'ao-shu* in the manner of Wang Hsi-chih, and *k'ai-shu* after the model of Chung Yu. He painted orchids, bamboo, plum-blossoms and stones in a free manner and gave "their meaning beyond their shapes".

In the *Kuo-chao hua-chêng lu* it is furthermore stated that Wang To followed Ching Hao and Kuan T'ung as a landscape-painter, and that "his hills were massive and lofty. He painted them without 'wrinkles' and used broad washes to produce vaporous effects. Sometimes he added light colours which altogether gave the effect of luxuriant growth." The characterization fits some of Wang To's typical landscapes more or less, though it is worded in superlative terms. The painter himself has, however, given a still more pertinent definition of his aims and attitude as a landscape-painter in a letter to his colleague Tai Ming-shuo, which is quoted in the same biography. This has the form of an opposition to the prevailing admiration of Ni Tsan's landscapes, indicating that the ideals which Wang accepted for his own guidance were of a different kind. The pronouncement is negative, but the positive implication seems evident: "Paintings which represent desolate views such as the works of Ni Yün-lin and his followers excite no strong emotions. They give the effect of quietude but cannot escape being dry and weak, like a sick man who is gasping for breath. They may be called airy and elegant, but how thin and insipid they are! Great masters are not like that!"

No other painter of the Ming period has, to our knowledge, given expression to a similar depreciation of Ni Tsan's art, a fact that may be said to characterize the critic even more than the object of his displeasure. It is evident that he represented an aesthetic attitude strictly opposite to that of most of the leading gentleman-painters, or *literati*, for whom Ni Tsan was an unattainable ideal, and had the courage to proclaim it in words as well as in his individual style of painting. As a result of this, Wang To may be said to stand somewhat detached from the main current of contemporary stylistic development and is as such historically interesting. His art has something of the robust and vigorous quality that reminds us of Hsieh Shih-ch'ên and other early Ming painters, though the dependence on models of pre-Sung date is perhaps more funda-

mental in his large landscapes. But these early models have been recast in quasi-baroque shapes with tumbled rocks, rushing streams and deeply overhanging trees.

Several of the paintings mentioned in our list of Wang To's works might serve as illustrations of these characterizing remarks, but since we are obliged to limit ourselves to a single example, we may choose the picture in the collection of Mr. Ernest Erickson which is dated 1651 (Pl.307). It represents an imposing mountain composed of innumerable grassy humps, clumps of trees, and winding brooks, with pathways in the crevices and small dwellings on the terraces of the river-bank at the foot of the mountain. The general design follows a diagonal line across the picture which is not too common, though sometimes used already in pre-Sung times. The picture is as such an interesting example of the survival of the *grande mode* of romantic landscape-painting, though the painter's interest in naturalistic details and his elaboration have to some extent blurred the fundamental grandeur of the motif.

The reactionary tendencies of style which we have observed in the paintings and pronouncements of Mi Wan-chung and Wang To may also, to some extent, be traced in the artistic activity of Tai Ming-shuo, also known under his *tzŭ* Tao-mo and his *hao* Yen-lo. He came from Ts'ang-chou in Hopei and was probably born at the very end of the sixteenth century, because he obtained his *chin-shih* degree in 1634 and was well known as a painter already before the end of Ming, though he is usually placed among the painters of the Ch'ing period because of his associations with the first Manchu emperor, Shun-chih.

According to *T'ung-yin lun-hua*,[1] his compositions were remarkable for their structural quality and their air was noble and bold. He grasped the form and character of Wu Chên's bamboo-paintings, but most of his own bamboos are done with a heavy brush; in spite of this they are quite to the

[1] Part II, vol.I.

point and painted with a force that makes "the brush penetrate the paper". But (in other cases) when he painted with the tip of the brush, he produced "spiritual (airy) and extraordinary effects. He could not quite avoid criss-cross (unrestrained strokes), he came very close to Hsia Ch'ang".

His bamboo-paintings are nowadays seldom seen, but at least two characteristic specimens of his land-scape-painting (in Chinese possession) are known in reproductions. The first is a large picture, dated 1647, which formed part of the Nanking Exhibition (*Cat.* No.299). It represents some imposingly broad and massive rocks in snow and dry trees rising above a mountain stream. According to the inscription on the picture it was done after a model by Ching Hao, which explains the rather bold simplification of the design.

The other picture (formerly in the Chang Kuo-jung collection) is a less austere and more romantic creation in Sung style (Pl.308B). It represents a deep gulley with a winding stream and a philosopher seated in meditation on the high bank under some beautiful pine-trees of perfect Kuo Hsi type. The mist is rising from the bottom of the gulley hiding the lower section of the split and twisted rock that fills the rest of the composition. The design is dominated by the curving rhythm of the mountain and rendered with a suggestion of a soft pictorial atmosphere. It illustrates the painter's technical skill and also his intention to manifest, so to speak, the superiority of the Sung ideals to those of modern painters as explained in the dedicatory inscription: "The manner of the North Sung masters has for a long time not been transmitted; I have now taken it up by chance in opposition to the Sung-chiang manner."

There may, indeed, have been other painters, active in the northern provinces, who were inspired by similar intentions, but they are less known than the three mentioned above. It may be that closer critical studies of some of the famous landscapes attributed to Kuan T'ung, Hsü Tao-ning, Fan K'uan, Yen Wên-kuei and others were executed by some of these highly skilled painters at the end of the Ming period, who were fired by the patriotic and aesthetic ambition to save the old classic ideals of landscape-painting from an increasing avalanche of modernistic improvisations.

Figure-painters

I

Traditionalists and Archaistic Painters

THE FIGURE-PAINTERS active at the end of the Ming period were not as numerous nor as prominent from an historical or artistic point of view as the landscape-painters. They did not contribute to the development of style or to the emergence of new modes or manners of painting to the same extent as the leading masters of landscape-painting; they remained on the whole more traditional, more firmly settled in the old grooves of professional painting. This was, as we know, pre-eminently characteristic of painters who filled the demand for Buddhist and Taoist pictures, but it applies also, though in a less degree, to others who devoted themselves to illustrative representations of historical or legendary motifs. Some of them gained considerable popularity, and also fame with posterity, yet their paintings were not generally placed on the same level as the works by scholars and *literati* who practised the art of painting as a complement to the art of calligraphy.

This relative estimate of landscape versus figure-painting may seem surprising to westerners, who may be inclined to reverse the estimate, but to the Chinese it was a natural outcome of their attitude towards every kind of manifested life. According to their view, humans were not essentially superior to other kinds of animated beings and not necessarily more perfect symbols for the creative forces of universal nature than flowers and birds, trees and stones, or mountains and streams. They became interesting through their interrelation with other forms of manifested life rather than by isolation, and they should consequently not be placed above

or beyond nature but *in* it as integral elements of a larger organism. Man became interesting to them in so far as in his consciousness he could focus the creative thoughts pulsating through various forms of visible nature and express them in his actions. Consequently he is usually represented in a significant surrounding (a framing landscape or habitation) which serves to emphasize the character or nature of the model and makes the picture more entertaining as a work of art. Such portraits are illustrative records rather than individualized character-studies, and this is also true, though on somewhat different grounds, of the full-size ancestral portraits which were produced in masses during the Ming and Ch'ing periods for the purpose of representing prominent ancestors in *effigie* at the sacrificial ceremonies. Some of them may have a special attraction for westerners owing to their characteristic types and decorative designs, but it should be remembered that they were never classified as real works of art by native connoisseurs. To them they were merely works of professional skill made for the purpose of recording and representing the ancestral guides of the clan.

* * *

The oldest and best known of these figure-painters was Ting Yün-p'êng, *tzŭ* Nan-yü, *hao* Shêng-hua Chü-shih, from Hsiu-ning in Anhui. "He painted Ta-shih (Kuanyin) and Lohans of a very agreeable appearance and expression. When one opens a picture of his it is like entering a room where Vimalakirti is in discussion with Buddhas and

Bodhisattvas. The eyelids and nostrils of the figures are all moving. His landscapes are filled with deep valleys and beautiful gorges like those of the old masters. Even Li Lung-mien and Chao Mêng-fu did not reach very far beyond him." To judge by this panegyric note in *Wu-shêng shih shih*, Ting Yün-p'êng must have enjoyed a reputation at the time which far exceeded his artistic importance, possibly because he was so successful in imitating the old masters. A more definite characterization of his style is found in *Ming-hua lu* (among Taoist and Buddhist painters): "Ting Yün-p'êng was skilled in painting Buddhist figures and grasped the style of Wu Tao-hsüan. In his Lohan paintings, executed in the *pai-miao* manner, he followed Ch'an-yüeh (Kuan-hsiu) and Chin-shui (Chang Hsüan), but he had also a style of his own. His landscapes, figures, and other kinds of pictures were all wonderful. Tung Ch'i-ch'ang gave him a seal on which were carved the three characters: *Hao-shêng-kuan*." (A study where every hair of the brush confers life.)

We may well agree with the general bearing or argument of the above characterization of Ting Yün-p'êng's merits as a painter, though the comparison with Wu Tao-hsüan must be taken as a flattering figure of speech rather than as a statement of fact. Most of the artist's paintings of Lohans and Bodhisattvas possess very little, if anything, of the mannerism and dramatic grandeur which are usually considered most significant of the T'ang master's style, yet it should be remembered that there are one or two remarkable exceptions in which possibly a faint echo of the old master's impetuous flight may be discovered.

Most significant in this respect is the handscroll in the Nelson Gallery in Kansas City which represents Five Forms (or Revelations) of Kuanyin in as many successive scenes, among which may be observed in particular the representation of the Dragon King paying homage to the Bodhisattva. He is riding on a dragon over rolling waves towards a projecting rock where the white-robed Kuanyin

appears in a cave, while a heavenly guardian in fluttering scarves hovers in the sky and monstrous giants support the overhanging rock. The opposition between these elements of restless movement below and the meditative Bodhisattva above is certainly effective, and of a kind that might have been inspired by some of Wu Tao-tzŭ's dramatic illustrations. But it must be admitted that if Ting Yün-p'êng had some such models in mind, he has recast them in a form which is more remarkable for refinement than for boldness or swing in the brushwork (Pl.309).

Another no less brilliant example of Ting Yün-p'êng's technical skill and faculty of characterization belongs to the Honolulu Academy of Arts, and represents the Sixteen Lohans. The figures are executed with gold solution in the finest *kung-pi* manner on purple silk. The dramatic expressiveness is here condensed in some of the single figures who are standing on the brim of deep ravines speaking and gesticulating; others are seated under the trees, lifting their bowls (as if receiving food from Heaven) or sewing their garments; they are all actively engaged (Pl.310). They can hardly be called individual portraits, yet they seem to be inspired by living models rather than by tradition, or earlier renderings of similar motifs. From a technical point of view this scroll-painting may be called a *tour de force*; it belongs to the best class of religious painting and has at the same time a strong appeal through its realistic characterization and holds as such a prominent place in the *œuvre* of Ting Yün-p'êng.

We have no reason to dwell here on his ordinary pictures of Bodhisattvas and Lohans, of which many are more or less known through reproductions.[1] They are archaistic in a rather depressing sense, reflecting elements of pre-T'ang style in schematic transformations. He appears decidedly more interesting in his illustrations of historical or legendary subjects, such as the picture of Confucius' pupil Tsêng Shên, who arrives at his mother's dwelling and finds the old woman biting her finger (as an

[1] *Cf. K.-k. shu-hua chi*, vols.XXVIII, XXXVIII, XL.

expression of her longing for her son). The some-what painful appeal of the situation is dramatically reflected in the various figures, and the composition is arranged in a picturesque setting of buildings and trees.[1] It is executed in the same kind of *pai-miao* technique as the Buddhist figures (Pl.311).

Among Ting Yün-p'êng's larger illustrative pictures in colour, which are to no small extent filled by landscapes that serve as settings for the figure scenes, may be mentioned the representation of the Indian missionaries arriving in A.D.67 with a white horse carrying Buddhist sūtra scrolls to Loyang.[2] Furthermore, the picture called Inquiring about the Way to Tan-tai (the Abode of the Immortals),[3] not to mention the landscapes without figures. The main interest is in these pictures centred on the archaistic transformation of the figures as well as the landscapes, the trees, the mountains and the clouds, which are more or less successful imitations after Chang Sêng-yu, Yen Li-pên, Li Ssŭ-hsün and others, but hardly ever transmuted to accord with patterns or a style of his own.

When one has seen a number of such illustrative pictures by Ting Yün-p'êng, executed in adherence to archaic models, it is surprising to find paintings by him which are inspired by works of Yüan masters and executed in a fluent manner with ink only. Most striking in this respect is the large cloudy landscape in a Japanese collection called Summer Mountains before Rain, which has the following inscription:[4] "Once I saw a picture like this by Kao K'o-kung; today the rain is pouring outside my window, and as a pastime I am imitating somewhat his ideas. On the first summer day in 1618. Ting Yün-p'êng."

Ting Yün-p'êng was evidently highly accomplished and had a command of the brush that none of the *literati* or amateurs could equal. He might have reached a more prominent place in the history of Ming painting if he had not been haunted by the ambition to equal the old masters in illustrative paintings. One of the most enjoyable works of his is the ink-painting representing Epidendrums and

Fungi by a Garden Stone, formerly in the Wang Shih-yüan collection in Peking.[5] It is executed with a firm yet supple brush which renders the freshness and growth of the plants perfectly (Pl.312). Tung Ch'i-ch'ang has written a colophon on the picture interpreting the symbolic significance of the motif and the beauty of the brushwork. "Master Hsieh[6] said: 'The fungi and the epidendrums are like trees of jade (*i.e.* talented boys or young men), they should be grown near the steps in the courtyard.' This picture is the work of my friend Ting Nan-yü. He painted quite unrestrainedly, for he had grasped the secrets of Mi Yu-jên's ink-plays. The owner of the picture will be nourished by the fungi and enjoy a long life; he will dream of the epidendrums (omens of bearing sons), which may bring him unicorns of jade (*i.e.* sons). The artist has here given life without a limit." The symbolic significance of the motif was evidently no less important to the connoisseurs of the time than the decorative beauty.

Chang Ch'ung, *tzŭ* Tzŭ-yü, *hao* T'u-nan, was of exactly the same age as Ting Yün-p'êng, his earliest dated picture is of the year 1581, but he did not reach the same level of artistic skill and fame. He was active at Nanking and according to *Wu-shêng shih shih* distinguished by gentleman-like manners. "He painted scholars and ladies, fat and lean, of many kinds, gathering them all at the tip of his brush", a characterization further qualified in *Ming Hua Lu*, where we are told that he painted "figures in the old style with a free and easy brush and fresh and beautiful colours". He too seems to have worked in the *kung-pi* technique, though with somewhat more colour than Ting Yün-p'êng. – The most representative example of his art known to us is the large picture in the Ku-kung collection known as *P'êng-shan ying mien*, or The Cart Arriving at the

[1] *Ibid.* vol.V.

[2] *K.-k. shu-hua chi*, vol.XXXIV.

[3] *Chung-kuo*, vol.I.

[4] *Nanju*, vol.19.

[5] *Ōmura*, I, 12.

[6] Hsieh Hsüan, a poet and statesman of the Chin dynasty.

Mountain of the Immortals,[1] which seems to illustrate a Taoist legend: The lady who has been riding in the cart, drawn by a white stag, is probably the fairy Ma Ku, and the man in white who is approaching amidst the flowering trees may be an Immortal welcoming her. They are both rendered in a very graceful style based on T'ang models, and the whole picture reflects the air of Taoist lore.[1]

Chêng Chung, *tzŭ* Ch'ien-li, who also was active in Nanking, is said to have been a devoted Taoist. He followed as a painter the same trend as Chang Ch'ung: "his style and pattern were refined and showed no deviations from the old rules", according to *Wu-shêng shih shih*. His figure-paintings, inspired by Buddhist and Taoist legends, were evidently faithful expressions of his own personality. We are told that he used to stay in high buildings enjoying incense and tea, and when he painted Buddhist figures he always washed and fasted before he grasped the brush. The picture in the Ku-kung collection which represents an Immortal seated on a mat surrounded by some antique vessels and the like and served by a boy,[2] is executed in close adherence to Li Kung-lin's *kung-pi* manner with great insistence on details. The other picture by Chêng Chung in the same collection is a landscape after Wang Mêng with very small figures and is called Ku-hung Moving his Residence (dated 1618).[3]

Ts'ui Tzŭ-chung, *tzŭ* Tao-mu, *hao* Pei-hai, from Lai-yang in Shantung, was, however, more important from an aesthetic as well as an historical point of view than the two last-mentioned painters. He is said to have shut himself up in a cave and starved to death when the national government was overthrown. In his earlier years he was a friend of Tung Ch'i-ch'ang and travelled with the master to the capital in 1633. It is furthermore related in *Wu-shêng shih shih* that "he was deeply attracted by the noble spirit of Ni Tsan and made a picture called The Washing of the Wu-t'ung-trees". The picture, which is in the Ku-kung collection, shows Ni Tsan in old-fashioned costume watching some maid-servants washing the trees, while two others are standing by with sacrificial vessels. According to the writer quoted above, it gave an impression of purity and made one realize how Ni Tsan's soaring mind was absorbed in dreams of the clouds.

In the *Ming-hua lu* it is pointed out that he followed the old masters very faithfully in his figure-paintings, imitating Ku K'ai-chih, Lu T'an-wei, Yen Li-pên, and Wu Tao-tzŭ, a fact which is furthermore confirmed by Ch'in Tsu-yung in *T'ung yin-lun hua*, who says that the painter "grasped the noble ancient manners, seeking his inspiration in the works of the Chin and T'ang periods and avoiding the ruts of the Sung and Yüan painters". According to his noble ideals, a picture should never be sold, simply given away; even when poor and hungry, he never accepted any money for his paintings, the result being that he collapsed from poverty and utter despondency over the political conditions. Another result of this seems to have been that most of his pictures were lost; there are hardly more than one or two known apart from the five large compositions in the Ku-kung collection.

No painter represents the archaistic tendency in Ming art more thoroughly than Ts'ui Tzŭ-chung. His pictures are either versions of famous early designs by T'ang or pre-T'ang masters or more realistic illustrative compositions, executed in an archaic *kung-pi* manner in which he has incorporated elements borrowed from some early works. To the first-named class belongs his picture representing the popular Buddhist motif called The Brushing of the Elephant, in a form almost exactly the same as in the picture in the Freer Gallery previously mentioned among imitations after Chang Sêng-yu.[4] The peculiar wavy drawing of the elephant's skin and the voluminous garments of the men, as well as the decorative stylization of the leafage, reveal the influence of an archaic model

[1] *K.-k. shu-hua chi*, vol.XXII.

[2] *K.-k. shu-hua chi*, vol.XXVII.

[3] *Ibid.* XXX.

[4] *K.-k. shu-hua chi*, vol.XXXV.

(Pl.313). According to tradition Chang Sêng-yu was the first to treat the motif, but his composition was transmitted (with some modifications) by Yen Li-pên in the seventh century. One of these early pictures may have existed in the Ming period, or at least copies of them which could have served Ts'ui Tzŭ-chung as models.

The other pictures in the Ku-kung collection are freer inventions but also archaistic from a stylistic viewpoint. One of them illustrates an anecdote from the life of Su Tung-p'o.[1] The poet is represented in conversation with his friend, the learned monk Fo-yin – both seated in root-chairs under shady trees – who put four questions to him that Su Shih could not answer. Consequently he departed in silence, leaving his belt behind. The figures are drawn in a style not unlike that of the preceding picture in spite of the fact that they represent personages of the Sung, and not of the T'ang period. The rocks and the trees are also conventionalized in a manner that may be called pre-Sung, though they form a natural setting for the figure group, which includes two servant-boys beside the two old men in the chairs.

The picture in the same collection which is known as Examining Antiquities in the Shade of Wu-t'ung-trees (dated 1640) is related to this by its motif, but represented in a more advanced style.[2] It is also connected with Su Tung-p'o, who is said to be one of the old men occupied in the fascinating pursuit of examining old bronze vessels. This takes place in a grove of beautiful tall trees rendered with the same admirable exactness of detail and refinement as the figures and the antiquities.

The last picture in the Ku-kung collection, which represents a mountain landscape where a man is seen riding on a water-buffalo, followed by two women and a servant carrying some boxes on a staff over his shoulder, has the rather surprising title "Chickens and Dogs amidst Clouds".[3] This is explained by the artist as follows: "He is taking his whole family to the mountains, where he will concoct the elixirs of immortality; his wife and children are entering on the mountain with him. Consequently dogs and chickens will be heard from the clouds; life there is just as among men. The Taoist Hsü's picture 'Chickens and Dogs among the Clouds' has been copied by various masters. I followed this old model without being tied by it."

In other words, it is an illustration to the kind of rustic mysticism which was growing popular at that time, executed in a somewhat fragile *kung-pi* style not based on actual studies of nature. Ts'ui Tzŭ-chung can hardly be called a great painter, yet he is interesting as a representative of the languid traditionalism to which so many of the able painters at the end of the Ming period succumbed.

During the last decade of the Ming reign, while living in Peking, Ts'ui Tzŭ-chung enjoyed great reputation as a learned and old-fashioned figure-painter. It was then customary to speak of "Ts'ui from the North and Ch'ên from the South", his rival being a somewhat younger painter from Chekiang called Ch'ên Hung-shou, *tzŭ* Chang-hou, *hao* Lao-lien (1599–1652), who earned a still greater reputation as a painter of figures and flowers according to old models. His career was also closely bound up with the fall of the Mings. In the Ch'ung-chêng period he was appointed a *kung-fêng* at the court, but did not accept the appointment. Then, during the last national government in Nanking, he was made a *tai-chao*, and at the fall of Nanking he became a prisoner, but when the commanding general of the Manchu army learned about his eminence as an artist, his life was spared, and he was allowed to return to his home in Chekiang, where he lived in retirement for half a dozen years, calling himself Hui-ch'ih (Tardy Repentance).

His artistic genius and mode of expression were quite uncommon, and aroused great admiration, eloquently expressed by Chang Kêng in *Kuo-ch'ao hua-chêng lu*: "He painted figures of very imposing appearance, drawing the folds of their costumes

[1] *K.-k. shu-hua chi*, vol.XXII.
[2] *K.-k. shu-hua chi*, vol.V.
[3] *Ibid.* vol.VI.

with fine and strong lines, combining the wonderful points of Li Kung-lin and Chao Mêng-fu; in his colouring he imitated Wu Tao-tzŭ. His natural vigour was extraordinary, surpassing that of Ch'iu Ying and T'ang Yin. For three hundred years there had been no painter equal to him. When he was a boy he crossed the Ch'ien-t'ang river to make a rubbing of Li Kung-lin's Seventy-two Pupils of Confucius, which were engraved on a stone tablet in the Hangchou school, and shut himself up in a room to make copies of it. But with each new copy he introduced changes. Another time he copied a picture of ladies by Chou Fang. People who saw his paintings said: 'Your copies surpass the originals; why do you keep on making copies?' To which he answered: 'That is just where I fall short; the merits of my pictures are easily seen, and so I have not attained supreme skill. Chou Fang's skill is consummate; yet he appears to possess no skill. This is what is really difficult.' " A statement which shows that the artist's self-criticism was no less developed than his admiration for the old masters.

Ch'ên Hung-shou's unusual qualities as an illustrator and a draughtsman have made him very popular among his countrymen, and consequently he has also served as a model for many skilful imitators. The intrinsic quality and peculiar rhythm of his drawing and rendering of form should, however, make his own creations distinguishable from those of his imitators, who may have been able to reproduce the ornamental appearance but never the actual structure of his figures and flowers.

His paintings may be said to fall into three distinct groups, i.e. (1) minor studies of flowers, tree branches, stones or rockeries; (2) landscape-compositions with or without figures; (3) illustrative pictures either profane or Buddhist. The first group contains apparently most of his early works, i.e. pictures of flowers, trees and the like. Many of them are in the Ku-kung collection; they probably corresponded to the taste of the court better than the somewhat grotesque figure studies which made him appreciated in wider circles.

The earliest of the flower-paintings, which represents a camellia and some narcissi growing by a rock, is dated 1626 and, according to the inscription, done after a picture by Lu Chih.[1] The indication is significant, because several of Ch'ên Hung-shou's flower-studies are of a similar type, and may be said to testify to the same influence, though this is not of lasting importance in Ch'ên Hung-shou's works. He becomes more independent and expressionistic with the years; the motifs are generally quite simple, consisting of garden stones or rocks with a few narcissi or bamboos, sometimes amplified by the knotty trunk of some old plum-tree bursting into blossom at the approach of spring.[2] They are as a rule very close studies of nature and distinguished by a remarkable degree of structural beauty and strength, which makes them excellent expressions of Ch'ên Hung-shou's individual genius as a painter.

When the plants and trees are introduced in larger compositions their linear quality is often still more accentuated, which sometimes produces effects not unlike those of silk embroideries or woven textiles. Their twisting and turning branches form intricate patterns against the sky or mountains, emphasized by light and shade, or by the colouring of the leafage in the intervals. This is perfectly illustrated in the large picture of deeply fissured rocks and leafy trees which is inspired by a view from the Wu-hsieh mountain.[3] The scene has been transformed into a very attractive pattern of twisting branches and dotted leaves which retains the soft and rich effect of a woven tapestry (Pl.315).

In other minor paintings such as the album-leaves in the collection of J. P. Dubosc in Lugano, the painter has produced similar effects with various kinds of trees, for instance the weeping willow drooping its wavy drapery over the pavilion on the river-bank from which a lady is watching a boat

[1] K.-k. shu-hua chi, vol.IX.

[2] K.-k. shu-hua chi, vols.XII, XVI, XXXII. Cf. also albums of flower studies, etc., published by The Commercial Press, 1934, and by the Ku-kung museum, 1933.

[3] Tōsō, p.376, formerly in the Kuan Mien-chün collection, Shanghai; now in Mr. W. Hochstadter's collection in New York.

arriving with two men (Pl.316); or the monumental pine-tree bending down protectingly which spreads a large umbrella of sturdy branches, twigs and needles over the poet who is resting on the ground. The unity between the tree and the man enjoying his wine in the shade of the fragrant pine-tree is most attractive (Pl.317).

Ch'ên Hung-shou's larger figure-compositions are as a rule not so successfully balanced, though partly dominated by a definite linear stylization. Most significant among these is the very tall picture (*c.*10 ft) in Mr. C. C. Wang's collection in New York, dated 1638, which represents how the learned old lady Hsüan Wên-chün, *i.e.* the famous mother of the minister Wei Ta (of the fourth century), lectured and explained the *Classics* to an audience of learned men.[1] This takes place on a large garden terrace, rising above a pond into a region of circling clouds which form white scroll patterns around dark trees. The setting is impressive and well suited for the solemn occasion, for the old lady, who is seated on a broad throne, is speaking to an audience of dignified scholars who seem to be submitting their writings to her. It is a motif of some significance represented in a form which has the solemn character of a ritual performance. The elements are borrowed from the masters of T'ang period, but they are individually transformed and combined in a truly impressive decorative unit (Pl.318).

The majority of Ch'ên Hung-shou's figure-paintings are of minor size, on short handscrolls or album-leaves, representing queer and ugly old men (often humorously characterized), or puppet-like young ladies dressed in T'ang fashion. Some of these are actually copied after originals by Chou Fang or other famous painters of female beauties. But there are remarkable exceptions in which the realistic interest of the master takes the lead, such as the picture (formerly in the Ti P'ing-tzŭ collection) called Hsiang-yen Warming herself over a Brazier: The girl is sitting on a mat-covered floor and bending over a brazier which is placed in a large bamboo-basket, spreading her clothes over it. The picture,

which has a note of graceful intimacy, must have been very famous, because it is provided with several poetic inscriptions referring to the motif, one of them by the well-known critic Kao Shih-ch'i, who has added the following explanatory note to his poem: "Li Jih-hua tells in his *Liu-yen chai-pi chi* that a friend of his in the capital had a maid-servant who was exceedingly graceful and elegant. Whenever she perfumed clothes over the incense brazier she bent over it and covered it with her whole body, and then when she offered cups to the guests at the table, there was none who did not become heady (so strong was her perfume). Therefore she was called Hsiang-yen (The Fragrant Swallow). This story served as inspiration for my poem" (1696); and it may also have served as inspiration for the painter, whose work looks like an illustration to the story.

Ch'ên Hung-shou's pictures of gentlemen, monks and male servants do not possess the peculiar charm of the puppet-like fairies or the traditional beauties, but they are psychologically more interesting, because they reveal a faculty of characterization which is not so apparent in the female figure. He chooses ugly types preferably, which offers him an opportunity to accentuate the queerness and weaknesses of human nature, which he does with a kind of sympathetic understanding that makes them interesting even when they are unattractive. The best among these are not the bold warriors or stately officials who pose with great self-assurance in some of the larger pictures, but the figures who serve as illustrations to popular tales or poems, usually forming a series or united in albums.

The illustrations to T'ao Yüan-ming's poem *Kuei Ch'ü-lai* are the best examples of such a series; they consist of twelve different scenes united in an album belonging to the Honolulu Academy of Arts. In the first picture the poet is seated on a flat stone, the *ch'in* at his side, holding some of his dearly loved

[1] In order to prevent the decadence of classical learning she opened a school where she lectured to many students. Giles, *Biogr. Dict.*, 802.

chrysanthemum flowers close to his face in silent enjoyment of their fragrance. In most of the other pictures he is represented in company with household folks or visitors, talking, admonishing, advising, or seated in solitary meditation. Each scene has a different psychological undertone indicated by the gestures and expressions of the gentleman and his assistants. They are all deeply immersed in their occupations and perform their parts with the imaginative intensity of the Chinese actors. This makes them entertaining also from a realistic viewpoint, even though they are transformed into decorative symbols to suit the painter's sense for linear rhythm (Pl.319).

Ch'ên Hung-shou was altogether a painter who stood apart and followed ideals quite different from those of most of his contemporaries, a great draughtsman and a highly imaginative illustrator. His art is well characterized in *Ming-hua lu* in the following words: "He specialized in figure-painting, forming (carving) his ideas according to the ancients and moved his brush as if it were revolving round a centre, completing a picture with one stroke like Lu T'an-wei. In illustrating the old stories he represented the figures with the mien and costumes of the various periods. He must indeed be placed in the *nêng* (skilful) class. His paintings of flowers, birds, grass, and insects were also refined and admirable; in his landscapes, however, he followed different ideas."

Wan Shou-ch'i, *tzŭ* Nien-shao, from Hsü-chou, who also lived in Nanking (where he passed the *chü-jên* degree in 1630), was a less known painter who also followed ancient models in his figure-painting. He was particularly esteemed as a seal-engraver, besides being a poet and a painter. According to *Wu-shêng shih shih*, "he painted scholars and ladies in T'ang costume after the models of Chou Fang, not necessarily of an attractive or bewitching appearance, but thoughtful and quiet. The landscapes, stones, and trees he painted according to his own ideas, beautiful and uncommon. He priced his own pictures very highly and did not give them away to those who came to ask for them without anything (money) in their hands, nor to those who asked too much in exchange. He said: 'I am acting like T'ang Yin who said: "In my leisure times I do my pictures of the blue mountains to sell and do not wish to cause any debts on one side or other" ' (he only wanted a fair price?). After the fall of the Ming dynasty he adopted a monk's robe and spent his time travelling in Wu and Ch'u." He is also said to have been skilled in mathematics, in chess, *ch'in* playing, and sword practice, and to have devoted himself to Ch'an Buddhism. His pictures, which were mostly executed in the *pai-miao* manner, are nowadays quite rare, possibly because he was so unwilling to part with them except for high prices. One of them representing a lady with a fan (dated 1642) is reproduced in the Shên-chou magazine, vol.1; another of more uncertain authenticity (though provided with the painter's signature) is in the British Museum and has the poetic title: The Lady in the Fragrant Snow Garden. Neither of them can be said to justify the painter's high esteem of his own art.

II

Portraitists and Illustrators

BESIDES THE painters who followed consistently in the footsteps of the ancient masters and did their best to re-awaken the stylistic ideals of T'ang and earlier periods, there were others, less guided by historical models than by current ideas and actual observations. Foremost among these should be mentioned Tsêng Ch'ing, *tzŭ* P'o-ch'ên, who was active in Nanking (1568–1650), though a native of P'u-

t'ien, in Fukien. He became known as the foremost portrait-painter of the age and is thus placed in a class which includes very few men of the time. In *Wu-shêng shih shih* we are told that "he painted portraits which looked exactly like reflections of the models in a mirror and grasped the spirit and emotions of the people in a marvellous way. His colouring was refined, and although the figures were simply on paper or silk, their eyes seemed to be moving and following the beholder as if they were eyes of real beings. Even Chou Fang who painted the portrait of Chao Tsung could not have surpassed him. In his portraits he gave the noble countenance of the high officials, the refinement of the hermits, the elegance of the ladies, the character of monks and priests, rendering their ugly as well as their beautiful features in his search for likeness. When you stand in front of his portraits trying to understand them, you forget both the picture and yourself. In painting his portraits he used several layers of colour and worked in a very minute fashion. He walked alone in the forest of art and was known all over the country, which indeed was quite natural."

The remark that Tsêng Ch'ing worked in a very minute fashion and used several layers of colour in his portraits has sometimes been taken as an indication that he was influenced by the European manner of painting, which first became known in China through Matteo Ricci, who reached Peking in 1610. But no such pictures by Tsêng Ch'ing as could be said to reveal a Western influence are known to us, and it may be remembered that in his notes about the Manchu portrait-painter Mang K'u-li (in *Kuo-ch'ao hua-chêng lu*) Chang Kêng contrasts the European manner, adopted to some extent by Mang K'u-li, Chiao Ping-chêng and others, with that of Tsêng Ch'ing, "who drew his pictures in ink", and was considered a far greater portrait-painter than all succeeding masters, including those who worked in the Western manner.

Tsêng Ch'ing's portraits in colour may have resembled some of the ancestral portraits of the Ming period in which occasionally the heads are strikingly characterized, though rendered almost entirely with lines and no shadows, whereas the costumes are painted with layers of colours and sometimes ornamented. They are rarely signed and commonly considered by the Chinese simply as ancestral images, not as works of art. Yet the best among them reveal a degree of individual character besides decorative beauty which makes them interesting as works of art.

Tsêng Ch'ing's portrait-paintings were evidently of a different class, *i.e.* more closely corresponding to the standards of works of art and as such admitted into the "*nêng*" class by his countrymen also. They were not done simply to serve as symbolic images in connexion with ancestral worship, but as intimate records of the model's personality and associations. The expressiveness of these pictures is not limited to the drawing of the face and the costume; in some cases it also includes bits of surrounding landscapes and associate figures, as may be seen for instance in the portrait of the painter Shao Mi seated in his garden where two small boys are gathering flowers for him in baskets.[1] The scenery is fairly extensive, yet the figures are dominant (Pl.320). Other portraits of a similar nature represent (according to inscription) Doctor Ko Ch'êng-fu[2] and a gentleman called Chou Ching-wên; the landscape is here limited to a very tall pine-tree and a few shrubs.[3] But there are also examples in which the landscape scenery has been added by another hand, as indicated in the picture of An Unknown Man, dated 1639, in which Ts'ao Hsi-ch'ih painted the rock.[4]

The portrait-paintings without any landscapes are perhaps still more penetrating and attractive as character-studies, as is proved by the pictures of Ch'ên Chi-ju with the Crane, and of Wang Shih-min as a Buddhist Disciple; they are both very expressive studies from life, made under different

[1] *Cf.* reproduction in *Shên-chou ta-kuan*, X.

[2] It was exhibited in *Hui Hua Kuan* in Peking, 1954.

[3] *Cf. Mei-chan t'ê-k'an.*

[4] Shown in Hamburg Exhibition, 1949, Cat. No.61.

conditions. The old philosopher and art-critic may have been painted on a cold day; he is seated in an armchair wrapped in a wide padded garment with his feet placed on the rim of a coal brazier, which stands between a large wine-jar and a crane on one leg (also seeking the warmth). The characterization of this composition is not without a tone of humour, but the gaze of the old man's wide-open eyes is searchingly sad (Pl.321).[1]

The portrait of Wang Shih-min, the future great painter, was painted in 1616,[2] when the model was only twenty-five years old. He is represented as a Buddhist student seated cross-legged on a straw mat, holding a fly-whisk in one hand and holding the other in a significant *mudra*. A wide garment falls in large sweeping folds around the slender figure and the head is covered by a broad cap. His whole appearance is exceedingly refined, rendered with lines and light washes of colour; only the large pensive eyes, which are directed straight at the beholder, have a deeper tone. They stand out in contrast to the pale face and add an expression of wonder and determination to this image of youthful awakening (Pl.322). The Chinese way of rendering the fundamental type of a man by means of reducing brush-strokes has here been utilized with perfect success. No wonder that the Chinese used to call pictures like this *ch'uan-shên* – they "transmit the spirit".

Here may also be recalled one or two figure-painters of a more common kind, who worked in a freer manner in accordance with the current styles of the period. Chou Lung, *hao* Tung-yang, from Ch'ên-t'ang, painted (according to *Ming-hua lu*) figures "with a firm brush yet not without ease and beauty". He seems to have followed to some extent the local traditions of his native place, his manner being derived from Tai Chin and Wu Wei, a connexion which may be observed in the handscroll in the National Museum in Stockholm, dated 1628, which represents The Sixteen Friends of the Wine Cup. The motif is evidently a kind of duplication of the so-called Eight Immortals of the Wine Cup (of

T'ang times), who are described in a colophon attached to the picture. The writing was done in 1642 by a man called Chên, who freely transcribes Tu Fu's poem on the Eight Immortals for a friend of his and says that "Chou Kung-lin painted figures and was famous in the T'ien and Ch'ung epochs" (1621–1642), which seems to imply that the artist was no longer alive at the time of this writing. The figures are placed in a continuous landscape and divided by rocks and trees, all in postures and situations which reflect their various stages of bibulousness.

There were many kinds of professional painters at the end of the Ming period who supplied the demand for religious as well as profane figure-paintings, but most of those who followed the beaten track of their predecessors are now forgotten and their works are lost in the general stream of anonymous paintings. We have no possibility of dwelling here at any length on this abundant, though undifferentiated material, which seldom attains the level of artistic significance. Yet a word may here be added about the painter Ch'ên Hsien, *tzǔ* Hsi-san, *hao* T'ai-hsüan and Pi-shui, not because of any outstanding artistic merits, but rather because of his peculiar historical position: He was a member of the Huang-po sect, a kind of reformed Ch'an Buddhism which was introduced in Japan about the middle of the seventeenth century by two monks called Yin-yüan and Mu-an, who came from Huang-po shan in Fukien. They founded a temple at Uji, near Kyōto, known as Manpuku-ji, which became a potent centre of Chinese art and learning in such forms as were cultivated by this school of Dhyāna Buddhism. The Chinese missionaries (or Japanese students returning from China) seem to have brought with them a number of Ch'ên Hsien's paintings with poetic inscriptions by one of the monks, and some of these are still in the possession of the temple, while others have passed into private collections in Japan; one of these has lately been acquired by the Freer Gallery, but no picture by

[1] Cf. Ōmura, *Bunjin Gasen*, I, 11, in the collection of Pao Nai-an.
[2] Cf. *Shên-chou ta-kuan*, I.

the master has (to our knowledge) been identified in China, where nowadays he is completely forgotten.

Most of these pictures represent Bodhisattvas and Arhats and have formed parts of didactic series put together as illustrations of Buddhist teachings regarding the Eighteen Forms of Kuanyin Bodhisattva, or the miracles performed by the holy men, or other kindred subjects. But the sentiments or conceptions expressed through these venerable Buddhist figures do not always seem to be as reverential as the traditional motifs might imply. The artist has been more inspired by his interest in realistic characterization than by veneration for the Buddhist patriarchs, and transformed the saintly men into ordinary human beings divested of their holiness. This is most noticeable in the handscroll in the Freer Gallery, which contains no fewer than twenty-four figures of various degrees (from ordinary monks or acolytes to Arhats and Šakyamuni himself), some of which are rather amusing expressions of uncouth realism: The sleeping Arhat and the one who is striding along in a beggar's guise are in this respect telling examples (Pl.323). Their movements and their garments are rendered in a somewhat sketchy fashion with an easily flowing brush, but the heads and hands are carefully modelled and coloured, which makes them stand out most realistically. The technical execution of these parts is quite different from the ordinary Chinese way of rendering the faces and limbs of such figures and reveals a foreign influence that seems surprising in Buddhist figures. This kind of pictorial realism in conjunction with the completely unconventional characterization of the men, makes some of them no less entertaining than Tsêng Ch'ing's afore-mentioned portraits. Yet, it should be remembered that these figures, as well as, for instance, the Eighteen Forms of Kuanyin,[1] are meant to convey a deeper sense or symbolic meaning, which in some cases is indicated by the inscriptions added by one of the Huang-po teachers. But this significance or these artistic ideas are to no small extent submerged in the kind of rustic realism and technical experimentation that evidently have absorbed much of the painter's interest.

The tradition reported in some Japanese publications that the artist died in the service of the national hero Ts'ai Tao-hsien (*i.e.* 1643 or before) is thus obviously misleading. He lived long after the fall of the Ming dynasty, though probably in the seclusion of a Huang-po monastery in Fukien, and may still have been alive in 1676, the date of Mu-an's inscription on Ch'ên Hsien's large picture of a white-robed Kuanyin (in the Takami collection in Nagasaki).[2]

[1] *Cf.* album published by Soindō, Kyōto, and also *Shimbi*, Nos.4, 19, *Nanju*, Nos.5, 10, 13.

[2] *Tōyō*, vol.X.

Painters of Epidendrum, Flowers, Trees and Bamboo

I

Wang Wei-lieh, Hu Ching, Ch'ên Chia-yên, Ma Shou-chêng,

Hsüeh Wu, Chao Wên-shu, Hsü I, Kuei Ch'ang-shih, Chao Pei and others

BIRD AND flower-painting, which was cultivated as a special branch by several prominent painters during the sixteenth century, stood no longer in the same favour at the end of the Ming period. Such graceful and pleasant motifs did not correspond to the spirit of this rather disturbed and fateful age when the general outlook on life was growing darker in every respect. Among the painters who have been mentioned in the preceding chapters were some like Ting Yün-p'êng and Ch'ên Hung-shou who occasionally painted flowers besides landscapes or figure compositions, but most of the painters who branched off into this field represented rather trees, or sections of trees, (with or without blossoms) than simply flowers or birds in the traditional way, as we have had occasion to observe in some pictures by Hsiang Shêng-mo, Huang Tao-chou and Ni Yüan-lu. Bamboos, of course, always retained particular importance as the favourite motif of scholarly men. The men who painted nothing but birds and flowers were relatively few and not of outstanding importance, but one or two merit to be remembered here.

Wang Wei-lieh, *tzǔ* Wu-ching, from Suchou, is characterized in *Ming-hua lu* in the following words: "He painted flowers and birds; stood below Chou Chih-mien but above Kao Yang. Those parts in his pictures which he did in the freest manner are most worth looking at." We have no definite date for his activity, but judging by his place in the Chinese records and the fact that he evidently was closely dependent on Chou Chih-mien, we may assume that he was active during the latter part of the

Wan-li reign. His bird-paintings are traditional, like those made by most of the Suchou painters of the sixteenth century, as is proved by a picture in the Ku-kung collection known as Two Magpies in a Bare Tree,[1] and a handscroll in the Fujii collection in Kyōto, representing water-birds in a river landscape;[2] both are executed in light colours. More effective in design is the picture in the Seikadō collection representing a pine-tree, bamboos, and branches of a blossoming plum-tree by a rockery, a composition intended as a birthday greeting: the pine (*pai-shu*) serving as a symbol for "a hundred years", bamboo for peace, and plum-blossoms for spring; the whole thing meaning: To live in peace for a hundred years.[3] The picture is, however, not merely a significant symbol but also an attractive decorative composition.

Wan Kuo-chêng, *tzǔ* Po-wên, from Nan-hai in Kuangtung, followed a different tradition of style. According to *Ming-hua lu*, he became a *hsiu-ts'ai* at the end of the Wan-li reign, and published a collection of poems on plum-blossoms. "He painted flowers and grass in ink and thin branches with heavy leaves, also birds. He was (to begin with) not detached from the Ling-nan (*i.e.* Kuangtung) school of painting, but in his old age he left the trodden paths, and his brushwork became light and wonderful." The only painting known by him (belonging to Nanzenji in Kyōto) represents a seagull standing below a rock from which some slender bamboos

[1] *K.-k. shu-hua chi*, vol.XVI.

[2] *Tōsō*, p.300.

[3] *Kokka*, p. 330.

bend down.[1] The style of the picture corresponds quite well to the above characterization and the connexion with Lin Liang's art is obvious. The bamboos are remarkable for their very thin almost string-like branches, which are weighed down by the large and heavy leaves.

Hu Ching, *tzŭ* Hsien-ch'ing, *hao* Chung-sung, who later in life became a monk and took the name Ch'êng-hsüeh (Pure Snow), was a man from Fukien. He is said to have made a journey to the Liu-ch'iu islands on the ship of an imperial embassy, where he made sketches of the scenery which he later on developed into pictorial compositions, but none of these has been preserved. There are only two signed pictures by Hu Ching known in reproductions, and the better of the two represents "A Tall Pine and a Pillar Stone", *i.e.* symbols of a firm and upright character.[2] It is dated in the *chi-yu* year, which presumably corresponds to 1690 (Pl.324B).

Ch'ên Chia-yen, *tzŭ* K'ung-chang, from Chiahsing in Chekiang, painted, according to *Ming-hua lu*, "flowers and birds in a free style imparting vigour and life to his works, which were excellent both in drawing and expression". If we may judge by still preserved paintings, Ch'ên Chia-yen was a more sensitive and gifted man than any of the aforementioned flower-painters. His picture in the Kukung collection which represents Irises, Lilies and other Spring Flowers growing at the foot of a tall garden stone, is painted in a rather soft colouristic manner with rich ink in broad spots and very sensitive delineation of the flowers, thus heralding some of Yün Shou-p'ing's delicate flower-paintings. It is dated in the *chia-ch'ên* year (probably corresponding to 1604) (Pl.324A).

Another interesting picture by Ch'ên Chia-yen (in a private Japanese collection) represents Clumps of Wild Narcissi and bamboo shoots at the foot of a hillock.[4] This, too, is painted in a kind of impressionistic manner by which the painter has suggested the soft and moisty atmosphere and the tender growth of flowers and moss. His paintings of birds in leafless trees are more traditional, reminding us of

Chou Chih-mien's bird-paintings or similar things of the previous generation.[5]

A special place among the flower-painters of this period must be accorded to Ma Shou-chêng – who received her *hao* or nickname, Hsiang-lan, from her great fame as a painter of epidendrums. She started as a "sing-song girl" and lived at the Ch'in-huai river in Nanking, but had a natural genius for poetry and painting and made herself a name in both arts. In her flower-paintings she followed the models by Chao Mêng-chien (from the end of the Sung period), and in her bamboo-paintings she followed Kuan Tao-shêng, the wife of Chao Mêng-fu. According to *Ming-hua lu*, "she developed a special style of painting epidendrums in ink, easy and free, beautiful and quiet, resonant with life." This may be perfectly appreciated in some small paintings from an album (in the Soyeshima collection) containing twelve leaves, six with landscapes and six with epidendrums, which have all been reproduced.[6] They are very simple in design but alive with the rhythm of the brush-strokes: a stalk or two with some flowers and buds, painted in transparently light ink, growing near a stone and accompanied with a few touches of the brush as lightly and easily as if they had been blown on the paper. The simple pictures bear witness to a mastery of the brush and a concentration no less remarkable than the feminine grace in the interpretation of the motifs. The landscapes in the same album, consisting of thin trees and small huts on river-banks represented against a background of open water or misty mountains, are inferior as works of art. They are variations on motifs which were interpreted with more emphasis by earlier followers of Ni Tsan, like Li Liu-fang and Shao Mi, and reflect a very thin flow of inspiration. One of them has an inscription

[1] *Tōyō*, vol.X.

[2] *Tōsō*, p.400.

[3] *K.-k. shu-hua chi*, vol.XXII.

[4] *Nanju*, vol.20. *Tōyō*, vol.X.

[5] *Sōgen*, pp.182 and 183.

[6] *Ōmura*, I, 2, 4, 5, 6, 7, and 8; a scroll of epidendrums by her is reproduced in *Tōsō*, p.329. Another belongs to the museum in Indianapolis.

of the year 1613, but another picture by Ma Shou-chêng, representing epidendrums and bamboos, is dated 1594,[1] while the latest date found on any of her pictures known to us, namely Bamboos by a Rockery, also in the Soyeshima collection, is 1627.[2] These dates for her activity tally also with the tradition that she was an intimate friend of Wang Chih-têng, author of *Wu-chün tan-ch'ing chih*, who died in 1612.

Ma Shou-chêng's sensitive brush is also reflected in the picture of a slender lotus-plant in the National Museum, Stockholm (Pl.325B). The composition is slight but the execution very graceful, and the picture receives a special significance from the poetic confession which she has added to her work. It gives an insight into the sadness following on her career as a prostitute, which evidently, in spite of its moments of happiness, led to regrets and bitter disappointments:

"I passed my childhood by the river-banks, not
 knowing any sorrows –
But now the storms and rains have brought the
 autumn chill to Ch'in-huai.[3]
I dare not turn my head again to roads I knew
 along the dykes.[4]
The trees are thin, the sun is low, and I a woman
 of the town."

To this poem she has added a note in which she expresses her disappointment over the fact that a friend of hers had taken a new concubine and says that she "composed this short poem and wrote it on the picture of lotus-flowers painted yesterday, to show it to Hsiao-shu and other connoisseurs in order to have their opinion about it". "Written by Ma Shou-chêng in The House by the Blue Stream."

Hsüeh Wu (or Hsüeh Su-su), *tzŭ* Yün-ch'ing, or Su-ch'ing, *hao* Jun-niang or Ch'iao-ch'iao, seems to have been a close parallel to Ma Shou-chêng as a painter and a personality. They were practically of the same age – Hsüeh Wu was born 1564 and died *c.*1637 – and spent most of their time in Nanking where they associated with some of the well-known painters and poets of the time, and both became greatly admired for their intellectual and artistic gifts, as well as for their charmful appearance.[5] Hu Ying-lin, who was a contemporary of Hsüeh Wu, gives the following description of her when she was a girl of 16:

"Hsüeh Wu looks amiable and graceful; her conversation is refined and her manner of moving is lovely. Her calligraphy in the regular style is excellent, her painting of bamboo and orchids even better. Her brush dashes rapidly; all her paintings are full of spirit. They are superior to those of most professional painters in town." The writer goes on to describe her skill in horsemanship and archery and expresses jealousy of the man she admired at the time. From other descriptions it appears that she was a rather wilful character who preferred manly sports and intellectual studies to the usual occupations of women.

Her long scroll in the Honolulu Academy of Arts representing tufts of orchids (usually called epidendrums) and rocks is certainly a masterpiece of a kind that hardly would be expected from a woman painter. The design of the whole is impressively bold, not to say powerful, in spite of the fact that it consists of a number of the most graceful and elegant garden-plants in China, the epidendrums. Their long wavy leaves sprout and spread from a few centres between the stones in a way that might be likened to spring-water gushing from Artesian wells. Every one of the numberless leaves, which extend all through the length of the scroll, is perfectly controlled and painted with continuous strokes of the brush. The controlling perseverance is here no less admirable than the graceful flow. In other words, the decorative stylization which is unavoidable

[1] *Chung-kuo*, p.60.

[2] *Ōmura*, I, 3.

[3] The river in Nanking.

[4] The city moats.

[5] The romantic life of Hsüeh Wu and her creative genius as a painter have been entertainingly retold with the help of contemporary records by Tsêng Yü-ho in an article in *Ars Asiatiques*, II, 3 (1955) called, "Hsüeh Wu and her Orchids in the Collection of the Honolulu Academy of Arts."

in a picture of this type, has not quenched the painter's individual conception of the motif, her reaction to its living rhythm (Pl.326).

There were no flowering plants which at this epoch of artistic refinement enjoyed greater favour among painters and poets than the *lan-hua*. This popularity is also reflected in the prominent place accorded to them in the repertory of painting and calligraphy known as *Shih-chu-chai shu-hua p'u* to which we shall return presently. A special volume of this publication is devoted to studies of epidendrum plants intended as models for painters. They are thus placed on a level with plum-blossoms (*mei-hua*) and the bamboo (*chu-tzŭ*). This high estimate of epidendrum plants was no doubt mainly due to the gracefulness of their endless leaves, which seemed as if painted by Nature herself, and to the playful elegance of the flowers. But it should also be remembered that owing to their deep, though subdued odour (their "secret perfume"), they were interpreted as expressions of love or intimate friendship. Most of the epidendrum paintings may thus be said to carry a message besides transmitting the enchanting atmosphere of spring and the decorative beauty of Nature's own designs.

It would hardly be of much use or particular interest to readers if we should here introduce the names and dates of several recorded artists who won their fame as specialists of epidendrum-painting, as long as we have no possibility of reproducing some of their works. They are too many and perhaps in some cases too simple to arouse immediate interest (in reproduction). It is only through a more intimate study and closer acquaintance with these relatively small and unobtrusive pictures that the sensitive amateur may be able to discover their quiet charm and individual distinctions. This is true, for instance, of the epidendrum-paintings by Chou T'ien-ch'iu, *tzŭ* Kung-hsin (1514–1595), and Tu Ta-shou, two prominent Suchou masters who almost exclusively painted tufts of epidendrum on short scrolls, album-leaves and fans of which a few examples may be seen in Western collections.

A third painter, likewise active about the middle of the seventeenth century, Ch'ên Yüan-su, is represented in the National Museum in Stockholm by a fairly large picture of a splendid epidendrum plant painted with a bold brush on gold-sprinkled ground. The decorative effect is here emphasized, yet the graceful beauty of the flowering plant is fully realized (Pl.325A). Plants of such extraordinary size were no doubt always rare; according to the inscription, they could be seen at Tu-liang (near Chin-chou) and the painter "carried them in his heart".

Like all these epidendrum-painters he was no less esteemed as a poet and a calligraphist. The rhythm and flow of his brush was reflected in his writing just as well as in his painting, and the living beauty which inspired the poet's heart found expression also through the painter's brush.

It may furthermore be recalled that some of the well-known figure and landscape-painters whose works have been discussed in previous chapters, such as Ting Yün-p'êng and Chên Hung-shou, did excellent ink-paintings of flowering epidendrums.

Wei Chih-huang and Wei Chih-k'o did not earn their fame solely through paintings of epidendrums; they also painted other garden flowers and landscapes; their production seems to have been very large and greatly appreciated all over the country. We are told in *Ming-hua lu* that Wei Chih-huang, the older brother, supported not only himself, but a whole family household of three hundred persons, with the earnings of his art. He was a highly skilled traditionalist who worked with colours in academic style; and the same seems to have been true of Wei Chih-k'o, the younger brother, whose handscroll representing the Twenty-four Flowers of the Four Seasons (signed and dated 1604, in the Lilly collection in Indianapolis) is an attractive example of this post-academic type of flower-painting.

A feminine aspect of this kind of academic flower-painting was continued by Chao Wên-shu, *tzŭ* Tuan-jung, the daughter of Wên Tsung-chien (the great-grandson of Wên Chêng-ming). She possessed excellent technical skill, as may be seen in

her small flower-pictures in the Ku-kung collection,[1] but would hardly be recorded as a creative artist if it were not that she did her best to carry on a highly venerated family tradition.

Hsü I, *tzŭ* Tzŭ-shao, *hao* Hsieh-kung and Hao-yin-tzŭ, from Wu-hsi in Kiangsu, claimed to be a late descendant of the great flower-painter Hsü Hsi of the tenth century. He was skilled in various kinds of painting, but specialized in lotus-flowers, which he painted according to the style of Hsü Hsi, *i.e.* in a kind of *mo-ku* manner with the utmost expression of life and fragrance. It was said that "one could smell the perfume of his flowers and hear the twitter of his birds". His picture in the Ku-kung collection which represents a bunch of lotus-flowers and leaves on tall stems may be said to illustrate this kind of naturalistic accuracy,[2] though they appear rather stiff if compared with lotus-paintings of earlier periods.

Bamboo-painting was also continued in accordance with the old traditions of style by several men whose names are known from literary sources, but whose painted works mostly have remained unidentified. Some of them were scholars and officials, who sought relaxation in this kind of occupation, others were painters of a more professional type, but their guiding ideals were as a rule the famous masters of Sung, Su Shih and Wên T'ung, or Wu Chên of the Yüan period. This dependence was characteristic of Chu Lu, *tzŭ* Po-ming, from Suchou, "who painted with broad washes and retained the rhythm of the bamboos", and also of Chou Tsu-hsin, *tzŭ* Yu-hsin, from Kuei-chou, who in his ink-bamboos "grasped the very heart impressions of Wên T'ung and Wu Chên". They were both active at the beginning of the seventeenth century, but we have not come across any works by them.

Other bamboo-painters are better known through their signed works in Western as well as Eastern collections. We may here recall Kuei Ch'ang-shih, *tzŭ* Hsiu-wên (or Wên-hsiu), from K'un-shan in Kiangsu (1574–1645), Lin T'ai-hêng, *tzŭ* Chao-ch'ing, from P'u-tien in Fukien, and Chao Pei, *tzŭ* Hsiang-nan, from Ssŭ-ming in Chekiang.

The first-named is represented by a hanging-scroll in the Princeton University collection, dated 1613, and a handscroll in the National Museum in Stockholm dated 1629. The latter is a work of definite individual character apparently influenced by studies of Wu Chên and Hsia Chang, executed in a very firm and energetic manner. Lin T'ai-hêng's tall bamboos in the former Takamatsu collection does not exhibit the same strength in the brushwork, yet it is written down with a spontaneous brush. (Pl.327A). Chao Pei, who was a well-known scholar and secretary of the Grand Council at the beginning of the seventeenth century, reached the greatest fame as a bamboo-painter. According to *Ming-hua-lu* he "painted ink-bamboos with a strong and unrestrained brush; those parts which were done in the roughest fashion remind us of the manner of Hsiang-lin" (?). The strength of his brush was evidently quite unusual and enabled him to master bamboo-painting even on a very large scale, as may be seen in a picture in the National Museum in Stockholm, which represents three stems of bamboo, more than ten feet tall (Pl.327B). They are executed with great firmness and vigour, each joint or section in a single stroke, which gives the roundness of the stems as well as their energetic growth. The leaves are sharp and clean-cut, likewise made with single touches of the brush; they wave and flutter against the airy background of clouds and light mist. The poetic inscription contains abbreviated allusions which are difficult to interpret, but the general meaning of it may be rendered as follows: "Who planted these jade-green bamboos by the river Wei? Their light and clustered leaves are wrapped in rising mist. Thou eastern wind, do not disperse the mist! Methinks a Wang or Yu[3] may still indulge in looking at this view. – Written by the seventy-eight-year-old Taoist from Hsiang, Chao Pei."

[1] *K.-k. shu-hua chi*, vols.II and XV.

[2] *K.-k. shu-hua chi*, vol.XXVII.

[3] Probably refering to Wang Hsi-chih and Chung Yu, the most famous calligraphists of antiquity.

II

Artists working for the Shih-chu-chai shu-hua-p'u

IN CONNEXION with flower and bird-painting at the end of the Ming period should also be mentioned the beautiful representations of such motifs which make up the well-known publication *Shih-chu-chai shu-hua-p'u*, i.e. the Repertory of Writing and Painting from the Ten Bamboo Studios, or Hu Yüeh-ts'ung's Treatise on Writing and Painting, as it was sometimes called. It contains a large number of pictures in the size of album-leaves, of flowers, birds, stones, fruits, bamboo, etc. which, though they are transposed in wood-engravings, in some cases have retained the quality of coloured paintings, as may be seen in the original editions of this work. The publication is generally considered as the most beautiful of the various books with woodcuts after paintings which were prepared in the seventeenth century, and it seems thus appropriate to add a few notes here about its contents, even though we cannot enter into a closer study of the technical and chronological problems connected with its publication.[1]

The man who planned the whole thing, brought the rich materials together, copied most of the paintings for the plate-makers and edited them, was Hu Chêng-yen, *tzǔ* Yüeh-ts'ung, from Hai-yang in Shantung, who lived in Hsin-an in Anhui, a place which at the time was the principal centre of wood engraving.[2] Hu Chêng-yen served for some time as a secretary in the Grand Council in the capital, but after his retirement he seems to have lived in Nanking and Hsin-an surrounded by a circle of artistic friends, among whom he found several able assistants in the preparation of the work under consideration. In the preface to the volume on Stones, written in 1627 by Wang San-tê, *tzǔ* Wei-ning, it is stated that Hu Chêng-yen started with the carving of ink-stones, then he turned to seal-carving, then to printing ornamental writing-paper and then to carving woodcuts after paintings ... "Recently he brought together a number of his woodcuts into a Repertory of Writings and Paintings ... This is now being published and may be acquired for a few cents by poets and painters, who thus can take it home with them and keep it on their table, together with the Five Classics, and the Three Histories. Hu has rendered them a great service."

[1] The problems relative to the manner and time of the publication of *Shih-chu-chai shu-hua-p'u* have lately been discussed by Robert T. Paine, Jr., in two articles, one in the *Bulletin of the Museum of Fine Arts* in Boston, December 1950, and the other in the *Archives of the Chinese Art Society of America*, 1951, based on a number of different copies of this work in public and private collections in U.S.A. According to Mr. Paine's investigations the eight volumes of the book were not brought out *seriatim* (as sometimes supposed), but altogether as a complete work in 1633, which is the date of the general Introduction, usually inserted in the first volume. But it is also evident that the volumes were prepared successively over a period of eight (or fifteen) years, a conclusion based on the dates inserted in several of these volumes ranging from 1619 to 1627 (not to mention the Introduction of 1633). The independence of the respective volumes is also marked by the fact that most of them have separate titles and introductions, but whether they ever were offered for sale separately is impossible to tell.

The difficulty of deciding the actual appearance and time of the first printing is mainly dependent on the fact that, to quote Mr. Paine, "no two of the early copies seen have turned out to be identical". They show, as a matter of fact, considerable disparities in the printing, and also in the distribution and numbering of the plates. When certain blocks, or parts of blocks, became too worn, they were replaced by others, which caused modifications in larger or minor sections of the plates. The men who did the printing and the binding were not tied down by the strict rules of modern book-making, but had a broad margin of individual liberties in their work.

Publication passed thus through a gradual series of transformations during which old blocks were mended and finally replaced by new ones. A complete new edition with an additional Introduction (praising the original editor) was brought out in 1643 and this again passed through series of reprintings showing a gradual decline of the artistic and technical quality. But as the demand for this work did not cease, new and simplified editions were produced during the eighteenth and nineteenth centuries.

The technical method of colour-printing in China has been explained in an article called "Color Registering in Chinese Woodblock Prints" by Jan Tschichold in *Printing and Graphic Arts*. The Stinehour Press, Luneburg, Vermont, Vol. II.1.

[2] A list of more than twenty books illustrated with woodcuts after paintings, published at the end of the Ming period, is included in Ōmura's *History of Fine Arts in China* (*Chung-kuo mei-shu shih*). Several of these were produced in Hsin-an, as for instance Ch'ên Lao-lien's *Five Kinds of Painting* with woodcuts by Huang Tzǔ-li, *Ch'êng shih mo-yüan* with woodcuts by Huang Lin, *Nü Fan* with woodcuts by Huang Yüan-chi, *Huang Ho-Ch'ing* with woodcuts by Huang I-pin and Huang Ju-yüeh, etc. To these may be added such well-known books of woodcut reproductions of paintings as *Li-tai ming-jên hua-p'u* (four books) by Ku Ping and *T'ang-liu-ju hua p'u* (paintings by T'ang Yin), to mention a few of the books which have served to make paintings of the Ming period known in wider circles.

Hu Chêng-yên's leading idea seems to have been to prepare a book, or a series of volumes, which by its reproductions of choice pictures and excellent specimens of calligraphy and the good advice contained in the introductions to some of the volumes could serve as a guide for students of painting and calligraphy. This practical purpose of the publication is definitely illustrated in the volumes devoted to paintings of orchids (epidendrums) and bamboo, which are arranged as progressive models for students and contain technical advice not only in the introductions, but also on some of the plates. The Epidendrum volume shows on the first plate a hand holding a brush in the proper position, and under this is printed the following announcement: "Hu Chêng-yen, *tzŭ* Yüeh-ts'ung, from Hai-yang, collected and edited (this work) and the following men supervised it: Kao Yang, Ling Yün-han, Wu Shih-kuan, Wei Chih-huang, Wei Chih-ko, Hu Tsung-chih, Kao Yu, and the monk Hsing-i", *i.e.* a group of men including some painters as well as experts on calligraphy and block-printing. Certain of these co-editors of Hu Chêng-yen have also signed plates reproducing pictures or poems in one or other of the various volumes. Then follow seventeen double pages on which separate leaves, flowers and epidendrum plants are reproduced in various combinations, and fifteen reproductions of epidendrum-paintings by the following masters of the Yüan and Ming periods, Wang Wên, Wang Ku-hsiang, T'ang Yin, Lu Chih, Shên Chou, Chao Mêng-fu, Wên Chêng-ming, Ch'ên Tao-fu, Sun K'o-hung, Chou T'ien-chiu, printed in black and white except the two last, on which some colour is added. This volume is usually placed second in the series of eight, *i.e.* between the first, which contains a miscellaneous collection of flowers, fruits, birds and garden stones, besides a number of poems, one with the date 1619, and the third volume, devoted to bamboo-painting, which includes a poem dated 1622.

The Bamboo volume has a lengthy technical introduction by Ch'êng Hsien, and seven double pages representing sections of bamboo stems, leaves and twigs, followed by seventeen large compositions of bamboos, and seventeen poems. Some of these pictures are printed in ink only, others in colour, and they reproduce designs by a number of recorded bamboo-painters such as Chao Pei, Kao Yang, Ni Ying, Kao Yu, Wei Chih-huang, Shên Ts'un-tê, Ch'êng Shêng, Ju-ts'an (a monk from O-mei shan) and Chu Lu. But others have no signatures. The poem by Liu Ku-tu is dated 1622, which presumably indicates an approximate date for the preparation of this and the preceding volume. Several of these bamboo-designs possess the living charm of actual ink-sketches and represent quite well the art of such prominent specialists in this field as Chao Pei and Chu Lu.

Some of the same artists' names appear also in the two following volumes, which both contain the date 1624 and may thus have been prepared approximately at the same period. One contains circular compositions of branches with fruits and flowers, bamboos, stones and fungi, intended for round fans, while the other is devoted to plum-blossoms. Hu Chêng-yen himself has drawn a composition of fungi; among the other artists are mentioned Kao Yu, Chu Lu, Ch'êng Shêng, Hsia Shên, *hao* Mao-lin, Kao Yang, Ling Yün-han, Chao Pei and three or four more. Some of these fan designs are the most elaborate in the whole series and they are printed in variegated colours. In spite of the decorative arrangement within clearly marked circular spaces, the flowers, the fruits, the stones and the bamboo leaves are not drawn with hard and fast outlines, but rendered with washes of colour or ink which sometimes seem to disappear almost imperceptibly into the paper. The printing is neat, yet without hardness. The forms stand out in full relief from the ground and are at the same time free from all restraint, like touches of a swiftly moving soft brush. The poems are here framed by thin bamboo stalks joined together in long lines of elegant design whenever the joints are clearly perceptible.

The Plum-blossom volume contains twenty-one

poems, one of them dated 1624 and signed by Hu Chêng-yen himself, and an equal number of pictures representing bits of blossoming plum-trees, sometimes in combination with stones, bamboos or flowers, partly by the afore-mentioned artists and a few of their colleagues, and partly by painters of a previous generation, to wit: Ling Yün-han, Kao Yang, Ch'ên Tao-fu, Kao Yu, Wu Shih-kuan, Chou Chih-mien, Chao Chih, Hsieh Tao-ling, Shên Shih, Hu Chêng-yen himself, Chao Pei, Shên Hsiang, Wei K'o, Ch'êng Shêng, Shên Ts'un-tê, Wu Pin, and Ni Ying. Some of the compositions, like Hu Chêng-yen's own, are quite simple representations of an old trunk with a few twigs which have burst into blossoms, but others show combinations of two or three different trees or plants. The former are printed in ink, but colours have been used in some of the latter, mainly light green and yellowish tones which are spread rather fluently and do not produce a very satisfactory decorative effect.

The three remaining volumes are devoted to Garden-stones, Birds and Fruits. None of the stone pictures is provided with an artist's name, but in a preface to this volume written by Wang San-tê, we are informed that the woodcuts were made after pictures by Kao Yang, *tzŭ* Ch'iu-fu, *hao* Yün-lü, who came from Ssŭ-ming (Chekiang) and was married to the daughter of Chao Pei. The writer says here among other things: "I recently obtained the volume of Yüeh-ts'ung's copies of Kao Yang's pictures of stones. When I looked at them, they seemed to me as if shaped by heaven and outlined by a spirit. Some were hollowed out and carved in open-work. Within the space of a small picture there were piled up cliffs and declivities, peaks and caves, etc., fully comparable to those of Yang Tz'ŭ-kung. Hu Yüeh-ts'ung offered these pictures to me, and I could not help shouting for joy." The volume seems thus to have existed before this preface was written; the latter is not dated (and not present in all copies), but the last poem in this volume, by Hsieh San-hsin, is dated 1625. These fantastic stones, sometimes

jagged and hollowed like storm clouds, sometimes deeply furrowed and worn like decaying mossy stumps of giant trees, form the most peculiar and specifically Chinese section in the whole collection of *Shih-chu-chai*. It is almost surprising how such simple motifs could be made to yield so rich a variety of decorative and artistic expressions.

The volume on Birds has a preface by Yang Wên-ts'ung, dated 1627, but no indication of artists who painted the originals. As the writer praises in particular Hu Chêng-yen's skill in representing birds, it seems, however, conceivable that most of the drawings were by him. The preface opens with some general remarks on "the six important points and the six merits in painting", which must be sought beyond the skilful use of brush and ink, and proceeds as follows: "Among the painters of birds Huang Ch'üan and K'ung Sung stood head and shoulders above all others. The only one after them who almost reached their level was Tiao Kuang-yin.[1] There were, furthermore, Pien Wên-chin and Lü Chi, who both grasped some points. Now, quite unexpectedly, after an interval of long ages, Mr. Hu Yüeh-ts'ung has appeared. His mind is alert and his technical skill marvellous; he surpasses all his predecessors. Although he uses a metal brush (instrument) instead of the soft brush and substitutes a wooden block for silk, he brings out beautifully the effects of the 'wrinkles' and the various qualities in the colours, representing everything with great skill and accuracy. Even the men who practise the same art as he take his works, when they look at them, for paintings and thus accomplish wonders." The pictures of birds are not altogether among the most successful plates in *Shih-chu-chai*; some of them are quite graceful as they convey impressions of the fugitive movements and playfulness of the birds, but others are somewhat stiff.

The volume containing pictures of various kinds of fruit is usually placed last in the series. None of

[1] Tiao Kuang-yin was not a follower, but the teacher of Huang Ch'üan and K'ung Sung, who both were active at the beginning of the tenth century.

these or of the specimens of writing in the same volume is dated, but it makes as a whole a unified and mature impression, and some of its plates mark the very culmination of colour-printing in China. Detached leaves from this volume have always been highly valued on the market. They are, as far as I know, not marked by any artist's name, but sometimes with the seal of Kao Yu, who may have been – at least from a technical viewpoint – the most advanced among the artists who collaborated with Hu Chêng-yen in preparing and printing the *Shih-chu chai shu-hua-p'u*.

The work was received with widespread appreciation in artistic circles, which also led to repeated reprintings during the seventeenth and eighteenth centuries. Hu Chêng-yen and his collaborators thus contributed no less than many of the greater painters to make flower and bird-painting widely known and beloved not only among his contemporaries but also by later generations.

The Advent of the Manchus

THE EVENTS which led to the destruction of the imperial Ming dynasty are of comparatively recent date and well known through many popular accounts.[1] They need not be retold here. The main causes of the catastrophe were again, as so often before, the degeneration of the ruling family, dissolution and corruption within the government and rebellious ambitions on the part of military leaders. The first definite blow which shook the ruling house to its foundations and caused the suicide of the emperor Ch'ung Chêng, was the sack of Peking by the hordes of the rebel leader Li Tzŭ-ch'êng in April 1644. This brought General Wu San-kuei with his army from the south in defence of the tottering government, but as he did not feel strong enough to deal alone with the rebels he invited the Manchu regent, who then was residing in Mukden, to assist him in the task, which resulted in a complete rout of the rebel forces at Shan-hai kuan. The assistance rendered by the Manchus was just as effective as the armed help of the Mongols had been against the Chin Tartars, the predecessors of the Manchus in the thirteenth century, and it led to similar consequences. The warlike neighbours were not slow to grasp the opportunity of realizing their long cherished hopes of taking possession of northern China. While the Chinese general went in pursuit of the flying rebels towards the west, the Manchus were left to consolidate their power in the north, which resulted in their final occupation of Peking and the enthronement of the six-year-old son of the lately deceased Manchu emperor T'ai Tsung as emperor of China under the style and title of Shun Chih. This took place in October 1644, but the real power of government rested in the hands of his uncle, the Regent Prince Jui, or Durgan, as he was commonly called.

The Manchu rulers tried also from the very beginning to act not as conquerors or suppressors of the Chinese, but as the legitimate successors of a dynasty which had been brought to an end by unworthy rebels. They paid all the traditional honours to the late emperor, and confirmed most of the government institutions of the Ming, with certain modifications, as for instance the duplication of the presidency and vice-presidency of the various Boards, so as to give equal place to the Chinese and the Manchus. The ruling class among the Manchus was in complete sympathy with the traditions of Chinese civilization and no less penetrated by Confucian principles than the native mandarins. This is characteristically illustrated in the famous correspondence between the Manchu Regent and the Chinese general Shih K'o-fa, who was in command of the Ming armies which had rallied in the Yang-tzŭ region and offered a stiff resistance to the enemy, while Prince Fu and his ministers made the semblance of an imperial government in Nanking. The letters are too long to be quoted in full, but a few extracts may be given; they serve better than any description to express the Manchu and the Chinese points of view in regard to the position of the new dynasty, which had been established in Peking under the name of Ta Ch'ing (Great and Pure).

The Regent's letter first refers to Confucius' statement that a sovereign's obsequies may not be

[1] *Cf* Backhouse and Bland, *Annals and Memoirs of the Court of Peking*, London 1914. MacGowan, *The Imperial History of China*, Shanghai, 1906, and other current books.

accorded while his murderer remains unpunished, and the consequent necessity to pursue Li Tzŭ-ch'êng, who was still active in the west.[1]

"After capturing Peking we proceeded forthwith to canonize your late sovereigns, and arranged for their burial in due accordance with the rites of ceremonial observance. We left to your surviving princes and high officials their original ranks, treating them all with the utmost consideration and generosity. Our troops were not allowed to loot; the markets remained open as usual, and the husbandman continued to till his field in peace...

"When our dynasty captured Peking it was not the Ming dynasty which was defeated by our armies, but the rebel prince Li Tzŭ-ch'êng who had violated your ancestral temple and desecrated your emperor's remains. To avenge *your* disgrace we spared no expense, and even imposed heavy taxes on our own subjects. Surely it behoves all good men and true to be grateful and repay this benevolence! Nevertheless, you have taken advantage of the respite which we have granted to our war-weary hosts, before continuing the pursuit of the rebels, to establish your forces at Nanking ... Only let your Excellency consider wherein lies the way of advantage. Nowadays many scholars and statesmen are apt to forget their duty to the people in their desire to win fame for themselves as men of unwavering principles. When a catastrophe occurs they are paralysed and resemble the man who tried to build a house by asking the casual advice of unknown passers-by. Remember the example of the Sung dynasty, whose rulers were busy arguing academic points even when the Mongol invaders had crossed the Yang-tzŭ and were knocking at the gates of the capital ...

"In the Book of Rites it is written: 'only the superior man can fully appreciate good advice'. Therefore I lay bare my inmost heart and respectfully await your decision. Across the Yang-tzŭ I turn in spirit to Your Excellency and entreat your early reply. There is still much which remains unsaid."

General Shih K'o-fa's answer to the Regent's essentially true and sincere appeal was no less eloquent; as may be realized from the following extracts:

"At a time of urgent military preparations like the present, your elegantly worded composition is indeed a godsend, and I have perused it again and again with full admiration for the sentiments which it conveys. It fills me with gratitude and at the same time with shame that your great nation should have occasion to deplore the delays which have occurred in destroying that parricide and rebel, Li Tzŭ-ch'êng. But I desire to make a few respectful remarks regarding your statement that we, officials and people of the great Ming dynasty, are forgetful of the outrages inflicted on the late emperor and have sinned against his memory in proclaiming His present Majesty at our temporary retreat south of the Yangtzŭ ...

"The disaster of the 19th day of the 3rd month, when Peking fell, was due to the infatuate errors of his ministers, and I was too far away at my post in the south to bring up reinforcements to his succour ...

"The grief of his officials and people in the south was like that of orphans mourning for their parents, and we burned to avenge our emperor by drawing sword against the traitor who caused his death. But it seemed good to our oldest and wisest statesmen to place a new emperor on the throne, not only for the sake of the ancestral shrines and the tutelary deities, but to satisfy the desire of the nation ...

"You may well be proud of your action in hastening so loyally to suppress the rebel invasion and in coming to the rescue of our dynasty. It has been worthy of the principles of Confucius and deserves to be remembered for all time ...

"If now, taking advantage of our misfortunes, you covet our territory and hope to benefit yourself by annexing portions of our dominions you will be open to the reproach that your good intentions were but transient, and that your actions, which began in good feeling, have ended in unrighteous cupidity. Then the rebels even may despise you as being no better than themselves. I am reluctant to believe this of the Manchus ...

"Looking northward towards the mausolea of our mighty ancestors my eyes can weep no more for lack of tears, and I feel that I deserve to die the death. My only reason for not following my late master to the other world was that I still hoped to render some service to the State. It is written: 'Strain every energy for your country whilst life lasts; be loyal and fear not.' My one desire is to be privileged to lose my life in the performance of my duty."

[1] *Cf. Annals and Memoirs of the Court of Peking,* pp.174–184.

The hope of the Chinese commander had been to obtain an amicable treaty from the Manchus, leaving the main territory of China to the heirs of the Ming against the payment of certain indemnities in the same way as when the wars between the Chin Tartars and the Sung emperors were settled. But events had developed too far and the representative of the Ming house in Nanking was too weak and indifferent. The fighting which ensued brought defeat to the Mings. The city of Yang-chou, which was the key to the south, soon fell into the hands of the enemy and was completely sacked, its inhabitants almost exterminated during a week of the most ruthless killing recorded in the bloody annals of China. Shih K'o-fa died probably by his own hand when his cause was lost. The way to Nanking was open; Prince Fu fled to Wu-hu, but was brought back and put to death together with a great number of officials and adherents, among whom were some painters already mentioned. Others of the Ming sympathizers escaped to the south, hid themselves or rallied round successive claimants, first Prince Ch'ang, who reigned for a few days in Hangchou, then Prince T'ang, who held out for nearly a year in Fukien with the help of the pirates, and finally Prince Kuei, who established a kind of independent government in Kuangtung and Kuangsi, supported by the last desperadoes and robber chiefs, until 1659 when he was forced to fly into Burmese territory. There he was killed a few years later by Wu San-kuei, the great general who then was pacification commissioner in the south, nominally under the Peking government, but actually an independent ruler.

The authority of the new government was by no means a firmly established and accepted fact in the south. The northern provinces had been a comparatively easy prey to the Manchus, and enjoyed considerable advantages in the form of good order and business prosperity, but the southerners saw no reason to accede to the claims of the northern Tartars. During the whole reign of Shun Chih (1644–1661) and the regency period during K'ang

Hsi's minority, the desire for revolt and hopes for a national restoration ran high in the south. And as most of the painters lived in this part of the country, it is evident that they were quite out of touch with the new imperial government, very few accepted official appointments and many of them lived in complete retirement as hermits or monks.

A common saying among the southerners at this time was: "Alive we do not submit to the Ch'ing, dead we do not submit to the Ch'ing", an attitude which finally resulted in the great revolt known as "the war of the second three provinces". Wu San-kuei as leader of the rebellious south and his Mongol sympathizer in the north made a joint attack on the Manchu garrisons at various places, and it looked for a while as if the new dynasty was going to lose its hold on the country, but the young emperor K'ang Hsi, who a few years before had assumed full powers, showed all the courage and decision that was necessary in this dangerous situation, and succeeded gradually in quenching the revolt. The struggle lasted however for four years, until the death of Wu San-kuei in 1678, and to a less extent even after that, since the grandson of the great general held Yünnan-fu as a last stronghold until 1681, when he was forced to commit suicide. Only then was the whole of China brought effectively under Manchu rule. The conquest had taken nearly forty years and been accomplished at an enormous cost in lives and property. Outwardly the empire was now at peace and remained, practically speaking, in this condition for more than a century, except for expeditions against aggressive border populations, such as the Eleuts, the Tibetans, and the Burmese, but internally there persisted, in spite of the personal authority of the great emperors K'ang-hsi, Yung Chêng, and Ch'ien-lung, a feeling of opposition between the south and the north, based on racial as well as on political and economic grounds. Most of the benefits of the well-ordered new administration and its lavish expenditure fell, by the force of circumstances, to the advantage of the northern provinces, and "the southerners came

to feel that the Manchu government was an empire run in the interests of the court of Peking and its neighbouring provinces, but sustained by revenue derived mainly from the south".[1] There was a never fully appeased feeling of distrust and discontent which was kept alive particularly by the large class of *literati* (with more or less developed artistic inclinations) who remained unemployed because so many of the government posts were allotted by law to the Manchus. They were, so to speak, forced over into the class of the discontented, and those who were the most advanced in thought and creative ability in various fields of literature and art had the least chance of being recognized or rewarded. The Manchu rulers and their trusted advisers were no doubt inspired by sincere endeavours to maintain the cultural traditions of China, and to revive the ancient customs and institutions of the country, but in doing this they acted with the same rigidity and disregard of individual freedom as in the field of administration. They became more Confucian than the Chinese themselves, and the State examinations which formed the gateway to official careers became more conventional and detached from actual life than ever. Those who looked for success were obliged to manifest absolute orthodoxy in thought and manner of expression and to avoid everything that might be interpreted as a departure from the classic tradition.[2]

The above historical remarks go far to show that the art of painting could find comparatively little support in official circles during the beginning of the Ch'ing period, in spite of the fact that the early Manchu rulers were not lacking in personal appreciation of painting. The first of them, Shih Tsu, or Shun Chih, was himself a gifted artist, as will be shown presently, and Ch'ien-lung is only too famous as an authority in matters of art. K'ang-hsi was a man of a more practical bent of mind, and his scholarly interests were directed towards scientific and historical studies rather than to artistic occupations. His protection of the Jesuit fathers who

brought some knowledge of Western sciences to China is well known, and the enormous encyclopaedic publications of a linguistic and historical character which were prepared in his reign have remained standard works to the present time. Among them may here be recalled in particular the *Ch'in-ting p'ei wên-chai shu-hua p'u*, the imperial encyclopaedia of calligraphy and painting, in 100 volumes, compiled by various officials under the direction of the painter Wang Yüan-ch'i, finished in 1708, and serving as a main source for the history of Chinese painting. The emperor was evidently inspired by a strong desire to reaffirm the Chinese tradition in the field of calligraphy and painting, to systematize all knowledge as well as the arts.

Another expression of the same official endeavour was the institution of an Imperial Bureau of Painting, which became known popularly as Hua Yüan, though it had little resemblance to an Academy of Painting in the traditional sense of the term. There was no instruction, no competition in painting (such as had been held under some of the Sung and Ming emperors), no *tai chao*, there were no painters among the officers in the imperial guard; only a few received the title of a *kung fêng* or a *chih hou*. The institution seems to have been more like a government office for the recording of paintings and the supervision of works executed by imperial command. The painters who, according to *Kuo-chao*

[1] *Cf.* Fitzgerald, *China, A Short Cultural History* (London, 1935), p.540.

[2] Fitzgerald, *op. cit.*, p.542. The following remarks by the same author are also worth quoting, because they are not without a bearing on the history of painting in the Ch'ing period:"This extreme conservative outlook was shared by the whole official hierarchy, Chinese and Manchu alike. Trained in a classical tradition which excluded all consideration of non-Confucian philosophy and based upon the most conventional interpretation of that philosophy, the type of mind that entered the civil service was a mind closed to all idea of progress, almost incapable of grasping the possibility, still less the use, for change. The men who rebelled against this training or found this tradition unsatisfying, did not succeed in these specialized examinations, or if they occasionally passed into the civil service, they found an atmosphere so uncongenial that they either resigned, or were relegated to unimportant posts where they exercised no influence. The system was self-perpetuating, seemingly immutable."

Yüan-hua lu, were attached to this institution were mostly men of little consequence as artists and practically unknown in the history of Chinese painting; only a few of them form exceptions to this rule, and they will be recorded in succeeding chapters in so far as works by them have been identified.

The emperor K'ang-hsi seems to have regarded painters whom he employed for recording festivities or campaigns or as illustrators of useful books as skilful artisans rather than as creative artists. Painting was to him an asset to history and to various branches of practical knowledge (besides being an agreeable decoration) rather than a free creative activity reflecting the soul of man, and if painting as art attained a relatively high level during his reign, it was due to men who had no connexion whatsoever with government support or imperial protection.

These conditions were to some extent modified in the reign of the emperor Ch'ien-lung, when more of the leading masters were attached to the Imperial Bureau of Painting, but even then the best remained outside the official ranks (as will be shown in the following) and the emperor's personal association with the arts was hardly calculated to raise the level of painting.

On the other hand it must be remembered that the official guidance and levelling conditions imposed upon the painters by the Manchu emperors did not reach all the artists. There were, as pointed out above, a fair number of highly gifted men who shunned all connexions with the imperial protectors and worked, so to speak, in an opposition to them sometimes aroused by their contempt or odium of the prevailing political conditions. They were at the time less known than the official painters, more or less strangers to the world who lived in seclusion. Absorbed in their writing and painting they devoted themselves to studies of Taoism and Ch'an Buddhism, the pantheistic or romantic currents of thought which at that time were again enjoying a renaissance in artistic circles in China.

Most of them were thus strongly marked individualists in their mode of life as well as in their method of painting, aiming at the inner significance of things (as reflected in their minds and hearts), which they transmitted in pictorial symbols with no or slight regard to traditional patterns and principles. The recognition of their outstanding artistic merits and historical importance has thus been reserved for later times. It has, as a matter of fact, during the last three or four decades been growing so rapidly that some of these individualists nowadays are placed ahead of the great masters of classic fame.

Court-painters in the Shun-chih and K'ang-hsi epochs

THE MOST artistically gifted of the Manchu rulers was no doubt the first, Shih Tsu, who mounted the Dragon Throne as a boy and left it when he was still a youth of 26. He must have been a character of an unusual kind among men in his position, apparently more interested in religious and artistic matters than in the affairs of the State. We have no occasion to enter here into a discussion of his puzzling personality or his life, which probably ended in a Buddhist monastery. But it should be noted that he was also active as a painter and preferably in a style which may have had some connexion with his mystic inclinations. One of his pictures (in the National Museum, Stockholm) represents Bodhidharma crossing the Yang-tzŭ on a reed; another, Chung K'uei, the demon-queller;[1] the two others, known to us in reproduction, are more ordinary studies of misty mountains by a river[2] and some flowers.[3] They are executed in a highly impressionistic fashion, the figures with broad outlines, as if with a stumpy brush or the finger, the trees and the flowers with splashes of rich ink. It seems as if they were the results of sudden impulses, more or less like the works of inspired Taoists or Ch'an painters. Although not of a very high class as works of art, they reveal a definite personality, a man who as a painter was more dependent on the inspiration of the moment than on any historical studies (Pl.328). Shun Chih's activity as a painter is reverently recorded in *Kuo-ch'ao-hua chêng lu*, where it is said that he painted "peaceful and attractive streams and valleys and mysterious and deep mist and clouds. Those who obtained his pictures treasured them more than real pearls. Once he amused himself by painting with his finger a buffalo wading a stream, which was so natural that it seemed alive. His ministers Wang Shih-lu and Wang Shih-chêng wrote poems to record this wonderful picture. After him there were many artists who painted with, the finger, like Kao Ch'i-p'ei, Li Shih-cho, and Chu Lun-han, but nobody seems to know that this kind of painting was started by the emperor."

Shih Tsu was not the only member of the imperial family at this time who showed some skill in painting; his cousin Shih Sê, known as Ni-an, or Prince Yü, was also an able painter, as witnessed by a landscape of his in the Ku-kung collection, dated 1682. It is a more finished picture than the emperor's works, more traditional in type, reflecting studies of the Yüan painters.[4]

It seems also that the emperor tried to encourage men with artistic gifts in his entourage. The most influential among these at the beginning of the new era was probably Tai Ming-shuo, who was briefly mentioned in our chapter on landscape-painters from the Northern Provinces, where he was characterized as a skilful traditionalist. He seems to have entered the service of the new dynasty unhesitatingly and won the personal confidence of the young emperor not only as a painter but also as an official. He rose to the position of a president of the Board of War but was censured for some critical

[1] *K.-k. shu-hua chi*, vol.XVII.
[2] *K.-k. shu-hua chi*, vol.V, dated 1655.
[3] *Sōgen*, p.235, in the collection of Prince Kung.
[4] *K.-k. shu-hua chi*, vol.XIV.

observations and deprived of his rank. Wu Wei, the poet and painter, who probably knew him personally, has left the following note about Tai Ming-shuo: "He was skilled in calligraphy and painting as well as in literary composition; his poems were deep and harmonious, lofty and original, superior to those of common poets. He continued his official career into the present dynasty, and both he and his son entered the palace service. Sometimes he was called into the presence of the emperor, who then gave him brushes and paper, colours and ink, besides some of his own paintings, which brightened up the palace walls."[1] A further proof of this imperial friendship is the dedication of the emperor's above-mentioned picture of Chung K'uei to Tai Ming-shuo, the president of the Board of War. The landscapes and bamboo-paintings by him which have been made known in reproductions are works of great skill, executed in a rather finished, yet strong brush-manner based on a thorough knowledge of northern Sung masters, as pointed out before. He is not in the least like his imperial master as a painter, but may have been an excellent guide for him with his technical skill and experience.

Another favourite of the young emperor was Chuang Chiung-shêng, *tzŭ* Yü-ts'ung, *hao*, Tan-an, from Wu-chin in Kiangsu (b.1626, *chin shih* in 1647), who seems to have been somewhat younger and not so closely attached to models of the Sung period. According to tradition (reported in *Kuo-chao hua shih*), "the emperor once visited the Academy and on the walls there saw a landscape by Chiung-shêng which pleased him very much. He gave orders that brushes and paper should be sent to the painter so that he should do more works. Chuang then made a picture of a fabulous horse to show his aspirations. The emperor was delighted with it and presented the painter with a golden bowl and two robes, appointing him tutor of the heir apparent and a reader to the emperor."[2] It is furthermore stated that he excelled in minor landscape-paintings which were "filled with a scholarly spirit".

He painted plum-blossoms as well as landscapes;

among the latter may be noted the large hanging scroll (in a private collection in Japan) which represents a scholar's pavilion among spare trees on the bank of a mountain river[3] and a minor handscroll in the J. P. Dubosc collection full of thickly wooded mountains and precipitous streams. Neither of these pictures possesses a very intimate individual character, but they reveal the brushwork of a highly trained painter who has paid more attention to the Yüan and early Ming masters than to those of the Sung period. He, too, looks backward, but not as far as Tai Ming-shuo and his conceptions are more independent.

Mêng Yung-kuang, *tzŭ* Yüeh-hsin, *hao* Lo Ch'ih-shêng, was also a highly gifted late follower of tradition who for some time worked in the palace. He would probably be entirely forgotten in his homeland (where no paintings by him have been identified), were it not for a large autumn landscape signed by him which used to be in the collection of the former royal family in Korea. Though born in the south, in Shan-yin, Chekiang, he spent most of his life in the north, *i.e.* in Liao-tung, and from there he went with the Manchu conquerors to Peking. He was of a wild and independent nature and did not like official positions, but because of his skill in art he was made a *chih hou* (painter-in-waiting) in the palace. He became quite a favourite of the emperor Shih Tsu, who ordered him to instruct the eunuch Chang Tu-hsing in painting." According to another tradition, he accompanied the Korean crown-prince from Peking to Seoul and was then engaged to decorate the royal palace in the Korean capital when the prince became king Ko So (1650-1659).

The only work by Mêng Yung-kuang known today[4] is the picture which until lately was in the collection of the former royal Li family in Korea,

[1] Quoted in *Kuo-ch'ao-hua shih*.

[2] Quoted in *Kuo-ch'ao hua shih* from *Ch'ang-chou* (Wu-chin) *Fu chih*.

[3] *Nanju*, vol.16 and Later Chinese Painting, Pl.166 B.

[4] *Cf. Kokka*, vol.275. According to the description in *Kokka* the picture "is a masterpiece, the equal of which must have been rare in even the palmiest days of the Ming dynasty".

and as this is the product of great skill and quite distinct artistic ideas, it should not be forgotten in our survey. It represents the sudden outburst of an autumn storm. Motifs of a similar kind were treated by various well-known masters at the beginning of the Ming period but seldom with the same combination of refinement and strength. The man who is seated in the open pavilion is evidently greatly disturbed at the sight of the trees bending under the onslaught of a violent wind and the leaves whirling like large snow-flakes. An autumn chill is in the air, but there is no way of shutting the open pavilion, so the scholar can only tie his garment more tightly around his waist. The dramatic undertone of the motif has been incorporated in every detail in spite of the almost finicky brushwork. It is quite unlike most of the contemporary Chinese paintings and could easily be dated earlier if it had not the signature of Mêng Yung-kuang (Pl.329).

The painter mentioned at the head of all the imperial artists in *Kuo-ch'ao yüan-hua lu* is Huang Ying-shen, *tzŭ* Ching-i, *hao* Chien-an, a man from the metropolitan province, who for some time held the post of a magistrate in Nanking, but was called by the emperor Shun Chih to serve as a painter at court. He continued as such also after the abdication of Shun-chih as is proved by the fact that he was commissioned by the emperor K'ang-hsi to make a picture of a military display. His usefulness and the official esteem which he enjoyed, were evidently connected with his skill as an illustrator and mastery of the refined technique of famous academic predecessors. The large picture in the former so-called National Museum in Peking which is said to illustrate a poem by Liu Yü-hsi of T'ang[1] is an excellent example of this. The picture shows a number of noble scholars gathered in a large pavilion situated among shady trees at the foot of high mountains. The monumental scenery is rendered according to classic models, the trees are highly coloured and finished and the figures are done with the greatest accuracy in *pai miao* technique. It is altogether an interesting document in the history of official painting in China which may serve to explain why Huang Ying-shên was so highly appreciated in court circles.

<p style="text-align:center">★　　★　　★</p>

Nearly a score of painters are mentioned as being attached to the Hua Yüan in the K'ang-hsi period, but most of them are simply names to us. The best known, some of whose works may still be seen, are Ku Chien-lung, Chiao Ping-chên, Lêng Mei, Ku Ming, Wang Yüan-ch'i, Wang Yün, Liu Yüan, and T'ang Tai, besides flower-painters like T'ang Tsu-hsiang and Chiang T'ing-hsi. But these too are, relatively speaking, secondary men of slight importance in the general history of Chinese painting.

Ku Ming, *tzŭ* Chung-shu, and Ku Chien-lung, *tzŭ* Yün-ch'êng (1606–1684), were both employed at court as portrait-painters; the former established his fame through his portrait of the emperor executed in 1671, and the latter was equally famous for his portraits and his illustrative pictures with historical or legendary motifs. Chang Kêng makes the following remark in regard to Ku Chien-lung: "Once I saw a picture of his representing T'ang Pin (the governor of the Wu province), which his son considered absolutely like; yet the brush and ink-work was not free from vulgarity."[2] One of the most attractive examples of Ku Chien-lung's art is the picture in the former Ti P'ing-tzŭ collection representing a young lady seated on a stool, leaning over a table in front of her, a little scene of feminine grace and abandon seen through a circular "moon door", which is shaded by the branches of a wu-t'ung-tree[3] (Pl.330). Pictures of this kind have probably attracted more interest from Western amateurs than other types of Chinese painting, because they fit in so well with the *chinoiseries* in lacquer and silks imported to Europe in the eighteenth century. Ku Chien-lung was, no doubt, responsible for other paintings of a similar kind, some of which may still be hidden in

[1] *Li-tai*, vol.IV.

[2] *Kuo-ch'ao hua chêng lu.*

[3] Chung-kuo, p.56, called "*Hors de Combat*".

Western collections. His skill as a *genre* painter is illustrated – less attractively – by a picture in the Boston Museum which represents A Girl (Flower) Drummer from Fêng-yang. She is dancing and beating time on a small drum in a spring garden in front of a rockery, while an old mendicant with a child on his back is accompanying the music by beating on a kind of tambourine, and a gentleman in a very free posture watches her steps attentively. Two children carrying branches of blossoming trees complete the scene, which is entertaining, though, as said by Chang Kêng, not free from vulgarity.

Another painter who in the later years of the K'ang-hsi reign had the honour of making portraits of members of the imperial family was Mang K'u-li, *tzŭ* Cho-jan (1672–1736), a Manchu who served as salt commissioner at Ch'ang-lu (south of Tientsin). Several portraits signed by him were formerly in the collection of Dr. Wu Lai-hsi in Peking, and one, which represents Kuo Ch'in Wang, the seventeenth son of the emperor K'ang Hsi, belongs to the Nelson Gallery in Kansas City. Chang Kêng is no doubt right when he says that Mang K'u-li's manner was based on the Western style: "he did not start by making an outline drawing, but worked directly in colours ... The expression of his figures was like that of real people. Those who saw his pictures could not help saying: 'This is exactly the man I know!' "

In addition to the notes on Mang K'u-li's paintings Chang Kêng makes the following general remarks: "The best manner of portrait-painting was that of Tsêng Ch'ing from Fukien, who drew his pictures in ink. This was transmitted to the left of the river (Kiangsu) and handed on from man to man, falling finally into the hands of simple artisans who had no real comprehension of it. Thus, although he had many followers, very few of them grasped his spirit; they were even inferior to those of the Western School."

Influences from European Painting

THE EUROPEAN manner of painting with shadows, so as to make the objects stand out in bodily relief against the background, had already become known in China at the end of the Ming period, as we have had occasion to observe for instance in the works of Ch'ên Hsien, but it was not until the K'ang-hsi reign that it spread in wider circles and was adopted particularly by some of the painters who were active at court. The man who first brought some knowledge of it to the Chinese was the Jesuit father Matteo Ricci (1553–1610), known in his country of adoption as Li Ma-tou. He arrived in Macao 1582 and reached the capital in 1601, where he, because of his knowledge in the mathematical, astronomical, and geographical sciences, became highly appreciated by the emperor as well as by certain mandarins of advanced mind. He acquired a good knowledge of the Chinese language and culture, and was thus able to communicate to the Chinese certain elements of Western technical knowledge including perspective and the art of representing objects in relief.

Matteo Ricci was not a painter himself but possessed some practical knowledge of painting and was well aware of the fact that religious images could serve him in his missionary work in China. He brought with him several pictures and probably a larger supply of religious engravings, among which should be mentioned in particular two Madonna paintings and a picture of Christ which he presented to the emperor.[1] He made friends with many of the native scholars and artists and freely criticized their manner of painting, particularly for its lack of modelling with shadows and its in-

accurate perspective, which to him caused the Chinese paintings to seem "dead and without any life".[2] And it is evident that his point of view and the examples of European painting which he placed before his Chinese friends made a deep impression on them; the proofs of this are found in written statements as well as in copies made at the time after such pictures or engravings as Matteo Ricci brought to China, though it is at the same time evident that the interest aroused by the Italian missionary in Western painting did not reach very far. It was limited to the circle of his personal acquaintances and was more in the nature of a passing curiosity than of a systematic study.

When Chiang Shao-shu wrote his often quoted records of the Ming painters, known as *Wu-shêng shih shih* (probably a year or two after the fall of the dynasty), he inserted in the last volume the following short note: "*Painting of the Western Regions*; Li Ma-tou brought with him an image of the heavenly Lord of Western Regions which showed a woman carrying a child in her arms. The eyebrows, the eyes, and the folds of the garments were just as in a reflection in a bright mirror, they seemed to be moving. It surpassed in solemnity and beauty anything that the Chinese painters could do." A somewhat further developed characterization of the Western manner is offered by Chang Kêng in *Kuo-ch'ao hua-chêng lu* (vol.1, 2.) as a kind of

[1] *Cf.* B. Laufer, Christian Art in China in *Mitteilungen des Seminars für Orientalische Sprachen*, xiii, Berlin, 1910.

[2] *Cf. Opere storiche del P. Matteo Ricci*, Macerata, 1911, and P. Pelliot, La Peinture et la gravure européennes en Chine au temps de Mathieu Ricci, T'oung Pao, vol.XX, 1921.

appendix to his biography of Chiao Ping-chên, and he, too, traces it to Matteo Ricci, though evidently through hearsay rather than through actual observation, his information being in part misleading, as, for instance, when he represents Ricci as a painter and makes him stay in the southern instead of in the northern capital. But his remarks on the principles of plastic modelling, as practised in European painting, have a considerable historical interest as witnessed by the following extract:

"In the Ming dynasty there was a man called Li Ma-tou from the Western region of Europe. He acquired knowledge of the Chinese language and came to stay in the southern [sic!] capital, where he lived in the district west of the Chêng-yang gate. There he made a picture of the founder of his religion representing a woman carrying a child in her arms which was an image of the heavenly Lord. It was full of life and spiritual expression and most attractive through its fresh and beautiful colouring.

"Once he said: 'Chinese painters know only how to represent the light side (of the figures) and consequently give no projections and depressions (i.e. relief), whereas the painters in my country paint the shadows as well as the lights; consequently the four sides (i.e. the volumes) are fully represented in their pictures. The figures are light in the front but dark at the sides, and through this addition of black colour on the sides the lighter front parts are made to stand out in relief.' Master Chiao grasped this idea and modified it to some extent. It did not, however, correspond to the scholarly taste and consequently connoisseurs have not accepted it."

The copies or imitations made in China after such Western paintings or engravings as Matteo Ricci had brought from Europe are no less noteworthy as testimonies of the interest aroused by him, though they can hardly be classified as works of art either from a Chinese or a European viewpoint; they are simply historical curiosities, in spite of the fact that some of them were done by no less a man than Tung Ch'i-ch'ang. His signature, "Hsüan-tsai pi shu", is found in an album of six pictures representing apostles and allegorical figures executed in colours apparently after some engravings or minor paintings of a very simple kind.[1] Whatever artistic qualities these may have possessed have been completely lost in the Chinese interpretations. The four compositions (of religious subjects) included in Ch'êng-shih Mo-yüan, the publication of ornamented ink-cakes, are more faithful reproductions of European engravings,[2] and as these were manufactured in series and furthermore reproduced in the above-mentioned publication, they must have become known to a great number of connoisseurs. Other Chinese paintings inspired by European models which have become known in reproduction or original, seem to be of later date, i.e. from the Ch'ien-lung period, when this mode of painting again came in vogue at court and in some official circles.

In addition to the above-mentioned documentary evidences of the relative interest aroused by certain elements of Western painting in China, it should be noted that Matteo Ricci and his fellow-missionaries also made serious efforts to transplant Western art into the Far Eastern soil through education and the training of young converts. A Neapolitan frate, Giovanni Nicolao, who from 1592 (or earlier) lived in Japan and later on in Macao, was evidently the most successful in this respect. He seems to have been a painter by profession and to have acted as the head of an art school established first at Nagasaki and then on the island of Shiki, where a number of young men received instruction in the elements of European painting. One of these art students, known as Giacomo Niva, who was the son of a Japanese mother and a Chinese father, came over to China in 1601, first to Macao and then to Peking, and there earned a considerable reputation as a skilful painter.[3] Matteo Ricci expressed great admiration

[1] These pictures are reproduced and described in Laufer's article, op. cit.

[2] At least one of these pictures is a highly simplified version of an engraving by Anton. Wierx. Cf. Dr. J. Jenne's article in T'oung Pao, XXXIII, 1937.

[3] The information re Nicolao and Niva is all gathered from Pelliott's above-mentioned article in T'oung Pao, 1921.

for Niva's artistic accomplishments in some of his letters and was eager to have his pictures for some of the newly established churches. When Matteo Ricci died in 1610 Niva was occupied with paintings in Nan-ch'ang (Kiangsi), but he returned to Peking shortly afterwards and there, on the request of the bereaved friends, he painted a portrait of their former leader, who then was commonly considered a saint. In addition to this he executed some mural paintings in the chapel containing Ricci's tomb, formerly a Buddhist temple which, by imperial decree, had been allotted to the Jesuit mission for this purpose as a token of the extraordinary esteem in which Matteo Ricci was held by official China as well as by his numerous friends and converts. But none of Niva's works has survived to our time.

The impulses in the field of painting brought to China at the beginning of the seventeenth century by Matteo Ricci and his fellow-missionaries did not, however, produce any deeper or lasting effects on the native painters; they were hardly more than slight ripples on the surface. But as the knowledge of European art and mathematical sciences gradually increased, the influence on Chinese thought became more obvious, and this had evidently also a certain repercussion in the field of art. At the end of the seventeenth century there appeared some artists who actually tried to form a new style by grafting linear perspective and plastic modelling on the traditional manner of Chinese painting, but even these remained isolated examples.

The most typical among these Chinese painters was Chiao Ping-chên who acquired his knowledge of perspective drawing and the like during his service in the imperial observatory as an assistant to some of the foreign astronomers, possibly to Ferdinand Verbiest (1623–1688). In *Kuo ch'ao hua chêng lu* Chang Kêng gives the following description of his art: "Chiao Ping-chên from Chi-ning (Shantung) served as an official in the imperial observatory and was skilled in figure-painting. His compositions give the effect of distance, the objects decrease in size from near to far with perfect accuracy without the slightest mistake, because he represented them according to the Western manner. In the K'ang hsi period he served as a *chih hou* in the palace. When the emperor ordered the preparation of the *Kêng-chih-t'u* (Illustrations of Rice and Seri-culture) in forty-six leaves, Chiao Ping-chên executed this command.[1] The pictures illustrate village scenery with farmers at work, each one according to his particular task, and they met with the complete approval of the emperor. The painter was liberally rewarded. Soon afterwards the pictures were carved on wooden blocks, printed and distributed among officials."

It is mainly through the instructive and entertaining illustrations of rice and seri-culture that Chiao Ping-chên has won a place in the history of Chinese painting. The original drawings for these illustrations are no longer preserved, but the compositions have become widely known through woodcuts and stone engravings. They were made, as told by Chang Kêng, at the order of the emperor K'ang-hsi, to serve as substitutes for an older corresponding series of illustrations which the emperor found so useful and interesting that he composed new poems to all the pictures. He also gave orders that Chiao Ping-chên should prepare a new set of illustrations along the same lines as the earlier ones. Chiao Ping-chên was to reproduce the illustrative contents of the earlier paintings without being tied down to their style or formal arrangements.

The earlier series, which at the time aroused the interest of the emperor, consisted probably of reproductions of paintings by the little known painter Ch'êng Ch'i of the Yüan period, whose illustrations to rice and seri-culture have been preserved in the form of two long handscrolls, one composed of twenty-one, the other of twenty-four pictures,

[1] The nature and history of this work has been discussed in special articles by Paul Pelliot, "A propos Kêng Tche t'ou" in *Mémoires Concernant l'Asie Orientale* (1913), and by O. Francke in *Kêng tschi t'u, Ackerbau und Seidengewinnung* (1913), but neither of these specialists was familiar with the earlier painted illustrations of the same series.

which belong to the Freer Gallery.[1] It should, however, be noted that neither these pictures nor Chiao Ping-chên's compositions were original inventions by the executing artist; according to the inscriptions they were done after a corresponding series of illustrations by a painter called Lou Ch'ou, who was active in the Kao-tsung reign (1127–1162), though not known through any preserved works. To what extent these earlier series had been made accessible in reproductions is not known, though it seems probable that Ch'êng Ch'i's pictures had been copied or possibly reproduced in woodcuts.

Chiao Ping-chên's drawings were published in 1696 in an album of forty-six leaves in very delicate wood-engravings which retain the character of the *pai miao* manner of the originals. In the later editions the illustrations have been modified (by Lêng Mei?) or freely recast, as may be seen in the lithographic reproductions prepared and published at the order of the emperor Ch'ien-lung in 1769.

A comparison between Ch'êng Ch'i's pictures and the woodcuts after Chiao Ping-chên's drawings makes it clear that the latter painter did not pay very close attention to the earlier versions of these illustrations. He seems indeed to have been less interested in any historical guides or models than in his own actual observations of the rural scenes which had to be rendered in these illustrations (Pl.331). This independent, fresh approach to the various motifs invests several of these illustrations with a kind of simple charm or rural atmosphere. The characterization of the labourers in the rice-fields has sometimes a humorous touch, whereas the lithe and diligent little women who are occupied with the preparation of silks and the spinning and weaving of them, are rendered with intimate sympathy and gracefulness. And they are all placed in perfectly measured and proportioned natural or architectural surroundings, such as gardens and farm yards or verandas, galleries and workshops, exact in every detail and well calculated to increase the impression of actual scenes from life. This was indeed something new in Chinese painting and

served to make Chiao Ping-chên's illustrations of rice and seri-culture appreciated by the emperors as well as by the amateurs of the day.

He was himself rightly most proud of his mathematical knowledge as is also evident from the signature on the last leaf, in which he says of himself: "The Official at the Imperial Observatory in charge of the Calendar Chiao Ping-chên painted this in Hung-lu ssŭ (*i.e.* the Bureau of Ceremonies), the engravings made by the assistant (*hsü-pan*) Chu Kuei".

Chiao Ping-chên's gifts as a painter in the Chinese style were not sufficient to counterbalance his scientific studies. The pictures with his signature offer very little, if anything of genuine artistic interest except in so far as they reveal his vain endeavour to combine Eastern and Western principles of pictorial representation.

The best known among the painters who followed in the footsteps of Chiao Ping-chên was Lêng Mei, *tzŭ* Chi-ch'ên, likewise a Shantung man who became employed as a painter at court. In the fiftieth year of K'ang-hsi (1711) he took part in the execution of pictures representing the imperial birthday ceremonies which were made under the direction of Wang Yüan-ch'i. These are mentioned among the eighteen items of Lêng Mei's pictures in the imperial collection, which also included another version of the *Kêng-chih-t'u* and several copies after earlier masters, as for instance Li Kung-lin's Eighteen Lohans, Ch'iu Ying's Spring Morning in the Han Palaces, and a rendering of a T'ang picture of Scholars Enjoying Plum-blossoms, besides original compositions under such titles as Fruit Gatherers, Clothes Makers, Picking Cassia Flowers, Collecting Mulberry Leaves, Flying Kites, etc.,[2] which apparently indicate *genre* scenes of the kind that made Chinese art popular in Europe in the eighteenth

[1] The scrolls with Ch'êng Ch'i's paintings and inscriptions by several well known persons of the Yüan period are shortly mentioned in a footnote to our discussion of the painter Liu Kuan-tao. (See vol.IV, page 35.)

[2] *Cf.* the list of the painter's works in *Kuo-ch'ao yüan-hua lu*.

century (and later) and contributed to the development of the rococo taste. Lêng Mei's figure-compositions, just like Chiao Ping-chên's, are somewhat tawdry continuations of Ch'iu Ying's paintings of a similar kind, modified by the absorption of Western perspective and (to a less extent) modelling by means of shadows. Two fashionable designs by him may be seen in the Boston Museum, both representing ladies with their servants or children, graceful and puppet-like figures such as we know from the much appreciated porcelain statuettes of the time. The garden view with ponds and canals which forms the background in one of these pictures, is developed according to European perspective and produces a strange impression of a rigid frame or setting into which the Chinese figures have been encased (Pl.332). The picture in the same museum which represents a young lady seated on a bench listening dreamily to the girl who plays the flute in a kneeling position has a more immediate appeal.

Lêng Mei, like Chiao Ping-chên, was particularly appreciated for his portraits, and rightly so, because they gave very agreeable reflections of the models. There is an excellent example of this style of picture in the British Museum representing a lady with a light blue scarf seated in a restful posture on a rustic bench made of tree-roots. The Western influence is clearly marked in the design of the picture, but it has been softened by the Chinese feeling for graceful linear flow, and the picture has thus taken on the appearance of a mixed product corresponding to the kind of Sino-European rococo style which was prevalent in Europe as well as in China at the beginning of the eighteenth century.

A number of anonymous paintings representing portraits or *genre* scenes from the life of the upper classes, in highly decorative form, might be remembered at this place, but as we cannot reproduce these pictures, we only mention here in passing two examples in Western collections, *i.e.* the portrait of a young woman in a dramatic posture in the Nelson Gallery, Kansas City, and the somewhat larger picture in the Freer Gallery, which represents three figures in nearly life-size. The scene is laid in a beautifully furnished interior partly framed by a moon gate. The psychological characterization of the figures makes the picture entertaining as an illustration, and the sinuous lines of the richly ornamented light garments have the languid rhythm appropriate to the romantic motif.

Yü Chih-ting, *tzŭ* Shang-chi, *hao* Shên-chai (1647–1705), was no less famous as a portrait-painter than Leng Mei, but also did landscapes and bamboo-paintings. He came from Yang-chou, but served as a *kung fêng* in the palace and was appointed by the emperor to a post in the Board of Rites. This, however, was not to his taste; he preferred to live on the Tung-t'ing island in T'ai-hu. Chang Kêng, who has transmitted some characteristic anecdotes about the painter,[1] writes that shortly before he departed from the capital a nobleman sent a servant with a horse to bring the painter to his house without delay. Yü Chih-ting, who came from the south, was not accustomed to riding; when he arrived at the house he was quite exhausted. Yet he had to step in, and he started to pay ceremonial courtesies to his host, but before he had finished he was brusquely told to paint. Kneeling down on the ground he started to work; but he felt that this kind of treatment was a great insult and decided to return home as quickly as possible. When he finally was leaving the capital his friend, the well-known scholar, poet and bibliophil Chu I-tsun, composed a farewell poem in which he said: "I – a banished official – have for six years been longing to live on the Tung-t'ing island. As you now are going there, please do find a small house for me, too, just large enough to hold a boatful of books."

In describing the painter's artistic accomplishments Chang Kêng writes: "His portraits were mostly executed in the *pai miao* technique, though he did not follow the style of Li Kung-lin, but imitated Wu Tao-tzŭ's epidendrum-leaf drawing and added some light washes of reddish brown in

[1] In *Kuo-ch'ao hua chêng lu*, I, 2.

the faces of the figures." The reference to Wu Tao-tzŭ's *lan-hua* manner is a kind of traditional metaphor intended to describe the long wavy folds in the garments of some of his figures, as may be seen for instance in the picture of Four Scholars Collating Texts.[1] In most of his other pictures known to me in original or reproduction the drawing is characterized by exactness without ornamental stylization. When at his best he transmits something of the emotional as well as the physical movements of the figures by the flow of the lines, as may be seen in a picture in the British Museum (dated 1684) representing a woman seated on the ground bending over a basket with a brazier to warm her clothes, while a maid is standing at the side with a lighted candle. The motif is practically the same as in Chên Hung-shou's picture of Hsien Yang warming her clothes over a brazier, but the treatment has a lighter touch. The emotional import of the older picture has been dissolved into a lighter tone of graceful enjoyment evoked by sensitive drawing and thin washes of light colours (Pl.333). Yü Chih-ting's style may have been better fitted for the representation of graceful young ladies than for portraits of elderly men, yet pictures such as the portrait of the writer Sung Wan (*hao*, Li-shang), dated 1677, or the one of Five Scholars in a Garden,[2] are not only faithful illustrations of types and modes, but also interesting through the characterization of the models. They reveal an effort in the direction of realistic figure-painting, no doubt promoted through contact with Western art, though Yü Chih-ting remained in his technical methods more faithful to the Chinese traditions than Chiao Ping-chên or Lêng Mei. This contributed no doubt to his popularity among his countrymen, who considered him the greatest master of portrait painting (Pl.335).

The most important among landscape-painters who followed academic traditions of Sung or earlier epochs and stood in favour at the court of K'ang-hsi and Yung-chêng, were Yüan Chiang, Yüan Yao, and Ch'ên Mei. The last named was commissioned by the emperor Yung-chêng to prepare a new edition of *Kêng-chih-t'u*, the illustrated treatise on rice and seri-culture. His illustrations are on the whole rather similar to those by Chiao Ping-chên, though with less marked leanings towards Western modes of space construction. Chang Kêng says that Ch'ên Mei "first followed the Sung masters and then T'ang Yin", which may be true, though his individual faculty of transmitting the art of the old masters was not sufficient to do them justice.[3]

Yüan Chiang, *tzŭ* Wên-t'ao, was a more important transmitter of the grand designs of the famous landscapists of Northern Sung. His works are rather frequent in Western as well as Eastern collections and have often been honoured with the names of the great masters whose designs they transmit. Kuo Hsi seems to have been his favourite model, but he has also tried his talent on Kuan T'ung's bulging mountains and Kuo Chung-shu's intricate architectural designs, which he copied with minute care. The legendary palaces of the famous rulers of the Han and T'ang periods are represented in mountain landscapes where the peaks rise through clouds and the very rocks seem to be twisting and turning in an effort to bewitch the beholder. An excellent example of Yüan Chiang's art is the picture in the Nelson Gallery, Kansas City, which is dated 1694, and represents oxcarts passing over a steep and misty mountain road winding between overhanging cliffs, which are creviced and hollowed like huge garden rocks (Pl.334B). His picture of one of the Yangtse gorges with two boats passing through whirling currents is filled with still more fantastic representations of split rocks (*Sōgen*, p.298). In other pictures, more akin to Kuo Hsi's designs, the trees seem to be writhing and wrestling, stretching their branches like dragon claws towards the sky, though they do this less convincingly than in the Sung master's compositions.

[1] *Shina Nanga*, vol.II, 10.

[2] Repr. *Shincho*, p.40.

[3] Reproductions of his works may be seen in *Shincho*, p.44, *Mei-chan t'ê-k'an* (dated 1728) and in *Po mei chi*.

A different style, but one no less characteristic of
the archaistic tendency in landscape-painting that
prevailed in the K'ang-hsi epoch, is illustrated by a
partly coloured and minutely drawn composition in
the National Museum in Stockholm, which is
inscribed Ku Yün-ch'ao, *i.e.* the *hao* of the scholar
Ku Fu-chên from Yangchou (1635–*c*.1716).[1] Ac-
cording to the inscription the picture represents the
Chien-ko Pass in Szechuan (Pl.334A). The precipi-
tous mountains rise like gigantic towers, and between
them are waters pouring down into a bottomless
cleft. The paths lead along palisaded roads over
precipices, and numerous travellers, on foot, or on
muleback, are wending their way there, up and
down the pass. But other men are resting in small
inns on terraces at different heights, where animals
are being unloaded and men are sipping their tea.
The trees are large, tinted in bright autumn colours,
and stand out effectively in contrast to the light
greyish mountains and the circling white clouds
which form layers, one above the other, marking
the successive storeys of the mountain towers. All
the infinite details in the get-up and outfit of the
men and animals and in the leafage of the various
kinds of trees are rendered with unfailing exactness,
but at the same time as integral parts of a very
attractive decorative pattern.

Ku Fu-chên, *tzŭ* Sê-ju, *hao* Sung-ch'ao and
Yün-ch'ao, is nowadays little known, but according
to Chang Kêng he was famous for his paintings in
the manner of the Little General Li.[2] As a youth he
amused himself with poetry and painting, but when
his father (who was a high official) passed away he
became poor and had to make his living by painting;
and he found that this could be best done through
imitations after Little General Li and other masters of
early date. His friend the poet Yüan T'ing praised
particularly his colouring in red, blue, gold, and
green and pointed out that his objects were quite
distinct even when represented as very far away.
These statements apply perfectly to the present
picture in Stockholm, which is one of Ku Fu-chên's
most important works and a typical example of the
survival of the T'ang mode of landscape-painting in
the K'ang-hsi period.

[1] Reproduced without attribution in *Tōsō*, p.402.

[2] *Kuo-ch'ao hua-cheng lu*, I, 2, and also *Kuo-ch'ao hua shih*, VI,
p.16.

Painters surviving from the Ming Period, the Two Older Wang and Contemporaries

I

Wang Shih-min

THE PAINTERS active at court in the K'ang-hsi and Yung-chêng eras were mostly traditionalists of an archaistic type and in some instances strangely influenced by Western modes of painting transmitted by the Jesuit fathers. They were as a rule professional men serving the new government either simply as painters or also in other capacities, and have consequently never been very highly esteemed by their fellow-countrymen.

But there were other painters at the beginning of the Ch'ing period who perhaps with no less reason may be called traditionalists, though they had no connexion with court circles. They belonged to the class of *literati* or scholars and practised painting as a pastime, or a means of intellectual expression, continuing in this respect the tradition of the "gentleman-painters" of the North Sung period. We know how consistently the painters of this kind followed the so-called Southern School all through the ages, and how thoroughly their intellectual leaders in the Ming period despised other kinds of painting. The early Ch'ing masters of this group were faithful to the same ideals, and some of them were even personal pupils of Tung Ch'i-ch'ang. In any case, in their whole attitude and their ideals they belonged essentially to the following of Tung Ch'i-ch'ang, and the change in the political conditions had no influence on the direction of their art. They also lived mostly in the southern provinces where the attachment to the remnants of the Ming dynasty and its cultural traditions was kept alive for more than a generation after the Manchu court had been established in Peking, and they might thus for aesthetic as well as personal reasons be classified as belated Ming painters, though they were active in the Ch'ing period.

This indeed also seems one of the reasons why these painters who survived from the Ming period and remained faithful to its traditions are so highly appreciated by their countrymen. They stand as representatives of an age-old tradition which had been set up by the greatest geniuses of former times, as guardians and interpreters of the scholarly spirit which to the Chinese was a *sine qua non* of real art. Among them may be distinguished two groups, the one including men of a scholarly type who followed closely in the footsteps of Tung Ch'i-ch'ang, *i.e.* the Southern School tradition, and the other, the hermits and independents, who were more detached from school traditions and lived isolated as Buddhist or Taoist monks. The former have, of course, become better known in the recorded history of painting, but the latter have in recent times attracted more aesthetic interest.

Foremost in the former class stand the two older of the famous Four Wang, *i.e.* Wang Shih-min (1592–1680) and Wang Chien (1598–1677), who, practically speaking, directed the main current of painting during the latter part of the seventeenth century. The historical information regarding these men is abundant; only part of it can here be quoted. The first of the Wang painters is recorded in *Wu-shêng shih shih* as follows: "Wang Shih-min, *tzŭ* Hsün-chih, *hao* Yen-k'o, born at T'ai-ts'ang, was the grandson of Wen Su-Kung (the prime minister Wang Hsi-chüeh) and the son of Hou-shan (Wang

Hêng). Already as a young man he was distinguished by his excellent education and reserved manners. In his landscape-paintings he followed the Sung and Yüan masters, and as he continuously discussed the principles of art with Ch'ên Chi-ju and Tung Ch'i-ch'ang he was strongly influenced by these men. He inherited from his father the *t'ai fên* title" (given to officials in charge of the imperial ancestral temple).

In addition to the above information regarding his official career the following is told in *Chiang-nan T'ung chih*.[1] "He was sent as an envoy to Ch'u (Hunan) and Min (Fukien), but did not accept a single gift. When the present dynasty came into power he closed his door and devoted himself to the study of ancient things. He then became prominent as a poet and prose-writer and was also accomplished in his refined *li-shu* calligraphy."

The biographical accounts by Wu Wei-yeh (1609–1671) and Chang Kêng are more explicit in regard to Wang Shih-min's position and accomplishment as a painter. The former writes in *Wu Mei-ts'un wên chi*[1] as follows: "In the discussions of painting during the Ming dynasty the four masters of the Yüan period were usually hailed as models. Shên Chou and Tung Ch'i-ch'ang brought together in their works all the best qualities of these men, and Wang Shih-min is hardly inferior to Tung. He was (from early years) a collector and a connoisseur; when he acquired a precious picture he used to shut himself up in his study, and there he remained in deep contemplation before the picture without uttering a word. But when he had understood some particular secret he would get up, run round the couch, jumping, shouting, and clapping his hands.

"From his early years he was thoroughly familiar with Huang Kung-wang's wonderful paintings, but in later years he gathered the merits of various masters and blended them in his own works. (He reached the point where one might say) he took off his clothes and sat cross-legged and was indeed like a king or spiritual being. In his painting he followed the ancient masters beyond all common rules."

Chang Kêng's account in *Kuo-ch'ao hua-chêng lu* is somewhat longer and contains the fullest information regarding Wang Shih-min's artistic development: "He was unusually talented by nature, deeply cultured and well read. He wrote poetry and prose, was a good calligraphist particularly in writing the so-called *pa fên* style, but above all, he was specially endowed as a painter. At an early age already he won the recognition of Tung Ch'i-ch'ang and Ch'ên Chi-ju. At that time Tung Ch'i-ch'ang was engaged in unveiling all the secrets of ancient and modern painting and establishing them as parts of the correct tradition. In Buddhist terms he was the patriarch, the head of the orthodox school. Wang Shih-min received this current directly from its source through the personal instruction of Tung Ch'i-ch'ang.

"Old Wên Su-kung was very fond of his grandson and loved him so much that he arranged a special country house for him where he could devote himself to the studies of antiquities. Little wonder that he profited greatly from this. His family collection was very rich, yet whenever he came across a true work by some famous master he bought it, even if the price was high, as for instance Li Ch'êng's picture of Boats in the Snow at Shan-yin, for which he paid 20 pieces of gold (400 taels).

"Whenever he acquired a precious scroll he closed the door of his study and remained in contemplation without uttering a word, but when he had assimilated the special secret of the work he would run around the couch, jumping, shouting, and clapping his hands, acting as if he had been drunk or mad. Once he selected some old pictures, perfect in execution and most expressive, twenty-four pieces in all, and made reduced copies of them. These were mounted in a large album, and wherever he went he carried them along with him as models and found support in them for his compositional arrangements, his brushwork, and the manner of using the ink-washes.

"From an early age he was thoroughly familiar

[1] Quoted in *Kuo-ch'ao hua shih*.

with Huang Kung-wang's wonderful ink-work, and in later years he became completely blended with the spirit of this master. The critics of painting who discussed the secrets of Huang Kung-wang's school have considered Wang Shih-min as his true successor.

"He inherited from his father the *fêng ch'ang* (or *t'ai ch'ang*) title, but did not care for official promotions. He preferred to spend his time with ink and brush, or in chanting poems in nature (among mist and clouds). During the present dynasty he was the leader in the field of painting. He always loved talent and thirsted to meet those possessed of it; he cared little for worldly conventions. Consequently painters from everywhere gathered at his door and those who received his instructions became well known (attained prominence), foremost among them being Wang Hui from Hai-yü.

"He passed away at the age of 89. His son Tsuan transmitted the Huang Kung-wang manner of his father and also was a refined and old-fashioned painter, and his grandson Wang Yüan-ch'i continued the same profession and was still more accomplished."

The extraordinary praise bestowed on Wang Shih-min by contemporary as well as later critics may seem to us exaggerated when we consider him at the present distance of time in relation to the preceding evolution. But it should be remembered that in his case, as in relation to so many others of the famous painters, the praise was not due merely to his artistic accomplishments but also to his character and intellectual personality. He formed an important link with the past, and what he said and painted carried a repercussion of the great ideals of classic times. He assumed the attitude of a humble scholar towards the old masters, as may be realized from some of the *t'i pa* quoted below, and characterized himself as a servant of the great painters of old. In other words, his ambition was not to represent any new ideas or exhibit his own skill, but to transmit, as closely as possible, the ideals of certain old masters, particularly the Four Great Masters of the

Yüan period and, of course, Tung Yüan and Chü-jan besides a few other representatives of the Southern School. He was, as said by Chang Kêng, "completely blended with their spirit", and succeeded apparently in expressing the essential significance of the old masters, though he never made close or exact copies. His pictures are, as a rule, interpretations, not as free as, for instance, Tung Ch'i-ch'ang's imitations, yet clearly marked by his individual brushwork and when at their best, congenial recreations of the masterpieces of old. Wang Shih-min was in this respect greater than any of his contemporaries or followers. He did not change his style according to various models like Wang Hui, nor did he content himself with incomplete or cursory renderings, as was often the pleasure of Tung Ch'i-ch'ang, on the contrary, most of his pictures are very carefully executed in a style that bears the stamp of his individuality – a fact which may serve to characterize his strength as well as his limitations as a painter.

These conditions make it also difficult to trace within the still preserved works of Wang Shih-min a definite line of stylistic development. It is true that he modifies his manner to some extent in connexion with various models that he followed from time to time, but these modifications were relatively superficial (at least during the main part of his life) and cannot be said to indicate regular stages in a stylistic development. A more inclusive line of evolution may be found in the growing tendency to elaborate the compositions and to differentiate and intensify the pictorial manner of expression. There is a gradual growth in his ideas as well as in his pictorial style.

Wang Shih-min's dependence on Tung Ch'i-ch'ang, his early teacher, is most noticeable in some of the album-leaves or minor pictures from about 1630, or before. Among the examples of these may be quoted the four leaves in the Ueno collection, river views with stones, trees and conic hills painted in a fluent manner with a soft brush and rich ink, more or less in the same manner as Tung Ch'i-ch'ang's sketchy records of the old masters' works,

but closer to nature than Tung's studies, more intimate and at the same time richer in tone-values, more vibrant of light and shade[1] (Pl.336).

Tung Ch'i-ch'ang's great personality and brilliant manner of painting must indeed have made deep impressions on the young Wang Shih-min, and also led him towards those old masters who henceforth became his ideals. Wang Shih-min's artistic activity may indeed be described as *un hommage* to the Four Great Yüan masters (officially singled out by Tung Ch'i-ch'ang) and a continuous effort to interpret their artistic significance in freely individualized terms.

He did the same also in writing, *i.e.* in the colophons to some of his paintings, as for instance in the following which, better than any lengthy descriptions, may serve to explain the fundamental importance of the Four Great Masters to Wang Shih-min.[2]

"The Four Great Masters at the end of the Yüan period were all descended from Tung Yüan and Chü-jan, but they transformed (their predecessors) by their bright spirit. They completely discarded the old ruts and ways, surpassed the others and stepped out of the common dust. The one among these men whom I admire most is Huang Tzŭ-chiu, because beyond the brush and ink (in his pictures) is a spirit of vigour and simplicity. It is like the creative force of Heaven, which cannot be reached through skill and work and which is difficult to find out by study. I have been very fond of him ever since my youth, and I used to have one or two of his works in my home, which I copied early and late (morning and night) until my old age, but I have only grasped a small fraction (of his art). But when in the *wu yu* years[3] the taxes were high and I was poor, I could not keep them but parted with them to a connoisseur. Since that time I have been like a blind man without a stick, wandering about without anything to lean on, and now I am getting old and decrepit. It is a long time since I touched brush and ink, but Mr. Fang Ai-hsien asked me nevertheless to paint, probably misled by the supposition that I am a great painter . . ."

This colophon, which must have been written in the 1670's, may serve to throw some light on the general direction or mainspring of Wang Shih-min's artistic activity; it makes us realize the truth of the biographer's statement, that he "became completely blended with the spirit" of Huang Kung-wang. This did not, however, prevent him from working also in the manners of other prominent masters such as Tung Yüan, Chü-jan, Li Ch'êng, Mi Fei, Hui-chung, Ni Tsan, Wu Chên, Wang Mêng and one or two more representatives of the Southern School in the Sung and Yüan periods. All these painters are named on pictures by Wang Shih-min, but no one nearly as often as Huang Kung-wang (Tzŭ-chiu). The pictures marked as in the manner of, or after, Huang form an unbroken chain or series all through the *œuvres* of Wang Shih-min for more than forty years. The earliest are mostly in the form of studies or sketches on album-leaves, whereas the latter are highly finished pictures increasing in size and intricacy. This general line of development may be followed through a number of dated pictures which, however, seldom are marked by such stylistic criteria as would enable us to date them without their inscriptions.

Wang Shih-min was evidently not afraid of repeating himself or of returning over and over again to the same motifs and the same models with minor variations. His very large *œuvre* consisting of landscape-paintings may consequently appear somewhat monotonous, not to say dull, to Western students whose attention is attracted by the compositional designs and their pictorial rendering, whereas Eastern amateurs who pay more attention to the brushwork, the *ts'un fa* and the varieties in the ink tones than to the formal models or patterns, may find a great deal of variety in the way of intimate

[1] *Yuchikusai*, pl.1–4.

[2] This and the other *t'i pa* by Wang Shih-min quoted in the following are reported in *Wang Fêng-ch'ang shu-hua t'i-po*, vols.I, II, Reprint 1910.

[3] The expression *wu yu* refers probably to the two years 1668 and 1669, *i.e. wu shên* and *chi yu*, respectively; there was no single *wu yu* year.

shades of emotional or sensorial expression in the technical execution or actual *ductus* of brush and ink. But such qualities have little importance if not discovered through the experience or sensibility of the student, they cannot be communicated through formal analysis but must be grasped directly through observation of the pictures or sufficiently large and distinct photographs, *i.e.* conditions which cannot be fulfilled (or met) at this place. We can only offer some minor reproductions of a few of Wang Shih-min's large landscapes which serve to mark definite stages and fundamental features in the development of his art.

The earliest of these stages is best observable in some minor paintings such as the four album-leaves in the Ueno collection,[1] which according to the inscription were painted in the autumn of the year 1630 in the Cottage of Wild Snow. They are free imitations after Yüan masters, not named but partly recognizable, for instance in the sketches that contain some reminiscences of Kao K'o-kung's and Ni Tsan's manners (Pl.336). The latter is recognizable in the River View with the bare willow-trees in the foreground and hills rising through the mist on the further shore, though the connexion is not very close. Wang Shih-min's sketch has a rather definite individual tone different from anything observable in Ni Tsan's works and more akin to Tung Ch'i-ch'ang's fluent sketches. The brushwork is soft and has a tonal quality which imparts pictorial beauty even to this fugitive sketch. Wang Shih-min's close study of Ni Tsan's art during his early period is furthermore illustrated by a very fine and careful copy after the master dated 1627, which is reproduced in Victoria Contag's book on the Six Great Masters.

Among other album-leaves of approximately the same period, though without dates, may be mentioned two from a private collection in China which are reproduced in *Shina Nanga*, I, pp.36, 37, and marked by inscriptions as free imitations after Huang Kung-wang and Wang Mêng respectively. The former is a very harmonious view over a river winding between wooded hills, whereas the latter represents a thicket of pine-trees in front of a steep cliff. Here, in the latter, the painter seems to have lost himself in a maze of trees and rocks, whereas the open view over the winding river after Huang Kung-wang has a wonderful sweep and atmospheric beauty that may be said to reflect Wang Shih-min's deep sympathy for and understanding of the Yüan master's artistic genius (Pl.337). He is in this respect, as an interpreter of Huang Kung-wang, superior to Tung Ch'i-ch'ang; and it may be added, he never succeeded equally well in his interpretations of other leading Yüan masters. His paintings after Huang Kung-wang were never done as reproductions of actual models, but more like recollections of pictures which he had seen on various occasions and which had become impressed on his sensitive mind. When the proper occasion presented itself, he recreated these memory pictures, filled them with new life and transferred them onto paper with the brush. How this was done is described by Wang Shih-min in the following colophon:

"Once I went to Nanking and in the house of Mr. Chang Hsiu-yü saw Huang Kung-wang's picture of Autumn Mountains, which was executed in colours. I enjoyed it during the whole day and felt very reluctant to leave. The picture remained in my memory, and I thought of it often. When again I passed through Nanking, I went to ask permission to see it once more, but Mr. Hsiu-yü refused to show it to me again. It simply could not be done. But when I travelled to the North in 1631, to assume my official position, I brought some silk with me in the boat, There I amused myself with brush and ink, whenever I felt inspired, and made a picture in which I reproduced his ideas. The thing was completed in three days, but the brushwork is weak and immature; it makes me feel ashamed when I look at it again."

The recollections of pictures seen at various epochs may not always have been very distinct or detailed and the re-creations became consequently

[1] *Yuchikusai*, pp.1–4.

sometimes too much mutually alike. Some of these paintings in the manner of Huang Kung-wang have a close resemblance, as may be seen if one compares the picture in the Vannotti collection (dated 1647) with the picture formerly in the P'ang Lai-chên collection (dated 1642),[1] both marked as imitations after Huang Kung-wang. On the latter the painter has furthermore added a few lines which also serve to show how freely and spontaneously these so-called "copies" were made: "On the 12th night of the 10th month (1642), when it was warm as in late spring and the moon was bright, I felt restless and lay down, but could not sleep; and as the moment was so beautiful, I lit the lamp and made this picture."

The compositions are in both cases dominated by a conical mountain, modelled by streaming "hemp-fibre wrinkles" in which some trees are rooted while the slopes below are formed by agglomerations of humpy boulders and rows of trees in mossy crevices. At the bottom there is the usual low building on the bank of the stream, and trees forming leafy clumps. But to describe these compositions in detail is hardly necessary; their essential elements are known from pictures ascribed to Huang Kung-wang, and they are here developed with a certain amount of pictorial elaboration.

Similar stylistic tendencies may also be noted in somewhat modified later versions of rivers and mountains of this type. They reveal more or less clearly the influence of Huang Kung-wang, sometimes also pointed out in the artist's inscription, but always quite evident in the brushwork. A typical example dated 1649 is reproduced in *Shên-chou ta-kuan*, vol.2. In spite of the rather poor reproduction, one may here observe how Wang Shih-min has imitated the brushwork of the Yüan master, characterized by an abundant use of horizontal and vertical short strokes or jets which serve to produce an effect of vibrating tone-values. But at the side of the mountain there is a bit of river scenery, half hidden by mist, not inspired by Huang Kung-wang but rather by Wang Shih-min's own observations of nature.

In other almost contemporary pictures such as the landscape formerly in the J. D. Chên collection (dated 1653) (Pl.338A) and the very tall, not to say overwhelming, composition in J. P. Dubosc's collection (dated 1654) the brushwork is of the softer and more sweeping kind which as a rule is characteristic of the Tung Yüan imitations. In the latter of the two above-mentioned paintings the composition shows a combination of winding mountain ridges over-grown with trees and shrubs and intersecting terraces which may be likened to gigantic steps leading up to the top of the twisting and turning mountain. It is a picture rich in movement and life in the frame of a firm structural design (Pl.338B).

The same may be said with no less reason of the long handscroll known as Mist Clearing over Green Hills in Spring, in which the painter's deep feeling for the living beauty of actual nature has found its most enchanting expression in a pictorial form based on his intimate studies of Huang Kung-wang and Wu Chên. According to the inscription this picture, which once formed part of the imperial collection, was painted in the spring of 1668, while the painter was travelling in a boat at Pi-ling near Wu-chin.[2] It is like a series of recollections of a long journey through mountainous country, along streams and lakes, hills and dales where human habitations are embedded amidst leafy groves, the beauty of which resides mainly in the infinite gradations of tone and the touch of the brush. The views change from open vistas over distant waters between low banks with scattered trees to deep gorges and creviced mountain walls, which rise beyond the limits of the picture. Wisps of white mist and long rows of dark leafy trees follow the valleys and the foot-lines of the grassy hills accentuating the distances; the air is moist and the soil fragrant (Pl.339, 340).

[1] *Shina Nanga*, II, p.7.

[2] This handscroll was presented by the last Manchu emperor, P'u I, to his venerated old teacher Ch'ên Pao-ch'ên. It is known to students by a series of excellent photographs made before 1930 by the Yen-kuan Co. in Peking. Its present owners are unknown to me.

The emperor Ch'ien-lung has made an attempt to describe the beauty of the picture in a poem, and Prince Kung has expressed his admiration of it in a colophon, from which the following may be quoted: "It is painted in the manner of Huang Tzŭ-chiu; the colours are refined and beautiful as in the works of Chao Mêng-fu. Most of the pictures by Wang Shih-min which I have seen are of smaller size, not like this which is filled with dense forests, peaks beyond peaks expanding into the boundless. It is mysterious and deep without limits; one may go searching through it and never find an end. It is certainly the best work ever done by the painter. He was old when he painted it, yet still in full vigour, bright and alert, not inferior to a young man. Consequently his descendants were also flourishing; they reached prominent positions and became pillars of the State. May the blessing be continued for ever! – Written in the *chi yu* year (1789?) by Kung Ch'ing-wang at Hung-chai by the Fêng-kuang bridge."

Whether this picture should be considered the best thing ever done by Wang Shih-min, as claimed by Prince Kung, is more than I can tell, but it is certainly one of the most attractive landscape-scrolls that have been preserved from the Ch'ing period. It reflects in equal measure Wang Shih-min's poetic temperament and his perfect familiarity with the Yüan master's grand style. – "His manner was bold yet careful, mature without suffering from sweetness, really the manner of a great master", to quote Yeh Hêng-chai.[1]

Wang Shih-min's artistic productivity seems to have reached a culminating point, quantitatively as well as qualitatively, towards the end of the 'sixties when the master was about seventy-five years old. At least ten of his pictures have dated inscriptions of the year 1668 and there may be a few more among the undated ones. Most of these are large compositions in the style of Huang Kung-wang, filled to the brim with creviced rocks and mossy boulders brought together into masses which are more overwhelming than attractive. These are not landscapes of the kind in which the beholder would like to dwell. They represent the grandeur and majesty of nature in symbols of mountains and streams. But they are so rich, so overflowing with details that the pictures may seem cramped or coagulated, particularly when reproduced on a small scale. A single example of this large class of mountain landscape may here suffice; this picture, which used to be in private possession in China,[2] was painted 1667 and two years later provided with the following inscription by the painter: "In this picture of mine I have taken great pains to follow Huang Kung-wang, but I am like the maid who felt ashamed, because she could not grasp the manners of her mistress whom she tried to imitate. In spite of all my efforts, it is not quite true (to the original), and as I now see it again, I cannot help feeling ashamed. Written posteriorly in 1669." The painter's friend Wang Chien was, however, of a different opinion; he has added the following statement: "Among the four great masters of the Yüan period Huang Kung-wang stood supreme through his manner of painting. Later students have rarely grasped his spirit; only Fêng-ch'ang (Wang Shih-min) has transmitted the secrets of his art completely. No other painter of the present time could dream of doing it (as well). This picture is indeed a masterpiece of Fêng-ch'ang" (Pl.341).

It is certainly a *tour de force* of its kind and as such worth all the praise bestowed on it, but it can hardly be said to do more justice to the spirit of Huang Kung-wang than Wang Shih-min's earlier and less pretentious interpretations of the great Yüan master. A further discussion of these and of the fairly numerous imitations after Tung Yüan, Li Ch'êng and Fan K'uan (mentioned in our List) may not be necessary in this condensed survey of Wang Shih-min's production.

The last decennium of his long and abundant activity can hardly be said to have offered any artistically important new results. In the inscription

[1] Quoted in *Kuo-ch'ao hua-shih* from *Kêng-tzŭ shu-hua p'ing.*
[2] *Cf. Sōgen*, p.230. Shao Hou-fu collection.

on a large painting (in the Ku-kung collection) representing Wooded Mountains Rising through Mist beside a purling stream, executed 1670 in a kind of coloured *pai miao* manner, Wang Shih-min complains of approaching old age and weakness in the wrist, a lamentation that hardly can surprise from a man of 88. In spite of the fact that he bestowed great care and elaboration on his pictures, from the beginning of the 'seventies, they bear witness to the declining vitality of the ageing painter. The life-breath begins to congeal and the rhythm to grow rigid. This was no doubt connected with adversities in his personal life, but as a contributing cause may also be recalled his association with Wang Hui, the leading master of the younger generation, through whose influence the old Wang was led into wider fields of eclectic imitations than he had tried before. His close association with Wang Hui, whom he considered as the greatest genius of the time, evidently constituted a very strong and stimulating influence during the last years of Wang Shih-min's life, but it was also disconcerting because it made the old artist cast off his moorings and steer into a wide sea of academic eclecticism where he was not so well at home.

Wang Shih-min's individual genius should, however, not be assessed exclusively from the more or less elaborate landscapes which are marked as imitations after one or other of the old masters; it also found expression in flower studies of a more spontaneous kind based not on historical studies but on intimate observations of the living models. Although he may be said to have continued the tradition from Shên Chou and Chên Shun as a flower-painter, he approached these motifs in another way than the masters of the early Ming period, because he did not select single specimens of the most beautiful garden-flowers such as lilies, carnations, peonies and the like, for pictorial representation, but whole bunches of them combined into decorative bouquets. Three such flower-paintings by Wang Shih-min are known to us, either in reproduction or in original, the largest is the picture in the National Museum in Stockholm, signed and dated 1657 (Pl.342). The others are in private collections in China and Japan, one representing a bouquet in a vase (likewise dated 1657), the other a somewhat thinner or stiffer bunch (without a vase) dated 1676, when the painter was eighty-four years old.[1]

These pictures reveal a surprisingly independent side of Wang Shih-min's artistic genius. They are, as said above, quite different from the traditional Chinese flower-paintings, but they possess a living charm or fragrant life-breath (*ch'i-yün*) no less appealing than in flowers by Shên Chou or T'ang Yin. The difference is not simply the result of the more impressive formal arrangement and decorative effect, but also arises from the brushwork, the creation of an atmosphere by light and shade which in spite of the fact that the painter has worked in ink only, suggests a colouristic effect. This, in connexion with the further developed formal designs, marks a new stage in the development of flower-painting in China and leads our thoughts to naturalistic French paintings of the nineteenth century rather than to any previous Chinese representations of similar motifs.

Wang Shih-min's leading position was, however, not based exclusively on what he accomplished as a painter; he was also a thinker and theorist in matters of art, who expressed his ideas on the principles of painting in writing and exercised a great influence on his friends and younger followers through personal teaching. This is particularly emphasized by his grandson Wang Yüan-ch'i, who in his theoretical writings (to which we shall return in a later chapter) has transmitted the ideas of Wang Shih-min, and one or two of his colophons are worth quoting at this place. They are mostly composed in praise of works by Wang Chien and Wang Hui, but also contain ideas on the history and ideals of painting which serve to throw light on the

[1] *Cf.* Ōmura, *Bunjin Gasen*, II, 4. The picture in the National Museum, formerly in a Chinese collection, is reproduced in *Shina Nanga*, II, *Chung-kuo ming hua chi*, II, 65 etc. For the third example see *Shina Nanga* III.

master's own works as well as those of his contemporaries; for instance the following:[1]

"Although painting is an art, the ancients devoted profound and thorough investigations to it and planned their works with great care. Their endeavour was to produce creations of the same kind as those produced by Nature. Their thoughts communicated (were connected) with the boundless chaos, consequently their works have survived for thousands of years and opened paths for later students. The various currents and schools of painting may all be traced to some original source, thus Li Ch'êng and Kuo Hsi of the Sung period both had their roots in Ching Hao and Kuan T'ung, while the four great masters of the Yüan period were all followers of Tung Yüan and Chü-jan. Nowadays painters are as numerous as trees in a forest, and there is not one among them who does not extol himself as the foremost and pose as a great master. But most of them simply follow the fashion of the time, and possess little of the knowledge of the ancients. Even those who have some knowledge of and admiration for the old masters and who try to imitate them, are so completely tied up in wrong habits that their brush does not follow the intention of their minds. There are indeed outstanding men among them, very clever and intelligent persons, but in their studies of the old styles they do not go beyond some special schools or certain masters. How could they then enter into the secrets of all the famous masters of past periods? Furthermore, even if they give the outward likeness, they do not reach the spirit; or if they give the spirit, they miss the outward likeness, whereas works which are truly like the originals correspond both in spirit and outward form with them."

The same ideas regarding the originators of landscape-painting, namely the great founders of the Southern School at the beginning of the Sung period, and its transmitters in the Yüan period, are expressed in several other colophons, and in some of them he also mentions artists of the Ming period, who, in his opinion, followed the right path and

contributed to keep the true spirit of painting alive. The final synthesis of them all was to him Wang Hui, his younger contemporary for whom he had an admiration that rather impairs his impartiality in regard to other contemporary artists:

"Calligraphy and painting have sometimes flourished, sometimes decayed during past dynasties, but the wonderful works by Chung and Wang[2] have seldom been reached. Students of painting in later times have tried to follow the superior path of Tung Yüan and Chü-jan, but although the mountains and rivers inspired them with their beauty, they were nevertheless dependent on the fashions of the time. After the T'ang and Sung periods the true current in painting was continued by the four great masters of the Yüan period, and by Chao Mêng-fu. Later on in my country of Wu there were men like Shên Chou, Wên Chêng-ming, T'ang Yin, Ch'iu Ying, and finally Tung Ch'i-ch'ang, who all used the brush differently, but nevertheless were all ardent students of the old masters and very close to them in every respect. But in recent times the Tao of art has been declining; the old manners have been lost. Most men try to express their own ideas and scatter about them evil seeds. They wander in false directions and cannot be saved from disaster.

"When Wang Shih-ku arose he again introduced the great masters of the T'ang, Sung, and Yüan dynasties by imitating and copying them very closely. As soon as one opens a scroll of his, one is impressed by the strong and rich colouring, and whatever the design or the 'short cuts' may be, they are quite in keeping with those of the old masters, and in his brushwork and spirit-resonance he is superior to them. Furthermore, when he imitates a master of old, he is entirely like this particular model and does not do it by introducing elements from various masters. If the picture is not signed, it cannot be distinguished from the original. No artist before him could do that, even Wên Chêng-ming and

[1] From *Wang Fêng-ch'ang shu-hua-t'i po.*
[2] Chung Yu and Wang Hsi-chih, the two great calligraphists of antiquity.

Shên Chou did not reach as far. As I have said before, it is a pity that Shih-ku was not born a little earlier so that he could have met Tung Ch'i-ch'ang. If that had been the case, Tung would, indeed, have admired him. Shih-ku himself also expressed regret sometimes that such was his fate."

Wang Shih-min's ideas on painting can hardly be said to have been very original, or far-reaching; he was strongly prejudiced by his early association with Tung Ch'i-ch'ang and the Sung-chiang current, which to him represented the acme of the Southern School. A great painter was to him not simply a man who could paint interesting pictures, but a person of wide learning and perfect knowledge of the leading masters of the past, someone who was able to express their ideals in a way which rendered justice to the spirit as well as to the form of the originals, and not too anxious to contribute anything of his own invention. But in spite of the fact that painting was thus tied up with rather definite historical viewpoints and principles, it did not degenerate to empty imitations but transmitted much genuine feeling and artistic significance in the works of true masters of the brush.

II

Wang Chien

THE SAME ideals and aesthetic attitude may also be observed in the works of Wang Chien, *tzŭ* Yüan-chao, often called by his *hao* Lien-chou, who was six years younger but died three years before Wang Shih-min. There was no blood-relation between the two painters, although they had the same family name, but they lived for some time at the same place, both being occupied with administrative duties in the Lou-tung district. They thus became personally well acquainted and much of their artistic activity developed under mutual influence; their reciprocal admiration was, indeed, a source of satisfaction to both of them. Yet it becomes evident from a closer observation of their works that they were not very closely akin in their individual temperaments or in their attitudes towards related ideals. They were both enthusiastic admirers of the great Yüan masters, but whereas Wang Shih-min approached them as distant ideals, or sources of inspiration, Wang Chien's leading idea seems to have been to imitate these models with the utmost fidelity in design as well as brushwork. His skill and suppleness in this respect are admirable and often dominate to such a degree that his individual share in the work is almost lost or invisible. To what extent this should be interpreted as the sign of a weaker artistic personality or considered as a result of a further developed facility in absorbing models or manners of former times, is a psychological question that here may be left open. The difference in the attitudes of the two masters is, however, well worth noticing even at this place. Wang Chien's paintings impress us more as faithful imitations after the great masters of the Sung and Yüan periods – often very close in spirit and brilliant in brushwork – than as original masterpieces by an individual genius of the same class as Wang Shih-min. His importance in the general development of painting (*i.e.* as a bridge between the Ming and the Ch'ing periods) was not equal to that of Wang Shih-min, yet he was hardly inferior as a painter and certainly able to give perfect interpretations of famous works originating in times of yore.

It seems superfluous to repeat here all the encomiums offered by contemporary and later Chinese historians on Wang Chien's exceptional

skill in imitating certain old masters; they are too well known to need much comment and they will be illustrated by some examples in the following. A few extracts from the main chronicles may here serve as an introduction to the study of his paintings. In *Kuo-ch'ao hua-chêng lu* we are told that whenever he saw some famous specimens from the T'ang, Sung, Yüan or Ming dynasties, he made copies of them "trying in particular to transmit their spirit... The masters of old seemed to live again in him, and thus he became a compass for later students.

"Yüan-chao behaved as if he were junior to Wang Shih-min, but in reality they were almost of the same age. They used to encourage each other, and both reached the level of the wonderful in art. According to connoisseurs of painting, both of them carried on the traditions of the past and opened the path for successors, which is quite true.

"Wang Chien started his career as a *chin shih* and served later as governor of Lien-chou (in Kwang-tung). People called him Wang Lien-chou, but Wu Wei-yeh, in one of his poems, dedicated to Wang Chien, says that he should not be called Wang Lien-chou, because he did not care for his official career."

To this may be added some words from *T'u-hui pao-chien hsü-tsuan* by which his manner of painting is well characterized: "His paintings were done with a pointed brush and rich and brilliant ink. His trees were luxuriant, yet not confused; his hills and valleys far and deep, yet connected, not broken up into pieces. He produced the *ch'i yün* with broad washes of ink and made no attempt to invent new kinds of wrinkles."

The pictures by Wang Chien are almost, though not quite as numerous as those by Wang Shih-min, and they are likewise generally marked as imitations after certain old masters, principally of the Yüan, but also of the Sung and T'ang periods. The painter most frequently mentioned in inscriptions on Wang Chien's (as well as on Wang Shih-min's) paintings is indeed Huang Kung-wang, but Wang Chien has also painted a number of landscapes in the manner of Chao Mêng-fu, Ni Tsan, Wu Chên, Wang Mêng,

and Wang Fu, more or less of the same class and character as those done by Wang Shih-min. Their relative importance in the *œuvre* of Wang Chien is, however, not quite the same as in that of his older friend, because Wang Chien's "copies" after the earlier primordial protagonists of the Southern School, i.e. Tung Yüan and Chü-jan,[1] are no less frequent and excellent. It seems as if Wang Chien had felt the deepest sympathy for and devoted the most thorough studies to these two masters who represented the most specifically pictorial trend in the early stage of the Southern School. In other words, the influence from Tung Yüan and Chü-jan is dominant in a great many of his paintings, even when these are indicated as imitations after Huang Kung-wang or Wu Chên.

Such is the case, for instance, in the earliest of his dated pictures, a beautiful view of steep hills, rising over an inlet of water, and a path that leads up to the houses on a well-protected terrace.[2] It is dated 1638 and marked by the artist as an imitation after Huang Kung-wang, but Wang Shih-min has described the picture more justly as follows: "In this picture by Yüan-chao the design of the hills and valleys is borrowed from Wu Chên, but the wrinkles are made in the manner of Tung Yüan and Chü-jan. No other painter of this generation could dream of doing it. Among the painters of today he must indeed be considered the foremost. When I opened this picture I could not help bowing down before it and brushing my ink-stone" (Pl.343).

The design is of a fairly common type and could well be inspired by Huang Kung-wang or Wu Chên, but the stylistically decisive features are the long hemp-fibre wrinkles, which seem to be streaming down along the hillsides. They are evidently taken over from Chü-jan, though more supple and more drawn out than in the old master's pictures, *i.e.*

[1] Single imitations after Wang Wei, Li Ch'êng, Fan K'uan and Chiang Kuan-tao may also be noticed in the List of Wang Chien's pictures, but they are stray products and of no particular consequence for the formation of his style.

[2] In the Ueno collection; reproduced in *Yuchikusai*, pl.6, *Shincho*, pl.4, etc.

modifications which make them still more effective in a decorative sense.

Observations of the same kind may be made in several of Wang Chien's works produced at various epochs, as for instance in the two well known pictures dated 1661 and 1667, respectively. According to the inscription the former is inspired by the following lines from Wang Wei's poem, The Hsiang-chi Temple: "The stream is sobbing 'neath the perilous cliffs, the colour of the day is cold, the pines are green".[1] The mountain stream winds in a deep furrow between softly bulging hills and a light mist is rising from the far-off crevices, the growth on the grassy slopes is rich and the tone is mellow. The picture is stylistically closely related to the preceding one, though executed in a somewhat broader and more fluent manner, still more reminiscent of Chü-jan.

The landscape of 1667 which is marked as an imitation after Wu Chên, represents a steep mountain ridge ending in a conical point; on the terrace at its side stand some well protected human dwellings, and at its foot is a broad stream spanned by a narrow bridge.[2] It is painted with rich gleaming ink and vivid contrasts of black and white in a very effective pictorial manner. This has been emphasized by the two younger colleagues of the painter, Wang Hui and Yün Shou-p'ing, who have written inscriptions on it; they agree in praising the rich and moist ink, and say that though Wang Chien has indicated Wu Chên as the model for this picture, it is more like the works by Tung Yüan and Chü-jan. It should, however, also be admitted that Wang Chien's own pictorial genius has here found a remarkably free and strong expression (Pl.344).

It may not be necessary to dwell on several pictures by Wang Chien which reveal the combined influences from the above-mentioned Sung and Yüan masters. In some cases these pictures are actually marked as imitations after Tung Yüan, or Chü-jan, or their follower Chiang Ts'an (though also reminiscent of Wu Chên),[3] while in other instances the inspiration is said to have been some

works by Huang Kung-wang, Wu Chên or Chao Mêng-fu, though the execution more or less reminds us of Chü-jan.[4] These pictures are all testimonies of Wang Chien's endeavour to blend certain elements gathered from earlier and later representatives of the Southern School, and they are most attractive when the pictorial temperament of the painter dominates over the refinements of old models.

These combined influences in Wang Chien's work have also been clearly expressed in one of Wang Shih-min's colophons in which he wrote: "Mei-hua Tao-jên's pictures contain the secrets of Chü-jan's art. His brushwork was spontaneously free and sweeping and he changed to some extent the manner of the Sung master. The governor of Lien-chou studied Chü-jan very deeply during his whole life; their pictures could almost be mixed up, but he also from time to time imitated Wu Chên, whose brush and ink-work was most harmoniously blended, deep and beautiful. It was formed after the model of the Northern Sung masters, but Wang Chien was quite unrestrained and not fettered by any hard and fast rules. He absorbed Chü-jan as well as Wu Chên. He was truly the greatest artist of all periods. Wên Chêng-ming and Shên Chou could not do as well as he . . ."

This enthusiastic appreciation of Wang Chien, written after his death (1677) by his older colleague, may sound somewhat redundant, but it is the outcome of the writer's close knowledge of his regretted friend's studies and ideals and gives, no

[1] The picture formed part of the Yamamoto collection; it has been repeatedly reproduced, for instance in *Shina Nanga*, IV, 2. *Ssŭ Wang Wu Yün*, pl.4. *Ōmura*, I, I, *Chung-kuo ming hua*, vol.10, etc.

[2] This picture, which was in the Chang Tsung-yü collection, has been reproduced in *Shina Nanga*, II, 12, *Chung-kuo*, II, pl.68, Contag. pl.12, etc.

[3] For instance Wooded Mountains after Tung Yüan (1668) *Shina Nanga*, II, pl.2, and Mountains and River after Chü-jan (1669) *Shina Nanga*, I, pl.33.

[4] Among the large examples may be mentioned Mountains in Autumn (1652) after Huang Kung-wang, *Tōan*, pl.44, and the coloured picture Floating Mist and Distant Peaks (1675). *K.-k. shu-hua chi*, vol.I. *Cf.* also the beautiful landscape after Chiang Ts'an, dated 1674, in *Chung-kuo*, II, 69.

doubt, an essentially correct view of his artistic evolution.

There are, however, also pictures by the master which may be said to form exceptions to the general rule or current influences prevailing in the majority of his works. The large mountain landscape in the J. P. Dubosc collection in Lugano is an interesting example of these exceptional paintings;[1] it is dated 1666 and marked with the name of Huang Kung-wang, yet quite different in style and spirit from other pictures by Wang Chien or Wang Shih-min indicated as imitations after Huang.

The far extending view is shown as from above; the stream that forms, so to speak, the spine of the design, issues from the gorge at the very top, cuts a deep bed between the rocks, broadens into a wider expanse in its middle course and is cut off, as usual, by the lower edge. It forms cascades over the rocks, where narrowed in, and strongly accentuates the downward rhythm in the design in contradistinction to the rising peaks and the calm horizontals of the rocks, which project into the middle and lower sections of the stream like balancing weights. The man who is standing with his hands behind him on the flat promontory in the centre of the picture acts like the tongue on the balance. He seems to be listening to the music of the water and at the same time absorbing the whole view in his mind.

Trees of various species stand in rows or in clumps but do not detach themselves too much from the creviced cliffs and squarely topped blocks, which form a solid bulwark against the rushing water. The picture is executed with a firm, clearly defining brush in various grades of ink with some addition of light colours, which contribute to bring about a well-unified decorative effect. There is nothing soft or fluent about it, as in some of the previously mentioned imitations after Chü-jan and Huang Kung-wang, on the contrary it is constructed of well defined cubic volumes – rocks, stones, clumps of trees and buildings – which are all integrated in a natural structure of impressive depth as well as height (Pl.346).

The picture is obviously not a direct imitation after Huang Kung-wang such as for instance the Mountain Gorge in the Saitō collection, dated 1657 (Pl.345), nor of any other Yüan or Sung master; it contains elements borrowed from recognizable predecessors, but these have been utilized with great freedom and integrated in a composition which is essentially his own creative work. It shows that he was able, when at his best, to transmit the inspiration or formal ideas borrowed from certain old masters in forms with a distinctly individual character. Wang Chien has rightly become known as the most brilliant interpreter of the Sung and Yüan masters in the K'ang-hsi epoch, the one most completely imbued with their spirit and formal ideas, but it would be wrong to conclude that this imitative activity was the result of deficient individual genius or inability to produce something of his own; he was apparently no less capable in this respect than Wang Shih-min or any other of his contemporaries, though he rarely allowed this phase of his creative spirit to take the lead. He preferred to work under the spell of certain old masters; it was to him a natural submission to the greatest geniuses of former times.

Many of Wang Chien's most interesting pictures are not among the large elaborate landscape compositions, but in the form of album-leaves, which occasionally give the impression of studies from nature, even though they may be executed in the manner of one or other of the old masters whom he admired. One of the best examples of this class is the picture in the Takashima collection in Kugenuma, representing A Few Spare Trees on a River-bank, which according to the inscription was painted 1639 in the manner of Shên Chou, though the treatment of this very simple motif has a touch of immediate observation that might lead to the conclusion that it was painted from nature.

The same may be said of the album-leaf (likewise in a Japanese collection) which was painted, according to the inscription, in 1633, and represents

[1] *Wang Fêng-ch'ang shu-hua t'i-po*, I, p.11.

Evening on the South Mountain, *i.e.* a free standing conical hill seen through a rather darkish crepuscular veil which has been produced by sprinkling the whole picture with ink. The method is unusual (it may be said to form a parallel to the pictures with gold-sprinkled background) and is here applied with surprising success (Pl.347).

Other album-leaves which contain fugitive sketches after old masters are, however, noted down with a soft and swift brush that does not neglect any details in spite of the fluent speed in the execution. Their beauty and expressiveness depend altogether on the brushwork, which may be called impressionistic, in the literary sense of the term, because they are simply notes of momentary impressions recorded in a way which imparts to them a fresh lustre of pictorial beauty.

These minor paintings reveal the pleasure of the painter and also how keenly he realized the danger of being too closely tied down by venerated models; his awareness of this is clearly expressed in his colophon to one of these albums of sketchy records in which he wrote: "There have been no good painters in Wu since Wên Chêng-ming and Shên Chou, yet the path of painting is crowded, and most of the artists lean towards the Southern School. Their fault is to make too much of a display of refinement and skill and not to be natural enough. This album contains some pictures of mine, and although I could not dream of being like the old masters, I do not follow the habits of the professional men."[1] Like all the painters of his trend and standing, he piqued himself on not being a professional artist but a gentleman-painter, a highly cultured, not to say learned, person who vied with the ancients and tried to transmit their ideals in so far as he had absorbed them during a lifetime of study.

We have already quoted one of Wang Chien's colophons on a painting by Wang Shih-min in which he extolled the merits of his older friend. The following expresses the same feelings in a still more uncompromising way: "Tung Yüan and Chü-jan held the same position in painting as Chung Yu and

Wang Hsi-chih in calligraphy. Later men who did not follow these masters were off the (right) path. The four great painters of the Yüan period transmitted the proper school. But in later times, after Wên Chêng-ming, Shên Chou, and Tung Ch'-i ch'ang, there has been no one except Yen-k'o (Wang Shih-min) from my Lou district who has grasped the secret of Huang Kung-wang. Besides him there has been nobody"[2] (yet the writer uses the occasion to name Wang Shih-ku and Shên I-tsai the greatest new lights in painting).

Wang Shih-min responded, as we have noted, with no less redundant expressions of praise on pictures by Wang Chien. One of these flowery colophons has been already quoted, but another may here be added as it acquires special importance through the historical observations by which it is introduced. For instance: "Works of painting are at present very abundant, but quite decadent. Looking all over the country I find nobody of whom I could approve. The painters all vie with each other in following the fashion of the time and leave behind them seeds of error. They claim quite foolishly to have started their own schools and move every day farther away from the old masters. Only Yüan-chao, the governor of Lien-chou, has the wonderful heart (mind) and strong hand to follow the old manners. He has absorbed the famous masters of old like Ching Hao, Kuan T'ung, Tung Yüan, Chü-jan, and those of the last dynasty, and is able to transmit (express) them all freely. And in regard to the resonance of the life-breath (*ch'i yün*) and composition, he often surpasses them. There can be no doubt that he is unique at the present time. Although the present picture is made in imitation of Wu Chên, it contains also the secrets of Chü-jan's art, and thus it is a combination of both masters. I opened it two or three times and found such pleasure in it that I could hardly leave it. Among the works that one sees (today) the wrong ones are most numerous, yet it is possible to distinguish the bright pearls from the

[1] *Hua hsüeh hsin-yin*, chap.iii, I, 53.

[2] *Hua hsüeh hsin yin*, chap.iii.

fishes' eyes without waiting for the examination by the Persians."[1]

Wang Chien's colophons, as we have seen, contain practically the same ideas in regard to the evolution of painting as Wang Shih-min's, and are perhaps still more stereotyped in their expressions of praise bestowed on the older friend and on Wang Hui, the rising genius. The following may here serve as an illustration: "In contemplating a beautiful landscape one often says: 'it is like a picture', and in looking at a good picture one often says: 'it is like the real thing'. From this one may know that there is no distinction between the real forms and their (painted) semblance (shadow). The semblance (false) is no less interesting than the real thing (true), when executed by an intelligent man; but if that is not the case, no skill can make the work of a superior class. Therefore the critics of painting have made a distinction between the divine and the wonderful classes, between the great masters and the famous artists; they drew a definite line between them.

"In the Ch'êng-hua and Hung-chih periods the district of Wu was the principal centre of painting in the whole country. The most famous painters there were Wên Chêng-ming, Shên Chou, Ch'iu Ying and T'ang Yin. They surpassed their predecessors and had no worthy heirs. Nowadays bows and arrows (the military arts) are highly prized and (artistic) culture is at an ebb. It may be said that those who produce mist and clouds with their brush, and carry hills and valleys in their bosom, are rare indeed (one in a hundred thousand)." According to the writer this deplorable state was only relieved by Wang Hui, to whom we shall return in a later chapter.

III

Some Contemporaries of the Two Older Wang

WANG SHIH-MIN and Wang Chien are generally classified as the heads of the Lou-tung or T'ai-ts'ang school, which like so many of these so-called schools represented a local current rather than a definite style. Their actual pupils were not numerous, but they exercised a considerable influence in wider circles. The most faithful transmitter of their ideals was Wang Yüan-ch'i (1642–1715), the grandson and pupil of Wang Shih-min, whereas Wang Hui (1632–1717), the third of the Wangs, who for some time was the pupil of Wang Chien, absorbed important elements from other quarters and became the head of a more eclectic current, often styled the Yü-shan school. Before we turn to these painters, some information may be added regarding a few men of the older generation who were contemporaries of the two Wang.

The oldest among them was probably Ch'i Chai-chia, *tzŭ* Chih-hsiang, from Shan-yin in Chekiang, who became a *chü jên* in 1627, and served first as a district schoolmaster and then in the Civil Office in the capital, retiring to his home at the fall of the Mings. He is recorded in the *Ming-hua lu* as follows: "His calligraphy was like that of Tung Ch'i-ch'ang. In his landscape-paintings he followed Tung Yüan and Hui ch'ung (a monk painter of the Sung period), but also knew the art of Mi Fei and Hsiang-lin (?) thoroughly. His manner of painting was luxuriant and beautiful, very free and spontaneous, the brushwork hasty and rough, yet there was a resonance of vitality in his works." According to Chou Liang-kung,[2] the literary friend of all these

[1] *Wang Fêng-ch'ang shu-hua t'i po*, i, I, 11.

[2] In *Tu-hua lu* quoted in *Kuo-ch'ao hua-shih*, i, 1, 17.

painters, Ch'i Chai-chia was a highly talented and many-sided personality, who among other things composed dramatic plays in which he himself performed the musical parts. "In 1654 he came to take farewell of me, as I was going to the North; when we reached Nanking he stayed for a month in my home and then went with me to Yangchou. While we were travelling together in a boat, he painted forty leaves of landscapes and flowers, besides some albums, and before he left me he wrote a poem. Ts'ao Ku-an said of him: 'Chih-hsiang's calligraphy is not inferior to that of Tung Ch'i-ch'ang; in his paintings he is equal to Ching Hao and Kuan T'ung; his poetry is beautiful, and he is furthermore a good singer, a chess-player, seal-engraver, skilled in card-games and ball-games; he masters every art.' For such a *chii jên* to hide himself at the Plum-blossom village showed that he was no ordinary man."

Ch'i Chai-chia must have been an exceptionally talented man and very good company, if we may believe the records quoted above. He earned his fame not only as a painter and calligraphist, but also as a dramatic actor, a musician and a singer, not to mention his skill in chess and juggling with balls. This many-sidedness made him no doubt known and famous in wide circles, but it did not contribute to make him more appreciated as a painter, nor did it increase his production or make his pictures more eagerly collected by his countrymen. They can never have been very numerous and they are nowadays seldom seen in China, whereas at least ten of them are preserved in collections of Japanese *literati*, who apparently have found them interesting as examples of the rather free and easy neo-impressionism that flourished in the wake of Tung Ch'i ch'ang.

The pictures are tall, like scrolls of writings, the motifs, recurrent in several of them, are made up of steep terraced mountain slopes partly covered by driving mist and, at their feet, one or two rustic pavilions and sparse trees on the bank of a narrow stream. Two or three of them are marked as imitations after Tung Yüan, others as recollections

of Huang Kung-wang or Wu Chên, but the actual likeness with works by these masters is not very marked, nor has it caused any important differences or variations in the compositions. They are painted mainly in ink, though with slightly toned washes in a fluent manner which at times borders on carelessness (Pl.348A).

The above statement by Chou Liang-kung that Ch'i Chai-chia had painted forty landscapes and flower-pieces besides other album-leaves while travelling in a boat along the Grand Canal from Nanking to Yangchou, may not be too much of an exaggeration; their style and general appearance are characterized by Ch'in Tsu-yung as follows: "In his landscapes he followed Shên Chou; they gave the effect of dripping with life. His brush was very strong and quite unrestrained, appealing to the hearts and eyes of men, but in all this glow and luxuriance there was not much ease and quietness."[1]

Ch'êng Chêng-k'uei and Wu Wei-yeh both passed their *chin-shih* degree in 1631 and became known for their poetry and learning as well as for their skill in painting. The former, whose *tzŭ* was Tuan-po, and *hao* Ch'ing-ch'i Tao-jen, came from Hsiao-kan in Hupei; he became a Han-lin member and served at the beginning of the Ch'ing dynasty as vice-president of the Board of Works, but retired 1657. According to *Kuo-ch'ao hua-chêng lu*, "he was a good landscape-painter who followed Tung Ch'i-ch'ang to begin with (receiving personal instruction from the great master), but later worked according to his own manner, using sometimes a dry and stumpy brush and painting with strength and terseness."

This characterization of Ch'êng Chêng-k'uei's manner of painting fits more or less the fairly numerous works of his which are known to us in original or reproductions (dated between 1650 and 1674). They are generally done with a relatively dry brush, the prevailing rhythm in the designs and contours is often jerky, reflecting more speed and

[1] *T'ung-yin lun-hua*, I, 2, p.10.

dash than finish. There is some reason for the statement in *Wu-shêng shih-shih* that "when Ch'êng Chêng-k'uei felt inspired, he worked with the speed of a rainstorm or rushing waters", as may be observed in the album-leaf (belonging to Mr. N. Masaki, Tōkyō) which, according to the inscription, represents "a place where people seldom came", a little wine-shop in the mountains almost hidden among the trees.[1] It is done somewhat in the same manner as Tao-chi's most brilliant landscape-sketches (Pl.349A).

Ch'êng Chêng-k'uei's personal contacts and friendship with some of the monk painters and leading men in the Nanking group, like Kung Hsien, is confirmed by literary records, such as his notes about contemporary painters, and also by colophons composed by his friends on his paintings. The most important section of these notes, called *Ch'ing-ch'i i-kao*, known to us through quotations in *Kuo-ch'ao hua-shih* (14.3), contains the records about K'un-ts'an's (Shih-ch'i's) early life and gives a vivid impression of the friendship between the two painters and particularly of Ch'êng Ch'ing-ch'i's profound admiration for K'un-ts'an. The two men were, as a matter of fact, tied together not only by mutual sentiments but also by their common origin in so far as they both came from the territory of the ancient Ch'u domain. Ch'ing-ch'i was born in Hupei, Shih-ch'i in Hunan, and they were sometimes spoken of as "the two ch'i from Ch'u". Tu Chün (*tzŭ* Yü-huang), a well-known Nanking scholar of the time, who also came from the same part of the country, wrote in a colophon to a picture by Shih-ch'i as follows:

"In our province of Ch'u there have been poets but no painters; only now two men have appeared, one is the Ch'an monk Shih-ch'i, the other the master Ch'ing-ch'i. I have seen on various occasions his large pictures and long scrolls representing cloudy peaks and rocks; they reveal the great secrets of Heaven. He based himself, to begin with, on works by old masters, but now he has taken nature as his friend and teacher, and his works seem to

me to be of the highest (divine) class. I do not know why no painters had come from our province for a long time; now, he who finally came is unrivalled."[2]

A more definite characterization of the two painters under discussion is offered in the following colophon written by Kung Hsien for a picture by Ch'êng Chêng-k'uei:[3] "There are many good painters in the city of Chin-ling (Nanking), some of them belonging to the divine class, and some to the unrestrained class (*i-pin*). The foremost in this are the two *ch'i*, Shih-ch'i and Ch'ing-ch'i. Shih-ch'i's paintings are like a man with coarse clothes and disorderly hair just like Wang To's[4] (Mêng-chin's) calligraphy. Ch'ing-ch'i's paintings are like women with ice pure flesh and jade bones (refined and graceful) and remind one of Tung Ch'i-ch'ang's calligraphy."

The symbols or similes used to characterize the pictorial styles of the two masters may indeed appear more picturesque than illuminating, yet they are at the same time indications of how vividly these men, critics or painters, reacted with all their senses to the individual qualities and the life-breath of the paintings and calligraphies. These ever-changing forms of artistic life (expression) possessed for them almost the same reality as human beings.

The artistic milieu in Nanking during the latter half of the seventeenth century included apparently a number of gifted men who were attracted by the spiritual and material culture in the southern capital. It was not exactly a home or birthplace of leading painters and scholars in the same way as Suchou had been during the Ming period (and Sung-chiang to a lesser degree), yet it was a meeting place for painters from minor towns in Kiangsu and

[1] *Sōgen*, p.242.

[2] Quoted from *Chieh-lin chi* in Yüan T'ung's *Shih Shih-ch'i shih-chi hui-pien*. Although this eulogy was written on a picture by Shih-ch'i, it refers, according to Chinese syntax, to Ch'ing-ch'i as well as to Shih-ch'i.

[3] This is likewise quoted in Yüan T'ung's pamphlet.

[4] Wang To from Mêng-chin (1592–1653), well known poet and calligraphist.

Anhui who came there for various reasons of a material or spiritual order. This will become more evident after we have made acquaintance with the Painters of Anhui and the Eight Masters of Nanking. Here may only be added that Nanking's special importance as a centre for artistic activity did not last after the end of the century, this privilege then gradually passed to Yangchou, the flourishing town further north on the Grand Canal, famous for its gardens and its school of painting.

Ch'êng Chêng-k'uei was, as said above, a Hupei man and started as a prominent official in the service of the Manchu government in Peking, but as his occupation with painting and poetry gave him more satisfaction than his responsibilities as a vice-president of the Board of Works, he left his official position rather early and moved to the south. This is said to have occurred about 1657 and after that date he seems to have been an active member of the artistic circle in Nanking. He was hardly one of the outstanding leaders, but he was a thoroughly grounded Han-lin scholar, well trained as a painter and a poet, and no doubt a very stimulating companion owing to his lively temperament and keen sense of artistic values.

His individual temperament may to some extent be recognized in his somewhat nervous and jerky management of the brush as well as in the use of slight washes of colour, mostly soft grey or pale chestnut – suggesting an atmosphere of twilight as may be seen, for instance, in a picture in the National Museum in Stockholm. According to the inscription this was executed for a friend in 1669; it represents two scholars seated in a small pavilion by a river on a moonlit night. Tall pine-trees form a clump on the opposite bank and a fantastically silhouetted mountain rises like a protecting shadow over the scene below (Pl.348B).

Compositions of this type consisting of winding streams and overhanging cliffs return in several of Ch'êng Chêng-k'uei's pictures,[1] but a still larger number of them are in the form of long handscrolls in which rolling hills, rocks and wide bays are set

into dioramic views enveloped in soft evening light. According to tradition he painted at least a hundred of them, but not nearly so many have been preserved. The earliest one (with a dated inscription of the year 1655) is done in a relatively broad manner with marked opposites of light and shade (Pl.349B), whereas the later scrolls are painted with a more freely flowing brush and richer modulations of tone.[2] The change of style in Ch'êng Chêng-k'uei's works which becomes noticeable may, indeed, have been caused by the painter's personal contacts (about 1670) with K'un-ts'an (Shih-ch'i), as is proved by the very beautiful mountain landscape in Hui-hua kuan (formerly P'ang Yüan-chi collection) on which Shih-ch'i has written a long encomium. It is a picture in which the flickering brushwork as well as pictorial effect illustrate the artistic relationship between the two painters.[3]

Wu Wei-yeh, *tzŭ* Chün-kung, *hao* Mei-ts'un (1609–1671), has been mentioned repeatedly in the preceding pages as the author of the famous poem "The Nine Friends in Painting", in which he characterized nine of his artist friends. "He served at the beginning of the Ch'ing dynasty as a Master of Ceremonies in the Confucian temple, and became known all over the country for his learning and skill in poetry. In his landscape-paintings he followed Tung Yüan and Huang Kung-wang. They were beautifully pure and harmonious, rich in expression and greatly to be treasured. He was a good friend of Tung Ch'i-ch'ang and Wang Shih-min and composed the poem 'The Nine Friends in Painting' to make a record of his friends."[4] To this may be added Chou Liang-kung's words:[5] "Wu Wei-yeh understood how to absorb the merits of various masters

[1] *Kokka*, 292. An Evening View of the Blue River; dated 1654.

[2] Typical examples of the later scrolls belong to Dr. F. Vannotti, Lugano (1669), Mr. Hochstadter, New York (1674) and M. Dubosc, Lugano.

[3] This picture is reproduced on p.80 of the publication called *Chin T'ang Sung Yüan Ming Ch'ing ming-hua pai chien*, edited by Liu Hai-ssŭ.

[4] Cf. *Kuo-ch'ao hua-chêng lu*, I, 1, 20.

[5] *Tu-hua lu*, quoted in *Kuo-ch'ao hua-shih*, i, 6.

but at the same time expressed his own ideas; all that he has painted is worth preserving." The same author quotes three poems apparently describing paintings by Wu Wei-yeh, one of which may be rendered as follows: "A rustic bridge, a running stream, half-hidden by the trees. A lonely man is leaning on his staff and looking at the cloudy peaks. Quite suddenly the sound of bells and stones falls on his ear. But where among the empty mountains can he find his friend?"

The pictures by Wu Wei-yeh known in reproductions have dates ranging from 1630 to 1667. The earliest among them (in the former Hashimoto collection), which is perhaps of the greatest interest, represents a mountain valley with a man on a galloping horse, and grassy knolls in the background.[1] The motif may be a personal record as suggested by the painter's inscription: "When returning home I composed this blurred view in which I represented freely the galloping shepherd at Ho-yang."

In some of his other paintings Wu Wei-yeh followed more closely in the footsteps of his greatly admired friend Wang Shih-min. This is clearly noticeable in the mountain landscape, dated 1655, formerly in the collection of Wang Shih-yüan in Peking.[2] and also in the picture of a bouquet of chrysanthemum flowers in a Japanese collection. The pictures which are illustrated by Ōmura in *Bunjin Gasen* (I, 3 and I, 12) are not particularly important, yet well worth noticing as examples of the relatively conservative type of landscape-painting that flourished in the wake of the Sung-chiang school. The same is true of the large album-leaf reproduced in *Shina Nanga* (I, 23), which represents a mountain ridge, spare trees and low buildings along a rocky beach enveloped in light mist. The motif as well as the fluent pictorial render-ing leads our thoughts involuntarily to Tung Ch'i-ch'ang and the dominating influence of his genius.

The painters who stood astride between the Ming and the Ch'ing epochs were as a rule more animated by loyalty to the past than by any endeavours to strike out in new directions and it may thus be difficult to say, and sometimes cause hesitation, whether they should be placed in an historical presentation at the end of the Ming or the beginning of the Ch'ing period.

Thus, for instance, Yün Hsiang's production was discussed in a preceding chapter devoted to the aftermath of the Wu School, though he continued his activity until 1655, whereas Ch'i Chai-chia, who was born before the end of the sixteenth century, is included among the Ch'ing masters, and the same is of course true of the two older Wang. The number of painters who held somewhat similar positions in the general current of development at this juncture was, indeed, quite large and many of them are well recorded in *Tung-yin lun-hua* and other chronicles of the time, but relatively few of them are known through characteristic works. This, combined with the compelling necessity to economize in space and plates, has led to the exclusion at this place of some painters who are discussed and illustrated in *Later Chinese Painting*, pp.97-99; their works are however mentioned in our Lists in so far as they are known through reproductions.[3]

[1] *Sōgen*, p.232. *Cf. Later Chinese Painting*, II, pl.177.

[2] *Ōmura*, vol.I, 12.

[3] This applies to the following painters: Ku Ta-shên, who came from Hua-t'ing and passed the *chin-shih* examination in 1652.

Fang Ta-yu (1569-1677) from Wu-ch'êng, Chekiang; well known as poet and calligraphist.

Hsü Fang (1622-1694) from Suchou; he retired from the world at the fall of the Mings and supported himself by selling straw hats and paintings.

Chin Chün-ming, likewise from Suchou, known also as a poet, etc.

The Painters of Anhui

THE TRADITIONAL Chinese way of recording certain painters as members of special groups is, as a rule, based on their places of origin rather than on definite stylistic affinities. Consequently it does not offer a safe basis for tracing the evolution of style (except in cases where the two points of view coincide), but it is often a help for the memory and for our attempts to establish a survey of certain periods or local sections of painting. With the enormous accumulation of fresh material at the beginning of the Ch'ing period such groupings become increasingly desirable (when not misleading).

The group commonly known as "The Masters of Hsin-an" (in Anhui) includes four painters active at the end of the seventeenth century who, as far as may be concluded from their still preserved works, had not very much in common from a stylistic point of view, yet formed the nucleus of an important group which included some of the most attractive painters of this epoch.

Sun I and Wang Chih-jui are nowadays almost forgotten; the small pictures with their signatures are few and of too slight importance to evoke any interest, though the men are well recorded. The two other painters usually grouped with them, *i.e.* Cha Shih-piao and Hung-jên, belong so to speak to a different class; they are well known and their fame has been rising in the same measure as their works have become better known. But it may cause some surprise that they are not as a rule grouped with other equally famous Anhui painters such as Hsiao Yün-ts'ung and Mei Ch'ing, who from a stylistic point of view might serve as their partners better than Sun I and Wang Chih-jui. They will here be discussed together, whereas Sun I (sometimes called a reborn Wên Chêng-ming) and Wang Chih-jui (said to have been a tempestuous character) hardly call for any further comments at this place.

Hsiao Yün-ts'ung, whose *tzŭ* was Ch'ih-mu, and *hao* Wu-mên tao-jên (the Sorrow-free Taoist), was born 1596 at Wu-hu and died 1673. He is said to have been a close friend of Sun I; the two painters may indeed have followed somewhat similar or parallel paths in their creative work; they were both to some extent eclectics and absorbed elements of Sung as well as Yüan. These however, in the case of Hsiao Yün-ts'ung were freely transformed into an individual style which seems to have matured with the years. He was not a very strong creative master but a delicate painter. Chang Kêng describes him in *Kuo-ch'ao hua-chêng-lu* (I, 1) as "a good landscape-painter who did not follow any of the common trends but formed a manner of his own which was very pleasant and attractive. On the walls of the Li T'ai-po pavilion at Ts'ai-shih (on the Yangtse) he once painted pictures of the Five Sacred Mountains, and when Sung Lo composed poetic texts to the pictures, they were engraved on stone slabs (presumably after the death of the painter). His pictures representing Peaceful Views and those illustrating the Li Sao ballads were engraved on wooden blocks and thus transmitted."

Hsiao Yün-ts'ung must have enjoyed a considerable reputation in his time for so many of his paintings to have been reproduced in engravings on stone or on wood, and it must indeed be admitted that this

fame of his has not vanished or faded with the passing of centuries. His pictures are still highly appreciated by collectors in the West as well as in the Far East, containing as they do so many of the essential elements of Chinese landscape-painting in a well-controlled, refined and harmonious form.

They are practically all handscrolls; there are about two dozen of them in our List of the painter's works, whereas hanging-scrolls and album-leaves are exceptional; they comply with the old Chinese demand that a picture should contain records of the painter's journeying through interesting country, his reactions to the changing views and moods of nature, and this expressed in a pictorial design that can be enjoyed only in successive sections. Hsiao Yün-ts'ung was a master of this classic form of composition, particularly in his mature (later) works in which he handled it in adherence to such great masters of the Northern Sung period as Kuo Chung-shu and Kuo Hsi, though with more insistence on minute details and a softer brush which, in spite of the use of slightly coloured washes, does not attain the same degree of atmospheric beauty as is to be found in the Sung paintings.

In his early works Hsiao Yün-ts'ung is more dependent on the Yüan masters, as may be observed for instance in the scroll in Mr. Chêng Tê-k'un's collection in Cambridge, which is dated 1649. According to the title the picture illustrates the famous Road to Shu, though not with the historic complement of an imperial cortège; there are only some isolated travellers on horse-back, in chairs and in boats, proceeding on palisaded roads between precipitous rocks or through the straits of a river. The changing views seem to be quite imaginary and though the rocks and boulders are piled up in masses and the roads and watercourses make dangerous turns, the general design can hardly be called grand or awe-inspiring, the prevailing impression is intimate and entertaining, particularly where the human figures appear. The tone is soft grey and the brushwork is distinguished by an easy flow. In the modelling of the rocks the painter has followed the

Chü-jan–Wu Chên tradition, or Shên Chou, who also did some scrolls of this type though with more structural designs. The painter is still feeling his way towards a style of his own.

In the somewhat later scroll (dated 1656) which we know through the reproduction in *Gems* (II, 20), he has taken a definite step forward. It represents Cloud-enveloped Mountains with scattered trees and buildings and is characterized by a firm structural brushwork and a perfect rendering of the cubic volume of the rocks and mounds, which are piled up one behind the other and often cut off into flat terrace planes at the top. The origin of this kind of rock-structure may be found in some of Huang Kung-wang's pictures, but the square shapes were most definitely developed and emphasized by Hung-jên, who was the contemporary of Hsiao Yün-ts'ung, and whose strong and independent manner must have exercised a rather strong influence on him.

The stylistic correspondences with Hung-jên are most noticeable in the above-named handscroll, yet they may also be observed in some of his later pictures such as the beautiful scroll of 1669 in the Los Angeles County Museum, where they are most successfully combined with traditional elements of earlier origin, such as lofty pine-trees, noble temple pavilions and picturesque galleries along mountain streams, into a very attractive and well-balanced composition. It is elaborated with minute exactness in every detail in the same kind of quasi *kung pi* manner as was used by Hung-jên, yet with sufficient strength to make us feel the structural unity of the continuous design (Pl.350). A picture like this might indeed, from a formal point of view, be said to represent an epitome of Chinese landscape-painting; it transmits the principles of visual transformation and compositional unity through all variations of detail which had been accepted and developed in China for nearly a thousand years, though with a fresh display of naturalistic details and in a lighter tone than in corresponding paintings by masters of former generations.

Hung-jên is the best known appellation of the painter Chiang T'ao from Hsieh-hsien in Anhui, who otherwise is known under his *tzŭ* Chien-chiang and the *hao* Mei-hua Ku-na (The Old Man of Plum-blossoms). He took the name when he entered a monastic order shortly after the final downfall of the Ming, possibly in memory of the founder of the national dynasty. He obtained the *chu-shêng* degree in the Ch'ung-chêng period (1628–1643), but did not enter the civil service. The public life of this turbulent epoch had no attraction for him. He found it more congenial to his artistic genius to become a monk and to devote himself to painting.

The discussion of Hung-jên's art might thus with good reason be reserved for a later chapter on the monks and hermits, but as he is best known as the foremost of the Anhui painters, he is recorded at this place. According to Chang Kêng, "he was skilled in poetry, literature, and landscape-painting; followed Ni Tsan in particular and led the way for many of the Hsin-an (Anhui) painters who clung to the Ch'ing-pi (Ni Tsan) tradition. When he died (probably soon after 1663) his friends planted a great number of plum-trees on his tomb in veneration of him, and he was thus the Old Monk of the Plum-blossoms, as he was called (posthumously). I once saw a real work of his which represented layers of cliffs and steep gullies, majestically lofty and imposing, not like those pictures of scattered bamboos and leafless trees which are made by the common painters, who, nevertheless, call themselves lofty hermits . . ." In *T'u-hui pao-chien hsü-tsuan* we are told that Hung-jên started by painting in accordance with the Sung tradition but after he had become a monk changed completely to the manner of the Yüan painters.

The contacts between Hung-jên and Hsiao Yün-ts'ung which become evident through certain correspondences of style and a colophon written by the latter on a picture by the former, may have been profitable to both painters, but there can be no doubt that Hung-jên was the stronger and more original genius of the two. His preserved works are

not so numerous as those by Hsiao Yün-ts'ung and mostly of minor size; some of them represent old trees or a few spare bamboos in combination with a human figure or low buildings, others consist of square boulders or sharply cut rocks bordering a mountain stream, or an open terrace where a scholar has erected his study-pavilion. They are all very neat, clear-cut, pellucid, more like abstractions of actual reality than like studies from nature, and as such quite different from those pleasant and enjoyable views which we have observed in the scrolls by Hsiao Yün-ts'ung.

Hung-jên did not have the same preference for long horizontal scroll compositions as his older colleague; there are only three such paintings by him known at present, *i.e.* two in the K. Sumitomo collection in Oiso, and one in the National Museum in Stockholm. They are all of a very original type, difficult to describe and appreciate except by close study of the actual pictures. The earliest one (in the Sumitomo collection), which is dated 1652 and signed Chien-chiang, may be described as a series of recollections of quiet walks along the reedy banks of a broad river, whose further limits are indistinguishable. There are flat rocks at some places butting out into the river and then, at the very end, a small homestead in a thin bamboo-grove, having no formal connexion with the rest of the picture. In other words, the painter has not worked according to a strict compositional plan or pattern like Hsiao Yün-ts'ung, but noted down a sequence of actually observed and recollected motifs along the river bank in a very sensitive manner which shows his particular dependence on Ni Tsan. Hung-jên could have painted very alluring imitations of that so to speak "inimitable" Yüan master.

The other Sumitomo scroll, which is dated 1661, and signed Hung (instead of Chien-chiang), is a maturer work executed in the more sharply defining linear manner which gradually became his final individual substitute for, or derivation from, the manner which is obvious in his earlier works and which is more imitative of Ni Tsan. It takes us

through a landscape of massed rocks, at some places rising into tower-like structures, at other places merging with flat blocks along a river-bank, a composition rich in detail and somewhat restless in its staccato rhythm. (This however is the type of Hung-jên landscape that has been mostly imitated.)

The scroll in the National Museum in Stockholm is dated in the same year as the preceding picture, *i.e.* 1661, but it is signed Chien-chiang *hsüeh-jên*, indicating apparently that he still considered himself a student (in a temple?) (Pl.352). After the picture follows a colophon by his friend Ch'êng Sui referring to common ramblings in former years. The picture itself, which may contain some reference to such recollections of shared impressions of old times, represents the hills and slopes of an open country beyond a river visible at a distance. The views have a broad sweeping movement; the rising and falling lines of the ground are brought out by rows of leafy trees standing out like dark borders against a pale reddish ground of sandy hills. There are some low buildings, narrow bridges and a few larger trees at the foot of the hills, nearer the river, but the details are all harmoniously integrated to accord with the dominant and grandiose motif: the peaceful rhythm of a hilly country on a cool autumn day.

The unusual charm of Hung-jên's genius as a painter is perhaps most easily discernible in some of his album-leaves. They are done with the greatest economy of means; a few touches of the brush are here sufficient to render not only the structure and volume of the rocks, or the splashing of the mountain brooks, but also the tactile beauty and colouristic appeal of such motifs. In the best of his small studies Hung-jên emerges as one of the most sensitive and genuine of all the painters of his epoch. He may indeed be compared with some of the French impressionists; he thinks and feels in values of pictorial expression and has the faculty to make us sense the beauty that he releases with the brush (Pl.352).

Ch'a Shih-piao, *tzŭ* Êrh-chan, *hao* Mei-ho San-

jên, from Hai-yang (1615–1698), is probably the best known of "The Four Masters". His life is related by Chang Kêng as follows: "He passed the *chu shêng* degree in the Ming period, but after the fall of the dynasty he abandoned further studies for examinations, and devoted himself particularly to painting and calligraphy. His family was well-to-do and possessed a large collection of old sacrificial vessels, as well as many authentic pictures of the Sung and Yüan dynasties, which helped to make of him a real connoisseur. He started as a painter by studying Ni Tsan, but in later years he also made studies with others of Wu Chên and Tung Ch'i-ch'ang. His pictures were done with a few strokes of the brush, and he treasured the ink like gold (used it very sparingly). The style of his paintings was careless, their *ch'i yün* (tone) was quiet and melancholy; they belonged essentially to the *i* (unrestrained) class.

"Once he saw some paintings by Wang Shih-ku which appealed to him, and invited Wang to his home where he asked him to do some pictures in the manners of the following four masters: Ts'ao Chih-po, Ni Tsan, Huang Kung-wang and Wu Chên, for them to serve as sources of inspiration for him. In later years he became a still more excellent painter and penetrated into all the secrets of the Yüan masters. Among his works was an album of pictures, Shih-tzŭ lin (The Lion Grove Garden in Suchou), which came into the possession of Mr. Sung Lo[1] and made this gentleman very happy. When he died in his eighty-fourth year (1698) at Yangchou, Sung Lo started to write his biography and published his poetical works with an introduction.

"He was by nature a carefree and leisurely man and very fond of sleep. Sometimes he did not rise before sunset. He disliked visitors and always sought some excuse to escape from them. When the emperor's son-in-law, Mr. Wang, who was a very rich and influential man, much sought after by the

[1] Sung Lo, *tzŭ* Mu-chung (1643–1713), was a prominent poet and connoisseur of painting who sometimes served as president of the Board of Civil Service.

people, called on him, he was not received, though he came back three times. And as this gentleman shortly afterwards was completely ruined, people admired the foresight of the painter.

"During his whole life he never spoke an angry word or made an injurious statement about anybody, and always sought to encourage the younger painters by praising them. Thus nobody was envious of him in spite of the fact that he enjoyed a very great reputation."

Ch'a Shih-piao's very sensitive but somewhat dreamy and languid nature is reflected in his pictures; they are executed in a fluent manner without much insistence on structure, cubic form, or realistic details, yet he knew how to express "much by little", i.e. to make not only the strokes of the brush, but also the empty spaces tell. The artistic significance of his works is mainly dependent on slight variations in the ink-tones and the suggestiveness of a misty atmosphere; when at their best, his album-leaves are hardly less evocative than those by Hung-jên, though executed in a more subdued scale of softer ink tones (Pl.353). But as he produced a fair number of relatively indifferent pictures after one or two models, the level of his art is below that of Hung-jên's or Mei Ch'ing's œuvre.

He must, indeed, have received important initiatory impulses from Ni Tsan's art (as stated by Chang Kêng), which no doubt appealed to him by its air of refinement and quietude, but these were gradually integrated in the stronger and more inclusive influences from Mi Fei, Wu Chên, Huang Kung-wang and possibly Shên Chou, models which are recognizable in his mature works and also mentioned in some of his sketches after old masters. It would take us too far here to enumerate illustrations of all the various elements in the somewhat eclectic production of Ch'a Shih-piao, but two or three examples may be quoted.

The relatively early picture known as Mist and Clouds over Hsiao and Hsiang, dated 1660, is a very suggestive adumbration of the Mi-style transposed into a lighter tone.[1] Another somewhat misty

painting, dated 1671, represents Autumn Trees in Twilight[2] and may be remembered as a more experimental expression of the painter's interest in subdued light-effects or dreamy atmosphere.

Shên Chou is mentioned as the model in the painter's inscriptions on at least two interesting landscapes; one of them (dated 1674) represents a Lake View in Evening Light[3] and may be said to show a free combination of elements borrowed from Shên Chou and Ni Tsan, whereas the other, which represents a mountain stream spanned by a bridge with a solitary wanderer, is described by the painter as follows: "Autumn fills the air; the mountains rise in silence. Frost has touched the trees, their leaves are red. A lonely man is filled with wonder at the view. He walks the hermit's path across the eastern bridge."[4]

A rather sketchy but amusing imitation after Wu Chên is called Looking at the Fishermen on a River.[5] It is painted in a spotted manner with plenty of empty spaces between the soft touches of his swift brush, suggestive in its way, but more summary than the Yüan master's works of a similar nature. Ch'a Shih-piao did not take much trouble to grasp the spirit of his models, merely borrowing general notions and designs which he transformed freely in his own easy way. This seems also to have been the case when he made his version of The Red Cliff, the motif which had become famous through Su Tung-p'o's poetic description and through several pictorial representations by masters of the Ming period. Ch'a Shih-piao has given an entirely different interpretation of the motif, rather summary but highly effective, not to say amusing, through the disproportion between the precipitous rock and the boat at its foot, which is "small as a leaf". In the inscription on the picture he says: "This mountain shall

[1] Cf. Nanju 3, and Sōgen 236 (Honda Collection. Tōkyō).

[2] Sōgen, 237. (S. Sawahara collection.)

[3] Chung-kuo ming-hua, v, 21. "Imitating the ideas of Master Shih-t'ien."

[4] Shina Nanga, vol.III, 6.

[5] Shina Nanga, vol.I, p.51.

remain the Red Cliff for thousands of years; whenever a small boat passes reminding us of Su Tung-p'o."[1]

A picture by Ch'a Shih-piao in the National Museum in Stockholm, which is dated 1675, represents a crest of hills projecting diagonally from the upper right corner, dividing the water which fills the middle section of the picture into two currents. The one is spanned as usual in these pictures by a small bridge, and here again is the solitary wanderer who contemplates the view, while the late autumn mood is accentuated by the bare willows in the corner. The text to the picture is borrowed from a poem by Wang Wei(?): "Cold mountains; no more verdant green. An autumn stream which murmurs all day long." Ch'a Shih-piao was evidently attuned to the melancholy side of nature and is in that respect a counterpart to Ni Tsan, though his reactions may be more fugitive. He paints the autumn chill and the evening dusk and in his inscriptions as well as in his pictures he strikes the notes of silence and loneliness which fill the mind of the solitary wanderer as he crosses the bridge of a mountain stream on foot or on muleback (Pl.354), or the fisherman in his boat or the meditative philosopher seated on his straw-mat in an open pavilion. There are many variations on these themes in his pictures but they are all in a minor key, like the tunes of the bamboo flute still sometimes heard among the hills in the south.

Wang Chih-jui, *tzŭ* Wu-jui, from Hsiu-ning, is also traditionally counted as one of "The Four Masters", but he must have been a strange character and as such the direct opposite to Ch'a Shih-piao. We are told by Chang Kêng[2] that "when he became drunk and the inspiration arose, he worked with the violence of a sudden rainstorm. He could keep on working for a whole day producing several dozens of paintings, and then, when exhausted, he lay down like a corpse and did not rise for several days." But to what extent these sudden outbursts of artistic production actually reflected his tempestuous temperament is nowadays impossible to tell because no work of any consequence by the painter has become known. The two small pictures reproduced in the *Shên-chou* album devoted to the Hsin-an school and in *Shên-chou ta-kuan hsü-pien*, V, are not distinguished by any extraordinary qualities of design or brushwork.

Mei Ch'ing, who was the youngest and most gifted of this group of Anhui painters, was never counted among "The Four Masters", but he must have known them quite well and he has gradually outdone them all in the esteem of modern collectors. This may be partly due to his personal associations with Shih-t'ao, who in late years has become the central figure of Chinese painting for this critical epoch, but Mei Ch'ing also reveals a remarkable creative faculty, in fact he renews or surpasses the models of the Yüan period which were his stylistic guides.

From the scanty biographical records brought together in *Kuo-ch'ao hua-shih* (V, 6) and some inscriptions we can draw the conclusion that Mei Ch'ing was born 1623 in Hsüan-ch'êng (Anhui) and died 1697. The family was artistic; two of his brothers also became known as painters; his *tzŭ* was Yüan-kung, but he called himself by various fancy names such as Ch'ü-shan, Hsüeh-lu, Mei-ch'ih (The Plum-blossoms' Fool), Lao-ch'ü fan-fu etc., exhibiting the same taste for *variabilia* in names as was still further developed by Shih-t'ao. But he did not become ordained as a monk (like his friend), nor did he spend all his life as a hermit.

Mei Ch'ing passed most of his life in his home province and must have studied its mountains and rivers very closely. Gradually he became one of the most thorough-going enchanted expounders of the fantastic formations and stirring scenes about Huang shan. We are told that he was a precocious youth with unusual gifts for painting and poetry; his appearance was noble and his manners refined . . . "When not occupied in singing or writing poems he did ink-paintings; moving the brush in coiled-up patterns all strange and unrestrained."[3] According

[1] *Tōyō*, vol.XII (formerly in Kuwana collection).

[2] *Cf. Kuo-ch'ao hua-chêng lu*, v.II, 1, 9.

[3] Quoted from *Shih yü-shan wên-chi* in *Kuo-ch'ao hua-shih*, V.

to another critic his landscapes could be placed in the class of wonderful works, but his pine-trees were divine (*i.e.* of the very highest class). Fortunately most of his pictures include pine-trees as their main element, but the precipitous or overhanging rocks are no less important and wonderful. Few painters have yielded themselves more unreservedly to the witchery of pine-trees and rocks than Mei Ch'eng but in the forms in which he represents them they frequently become something like fantastic symbols, derived from forms of nature, but made subservient to his creative imagination.

In some of his pictures the pines are represented as single pillar-like trees in combination with one or two tall rocks or boulders. They are remarkable for their structural form and illustrate the painter's sense for balance and rhythm in introducing his studies from nature. This may be seen in two excellent examples in Japanese collections,[1] dated respectively 1685 (see, *Shina Nanga*, I, 50) and 1689 (see, *Sōgen*, pl.245). Here may also be mentioned a minor landscape in the National Museum in Stockholm, because it bears the following homage to Wu Chên: "I love the Taoist of the blossoming plum-trees, he waved the brush and touched the paper like a god. He emptied the cup of ancient nectar from the Island of the Immortals – and lo! it was spring to him at every season in Chiang-nan!"[2]

As a master of brush and ink Mei Ch'ing evidently learned more from Wu Chên than from any other painter, but his compositions are mostly quite original and of a new type. His combinations of rocks, trees and rushing water are different from those of other painters. The gullies are deep and narrow, embedded between very tall, sometimes overhanging cliffs which almost span the gap over the stream. He may indeed have had occasion to observe such formations on Huang-shan, where he rambled about during certain periods with Shih-t'ao, but he has given them an individual meaning by emphasizing their imperious grandeur. Sometimes when these natural elements are, so to speak, interlaced or winding into each other and are partly

veiled by mist as in the nearly two-metre-tall picture that used to be in the Piacentini collection in Tōkyō, it seems like a vision rather than a view of mountains and water (Pl.355B), but in other examples the human element makes the composition more approachable. This is characteristic of the picture in the former Abe collection (Ōsaka Museum) which represents An Angler in a Boat at the Foot of a Cliff. This forms a perpendicular wall from the level of the water to the very top of the picture, where it ends in a kind of overhanging boulder from which a long pine-branch hangs down, reaching almost to the angler's boat. The two verticals, the cliff and the pine-branch, balance each other, and both serve to accentuate the extraordinary height of the whole scene, particularly if we place ourselves in the position of the fisherman in the boat. The same principle of design is repeated in the picture in the National Museum: the cliff rises boldly and overhangs at the top, but the corresponding falling movement is not indicated by a hanging branch but by a copious flow of water that plunges right down from the cliff-head to the river below, where a clump of pine-trees form a protecting foreground. The picture may well have been inspired by some actual formations on Huang-shan or Lu-shan where Mei Ch'ing seems to have gathered his most stirring and lasting impressions, but it has been filtered through his poetic imagination (like Tao-chi's renderings of a similar scene) and it is executed with rich ink on satin which gives the picture a deeper glow (Pl.355A).

The most intimate expressions of Mei-ch'ing's genius as a painter may, however, be found in some of his album-leaves, of which a fair number have been made known in reproductions. They represent low pavilions at the foot of rocky ledges, dry trees with stones or rocks, fishermen in small boats on a river, *i.e.* motifs of the same kind as we know from Wu Chên's sketchy records, and are noted down with the same kind of rich ink and stumpy brush

[1] *Cf.* Ōmura, *Bunjin Gasen*, v.I, 1 and 3.

[2] *Later Chinese Painting*, pl.181.

as the Yüan master loved to use.[1] The correspondence is, however, not confined to the technical methods, it also results from the two painters' similar approach to the phenomena of nature as symbols of an inner life. Yet nothing would be more misleading than to claim that Mei Ch'ing simply transmitted what he found in Wu Chên's art.

This becomes clear when we glance at the sketches which record his enraptured ramblings on Huang-shan, that glorious mountain in Anhui, the favourite haunt of so many romantic painters.[2] These fugitive views, in which the forms are suggested rather than represented, reveal a sensibility to mist and clouds and an imaginative faculty of transformation which are quite distinct from the genius of any older painter. They are no longer simply pictures of peaks and torrents, or of misty chasms and distant ridges outlined by rows of trees, but visions faintly issuing from a bottomless sea of luminous mist or suggestive of cosmic forces which seem at play with streams and mountains, till they whirl like storm-clouds in a gale. In these pictures we recognize the same kind of almost violent expressionism that has made Shih-t'ao so famous in modern times, somewhat less emphatic perhaps, but nevertheless of the same kind.

* * *

The pictorial activity in Anhui seems to have been quite intense at this time, including many secondary men who, though recorded in history, are little known because their works are seldom seen and rarely reproduced. One or two of them may be shortly mentioned here since examples of their works have reached Western museums.

Ch'ang Sui, *tzŭ* Mu-chien, *hao* Chiang-tung Pu-i and Kou Tao-jên, came from Hsieh-hsien in Anhui but settled later in Yangchou. He may in some respects be considered a link between the two groups. The majority of his known works are album-leaves painted with a relatively dry brush in a kind of expressionistic manner by which the rhythmic structure of the mountains and the light effects seen

through the dark foliage of trees are successfully suggested. The large landscape with two men seated on a ledge at the foot of awe-inspiring wild rocks, lately acquired by the Freer Gallery, is a very original work owing to the peculiarly hatched brushwork and reminds us of a crayon drawing rather than of an ordinary ink-painting with slight washes of colour.

In addition to the painters who by their birth and artistic origin belonged to the Anhui group may be mentioned a man who came from Shantung, but spent much of his life in Anhui and was well acquainted with some of the hermit painters in this province. His name was Fa Jo-chên, *tzŭ* Han-ju, *hao* Huang-shih (1613–1696); he passed his *chin-shih* degree in 1646 and became in 1678 a member of a learned society or academy known as Po-hsüeh hung-tz'u, served as a teacher of the Classics in a Confucian school and became governor of the Anhui province. According to *T'ung-yin lun-hua* "he did not paint very often but stood nevertheless above common men and was unstained by the dust of the world ... The effect of his paintings was ample, it reached beyond the brush and ink-work. He was a true scholar who painted only for his own amusement and followed a path of his own, independent of all predecessors."

The characterization of Fa Jo-chên as a gentleman-painter may be rather flattering, yet it is quite well supported or illustrated by his relatively rare pictures of which half a dozen may be seen in Japanese collections, and one in the National Museum in Stockholm which represents Driving Clouds and Mist in the Mountains (Pl.357A). The elements of the motif may be traditional, but they are here represented in a state of intense movement, not only the rushing water and the circling clouds but the very rocks and boulders; it is as if they all had been shaken by a sudden shock and thrown out of

[1] *Cf.* Album of twelve leaves with studies of Trees, Rocks and Water, dated 1692, published by The Commercial Press, 1934.
[2] *Cf. Mei Ch'ü-shan, Huang-shan shih-chin-ching ts'e.* Commercial Press, 1934.

balance, even the mountain has cracked and vapours are rising out of the interior of the earth. The master's brush has brought everything into swirling movement.

In an inscription at the side of the picture, written in 1855 by a man called Tz'ŭ-chih, we are told that Fa Jo-chên during his sojourn in Anhui was a good friend of the monk painter Shui-kung with whom he used to work; but the present picture, which is inspired by a T'ang poem on the majesty of mountains, and shows "a thousand rocks and ten thousand caves" . . . is "better than any of Shui-kung's pictures, and may indeed be called the work of a genius". Shui-kung is no longer known through records or signed works, but Fa Jo-chên is worth remembering as a highly gifted and independent gentleman-painter, even though he can hardly be called a genius.

Painters in Kiangsu and Kiangsi

THE ANHUI painters mentioned in the preceding chapter may well be said to have formed the most refined and specific provincial group among the mass of gifted painters who were active during the three or four last decades of the seventeenth century, but their activity was mainly confined to their home province and did not reach any larger circles of contemporary painting. If we are to reach a broader, more inclusive view of the development of painting at this particular period we have to direct our attention also to other provincial centres of artistic activity likewise situated in the Yangtse valley or further south, *i.e.* in the provinces of Kiangsu and Kiangsi, and in Nanking, where the cultural and artistic traditions of the Ming period were still entrenched.

It would be easy to fill a whole volume with accounts of the painters who at the time were active in these provinces, because a great number of them are recorded in local chronicles and the historical records quoted above, but it would require far more space than we have at our disposal and many more plates than we can allot to them. Their relative importance and place within the great mass of contemporary Chinese painting is rarely of the highest grade and consequently they cannot be as fully illustrated as some of the previously mentioned leading masters. Nevertheless a few prominent representatives of these groups must be introduced and illustrated, leaving special studies of the minor men to be based on the reproductions noted in our Lists.

Tan (or Ta) Chung-kuang, *tzŭ* Tsai-hsin, *hao* Chiang-shan wai-shih and other names (1623–1692), came from Tan-t'u in Kiangsu.[1] He passed most of his life at Mao-shan, near Tan-t'u, as a student of Taoism. He is described in *Tung-yin lun-hua* as "a scholarly gentleman with free and easy manners ... Sometimes he painted landscapes of a very pleasant and attractive kind, filled with noble feelings. He was able to express it all at the tip of his brush, because of his expert connoisseurship. His paintings were rich but not vulgar, soaked (with ink) but not turbid. If one compares him with those painters of the world who had brush but no ink, or ink and no brush, he stands as high above them as the sky above the earth."

Tan Chung-kuang only represented the mountains and rivers of his home country; his pictures are tall river views harmoniously balanced, spacious and airy. Water fills the lower portions of the pictures; there are a few bare trees on rocky promontories in the foreground; further away there are mountains partly veiled by mist, and some small boats on the water help to give an idea of far distances. The best example of such views is the picture in the former Abe collection (in Ōsaka Museum)[2] dated 1686, but the picture in the National Museum in Stockholm painted five years earlier is hardly less characteristic. Both pictures are provided with poetic inscriptions in large letters, written in Su Tung-p'o's manner; in the latter inscription he says: "The sails were pulling, and it was like sitting in the sky. The mountains on the other shore were radiant with smiles" (Pl.358A).

[1] *Cf. Chung-kuo hua chia ta tz'ŭ-tien.*
[2] *Cf. Sōraikan,* I, p.52.

These are late works painted with great ease while he was living as a hermit on Mao-shan. Earlier examples, for instance the landscapes dated 1660 and 1671 respectively,[1] are more traditional and based, in part, on studies of Shên Chou's art. It should be added that Tan Chung-kuang also painted figures occasionally, as may be seen in the little picture of a Kuanyin executed in a rather sketchy fashion with a facile brush.[2]

Tan Chung-kuang's fame was, however, not based simply on his paintings, but also on his writings, published under the name of *Shu Fa* and *Hua Ch'üan*. The latter treatise became much appreciated by students of painting, because it contains a certain amount of practical advice with regard to the composition of landscapes and their various parts and, in addition to this, theoretical ideas of general interest. His attachment to nature and particularly to the mountains and rivers of his home province form a significant undercurrent in his advice to the painters. His appeal to the painters to devote themselves to the study of actual nature, or the surroundings in which they lived, instead of giving abstractions of the old masters and following beaten tracks, sounds almost as if written in opposition to the general tendency of *wên-jên-hua*, the literary men's painting, which still had a wide influence particularly among the devoted pupils of Wang Shih-min and Wang Chien. As in all the writers on Chinese painting Tan Chung-kuang's discussion leads finally up to the axial point, the importance of *ch'i-yün*, but in doing so he shows the practical import of this term. A few extracts of general interest may be quoted here:[3]

"It does not matter whether the figures are clumsy, if only their spirit is properly expressed, nor whether the scenery is strange, if only it conveys some impressions of an actual place. Tung Yüan's and Chü-jan's mountain peaks and ranges were all from the surroundings of Nanking, Ni Tsan's and Huang Kung-wang's trees and stones were all taken from places in Wu and Yüeh. The two Mi's manner of using the ink was derived from the region south

of Jun-chou, the forms of Kuo Hsi's pictures from the west side of the T'ai-hang mountains", etc. . . .

"Ever since those times painters in search of the wonderful have been linked to the mountains and streams which they represented; good students have followed the operations of nature, while poor ones have simply imitated (other pictures). Those who stuck to a definite manner kept within the rules of a school, while those who did not stick to a manner changed the school rules. Tung Yüan's manner was changed by Huang Kung-wang; Mi Fei's manner by Kao K'o-kung; Wang Mêng followed Wang Wei, but had his own exuberant depth; Wu Chên followed Chü-jan, but remained true to his own nature; Fang Fang-hu was unrestrained, and Chao Mêng-fu highly refined; all these painters brought out the flavour and the forms (characteristics), each in his own way. They realized the significance of the motifs by penetrating into their spirit in accordance with the creative power of heaven.

"Artisans give the shapes of things, but they do not produce resonance of the life-breath. Scholarly gentlemen grasp the ideas, but their compositions are not well-balanced. Former generations discarded the habits of professional painters; they grasped the ideas but forgot the forms. Present-day painters simulate the spirit of scholars in order to hide their lack of skill and deceive others. Thus, if one exerts oneself in copying, one will find it difficult to express one's own nature, but if one has become aware of the art of painting, it is difficult to cling to the rules.

"If ten pictures by the same man are all alike, the hills and valleys in his bosom are easily exhausted, but if each one is (in some respect) better than the last, the mist and clouds under his hand are inexhaustible. If the whole plan is complete in the mind (heart), extraordinary effects will be born

[1] Cf. *Shina Nanga*, I, 48, and ii, 3.

[2] *Shina Nanga*, I, p.47.

[3] The *Hua Ch'üan* is reprinted in the first volume of *Mei-shu ts'ung-shu* and in *Hua-hsüeh hsin-yin*, vol.IV, with commentaries by Wang Hui and Yün Shou-p'ing.

under the hand, and if the influence of the life-breath is strong and far-reaching, the work will bear the marks of a great master. The resonance of the spirit (*shên yün*) will be deep and free, and the work may be placed in the *i* class. It will never be forgotten and always remain famous, whereas one soon turns away from ordinary pictures and forgets them."

In the continuing paragraph the painter speaks about the representation of mountains, trees, and buildings, and how they should be made attractive so that the beholder may like to dwell in the picture. Then he discusses pictures executed in a broad fashion which may seem careless at close range, but when seen from a distance, produce beautiful and distinct effects. To this the commentators have appended a short paragraph on *ch'i yün*, which seems of particular interest:

"Among the Six Principles of Painting *ch'i-yün shên-tung* is the most important. Everybody talks about it, but nobody can grasp it. It all depends on the use of the brush and the ink. When painting one must grasp the creative force of nature by which the *ch'i* (vitality) is produced (born). But only those who are enraptured with mist and clouds, hills and gullies, can realize it in their minds and absorb it in their spirit. If that is not the case, they may study the manners of the old masters during their whole life, yet be separated from it by worlds of dust."

The painter's observations on the spacing of the compositions are important from a theoretical as well as a technical point of view:

"Empty space is difficult to represent in a picture, but if the solid portions are clear, the empty space will also be brought out. The spirit cannot be depicted, but if the picture is very like the real thing, the spirit of the motif will also become manifest. If the positions of the various elements are mutually conflicting, many of the painted portions become piled up like tumors, but when the empty and the solid parts stand in proper mutual relation, those which are not painted also contribute to the wonderful effect of the whole thing . . .

"The manner of painting must not be stiff,

because then no resonance of the life-breath will be produced; and if the picture has no resonance of the life-breath even the liveliest movements are of no avail. Painters must also avoid being too delicate (tender), because then their forms will not be true to nature, and if the forms are not true to nature, even the most expert skill will be of no use."

The above quotations may serve to give an idea of the general scope and nature of Tan Chung-kuang's treatise. It is certainly not a simple repetition of current aesthetic notions or critical opinions formulated by more famous artist-writers of preceding periods; it contains some independent observations and practical advice based on the writer's personal experience and communicated in a way that has made this treatise much appreciated by painters and amateurs. The most interesting portions of it are evidently not the remarks devoted to *ch'i yün* and similar philosophical concepts, but the discussions of more concrete subjects such as the planning and composition of the pictures, and above all the writer's repeated references to the fundamental importance of studies from nature. It is true that similar demands had been expressed by earlier writers also, but they are here put forth with more emphasis and in a more definite form than before, and may thus be said to reflect a more natural or realistic attitude than had been prevalent for some time. In his treatise Tan Chung-kuan appears as a representative of the new movement in landscape-painting that grew up at various places during the latter half of the century and formed the general background also for the so-called individualists who injected more creative imagination and, at the same time, more penetrating naturalism into Chinese landscape-painting.

* * *

Lo Mu, *tzŭ* Fan-niu, *hao* Yün-an (1622–c.1705), from Ning-tu (Kiangsi), passed most of his life in Nan-ch'ang, the provincial capital, where he enjoyed great local fame. According to *Kuo-ch'ao hua-chêng lu*, "his brush-manner lay between that of

Tung Yüan and that of Huang Kung-wang. He painted trees and valleys, luxuriant and beautiful; the effect of his ink was like rising mist. His works were truly of the *miao* (wonderful) class. Even some of the painters from Kiangsu and Anhui (between the Yangtse and the Huai) followed his style, which became known as the Kiangsi school."

As a personality "he kept close to the Tao of old, and esteemed friendship very highly". Among his friends was Sung Lo (Mu-chung), who at the time served as governor of Kiangsi, and composed an essay on the *Two Mu* which he presented to the painter. "He was also an able poet, a great wine-drinker, a good writer of *k'ai shu*, and a specialist of tea culture."

Lo Mu was evidently an able and prolific painter, and as his works show only slight variations, it seems hardly necessary to study several of them. They represent as a rule rocky shores and scraggy trees, usually arranged in a unilateral fashion;[1] the cliffs and promontories project from one side, while the other side is a shoreless expanse of water. It was a type of composition used by many artists at the time, though with considerable individual variations. One of Lo Mu's most successful creations of this type is the picture in the Saitō collection, which is dated 1693. It represents two bare cedar-trees growing on a stony bank by a low open pavilion. The compositional elements are much the same as in some of Ni Tsan's paintings, but the manner of painting is quite different and may be said to have more in common with Wu Chên's dewy ink-style. The ink is very rich and it is laid on with a firm brush that accentuates the broad outlines and brings out the cubic values by strong opposites of black and white (Pl.358B). There is a stylistic relationship between this picture and Tan Chung-kuan's land-scape in the National Museum in Stockholm, possibly suggesting contacts and some mutual in-fluence between the painters of Kiangsu and Kiangsi.

Lo Mu must have enjoyed considerable local reputation as a painter; he became generally known as "the head of the Kiangsi school", which evidently was not limited to painters born in this province but also included men from the neighbouring provinces of Chekiang and Kiangsu, who were attracted by Lo Mu's somewhat simplified and effective style.

Shên Tsung-ching, *tzŭ* K'o-ting and Nan-chi, *hao* Shih-fêng (1669–1735), is one of the best recorded among these followers. He came from Sung-chiang in Kiangsu and seems to have followed quite faith-fully in the footsteps of Huang Kung-wang. His most important paintings are the two Mountain landscapes with Pine-groves in the Ku-kung col-lection[2] and the picture in a Japanese collection representing a Man on a Bridge at the foot of high mountains, which seems closer in style to Lo Mu.

Lü Huan-ch'êng, *tzŭ* Chi-wei from Yü-yao (Chekiang), was apparently somewhat younger; his pictures (in Japanese collections), dated between 1732 and 1758, are more uneven, but at least one of them, representing A Solitary Pavilion and a few trees on the bank of a mountain stream, is a typical Lo Mu composition.[3]

Lu Wei, *tzŭ* Jih-wei, *hao* Sui-shan-chiao from Hua-ting in Kiangsu, was a more original painter. Because of his eccentric character he was commonly called Lu the Fool (Lu-Ch'ih). According to *Kuo-ch'ao hua-chêng-lu* "he painted with a picking brush in a dotted manner. The vapours seemed to rise between the trees, the mountains, and cliffs, envelop-ing the pictures and making them look very attrac-tive. His compositions were of an original kind and sometimes very large, up to eight or ten feet in height. Governor T'u of Chekiang gave him a house by the West Lake, and there he lived for a year before he died." The finest examples of his misty landscapes are two pictures formerly in the Kuwana collection,[4] representing river views with moun-tains and trees emerging out of a soft hazy atmos-phere. The mountains and waters are painted with

[1] Typical works of this kind may be seen in *Nanju*, vols.3, 5, 15, and 20; *Tōyō*, xii; *Ōmura*, I, 8, *Bunjin Gasen*, I.

[2] *K-k. shu-hua chi*, vols.XXXI and XXXVII.

[3] *Nanju*, vol.16.

[4] *Nanju*, vol.10, and also in *Tōyō*, xii.

light washes of ink merging into the tone of the background, but the trees are brought out with a "picking brush", which makes their twigs and branches stand out in an effective pattern against the light grey background. The manner of execution imparts a note of individual expression to the otherwise traditional pictures. The monumental Pine-tree in the Ku-kung collection (9 ft. 8 in. × 4 ft. 5 in.) is an example of his very large compositions[1] (Pl.357B). In this the soft and broad manner which he had learned from Mi Fei and Kao K'o-kung is completely discarded; the majestic tree which bends in a long curve with only a few branches, is drawn with emphasis on its elastic strength. It makes us admit that the painter was no "fool" in spite of his name.

Several other painters might be mentioned here who were men of a certain culture and whose art is known through signed works, but they can hardly be appreciated as distinct artistic personalities if we do not have their works under our eyes. This is true for instance of the Chang family painters from Hangchou, who were active during the second half of the seventeenth century, and specialized in landscapes based on studies of the Sung masters of the Southern School. The oldest of them was Chang Ku *tzŭ* Yen-tsai, *hao* Ku-yü, who was represented by no less than nine large mountain views in the collection of Marquis Sho, dated in the year 1644, and formerly also by similar landscapes in the Kuwana (Kyōto) and Nakamura (Owari) collections.[2] He was evidently a skilful painter, besides being a good writer of *pa fên* and *li shu* script, but "the hills and valleys in his bosom were soon exhausted", to quote Tan Chung-kuang. He repeats himself quite often and gives no new turn or impetus to traditional landscape-painting. His sons Chang Ts'ai, *tzŭ* Tzŭ-chên, and Chang Shêng, *tzŭ* Tzŭ-hao, who also are often met with in Far Eastern collections, painted in a more eclectic manner, following as far as they were able the direction of Wang Hui.

[1] *K.-k. shu-hua chi*, vol.15.

[2] Six of these landscapes are reproduced in Ōmura, *Bunjin Gasen*, vol.1, 4, 5, 6, 7, 9, and 11; others in *Nanju*, vol.9, and in *Kukwa*, II.

The Eight Masters of Nanking

THE EIGHT MASTERS OF NANKING is a designation traditionally used for certain painters who were active approximately between 1650 and 1695, in the Southern capital. The recording of these men in a special group seems, however, to have been a matter of convenience or common parlance rather than based on a critical study of their artistic merits or a result of their common origin. Most of them came, as a matter of fact, from various places in Kiangsu (including Suchou), one was born in Chekiang and another in Kiangsi. They might with equally good reason be said to have formed a Kiangsu group, which, however, would have included more than eight artists.

Their respective individual importance in the history of Chinese painting is rather uneven and their stylistic relations are not very marked, in spite of the fact that they were active at the same time and the same place. Nor would this group have attracted much interest in the history of Chinese painting if it had not included one master of outstanding importance, who nowadays is recognized as one of the leaders in the field of painting at the time. His name was Kung Hsien, and his position at the head of the Nanking group is well established and has been ever since his life-time. A closer study of a few of his preserved works and those of his contemporaries will show that he had little in common with anyone else, nor does he seem to have exercised much influence on the younger generation. Chang Kêng's first-hand remarks about the whole group may here serve as an introduction to our study of these Nanking painters.

"Kung Hsien, *tzŭ* Pan-ch'ien, *hao* Ch'ai Chang-jên, was born at K'un-shan but moved to Nanking. He was an old-fashioned man skilled in poetry and prose-writing, author of a work called *Hsiang-ts'ao-t'ang chi*, and was also a good calligrapher and painter. He was so poor that when he died there was not enough money (for the family) to buy a coffin. But it happened that K'ung Tung-t'ang from Ch'ü-fu (a descendant of Confucius) was then in Nanking; he arranged the funeral, took care of the orphan children and collected Kung Hsien's writings.

"In his brushwork he followed Tung (Yüan) and painted in a bold and vigorous manner (dived into the strong and penetrated into the thick). Only it is a pity that he did not have more refinement and resonance.

"His famous contemporaries were: Fan Ch'i, *tzŭ* Hui-kung; Kao Ts'ên, *tzŭ* Wei-shêng; Tsou Chê, *tzŭ* Fang-lu; Wu Hung, *tzŭ* Yüan-tu; Hu Tsao, *tzŭ* Shih-kung; Yeh Hsin, *tzŭ* Jung-mu; and Hsieh Sun. These were the so-called Eight Masters of Nanking. K'ung Tung-t'ang wrote a poem in praise of Fan Ch'i's landscapes; he says that half of them were painted in the T'ien-ch'i and Ch'ung-chêng periods (1621–1643), and that many of them were collected in the palace."

Of the painters mentioned above, only the first five are known through works of individual character, whereas the very rare paintings signed by the two last are too indifferent for special consideration at this place. The literary records about these "Eight Masters" are, however, in some degree more interesting than their preserved paintings, and merit

to be reported as a background to Kung Hsien's dominating personality.

Fan Ch'i, usually called Hui-kung or Hsia-kung, was probably the oldest of this group. He was born 1616, and still alive in 1694, when he signed a picture. Chou Liang-kung (1612–1672), the author of *Tu-hua-lu*, who knew the painter personally, records the following experience relating to the appreciation of Fan Ch'i's works.[1]

"When I travelled to the north in 1650 I met at an inn Mr. Wang To (the painter) and we looked at an album of paintings by Hui-kung (Fan Ch'i), which I had brought with me. He admired them very much, and though he was sixty years old, he wrote in the lamplight a colophon on one of the pictures with characters no larger than a fly's head, in which he said: 'I do not know who Hsia-kung is. This little picture is painted entirely in the manners of Chao Mêng-fu and Chao Ta-nien; it is very deep and quiet like the work of a virtuous scholar, honest and clear without the least fault or blemish. When looking at it in the lamplight one feels, as it were, the rolling of thunder. Bits of purple streams and white peaks have been transferred to this paper.' He said furthermore: 'It is the brush of an old master, not that of a modern man'. Painters of today are like such poets as Chung Hsing and T'an Yüan-ch'un.[2] The seal was very small and not distinct and he made a mistake in calling him Hsia-kung instead of Hui-kung."

The characterization of Fan Ch'i's art may be somewhat exaggerated in its praise, but it is essentially correct, in so far as Fan Ch'i was a refined traditionalist who followed closely in the footsteps of the masters mentioned above. His handscroll in the former Museum of Far Eastern Art in Berlin,[3] which represents wide views over a river between humpy rocks with a few bare trees, is obviously inspired by some of Chao Ta-nien's paintings of a similar type, but the model has been transformed into a more rustic, not to say austere, tone which adds grandeur to this very carefully executed *kung pi* picture. Somewhat similar transformations of

Northern Sung models may be observed in several of Fan Ch'i's highly finished landscapes which, in spite of their imitative nature and somewhat dry execution, are not lacking in charm (Pl.359). Fan Ch'i was no doubt pre-eminently a traditionalist but he had a very keen sense for the living beauty of plants and flowers, as may be seen for instance in the handscroll in the Chêng Tê-k'un collection in Cambridge. The plants and flowers are there painted with light colours and a soft brush in a kind of *mo ku* manner, one which also was adopted by such painters in the Ming period as T'ang Yin and Chên Shun. They represent a very attractive combination of natural charm and technical refinement.

Tsou Chê and Kao Ts'ên were both talented painters, quite unlike Fan Ch'i and of rather uneven merits. Tsou Chê did not choose his models among the refined masters of the North Sung period, but relied more on the Yüan tradition of landscape-painting; his production is uneven but his most interesting works are minor pictures in which he has noted down impressions of landscapes that he knew by daily observation.

He was born 1636 in Suchou as the son of the painter Tsou Tien, but moved to Nanking and continued his activity there up to 1700 (possibly later). He is said to have painted flowers as well as landscapes, but only the latter are known to us, and the principal motifs in practically all of them are the tall and lanky pines growing in slanting rows on sandy slopes (Pl.360) or standing straight as pillars at the foot of the fissured rocks. His pictures of this type may be said to have a note of rustic intimacy, an impression sometimes emphasized by the low buildings and human figures under the pine-trees.[4]

[1] *Tu-hua-lu*, quoted in *Kuo-ch'ao hua-shih*, vol.IV, p.19.

[2] These poets were considered as rather muddled and unintelligible.

[3] The same style as in the Berlin scroll may also be observed in Fan Ch'i's mountain-landscape reproduced in Chung-kuo ming-hua XXII (1668), and in the Spring-landscape, dated 1694, repr. in *Gems*, I, 59. etc.

[4] Typical examples of Tsou Chê's pictures with pines in *Shên-chou*, IV; *Gems*, I, 60; *Nanju*, 21 (1668); *Chūgoku*, 7 (1679).

Kao Ts'ên was a man from Hangchou and may have been a little younger than the afore-mentioned painter; the only fixed dates referring to his artistic activity are to be found in the signatures written between 1668 and 1672. From a stylistic point of view he may be said to stand halfway between Fan Ch'i and Tsou Chê; he is essentially a traditionalist, though not so closely dependent on Sung models as Fan Ch'i. He has also made free versions of Yüan painters and he adjusted his technical methods in accordance to the varying nature of his models or motifs, a proclivity also indicated by Chou Liang-kung in his picturesque account of Kao Ts'ên's way of studying and working.

He wrote in *Tu-hua-lu* as follows:[1] "I was for a long time a friend of his brother Kao Fu, but did not meet Kao Ts'ên before I was an old man. He had a beard like a halberd and looked like a knight in embroidered garments on a fine horse, but he was also a devout Buddhist. He did not pursue his studies for examination, but turned to poetry and wrote many fine lines. As a pupil of the monk Tao-hsin he lived for many years in a temple, eating only vegetable food, and although he was still young, he was very quiet and self-controlled." The author then goes on to tell how Kao Ts'ên and his teacher, the monk Tao-hsin, discussed painting in great detail. "Whatever Kao Ts'ên grasped from these discussions he quickly put down on paper, but as soon as he had done half of it, the two men again started their discussions. And when the picture with all its mysterious details finally was completed, not a single brush-stroke of the first plan remained. In this way it became as fine as if it had been engraved on bone; every part of it was wonderful."

The best illustration of this description is evidently Kao Ts'ên's somewhat surprising version of Fan K'uan's Autumn Mountains and a dense Grove" (*cf. Gems*, I, 58) (Pl.361). The origin of the design is evident, though rather freely transformed and exaggerated, particularly in its upper portion, and the very elaborate transposition is performed in a manner more akin to regular *kung pi*

work than to the well-known *pointillism* of Fan K'uan. This may indeed have been the result of the deliberations described by Chou Liang-kung, making it "as fine as if it had been engraved on bone".

Yet at other times, when Kao Ts'ên amused himself to play with the brush "in the manners of Sung and Yüan masters in the thatched hut of creeping plants" (*Pi-lo ts'ao-t'ang*), he produced charmingly fresh and luminous small paintings such as the album-leaves in the Berlin collection[2] (Pl.362).

Wu Hung, *tzŭ* Yüan-tu, *hao* Chu-shih, came from Chin-ch'i in Kiangsi and may be said to form a link between Lo Mu's "Kiangsi school" and the Nanking masters. Only few works of his have become known (see List) and they do not convey the impression of a master who rose above the average level of landscape-painting, yet he is flatteringly recorded by his friend Chou Liang-kung,[3] who for some time lived near Wu Hung "between Yün-lin and Pai-ma" (in Nanking?). The historian gives the following biographical account of the painter: "He was born by the Ch'in-huai river, and from his earliest youth he showed great inclination for painting. He cut a path of his own in this art and never cared to follow other people. In 1653–1654 he crossed the Yellow River and travelled to Hsüeh-yüan (The Snowy Peak). When he came back he had changed his art to some extent; it became very free, beautiful and luxuriant. He assimilated the merits of various old masters, but at the same time expressed his own ideas. Once I said to him: 'You possess enough wisdom and courage to pull down a world, and you have the mind and bosom of the old masters; you are truly the Ch'ên T'ung-fu[4] of painting. Fan Chung-li was called K'uan, because of his generous disposition, but you, Master Yüan-tu, are just as magnanimous in your

[1] *Tu-hua-lu* quoted in *Kuo-ch'ao hua-chêng-lu*, v. IV, 1, 20.

[2] Most of the reproduced pictures by Kao Ts'ên are album-leaves; the three larger pictures noted in one List are inferior.

[3] *Tu-hua-lu*, quoted in *Kuo ch'ao hua-shih*, vol.III, 1, 6.

[4] A bold general of the Sung period.

life and art and free from the trifles of the world; you will indeed live to posterity at the side of Fan K'uan."

It is true that Wu Hung's best landscapes and bamboo-paintings are expressive of a certain boldness and painted with emphasis on the opposition of tones and the decorative effect, but to compare him with Fan K'uan's great works seems indeed far-fetched. A good example of his art is the snow-landscape in the National Museum in Stockholm.[1] Bare trees stretch their scraggy branches towards a bleak sky; an air of wintry chill and quietness is suggestively rendered, but the painting does not carry us very far beyond the obvious motif.

Kung Hsien's strange, not to say unapproachable personality and dynamic genius seem to have left a deep impression on his contemporaries and attracted no less attention than his accomplishments as a painter and a poet. We have already quoted Chang Kêng's short remarks about this old-fashioned man who lived and died in utter poverty, never caring to make his art a source of income or social prestige.[2] A somewhat closer characterization of the man and the painter is offered by his friend Chou Liang-kung who describes him as follows:[3]

"Kung Hsien was of an eccentric nature and found it difficult to associate with other people. As a painter he swept away the common mannerism (trodden path) and produced very deep and original works. He said of himself, 'there has been nobody before me and there will be nobody after me'.

"Ch'êng Chêng-k'uei, the very able painter, who seldom approved of contemporary artists, wrote on a picture by Kung Pan-ch'ien: 'In painting there is an enriching and a reducing manner in respect of brushwork, but this does not apply to the boundaries (compositions). The paintings by North Sung masters contain thousands of hills and ten thousand valleys, and there is not a single brush-stroke which is not reducing (abbreviated), whereas in the Yüan masters' paintings of dry trees and thin rocks there is not one stroke which is not enriching (making them more complex). The only one who

understood this thoroughly was Pan-ch'ien.'

"In his early years Pan-ch'ien grew tired of the restless life in Nanking and moved to Kuang-ling (i.e. the prefectural town of Yangchou), but some time afterwards he had had enough of Yangchou and returned to Nanking. He built himself a cottage at the foot of the Ch'ing-liang Hill where he cultivated half an acre (pan-mu yüan) with flowers and various kinds of bamboo. There he lived happily, never visiting the market-places of the town, spending his time in the company of old friends of the defeated dynasty when not practising painting and poetry."

Kung Hsien's preserved and reproduced paintings are quite numerous and at least eighteen of them are provided with dated inscriptions which range from 1635 to 1689. Within this span of time, approximately half a century, the painter must, indeed, have passed through various stages of development and assimilated many influences which affected his style and manner of painting, but to follow these in detail would take us beyond the limits of this condensed presentation of a very rich material. It must be left to students who may have an opportunity to illustrate Kung Hsien's artistic career monographically with a sufficient number of characteristic plates. Here we are at present limited to three or four which naturally will be chosen with a view to the fundamental characteristics of Kung Hsien's art. These may be said to remain constant, even though they are presented with variations in the pictorial form and the technique.

The earliest of Kung Hsien's dated pictures known

[1] Cf. Later Chinese Painting, Pl.186.

[2] Students specially interested in Kung Hsien's art and personality are referred to the article by Dr. Ashwin Lippe in Oriental Art, ser. III, I (1956) written on the occasion of an exhibition of "Kung Hsien and the Nanking School" held by the Chinese Art Society of America in New York, March–April 1955. The Catalogue of the exhibition and the article in Oriental Art, both by Dr. Lippe, contain more detailed information about the painter's curriculum vitae, his friends and historical background, than could find place in our condensed presentation of the subject.

[3] Cf. Tu-hua-lu quoted in Kuo-ch'ao hua-shih, III, p.5.

in reproduction is a tall fantastic mountain land-scape with deeply split and sharply outlined per-pendicular crags. The linear emphasis of the rather elaborate design produces the impression of a carving in stone or wood rather than of an ordinary work with brush and ink. Yet the rugged trees at the foot of the mountains with their scanty leaves and cracked bark are of the same type as in Kung Hsien's better known later works, only less promin-ent. The whole picture may thus be described as a somewhat thin and immature forerunner of the master's mountain landscapes of later date[1] (Pl.363A).

Dated examples which might serve to illustrate a gradual stylistic development are, however, missing and we must thus base our conclusions mainly on stylistic considerations. The only dated specimen between 1655 and 1671 is a small album-leaf of 1669, which, however, is too poorly reproduced to be of any service in this connexion. The next dated exam-ple of any importance is the beautiful river-land-scape with low buildings and a topped mountain (on the opposite shore) which is called The Village of the Green Willows and dated 1671[2] (Pl.364).

It is one of Kung Hsien's most pleasant pictures, animated by a sensitively graded pictorial atmos-phere and harmoniously balanced according to a compositional type well known from some of Wu Chên's landscapes. The spatial effect or horizontal spread is, so to speak, marked by three stages: the spare trees and low cottages in the foreground, the low spits of marshland washed by the river in the middle ground, and the verdant hills rising into a centralized cone in the background, i.e. elements of a river view quite common in Wu Chên's work and here steeped in a soft evening light. The picture is, as such, an interesting historical document illustrating a characteristic phase in Kung Hsien's development as a painter, which also has been recorded by con-temporary critics, as in the following remarks from Kuan Chiu-lu reported in Kuo-ch'ao hua-shih (III, p.6): "Pan-ch'ien liked to imitate the brush-work of Mei-hua Tao-jên. Once he did a small portrait of himself in the form of a monk sweeping

fallen leaves, and from this he called his house Sao-yeh lou (the House where the Leaves are Swept)." To which may be added that a house with this picturesque name existed on the outskirts of Nanking before the last war.

If we use this dated picture of The Village of the Green Willows as a point de départ, placing it at the side of a few other characteristic, though undated works by Kung Hsien, we can hardly avoid the con-clusion that it represents his art in a fully developed mature stage. He must have produced remarkable paintings before as well as after this, and if we look for the former, i.e. pictures which represent a less accomplished stage in the master's stylistic develop-ment, we may choose as an example the large mountain landscape in the Los Angeles County Museum, in which a dense grove of tall and stiff trees fills the lower part of the composition while the upper half is filled by sharply outlined craggy ridges. The construction and drawing of these is much the same as in the above-mentioned picture of 1655, though the mountains in the former picture are more archaistically conventionalized. The picture in Los Angeles shows a somewhat freer or more advanced pictorial style; there are white clouds circling between the mountains and rich leafage on the trees which surround the temple pavilion. The individual style of Kung Hsien is here fully recog-nizable though in a more tentative than finished state. The painter seems still to be in search of the bold individual manner by which he, in his later works, emphasizes the swelling forms and woolly texture of the rocks and the plumy leafage of the trees (Pl.363B).

This more mature, not to say manneristic, style is fully developed in pictures executed in the 1670's, as may be observed in the example reproduced on plate 763 in Pageant which is dated 1673. It represents a pavilion built on poles across a mountain stream surrounded by dark trees. It is one of the rather excessively heavy, not to say muddy, compositions

[1] Nanking Exhibition Cat. pl.264.

[2] Liu, pl.97. Private Chinese collection.

that are difficult to enjoy (particularly in reproduction) owing to the abundant use of dark ink tones. We are here reminded of the statement in *Chiangning chih* (quoted in *Kuo-ch'ao hua-shih*): "Kung Hsien's landscapes were deep, melancholy, impenetrable, overflowing with life-breath. He surpassed all the others, but few people realize the depth of his art."

Another dated, typical example of this somewhat heavy and pompous manner is the large picture in Dr. Lo Chia-lun's collection in Taipei which, according to the inscription, was painted for I-lin, "The Old Tao-man", in the early autumn of 1684. It contains such characteristic elements of Kung Hsien's art (also mentioned in the poem) as the squarely cut rocks (which rise to heaven), the hoary old trees (in which the *huang* and the *luan* bird come to rest) and the house on the terrace that faces the setting sun – all rendered with rich ink and a soft brush which in combination has produced a woolly texture effect (Pl.365).

But Kung Hsien also, at the same time, did minor paintings on album-leaves and fans in which the knotty old trees produce an effect of poverty and endurance. They are, as a rule, painted with a stumpy brush which applies the ink in short vertical and horizontal jets or strokes by which some of them become more like woodcuts than ordinary ink-paintings. We shall find occasion to observe some of these in Kung Hsien's illustrations to his discussions of painting to be mentioned below.

When this kind of abruptly accentuating brushwork is combined with softer patches of deep ink (in the foliage of trees and the moss on stones) and with fleeting vapours of mist in gullies and around the tops of mountains, the atmosphere is intensified and sometimes condensed into a kind of mysterious *crepuscolo* which impresses us as conveying the very life-breath of Kung Hsien's individual genius. It would take us too far to enumerate several examples of this, because there are dozens of them among the album-leaves as well as among the large decorative compositions, executed in the 1670's and 1680's.

We only refer in passing to the large and impressive paintings in the collections of Mr. Frank Caro and Mr. Hochstadter, both reproduced in the catalogue of the Kung Hsien Exhibition in New York 1955,[1] and to the very beautiful composition in the former Maruyama collection in Ōsaka, in which a group of thatched pavilions appear among leafy trees on a steep mountain partly enveloped by floating clouds.[2] To most of these pictures the painter has added short poetic paraphrases on the motifs depicted, such as the following (on the Maruyama picture):

"The middle peak is covered all around with verdant growth. The high pavilions are enwrapped in brilliant light. The trees are old; the *fêng* and the *luan* bird come here to meet. The clouds are deep. The bells and chimes are faint. The water rushes out between the stones, and the cascades will never cease. I wish that I could go there with my *ch'in* and books, to stay in the Immortals' home in perfect peace."

According to the tradition reported in *T'u-hui pao-chien hsü-tsuan* and other records, Kung Hsien "started by building his foundation on the North Sung masters, but he changed their manners", a statement more or less supported by some of our above-noted observations. The earliest among his dated pictures reveal the closest dependence on Sung or pre-Sung models of Ching Hao's or Kuan T'ung's type, not to mention the still closer imitation after Li Chao-tao (in Yūrinkan in Kyōto) which is dated 1672 and painted with green and gold on dark-toned silk. Among the various album-leaves of later date are several which, according to the inscription, are inspired by early masters like Tung Yüan, Chü-jan, Mi Fei, and Ni Tsan, but the approach to these or other old masters is in most cases not very close. These studies may have been of some importance for the development of the master's style, but he has transformed the styles of the old models quite

[1] *Cf. Toronto Exhibition. Cat. 52.*
[2] *Nanju*, vol.25. *Cf.* also *Nanju*, vol.5 and other vols. in same series.

freely in accordance with the fundamental *animus* of his own genius. It seems, however, well worth remembering that these historical studies did not merely mark a short passing phase in Kung Hsien's development. They were continued all through his life, as may be concluded from his inscription on a mountain landscape in the manner of Li Ch'êng in the Honolulu Academy of Arts[1] (Pl.366). The picture, which is a surprisingly close imitation after an early Sung model, is dated at the very end of the master's activity – 1689 – and the inscription on it may thus be said to contain an epitome of his views on painting. It is hastily written and not quite clear in every detail, but the main part of it contains the following:

"Painting should be done in accordance with the principles of the Sung and Yüan periods quite freely, then it becomes of the *i* (unrestrained) class. It may consist of a few scattered strokes, yet the six principles of painting will all be there, and it will have an air of refinement and the stamp of scholarship. Such is the distinction of the works of leisurely scholars but not of labours which make the critics laugh. Mên-tuan (Wang Fu) did his pictures in his late years in play and followed Tung (Yüan) and Chü(-jan) as his models. Now he has become my master; and what a model! As this (painting) now is ready and finished, I have also recorded the meaning of it with the brush. Kung Hsien; in the spring of 1689."

Kung Hsien must also have exercised a considerable influence as a teacher (though very little is reported about his pupils with the exception of Wang Kai), because he has left at least two sketchbooks with scattered notes on landscape-painting for the benefit of students, besides elements of a short treatise called *Hua chüeh* (Secrets of Painting) which was edited after his death. Some of the annotations in the sketch-books and the treatise are the same, others are different, and they are all in an unfinished preparatory state. It is consequently difficult to say definitely which of the two elements may be the earlier, but it seems to us most probable that the

sketchy notes possess primary significance. The text of the *Hua chüeh* may have been compiled by an assistant from notes by the master. The ideas and practical advice contained in the notes can hardly be said to offer anything new or unknown to writers of the Sung and Ming periods on similar topics. Kung Hsien follows the same general lines of thought, but he illustrates these with pictorial sketches which have a distinct individual value, and certainly merit to be observed by students of the history of Chinese painting.

The edition of the sketch-book (in the collection of Chang Chang-po) issued by the Commercial Press (Shanghai 1935), consists of twenty double-leaves containing progressively arranged elements of landscape-painting accompanied by notes.[2] The first five leaves are filled with sketches of trunks and branches of trees, their jerks and bends. The sixth shows various types of leaves to be used in a picture. The seventh, eighth, and ninth are occupied with stones, boulders and rocks, their most effective shapes and groupings in pictures. The tenth leaf contains sketches of thatched pavilions, gateways and bridges, and then follows a view of a river between low hilly banks over which the painter has written the following observations relating to various distances and successive heights in a picture: "There are three distances in painting, the level distance (*p'ing yüan*), the deep distance (*shên yüan*), and the high distance (*kao yüan*). The first is an open sea-view, the second is mist and clouds, the third is (used for) large hanging-scrolls. If you paint a scroll of medium size, you should use the deep distance. There are three kinds of slopes (*p'o*, vertical divisions); at the bottom the sandy shore, in the middle the rocky banks, and above these the far-away mountains. The lowest

[1] The modern painter and critic Chang Ta-ch'ien writes in a colophon to the picture: "Pan-ch'ien was the only painter surviving from the Ming period who was able to carry on the tradition of Tung and Chü. This picture is a masterpiece of his late years, comparable to the works by Wang Fu and Shên Chou."

[2] The same book was also published by Ōmura Seigai and later reproduced in *Nanga Taisei*, Add.III, 244–263. Another similar album was published as part of *T'ai shan ts'an lou* series, and also reproduced in *Nanga Taisei*, Add.III, 234–243.

and the middle slope should not be too thick; the far-away mountains not too thin. Thin (light) ink may be used in the banks of far-away rivers and lakes."

The twelfth leaf is occupied by mountains partly covered by vaporous mist, and here the artist has written: "Clouds on mountains should be thick. I tried to understand this for thirty years but could not grasp it. Then my old teacher said to me: 'Make the mountains thick, then the clouds will be thick'." (This advice seems to have made a deep impression on the painter, because thickness is rarely wanting in any of his works.)

The thirteenth leaf is a study of pine-trees by a shore; the fourteenth represents leafless willows by a shore, "their trunks are short, their branches long". The fifteenth shows leafy trees in front of a mountain wall, the sixteenth a view of a pavilion under beautiful wu-t'ung trees (Pl.367). The seventeenth represents cedars and maples at a temple gate; the eighteenth is a shore-landscape with bare trees in the manner of the Yüan masters, and contains the following inscription: "Use Ni Tsan's reducing and Huang Kung-wang's relaxing brush, bring Ni into Huang, and Huang into Ni, then the brushwork will be old-fashioned and beautiful, the ink rich and brilliant". The nineteenth leaf shows some thin trees on a low river-bank; the lengthy inscription refers to various manners of painting leaves, as for instance: "Trees with scattered leaves should be painted with a full brush, if painted with a flat brush, they are of the Northern School". The last leaf shows a very fresh and spontaneous sketch of a narrow strait between rocks spanned by a frail bridge, a sailing-boat, and a distant shore-line marked by a faint row of trees. The pictures are, as said above, mainly elements of study, but in some of them such as the last river-views and the willows, the pines and the wu-t'ung trees, one may indeed observe the painter's characteristic brushwork most intimately and feel the pulse-beat of his brush, one might even say of his creative mind (life-breath). They make it easier to understand the extraordinary combination of sensi-tiveness and unquenchable will so characteristic of his personality and his art which his friend Ch'êng Chêng-k'uei described with the following words:

"Pan-ch'ien used his brush like a dragon riding on the wind or like clouds sweeping through the sky, appearing and disappearing, changing continuously, impossible to grasp. He surpassed all others by the reverberation of his life-breath, not just by sheer strength."

* * *

The same trend of theoretical discussion based on a study of the old masters, and supported by artistic illustrations, was continued and further developed by Kung Hsien's pupil Wang Kai, tzŭ An-chieh (also known as Lu-ch'ai), who has become famous to posterity as the main compiler of the Chieh-tzŭ yüan hua-chuan. According to Chang Kêng, "he studied the manner of Kung Hsien and became a good painter of large landscapes and of pine-trees and stones, which he painted in a bold and spontaneous fashion. They were luxuriant and strong, but not very harmonious. He sought the company of distinguished officials, which caused the saying: 'Wang An-chieh is a constant visitor everywhere' (t'ien-hsia jê-k'o). He was also versed in poetry and literature and wrote a fu poem on the Ch'êng-hsin-t'ang paper,[1] which was famous at the time."

To judge by this description, Wang Kai's reputation seems to have been that of an ambitious amateur rather than of a prominent painter, and it may well be that his learning was greater than his artistic gifts. The pictures by him which have become known in reproduction are mostly album-leaves of no great importance as works of art. His place in the history of Chinese painting is mainly based on Chieh-tzŭ yüan hua-chuan, A Repertory of Painting of the Mustard Seed Garden, a book well worth recording at this place in spite of the fact that it is not mentioned by Chang Kêng or any other contemporary art-historian in China. It became, however,

[1] A very fine thin and glossy paper invented in the South T'ang period.

very popular in the Far East, and it has remained so until recent times, because of its practical usefulness as a handbook for students of painting. The interest aroused by this publication in the West is mainly due to its woodcut illustrations, some of them coloured, but the text has also been made accessible to Western students by the French translation prepared by Raphael Petrucci.[1] A thorough bibliographical study of the preparation of the book, and its numerous successive editions prepared in China and Japan, has lately been published by A. K'ai-ming Ch'iu in *Archives of the Chinese Art Society of America*, vol.5, 1951. We may thus limit our comments at this place to a few remarks regarding the artistic character of the illustrations.

The name of the book took its origin from the so-called Mustard Seed Garden in Nanking, owned by Shên Hsin-yu, a wealthy amateur, and much frequented by artists and poets of the time. Shên Hsin-yu had in his possession a series of forty-three drawings with comments by Li Liu-fang referring to the study of painting, and these he handed to his friend Wang Kai with the proposal that the latter should complete and systematize the collection into a more useful work. Wang Kai did this apparently with much interest and care; he elaborated the series into 130 leaves, and to accompany these he compiled extracts from a number of prominent writers of ancient times, which he arranged in a more or less systematic order. The drawings, together with the text, were reproduced on wood-blocks and published in a book consisting of five *chüan*, or thin volumes, in 1679. The general introduction to the book was composed by Li Yü, Shên Hsin-yu's father-in-law, who was a writer of good standing.

The first volume contains only text, borrowed mostly from well-known historical sources, and devoted to explanations of the general principles of painting and the nature of various colours. The second volume contains drawings of different kinds of trees, their branches and leaves, which could be used in paintings. The third volume is devoted to stones, rocks, mountains, and the like, giving detail-

ed and illustrated advice as to their shapes, wrinkles, and combinations in pictures. The fourth volume mainly contains studies of figures, but also of animals, birds, buildings of various kinds, bridges, boats, and furniture. The last volume is filled with a series of pictorial compositions freely copied from old masters, some in the shape of square album-leaves, others on round or folding fans. The illustrations in vols.2–4 are quite simple ink-drawings of the various pictorial elements indicated above, whereas those in the fifth volume are complete landscapes of which not a few are printed in two or three colours. They should, so to say, contain the final completion and consummation of the studies pursued through the preceding volumes, and it is rather disappointing to find that these illustrations (even in the early editions) do not maintain the high standard of wood-block printing which had been reached at the end of the Ming period. They are not comparable with the wood-blocks in the early editions of *Shih-chu-chai*. The colours are lacking in depth and sometimes carelessly applied; the technical execution is deficient, and the drawings are made in a somewhat hasty manner which retains very little of the characteristics of the various masters here reproduced. Wang Kai may, indeed, be more praised for his compilations from the old writers than for his attempts to reproduce the old painters' styles.

The success of this first collection inspired the compilers to prepare a continuation which was begun in 1682, and brought to completion in 1701, when it was published in two *t'ao* (covers), each containing four *chüan*. The first four are devoted to the study of epidendrums (*lan hua*), bamboos, plum-blossoms, and chrysanthemums, and the drawings

[1] The French edition which was published in Paris 1918 (the year after Petrucci's death) under the title *Encyclopédie de la Peinture Chinoise*, in one folio volume, is based on a lithographic reprint of the book brought out in Shanghai 1887. The illustrations are incomplete. Better reproductions of some of the woodcuts and German translations of parts of the text are included in Julius Kurth, *Der Chinesische Farbendruck*, Dresden 1922. A new English translation by Mai-mai Sze of this work under the title *The Tao of Painting* has been announced by the Bollingen Series N.Y. (published in London, 1957).

for the plates were mainly done by the painters Chu Shêng (epidendrums and bamboos) and Wang Yün-an (plum-blossoms), whereas Wang Kai and his two brothers (who also were called in as assistants) supervised the editing and compiled the comments. The artists who collaborated in the preparation of this collection seem on the whole to have been able to maintain a higher artistic standard than Wang Kai. The paintings of the bamboos and plum-blossoms have more artistic character and beauty than the landscapes in the first section, and the colour-printing is better, though still of moderate quality. In the third collection, which was published together with the second, the first volume is devoted to flowering plants and studies of insects, the second to plants with insects, the third to flowering trees (or shrubs) and single birds, and the fourth to flowering trees combined with insects and birds. Wang Kai's brother, Wang Shih, seems to have taken a leading part in the preparation of this third collection, which for some reason or other is nowadays more difficult to find (in its original edition)

than the preceding sections of the same work. This brought Shên Hsin-yu's and Wang Kai's publications to a conclusion. A later uniform *t'ao* containing drawings for figure compositions with text by a man called Ting Kao, was brought out in 1818 with the false pretence to be a continuation of the original *Chieh-tzŭ yüan*.[1] It has really no artistic or organic connexion with the main work.

The main interest of *Chieh-tzŭ yüan hua-chuan* lies in the theoretical field, in the systematic demonstrations and discussions of the principles of Chinese painting. As a collection of artistic reproductions in woodcut it cannot be placed on a level with *Shih chu-chai* or a few other of the best specimens of wood-block printing produced in the Ming period. But the practical purpose and arrangement of the book has secured it a very wide circulation through many editions in the Far East, including some modern photo-lithographic reprints.

[1] A translation of Ting Kao's text in vol.I of this publication was published by Dr. Victoria Contag in vol.XXXIII (1937) of *T'oung Pao* under the misleading title "Das Malerbuch für Personen-Malerei des *Chieh-tzŭ yüan*".

The Great Monk Painters

I

Fang I-chih, Fu Shan and Chang Fêng

IN RECENT historical discussions of the development of Chinese painting during the first half-century of the Manchu rule a special privileged place is usually allotted to a few highly independent, not to say erratic, painters who, broadly speaking, belonged to the scholarly class, though most of them sought refuge in the secluded life of hermits or monks. They stand more or less detached from the provincial centres or local schools to which most of the contemporary painters are commonly assigned, but they have not very much in common as artists except in so far as they all shunned time-honoured rules and models and found their pleasure in manifesting their individual characters in more or less independent pictorial manners.

Their course of life was in most cases decided by the débâcle of the Ming dynasty which made official duties or life in the market places unbearable to them and drove them to seek refuge in religious orders far from the turmoil of political upheavals. This flight from the world is characteristic of them all, and also their relative independence of traditional rules and patterns, but as painters and men of the brush they all follow distinct individual paths.

Some of them were personally acquainted, yet their mutual influence does not seem to have been very marked. They will here be discussed in four chapters, the first devoted to three minor older talents, *i.e.* Fang I-chih, Fu Shan and Chang Fêng, known through relatively few works, and the following to the three great successive masters K'un-ts'an, Pa-ta shan-jên, and Shih-t'ao, each of whom would offer sufficient material for a separate

volume. They were all contemporaries, but marked different stages or degrees in the kind of independent expressionism which may be said to have formed their common artistic background or germinal soil. And it may be added, to avoid misunderstandings, that if we use the term expressionism, *faute de mieux*, as an artistic denomination with regard to these masters, it must be understood that it does not imply any such independence or deformations of nature as in later times have been associated with this term. On the contrary, the art of these masters was based on a very close and accurate study of natural phenomena which they expressed in highly concentrated form filled with life and movement.

* * *

Fang I-chih, *tzŭ* Ch'ang-kung, *hao* Lu-ch'i and Mi-chih, who came from T'ung-ch'êng in Anhui, was probably the oldest of this group. He obtained the *chin shih* degree in 1640, but after the defeat of the Ming dynasty he entered a monastic order and called himself Hung-chih, *tzŭ* Wu-k'o, *hao* Yao-ti. Chou Liang-kung (1612–1672), who probably knew him personally, offers the following information as to his earlier life and personality in *Tu-hua-lu* (vol.II, 8):

"The great monk Wu-k'o was, in the year 1640, on the same list of successful candidates as I. He was then called Fang Mi-chih, and his name was I-chih. He was an uncommonly gifted boy, the son of a distinguished family, and quite young when he passed his *chin shih* degree. He was skilled in poetry,

138

prose-writing, ballads and songs, music, calligraphy, painting, various kinds of stone-engraving, dice-playing, and other games, and furthermore also in playing the flute and drums, in performing theatrical plays, and in telling stories. There was no art which he did not master. He led a very gay life before the age of 30, but after the change of dynasty he shaved his head, entered a monastic order, and started life as a hermit. He wore coarse clothes and his food was simpler than that of the poorest scholar. He severed all his connexions with the world, but when inspiring thoughts arose, he would express them in poems or paintings, and most of it was done according to the Ch'an mode, simply as self-expression without any attempt to make it intelligible to others. Shih Shang-po[1] said: "Once I was travelling with Wu Tao-jên (Fang I-chih) from Ts'ang-wu (in Kuangsi) to Lu-shan, and there I saw him paint in a moment of inspiration, using a worn-out brush and without aiming at any likeness. In showing people his pictures he often amused himself by asking: 'Can you guess what this is? It is what Wu Tao-jên has made out of nothing' (wu). From these two remarks it becomes evident that the meaning of his pictures was of Ch'an origin."

Fang I-chih was evidently less of a painter in the proper sense of the word than an all-round scholar, trained in every kind of art and intellectual pursuit, or, to quote T'u-hui pao-chien hsü-tsuan: "a very learned and deeply cultured man who among other things wrote the T'ung Ya (a philological work in 52 chapters) as well as other books". We are also told in the same record that he was a pupil of the abbot Hsiao-fêng of the Ch'ing-yüan monastery in Chi-chou (Kiangsi).

If we may judge by the paintings known to us in original or reproduction, Fang I-chih was a gifted and rather original painter though not of the highest class. The earliest example of his work, signed with his personal name and thus presumably painted before he entered the monastic order, represents A Steep River-bank and a Man walking along a path which winds around an overhanging cliff. The wide expanse of water below and higher up gives it a note of peaceful grandeur[2] (Pl.368A).

Another characteristic picture by the master representing A Donkey-rider passing by a tall Wu-t'ung-tree, was exhibited in Hui-hua kuan, the picture gallery of the Peking Palace Museum, in 1945, and on this the signature contained the painter's monk name: Hung-chih. A third picture, likewise from his later period, shows again a misty river valley with some spare trees and a steep mountain peak, and is painted with a very light and supple brush like a hasty record.[3] It is dated 1652 and the inscription contains the advice "Don't speak of Ta-chih (Huang Kung-wang) in connexion with pictures as strange as this!" – which hardly seems necessary. The picture may, however, be said to illustrate the above-quoted statement in T'u-hua-lu that Fang I-chih did most of his paintings "according to the Ch'an mode, simply as self-expressions", even though he studied in particular the great landscape-painters of the Yüan period.

Fu Shan, tzŭ Ch'ing-chu, hao Sê-lu, who was born in T'ai-yüan, Shansi (1605–1684), is also described as a brilliantly gifted boy, who in early years already acquired a wide knowledge of the Confucian Classics, the Histories, and other standard works. He passed the hsiu ts'ai examination in the Ch'ung-chêng period and became famous because of his daring intervention on behalf of an examiner who had been arrested on false accusations. "After the collapse of the Ming, he donned the robe of a Taoist monk and began to practise medicine. In 1679 he was summoned by the emperor to the capital (to become an academician), but he refused the appointment because he was old and ill. He received, however, the title of a Secretary of the Grand Council, and then he returned home to the mountains. He was a good poet, prose-writer, and landscape-painter. He did not rub with the brush or use many wrinkles in painting mountains, but piled

[1] Shih Yü-shou or Shih Jung-chang (1618–1683).
[2] Nanju, vol.9. Morita collection, Owari.
[3] Tōsō, p.405. Chou Hung-sun collection.

up hills and valleys of excellent structure, and his paintings of ink bamboos were full of life."[1]

A similar appreciation of Fu Shan's art and particularly of his structural drawing is included in *T'ung-yin lun-hua* (vol.I, 2, 6), where it is said that he completely discarded the ornamental details commonly used by ordinary painters and gave his pictures a structure of a superior kind. "His mind was filled with boundless thoughts and he produced marvellously free effects with the brush." Fu Shan's originality as a painter is strongly emphasized also by other recorders who from this draw the natural conclusion that he should be placed in the *i* (unrestrained) class.

The still preserved dated paintings by Fu Shan which are accessible in public collections or in reproductions are of various kinds and somewhat uneven but all interesting. The earliest is in the Hui-hua kuan of the Peking Palace; it is dated 1666 and represents Bridges and Pavilions on poles in a mountain stream. The second in date (inscribed 1675) is a Misty Mountain Landscape with some buildings among leafy trees which is painted with richer ink in a broader manner (formerly in the Kuan Mien-chün collection),[2] while the third picture with a date (1684) reveals the failing strength of the old master.[3]

More important than any of the dated specimens are the two undated but fully signed pictures in the Abe collection in Ōsaka Museum, the one representing sections of An Old Cedar-tree, and the other A Steep Rock by a Shore and boats far away. The pictures are both executed in a very free *hsieh-i* manner and may as such be called masterpieces of expressionistic shorthand, remarkable for their suggestion of unlimited space. The major portion of the picture-field is in both cases empty, the branches of the cedar-tree occupy only a narrow stretch along the border, and the cliff is reduced to some contours, but these elements are rendered with effective touches and quick accents of the brush – suggesting in the one case the twisting and winding of the branches, and in the other case

the height of the precipitous cliff – just enough to make the beholder feel (in thought) the essentials of the compositions (Pl.369). The pictures are written down in harmony with the large inscriptions in running characters, or *vice versa*, and in so far are conventional interpretations of certain motifs, yet in both cases expressive of individual ideas and brilliant examples of spontaneous brushwork.

Fu Shan was, however, not exclusively a landscape-painter; he also did figure-paintings of a kind that may be called memorial portraiture, because of their inscriptions. The best example of such is the picture (formerly in the Ho Kuan-wu collection in Hongkong) in which the portrait of the old monk – apparently the teacher of Fu Shan – to whom it is dedicated, forms, so to speak, the foundation or keystone to the calligraphic composition which fills at least four-fifths of the tall scroll. It is written in a strange, almost undecipherable running script that enhances the decorative effect as well as the mysterious significance of this rare combination of painting and writing[4] (Pl.368B).

Fu Shan had a special predilection for tall and narrow scrolls, which also confirms the close parallelism between his calligraphic and pictorial works. He never painted a horizontal handscroll (as far as we know), only album-leaves and tall hanging-scrolls which in spite of their extraordinary height represent views of mountains or trees as if seen from above, *i.e.* to be looked at in the same way as scrolls of writings. The term *hsieh-i* (idea-writing) may thus be said to characterize his work in a double sense, and he also amused himself by painting flowers with his fingers.

Chang Fêng, *tzŭ* Ta-fêng, *hao* Shêng-chou Tao-shih, was practically of the same age as Fu Shan.

[1] The main information regarding Fu Shan is reported in *Kuo-ch'ao hua-chêng lu*, vol.I, p.7, but additional minor details are found in *T'ung-yin lun hua* and also in *Kuo-ch'ao hua shih*, vol.II, p.13 (quoted from *Ch'ih-pei ou t'an*).

[2] *Tōsō*, p.382.

[3] *Nanju*, vol.19.

[4] Cf. *Shên Chou*, vols.2 and 22, and the fan-painting of some bare trees on a river-bank reproduced in *Shoman*, p.36.

Born in Nanking he passed his *chu-shêng* degree in the Ch'ung-chêng period, but after the fall of the Ming dynasty he renounced this degree, retired completely from public life, and lived in the utmost poverty in a hut which was hardly large enough to allow him to sit down. The biographical account in *Kuo-ch'ao hua-chêng lu* (vol.I, p.18) contains furthermore the following notes on his artistic activity: "He was a good painter of landscapes, flowers, and grass, and followed no master in particular, but painted according to ideas of his own which gave him the greatest satisfaction. In handling brush and ink he was like a carefree Immortal, and used to add the following words: *Chên-hsiang Fo k'ung-ssŭ-hai* (True Incense Buddha sees World as Empty).

"When he travelled to Yen and Chao, (*i.e.* the North), many noblemen and high officials hastened to entertain and welcome him, and Chang Fêng recompensed them for their hospitality with his paintings. But when a palace eunuch invited him to drink and wanted him to stay on in the house, Chang Fêng rose from his seat, stared at the man and gave no answer; but as soon as the wine was finishing he hurried away."

In *T'ung-yin lun-hua* (vol.I, p.7), it is also said that he followed no special teacher, but painted according to his own ideas; yet "he grasped the mysteries of the Yüan masters (entered their inner chamber) and in his landscapes reached the very limit of nature's creations. Sometimes he also painted figures and made their spirit expressive of quietude and leisure without the least taint of vulgar beauty or seductiveness; because he was absolutely free from the dust of common tracks and opened a path of his own

"He looked very dignified, like a Taoist medicine-man from the mountains; and wore a beautiful beard. He was also well known as a seal-engraver and for his well composed poems in the *fu* and *tz'ŭ* styles, and 'he lived in peace with everybody, never showing bad temper, because he was by nature very retiring . . . He found satisfaction within himself.'"

To judge by these records emanating, at least in part, from persons who may have known Chang Fêng personally, he must have been an interesting character as well as an original artist. The pictures by him, still to be seen, are not very homogeneous but interesting; some are executed in a highly finished pictorial style, while the others are done in a sketchy manner with reducing brush-strokes. Most important among the former are two landscapes in private possession in China, one representing a mountain gorge with rushing water and a pavilion built on poles over the stream (dated 1646),[1] the other a hermitage in a thickly foliated mountain valley which is overshadowed by some bulging rocks (dated 1658).[2] The elements of these pictures are fairly traditional, but they are rendered with individual accents noticeable in the designs as well as in the forceful brushwork, which is effective in a pictorial sense. One can almost realize the truth of the artist's note on the first-named picture: "While I was painting this the plum-blossoms were opening and they imparted their perfume to my brush and ink". The rich ink and careful study of the trees with their shady, spreading branches give to these pictures the refreshing air of spring verdure. It may also be noticed that they are not like Fu Shan's landscapes composed so as to be seen from above. They are represented in front view, and we are invited to follow the horizontal opening between the trees towards the mountain, which serves to increase the naturalness and romantic feeling of the presentation, at least in Western eyes.

Chang Fêng's pictures in the free *hsieh-i* manner are written down like running script, the forms are reduced to a few significant strokes, but an impression of atmosphere is nevertheless suggested. This may be observed in the album-leaves, known from the London exhibition 1935–1936 (Nos.2981, 2982), which represent river views with bare willows and dry pines along the shores and men walking over low bridges which project into the pictures. They

[1] Ōmura, *Bunjin Gasen*, II, pl.5. (after a Yüan master.)

[2] *Shina Nanga*, I, p.38 and in *Chung-kuo*, II, p.140.

are apparently done on the spur of the moment in a somewhat loose spotty manner which, however, has a rhythmic coherence that gives the small pictures attraction (Pl.370).

The landscape in a private collection in Etchu (Japan) which is dated 1660 is a larger example of the painter's manner of reducing brush-strokes. It represents a man standing on a cliff overlooking a precipice;[1] the cliff on the one side and some branches of a blossoming tree on the other side of the picture are indicated with a few light strokes and thin washes; between them is a misty space which seems overwhelmingly deep and wide in proportion to the little man standing at the edge of the precipice (Pl.371A). It may be called an ink-play, but the painter informs us in his inscription that the fine quality of the picture is also due to the paper: "This picture has brush and ink, because the paper is excellent. The mulberry-tree (from whose bark the best paper is made) has held since ancient times the foremost place among the treasures of the scholar's study"; and he calls himself "The Old Man from

Nanking Drunk with Wine". But it did not lessen his appreciation of the "treasures of the scholar's studio", i.e. the brush, the ink, the ink-stone and the paper in particular.

A similar scholarly refinement and concentration on linear beauty and purity is also characteristic of Chang Fêng's freely composed portrait figures here represented by a presentation of the famous patriot Chu-ko Liang of the Three Kingdoms period. The man, who is wearing a wide mantle and a small cap, is seated in profile, gazing upwards, and could hardly be identified if it were not for the inscription in six large characters: *Hsien-ti chih ch'ên chi shên* (the late Emperor knew that his servant was heedful), which is a quotation from Chu-ko Liang's petition to the second Han emperor, considered as a document of loyalty (Pl.371B). But from an artistic point of view the main interest is concentrated in the exquisite refinement of the brushwork, here reduced to a few essential lines, bold and sweeping in the swelling cloak, incredibly fine and sensitive in the up-turned face with the thin silky goatee under the chin.

II

K'un-ts'an

It MAY seem surprising that K'un-ts'an, in spite of the fact that he is the most fully recorded of the "individualist" painters at the end of the seventeenth century, has not become so familiar and widely appreciated among Western collectors as his two famous contemporaries Pa-ta shan-jên and Shih-t'ao. The reason for this may be connected with the nature of his art, which was more tempered and restricted than Pa-ta's and Shih-t'ao's productions, and the fact that his expressionism is less obvious.

The principal records about his long personal life which lasted over eighty years (from c.1610 to c.1693), were composed by two of his closest

friends, the painter Ch'êng Chêng-k'uei (Ch'ing-ch'i), active c.1610 to 1680, and the art expert Chou Liang-kung (1612–1672), and included among the *Ch'ing-ch'i i-kao* by the former and *Tu-hua-lu* by the latter, two sources which are extensively quoted in Fêng Chin-po's *Kuo ch'ao hua-shih* (1797) and in later books. The most important among these is a pamphlet (with no year or place of publication) issued by a man called Yüan T'ung under the title *Shih Shih-ch'i Shih chi hui pien* with a preface by Yü Hsiang dated 1941. This article or pamphlet also contains Chang Kêng's record about K'un-ts'an

[1] *Nanju*, vol.17.

(from *Kuo-ch'ao hua-chêng lu*) as well as quotations from letters of the painter and a number of colophons written by himself or by his friends. These various historical elements which contribute to the characterization of the artist and his *milieu*, are completed by a list of forty-two dated and twenty-six undated paintings (known only from the literature) which cover the period from 1657 to 1692. The colophons are in part interesting but the descriptions are as a rule not sufficient for identifications of the pictures. Ch'êng Chêng-k'uei's account of K'un-ts'an's life may here serve as an introduction:

"Shih-ch'i was a monk who came from Wu-ling in my country (*i.e.* the province of Hunan). His family name was Liu. In his childhood already the character which he had inherited from a former life was evident. He was surprisingly clever and studied hardly anything but moral scriptures (of the right way). He never approached a woman. When his father and mother wanted him to marry, he did not obey. He rejected the scholarly profession, and when he was 20 years old (according to other reprints, 40) he cut his hair and became a monk, studying and practising meditation in many monasteries. Everywhere he was regarded with great respect.

"The two abbots, Chüeh-lang of the Pao-ên (Mercy Reward) temple and Chi-ch'i of the Ling-yên (Spirit Peak) temple, were closely united with him for many years. He was accepted as a member of the monastic order and had often animated discussions with the abbots. He was not ordered to serve as a common monk or to carry the fly-whip, nor did he simply accept the teaching transmitted; but acquired knowledge through his own efforts. He walked alone like a lion and did not look for companions. His character was firm like a strong bow, and he had only a few friends. Whole days passed without his speaking a single word; and he was often ill.

"He used to live at the very top of the Yu-ch'i (Peaceful Solitude) mountain, and there he closed all the doors and windows of his hut, retiring into complete silence with only a small kettle and a table. Thus he passed months and years without seeing anybody. Even the people who lived in the monastery rarely saw him. But when I came to the place I simply opened the door and stepped right in. We looked at each other and burst into laughter. We moved our beds closer to each other, and so we spent the whole night talking with no fatigue. One day he took me to the bath-house and there we remained for most of the day. Another day we took our staffs and walked beyond the vegetable garden to the fence by the mountain to gather wild vegetables. From these he prepared a soup which was enough for hundreds of people who lived in the monastery. They were all greatly impressed and considered it a miracle . . .

"From time to time he did some calligraphies and paintings merely as relaxations. He grasped the manner of the Yüan painters, his paintings were alive, vigorous, deep and beautiful, almost equal to the old masters' works. He often told me how in the *chia shên* year (1644), when the country was in a state of war, he wandered far into the hidden "land of the Peach Stream" and in these ramblings saw the most wonderful mountains and rivers, many strange trees and rare animals and birds. He heard the sounds of the mountain elves and saw the shades of the spirits, (things) which cannot be described, because no one else has met with them. He led the life of a vagrant tramp; sleeping sometimes by a mountain stream with a stone for pillow and rinsing his mouth with fresh water, or (at other times) on the top of a rock, like a monkey or a snake. There were times when he had to drink blood (instead of water) and warm his feet with urine. Sometimes he lived in a pigsty, and at other times found shelter from the storm in a tiger's den. He went through all these miseries and hardships during three months and experienced more extraordinary things than those described in *Shan-hai ching* and *Ch'i-hsiai chih*.[1]

[1] *Shan-hai ching*, the so-called "*Hill and Water Classic*", supposed to date from the Chou period. *Ch'i-hsiai chih*, a collection of strange stories of uncertain date.

"I (Ch'ing-ch'i) sighed and said: 'It seldom happens that a man has to experience so many strange things in one life; on no account, then, should they be passed over too easily. Master Shih, however, has an observant eye and dexterous hands. He takes no action, nor reasons about events, he is thus not hindered by events. Rather he extracts their significance from them tranquilly, which is (may be seen) in his calligraphy and painting as well as in his writings and moral discipline.' "

Chou Liang-kung's record about K'un-ts'an's way of life as a monk and a painter is less detailed and picturesque than Ch'êng Ch'ing-chi's anecdotes, yet it contains a few points not mentioned by the latter and merits thus to be quoted here in part. It was, as said above, first published in *Tu-hua-lu:*

"Shih-ch'i was a monk called K'un-ts'an; his other *tzŭ* was Chieh-ch'iu (also T'ien-jang, Shih-tao-jên, Ts'an-tao-jên and An-chu-hsing-jên). He came from Wu-ling in Ch'u (Hunan). He lost his mother at an early age and decided to enter the priesthood. One day his younger brother brought him a felt hat to protect him against the cold. He put it on his head and looked into the mirror time and again, but suddenly he took a pair of shears, cut the hat into pieces and his hair as well; and so he went away. First he arrived at the San-chia temple on the Dragon Mountain, but afterwards he went to many other places to receive advice and instruction, and thus he was awakened to full perception. Finally, arriving in Chin-ling (Nanking), he received the frock and the bowl (was ordained) from Lang-chang-jên. Chang-jên regarded him with deep respect as one possessing insight which no one else could reach. He stood head and shoulders above all the others in moral behaviour as well as in the use of brush and ink. He made friends only with a few who all lived as hermits after the fall of the Ming dynasty. His paintings were of a superior kind, but he rarely worked for other people . . .

"I was introduced to him by Mr. Chang Yao-hsing and asked him to paint some album-leaves for me, which he did with pleasure, adding the following inscription: 'The remnants of our (national) mountains and waters offer some livelihood still for your friend the Tao-jên (man of righteous ways). But now the old fellow Li-yüan (*i.e.* Chou Liang-kung) has snatched away the first place. The old monk has only half a taro-root left on the stove and this is for the disembodied spirits. Yet, when we meet again, he will offer another meal' (to his friend)."

Whatever the implications of K'un-ts'an's somewhat cryptic colophon on the picture painted for Chou Liang-kung may be, it conveys a strong impression of the utter simplicity of his livelihood and of his attachment to the defeated Ming dynasty. He was evidently one of those who still adhered to the forlorn cause, a fact which no doubt influenced his whole outlook. Yet, in his art, he stands singularly independent of the historical traditions and seems on the whole to have been more influenced by religious ideas than by the depressingly dark and turbulent political conditions.

This orientation towards moral rather than aesthetic ideals and the close connexion between K'un-ts'an's religious and artistic activities are repeatedly emphasized by his friends and biographers. The sympathy, not to say veneration, that they felt for the poor and ailing monk forms the undercurrent in many of the colophons even when these are written in praise of his paintings. The following by Ch'êng Chêng-k'uei is in this respect typical: "Shih-ch'i was quite often ill; it seemed as if his illness had no end. He took little food; sometimes he lived on a few grains of rice. His paintings were often made in devotion to Buddha, and he expressed in them the deepest mysteries. But the strength of his brush was 'enough to carry a tripod and transplant a mountain'. He was just as good as Huang Tzŭ-chiu and Wang Shu-ming in his painting. Nobody could tell which of the three was the best. He was almost like Wei Mo-chi, who in his illness explained the highest path."

In other words, according to his friends, there was a spiritual undercurrent in Shih-ch'i's art which had

nothing to do with any formal religious teachings on the subject of his paintings. He worked mainly *ad majorem gloriam Dei* or "in devotion to Buddha", because the Buddha-nature, or the breath of spiritual life, was present, according to him, in every form of nature, be it rock or water, tree or bird. But it had to be discovered by an artist attuned to its rhythm.

K'un-ts'an was essentially a Ch'an Buddhist even though he may have been ordained in other schools of Buddhism and lived in monasteries where teachings of a more formal kind were transmitted. He is often referred to as "the Ch'an monk", and the colophons on his paintings by himself or his friends all lead in the same direction. This view is also supported by Chang Kêng, who in the following colophon speaks of the quality of his brushwork as a result of his religious meditation.

"His landscapes represent mysterious scenery, far-reaching, deep and quiet, alluring to the hearts of men. His brushwork was noble and simple (as of old), his colours pure and deep as in the great Yüan masters' works. It was indeed a kind of brushwork which for a long time had not been seen in the world. And this was the result of his religious meditations (his sitting on the straw mat), which made him superior to all others."

Painting was apparently never the principal or dominating occupation in his life; according to the records quoted above he did his paintings and calligraphies mainly in moments of relaxation when he was free from the duties connected with his religious practice and duties as an abbot of a large monastery. Yet he was a master of the brush and developed a very effective technique of his own. He was not a *hsieh-i* painter of the same class and kind as Pa-ta shan-jên or Shih-t'ao, and his pictures had seldom, if ever, the character of shorthand notes hastily written down on the spur of the moment. Most of them are, as a matter of fact, carefully prepared and finished with close attention in every detail. As a consequence of this pictorial elaboration and the use of light washes in reddish brown and bluish tones, the pictures sometimes have more like-ness to Western water-colours of the last century than to average Chinese ink-paintings, a likeness that may be increased by the somewhat flossy surface effect of K'un-ts'an's pictures (Pl.372,373).

He painted landscapes almost exclusively; when figures are introduced they seem to be autobiographical or serve to illustrate personal recollections rather than to be organic parts of the motifs. These consist as a rule of bulging masses of rocks and trees, enveloped and interspersed by rolling clouds and trailing wisps of heavy mist. The motifs are often difficult to penetrate or to fully comprehend, particularly in monochrome reproduction, and may thus, at first sight, seem more mysteriously impenetrable than they are meant to be. One cannot escape the impression that some of the misty gorges with thickets of leafy trees and rushing cascades of melting snow have been painted by a man who visioned the wild scenery in colour, even though his means of expression were limited and his adherence to the traditions of Chinese ink-painting quite close. On the other hand, it must be admitted that the artistic significance of his landscapes is greatly enhanced by the actual brushwork. He has a strong and supple ductile brush with which he can suggest sailing clouds, trailing mist and the rush of cascades, but equally the sharpness of the cracked and fissured cliffs, the rugged strength of dry trees.

While K'un-ts'an's artistic production was not so large as that of Pa-ta shan-jên or of Shih-t'ao, no less than sixty paintings are briefly indicated in Yüan T'ung's pamphlet. Only a few of these can, however, be identified from the scanty descriptions. The List that we have established mainly on the basis of reproductions contains a somewhat larger number of paintings, the earliest one being dated 1657 and the latest 1674, but to these may be added four later pictures (of the years 1685, 1686, 1690 and 1692), the last of which is called Evening Snow over a Lonely Village.

Any attempt to describe in detail a number of these pictures seems, however, futile because they have so many features in common and cannot be

individually appreciated and distinguished except in the original. They are more or less impressive reflexes from the depths of the mountain regions in the Yangtse valley where K'un-ts'an passed so many years of his life. The colophon that Ch'in Tzŭ-yung composed to one of these landscapes might just as well fit several of them. He wrote:

"The brush and ink of K'un-ts'an are bold and noble; his compositions are as if created by Heaven and possess the faculty of leading the wanderer farther and farther toward a place of supreme beauty. When I look at his pictures on a hot summer day I soon feel refreshed"; (i.e. they represent un-restrained peace and grandeur transmitted by a noble brush).

In some cases the pictures are, however, marked with inscriptions through which we learn that they represent surroundings of the mountain temples where the painter spent many years of his life (Pl.374). The largest and most impressive among these is the well known picture in the Sumitomo collection which is dated 1664 and apparently re-presents the rocky promontory on which the Pao-ên monastery was situated. The view from this site must have been very wide and impressive, reaching across a broad section of the river, with fishing-boats and low islands appearing in the distance. The sharply cut rock-formations, the pavilions and the pagoda of the temple, the winding paths, the bridges, houses, scraggy trees, and the buildings on poles along the shore are all rendered distinctly and care-fully, but all brought together into a perfectly uni-fied pictorial composition by curving and trailing wisps of white mist and a slight haze enhanced by the reddish tone of the sky.

This neighbourhood, well known to him from frequent ramblings at various seasons, inspired the painter to a number of very interesting pictures executed in the 'sixties. The compositions consist mainly of craggy rocks partly overgrown with moss and deeply hollowed by turbulent streams which form splashing cascades over successive terraces (Pl.375). The trees grip the rocks with their claw-like roots and are old and knotty yet vigorous, writhing between the boulders like dragons awaken-ing from their hibernating sleep. There is an abun-dance of life reflected in every element, an overflow of inner commotion in the rocks as well as in the water, and all brought together in the triumphant *Leitmotif*, with broad wisps of thick mist floating down from the highest mountain pass like streams and highways of empyrean vitality (Pl.376). The only elements in these pictures which do not reflect this inner commotion are the human figures, the old scholars who are seated alone, or with a friend in the open pavilions mostly built on poles over the water or clinging to the banks of the main torrent. The men who sit there in silence plunged in admiration of a majestic spectacle may well be taken to repre-sent (at least symbolically) the painter and one of his intimates, those men of T'ao who sought to absorb and interpret the message of rippling streams and circling vapours in pictures of inexhaustible life and mystery (Pl.377). In the best pictures of this type such as the large landscape in the collection of General Chang Chün in Taipei, the motif has been transformed from a scene of ordinary rushing streams, trailing fog and cloud-enveloped mountains into a vision of world-wide breadth revealing nature's creative forces in their full activity. Their effects are intensely dramatic and their significance indescrib-able in words. There is no other painter of this epoch who to the same extent as K'un-ts'an has been able to lay bare the heart of Nature and make us feel the very pulse beat of universal life in her shifting phenomena.

K'un-ts'an's extraordinary faculty in this respect must always have been recognized and admired, because the imitations after the master's works are mostly of the type and kind described above and some of them have dated inscriptions. To enumerate examples of such works here seems, however, quite futile without a sufficient number of reproductions. If anyone asks why these pictures may be called imitations instead of being accepted as the master's works in accordance with the inscriptions, the

general answer must be in most cases: K'un-ts'an's characteristic features are here exaggerated, the misty gorges have become too muddy, the sweeping mists too wide or heavy, the inner movement has congealed. Definite criteria, however, can hardly be enumerated because every case has its own strong and weak points, and the imitations are of varying age and merit. It seems quite possible that some were made in the lifetime of the master, when his name had become famous and his productivity was declining.

In addition to the above-mentioned mountain paintings of somewhat dusky appearance may be recalled a variation on a similar motif which is dedicated by K'un-ts'an to his friend Chou Liang-kung. The picture is dated 1669 and has beside the painter's dedication inscriptions by Shih-t'ao, Hung-jên and Ch'a Shih-piao, probably written on the invitation of Chou Liang-kung, and thus possesses special interest as a document of friendship[1] (Pl.380). It represents a scholar's summer retreat at the foot of steep rocks rising in successive terraces towards the clouds. There are various pavilions under the trees and in one of them two scholars are seated in conversation. A bridge leads over the stream, a low fence encloses the garden, dividing it from the courtyard where a boy is sweeping the ground and a heron is posturing under a tree. Judging by the dedication, this is the summer homestead of Chou Liang-kung, the connoisseur and poet who, as noted above, was one of K'un-ts'an's most devoted admirers. Hung jên and Ch'a Shih-piao composed short poems and Shih-t'ao wrote a colophon in which he said: "In olden times no writing was done on the pictures but only on sheets attached to them. Why should I then stain with my writing a picture by the Ch'an monk Shih-ch'i? But as master Li-yüan (*i.e.* Chou Liang-kung) showed me the picture and asked me for writing, I have written this to exhort all who look at it in the future to appreciate it highly."

K'un-ts'an was probably little known in wider circles of artists and connoisseurs, but the few who

were acquainted with his works could not help realizing that he held a place of his own far above the rest. His very peculiar and inaccessible personality is illustrated in the most striking fashion by an autobiographical picture and its inscription (in private possession in China), known to me through an old photograph. The picture represents a monk seated with his chin on his raised knee in a kind of large bird's nest on a dry tree-branch and at the top of it is the following inscription: "The question is how to find peace in a world of suffering. You ask why I came hither; I cannot tell the reason. I am living high up in a tree and looking down. Here I can rest free from all trouble like a bird in its nest. People call me a dangerous man, but I answer: 'You are like devils'. According to my understanding, all that exists is emptiness. There are plenty of Buddhist books, but listen now to my proclamation: 'The numberless beings (the sands of Ganges) and the three boundless continents are all in Amida Buddha'. – Written 1662, on Buddha's birthday by I-jang Shih-ch'i Ts'an Tao-jên" (Pl.378).

If we are to accept the testimony of this document, K'un-ts'an must have had recourse to the most extreme measures in his flight from the world of common human beings. It may safely be assumed that he was the only painter who ever lived like a bird in a tree, even though many of them tried to look upon the world from above. The experiment can hardly have lasted very long; some time afterwards he settled down in the Bull Head monastery where he assumed the duties of an abbot and led an extremely industrious life, as witnessed by himself in the colophon to the beautiful handscroll known as Endless Mountains and Streams. The picture, which has been published in a separate album,[2] represents a long river view evidently inspired by some actual scenery (Pl.379). The changing panorama of wooded hills, rocky promontories, fishermen in boats, high

[1] This picture formed part of the famous T. Yamamoto collection in Tōkyō and is probably now in some other Japanese collection.

[2] By the Commercial Press, Shanghai, 1935. The picture is in the Fei-tun lu collection.

mountains with magnificent pines, surging streams, and winding roads which finally lead up to a temple at the very end of the scroll, are rendered with a combination of strength and intimacy which places it on a high level as a work of monochrome painting. The firm brushwork (with short strokes and dots) and the brilliant ink stand out in luminous contrast to the empty spaces, more or less as in paintings by Wu Chên or Shên Chou. The inscription in large letters at the end of the scroll is a remarkable record of K'un-ts'an's religious fervour and his artistic ideals:

"It may be said that man is a product of Heaven and Earth, and he should lead a pure and diligent life, not falling into idleness. If he gives cause to be called a lazy fellow, he will be of no use anywhere. When the monks, for instance, are idle, their 'Buddha face' does not look dignified, and nobody fills their bowls. Such is the spirit of all the three religions.

"I, K'un-ts'an, am now living in the Bull Head temple. In the mornings and evenings I burn incense and recite sūtras, but whenever I have some moments of leisure I go up on the mountains to visit places of beauty, and as soon as I have grasped something I do a few landscapes or write one or two paragraphs. Thus I never waste my free time.

"It has been said that quietness gives rise to action and movement finds expression in work. And it may well be said that such a man (one who lives accordingly) stands without shame between Heaven and Earth, whereas if he is lazy and indifferent without feeling the shame of it, there is no difference between him and a plant or a tree.

"Now Yeh-so, the Taoist priest, came to see me in my Ch'an study. He was pleased to listen to my foolish talk and asked me to write it down. I did so and presented it to him together with this picture of Endless Mountains and Streams. – I-jang Shih-ch'i Ts'an Tao-jên salutes you."

The above lines by which K'un-ts'an expresses his loathing of idleness and gives a hint of how little leisure his daily duties and meditations left him for artistic pursuits, offer an interesting background for

a proper understanding of this struggling genius. As a painter he followed the same general direction as the famous Ch'an monks at the end of the Sung period, though perhaps in a more restricted way and at a slower pace than his predecessors. He was less of a visionary or a romantic dreamer than Mu-ch'i or Ying Yü-chien; his feet were more firmly placed in the objective world, and he drew more immediate inspiration from intimate contact with grand and impenetrable natural scenery. Nor should it be forgotten that he lived in a period which made other demands on an inspired and creative man than the easy life in the Ch'an monasteries at the end of Sung in heavenly Hangchou. In spite of all this and the fact that K'un-ts'an as a painter represented a later stage in the formal development of Chinese landscape-painting, the inspiring undercurrent in his activity as a painter was strongly imaginative, issuing from the realm of the spirit rather than from that of the senses.

No one has better characterized the fundamental features of the man and the painter than his friend Chang I, *tzŭ* Yao-hsing, in the following colophon:[1]

"Among the poets of the world, how many express their souls? Among the painters of the world how many take Heaven and Earth as masters? Among those who practise Ch'an, how many are there who cast off the old scriptures and draw in the thing with their breath? Chieh-ch'iu, the great monk, was in all these things like a dragon or an elephant. He placed himself at once on the mat of a leader. He did not sound (strike) the prayer bell (gong) or use a fly-whip, nor any other detestable means. Occasionally he amused himself by playing with the brush, and the resulting performance was always outstanding. This picture is, according to himself, painted in imitation of Mi, father and son, but I fear that Mi, father and son, would not have been able to equal him. Thus he might have said: 'I am not sorry at not having seen the ancients, but regret that they have not seen my work.'"

[1] Quoted from *Shih shih-ch'i shih-chi hui-pien* and also in *Kuo-ch'ao hua-shih*, vol.XIV, pp.3,4.

III

Pa-ta shan-jên

PA-TA SHAN-JÊN is one of those alluring phen-
omena in the history of Chinese painting which are
difficult to grasp or analyse intellectually, because
they are enveloped in a kind of legendary sheen
produced by their personal eccentricities and the
flash-light characteristics of their painted works.
The popular tales woven around such personalities
are generally apt to harden and become more
opaque rather than to dissolve with the passing of
time, thus confusing any view of their artistic
merits as well as of their individual weaknesses.

It is only during the last few years that specialists
in the Far East as well as in Europe have tried to sift
the wheat from the chaff in dealing with the tradi-
tions about Pa-ta shan-jên, and though considerable
progress has been made in this respect, it must be
admitted that full clearness or a complete solution of
all the riddles in the *curriculum vitae* of Pa-ta shan-jên
has not been reached and that we are still confined to
hypothetical conclusions in the dearth of historical
data regarding many important events in the life of
this perplexing individual. Yet a great deal of
pertinent biographical material has been brought
into light which enables us to obtain a more com-
plete view of Pa-ta shan-jên than was possible a few
years ago.[1]

The Chinese recorders who have occupied them-
selves with the history of Pa-ta shan-jên have, as a
rule, introduced him as a scion of the imperial house
of Ming, a relationship which also has been accepted
as a reason for the name *Chu* which the artist is said
to have used in common with other descendants of
the same lineage. But this *Chu* family belonged to a
rather distant branch of the main stock, the so-called
Ning-fang line, which had lived in Nan-ch'ang, the
capital of Kiangsi province, for several generations.[2]
The year of his birth is now generally indicated as
about 1626, *i.e.* almost two decades before the final
collapse of the Ming dynasty, which was the first

fateful event in his life, soon followed by the death
of his father when the youth was hardly 20.

According to Shao Ch'ang-hêng's most frequent-
ly quoted biography the young man would have
left the family home in Nan-ch'ang shortly after the
father's death, have retired to the Fêng-hsin moun-
tain and become a monk who gradually won a great
reputation as a religious teacher. When he entered
the monastic order he took first the by-name
Hsüeh-ko (Snow-flake or Snow Hamlet?), but called
himself later by such names as Jên-wu (Room for
All Human Beings?), Lü-wu-lü, Ko-shan-lü (The
Donkey Fellow), Shu-nien, Wu-lü, etc., and finally
Pa-ta shan-jên, the only name which is found on his
paintings and which has given cause to various
hypothetical explanations, involving rather abstruse
philosophical ideas. It may be enough here to quote
Ch'ên Ting's statement: "He called himself Pa-ta
shan-jên and said about this: 'Pa-ta, the eight great
ones, are the four chief and the four secondary
quarters of the sky, in all of which I am great and
none greater than I'." – A statement which may be
said to have a taint of the excessive self-esteem that
followed with the painter's increasing madness.

[1] The most important of these contributions are the articles by
Chên Ping-shan and Fu Pao-shih about Pa-ta shan-jên and Shih-
t'ao in the Shanghai review *Ku Chin*, 1948. They have been
utilized to some extent by Dr. Victoria Contag in her book *Die
Beiden Steine*. The principal biographical material regarding Pa-
ta shan-jên, published by Shao Ch'ang-hêng (1639–1704) and
Ch'ên Ting, has been made accessible to Western students in
German translations by Professor Herbert Franke in an article
called "Zur Biographie des Pa-ta shan-jên" in *Asiatica*, Fest-
schrift für Friedrich Weller, 1954. The contents of these articles
were probably also known to Chang Kêng when he composed
his biography of the artist in *Kuo-ch'ao hua-chêng lu* (1739). The
various accounts complete each other to some extent, yet they
are all fragmentary, and do not offer more than scattered contri-
butions to the discussion of Pa-ta shan-jên's artistic importance.

[2] His personal name has never been definitely settled; according
to records mentioned in the well-known dictionary of Chinese
painters by Sun Tê-kung (1934) it would have been Yu-sui, an
appellation which, however, is not mentioned by any of the
leading biographers.

Other explanations based on Buddhist scriptures are hardly more satisfactory, but it seems evident that all the names or appellations that he used were composed with a view to the metaphysical or religious ideas which occupied him at the respective periods and consequently had a symbolic significance.

The above-quoted statement by Shao Ch'ang-hêng that the young man withdrew into the mountains, cut his hair and became a monk, and then acted as a teacher to numerous pupils during a period of about twenty years, can hardly be reconciled with Ch'ên Ting's report about his marriage, wife and children, and inability to speak from the moment of his father's death, said to have occurred at the time of the Ming débâcle. According to this recorder, the father, who was a good painter and calligraphist, but congenitally dumb, died in 1644. "Jên-wu continued the father's example and became dumb too. When people around him were to receive instructions, mutual understanding had to be reached with the eyes and by nodding or shaking the head. To converse about weather with guests he used his hands. When he heard people tell stories of old times and new, and he approved of them, he would break out into laughter. He continued like this for over ten years, after which he left his home and became a Buddhist monk. He took the name Hsüeh-ko."

If this actually occurred after 1654, as implied in the statement by Ch'ên Ting, it may have been preceded by a period of married life (in spite of the painter's dumbness), but hardly by a twenty years' activity as a religious teacher (as indicated by Shao Ch'ang-hêng).

It seems, indeed, difficult to avoid the conclusion that the last-named author composed his account of the early life of Pa-ta shan-jên rather freely in spite of the fact that the two men met in later years.

Pa-ta shan-jên's married life may not have lasted very long or been of great importance for his development as an artist, and there is hardly reason for us to dwell on the fact further at this place. We would rather like to know just when and how the painter's dumbness developed, because this must have implied grave consequences for the character of the man and his artistic development. A certain nervous disposition for this disability may have been congenital, but the development was apparently accelerated by his father's death. It was like a deep shadow sweeping over the young man's path and making him feel more isolated than ever, but perhaps also more prone than other painters to give painted or written expressions to his inner reactions. It may also have contributed to develop other forms of mental disorder which gradually appeared in the painter's behaviour.

In their lives of Pa-ta shan-jên both the aforementioned biographers have included vivid descriptions of his fits of madness and the strange behaviour to which he had recourse to counteract the effect of his dumbness. The stories are too long to be quoted here *in extenso*, but some extracts may be useful for a better understanding of the man and his art.

From the moment when the painter affixed the character *ya* (dumb) on his door, Shao Ch'ang-hêng writes, he did not speak a word to anybody, and yet "he was fond of merriment and still fonder of drinking. If anyone invited him to drink, he would tuck in his chin, clap his hands, and give a ringing laugh. He also took pleasure in games like 'Hide the tumbler' or finger games . . . "

More interesting than these general indications are the observations of how the painter used gestures, movements of the head, and his brush, instead of words, to make his meaning clear. The writer had an excellent opportunity to observe all this when he met Pa-ta shan-jên in the Northern Orchid Temple near Nan-ch'ang (probably between 1684 and 1692),[1] at which time their mutual friend, the monk-poet Tan-kung, was living in the temple. He wrote down the following record from memory:

"As soon as he (the painter) saw me he took my hands in his, looked at me for a long while, and then

[1] This approximate date is proposed by Prof. Franke with a view to Shao Ch'ang-hêng's travels. *Op. cit.*, p.127.

broke into loud laughter. We spent the night in the temple, talking by candlelight. Shan-jên was so irritated (at his inability to speak) that he could not contain himself and began gesticulating, talking with his hands. Then he demanded a brush and wrote his questions and answers on the table. When the candle was burnt out he was still not tired."

In other words: Shan-jên felt much handicapped and depressed by his inability to speak; but he was still able to take genuine pleasure in following the dialogue between two esteemed friends and joining in it with the aid of a brush.

But there were evidently moments when the insanity found more disturbing expression; "when the madness set in he spent days laughing loudly or crying out in pain", to use the words of Shao Ch'ang-hêng, who further enlarges on the account of Shan-jên's illness with the following anecdote:

"One evening he tore up his monkly garment, burned it, and hastened back to the provincial capital, where he behaved like a madman among the market booths. Wearing a linen cap on his head, a long garment, with a high collar, trailing behind him, and worn out shoes, he ran about in the market, dancing and waving his sleeves with the boys running after him making a great noise, laughing and gaping at him. Nobody knew who he was until a nephew of his recognized him and took him home with him, where after a long time he got better."

The same or a similar scandalous event is also described by Ch'ên Ting, who completes the record by telling that the market people, who felt much upset by the disturbances caused by the riotous painter, "used to make him drunk with wine, because then his madness abated", thus using the same means of stimulating the more agreeable sides of his vagrant mind as the people who offered him plenty of wine to make him paint. Among art-lovers it was well known that the surest way of obtaining pictures from Pa-ta shan-jên was to ply him with enough wine to free his genius for the moment from all restraints and disabilities, accelerate his pulse and make his hand and brush respond instantly to the flashes of inspiration. It seems indeed that Pa-ta shan-jên hardly ever painted except in a state of intoxication, and even then this state of mind was no guarantee that he would do his work as expected. It also depended on how and by whom this wine was offered. "If highly placed persons offered him a cask of wine worth many pieces of gold, they obtained nothing; if they brought silk for painting, he made no bones about accepting it, but said: 'I shall make myself stockings from this!' " For this reason highly placed persons who wanted pictures by Pa-ta shan-jên turned to poor scholars, mountain monks, butchers and inn-keepers – i.e. to the kind of people who obtained pictures from him, because they had no ulterior motive, only the wish to make him feel free and happy. When these people invited him "he would go at once, and at once get drunk, too!"

The same writer has left us a vivid picture of the painter at work:

"When he felt inclined to write, he would bare his arm and grasp the brush, at the same time emitting loud cries like a madman. The ink flowed abundantly with no interruption. He would finish a score of sheets of paper or more in a trice."

His attitude of contempt or disdain towards people in high positions and ordered society must have appeared incomprehensible to his contemporaries, but nothing was more characteristic of a man like him, shy, dumb, and poor as a mountain monk, yet proud and unapproachable for anyone who thought that the value of his art could be weighed in gold. It was only at moments when all such considerations were forgotten, usually under the stimulation of wine, and when there was nothing to hinder or becloud his vision of the impalpable life in nature, that he was willing to work. His biographers knew it from their own observation, and dwell on it over and over again, but see no other way of explaining it than by calling it craziness. To quote Ch'ên Ting:

"To all this his private biographer would remark: Shan-jên was really crazy! But how then can the

productions of his brush have such strength? Formerly I saw poems and pictures by Shan-jên. They breathed the spirit of men from T'ang and Sung times, and his calligraphies were in the manners of the Chin and Wei epochs. I have interrogated people from his home, and they all said: 'He accomplished it all while he was drunk'. Alas, alas, one can get drunk as he did, but not crazy as he was!''

We cannot hope to do better than Ch'ên Ting, who tried his best to understand and explain the riddle of the artist's psyche but had to leave it open. We are in no better position in that respect, even though our approach to the subject may be different. The above remarks must here be sufficient as a background for a study of a few examples of his painted works.

Chang Kêng, who wrote his *Kuo-ch'ao hua-chêng lu* some thirty or twenty-five years after the death of the painter and was less influenced by personal anecdotes and traditions, does not dwell on his drunkenness or craziness but covers it all, so to speak, with the Taoist formula: "Pa-ta shan-jên had the genius of an Immortal who disguised himself as a calligraphist and a painter", to which he added the remark based on observation: "The colophons which he wrote on his paintings were so strange that no one could understand them . . . As a painter he did landscapes, flowers, birds, bamboos and trees. His brushwork was impulsively reckless, he did not stick to any established method, but worked in a firm and thorough yet often unrestrained manner, discarding the use of compasses and squares (as the saying goes) and despising minute details."

Practically the same information about the painter's work is given by Shao Ch'ang-hêng in his remarks: "Pa-ta shan-jên was fond of doing ink-paintings of bunches of bananas, curiously formed stones, flowers, bamboos and wild geese in marshy ground, or ducks on a sandbank, but he did not feel bound by the usual restrictions and rules of the painters."

The descriptive lists of Pa-ta shan-jên's pictorial motifs offered by Shao Ch'ang-hêng and Chang

Kêng are practically speaking exhaustive, they contain all the various kinds of paintings by the master which still may be seen in more or less perfect examples. But anyone who wants to particularize within the various classes mentioned above, might point out that the landscapes consist mainly of split rocks and dry trees in combination with mountain streams, the birds are not only ducks and geese but also minahs, quails and fluttering small birds, the flowers include chrysanthemum, narcissus, epidendrum, mu-tan, magnolia and other shrubs (besides lotus), and there are also various kinds of fruits and studies of solitary fishes and occasionally butterflies and insects. The master was evidently a keen observer of the forms of "life-movement" in the various realms of nature, except the human, which he, to our knowledge, never explored or displayed with the brush.

The brilliantly free and spontaneous *hsieh-i* manner, which is more or less characteristic of all these pictures, has been repeatedly described in the preceding pages. It was, indeed, the vital nerve of the master's creative work, something that must be felt and appreciated through actual observation rather than through literary descriptions (Pl.384). We shall presently direct attention to a few examples of such pictures which are accessible in excellent reproductions, but before we turn to them it should be recalled that Chang Kêng claims (in *Kuo-ch'ao hua-chêng lu*) that Pa-ta shan-jên also occasionally did other kinds of pictures. He wrote:

"It has been said that his best pictures represent pine-trees, lotus and stones, a statement which, however, does not include all his works. Once I visited Nan-ch'ang and there the *chü-jên* Ch'iu Yüeh-chü said to me: 'Pa-ta shan-jên is well known for his simple and sketchy brushwork, but few people know that he also painted in a very fine and detailed manner. Such works of his are the best he ever did, but they are scarce and nowadays difficult to find. There are many forgeries handled by the dealers, and it does not take a man with bright eyes to discover the worst of them."

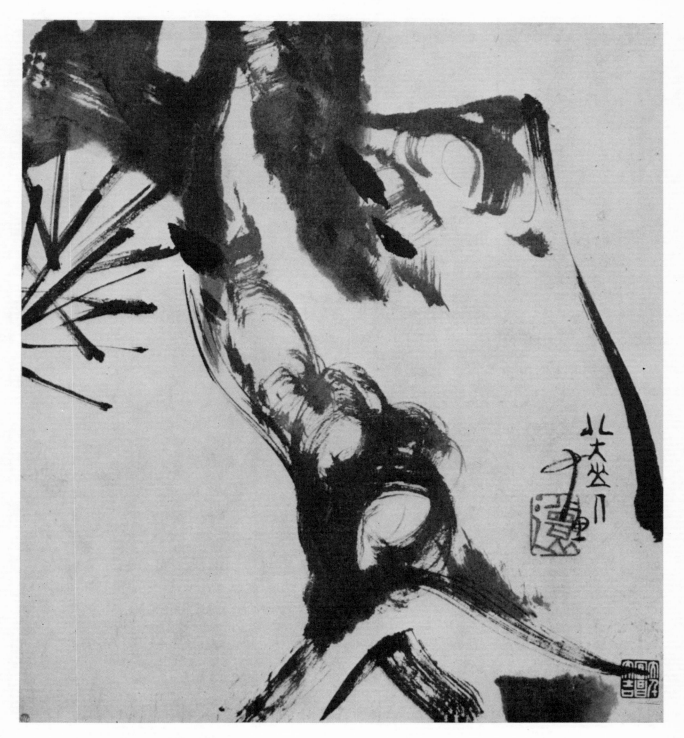

FIGURE 1. Pa-ta shan-jên, A Tree-trunk. Album-leaf. Freer Gallery of Art, Washington.

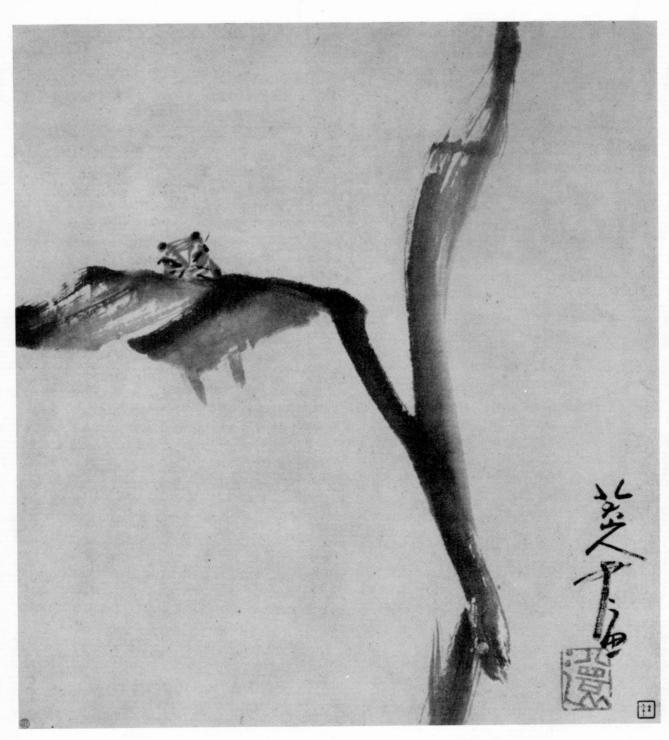

FIGURE 2. Pa-ta shan-jên, Beetle Nibbling a Leaf. Album-leaf. Freer Gallery of Art, Washington.

At the time discriminating collectors must have realized better than those of today that the only safe criterion for distinguishing the false from the genuine (*i.e.* the "fishes' eyes" from the "pearls") was in the quality of the brushwork, which transmits the high tension or "craziness" of his genius. But it is interesting to note that there were amateurs who felt that the sketchy paintings in a bold *hsieh-i* manner were not so good as the carefully finished specimens of the master's brush. They must indeed have been very rare, because none of them has, to our knowledge, survived or become known in reproduction.

The great majority of Pa-ta shan-jên's painted works must always have consisted of the spontaneous studies of flowers, trees, stones, birds and fishes enumerated above, usually made on album-leaves or on short handscrolls. Several of them form parts of albums which have been reproduced in collotype or woodcuts in China and Japan. They may serve to give a general idea of the style and the designs, even though the nerve of the brush-strokes is not always fully appreciable in them. The most remarkable among these reproductions are the fifty plates in folio published by the Juraku-sha in Tōkyō, 1938, and the ones which are included in the albums brought out by the regretted K. Sumitomo, whose collection in Ōiso contained many of Pa-ta shan-jên's masterpieces, including such as the fifteen leaves in the album dated (according to the introductory remarks) in 1694. Plants, stones, birds and small animals are here represented in startling combinations or contrasts; a mouse on the top of a huge gourd; a long-beaked little bird on the very tip of a bending stalk, poised on one leg and inclining its head pensively; a larger bird on a lotus leaf (Pl.381), or on a bare rock, steeped in meditation, a kitten or a little fish, done with a few splashes of the brush in the centre of an album-leaf otherwise empty (like limitless space); a pottery vase with a single small twig; branches of twisting vine or other climbing plants; peonies and lotus too, though these are never represented in their entirety as complete plants,

simply in bits or sections appearing at one edge or corner of the picture and sending out a thin branch or slender tentacle across the paper which emphasizes the expressiveness of the design like the reverberations of the last line in a lyric poem.

Pa-ta shan-jên makes us realize the inherent fullness of empty space; it may indeed have conveyed to him something of the same kind as the deep silence which he treasured so highly. He knew how to make space come to life under the touches of his brush, when with a few splashes or strokes he evoked the semblance of a bird with fluffed-up feathers on a cold winter morning, a flower opening into the moist air of summer, or a little fish in the measureless depths of the sea. And in introducing these representatives of various kingdoms of nature, he makes them expressive of definite states or thoughts reflecting the painter's mentality as well as the characteristics of a certain kind of flower or bird. Thus the quails in his pictures express by their postures and searching eyes deep concern with the inclemencies of life in a world where they are esteemed as food (Pl.382), whereas the minah birds bulge and plume their breasts and are evidently proud, and the wee kingfisher balances joyously at the top of a lotus stem, ready to dart away for fish or flies. The concentration on the essentials could not be more complete or conducive to an instantaneous apprehension.

The minor pictures of flowers, fruits, birds and insects, which possess illustrative interest besides their pictorial merits, form no doubt the most popular examples of Pa-ta shan-jên's pictorial activity. Their attractiveness is often obvious, but they seldom offer full scope to his genius as a master of the brush. His importance as such becomes more evident in some of the landscape-studies, which reveal a pictorial style by which they are placed in a class of their own. They are of varying size, some hardly more than rapid sketches noted down on album-leaves, others reaching very large proportions, yet they all show the same style, the same endeavour to render visual impressions in values of

cubic form, structural design, space and atmosphere. The stylization is of a rather definite kind and the brushwork is distinguished by brilliant spontaneity and a very sensitive scale of tone-values. This is true of his small as well as of his larger landscapes, though the former possess a degree of spontaneous freshness and immediacy which seldom characterizes the larger compositions to the same extent.

These may be said to illustrate more obviously Pa-ta shan-jên's historical studies and dependence on traditional models of the Sung and Yüan periods. Two or three of these are specially mentioned in the painter's inscriptions and a few more might be established through comparative studies. Two outstanding examples are the large pictures in the museums in Cleveland and Stockholm, the former marked as in the manner of Kuo Chung-shu, while the latter is said to represent the style of Tung Yüan. The large picture in the Abe collection (in Ōsaka Museum) reveals a somewhat closer dependence on Huang Kung-wang, and among minor sketchy paintings are imitations after Ni Tsan and possibly other Yüan masters (Pl.386). But no one of these pictures could be said to transmit a really convincing and faithful idea of the style of the master who is said to have served as model for a particular work by Pa-ta shan-jên. He may, indeed, have known these predecessors quite well, but whatever impressions he received from them he transmitted with supreme freedom, selecting and accentuating such features and qualities in the models as corresponded to his sense of style.

Pa-ta shan-jên's attitude towards the old masters who from time to time served him as models could not be better illustrated than by the large picture in Stockholm which represents bulging rocks and spiky pines rising over a mountain river, a somewhat unwieldy composition in which the reminiscences from Tung Yüan have been completely absorbed by the forceful brush-strokes of Pa-ta shan-jên (Pl.387). The picture is almost entirely built up with those sweeping and curving movements of the brush characteristic of him; they serve to define the forms, to emphasize the billowing movement of the rocks and boulders, to infuse life and to suggest a depth out of which they emerge by degrees. The somewhat fluttering modulation of tones in the spare trees and the split rocks is pictorially effective, but the essential significance of a picture like this does not depend on its design, nor on its tonal quality, but on the bold transformation of the whole thing into a huge *hsieh-i* pattern, a highly effective piece of "idea-writing" which reflects the genius and temperament of Pa-ta shan-jên more closely than any ideas borrowed from the old masters.

Pa-ta shan-jên knew the old masters just as well as Wang Shih-min or Wang Hui, but his main interest or leading thought was not centred on things of the past but rather on the transformation of his visual impressions (inspired by observations of nature or of classic models) into structural compositions of rocks and water with sometimes a few trees and buildings. His artistic vocabulary is mainly based on strongly emphasized cubic forms and firmly built rhythmic structures enveloped in an atmosphere which makes them suggestive of a definite mood but also parts of a limitless universe.

The most evocative of these minor landscapes are those which leave the largest scope for the imagination, stimulating it to fill out and complete forms which are but faintly suggested by some light touches of a soft brush (Pl.383A). They are done in ink only and their atmospheric beauty is produced by the vibrating lights and shades. But there are others of a more finished kind in which the pictorial effect has been emphasized with light colours in combination with ink; they are relatively few, but they offer the most convincing illustrations of Pa-ta shan-jên's eminence as a landscape-painter (Pl.385). In these he places himself fully on a level with Wang Yüan-ch'i at his best, and we can only regret that he did not work more consistently along these lines. Judging by the beautiful colour reproductions in the album (in folio) which was published by the Juraku-sha in Tōkyō 1938, it seems that the superior quality of these landscape-studies is largely the result of the

excellent rendering of the depth-dimension or space into which the solid forms extend and from which they obtain their fundamental grandeur (cf. frontispiece). The way in which this is accomplished leads our thoughts involuntarily to Cézanne or his immediate followers. Pa-ta shan-jên has sensed the secret of the intervals as means of expression, and understood how to bring them out (accentuate them) in contrast to the solid forms. This essentially expressionistic quality which Pa-ta shan-jên has in common with Cézanne and his followers, places him in the very front rank of the great landscape painters in China. He is no less Chinese, no less faithful to the general spirit of Far Eastern landscape-painting than any other master, but he concentrated to an unusual extent on the essentials, the inner significance of the Chinese tradition, in a way that made him surpass its limitations.

Another group of Pa-ta shan-jên's works, which merits special attention, consists of paintings with inscriptions that contain biographical or political references. A number of these are found in the album published in 1934 by the Commercial Press (with a colophon by Lu Tai from Chang-sha). The pictures are expressionistic sketches of an excellent quality, some of them transmitting studies of old masters. The first leaf has the following explanatory inscription: "On an autumn day when at leisure I played with the brush to express my mind. I borrowed ideas from various masters of former dynasties, such as Ni Tsan, Huang Kung-wang, Tung Yüan and Kuan T'ung, whose paintings are close to nature and appeal to my heart." Even without this written testimony one might trace in these river-landscapes with sparse trees on rocky shores some influence from Ni and Huang, though it has been freely transformed in accordance with the painter's emotional state. Some of the following leaves contain short poems which refer to the motifs and at the same time offer some insight into the master's psychology. For instance: "I will go to the mountains and cliffs which rise into empty space; the pine-trees are queer and old like myself."

The reference is here mainly personal, but it strikes a tone of loneliness and abandonment caused by the political conditions. This becomes more evident in the inscription on the next leaf: "My tears stream when I look at the mountains and rivers, which are still as of old, (but) the ink-drops have no soul. Only stones piled up in the stream and the naked trees in the twilight remain and can be rendered with the brush." That these are only mitigations or empty palliatives to the painter's over-sensitive soul is confirmed by a last inscription: "The brush may paint the mountains and stones, but the actual ground is lost." This loss to Chinese sovereignty was at times the deepest source of sadness, if not despair, to Pa-ta shan-jên as well as to a few of these other painters who followed paths parallel to his and sometimes sought refuge in the temples.

Some of them have been mentioned in the preceding chapters, and we shall have occasion to revert to the most prominent among them, i.e. Shih-t'ao, who also spent many years in a Buddhist monastery in order to escape from the political turmoils. He was about fifteen years younger than Pa-ta shan-jên, but like him a scion of the imperial Chu-family and consequently a distant relative of Shan-jên's. The relationship was so remote that it would hardly be worth mentioning, if the two men had not shown a certain correspondence of character and similarities in their attitudes as painters, as will be shown in our presentation of the younger artist. He is mentioned here mainly because he held a prominent place as a friend and collaborator of Pa-ta shan-jên. There is at least one picture preserved which is signed by the two men conjointly. It represents Bamboos by a Rock and some tufts of Epidendrum,[1] i.e. motifs familiar to both of them, though we have reason to assume that Pa-ta shan-jên did the rocks, while Shih-t'ao painted the bamboos and epidendrums for which he was most famous.

A more telling testimony of the friendship, well worth recording at this place, is the letter written

[1] The picture is reproduced in *T'ai-shan Ts'an-shih-lu ts'ang-hua*, vol.I.

by Shih-t'ao to Pa-ta shan-jên, whom he approaches with reverence and admiration.[1] The letter, which must have been composed in 1688, is introduced by some remarks as to the respective age and health of the two men. "You, master", writes Shih-t'ao, "have now reached the age of 74, but you still climb mountains as if endowed with wings; you are truly one of the Immortals. I am only about 60 (59) but have not been able (lately) to do any work, and have not received any visitor for the last ten years." The writer goes on to tell how he appreciates the paintings and calligraphies (apparently received from Pa-ta shan-jên), though he has dropped all correspondence, owing to poor health, and exclaims: "It seems ridiculous that I could be so weak in comparison with you! Now, as Li Sung-an is returning to Nan-chou, I beg you to do a small hanging-scroll, 3 × 1 ft., and to represent on it a few small houses on a slope surrounded by old trees, and in one of them an old man; it would be a picture of myself in my thatched hut. And if there is room on the scroll, please add some writing which would make it my most precious possession; but do not call me *ho shang* (a monk), because I am wearing (at present) my hair long and a cap."

It must have been a real pleasure for dumb old Pa-ta shan-jên to receive from the younger painter and critic a letter inspired by so much sympathy and admiration. This can hardly have been the only one of its kind; the two painters no doubt exchanged several letters, calligraphies and paintings, and Shih-t'ao may have had occasion to watch the old man's vivid gestures and play of features when they met. They, too, had enough in common to understand each other even without words, because in spite of their highly diversified and unapproachable personalities, they both hid the spirit of an Immortal (to use Chang Kêng's symbol) in the guise of a painter and calligrapher. This made them lonely, solitary and lost in this world of rivalries and scrambling; neither of them was easy for common men to understand. Which of the two was the more unintelligible and baffling to his contemporaries it is difficult to tell, but it should be admitted that if Pa-ta shan-jên worked under the spell of madness or intoxication, such state or condition did not involve the loss or impairment of his creative faculty. He suffered, and there were apparently moments of agonizing struggle between contending forces in his nature, but the balance was never completely lost, nor the sometimes almost indistinguishable line between madness and genius overpassed. Both are difficult to understand, though the former may be more easily grasped than the latter. It was simple to say: "he did it all while he was drunk". To this we can only add Ch'ên Ting's words: "Alas, one can get drunk as he did, but not crazy as *he* was!"

IV

Tao-chi

TAO-CHI, or Shih-t'ao, to use his best known *tzŭ* or by-name, was the youngest of the trilogy of great monk painters which also included K'un-ts'an (Shih-ch'i) and Pa-ta shan-jên. He was a friend of the two others, as proved by some letters and inscriptions, but they do not seem to have had much in common or to have actually influenced each other as painters. If Shih-t'ao has become more popular than the two others, that is due not only to the

[1] Reproduced in the *Chang Ta-ch'ien Catalogue*, vol.II.

richness and variety of his painted *œuvre* but also to his eminence as a poet and philosopher. His achievements as a calligrapher and a literary writer were hardly less remarkable than his pictures, which usually are accompanied by lengthy inscriptions.

According to the records transmitted by Ch'ên Ting in *Liu-ch'i wai-chuan* and by Chang Kêng in *Kuo-ch'ao hua-chêng-lu*, he was born in Ch'ing-hsiang hsien, the present Chüan-hsien, not far from Wu-chou in Kuangsi in 1630. He belonged to the same widely branched Chu family as Pa-ta shan-jên and is said to have been descended from Prince Ching-chiang, a great-grandson of the elder brother of the founder of the Ming dynasty, and was called accordingly Chu Jo-chi a name which he "lost" when in 1644, he took the vows of a monk. He was then called Hsia-tsun-chê, with the *tzŭ* Shih-t'ao, or by other more or less descriptive names to be mentioned in the following.[1]

His connexion with the monastic order seems, however, to have been a matter of practical convenience rather than the result of religious devotion. He evidently enjoyed great freedom of movement and spent most of his time in philosophical studies and the practices of painting and calligraphy. From early years the artistic and poetic bent of his genius was evidently the leading force in his life, and there are, indeed, reasons to presume that he had opportunities to practise painting under proper guidance while living as a monk in Ch'ing-hsiang or Wu-chou. According to Shih-t'ao's own inscription on a picture that seems to be lost, but which is quoted in vol.II of Chang Ta-chien's catalogue, he "started painting epidendrums at the age of 14", *i.e.* 1643. Seven years later (1650), when he was 20, he went to Lu-shan, the famous mountain in Kiangsi, to visit his friend Ch'ien Ch'ien-i. We do not know the length of his first stay at this far-off place, but it is evident from a study of his paintings that he returned there more than once, and spent much time rambling about among the fantastic formations of this mysterious mountain region. We shall have occasion to examine several

paintings of his, originating from this place. He may also have met other painters there who preferred to live in this solitary mountain abode far from the turmoil of the political centres, and such contacts may have been of some importance for the young man's gradual development into a full-fledged master of the brush. But more important than all human contacts for his development as a painter and a poet were no doubt his incessant ramblings amidst mountains and streams, his sensitiveness to the inner life of nature and his ability to grasp and retain in paintings (and poems) even the most fugitive moods and movements on the ever-changing stage of her dramatic displays.

Shih-t'ao was continuously in search of fresh motifs, transmuting scenes that revealed to him new aspects of her activity. His biographers (and the inscriptions on paintings) give us some idea of his travels and studies in various parts of China. Thus, for instance, Ch'ên T'ing writes:[2] "He travelled along the mountains and rivers all over the country, visiting the Hsiao and Hsiang rivers (in Hunan), the Tung-t'ing lake (in Kiangsu), the K'uang and Lu mountains, the T'ai-hang range (in Shansi), the Five Sacred Mountains, the Four Rivers and many other places, which all caused great progress in his painting and increased his skill in calligraphy." In other words his imagination was enriched, his creative activity stimulated through travel and thought rather than through any kind of systematic traditional form of study (as is also emphasized in his writings of later years).

[1] *Cf.* Ch'ên Ting, *Hsia-tsun-chê chuan* in *Liu-ch'i wai chuan*, which is included in *Chao-tai ts'ung-shu*, Part V, vol.42, f.18, as an appendix to Shih-t'ao's treatise *Hua-yü-lu*. The chronology of the life and pictorial activity of Shih-t'ao have in recent times been discussed by Fu Pao-shih in his article *Shih-t'ao shang-jên nien-p'u* (1948), which also exists in a separate pamphlet with preface by Lo Chia-lun. The main historical data from this article were reported by Mr. K. Tomita in *Bulletin of the Museum of Fine Arts*, Boston, October 1949, and in Dr. Victoria Contag's book *Die Beiden Steine*. A condensed chronological table for Shih-t'ao's biography is included in vol.II of Chang Ta-ch'ien's catalogue.

[2] In *Liu-ch'i wai-chuan*, see the preceding footnote on the biographical sources.

According to inscriptions on some paintings he visited Hangchou and enjoyed the scenery of the West Lake at the age of 27. When he had reached middle age he spent some time on Huang-shan with his artist friend Mei Ch'ing, and at the age of 53 he climbed the T'ien-t'ai mountain in Chekiang. It would, however, be wrong to imagine that Shih-t'ao was somewhat of an itinerant monk or poet in search of motifs. During the latter part of his life, from about the end of the 'eighties, he was mainly settled in Yangchou, though still moving about when occasion arose. His presence there is proved by records of the years 1687 and 1693, and we are furthermore informed by Chang Kêng that most of Shih-t'ao's paintings were found in Yangchou after his death. But it should be particularly remembered, as pointed out by Li Tou in his chronicle *Yangchou hua-fang-lu*, that Shih-t'ao's activity in this flourishing city on the Grand Canal was not limited to "painting landscapes and flowers in a very free manner according to his heart's desire", but comprised also "piling up stones", *i.e.* the creation of landscape-gardens and picturesque stones or rockeries. And in confirmation of his statement he adds: "Yangchou is known for its gardens, and their fame depends particularly on the rockeries. Among them is the Garden of Ten Thousand Rocks belonging to the Yü family, which was composed by Tao-chi and considered a most beautiful creation."

Nothing of these wonderful gardens, except their fame, has survived to the present day, but the notice about Shih-t'ao's activity as a garden builder is a valuable contribution to the characterization of his artistic genius, which found expression not only in works of brush and ink but also in a more direct co-operation with nature and the utilization of her living materials for artistic purposes. Shih-t'ao's prolonged sojournings in Yangchou must also have been of importance for the younger generation of painters who had settled there, and thus formed a nucleus of the so-called Yangchou school in which some reminiscences of Shih-t'ao's genius survived.

The fame of Yangchou as a centre of wonderful gardens and original painters grew rapidly during the latter part of the K'ang-hsi period, and the place was visited at least twice by the emperor himself. On one of these occasions, in 1689, when K'ang-hsi went there accompanied by the Manchu scholar Po Êrh-tu, Shih-t'ao is said to have been introduced and presumably invited to come to Peking. His presence in the capital is proved by the signature on the bamboo-picture (in the Ku-kung collection) which he painted in 1691 in co-operation with Wang Yüan-ch'i. Two years later he was back again in Yangchou, as is proved by a signature of 1693, but did not stay on for more than a year or two, because in 1695 he again visited the West Lake in Hangchou and then (the following year) once more Huang-shan in Anhui. But he returned to Yangchou, which had become his second home, and remained there until his death, which probably occurred at the end of 1717.

The data quoted above, which are based on inscriptions (mostly reported by Fu Pao-shih), may serve as a chronological frame for the biography of Shih-t'ao. They indicate the main succession of events and general trend of his life. It should also be noted that his position as a monk did not limit his freedom of movement and through his own letter to Pa-ta shan-jên, written in 1688, we are informed that Shih-t'ao had abandoned the monastic life many years before and let his hair grow freely. It had never been to him a haven of peace and happiness, a fact also born out by Ch'ên Ting's remark (reported in full below), that "though Shih-t'ao at an early age followed the call to Buddhahood, he did not feel happy 'waving the duster' and 'grasping the staff', or calling and crying out to heaven and men". His devotion was, as a matter of fact, of a more subtle quasi-aesthetic kind, and if he longed for release from the bonds of the common world, it was in order to penetrate deeper into the realms of nature as seen through the eyes of an Immortal.

Shih-t'ao's extraordinary personality has been characterized by several well-known writers, such

as Chang Kêng[1] and Ch'in Tsu-yung,[2] but the most intimate presentation is offered by the same Ch'ên Ting, *tzŭ* Ting-chiu, from Chiang-yin, who also wrote an account of Pa-ta shan-jên's life besides biographies of several members of the so-called Tung-lin society in the K'ang-hsi period. One of his books, the *Liu-ch'i wai-chuan*, contains the *Hsia-tsun-chê chuan*,[3] *i.e.* a short life of Shih-t'ao, in which the painter is characterized partly through the use of his own words. If we quote the main sections of Ch'ên Ting's essay it will also make up for most of what the other biographers have to say.

"Hsia-tsun-chê, who had lost his family name (when ordained as a monk), came from Wu-chou in Kuangsi ... He was a resolute and upright character and did not like bowing down before others. Sometimes he was boastful and overbearing, looking down upon everybody, sometimes very haughty and inaccessible. He would not condescend to anything impure and kept far away from the people (of the world) so as not to become defiled.

"Already in his youth he was highly skilled in calligraphy and good in painting and poetry. The people of Nan-yüeh (Kuangsi-Kuantung) treasured every scrap of his writings and paintings, esteeming them like luminous pearls. He did not give away his works lightly, yet men of high character (scholars who possessed Tao) received them without asking, whereas vulgar people tried in vain (to obtain some) by sending him hundreds of taels. This made him simply close his eyes and turn his head away without paying the least attention to the offers. Consequently he became much beloved by superior men and loathed by the vulgar. Even when grossly slandered, he paid no attention to it.

"When the dynasty fell he shaved his head and became a monk. He took the name Yüan-chi, *tzŭ* Shih-t'ao, and the *hao* K'u-kua (Bitter Cucumber), using also another *hao*, Hsia-tsun-chê (the Venerable Blind One). When someone remarked: 'Master has two bright eyes; why does he call himself the Blind One?' He answered: 'My eyes are different from those of ordinary men; when confronted with money, they become blind. They are not as keen (greedy) as those of ordinary men. Why shouldn't I call myself blind?' "[4]

The paragraph following this, which contains the general statements regarding Shih-t'ao's travels and visits to the Sacred Mountains and other famous places, was quoted above. The author then goes on to quote various sayings by Shih-t'ao which reflect his psychological and artistic attitude; for example:

"He once said: 'Tung Pei-yüan represented the real landscapes of Chiang-nan; this shows that one may find the true face of nature in landscapes, just as one may observe in writings (calligraphies) traces like the branches of a hairpin or the furrows of trickling water'

"His poetry became increasingly bold; once for a friend he wrote the following poem, called 'Drinking by Night':

'Do you recall in former days our meetings
　　　　　　　　　　and the wine?[5]
We used to sit and talk and talk of everything
　　　　　　　　　　on earth.
But now our hair has turned white, and we are
　　　　　　　　　　very old.
I look around and find no friends; the air is
　　　　　　　　　　cold as steel.
Yet hand in hand amidst chrysanthemums we
　　　　　　　　　　stroll about and laugh.
We look at many picture scrolls, their skies
　　　　　　　　　　and seas now void.
And as the lamp is burning bright the night is
　　　　　　　　　　turned to day.

[1] *Kuo-ch'ao hua-chêng hsü lu.*

[2] *Tung-yin lun hua.*

[3] Reprint in *Chao-tai ts'ung shu*, part V, vol.42, p.18 (appendix to *Hua-yü-lu*).

[4] In addition to the by-names or *hao* quoted above, Shih-t'ao also called himself by the following names: Ta-ti-tzŭ (the Pure Fellow), I-jên (the Hermit), Ch'ing-hsiang Yeh-jên and Ch'ên-jên (the Wild Man and the True Man from Ch'in-hsiang). He used these names and several others with great freedom in his signatures, probably to characterize temporary moods. *Cf. Maler und Sammler Stempel* by V. Contag and C. C. Wang.

[5] The expression *Huang-po*, here translated wine, is also used for a medical drink.

The breath of wine is strong enough to reach
 the very heaven.
I am the host who once began a second life as
 monk,
and who, when drunk, reveals his inmost real
 self.
You are the honoured one among the thousand
 guests assembled in the hall;[1]
A brave and brilliant man, a noble soul.
And as I grasp the well-worn brush I smile at
 you, my friend.
I rise to dance – exploding into shouts that
 reach the sky,
where now the moon is full, though small in
 boundless space.' "

* * *

"For another friend he did a picture of a spring
river and added the following colophon on it:

"Writing and painting are no small Tao; though
men of the world think that they give but formal
likeness. The brush shapes things out of chaos.
When it attains simplicity, cleverness fades away.
The principle may be complete, but the method not
complete. When the method is complete then the
principle is also produced. The method and the
principle are really not to be transmitted, yet the
ancients could not but try to do so.

"While painting this view on the paper my heart
entered the waters of the spring river. The flowers
by the river opened, and the water moved according
to my wishes. I held the scroll in the River view
pavilion and shouted aloud: 'Tzŭ-mei!' (Tu Fu).
And lo, my shouts brought down the very clouds
. . . Open the picture; it conveys by magic the
very essence of spirit." The author adds to this:
He followed early the call to Buddhahood, but did
not feel happy "waving the duster" and "grasping
the staff" (i.e. the life of a monk), or calling on
heaven and scolding men. In fact, he was better able
to understand what he came across along the path
of life.

"Those who are trying to correct the world and

to break away from a vulgar life, are usually not in
harmony with their time. They often give cause for
misunderstanding and slander. With his lofty and
pure nature Hsia-tsun-chê would never become
like those who float like ducks on water, moving
along with the waves. No wonder that he was dis-
liked by the common crowd of the world."

The above quotations transmit the impression of
a personality far removed from the walks of
ordinary men, a hermit and, perhaps, a genius, but
unbalanced and contemptuous towards the rest of
humanity and consequently difficult of approach.
And it may well be admitted that this attitude of
detachedness and contempt towards the rest of
humanity is reflected in much of what he produced
as a painter and a writer.

The earliest picture by Shih-t‘ao mentioned in the
records is (as pointed out before) a scroll of epi-
dendrum plants which he did at the age of 14,
i.e. 1643. Through other records and a few still
existing dated pictures it is also confirmed that Shih-
t‘ao specialized to begin with on plants, stones and
garden-flowers, i.e. motifs which offered excellent
scope for his mastery of the brush and which also
must have been well known to him from his work
with the gardens. The earliest dated examples of
such paintings known to us are two handscrolls, one
in the collection of the regretted K. Sumitomo in
Ōiso, and the other in the Museum in Cleveland.
The former, which is dated 1654, represents a
fantastic garden rock, a group of large chrysanthe-
mum, climbing vine with grapes, a cabbage plant
with broadly spreading leaves and fields of narcissi on
the borders of a stream.[2] The open spaces between
the plants are covered by lengthy inscriptions in
which the painter describes how the different motifs
should be rendered, and at the very end of the scroll
he tells us that the picture was accomplished in two
different sections during the same year, to which he

[1] It refers to the Three Thousand Guests at Mêng Ch‘ang-chün's
grand feasts. See Giles, Biogr. Dict., 1515.

[2] The complete scroll is reproduced in Sōgen, pl.225. Some
portions of it in larger size in the Sumitomo album III devoted to
Shih-t‘ao, Shih-ch‘i and Hung-jên.

adds the following exuberant remark: "I splashed and brushed, after drinking, without any regard either to skill or blotches. The brush flew and danced with happiness; it was a brush quite different from that of ordinary work."

It seems to have been a work done quite impromptu and it has retained something of that captivating joyful ease in the touches of the brush and the speed of the running script, which was characteristic of the painter in his early years.

In addition to this early specimen in the Sumitomo collection should be mentioned the scroll in the Cleveland Museum which is dated 1662. The composition consists mainly of epidendrum but includes also two slender branches of bamboo and a garden rock.[1] It is exquisitely balanced in design as well as in tone and executed with the utmost refinement. The far extending sinuous leaves of the magnificent plants, which are bending and undulating with the suppleness of living nerves, seem to reflect the sensitiveness and shifting thoughts of the painter like the strings of a violin vibrating under the touch of a master's bow. In the poetic inscription the painter gives some hints as to the essentials of proper flower-painting, summing up in the advice: "If you can catch the quiet mood of piled up stones and fragrant epidendrums, their feelings will be at the point of your brush"[2] (Pl.388B).

There can be no doubt that Shih-t'ao from the very beginning of his career as a painter showed a special liking for flowers, they are most frequent in his early works, while later on other motifs such as trees and rocks and illustrative paintings occupy the main places. In other words, he was gradually broadening out into "wider fields", to use the expression of Chêng Pan-ch'iao, the famous bamboo-painter who devoted careful study to Shih-t'ao's art. He wrote as follows: "Shih-t'ao was an eminent painter of many kinds of subjects, among them bamboos and epidendrums. I, Pan-ch'iao, have now been painting only such things for fifty years. While he was cultivating wider fields I have been specializing, and why should not a speciality be as good as a wider field? Shih-t'ao's manner of painting was rich in transformations, eccentric and strange, yet he could also paint very fine and elegant works in which everything was properly arranged. If one compares him with Pa-ta shan-jên, it may be said that he fully equalled his predecessor and surpassed him in some respects. The fame of Pa-ta shan-jên spread all over the country; why did not the name of Shih-t'ao reach beyond Yangchou? Pa-ta shan-jên used only an abbreviated manner of painting, whereas Shih-t'ao's manner was refined and rich. Pa-ta shan-jên had only one name, which was easy to know and to remember; Shih-t'ao's name was Hung-chi (probably miswriting for Yüan-chi) and he used the following by-names: Ch'ing-hsiang tao-jên, K'u-kua ho-shang, Ta-ti-tzŭ, Hsia-tsun-chê, besides others which all together caused confusion. Pa-ta shan-jên was called only by this name, and I am called only Chêng Pan-ch'iao, thus not being able to follow master Shih-t'ao's example."[3]

Chêng Pan-ch'iao's way of explaining Shih-t'ao's lack of popularity does not sound very convincing, nor is the comparison with Pa-ta shan-jên correct (because the latter used many different appellations, except in his signature), yet it is quite possible that these strange painters used their fancy names rather freely in order to confuse common people and to escape too much attention from a curious crowd. In the case of Shih-t'ao this habit of changing names was no doubt closely connected with his impulsiveness and restless temperament; he did it most freely in early years. When in later years he came in contact with people of the official class as well as scholars and artists, it gave him more balance and self-control, as may also be noted in his manner of writing.

The gradual change or development of his style may to some extent be observed in dated pictures,

[1] Cf. *Chung-kuo Ming-hua*, vol.24.

[2] This colophon is published together with Ch'en Ting's biographical notes in the appendix to *Hua-yu-lu*.

[3] Pa-ta shan-jên and Shih-t'ao signed conjointly a picture of bamboos and rocks.

but these are relatively few and do not offer sufficient support if we try to establish a regular succession of definite stages in his stylistic evolution. An impulsive artist like Shih-t'ao is always apt to cause surprises, and he apparently produced pictures of unequal merit and style at various periods. Painting was to him just as natural as writing, and as he played with the brush incessantly he could no more help repeating himself than he could help giving somewhat varying expressions to the same motifs. His very rich painted *œuvre* thus offers many problems that would require a more detailed analysis than can be devoted to them at this place. In this summary presentation of the material we shall mainly refer to dated or datable examples and such as are closely connected with these.

Among the earliest dated landscapes should be remembered two large album-leaves, formerly in the Lo Chên-yü collection and reproduced in *Kokka* Nos.263 and 313. The latter picture, which is dated 1669, represents two men in conversation under a leafless tree at the foot of a steep rock. It is executed in a rather soft pictorial style, though with a firm brush and clear definition of all structural details. The poetic inscription, written in a rather free quasi-running style, holds an important place and attracts no less attention than the figures.

A somewhat larger landscape is dedicated by inscription to Chou Liang-kung, the well-known amateur and collector who passed away in 1672, which date may be accepted as terminus *ante quem* for the picture. The composition is of a rather traditional type; it is dominated by a steep rock forming the further bank of a mountain stream which, at the lower edge of the picture, is spanned by a bridge. A wanderer is approaching; he is directing his steps towards the thatched pavilion among the bare trees on the river-bank. Some influences from Wu Chên and Ni Tsan are noticeable in the painting of the rocks and trees, but they have been absorbed by a master who has given his work a rather definite individual stamp.

An undated landscape in the National Museum in Stockholm should here be remembered because the composition is somewhat similar to that of the preceding picture, even though the general effect is different owing to the very fluent brush-manner and the addition of bluish and reddish-brown pigments. It represents A Wanderer on a Mountain Path that winds around the foot of a steep rock; on the opposite side, in the foreground corner, are a few bare trees and, further away, some faintly visible buildings. The elements are practically the same as in the preceding example, but they are blended in a somewhat freer fashion by the use of a light mist which partly conceals the valley below the rocks and the buildings among the shrubs. The colouristic hue is subdued, yet very effective and might cause the impression that the picture is of later date, yet the composition as well as the brushwork (particularly in the trees and the overhanging rock) offer, in my opinion, convincing proofs of its being the master's work at a relatively early period. The same is true of the very prominent inscription, which by its literary form and style reveals Shih-t'ao's spontaneous early manner of writing and composition (Pl.389). It also has some interest from an historical point of view, as it reflects some glimpses of the painter's happy rambles in the woods and mountains and merits thus to be quoted here in part:

"My inborn nature cares not for life in the cities.
I fled from the noise and made me a straw-
 covered cottage
 far off in the depth of the mountains.
I follow the thoughts of the moment while
 rambling about.
When spring days come I watch the play of
 the birds;
On summer days I bathe in the waves of the
 stream,
On autumn days climbing the loftiest peaks.
When winter has come I warm myself in the
 sun.
And so I enjoy my pleasures according to season;
Leaving the crow and the hare to take care of
 themselves.

In moments of leisure I read the sacred scriptures,
And when I get tired I sleep on my bed of straw.
If someone asks me what I see in my dreams –
 my answer is: Hsien Huang-ti (the Yellow
 Emperor).
Hsien Huang-ti transmitted the secret doctrine,
 though this is not known in detail by the
 Taoists.
I have worn the black robe of a monk for
 decades now.
The air of the teaching is vast like the ocean's self.
When I take to the brush and paint, the good
 works have no limit.
What can compare with this (kind of life)?"

The above programme or outline has the stamp of experience and may serve to give an idea of Shih-t'ao's life during the periods when he spent most of his time wandering in the regions of Lu-shan or Huang-shan or other mountains in central China, where with the searching eyes of a poet and painter he absorbed the thrilling views which he then, after his return to Hui-chou, Nanking, and Yangchou, transposed into recording pictures. Most of his paintings executed during the 1680's and 1690's are of this kind and, to some extent, records of his journeys, which brought him repeatedly to the above-mentioned places. They are often mentioned in his inscriptions, but to report them here in detail would carry us too far. The place most often mentioned by Shih-t'ao after 1686 is Yangchou, where he must have spent most of the last two decades of his life occupied in painting, writing and the planning of gardens, of which we have heard.

This conclusion is also confirmed by Chang Kêng's remark that the greatest number of Shih-t'ao's paintings were found in Yangchou after his death. These pictures were probably of a rather advanced type unlike those earlier paintings by him which were best known and appreciated in Kuang-tung and Kuangsi.

Among the early pictures should also be mentioned, a self-portrait done at the age of about 40, in the collection of Dr. Lo Chia-lun in Taipei.[1] The composition is in the form of a short handscroll; the figures are executed in refined *kung-pi* manner, but the trees and rocks with richer ink (Pl.388A). The painter, who is wearing his long white summer gown, sits on a stone at the root of a beautiful pine-tree occupied in supervising the transportation of smaller trees for planting, the work being performed by a servant-boy and a creature which looks more like an anthropoid than a human being. Through this the situation gets a touch of humour, though the extraordinary being is not meant to amuse anybody; the master himself seems indeed to be filled with melancholy thoughts as he watches the perform-ance.

A number of Shih-t'ao's best known large land-scapes must have been executed in the 1670's and 1680's. They are uneven in quality and not always so attractive as his spontaneously painted records on album-leaves, yet often remarkable for the bold manner of execution and the very free way in which the master has made use of impressions received from studies of classic models of the Sung and Yüan periods. The earliest dated example of this group is the large hanging–scroll in the Musée Guimet, which is provided with an inscription of the year 1671 in which the painter gives the follow-ing information about his natural inclinations and way of working: "Lazy by nature and often ill, I wanted many a time to bury my brush and burn my ink-stone, to get rid of my body, and to throw off my skin – but that I could not achieve.

"In my loneliness I went to the study of an artist friend, and there I found on the table some genuine works by Ni, Huang, Shih, and Tung; and as I met with them (studied them) day after day, I became united with them, and after a few days more I was with them even while eating and sleeping ... Written 1671 in the Chih pavilion by Shih-t'ao chi"[2] (Pl.390).

[1] A copy of a part of this picture, executed by Chu Ho-mien in 1807, is included as frontispiece to the Shih-t'ao album published 1930 by the Chung-hua Co.

[2] The same inscription is said to exist on a picture dated 1679.

The composition is crowded and shows that the painter has here been struggling with problems which were new to him. He must have realized the insufficiency of his early training, which perhaps caused the depression that he speaks of, and then gradually discovered an antidote to this in a more intensive study of the well-recognized old masters such as Ni Tsan, Huang Kung-wang, Shên Chou (Shih-t'ien) and Tung Ch'i-ch'ang – to which he could have added a few more names not only of Ming and Yüan dynasties, but also of Sung and earlier times. These studies, which evidently exercised a notable influence on Shih-t'ao's manner of painting and writing, seem to have been carried on with marked progress during the 'seventies and 'eighties, sporadically also later, and as a consequence of this he became recognized as one of the greatest masters of the brush even by contemporary traditionalists, such as Wang Shih-min and Wang Chien. This is particularly emphasized by Ch'in Tsu-yung in T'ung-yin lun-hua (Part I, 1), where he writes perhaps too sweepingly yet not without good reason: "All his paintings were executed in harmony with the old masters; he would certainly not have reached as deep in his art, if he had not absorbed the T'ang and Sung masters into his soul and heart. His bamboos and stones, plum-trees and epidendrums were all surpassingly wonderful. He was also an excellent writer of pa fên and li shu. Wang Shih-min said of him. 'There is no painter south of the River who can be called the equal of Shih-t'ao' – which indeed is the highest praise that could be bestowed on him."[1]

Among the painted records of Shih-t'ao's studies of early masters should be remembered in the first place a large mountain landscape after Chang Sêng-yu, the famous master of the sixth century, painted "in green and blue".[2] It is dated 1686 and apparently executed with great care in adherence to the archaic manner of Chang Sêng-yu; nor is it the only landscape executed in colour ascribed to Shih-t'ao. No less surprising is it to find pictures by Shih-t'ao in the manner of rather academic Sung models. Best

known among these are his Sixteen Lohans in the Ku-kung collection, painted on album-leaves in the manner of Li Lung-mien.[3] Another example is the long handscroll representing garden rocks, blossoming trees and gathering birds, painted, according to the inscription, for a friend after a Sung model in the palace collection.[4]

The Yüan masters of greatest importance for Shih-t'ao were evidently Ni Tsan, Huang Kung-wang and Wang Mêng; they have all left more or less evident traces in his later landscapes, but in his inscriptions he dwells particularly on Ni Tsan, for whom he felt a deep sympathy.

The most eloquent expression of this is the colophon on the picture in the former Abe collection (Ōsaka Museum) which represents some dry trees and a low pavilion at the foot of a pointed rock by some water.[5] The design may well be derived from Ni Tsan, but the model has been freely translated into a more colouristically effective work. The colophon contains the following poetic interpretation of the Yüan master's art: "The paintings by Master Ni are like waves on a sandy beach, or streams between stones, which roll and flow and issue by their own force. The air of supreme refinement and purity is so cold that it overawes men. Painters of later times have imitated only the dry and desolate, or the thinnest parts, and consequently their copies have no far-reaching spirit."

This inscription was written in 1699; two years later he makes another reference to Ni Tsan in the colophon on an album-leaf representing a low pavilion under some dry trees on a rocky shore:[6] "The rude fellow (i.e. the artist himself) treasures ink like gold. He sketches spare trees and bare mountains with light and deep tones and places

[1] Similar words of praise are attributed to Wang Chien by a writer quoted in Kuo-ch'ao hua-shih, vol.14.

[2] Cf. Sōgen, pl.217, in a private collection in China.

[3] Published by the Palace Museum, Peking 1935.

[4] Nanga Taisei, XV, 35.

[5] Sōraikan, I, pl.53.

[6] The last leaf in Album No.1, published by the Chung-hua Co. 1930.

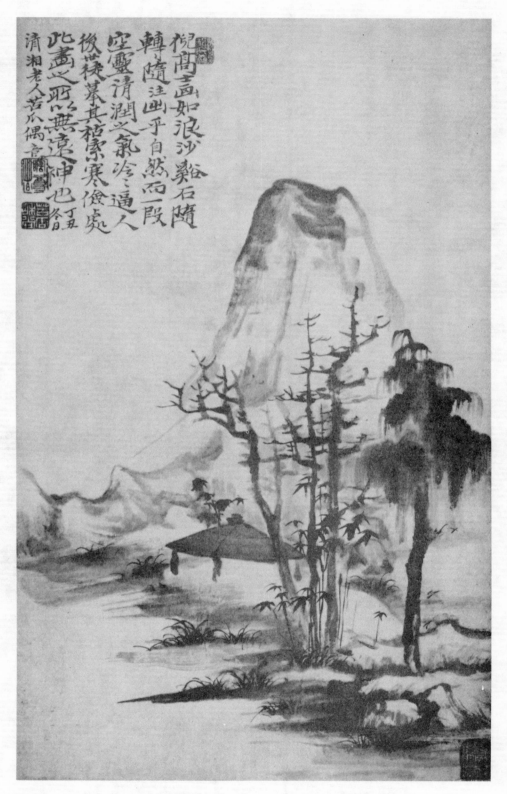

FIGURE 3. Shih-t'ao, Old Trees by the Shore, after Ni Tsan. Dated 1697.
Abe Collection. Courtesy Ōsaka Museum of Art.

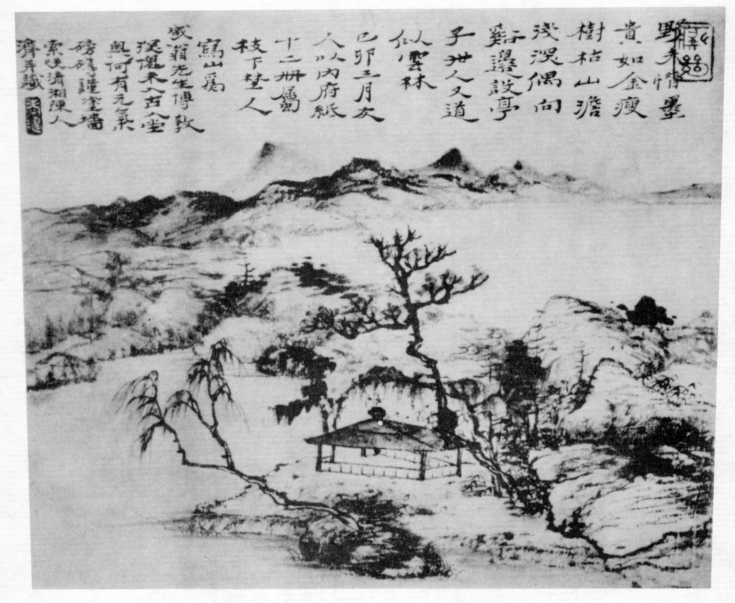

FIGURE 4. Shih-t'ao, View over a Wide Bay, in the manner of Ni Tsan. Album-leaf dated 1695. Chung Hua Album.

casually a pavilion by the stream. That makes people say, 'it is like Ni Tsan'. "

Shih-t'ao seems to have known by experience how easily a certain general resemblance to Ni Tsan could be produced through the introduction of some typical motifs, but in the continuation of the same inscription he confesses to be "deeply ashamed of not having entered the inner chambers of the old masters", and asks, "how could I then have caught the all-pervading life-breath?"

In other colophons he speaks of Ni and Huang together; he seems to think that they were so closely related that they could serve together as models for one picture. Such works may not have been as much of a success as the pictures based on Ni Tsan alone, yet there is at least one example worth remembering at this place, a mountain landscape with rushing streams and sparse trees, said to represent Mr. Kuo-wêng's Mountain Cottage of the Soughing Pines.[1] According to the inscription, dated 1701, this gentleman sent Shih-t'ao a poem describing the place, and some good Sung paper (to obtain a picture of it). In order to please Mr. Kuo-wêng, who loved Ni most among painters and esteemed Tung Ch'i-ch'ang highest among calligraphers, Shih-t'ao says: "I followed the paths of Ni and Huang in painting this and did it with a straight brush to sweep the sky of autumn" – which possibly may refer to the boldly pointed peaks (Pl.396B).

If we compare this picture with the above-mentioned album-leaf in the manner of Ni Tsan, we cannot but recall Chang Kêng's remark, "his small pictures are excellent, but it is to be regretted that his larger compositions are not well connected by vital veins" – an expression referring to the structural lines of the design, which appears somewhat blurred though not to the same extent as in some of Shih-t'ao's earlier landscapes.

Among other, still larger landscapes painted, according to the inscriptions, in the manner of certain old masters, should be mentioned The Stone Bridge on T'ien-t'ai shan and The Waterfall on Lu-shan, both in Japanese collections. The former,

which represents a curving bridge over a deep gorge where the water forms steep cascades, is said to be in the manner of Wang Mêng. The influence of the Yüan master is, however, not very marked unless in a certain endeavour to give the rocks and peaks more structural strength than is usual in Shih-t'ao's mountain-landscapes. The design, taken as a whole, is one of his most successful creations.

The Lu-shan picture (in the regretted K. Sumitomo's collection in Ōiso) is by its extraordinary size and imaginative grandeur the most impressive of Shih-t'ao's large landscapes in spite of its lack of conventional structure (Pl.396A). The painter takes us here right into the heart of a wild and inaccessible mountain, to a place on a rocky ledge rising out of mist, where he stands looking at the foaming waters and the circling wisps of light fog between the rocks, while his companion is resting by a tree. The whole scene is, so to speak, detached from the common world. The foreground or lowest section is marked only by the tops of some trees projecting from the unseen, while the foot of the cliff on which the painter stands is lost in a bottomless gorge. Far beyond rises the precipice in successive steps washed by the foaming water and partly covered by layers of clouds and mist. The final stage at the top is marked by the broad square peak on which the leading lines of the composition converge. The rising rhythm is accentuated by the cliff that projects obliquely into the picture, enclosing the place in a kind of gigantic cavern filled by phantoms of swaying mist. The very rocks seem to re-echo the din of the cascades and vibrate with the surging life that pulsates through the gorge; it is a picture in which the dramatic import of a gigantic motif has been rendered by an inspired brush.

At the top of the picture there are two inscriptions, one of them being a copy of Li Po's poem on Lu-shan, while the other is a composition by Tao-ch'i himself, in which he, without concealing his

[1] Reproduced in Sōgen, pl.214, then in the collection of Chu Lu-shêng. It is now in the collection of Mr. C. C. Wang in New York.

self-conscious pride, gives some hints about his studies of certain old masters:

"People say that Kuo Hsi's paintings are based on Li Ch'êng's manner. He gave the effects of clouds and mist appearing and disappearing, of peaks hidden and visible, and stood quite alone at the time. In his early years he painted in a very careful manner, but in later years his brushwork grew bolder. I have seen in my life more than ten pictures by him which people all considered good, but I did not express any opinion on them, as I did not find in them a very penetrating manner. Recalling my travels of former years and choosing Li Po's poem on Lu-shan (which he wrote for his friend Lu), I combined them according to my own method, with what I have seen myself, and painted this picture. It might be considered a picture by Kuo Hsi. What need is there then of the old masters! Ch'ing-hsiang Ch'ên-jên."

It is interesting to note that Tao-chi drew, at least in part, his inspiration for this great picture from a poem by Li Po (combining it with visual impressions), whereas the formal design and method of expression were adapted to accord with the manner of Kuo Hsi, the Sung master, who interpreted "the great message of forests and streams" not only in magnificent paintings but also in words (recorded by his son). Tao-chi's admiration for the dramatic landscapes by a master like Kuo Hsi was no doubt deep and sincere, but owing to his exaggerated self-esteem he seems to have found it necessary to conceal it under rather misleading words. Yet he knew the value of the old masters as guides and acknowledged his indebtedness to them in colophons partly quoted before.

The Lu-shan picture marks indeed a peak in Shih-t'ao's creative activity because here he has released the wind of the Spirit, so to speak, so that it sweeps through the brush-strokes, opening up a vista into the empyrean, even though it may not be his most successful pictorial creation (Pl.397). Some of the minor landscapes, in the form of album-leaves, painted about the same period, i.e. shortly before or after 1700, are perhaps more perfect examples of his professional skill and power of revealing the soul of a landscape. Some of them are spontaneous sketches jotted down while he was travelling along rivers or resting during his rambles in the mountains, others are more elaborate imaginative compositions illustrating poetic or philosophical ideas sometimes also expressed in words.

They form the largest section of Shih-t'ao's pictorial work, and, owing to their convenient size, many of them have been successfully reproduced in China and Japan and thus have contributed more than other paintings to Shih-t'ao's growing popularity (Pl.394).

Among such reproductions should be mentioned in the first place the four albums published by the Chung Hua Co. in Shanghai 1930 and reissued in several later editions. The pictures reproduced in these albums were at the time, according to the preface, in the possession of the two Chang brothers, Shan-tzǔ and Ta-ch'ien, who with the consent of their mother (also a painter) and the co-operation of the well-known expert Chên Wu-ch'ang had them reproduced. This was done when Chang Ta-ch'ien returned from a long stay in Japan (where he had witnessed the great appreciation of Shih-t'ao) and it represented the first attempt in modern times to make the painter better known in his home-country. It started a vogue which found expression in several similar publications in China as well as in Japan.[1]

These four albums – some of ten and others of

[1] A few minor albums by Shih-t'ao with studies of landscapes or flowers and bamboos had been brought out in China before 1930, but they were not so successful as the albums published by the Chung Hua Co. Among them may be recalled three publications by the Yu Chêng Book Co. in Peking (1924–1932), the first dated 1701. The Wên Ta Company published two in 1924 and 1925. The album belonging to Lin Lang-an (now in the Sumitomo collection) was first published by the Commercial Press 1929; another album by the same firm 1932, and one by the T'ai-shan Ts'an-shih-lu tsang.

The first important publication in Japan was Hashimoto, Shih-t'ao, Tōkyō 1926, which contains twenty-six illustrations, made up of scrolls and album-leaves in the author's collection. Shortly afterwards two different albums were brought out by the Hakubundō Co. These were later included in the more comprehensive publication in folio (partly in colour) which was

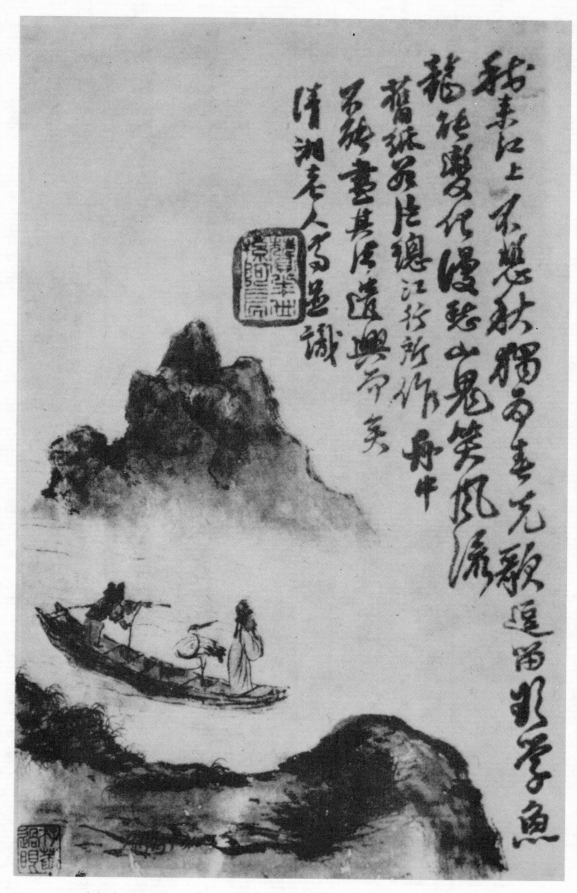

FIGURE 5. Shih-t'ao, A Man and a Crane in a Boat. Album-leaf. Chung Hua Album.

twelve leaves – are among the most authentic of their kind, though unequal in quality, and should consequently be remembered by students. The first and the fourth are made up of relatively large horizontal views, some with inscriptions, the first being dated 1699 and the fourth 1695. The first-named (which is later in time) shows a very free use of scorched ink, forming large patches of deep black, applied with a firm, not to say heavy, brush. A proper appreciation of the tonal or colouristic qualities cannot be obtained simply through repro-ductions, because the contrasts of black and white appear cruder in these than in the original paintings. The designs are in several instances beautifully balanced and very effective in spite of the relatively small size of the pictures.

In vol.IV some of the pictures are spontaneous sketches of rocks and trees, while others represent more complete views, mountain ridges in successive layers, and trees and cottages along streams. The tonal values are here sensitively indicated and evocative of a pictorial atmosphere.

Vols.II and III are not dated, though the pictures in the latter are accompanied by inscriptions con-taining imaginative references to the motifs. Most of these represent impressions gathered while the painter was travelling in a boat on rivers, such as the Yangtse and Ch'ing-huai; they contain records of the views that appear and disappear as the boat is borne along by the stream and the wind which fills its rush-cloth sails (Pl.395). Similar impressions have also inspired the painter to some of his lyrical improvisations:

"The night is near; a little skiff afloat. –
A song is heard; the moon is not yet out.
The waves of autumn rise with snow-white caps.
The rushes are reflected in the icy water.
But in the middle of the stream a certain man
escapes –
quiet in his heart; free from the din and dust of
market-places."

One of Shih-t'ao's most interesting minor albums is made up of eight leaves representing sites or views of outstanding beauty in the Yellow Mountains (K. Sumitomo collection, Oiso) (Pl.392B). The pictures have evidently been executed *in situ*; they are very exact as illustrations but at the same time pictorially effective, owing to the sensitive colouring with light tones of greenish-blue, reddish-brown and shades of grey ink. The strangely silhouetted peaks and terraces, the knotty pines which jut out of the mountain walls like startled dragons, the waterfalls and the temple pavilions in the gullies are all render-ed with perfect faithfulness, yet enveloped in an atmosphere which gives them the tone of fleeting visions. In some pictures the illustrative character is dominant, while others seem further removed from the world of mortals. Among the former may be mentioned the picture representing four men bathing in the hot-springs in a ravine. The humorous tone makes it entertaining even though it has a rather serious undercurrent, as explained in

started 1936 by the Jurakusha under the title *Shih-t'ao Meigwafu*, vols.I–VI. It was intended to contain a selection of Shih-t'ao's best pictures and among these are the following series of album-leaves (some also published elsewhere): 1. *Eight Huang-shan Views* (Sumitomo collection); 2. *Shan-shui ching-p'in ts'e* (also by Commercial Press, likewise in Sumitomo collection); 3. *Ch'ing-hsiang Lao-jên shan-shui ts'e*, 1691 (Sakuragi collection); 4. *Twelve illustrations to Su Tung-p'o poems of the seasons* (Abe collection); 5. *Ta-ti-tzŭ, Shan-shui t'sê* (1703), i.e. nine pictures from the album now in the Boston Museum; 6. *K'u-kua Miao-t'i ts'ê*, seven leaves in the same size as the previous album and with the same date, but some of them inferior in quality; 7. Seven leaves from a large *Album of Flower-painting* and eight leaves smaller in size of poetic inscriptions, some referring to the *Huang-shan pictures*. Among the great number of pictures reproduced under the name of Shih-t'ao in *Shina Nanga Taisei* are also several series of album-leaves; the best among these are known from other publications, while some of the others seem less convincing as works by the master.

The great number of album-leaves, more or less similar in their motifs and general effect (and provided with Shih-t'ao's seals and signatures), though of various size and quality, cannot but evoke the question whether the master in later years repeated himself – to satisfy friends and clients – or other painters at the time were able to produce deceptive imitations of his works? The question must here be left open; Shih-t'ao's popularity and great influence on the development of modern painting in China has made it still more difficult to solve, though modern imitations are, as a rule, recognizable by their lack of structure and the splashy use of ink.

the inscription: "Travellers who wish to stay over-
night in the Hsiang-fu temple must first bathe in the
hot-springs. They should completely wash away the
sins of the past and the cause of their pollution. Only
then will they be able to reach the mountain top and
compose some poetry" (Pl.393). The washing had
evidently also its symbolic significance like the
bathing of neophytes before they could enter the
sanctuaries of initiation in the ancient world.

In another of these pictures representing a pre-
cipitous mountain rising above some pines around a
temple, one may distinguish a rock-formation
resembling a human figure of gigantic dimension, if
compared with the trifling figure on the road below.
(Pl.392A). At the side of this fantastic rock the
painter has written:

"Bone of jade, heart of ice, a man of iron and
stone; such is the master of Huang-shan, a subject of
Hsien-yüan." The last name signifies the Yellow
Emperor (Huang-ti) who apparently was considered
as the mystic ruler of Huang-shan, one of the regions
where Shih-t'ao felt most at home. It gave him what
he wanted, inspiring grandeur and remoteness; it
was a place suited for the immortals and the heroes
of a legendary age. He visited Huang-shan repeat-
edly, living there in one or other of the temples for
long periods, fascinated by the awe-inspiring peaks
and chasms of this gigantic mountain. It is conse-
quently not easy to indicate a definite date for the pic-
tures in this album, but for stylistic reasons I would
place them in the 1690's. In the inscription on a
handscroll (likewise in the K. Sumitomo collection)
representing continuous rows of peaks along some
valleys and streams, he states that the scroll was
painted in the year 1699 for a gentleman called
Ching-an, who on his return from Huang-shan gave
a feast for all his friends who had visited the moun-
tain. In doing it the painter says that he recalled and
combined impressions from the place gathered
during the previous thirty years. In other words, the
picture is freely composed and based on memories
rather than on direct observation and it has very
little of the immediate appeal of the album-leaves.

Huang-shan meant something more than simply
grand mountain scenery to the painter, it was a su-
preme manifestation of that great creative power
that he sensed everywhere in nature and tried to
express with his brush. It also forms an undertone in
some of his poems:

"The mountain path emerges from the sky.
Would I might ride upon the wind in boundless
 space,
 and live among the peaks and gullies.
I have no fear of any dangerous paths.
Within the vault the bluish clouds are rolling.
The peaks are red, the cliffs are bold.
How can I tell it all, or paint in words,
 the scarlet leaves now scattered by the frost?"

In 1691 he painted mountains and streams of a
different type, forming them into some larger care-
fully balanced horizontal compositions which fill
the album in the former Sakuragi collection (*Cf.
Shih-t'ao meigashū*). These pictures look almost like
sections of a large handscroll, but they do not form
a continuous view, each one represents a different
motif. They are painted with a fat brush and rich ink,
which gives them a distinct pictorial beauty. They
represent grassy promontories with fishermen's
cottages, rocky shores and hillocks with low build-
ings mostly painted in a rather heavy manner with
brush-strokes that serve to accentuate the cubic
quality of the forms, whereas the leafy trees and
other growths on the mountains are painted with
washes of deep ink. Some of these views might
almost have been painted by Claude Lorraine;
though it may be doubted whether Claude ever
reached the degree of mastery shown here in the
handling of ink. In Tao-chi's picture, to use his own
words, "the brush brings out the fragrance of the
mountains and the water, the colouring suggests a
vast expanse of misty trees", whereas in Claude's
sketches their main accent is on the decorative effect
of the scene in general (Pl.398B).

Among the albums by Shih-t'ao there are some
devoted entirely to flower-paintings, intimate
motifs rendered impressionistically in small pictures

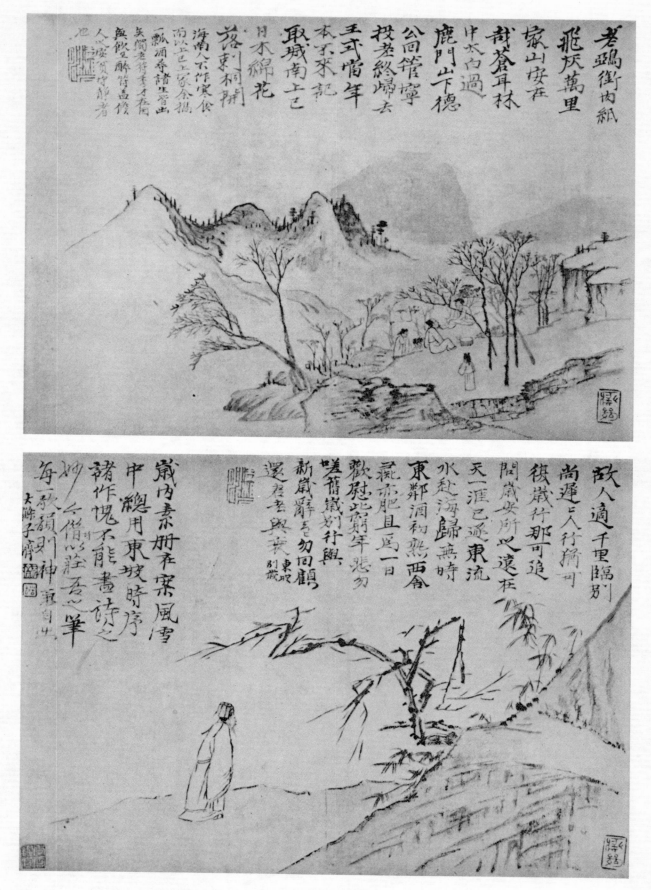

FIGURE 6. Shih-t'ao, Two album-leaves illustrating poems by Su Tung-p'o.
K. Sumitomo Collection, Ōiso.

which offer little material for description. Whatever the flowers may be, hibiscus, or plum-blossoms, chrysanthemums or epidendrums by a rockery, a few sprigs of bamboo, or old banana-leaves, they are transmuted into impressions of light and shade, movement and growth, all reverberant with life-breath transmitted through the point of the brush, *i.e.* in the proper *hsieh-i* manner. And in addition to these there are the bamboo studies which Shih-t'ao did all through his life and in which the energy, decision and concentration expressed in the brush-work are most impressive.

The above-mentioned flower-paintings have no poetic inscriptions, but in some of the poems recorded for instance in Hashimoto's monograph, Shih-t'ao gives very intimate personal glimpses of his attachment to certain trees and flowers, which are worth quoting. One example may be inserted here. It is entitled Plum-blossoms:

"I passed my life 'midst woods and valleys;
 and they were not insensible to man.
The plum-tree alone, when all in bloom,
 looked scornfully down on me.
He asks: 'Why should the white eyed blossoms
 be so proud?' And answers:
'If I hold a branch of plum-blossoms to the moon,
 who would not rejoice at the sight?'"

Shih-t'ao was a true lover of flowers; he understood their silent message and knew how to interpret the fragrance in poetic and pictorial symbols, but it would carry us too far to dwell here further on this phase of his art.

One of Shih-t'ao's most interesting series of album-paintings is composed of illustrations to Su Tung-p'o's poetic descriptions of the seasonal aspects of the year. On the last leaf of this album (in Abe collection, Ōsaka Museum), the painter wrote: "This album lay on my table for a year with blank leaves. One day, when a snow-storm was blowing, I made use of Tung-p'o's writings on the seasons, but I am ashamed that I have not been able to render the marvel of his poems. In order to make the pictures more interesting, I have copied the poems (at the tops of the pictures). When you chant the rhymes, the spirit of life in the pictures will come out quite naturally." It is indeed true, really to enjoy the pictures one has to read them together with the text, but as there are no less than twelve, the method cannot be tried here. Su Tung-p'o is represented in them in various situations, travelling, reading poems, drinking with his friends, praying for rain in a temple, looking at the mid-autumn moon, etc., and in the last picture quite alone walking on an open terrace towards a knotty old willow, whose jerky branches seem to reflect his tired state of mind. The rest is emptiness; there is a sense of solitude and fatigue – the fate that overcomes a noble soul when his years are many.

The large album in the Boston Museum dated 1703 has been completely reproduced and commented upon in the Bulletin of the Museum.[1] It is one of the most varied of Shih-t'ao's albums, containing landscape studies of different types (some with figures) and also inscriptions of great interest. The paintings are done partly in ink only, and partly with the addition of light colours. They are more finished, less sketchy than the landscapes in the minor albums and the same may also be said of most of the inscriptions, which are done in a firm *li-shu* manner. The pictures and the poems are in several cases interdependent.

We may choose as an example The Returning Fishermen. The atmosphere of a late summer evening is here suggested by transparent tones of light blue and vaporous ink. The mist is hanging low – it covers the mountain side and the creek, but the silhouettes of distant peaks and ridges appear above the curtaining vapour before they fade into the background. Two fishermen are walking home through grass that reaches to their waists; the cottage is half-hidden behind some wind-swept trees. The dreamy silence of a summer-eve here suggested by the softness of these tones has also found expression in the inscription:

[1] October 1949, by K. Tomita and K'aiming Chiu. Only nine of the pictures are reproduced in *Shih-t'ao Meiga-fu*.

"Jade-green grass reaching to the waist, and
 covering the path;
A bamboo-gate ajar; creepers hidden in the
 dusk.
The moon appears above the river village; a
 dog is barking . . .
Two fishermen are walking home with torches
 in their hands" (Pl.399).

On another leaf he has fixed the impressions of a
shallow creek or lake in summer when the water is
burgeoning and half over-grown with water-lilies
on high stalks. The foreground is set off by some
large stones, luminously black against the misty
water. The growth on the opposite shore is faintly
indicated, but the little boat with the man, who may
be gathering lotus seeds, is distinct, and the whole
scene is again dominated by a distant mountain
silhouette. The poem can hardly be said to describe
the scenery as closely as in the previous picture, but
it has its own value as a lyrical composition:

"There is music in this landscape;
 for the one who grasps it, it is his heart.
Springs that wash the feet of cliffs
 lave with coolness mind and ear.
When can I remove my dwelling,
 plough and fish 'midst distant clouds?
When I think of it, my heart is filled with
 longing.
Winds of spring begin to blow, the moon to
 rise."

In others of these pictures the inscriptions are
more thought-provoking than the scenery; they
lead us into the realm of the painter's philosophical
or aesthetic speculations. They are apparently copied
out of a note-book and reveal more of the painter's
excessive self-esteem than of his creative genius.

"Before the ancients established any rules
(method), I do not know what rules (method) they
followed. After the ancients had established rules (a
method), later (present day) men were not allowed
to (or: could not) step out of the method of the
ancients. So it has been for thousands of years, and
that is the reason why later (present day) men have

not surpassed the ancients. They are simply walking
in the footsteps of the ancients, but do not grasp the
heart (essentials) of the ancients. No wonder that
they cannot rise above the ancients. What a pity!"

Tao-chi as a matter of fact, felt great contempt for
the methods and rules of his contemporaries; they
were, according to his notions, slaves to conventions,
whereas he had established a method of his own
which was practically equivalent to complete free-
dom. But although he considered himself superior
to all his famous predecessors of historical times, he
did not find it superfluous to imitate some of them
quite closely, as we have seen.

* * *

Shih-t'ao's genius found expression in various
fields through different forms of artistic creation,
and it is sometimes difficult to tell whether painting,
poetry, calligraphy or Taoist philosophy (not to
mention rock-gardens) was to him the most natural
medium of expression. He has on the previous pages
been introduced mainly as a painter, but some of the
pictures, album-leaves in particular, are adorned
with inscriptions of outstanding calligraphic beauty.
He must have practised calligraphy no less than
painting, and his mastery of this art grew con-
tinuously towards his old age. In his early days he
wrote mostly a rather loose, though expressive
hsing-shu, but towards the end of his life he wrote
pa fên and a beautifully controlled noble form of
li-shu. He must have studied very closely some of
the great calligraphists of earlier periods, such as
Su Shih and Mi Fei, whom he imitated with success.
But in this field as in that of painting he gradually
formed a style of his own, supple and versatile, yet
firm and proud, and it may be admitted that his
writings often have a more archaic, or archaistic,
appearance than his paintings.

We have no intention to devote special study here
to his literary writings. The poems quoted on pre-
vious pages are mainly supplements to his paintings.
The situation is different with regard to his theo-
retical writings; they reveal or lay open the deepest

undercurrent of his artistic inspiration. These writings consist partly of colophons to some of his paintings, but mainly of a series of notes combined, after his death, into a treatise of eighteen short chapters, called *Hua-yü-lu*.

This collection was published in 1728 by a man called Chang Yüan, *tzŭ* Yü-Ch'iu-shêng, and it has been reprinted in various editions in China, but never became very widely known, because it is written in a rather abstruse form interspersed with strange terms, mostly of Taoist origin, and abstract philosophical deductions, a serious drawback pointed out already by the first editor in the following remarks: "Ta-ti-tzu has penetrated deep into the mysterious origin (of painting) and expressed original ideas of his own mind in a style which is old-fashioned and vigorous, but very difficult to interpret."

It would require too much space to reproduce the full text of the *Hua-yü-lu* at this place, but three characteristic chapters (I, II and XV) have here been chosen as representative of the whole treatise. The fundamental problems which occupied Shih-t'ao are discussed in them, *i.e.* the origin of the art of painting and the necessity of an all-inclusive method (one which would do away with the restrictions of ordinary methods). They may serve to complete our presentation of Shih-t'ao's searching genius.

Chap. I. I Hua, the Unifying One-stroke

In great antiquity there were no methods; the great state of natural simplicity had not been broken up.[1] Once this state of natural simplicity had disintegrated, methods (rules) were established. Upon what were these methods based? They were based on the unifying one-stroke. This is the origin of all that exists, the root of the innumerable phenomena. Its operations lie open to the gods but have been hidden from men; and seeing that the people of the world do not know it, I have established it. The establishing of this method of the one-stroke means to give birth to a method from no methods and to make it pervade all methods.

The art of painting emerges from the mind. If one cannot completely enter into the reason and absorb all the aspects of beautiful landscapes and figures as well as the nature of birds, animals, plants and trees and the correct proportions of ponds, arbours, buildings and terraces, one can never grasp the great principle of one-stroke painting. Though one may travel far and climb high one always starts with a small step. Thus one-stroke painting includes everything, extending even beyond the sphere of phenomena, and of the works beyond number of brush and ink there is none which does not find its beginning and end in it. It is there awaiting the man who can grasp it. If a man possesses it even to a small degree,[2] his ideas will be clear and his brushwork penetrating.

If the wrist is not empty [unhampered] the painting will not be right; when it is not right, there is no creative force [spirit] in the wrist. The movements [of the brush] must be effective [revolve], the turning [of the ink] must give brilliancy, and one should be at ease. Move outward as in cutting, and draw inward as in ripping; then you will be able to make circles and squares, straight and curved lines, to go upwards and downwards, to balance left and right, to make dwellings and hollows, to break and to cut resolutely, to move horizontally and vertically just like water that runs downward or fire that rises in flames. All these movements must be entirely natural and not in the least forced. Then the usage [manner of working] will be simply divine and the method will encompass all methods, and the reason [of things] will be completely absorbed and all aspects [of nature] will be brought out. By one spontaneous movement of the hand, mountains, rivers, human beings, birds, animals, plants, trees, ponds, arbours, terraces and buildings will assume form in accordance with their characteristics; they will all be drawn as if alive, and their meaning will be revealed. The landscapes will express the flow of

[1] Referring to a pre-cultural Saturnian age, as conceived by the Taoists.

[2] *Cf.* Mencius: Book II, Part I, Chap. II, 20.

emotions, some parts of them being open and distinct, some hidden and concealed.

People cannot discover how such paintings are made, yet such paintings are never contrary to the heart's desire. For when the great state of natural simplicity was shattered, the one-stroke method was established [in the world], and when this was established innumerable things were made manifest. Therefore it was said: "My doctrine is that of an all-pervading unity".[1]

II. To Understand the Method (Liao Fa).

Compasses and squares produce perfect circles and squares.[2] Heaven and Earth show the living application of compasses and squares. The world knows that there are compasses and squares, but it does not understand the significance of the hidden forces of heaven (Ch'ien) and earth (K'un).[3] Hence Heaven and Earth tie men to certain methods, and men are enslaved by them from their childhood. Although they absorb these methods through their natural dispositions or from what they have learned, they never really understand the reasons for them. And as they cannot understand the methods, though they possess them, these become merely obstructions.

The misunderstanding of the obstructions arising from the methods was due to the fact that men did not grasp the reason of one-stroke painting. When one-stroke painting is understood there are no more obstructive veils before the eyes, and painting is done quite freely (issues from the mind). When painting is done quite freely, the obstructions are naturally removed. Painting means to give shape to the innumerable things of heaven and earth. But who could represent things without brush and ink? The ink is a natural product (derived from Heaven); it may be by nature thick or thin, dry or moist, but the brush is conducted by man; he draws the outlines and wrinkles, using washes of different tones. The ancients did not work without a method. If

there is no method nothing has proper limits. One-stroke painting does not delimit (give shapes) without limits or by the application of a certain method. It does not involve the obstructions of a method (nor a method with obstruction), because when the method is born from the painting the obstructions leave the painting. When the method and the obstructions are not mixed, the significance of the circulations of Heaven (Ch'ien) and Earth (K'un) have been grasped, the Tao of painting has become manifest, and the principle of one-stroke painting has been understood.

XV. Far from the Dust (Yüan Ch'ên)

Men whose minds are beclouded by (material) things become attached to the dust of the world. Men who are dominated by (material) things reap trouble in their hearts. With such trouble in their hearts they carve their pictures and wear themselves out. The dust of the world beclouds their brush and ink, and they become tied up. Such painters are cramped. There is no advantage, only disadvantage in it. It brings after all no joy to the heart.

As to me, I leave (material) things to be concealed by things and let dust mix with dust. Thus my heart is free from trouble; and as it has no trouble, painting ensues (becomes natural). Painting may be executed by anyone, but not one-stroke painting. The most important point in painting is thought; only when the thought reaches all-pervading unity (i), is something brought out (set forth) in the inspired heart. The painter's work will then penetrate into the very essence of the smallest things and become inscrutable. As it seems to me that the ancients have not taken note of this, I mention it in particular."

[1] Words by Confucius in Lun-yü, Book IV, Chap.XV.

[2] Cf. Mencius, Book IV, Chap.II, 1.

[3] Ch'ien is an expression corresponding to yang (or heaven), while K'un corresponds to yin (or earth).

The Four Great Masters of the K'ang-hsi Reign (1662–1722)

I

Wang Hui

THE ENORMOUS output of painting which ensued during the K'ang-hsi and Yung-chêng reigns can here be discussed only in the most summary way for lack of space. The materials produced in these times and in the Ch'ien-lung period are so rich that they would easily fill several volumes of their own, as may be ascertained by looking through our Lists; it need hardly be pointed out that it is impossible to do justice to hundreds of painters and thousands of pictures in a few pages. But something may, even in this case, be preferable to nothing. A few of the most important personalities among these later men will here be discussed, but for the mass of minor artists we must refer the reader to our Lists, which contain enumerations of their principal works and indications of their origin and their dates. The principal court painters and some of the older scholarly men have already been considered as well as the hermits and monks, and it may well be admitted that these marked a culminating point hardly surpassed by painters of later date. However talented and highly educated, in a scholarly as well as in a technical sense, some of the later men may have been, they did not contribute much to the general development of painting, but mainly followed beaten tracks. Occasional efforts in new directions did not meet with much success or approval, particularly not in official quarters or from the imperial patrons of art. The general tendency was towards eclecticism; the school distinctions which had existed during the Ming period gradually lost their importance; there were few local centres of primary importance or pro-

vincial schools comparable to those of earlier times.

This tendency towards an increasing eclecticism and the dissolution of the former groups or divisions of style is shortly indicated by Chang Kêng, the best informed art-historian at the end of the K'ang-hsi and the beginning of the Ch'ien-lung reign, who, in the introduction to his *Hua-lun*, gives a short résumé of the schools mentioned in previous chapters, indicating their subsequent decay and disappearance. It may be quoted here as a recapitulation of some of the principal points in the evolution leading up to the conditions at the beginning of the eighteenth century:[1]

"The division of painting into a Southern and a Northern school started in the T'ang period, but schools were not named after localities. At the end of the Ming dynasty the name of the Chê school was introduced. This school started with Tai Chin and was completed by Lan Ying. It had four faults: it was hard, stiff, bare (ungraceful) and clumsy. The school of Sung-chiang started in the present dynasty; it followed the ink-wash manner of Tung Ch'i-ch'ang and Chao Tso (Wên-tu); it became gradually delicate, soft and weak. In the Chin-ling (Nanking) school there were two divisions, one resembling the Chê, the other resembling the Sung-chiang school. The Hsin-an (Anhui) school attracted many people, since Hung-jên (Chien-shih) excelled in the manner of Ni Tsan. If it had not the fault of knotting (or tying), it had the fault of a too loose brushwork. That was the third school. Lo Mu rose to eminence in Ning-tu (Kiangsi) and transferred his

[1] *Hua-hsüeh hsin-yin*, vol. VII.

173

art to the provincial capital (*i.e.* Nan-ch'ang). His fame reached the dukes and ministers; the students all took him as their master, and this is now called the Hsi-chiang school. Its fault is too much ease and polished smoothness. The manner of the Fukien schools is thick and muddy. The manner of the painters from the North is heavy and clumsy. These various schools were all descended from famous masters, but in the course of their transmission they deteriorated through successive imitation.

"These are the general lines, since the beginning of the dynasty. Among those who could avoid confining themselves in such (school) habits and follow in the steps of the ancients, and who were fitted to take their seats at the side of the wise ones and become the models of later men, Wang Lu-t'ai is probably unique. As to Wang Shih-ku, he was very talented, but he could not entirely avoid the habits of professional painters."

Chang Kêng's enumeration of the various schools could have been made more complete; he might have mentioned the painters at court, who absorbed some European influence, and the great monk painters who stood more independent of the traditional currents of style, but his aim was evidently only to point out how certain popular schools deteriorated and lost their original impetus. He had observed the fallacy of the school doctrines and looked upon them as more or less serious barriers, a standpoint which was accepted by most of the leading painters at the time, some of them, like K'un-ts'an and Tao-chi, going even further in that they discarded practically all models and schools. They were, however, exceptions; the general contention among the great painters of the time was that the student should not tie himself down to a particular school or master but pick out the good points from various sources and utilize them according to his own temperament and ideas. This is expressed over and over again in the writings of Wang Shih-ku, Wang Lu-t'ai, Yün Nan-t'ien, and others who all were eclectics in theory as well as in practice. No better introduction to a study of Wang

Shih-ku's art could be found than the following words in which he indicates his own line of development.[1]

"Alas, how the art of painting has declined nowadays! The decline started in recent times by the branching off of a number of separate schools, which produced corrupt practices. Ku K'ai-chih, Lu T'an-wei, Chang Sêng-yu, and Wu Tao-tzu, how far they are today! From the time of the Great and Little General Li and Wang Wei and Ching Hao to that of Li Ch'êng, Fan K'uan, Tung Yüan, Chü-jan, and the four great masters of the Yüan dynasty, each period had its famous masters who did not simply live on the remnants of their predecessors or follow the common stream. Thus, Huang Kung-wang's manner was sweeping and rich, Ni Tsan's detached and peaceful, Wu Chên's profound and strong, Wang Mêng's dense and beautiful. They all followed Tung Yüan, but changed his manner so that they were all different, and each one has served as a model for many generations, never causing any harm. But in recent times the manners of painters have declined, their habits have become weak and subservient and a number of schools have branched off. Tai Chin and Wu Wei with their followers established the Chê school, whereas Shên Chou and Wên Chêng-ming established the Wu school. Tung Ch'i-ch'ang rose in a period of decay as a saviour of painting and grasped the essentials of Tung's and Chü's art. Later students who followed the same style called it quite wrongly the Yün-chien school.

"The two Wangs from Lang-ya and T'ai-yüan had their origin in the arts of the Sung and Yüan periods; their paintings are equal to those of their great predecessors. Painters from far and near competed eagerly in imitating these masters, and thus the Lou-tung school was started, besides many minor currents. Every painter started his own school; they became more numerous than can be counted on the fingers. Most of them transmitted wrong habits and accentuated the mistakes; the real styles and manners disappeared completely.

[1] Cf. *Ch'ing-hui hua-po*, quoted in *Hua-hsüeh hsin yin*, vol.IV.

"I started to paint when I was a boy, and have until the present day devoted all my energy to this art. I was fettered and bound by the common and vulgar minor schools and did not know how to free myself from them. Those who sided with the Yün-chien school severely criticized the Chê school, and those who followed the Lou-tung school slandered the Wu school. Thus, I did not know whom to follow in my painting. It was difficult for me to understand the fine points and to see through it all. Then I followed a teacher and took his advice. Subsequently I visited connoisseurs and collectors in the south-east and had an opportunity of studying Wang Wei, Li Ssŭ-hsün, Ching Hao, Tung Yüan and the Yüan masters, hundreds of pictures which covered more than a thousand years. I learned to understand the subtlest points and the many different aspects in the study of painting. I was brought to realize that it cannot all be found in one master or one school; from that time I concentrated my whole soul and continued my search with the utmost determination. When I painted I always thought particularly of the points on which the old masters concentrated their minds. This deep and continuous thinking made me realize that every point and every stroke reflects the impetus of the style, that each stone and each watercourse has a proper place in the composition, that the ink-washes produce the distinction between *yin* and *yang* (light and shade), and that in the application of colours one may bring out the distinction between the ancient and the modern. I treasured it all in my heart and tried to express it with my hand, and I am glad that I can no longer be led astray by the current schools and may feel some self-confidence."

The very prominent position traditionally allotted to Wang Hui in the history of Chinese painting and the extraordinary praise bestowed on him by contemporary painters and critics is usually supported by a reference to his perfect imitations after Sung and Yüan masters, and beside this he is admired for his skill in utilizing and combining the best points of various schools and masters. The ful-lest account of his life and work is given by Chang Kêng in *Kuo-ch'ao hua-chêng lu* (vol.I, 2).

"Wang Hui, *tzǔ* Shih-ku, *hao* Kêng-yen wai-shih, came from Ch'ang-shu (*i.e.* Yü-shan in Kiangsu). Already as a boy he loved to paint, showing a natural genius in his brushwork and his skill in composition, thus surpassing the common painters of the time. When Wang Lien-chou from T'ai-ts'ang came to Yü-shan, Wang Hui made a fan-picture and asked a friend to present it to Lien-chou. This gentleman was greatly surprised by the work and asked to see Wang Hui. The young man presented himself in the attitude of a disciple. After some conversation, Wang Chien found Shih-ku still more uncommon and said: 'If you keep on studying you will certainly reach the level of the old masters', and he took the youth home with him. He advised him first to study the old masters' calligraphy. After several months he instructed him personally by means of famous paintings and sketches, which all caused great progress. Then when Wang Chien was sent as an official to a distant place, he thought that there was nobody other than Wang Shih-min with whom Shih-ku could complete his studies, and consequently he introduced him to Fêng-ch'ang. The old man inquired about his studies, and exclaimed then: 'He could be my teacher!' When Wang Shih-min travelled along the Yangtse river, he took Shih-ku with him, who in this way had excellent opportunities of seeing and copying many precious works in private collections. It was not simply because Wang Shih-ku was a highly gifted man and a great student that he became the foremost painter of the time, but also because of the instructions that he received from the two older Wangs. Whenever Wang Shih-min saw Wang Hui's studies, he said with admiration: 'The resonance of the life-breath and the composition are just as lively and natural as in the old masters' works. My life is drawing to its close, what good fortune, that I could still meet Shih-ku. I only regret that he was not old enough to meet Tung Ch'i-ch'ang.'

"When Wang Chien later on saw his pictures, he

remarked: 'How far he has reached; the master is not always wiser than the pupil'.

"The emperor Shêng Tsu (K'ang-hsi) ordered him to make pictures of the imperial journey to the south. This order was perfectly carried out. The painter was richly rewarded and left for home. Some nobleman at court sent him a tablet which contained the three following characters: *Ch'ing Hui Ko* (Pavilion of Pure Radiance), and henceforth he called himself the Master of Pure Radiance (Ch'ing-hui).

"He lived for thirty years in his home, entertaining many people with his works, which he did even at night by candlelight. He used to say: 'I am quite happy and know no fatigue'. Sometimes when he did not feel quite satisfied with his work, he reproached himself severely. All the poems and writings which had been addressed to him by noblemen and officials, he carved on wooden tablets and published in ten volumes called *Writings Offered to Ch'ing-hui*. His correspondence was published in two volumes and he died at the age of 89."[1]

In addition to this biography may be quoted a few notes on Wang Hui's art by other critics who knew him personally. The earliest among them is probably Chou Liang-kung, who wrote his work *Tu-hua-lu* before 1672, when Wang Hui was still a young man of moderate fame, but nevertheless highly esteemed:[2] "Shih-ku's copies after Sung and Yüan masters are absolutely faithful to the originals. The people in Wu used to ask him to paint, and then they mounted his paintings in the fashion of the old masters' works, so as to fool connoisseurs. Among all the painters who copied the old masters there are really only two, *i.e.* Chao Ch'êng (Hsüeh-chiang) and Shih-ku. The former is very closely bound by the old rules, and does not give anything of himself, whereas Shih-ku is a great genius by nature, youthful and strong. What he paints may indeed be placed on a level with the old masters' works. He is the greatest painter that has appeared for a century.

"In the *chi yu* year (1669), when I had returned from my official post, he came to visit me in Nanking. He lived in the Hsü-têng temple and painted sixteen pictures for me. In my old age and amidst all my troubles I found great pleasure in these paintings. I have in my collection fifty albums collected in forty years, but this album by Shih-ku is the latest acquisition and it brings my collection to a close."

We have already had occasion to quote some of the very enthusiastic opinions about Wang Shih-ku's art expressed by his two older colleagues Wang Shih-min and Wang Chien. Both had an almost limitless admiration for his talent and his skill as a transmitter of the old ideals, and neither of them spared superlatives in characterizing their idol. One or two short quotations from their colophons may here be added. Thus, Wang Shih-min wrote:[3] "Mr. Wang Shih-ku from Yü-shan is a great genius by nature and a pupil of Lien-chou. From him he received the true teaching and devoted himself to a very close study (copying) of the old masters and grasped the deepest secrets of this art. Recently he came to see me together with Lien-chou and they asked me to show them my collection of Sung and Yüan paintings. They studied them all in a very intelligent way and understood how to pick out the mysterious points beyond the brush and ink, something which other men of this generation could hardly do. He will certainly keep on advancing continuously in the future. This picture of his is an imitation after some Sung and Yüan masters and contains impressions which he gathered during his life from famous pictures. He carried them in his bosom and expressed them with his brush. His *ch'i yün* is, in parts, even superior to that of the originals. He expressed with his hands what he perceived with his eyes. Certainly, he marks the highest perfection of the art of our time. It is only through him that painting in Wu may be saved from the decline into

[1] According to Wang Hui's epitaph quoted in *T'ung-yin Lun-hua*, he died in 1717 at the age of 85 (or 86, according to Chinese reckoning).

[2] *Kuo-chao hua shih*, vol.IV.

[3] Cf. *Wang Fêng-ch'ang Shu-hua t'i-po*, II, 1, 28.

which it has fallen. He may be called not only a hero of his own time but one who will always be admired."

The various colophons in which Wang Chien has commended and applauded the younger master are not of great interest, but a few lines from one of them should here be added so as to give an idea of the teacher's admiration for his pupil:[1] "Last winter I met Wang Shih-ku and Shên I-tsai in Suchou and had an opportunity of seeing their works. Both followed Huang Kung-wang, but they both produce still greater wonders. They are like the brightness of the moon meeting the glow of sunset, and keep the beholder busy and breathless. This scroll was completed in one evening by Shih-ku as a gift for I-tsai. The brushwork is vigorous and beautiful, the inspiration overflowingly rich. I liked it so much that I wanted to take it with me, acting like the mad Mi, who carried away pictures quite shamelessly in his boat. But that would not be the proper thing to do to a friend. Therefore I wrote this colophon and returned the picture."

Among the numerous literary men who have expressed themselves on Wang Shih-ku, Han T'an (1637–1704) was, no doubt, one of the best informed. He served as Chancellor of the Han-lin Academy, president of the Board of Rites and in other prominent positions and seems to have taken a keen interest in painting. In his work called *Yu-huai t'ang chi* he included the following characterization of the painter:[2] "Wang Hui was a recluse (*shan-jên*) with a wonderful spirit and mind. His knowledge of Tao enriched the world. His bosom was filled with hills and valleys which flowed out on the paper and the silk. He was able to combine in his works the Six Principles and to follow the two schools. When the imperial prince, who was then the heir apparent, heard about his fame, he summoned the painter to the palace, treated him as an equal, offering him a seat at his side, and allowed him to wear his hermit's cloak. Then, when Wang Hui was given his task, he painted in a majestic fashion, quite unfettered as if he had been in his own studio, and was greatly admired by the prince, who wrote for him four large characters: *Shan-shui ch'ing-hui* (A pure and luminous landscape), an expression taken from a line of poetry by the Chin poet Hsieh Ling-yün."[3]

Wang Hui's position in the history of Chinese painting and his artistic importance are indeed questions which may be differently answered, according to the point of view from which they are considered. Few painters have been as highly extolled and eulogized by their contemporaries as he, few have corresponded as completely to the ideals prevailing among the leading critics of the time. From their point of view he was the greatest artist that had appeared for a hundred years (*i.e.* since the time of Tung Ch'i-ch'ang), and those who wrote about him at a somewhat later period could, with equally good reason, say that there was nobody after him who could be placed on the same level.

But if we consider Wang Hui's artistic personality and enormous output of painting from a more detached viewpoint, in relation to the whole history of Chinese painting, the conclusions must be different; he can hardly be placed among the greatest creative personalities or those who have contributed important new elements to the development of painting. He lived largely on the inspiration of his predecessors, and transmitted their ideas with remarkable success. This did not constitute to the Chinese a drawback or limitation as long as it could be admitted that the transcriptions of earlier models reflected the spirit of the old masters as well as their formal manners. To us it may be more difficult to discover the merits of an artist who is striving for perfection within the accepted limits of established schools of patterns than of one who introduces new modes of expression and does not hesitate to give vent to his own temperament. But with the Chinese the case was reversed; they never forgot or denied that traditionalism was the very backbone of their

[1] *Hua-hsüeh hsin-yin*, vol.III.

[2] Quoted in *Kuo-ch'ao hua shih*, IV, 1, 2.

[3] Another more elaborate version of the tradition how Wang Hui received his *hao* Ch'ing-hui.

pictorial art. Hence it was natural that Wang Hui became to them an ideal painter, a creator as well as a transmitter, and one who was well fitted to serve as a model for later generations.

The very numerous works by Wang Hui preserved in Far Eastern collections and to a large extent known in reproductions, are with a few exceptions free renderings of paintings by earlier masters. But there are wide differences in regard to the faithfulness of these "imitations". Some are evidently quite close copies painted after definite originals, others free rhapsodies or variations on the themes, or in the manners, of certain predecessors. Most of the minor album-leaves are of the latter kind; they contain impressions or souvenirs of old masters without being faithful reproductions of their works. We have seen that Wang Shih-min and Wang Chien did many pictures of this kind; they were, on the whole, more independent as artists in spite of their profound veneration for historical tradition. Wang Hui's penetration into the old models was more complete, his suppleness and versatility still greater, but whether he actually reached a higher standard as an artist (as asserted by his older contemporaries) seems to us less obvious (Pl.400).

Most of his paintings are marked by the names of the artists whom he followed, and although we are not always in a position to decide just how closely he has imitated them, we may draw certain conclusions from such inscriptions as to his studies and preferences among the old masters. The T'ang period is represented by two well known names, Wang Wei and Lu Hung-i; one leaf in the album of coloured landscapes (dated 1706)[1] is an imitation after Wang Wei, while another album is made up of illustrations to Wang Wei's poems. Lu Hung-i's famous picture of his Straw-covered Hut on the Sung Mountain (mentioned in a previous chapter) interested Wang Hui in particular; he borrowed it, according to an inscription, from its owner and copied it (1688) in a rather free manner, but when he saw Wang Mêng's version of the same picture (1694), he found it still better and he made a copy of

this (which shows considerable difference in design and execution).

The great landscape-painters from the beginning of the North Sung period were among his principal models. He copied or imitated most of them during his long life in large compositions as well as in album-leaves. The name of Kuan T'ung appears on seven pictures (Pl.401), Kuo Chung-shu on two pictures, Ching Hao on three, Li Ch'êng on a dozen, including a separate album of studies after him, Fan K'uan on four, Hui-ch'ung on three, Chiang Ts'an on three, including a long horizontal scroll (1695), Hsü Tao-ning on two, Tung Yüan on eight or nine pictures, some of which may be classified among Wang Hui's most important works, Chü-jan on more than a dozen pictures, among which should be noted a complete copy of the master's famous scroll: The Lin-an Mountains (1696); Yen Wên-kuei on three or four important pictures. Mi Fei and Mi Yu-jên also appear among the models of Wang Hui; he has imitated their vaporous manner in at least half a dozen of the pictures reproduced. But he also studied and copied with great care painters of a more refined academic type, such as Chao Ta-nien (four pictures), Li Lung-mien (one picture), Chao Po chü (five pictures), Liu Sung-nien (two pictures), and in addition to these he made copies of Hsia Kuei and Hsiao Chao.

The pictures executed after, or in the manners of the Yüan masters are hardly less numerous, though generally of a freer kind, many of them being simply sketches in the style of, or according to the characteristics of so and so. This is true of the album-leaves marked with the names of Wu Chên (three), Ni Tsan (eight), and Huang Kung-wang (ten). Yet even among the pictures after these men there are some complete copies such as the long handscroll reproducing Huang Kung-wang's *Fu-chun shan-shū t'u*, now in the Freer Gallery, and Ni Tsan's Bare Trees by the Shore.[2] Chao Mêng-fu, the

[1] In the possession of Mr. Wu Ch'ing-ch'ing, published in colours by the Yu-chêng Co.

[2] *Ōmura*, I, 5 (former Abe collection).

transmitter of the classic ideals and great virtuoso of the brush, was evidently a master who accorded with Wang Hui's taste. He painted at least a dozen "copies" after Chao Mêng-fu, some on a minor scale, but others of large size in close imitation of important compositions, as for instance the Mountains in Spring with Rushing Waters (1671), on which Tan Chung-kuang has written the words: "The only one after Chao Mêng-fu",[1] and the Mountain of the Immortals (1689), a very imposing view of high mountains and luxuriant trees, partly enveloped in mist, executed in a fine *kung-pi* manner,[2] or the long scroll in the National Museum in Tōkyō, called The Endless River and Mountains. It may be said that Wang Hui had many points of natural contact with Chao Mêng-fu, which made his interpretations of the Yüan master almost worth the originals.

His pictures in the manner of Wang Mêng, of which there are a fair number, are more uneven, some of large size representing magnificent mountains, deeply creviced with rushing streams and luxuriant trees, some in the shape of more sketchy album-leaves. The former can hardly be said to belong to Wang Hui's more successful works, because although the imposing designs are faithfully rendered, the brushwork has not the structural quality which forms the backbone of Wang Mêng's paintings.[3] The latter are often interesting and expressive, because in them Wang Hui plays with the brush in the firm and strong mode of the great Yüan master. We shall have occasion to point out some of these sketches in particular. Here it need only be added that he also painted close imitations after Kao K'o-kung (three), Fang Ts'ung-i (two), Ts'ao Chih-po, and other Yüan masters of the same highly expressionistic kind. His brushwork was strongly influenced by them, even though he could work with equal success in the *kung-pi* manner of Sung academicians.

Wang Hui's studies also included several leading masters of the Ming period. He painted single copies after Wang Fu, Chu Fei, Tung Ch'i-ch'ang and others; two are marked with Shên Chou's name and

six with T'ang Yin's. In some of these he has rendered the Ming master's imposing mountain designs with great care, as may be seen in the large picture in the National Museum in Tōkyō (1690).[4]

The pictures and the names enumerated above by no means include all Wang Hui's imitations after old masters; the materials from which they are gathered are fragmentary, and even among these there are several specimens marked simply as imitations after old masters (without specific names), and others which have no indications of the kind, although they are obviously painted in the manner of Tung Yüan, Chü-jan or some other more or less recognizable masters.

It seems, after all, that Wang Hui had so thoroughly absorbed the manners of the old masters and acquired the habit of reproducing them that even when he simply played with brush and ink, or painted things directly from nature, he did it in adherence to one or several of these predecessors. As an example of this may be mentioned the picture of his own study in a bamboo grove called the Kêng-yen Cottage (1682), which is painted in the same delicate manner as we know from some of T'ang Yin's pictures,[5] whereas the two leaves which he painted in the album devoted to the journey of the master and his four pupils to Yü-shan (1701), are executed in a manner combining elements from Wu Chên and Huang Kung-wang. The combination of characteristic features or elements of style borrowed from various old masters is not uncommon in Wang Hui's paintings; he evidently had absorbed the best of the old models so thoroughly that he seldom or never could completely free himself from their domination. In other words, he speaks with a borrowed vocabulary even when he has something of his own to say. But this kind of

[1] *Ssŭ Wang*, p.14 (Yamamoto collection).

[2] *Nanju*, vol.19 (Baron Sumitomo collection).

[3] Cf. *Chung-kuo*, pp.87 and 93; *K.-k. shu-hua chi*, vols.7 and 8.

[4] Cf. for inst. *Chung-kuo*, pp.87 and 93; *K.-k. shu-hua chi*, vols.VI, VII (1684), VIII (1693), etc.

[5] *Yuchikusai* (Ueno catalogue), p.9.

consummate traditionalism (if we may call it so) did not prevent him from devoting close studies to nature or from painting time and again rather intimate portrait landscapes.

Among such paintings may be mentioned the handscroll called Transporting Bamboos, which he painted for his friend Ch'ing-yün in 1698, when he was staying in the pleasant garden by the river to which the bamboos were brought (Pl.408, 409A). It contains some characteristic scenes from this place, bits of the garden with its pavilions and trees along the canal, transports approaching on the river (one of the boats loaded with bamboo plants) and small houses around the various courtyards enclosed by wattled fences. Every detail is faithfully rendered and there is a tone of intimacy over the whole picture, yet one cannot help noticing the painter's dependence on the brushwork of such predecessors as Wang Fu and Shên Chou. Some portions might have been painted 200 years earlier even though the brushwork may seem a bit dry.

Another of Wang Hui's landscapes that may be remembered in this connexion is the River View in Mr. Ernest Erickson's collection which is dated 1694 (Pl.402). Here the artist has apparently tried to give the view over the river as actually seen from a definite point in front and almost on a level with the water. The foreground is accentuated by a kind of screen-like rock wall, which rises to the middle height of the picture, beyond which the water forms a wide plain stretching to a distant horizon of wavy hills. Only a small stream rushes down between the rocks in front, while the main portion of the river is, so to speak, dammed up in a wide reservoir or upper level, which forms an effective contrast to the foreground screen. This rather peculiar juxtaposition of the horizontal and vertical elements of the composition could hardly be an invention of the painter; it must have been observed in nature, and he has apparently taken great pains to render it faithfully with the inclusion of such details as the numerous human dwellings on various levels and the wanderers approaching on the bridge that spans the stream.

Other river scenes of a more ordinary type with low shores, rushes, bridges and boats which are included in some of Wang Hui's sketchbooks, confirm the impression that he was no less eager in his studies of nature than in imitating the old masters, even though the latter were of greater importance for the development of his style and brushwork.[1]

Further descriptions of Wang Hui's "copies" or interpretations of the old masters, as mentioned above, would require more space than we can allot to the subject in this place;[2] they are very numerous and offer interesting material for retrospective studies of Chinese landscape-painting from the tenth to the sixteenth century, though it must be admitted that Wang Hui has rarely grasped as much of the individual significance or the spirit of the old masters as for instance Tung Ch'i-ch'ang. He gives the designs and general appearance of the models very carefully, but in a more or less undifferentiated manner which seldom serves to transmit the more intimate individual features of the models. Practically all his imitations, as well as his other pictures, are brilliant testimonies of his wide historical knowledge, skill and mastery of the brush, but reveal as a rule less of his own artistic temperament than the pictures he painted as records of observations of nature and actual landscapes. One of the best series of such studies are the eight large leaves, dated 1677, which together with some poetic inscriptions by Yün Nan-tien (on separate leaves) form an album which I saw 1929 in a private collection in Peking. They may here serve as typical examples of Wang

[1] Cf. for inst. the sketches by Wang Hui and some of his friends recording their journey to Yüshan in 1701, published in a Chung hua album 1920.

[2] Among the great number of reproductions published in China and Japan of Wang Hui's studies or copies after old masters, the following should be noted: Albums published by the Chung-hua Co., Shanghai 1918 (dated 1703), 1920 (dated 1701), 1919 (dated 1682), 1921 (dated 1696), 1922 (dated 1705; Li Ch'êng only). Shina Nanga, vol.I, pp.61–70 and vol.II, pp.1, 3. 7, 9, 12 represent somewhat larger and more elaborate copies of the famous masters. Other albums of similar kind have been published by the Yen-kuan Co., and the Commercial Press in Shanghai. There is hardly any other painter in China whose works have been more abundantly reproduced than Wang Hui's.

Hui's qualifications as an interpreter of life in nature in words as well as in visual representations.

The first leaf represents two leafless trees and some thin bamboos on the rocky shore of a wide bay (Pl.403); it has the following poetic inscription:

"The view is bleak and desolate, the year is ending.
The frost has coloured all the woods and hills.
The trees are old, but still their hearts are strong,
 the bamboos thin, yet high, their hearts un-
 quenched.

A play with brush and ink while on the way to Yü-fêng." (1767).

The second leaf represents a mountain hump and trees partly enveloped in mist, painted with a soft brush in the Mi Fei manner (Pl.405). The inscription contains the following explanation of the motif:

"The blue mountain is the father of the white clouds; the clouds are the children of the blue mountain. They trust (lean upon) it all day long, although the mountain does not know it. – Chien-mên Ch'iao-k'o."

The third is a view of a river at the foot of high mountains. On the rocky shore in the foreground, where the water is rushing between the boulders, is a low straw-covered pavilion and some jerky old trees. The painter has noted on this: "My boat is moored at Lou-kuan, and I am painting Ni Tsan's quiet stream and dry pines" (Pl.404). But in addition to this, Yün Shou-p'ing (in 1683) wrote a poem and a note on an adjoining leaf which expressed a different opinion:

"When were these rugged mountains chiselled by
 the demon's axe?
When did the spirit of the mist reveal the valley?
The moon that stood above the pines is moving
 now behind the mountains.
The cranes are startled in their nest. One hears a
 crying in the night.
"I once saw a small picture by Lu Kuang which was so much like this that the two might have been by the same master's hand. Shih-ku wrote quite wrongly that it is like Ni Tsan, which I now correct."

The fourth is a shore view, with a man in a pavilion built over the water under an overhanging leafless willow. No old painter is mentioned in the inscription but the manner, which is admirably free and light, seems in this case even closer to Ni Tsan's than in the previous instance.

The fifth represents a narrow valley between steep terraced cliffs where a stream is winding down, and contains the inscription: "Spare trees and creviced cliffs, after a picture by Ni Tsan", an indication which again must be interpreted in a very general sense, because the resemblance is quite vague.

The sixth represents a high precipice of a verdant mountain. The valley below, where some huts are built over the stream, is filled with mist. It is painted in a soft, fluent style, partly with light washes, and in the short inscription the painter says: "Between Ta-ch'ih (Huang Kung-wang) and Chung-kuei (Wu-chên)", an indication which again is corrected by Yün Shou-p'ing in his adjoining inscription. He says that the picture resembles rather Chang Yü (of the Yüan period) and Chao Yüan (early Ming period), "but this reminds me of Su Tung-p'o's words that 'those who judge pictures by the outward likeness are like children'. Let us wait; when Shih-ku sees this, he will laugh at me."

The seventh represents a rocky hump with some bamboos and a leafless tree. It is also an autumn scene with a poetic meaning reflected in the poem:

"The sun is pale, the wind is strong, the tree-
 leaves falling.
But still the slender bamboos move with ease.
The hermit grasped the thoughts of trees and
 springs,
And came to know them all in his profound
 seclusion."

The eighth picture offers still another variation on the leading motif of stones, bamboos, and leafless trees no less remarkable for life-breath and strength of brushwork than any of the preceding renderings of the same motif. According to the inscription, it was painted by candlelight at a place where the painter had been forced to stop by rain. Like all

these pictures it is an "ink-play", written down as a lyric improvisation in those symbols of nature which were closest to the painter's heart. The brilliant brushwork of these pictures is evidently based on Ni Tsan and Huang Kung-wang, though it must be admitted that Wang Hui has not quite reached the atmospheric beauty and airiness which is perhaps the most essential quality in their works. Wang Hui paints with a somewhat heavier hand, stronger opposites of black and white, and more emphasis on the outlines of the single forms than his predecessors, a tendency which becomes still more evident in his later works. In his colophon to this album Wang Chien says that "in Shih-ku's paintings every single brush-stroke reflects the spirit and the marrow of the Sung and Yüan masters", which may be true in a general way, because most of what Wang Hui did is permeated by recollections of some old master, though his actual brushwork is not always modified accordingly. It all depends on the degree of sympathy that he may feel for the master.

His extraordinary versatility as a painter and interpreter of the old masters makes it very difficult, not to say impossible, to trace in his very rich œuvre a gradual development of style and brushwork, though he has, on the other hand, greatly facilitated an historical study of his works by dated inscriptions on the great majority of his paintings. No other painter has (to our knowledge) signed and dated so many pictures as Wang Hui, but since the consecutive dates do not correspond to a clearly marked succession in the stylistic character of the picture, they are not so helpful from the student's point of view as might be expected. The general tendency in his evolution of style may be said to be towards increasing freedom and strength in the brushwork; but the versatility is also increasing. In other words, his mastery as a virtuoso of the brush becomes more evident, and he is quite able to produce in the same year pictures in the manners of Li Ch'êng and Chü-jan, or of Chao Ta-nien and Mi Fei. The stylistic models influenced the brushwork, but they were not as a rule of primary importance.

The greatest works of his later years are the long handscrolls representing the so-called Ten Thousand Miles of Rivers and Mountains, generally inspired by the views along certain sections of the Yangtse River, freely arranged and interpreted in accordance with the stylistic principles of some earlier master. Three of these scrolls may here be mentioned as typical examples of the trend of stylistic development and leading influences in Wang Hui's later works.

The first is the so-called *Wan-li shan-ch'uan t'u* in the H. C. Wêng collection in Scarsedale, N.Y. (Pl.406). According to the inscription this was executed in 1699 in the manner of Yen Wên-kuei, the Sung master who is often mentioned as a model for late Ming and Ch'ing painters and whose individual style is quite well known through still preserved original paintings. The stylistic similarity between these and Wang Hui's scroll is, however, so slight that it can hardly be said to offer any actual support to the statement of the inscription. Wang Hui's paintings are executed in a very refined *kung-pi* manner with addition of colour and thus quite unlike Yen Wên-kuei's somewhat harsh and forceful ink-paintings. It is a supreme effort of technical skill carried out on a very extensive scale, highly entertaining as an illustration of the life on land and water along the great river and exquisite as a colourful miniature of archaistic type.

The long scroll which Wang Hui painted ten years later (1709) forms by its stylistic character and execution an opposite to the above-mentioned picture. It is known as Snow on a River (*Hsüeh-chiang t'u*) and has always been treasured as one of the most famous pictures in the imperial collection. But no critic could possibly suspect that these two scrolls were painted by the same artist; they represent totally different currents of style. The later one is a pure ink-painting executed in a rather bold and rash manner, very effective in design as well as by the rich variation of ink-tones from the jet black through the pearl greys to pure white, which produce altogether the moisty atmosphere of new fallen

snow. We are here invited to travel with the small donkey-riders through a landscape of imposing grandeur that unfolds new aspects at every step. It is essentially of the same kind as some of Shên Chou's later works, even though it does not possess the poetic suggestiveness or undertone of the Ming master's creations.

Twelve years later (1711) Wang Hui painted a third scroll of almost equal dimensions. This picture, which forms part of the Ernest Erickson collection, is known as Innumerable Peaks in Mist along a River and is also marked by the painter's inscription as a work in the manner of Yen Wên-kuei, a statement which here seems more convincing than with regard to the scroll of 1699 (Pl.407). The two scrolls have hardly anything in common, nor has this long display of Innumerable Peaks in Mist any stylistic relation with the Snow over a River; it represents a different style and is painted in a different manner than the preceding example, though they are both ink-paintings on paper. Wang Hui has here made the greatest effort to remain as faithful as possible to the Sung master whom he has chosen as a stylistic model or guide. Yen Wên-kuei's manner of forming a dense composition of innumerable misty peaks, cloud-like rocks, curving streams filled with stones, and massed trees in the folds of the mountains is perfectly imitated, though in a manner which tends to become rough owing to excessive emphasis on every detail. Wang Hui has returned here to his ideals of early years, when he followed the great masters of the North Sung period most closely, yet he now feels more independent (or self-satisfied) and takes greater liberties in interpreting the classic models. The supple charm of some of the earlier imitations of Sung paintings has been replaced by a bolder and more rugged handling of the brush.

This is further illustrated by the picture that he executed at the age of 85 (1717), in which he has given his version of a typical composition by Li Ch'êng; but the motif and the way it is rendered may also lead our thoughts to Wên Chêng-ming's

paintings of the kind executed at a corresponding age. It may be said to express a similar state of mind, a similar concentration on the rugged strength of the old trees to what we find in works by the Ming master. The bare trees against the bleak sky and the small birds swarming in their tops convey an impression of chill and approaching death – snow will soon fall and spread its peace over a life which is exhausted. This picture may, indeed, be considered as a swan-song – and not very brilliant as such, because the aged master was well conscious of his failing forces as the years passed and the fact that he had reached his peak at an earlier age. Several years before he did this picture he wrote in a colophon:[1]

"This picture was painted forty years ago; the years have been running quickly. My old friends are now all scattered, and I do not remember for whom it was painted. Now I am old and have neglected practice for many years; my energy is spent and worn out. But I feel that my works of former days are to some extent like those of the old masters. I begin to realize that the Tao of painting is very difficult and that the more one searches for it the further it recedes. I opened this picture, looked at it and wrote these few words to make a record of my feeling of humiliation." (Dated 1701.)

In some of his other colophons Wang Hui has noted down general remarks and advice in regard to painting; for instance: "Every picture should contain portions made with a coarse brush and others executed with a fine brush, i.e. thick and light, dry and moist parts; then it will reveal a good hand. If the brushwork is uniform all through it will look empty.

"Painting has its light and its dark parts which are just like the two wings of a bird; it cannot dispense

[1] Sixteen of Wang Hui's colophons are reprinted in *Hua-hsüeh hsin yin*, vol.IV, pp.33, 34, under the title *Ch'ing-hui hua-po*, but whether a separate book under this title ever existed seems uncertain. It is not the same as *Ch'ing-hui tsêng-yen*, which contains miscellaneous poems, dedications and writings by friends of the painter, etc., a collection arranged by Wang Hui himself and re-edited by a descendant of his (in 10 vols.) in 1836.

with either of them. If one can give the proper combination of light and dark, the spiritual expression will ensue.

"Take the brush and ink of the Yüan masters and paint with them the hills and valleys of the Sung masters; enrich the work with the *ch'i yün* of the T'ang masters, then your work will become perfect."

Such was the programme which Wang Hui was trying to carry out in his artistic activity – with obvious success. If he did not reach the level of the great creative masters, the fault was perhaps less in his own personality than in the programme which he accepted, like most of the great painters of the time, as the safest road leading towards the ideals of the old masters. The opinion expressed on him in *T'ung-yin lun-hua* (vol.I, p.2) epitomizes perfectly his attainment as a painter and the appreciation accorded to him by later generations: "Wang Hui's

natural gifts as well as his faculty of incessant work were of the highest order. He combined in the work of his brush the Northern and Southern schools which, since olden time, had been like a round hole and a square peg, which did not fit together. He started a new school and was, indeed, a sage in painting ... No other master could reach him. He belonged to the class of the skilful painters (*nêng p'in*)."

Wang Hui had a large following; he was just the kind of painter from whom the younger generation could learn professional secrets; a great number of them were influenced by him even though the Yü-shan school, as such, was a very vague proposition in consequence of its prevailing eclecticism. Before we turn to these younger painters, we must, however, pay attention to Wang Hui's most prominent contemporaries, Yün Shou-p'ing, Wu Li, and Wang Yüan-ch'i.

II

Wu Li

Wu Li, better known under his *tzŭ* Yü-shan and his *hao*, Mo-ching Tao-jên (the Taoist of the Ink-well), was to begin with a close companion of Wang Hui. They were both born in 1632 in Lou-tung (Ch'ang-shu), and they started their artistic careers together as pupils of Wang Shih-min. They were equally gifted as painters and it seemed as if they were going to follow parallel paths through life until Wu Li was led in a different direction by his devotional nature and the influence of some Jesuit missionaries. This may not have caused a definite breach in their friendship (as is asserted by Chang Kêng), but it certainly brought with it a deep estrangement which evidently was not lessened by Wu Li's attempt to arouse in Wang Hui a response to a foreign and devotional religion.

The records of Wu Li's life are not very complete; in the local chronicle of his home, *Ch'in-ch'uan chih*, it is said that "he was a descendant of Wu Na, whose posthumous title was Wên-k'o-kung. He was a man of simple ways, who kept away from the crowds of the world; an excellent *ch'in* player as well as a poet and a landscape-painter; through all these arts he expressed his noble spirit. Wang Shih-min praised him highly. In his old age he retired completely from the company of men and no one knows whither he went."[1]

In *Kuo-ch'ao hua-chêng lu* (I, 2, pp.21–26) he is characterized as follows: "Wu Li was a good painter of landscapes who followed the Yüan masters and particularly Huang Kung-wang. He expressed quite

[1] Quoted in *Kuo-ch'ao hua shih*, vol.IV, 1, 4, 5.

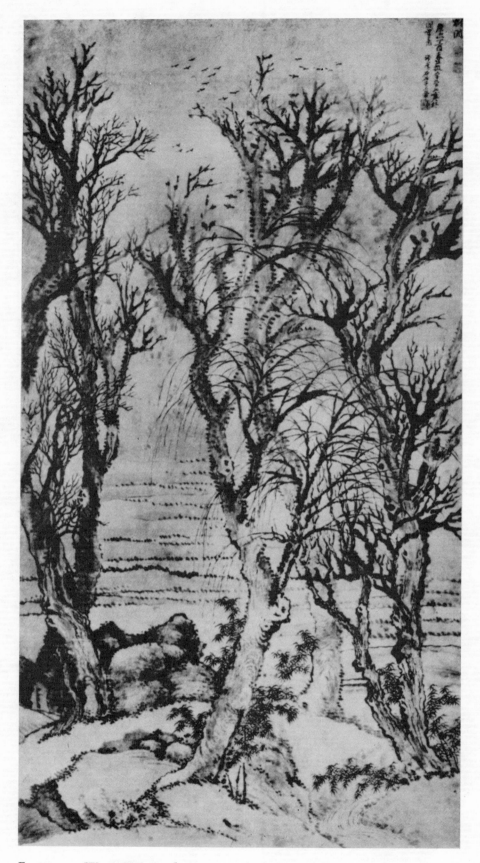

FIGURE 7. Wang Hui, Leafless Trees and Black Birds by a Stream. Dated 1717. Formerly T. Yamamoto Collection.

independently his own thoughts and heart in paintings of ranges of mountains and peaks beyond peaks, presented in a heavy atmosphere, tinged with melancholy. He utilized well the legacy of Wang Shih-min. In their early years Wu Li and Wang Hui were close comrades in painting and perfectly adapted to each other, but when Wu Li later on borrowed Wang Hui's copy of Huang Kung-wang's Steep Cliffs and Deep Woods and did not return it, this caused an estrangement between the former friends." To this characterization the writer adds the following note: "It seems to me that Wang Yüan-ch'i in his discussions of painting often favoured Wu Li and depreciated Wang Hui. He said to his pupil Wên I, that there was really only one painter at the time, *viz.* Wu Li, and that all the rest were not worth counting. However, in the works by Wu Li that I have seen, the strength of the brush-work is not half as good as in Wang Hui's paintings. In comparing the two masters Wang Yüan-ch'i did not avoid the bad habits of celebrities and was not quite just."

Chang Kêng was evidently not very well informed about Wu Li's life; he gives no indication of some of its most important events which, however, must have had a great influence on the painter's activity. Somewhat more detailed, though still rather incomplete, is the biography in *P'u-an-wên ch'ao*, a book apparently written about the same time, though the author is unknown to us:[1] "At the place where Wu Li lived (*i.e.* Ch'ang-shu) there existed the so-called Ink Well of Yen-tzŭ (*i.e.* Confucius' disciple Yen Yen), and from this the painter took his *hao*: Mo-ching Tao-jên. In his calligraphy he followed Su Tung-p'o. Once he started for Wu-hsing (in Chekiang) in order to pay a visit to the prefect, but before he arrived at his destination he came to a monastery, and there he saw an actual manuscript by Su Tung-p'o, called *Tsui-wêng t'ing chi*.[2] This caused him great joy, and he asked the monk to find him brush and paper. He sat down on a mat, opened the scroll, and copied it for three or four days. In the meantime, the prefect

searched for him everywhere but could not find him. When he had finished the copy he went away.

"Later in life he started on a sea journey to Western lands; he travelled thousands of miles and saw then the strangest things in his life. After he came back he lived in seclusion in Shanghai, but often also stayed in Chia-ting, but did not go to any other place. His paintings became freer and more original, which could not be achieved simply by dint of study.

"In his early years Wu Li studied with Wang Hui under Wang Shih-min. Wang Hui became famous all over the country, and all sorts of people, high officials and rich merchants, came to him with silk, whereas the Taoist Wu Li, who lived in retirement by the sea shore (*i.e.* in Shanghai), was little known, and nobody could obtain even a small picture from him."

In the above account the great changes which took place in Wu Li's life about middle age are vaguely indicated, but the real cause of them, *i.e.* his conversion to Christianity, not definitely stated. This well-known fact is, however, recorded by other writers, particularly a man called Hsü Tzŭ-shan, who wrote an inscription on a portrait by Wu Li based on the epitaph of the painter.[3] He informs us that Wu Li's tomb was in the graveyard of the Jesuits outside the south gate of Shanghai, and that the stone on it had the following inscription: "The tomb of the Jesuit Father Yü-shan, Master Wu." At the side of this was an additional inscription in minor characters: "His name was Li and his saint's name (after he had been baptized) Simon, from Ch'ang-shu. He entered the Jesuit order in the 21st year of K'ang-hsi (1682), and in the 27th year of K'ang-hsi (1688) he became a *to tê* (*i.e.* a priest) and was sent to Shanghai and Chia-ting as a missionary. In the 57th year of K'ang-hsi (1718) he

[1] Quoted in *Kuo-ch'ao hua-shih*, vol.IV, 1, 4, 5.

[2] A copy of Ou-yang Hsiu's famous essay on The Pavilion of the Old Drunkard.

[3] *Cf. Chung-kuo hua-chia jên-ming ta-tzŭ-tien*, where Wu Li's life is related rather extensively and several minor chronicles, difficult of access, are quoted.

fell ill and died on the day of the Holy Virgin. He was then 87 years old."

These are apparently the principal dates from the life of Wu Li after he became a Christian. They have been repeated with slight variations and emendations by various authors, including P. de Prunelé, in an article in *Ostasiat. Zeitschrift* (vol.ii, 1914), who furthermore tells that Wu Li was baptized *c.*1680 by P. Couplet, the Jesuit father in Ch'ang-shu, and took the Christian name of Simon Xavier. This missionary invited Wu Li to accompany him on a journey to Rome, and the two friends embarked the following year (1681) on a ship which took them to Macao. There they lodged in the Portuguese monastery, which then was flourishing and influential, but when they related their plans to the superior of the monastery, he dissuaded Wu Li from the long journey and offered him instead an opportunity of studying at Macao. P. Couplet continued alone and Wu Li remained with the Portuguese Jesuits, probably until 1688, when he was ordained as a priest, under the name of Acunha, and was sent as a missionary to Shanghai and Chia-ting. He lived mainly at Chia-ting during the last thirty years of his life, and is said to have been a zealous expounder of Christian doctrines, but the tradition that he gave up all artistic work and burned most of his earlier paintings when he became a Jesuit priest is evidently misleading, because there are several important pictures by him dated after 1688 and these, like his earlier works, are signed: Mo-ching Tao-jên Wu Li, or Yü-shan, and it might be added that at least one of these pictures (dated 1700) expresses definite Buddhistic ideas in its motif as well as in the accompanying inscription. Wu Li may have become a sincere and devoted Christian, a conversion which, however, did not involve the abjuration of earlier ideas and occupations. It brought out a new facet of his strongly religious and speculative mind without changing its fundamental character. It should also be noted that the tradition of a rupture of the friendship between Wang Hui and Wu Li (reported for instance by

Chang Kêng) is misleading, because late in life the two artists still wrote colophons expressing great mutual appreciation, though they seem to have had little, if any, personal intercourse after Wu Li retired from the world and became active as a Christian propagandist in Chia-ting (Pl.410B). As a proof of this may be quoted the following inscription by Wang Hui, written in 1703, on a picture by Wu Li, executed in 1677:[1]

"Mo-ching Tao-jên, my study companion, was of the same age as I and came from the same district as I. Later on he concealed his whereabouts and retired from the world, and as I have been travelling all over the country, a long time has passed since we met. But whenever I see any of his wonderful ink-paintings, so very like those of the Sung and Yüan masters and absolutely perfect of their kind, I cannot help appreciating them very highly. This picture was painted for Mr. Ta-nien more than twenty years ago and is entirely free from common mannerisms. When looking at it one is in the presence of a great hermit, in deepest peace and solitude, *i.e.* with a man who is absolutely pure both inwardly and outwardly. It may be ranked with Ni Tsan's 'Shih-tzŭ lin' and Shih-t'ien's 'Hsi Ch'uan' picture and will be treasured like these for ages. I wish I could continue his work, but I fear it is too difficult to follow in his steps. There is no help for it! Wang Hui."

The picture in question, which represents some pavilions in a bamboo grove by a mountain stream, is called The Study in the Fêng-o Mountains, and is executed in a style based on studies of the North Sung masters[2] (Pl.411). It belongs to a group of early works by Wu Li which all reflect more or less the same influence from classic models of Northern Sung times. The earliest is a picture in the Ueno collection, painted in blue and green and dated 1659, which gives a free version of the Island of the Immortals.[3] The view is rather idyllic, with some straw-covered pavilions placed under shady trees by

[1] Quoted in *Hua-hsüeh hsin-yin*, vol.4, 1, 32.

[2] *Chung-kuo*, p.73.

[3] *Yuchikusai*, p.12.

a riverside. The mountains in the background rise through layers of mist; on the promontory in the foreground some Immortals are wandering in search of the mysterious fungi of longevity. On the picture there are no less than four poems, of which one is by Wu Wei-yeh, one by the well-known scholar and poet Ch'ien Ch'ien-i, and one by the painter himself, who writes in a highly Taoistic strain: "On the Shih-chou island the fungi of gold and the grass of jade grow everywhere; they do not wither for thousands of years. In the thickets on the mountains the spirits of earth have their homes, and here the fungi which grow by the paths are large as golden umbrellas. Heaven is moved by virtue alone, which even precedes the breath of the trees and the grass. How can its praise be chanted? The superior man may live for thousands of years."

The long horizontal scroll in the former Abe collection (Ōsaka Museum) is a more important work. It was painted in 1666 for Chu I-tsun and represents Spring in Chiang-nan, *i.e.* a distant view over a river landscape with leafy trees and small villages along low shores, and fishing-boats on limitless waters.[1] It is a picture of great beauty and refinement, executed with a fine brush that brings out all the details perfectly and at the same time suggests atmospheric values. The style reminds us of Chao Ta-nien's works, a master whom Wu Li evidently studied very closely, as proved not only by the inscription (and style) of this scroll, but by some other pictures such as the landscape representing a river beach with willows along the bank.[2] The style is the same in the two pictures, and in the latter Chao Ta-nien is definitely mentioned as the model.

In other early pictures Wu Li has imitated Wang Wei and Li Ch'êng with great success, as may be seen in a picture representing mountains in snow dated 1667 (formerly in the Yang Yin-pei collection in Peking).[3] Several artists wrote their appreciations on it, among them Wu Wei-yeh and Wang Shih-min, who said that "Yü-shan's snow landscape is light, noble and cold. He has truly transmitted the ideas of Wang Wei. Mo-kung (for whom it was

painted) is a solitary genius of the same kind as Wu Li, and therefore this picture is also in perfect harmony with him. When I opened it and looked at it, I could not suppress my admiration." We may agree; the picture has a strong atmosphere of winter chill and is apparently very close to the T'ang original.

The horizontal scroll after Li Ch'êng (in the Ueno collection) is dated 1673 and represents Clearing after Snow with Birds gathering in Bare Trees.[4] The stream flows at the foot of bulging mountains, drawn compactly in the manner well known from Li Ch'êng's works; bare willows mark the foreground at the beginning of the scroll where black birds are congregating. The continuation is formed by cliffs and mountain humps divided by crevices and groups of trees sprinkled with snow. It is light in tone and drawn in the firm structural manner of Li Ch'êng, though perhaps with greater refinement than we find in the Sung master's works. His emotional power and austerity have been transposed into effects of lighter lyric beauty.

Wu Li's close studies of certain Sung masters may also be traced in the very neat and refined technical execution of some of his intimate studies from nature. He seems to have absorbed the purely technical methods of painters like Chao Ta-nien and Li Lung-mien to such an extent that he could use them freely also when painting directly from nature. An excellent example of this is the little picture of a pine-grove in a mountain valley in the Saito collection[5] which by its closeness to nature and neat linear execution leads our thoughts to some of the most refined Dutch drawings of the seventeenth century no less than to Sung painters of the kind mentioned

[1] *Sōraikan*, p.53.

[2] *Chung-kuo*, p.72, also in *Shina Nanga*, I. p.60. Here may also be mentioned the handscroll representing Scholars Enjoying the Summer in Open Pavilions by the Riverside, which is dated 1679. It used to be in private possession in Hongkong; *cf.* our plates 408, 409B.

[3] *Ōmura*, II, 2.

[4] *Cf. Yuchikusai*, p.14; also in *Ssŭ Wang*, p.31.

[5] *Cf. Tōan*, p.50.

above (Pl.410A). The sincerity and charm of this simple little study from nature, rendered with utmost exactness, are furthermore emphasized in the artist's inscription: "It is difficult to master skill in painting, yet more difficult to establish proper relations in a painting (?) without skill. Therefore it is said: Follow nature outwardly but inwardly your heart."

No less attractive, though executed in a more sketchy manner is the ink-painting representing a small pavilion and tall trees by a river at the foot of high mountains, belonging to T. Matsui,[1] but the style is freer, formed after the Yüan masters rather than after models of the Sung period, an influence which increases rapidly in Wu Li's works after 1673. From this time onward most of his pictures reflect continuous efforts to follow in the footsteps of Wu Chên, Huang Kung-wang, and Wang Mêng. These names, and particularly that of Wu Chên appear henceforth very often on his pictures and in his colophons. A mountain landscape formerly in the Yamamoto collection, dated 1673, is indicated as having been made in the styles of Chü-jan and Wu Chên (Pl.412B). The motif is characterized in the inscription: "The woods are deep, the birds are happy. The dust is far away, the pines and bamboos pure."[2] The brush and ink-work has something of Wu Chên's clean and firm rhythm; it is richer than Huang Kung-wang's, yet not as dense as Wang Mêng's. Other pictures of a rather similar kind, likewise executed after designs by Wu Chên and in close imitation of his brushwork, are to be seen in the Ku-kung collection and in private possession in China and Japan,[3] but to describe them here in detail seems hardly necessary since they are all painted in the same style as the one mentioned above.

It may also be interesting to take note of some of the colophons written by Wu Li in praise of Wu Chên: "Mei Tao-jên's brushwork was pure and strong, original and rich, always full of variation. He expressed new ideas but kept nevertheless within the rules of the style. The wonder of his art reaches beyond the unrestrained; it is perfect, as if accomplished by Heaven. His ink contains all the five colours. Such was Wu Chên's particular genius. No later painters have been able to reach it."[4]

Wu Li returns several times to the same points which aroused in him such a deep and warm admiration for the pure and harmonious brushwork of Mei Tao-jên; and he praises in particular the master's way of using ink-dots: "Mei Tao-jên thoroughly understood Tung Yüan's and Chü-jan's manner of dotting moss. He often left so many of his paintings (unfinished) without dots that they filled up a whole box. When someone asked why he did so, he answered: 'Today my thoughts are troubled and dulled; I must wait until my mind becomes clearer again, then I shall do it'. The training of painters in former times was like the melting of gold in fire."

Wu Li seems to have felt the most spontaneous sympathy for Mei Tao-jên, but his admiration for Huang Kung-wang as a painter was certainly no less. He has paid homage to Ta-ch'ih in several colophons and also in paintings of great interest. It may be recalled that he made a copy of Huang Kung-wang's famous Fu-ch'un scroll, which he describes in detail, and also of another picture by the master called "Floating Mist over Warm Green" (Hills), which later on was buried with its owner. A large album-leaf (in private possession in China?) which represents a hilly slope overgrown with luxuriant verdure is inscribed by Wu Li as being an imitation after the Fu-chun picture (or rather a small portion of it.)[5] It is, as a matter of fact, rather different from other paintings marked as copies of the Fu-chun scroll, but certainly not inferior. In the intricacies of the design and its rich pictorial effect it surpasses the pictures by the two older Wang or

[1] Cf. Toyō, vol.XII.

[2] Ōmura, I, 10.

[3] Cf. K.-k shu-hua chi, vol.9; Ōmura, I, 3, likewise in the Yamamoto collection; Ssŭ Wang, p.33, Lo Chên-yü collection; Chung-kuo, p.71, also in Shina Nanga, I, p.58; and Shina Nanga, part iii, vol.8.

[4] Sixty-three colophons by Wu Li are reprinted in Hua-hsüeh hsin-yin, vol.IV, and in Chao-tai ts'ung shu under the title: Mo-ching hua-po.

[5] Reproduced in Shina Nanga, vol.I, p.56.

other contemporaries based on Huang Kung-wang. Wu Li has apparently succeeded in transmitting more of the original atmosphere than the other students of Huang Kung-wang, and thus makes us feel the pictorial beauty and life-breath of the great Yüan master's works which made them so highly appreciated by all painters.

He gives a characteristic testimony of his admiration for Huang Kung-wang in the following colophon, in which he also relates an anecdote in order to emphasize the master's superiority in handling the brush as an instrument of expression:

"Wang Mêng once swept his studio and burned some incense, and then invited Chih-wêng (Tzŭ-chin) to come in. He took out some of his paintings and asked to be treated as a student. Tzŭ-chin looked at them very carefully; then he grasped the brush and added a few strokes. These were enough to make you feel the life-breath and the likeness of the Tai and Hua mountains. These pictures were afterwards regarded as joint works of Huang and Wang."

Wu Li was indeed one of the most faithful interpreters of the actual spirit and significance of the great Yüan masters and in many of his colophons he has also characterized them beautifully in words:

"The Yüan masters selected quiet and secluded places and there they constructed high towers in which they painted. They rose early in the morning to observe the changing effects of mist and clouds, and whenever they received a new impression from nature, they transferred with pleasure this inspiration into painting. Their way of painting was like writing in the running style (ts'ao-shu); they wrote down quite spontaneously impressions which they had gathered in their bosoms, and even a single stone or tree by them is different from those by other men."

On another occasion he gives the following characterization of the general attitude of these painters: "At the end of the Yüan dynasty men devoted themselves to painting in order to avoid the fame of the world. They spent their lives among

woods and springs where they could work in quietness. And in another colophon he says: "Everything in this world, be it large or small, is like a dream. But isn't painting also a dream? The things of which I dream are brushes and ink, and what I see in my dreams are mountains and streams, grass and trees; that is all."

Wu Li was indeed by his whole nature in perfect sympathy with the attitude of the Yüan painters, a hermit at heart, seeking for Tao in nature, dreaming of it and trying to express it in his paintings. In earlier years he was more of a student, interested in the manners of various old masters of Sung and Yüan times; in later years he became more and more absorbed in his dreams and in his search for Tao (also in the Christian religion), and the master who then served him most frequently as a model was Wang Mêng (Pl.413). He extolled the depth of Wang Mêng's art in some of his colophons and tried to convey it through paintings which are quite in the spirit of the Yüan master even though they are not copies after his works. The ones dated are of the years 1676, 1693 and 1696, but there are other pictures without date, executed in the same manner, all representing high mountains, deeply folded, bulging and writhing in cloud-like shapes, clothed with moss and shrubs, while large pine-trees in the foreground by a stream form dark masses against a misty atmosphere.

Two of the most successful among his Wang Mêng imitations are the large composition called Grass-covered Huts by a Mountain Stream, dated 1674, in the Chiang Mêng-p'in collection,[1] and the tall mountain view, named after the dominating motif in the foreground, Pine-trees by a Stream, painted in 1696 at San-sung t'ang for a friend, called Yün-fêng (formerly in the Kikuchi collection, Tōkyō)[2] (Pl.412A). It is deep in tone, the ink is rich, but the brushwork is firm and structural, proving that Wu Li had not lost anything of his old mastery of the brush in spite of increasing age and the fact that he

[1] Ōmura, II, 4.
[2] Ōmura, II, 1.

did not work with the painter's brush as often as in earlier years. Yet there were periods when he felt an irresistible urge towards painting. We are reminded of these shifting moods by the following colophon written probably about this time: "In recent years I have been both diligent and idle as a painter. Sometimes I forget cold and heat, nay, even my meals, quite absorbed in incessant painting. Whereas at other times in the warmth of spring, when seated at a clear window with excellent paper and ink before me, I feel quite sleepy, I do not know whence such illness comes. Someone said that it is the result of old age, but young people often have the same experience. A few days ago I felt that my wrist was vigorous and healthy, my brush strong, and I freely imitated Wang Mêng in a small scroll. I do not want to give it away but will keep it as a source of joy for my old age."

The most extraordinary picture by Wu Li from an illustrative point of view, and the latest with a date, is, however, the view of certain fantastic formations on Huang-shan (in Anhui), known as Hsüeh-Lao-jên (The Old Snow-man), which he painted at the age of 71 (1703), following freely a composition by Wang Fu (Pl.414). The picture is known to me only through a photograph (acquired some thirty years ago in Peking), but this gives a clear idea of the original, which is executed mainly in ink in the somewhat woolly manner which is characteristic of Wu Li's later works, though with great care in the modelling of the different parts of the strange formations which form the principal motif. The mountain peaks rise straight from a gully filled with mist and their enormous height may be estimated by comparison with the two tiny figures which walk on the path below. A closer examination of the design will lead to the discovery of some birds, animals, and human figures which form parts of the cliffs, all dominated by the elliptical cone at the very top, but their significance could hardly be understood without the explanatory inscription by the painter, a long poem from which the essential parts may here be quoted: "Between Heaven and Earth

the world is wide; the pictures by the many masters of the past do not contain everything. There is a particular place on Huang Shan called Hsüeh Lao-jên. When first it was represented, nobody could believe that it was true, but if you go there your doubts will be dispelled. . . . Strange forms, changing continuously, follow you at every step; you may count them in thousands and tens of thousands. The Creator has here been playing and trying to fool men, but fortunately as we often see many strange shapes, we become accustomed to them, till we see only the Cloud Boat along the old path. What a beautiful peak, standing free and reaching to the sky! It is the abode of Kuanyin with the Fish-basket, who here is proclaiming the law (*shuo fa*). But only by crossing over the peak can we see the next one. The boy Shan-ts'ai (the acolyte of Kuanyin) is praying below; he bends one knee, and his raised hands are folded not covered by the sleeves, whereas his head is crowned by a tuft of hair . . . he looks indeed like the true sage-boy. The rabbit from the moon, which grew tired of churning, has fled to a lofty place on another peak. It did not like the work allotted to it by its superior, but preferred to seek the company of hermits.

"It is a place which men seldom reach, yet the Immortal made of stone is helping here by pointing out the way. He leads men on to Tao-ch'ang (the place for the delivery of souls from purgatory) in Tushita (heaven). There he stands acting for the people from everywhere like a great Buddhist priest. Furthermore there is a parrot (at the lower edge of the picture) too wonderful for words. Its body and green feathers are formed of moss. Heaven and Earth form the fitting cage for this bird, which is always at the service of Kuanyin with the Fish-basket."

Then the painter tells how his friend Mr. Pan-yüan showed him Wang Fu's imitation after Wang Wei's picture of *Huang-shan hsüeh-lao-jên*, which was a most marvellous work, "fascinating to the spirit and pleasing to the eyes", and asked him to make a copy of it. But "I lost both the form and the

spirit of it and must say with old Mi: I am profoundly ashamed. Mo-ching Tao-jên at the age of 71."

If he has lost some characteristics of the original he has evidently substituted for them qualities of his own. It may truly be said that his work is significant in every part through the artistic transformations of its symbolic motifs. Western art-critics may be reminded of illustrations by Blake or some other equally imaginative symbolists, but the conceptions of Wu Li's picture are more definitely coloured by his interpretations of the imagery of nature and thus of a more universal kind than may be found in Western paintings of a corresponding kind. The ideas are evidently derived from Buddhist as well as Taoist sources, at which Wu Li's romantic symbolism had been nourished in earlier years. But it seems hardly possible to find a single trace of Christian thought or mysticism in this picture. Whatever he may have assimilated of Christian teachings during his long stay at Macao or afterwards, it did not change his attitude to nature and art, though it may have served to deepen his sense of moral responsibility and to fill his speculative mind with thoughts of salvation in accordance with Christian doctrines. This appears from a letter that he wrote to his old companion Wang Hui at the time of his conversion to Christianity:[1]

"I remember when we used to meet in the hall at Suchou (Su-t'ang), now more than twenty years ago. Human life is not very long, yet for such a period have we been separated. I look up to your fame and wisdom, which are much greater than those of ordinary men. But have you made any preparations for the hundred years (the after life)? If you are busy only with the present but forget the future, gaining the earth, but losing heaven, that is no real wisdom. Considering your welfare, I would say you should every morning and evening think over your life from childhood up to your present age without concealing the least thing, for when we are about to pass away we should open our hearts and reform ourselves, so that when we are freed,

and have redeemed our debts, we may reverently receive the holy body of Jesus and the holy Grace which will increase our spiritual strength – and then we shall have the privilege of ascending to heaven. This is indeed the most important of all affairs. I hope that you will not consider it a small matter; as I could not see you, I have entrusted it to the brush. Your fellow-student Wu Li salutes you."

The human interest of this letter, addressed from one great painter to another, may justify its inclusion at this place, though it actually has very little, if any, connexion with their artistic occupations. As stated above, we look in vain in Wu Li's paintings for any kind of Christian ideas or inspiration; there was evidently a complete division between this new world of religious thought and life and his creative activity as a painter. This could not be fitted into the Christian framework, or vice versa. His difficulty in accommodating himself to Western ways of life and thought is also clearly illustrated in some of the notes written while he lived at Macao, as for instance:

"Mo-ching Tao-jên is now almost fifty years old, and he is studying Tao at San-pa. He sleeps and eats on the second floor of a high building, and passes the day contemplating the tides of the sea. Five full months have already passed since he came to this place. During the fifty years he looked at the clouds of the dusty world, but now he is outside the world and looks at the tides of the sea. He does not realize whether he was wrong yesterday (i.e. in former years), or if he is wrong today. Nor does he know whether the sea or the world is more dangerous. He simply grasps the brush and makes a picture. Those who possess the eye of Tao should be able to tell."

If we may judge by this and some other colophons, he never felt at home, or happy, in the theological circle at Macao, and one may ask whether he was ever able to read a theological book or to understand the rituals and sacraments of the Christian

[1] This letter is reproduced in facsimile in *Yuchikusai*, the catalogue of the Ueno collection.

services. All such things probably remained very nebulous to Wu Li, whereas he must have had a strong feeling for the moral value of the Christian conceptions, as witnessed by his letter to Wang Hui. As a painter and calligraphist he of course paid special attention to the Western manners of painting and writing, but could not find that they were in any way superior to the Eastern manners, rather the contrary, as appears from the following remarks:

"Our writing is composed of dots and strokes and the sound comes after (is a secondary consideration), but to them the sound comes first and the written signs afterwards, and they write their signs composed of hooked strokes in horizontal lines. Our painting does not grasp the formal likeness or fall into ready-made patterns; it may be called spiritual and unrestrained (*shên i*). In their painting they always use lights and shadows, and work out the formal likeness with bodily relief (front and back) and ready-made patterns (*k'o chiu*). As to the signatures, we place them at the top, but they write them at the bottom of the pictures. And our way of using the brush is quite different. These are only some of the points; I could not state them all."

If Wu Li's conversion to the Christian faith had any influence on his artistic activity, it was probably of a negative kind. Judging by his dated paintings, it must be admitted that his productivity gradually diminished after the middle of the eighties and that no new elements of importance or stylistic development are to be observed in his later pictures. His most appealing studies from nature and excellent interpretations of Wu Chên and Huang Kung-wang are from earlier years. Yet the undercurrent in his art, his attitude towards nature remained the same all through his life; it was a search for Tao, for the ultimate reality or meaning of shifting views and phenomena. In other words, his poetic genius was aware of something that had to be discovered and displayed by the painter. This did not apply only to such extraordinary formations as the Old Snow Man on Huang-shan, but also to more ordinary sights and simple views along the rivers and mountains in his home country; they all had a hidden meaning, an inner beauty which he tried to convey with the utmost faithfulness and sincerity. This constant search for the inner significance of art and life confer an unusual interest on many of his paintings and notes. No better definition of the general trend of his search and his art could be found than the following words by himself.

"The scholars of antiquity did not seek for promotion, and the best among the painters did not look for honours. They said (in the words of Su Tung-p'o): 'I write in order to express my heart, I paint to give vent to my thoughts. I may wear clothes of grass and eat coarse food, but I do not ask for support from others.' Neither kings, nor dukes or noblemen could command these painters; they were beyond the reach of worldly honours. The Tao of painting cannot be grasped by those who do not themselves possess Tao."

III

Yün Shou-p'ing

IF WE were classifying the painters of the K'ang-hsi period according to their popular fame and the traditional estimate of the general public, we would have to reserve one of the foremost places to Yün Shou-p'ing; his admirers have been uncountable, particularly in his homeland. But the very ease and abundance of his pictorial production may sometimes give cause for hesitation or a question whether it all is the work of a great master or simply the output of a highly skilled man of the brush.

He was exactly contemporary with his friend, Wang Hui, born 1633 in Wu-chin (modern Ch'ang-chou), but died comparatively young at the age of 57 in 1690. The fullest account of his life is offered by Chang Kêng in *Kuo-ch'ao hua-chêng lu* (vol.1, 2). "Yün Shou-p'ing was known by his *tzǔ*, not by his personal name, which was Ko. He also used the *tzǔ* Chêng-shu; his *haos* were: Nan-t'ien and Po-yün wai shih (or Yün-ch'i wai-shih). He was the scion of an eminent (but very poor) family, skilled in poetry and prose writing, and showed great inclination for landscape-painting. He made it his aim to revive the old styles, but when he met Wang Shih-ku from Yü-shan he thought that his talent was not equal to Shih-ku's, and he said to the friend: 'I will leave you alone on your path, because it makes me humiliated to be only the second in the world; thenceforth he gave up land-scape-painting and devoted himself to the study of flowers. He studied closely both old and modern masters and finally selected Hsü Ch'ung-ssŭ of the North Sung period as his model. He washed away the bad habit then prevailing, and started a new kind of painting from life, *i.e.* flower-painting, which then became the leading school followed by all the students in the field.

"Chêng-shu and Shih-ku were very close friends, and used to discuss everything down to the smallest details in painting. Whenever Chêng-shu wrote a colophon on Shih-ku's paintings, he brought into full evidence all their merits in the brushwork, the colouring and the composition. Although he specialized in flower-painting, he sometimes also painted landscapes, such as a small view of the Red Hill and a Village by the River, after Chao Mêng-fu, or the picture of Slender Willows and Leafless Poplars. They were all painted in a very free manner, and of high class. He had completely grasped the quiet, deep and beautiful effects of the Yüan masters, but because of his modesty he did not paint such things very often. Once he wrote a letter to Shih-ku in which he said: 'The greatest difficulty for me in landscape-painting is to get rid of

the thing expressed by the word *chün* (to feel em-barrassed); I am too much tied by the rules and manners of the old masters.'

"Chêng-shu's flower and bird paintings are simple, pure, refined and accurate; their colours are bright and beautiful. The secrets of nature and the life of such things are all at the tip of his brush. His manner was really that of a great master, and it was the object of a never ceasing admiration from Shih-ku ... (follows a poem on Shih-ku).

"Chêng-shu was of an open, generous and refined character. When he met someone who understood him he could work a whole month for the man, but if it were not the right kind of person, he would not let him have a single flower or leaf even for a hundred taels of gold. Consequently he always remained poor, even though he had been active as a painter for scores of years, but he never showed a sad face to his people at home. He simply kept on humming poems, writing and painting. The place where he lived and worked was called *Ou-hsiang kuan* (The Study of the Fragrant Pot), and there many of the famous scholars and poets of the time used to meet. He died at his home over 60 [*sic*] years old. His son had not enough money to meet the funeral expenses, but Shih-ku arranged the matter."

Other contemporary recorders such as the writer in *Chiang-nan t'ung chih* likewise bestow great praise on Yün Shou-p'ing's all-round gifts, which made him equally eminent as a calligrapher, a poet, and a painter, so that people could say that he "reached the very limit in the three arts". We need hardly quote more of these encomiums, but the following short note by his friend Chu K'uang-ting may be remembered as a fugitive glance into the painter's simple home:[1]

"Once I visited Yün Chêng-shu, and when I entered the place, I found that the courtyard was absolutely quiet, without a single human being. Chrysanthemums grew in abundance along the steps. It was truly the home of a scholar. He painted

[1] Cf. *Kuo-ch'ao hua-shih*, vol.4, p.4.

for me a picture called Night Rain over Hsiao and Hsiang, and composed two poems which he likewise presented to me."

All the early works by Yün Shou-p'ing are, as said above, landscapes and most of them painted in rather close adherence to leading masters of the Sung, Yüan and Ming dynasties; in other words, they illustrate the painter's ambition to "revive the styles of old", as said by Chang Kêng. His main interest was evidently centred on the Yüan masters; the imitations after Sung painters are relatively few, and not so close to the originals as those after later painters, the majority of them being simply sketchy album-leaves. The following painters of early times are represented among his works (most of them by several specimens): Li Ch'êng, Tung Yüan, Chü-jan, Hui-ch'ung, Kuo Hsi, Mi Fei, Mi Yu-jên, and Ma Yüan, beside Hsü Ch'ung-ssŭ who gradually became his standard model for flower-paintings. Most remarkable among the imitations after these masters is the horizontal scroll of Endless Mountains and Rivers after Chü-jan, a very beautiful and sensitively executed ink-painting, which transposes the original into a lighter tone.[1] The rendering of Ma Yüan's Fishing Boats on a River in Autumn is also a complete picture which apparently reproduces the original design quite faithfully, but in a manner which is more akin to the Yüan masters than to that of the Sung master.[2] The most sympathetic and congenial among Yün Shou-p'ing's imitations after Sung masters are perhaps, after all, the sketches inspired by the monk painter Hui-ch'ung who was one of the most characteristic representatives of the Southern school.

The earliest dated work by Yün Shou-p'ing is a tall river landscape framed by a mountain peak in the background and a leafless willow in the right-hand corner; it is painted in a rather flossy manner recalling Ts'ao Chih-po's works.[3] It may have been composed some time before 1664, because in the inscription of that year the painter says that he got hold of his picture again (which had been in the collection of a friend) and "added something to it to improve the effect of distance", a statement which shows that posterior improvements were, after all, not impossible even in ink-paintings. Here should also be mentioned the mountain landscape in the Ku-kung collection which, according to the inscription, dated 1668, is inspired by Huang Kung-wang's Fu-ch'un scroll, but as the picture is a tall vertical composition and not a handscroll, the correspondence is evidently not very close.[4] It is slightly coloured and executed in the typical Huang Kung-wang manner. Like all the other great painters at this time Yün Shou-p'ing placed Huang on a high pedestal and considered his Fu-ch'un scroll as the most consummate example of landscape-painting accomplished after Tung Yüan. He describes it in detail and mentions three copies, but evidently he had not the same close personal relation to this famous picture as Wu Li and Wang Hui, who both copied it. Yün Nan-t'ien's occupation with the great landscapists of the past was a passing phase in his evolution.

Chao Mêng-fu's art is excellently represented by several minor pictures and one of large size, the so-called Scholar's Study among Blossoming Plum-trees.[5] The mountain stream which forms the central motif of the picture is bordered by the blossoming trees. Two pavilions are built out over a stream and there some solitary poets are contemplating the return of spring, while a third is standing on the bridge that leads across the stream quite enraptured by the beauty of the scene. The execution – mainly in kung-pi and colour – is perfect of its kind. A more sketchy but pictorially effective rendering of a Chao Mêng-fu painting is the view of a misty beach where the buildings and trees on the shore emerge only in part from the heavy atmosphere.[6] In the note on the picture the painter says

[1] Nanju, vol.12, belonging to Mr. Hattori.

[2] Ōmura, I, 12. Yamamoto collection.

[3] Sōgen, p.263, belonging to Wang Hsiang-ch'üan.

[4] K.-k. shu-hua chi, vol.XXX.

[5] Ibid. vol.XXVII.

[6] Ssŭ Wang, p.42, belonging to Mr. Kurokawa.

that "Chao Mêng-fu's Village by the Water and Huang Kung-wang's picture The Sandy Beach come from the same loom". Other imitations after Chao Mêng-fu will be noted in the albums to be mentioned presently. But it may be of interest to look first at some of the larger pictures in the manners of the Yüan masters.

Wang Mêng is represented by several imitations of varying importance. The largest and possibly earliest among these is the picture in the Ueno collection called Old Pines and Piled-up Peaks, a somewhat traditional composition painted in the Pao-hua temple in Wu-hsi.[1] The transposition is in a lighter vein than we find in corresponding pictures by the four Wangs; the piled-up peaks are not so crowded as often in Wang Hui's imitations. Another important picture, indicated in the inscription as a free imitation after Wang Mêng, was formerly in the Yang Yin-pei collection (Peking). Craggy mountains border a bay, and on the rocky promontory in the foreground there are bare trees and low buildings.[2] The poem by the artist contains the following thoughts: "The mountains form a vast expanse; the grass and the trees are covered by mist. The days and the months at this place never make a year. I sit and look at the glimmering light while feathers of frost are falling. Why should I wait for a music which is played by men on strings?"

One of Yün Shou-p'ing's latest imitations after Wang Mêng is a short handscroll in the former Ōgawa collection in Kyōto, representing Rocks by the Sea Shore and dated 1684. It is painted in a lighter tone than the previous examples, but nevertheless with close definition of all details and emphasis on the imposing structure of the mountain walls.[3] Several minor sketches after Wang Mêng and his pupil Wang Fu are also included in the various albums.

Other Yüan painters whom Yün Shou-p'ing has rendered freely in large as well as in minor pictures are Ts'ao Chih-p'o,[4] Lu Kuang,[5] and K'o Chiu-ssǔ,[6] (Pl.415), but it may not be necessary to describe them all. Even among his very numerous fan-paint-

ings there are several representing leafless tress and bamboos by rockeries or bits of landscape compositions suggested by works by these masters. They remained his guides all through his life.

Yün Shou-p'ing seems indeed to have preferred to express himself on a small scale, i.e. on album-leaves and fans; they suited his lyrical talent better than large compositions. He painted a great number of albums, some of landscape-sketches and some of flowers, fishes and birds of which several have been made known in reproductions. Prominent among these is the album of eight double leaves, published by the Hakubundō Co. in coloured facsimiles. Each leaf has an explanatory inscription; on the first, which represents a huge cliff by a shore, red trees and a man walking over the bridge which leads thither, he has written: "Chü-jan certainly formed a school of his own, but if you learn from him only the effects of desolation, you will not enter his art". The second represents a man in a small pavilion below a cliff in a bamboo grove: "The bamboos are green and moist; the stones are blue and cold. I am seated here in the lonely hut facing the stones. My eyes are thirsty but my heart is quiet." The third represents old trees and bamboos by a strangely shaped rock: "There is a picture by Ni Tsan called Fist-like Stones and Scattered Trees. I saw it in the Chên family at Yang-hsien. It was supreme among all Yüan paintings, but I recollect it only vaguely (from afar)" (Pl.417A). The recollection has, however, inspired him to a very expressive rendering of the motif. The fourth picture represents a temple hidden in part by steep rocks near the shore. It is based on similar recollections: "I offer sacrifice to Ni Tsan and would be the coach-driver of Huang Kung-wang. When facing their landscapes I absorb

[1] *Yuchikusai*, p.17.

[2] *Sōgen*, p.265.

[3] *Ssǔ Wang*, p.39.

[4] *Yuchikusai*, pp.18, 24.

[5] *K.-k. shu-hua chi*, vol.XLV.

[6] *K.-k shu-hua chi*, vol.XIII, and some leaves in one of the *Yu Chêng* albums.

their feeling; a new spring opens in my heart." The fifth picture is a vast river view with blue and reddish rocky islands and bare trees in the foreground, according to the inscription "painted on the way to Chia-ho (Chia-hsing) in the manner of a Sung master whom I remember vaguely". The sixth shows a man seated under autumn trees, some bare, some with red leaves, the hermit scholar in meditation, characterized in the inscription: "Cutting wood on the mountains and fishing in the streams give me satisfaction; I do not listen to the call of high officials or mount their chariots" (Pl.417B). The seventh is another autumn view with trees that are dropping their leaves against a background of blue cliffs, and below is the human motif: "The lonely pavilion holds a proud scholar; the blue colours of the mountain are dropping on a tranquil heart". The eighth is a winter scene, the terraced mountains are covered with snow, the water is grey and a lonely fisherman is seated under a bamboo hood on a bridge: "In painting snow scenes Li Ch'êng was the only master after Wang Wei, he knew the right method. He was just as good as Wang Wei."

Though small in size, these pictures are perfectly finished compositions, often with striking colour effects; they are painted with a certain care, though in a spontaneous manner, and in this respect rather different from Yün Shou-p'ing's later album-pictures, as for instance the eight leaves included in *Ssǔ-wang wu yün*, pp.44–51, which for the most part consist of fugitive impressions conveyed by a few dots or sweeping strokes of the brush which stand out in contrast to the empty paper. Yün Shou-p'ing's way of painting evidently became with the years ever freer and easier, and less dependent on historical models (except in the flower-paintings).

A middle stage between the two above-mentioned series is marked by the album of ten landscape views which have been published by the Yen Kuang Co. in Peking in photographic reproductions, and several of these pictures gain an added interest from the explanatory or poetic inscriptions. The first

represents a mountain gully with rushing water and large trees on the slope (Pl.418). The inspiring models are indicated in the inscription as follows: "Wang Mêng's pictures The Summer Mountains and A Spring Morning on Tan-t'ai are two divine works. This picture is intended as a combination of the merits of both. But it is a pity that my brush is lacking in the strength which would enable me to share in his mysterious spirit." The second picture is perfectly described in the inscription: "Old trees and crows at dusk; a scene of loneliness and quietness in which I tried to grasp something of Li Ch'êng's manner". Li Ch'êng's art is then described in traditional terms, and the artist winds up his admiration with the following words: "His thoughts were pure and his brush was strong (old); he stood without an equal among the ancients." The third is simply marked: Lu Kuang (T'ien-yu), Spring Mountains before Rain. The fourth: I-fêng Lao-jên (*i.e.* Huang Kung-wang), Ten Thousand Valleys and Pines in Wind. The fifth represents a man in a boat on a river and plum-trees in blossom on the shore.[1] The motif which is borrowed from T'ang Yin, is explained in the following poem:

"Light mist is sweeping through this night in
 spring;
Sweet odours fill the moisty air.
Nearby are flowers, but beyond a gleaming lake
One sees the Tung-t'ing island far away.
A gust of wind is rising.
A thousand trees in snow.
When morning comes the verdant colour of the
 hills is lost."

The sixth is a rendering of Ts'ao Chih-po's picture, Autumn in the Mountains (Pl.419), and described as follows:

"A little dwelling in the mountains without a
 neighbour.
The sailing clouds and lonely cranes my only
 friends.

[1] Another version of T'ang Yin's Spring Night with Blossoming Plum-trees, by Yün Shou-p'ing, is reproduced in *Shina Nanga*, I, 40. In this picture the man is walking by the river.

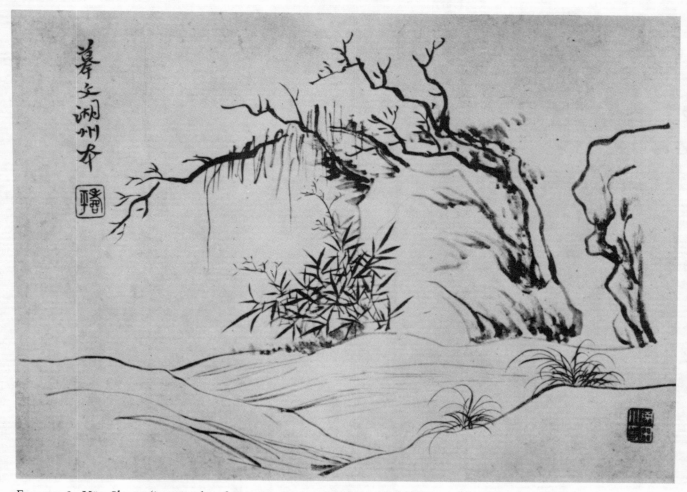

FIGURE 8. Yün Shou-p'ing, *Study of Bare Trees, Bamboo and Epidendrum*. Private Collection, Japan.

Who'll find the lonely path that leads here
 through the depths?
Who'll be knocking at my door and come to see
 my bamboos?"
The seventh picture represents water rushing out
amidst cliffs: "From out the cave comes a sound of
water bubbling round the stones. The frosty trees
reach to the clouds. Imitating Chao Ch'êng-chih
(Mêng-fu)." The eighth picture represents bare
willows on a river-bank after Hui-ch'ung. A boat
with two men is seen in the misty distance, which is
suggested rather than painted. The ninth picture is
an autumn scene with leafless trees in front of high
mountains. It has two inscriptions, the one explain-
ing its origin: "Tung Ch'i-ch'ang was a good painter
of leafless trees; he grasped their spirit and beauty,
their effect of strength and freedom. He said him-
self: 'I learned it from practising *chuan-*, *chou-* and
fei-pai writing'. His spirit was in harmony with
their secret, and he explained it. No painter of the
present time can do it."

The tenth picture has no inscription referring to
old masters, though the style of it reminds us both
of Li Ch'êng (in the leafless trees) and of Chü-jan
(in the softly rounded hills). The ease of the brush-
work is particularly significant and it is also empha-
sized in the inscription: "When I am painting I do
not wish a single brush-stroke to show on the paper.
I simply want to make people feel that they can
travel (in the picture) quietly, freely, as far as they
may wish, not knowing whether it is a fragment of
nature or a picture" – a wish which is most signifi-
cant of Yün Shou-p'ing's whole attitude as an artist.
His works reflect an extraordinary ease both of
mind and brush; they seem to flow out of him like
the music of a born singer. The same ideal guided
him in the study of old masters; he preferred (as we
have seen) those who worked with the greatest
ease without any apparent effort, an association
which has also found expression in some of his
colophons:[1] "Chü-jan's brush moved like a dragon.
In a picture no more than a foot square, he could
give the effects of thunder and lightning, and these

seemed to come right down from heaven as did his
brush. No traces of it could be found (on the paper),
but the spiritual impetus was overwhelming and
opened the eyes of men. No one knew how it was
done."

Again he makes the following observation refer-
ring to the same fundamental condition: "The
people of Sung times said that one should try par-
ticularly to approach those passages in the old
masters' works which are not deliberately worked
out (in which they used no intentions). They also
talked about painting as idea-writing (*hsieh-i hua*).
These two observations are very subtle and have
easily led people astray. I do not know how to
apply my mind so as to reach those passages in the
old masters' works in which they used no intentions,
nor do I know how to express my thoughts in idea-
writing." Yün Shou-p'ing's self-depreciation in this
respect is not warranted by his works, which often
bear witness to great ease and spontaneity. Few
painters have freed themselves better than he from
the trammels of elaboration, as may be seen not only
in the landscape-sketches mentioned above, but also
in a great number of his flower-paintings, particu-
larly when executed in a fluent ink technique.

Yün Shou-p'ing's flower-paintings are very
numerous – perhaps too numerous – and like his
landscapes executed either in large size as complete
decorative compositions, or on album-leaves and
fans in a more sketchy manner. The former are
always done with colours, for the latter he uses both
ink and colours, though always very light and
fluent. His main ideals in flower-painting were Hsü
Hsi and (particularly) Hsü Ch'ung-ssŭ, who had
introduced the so-called "boneless" manner (*mo-ku
hua*), *i.e.* painting without outlines of ink, producing
the shapes simply by the opposition of the colour
tones in various depths and shades. This manner of
painting had, however, already been used in earlier
times by certain landscape-painters, as pointed out

[1] A great number of Yün Shou-p'ing's colophons (more than
100) have been made accessible in *Hua-hsüeh hsin-yin*, vols. V–VI,
under the title *Ou-hsiang huan-hua po*.

by Yün Shou-p'ing in the following colophon: "Flower-painters reached their greatest effects by *mo-ku hua*. Chang Sêng-yu painted landscapes in colour which were like the cloud brocade of the Weaving Maid, which cannot be imitated by any human being. The Hsü family painters of the North Sung period gave careful consideration to the ancient styles and attached themselves finally to Chang Sêng-yu's manner of using the five colours. Their contemporaries such as Huang Ch'üan and his son bowed to them."

In another colophon Yün Nan-tien brings out the characteristic differences between the technical methods prevailing in the Sung and the Yüan periods; he writes:

"The Sung manner was the *k'o hua*, the Yüan manner was *pien hua* (transformations). Yet *pien hua* had its origin in *k'o hua*. The greatest wonder in painting is to blend the two manners harmoniously. Students who look upon them as two separate ways are quite confused. The two manners are like the different methods applied by the generals Li and Chêng in handling their troops, the one being lenient, the other very strict. General Li found no difficulty in beating the alarm (calling to immediate action) and general Chêng had no difficulty in making the soldiers fight freely. All depends on how one applies the transformations."

A picture of Tree-peonies by a Rockery in the National Museum in Stockholm may here be mentioned as a typical example of Yün Shou-p'ing's imitations after Sung models. According to the inscription it is a transposition of a work by Hsü Ch'ung-ssŭ, which seems quite evident, but whether it was executed by the master or an assistant is more uncertain. Practically all the paintings of *mu-tan* flowers ascribed to Yün Shou-p'ing and most of the chrysanthemums are imitations after Hsü Ch'ung-ssŭ, *i.e.* painted in a formal way with more care and refinement than spontaneity, whereas the irises, lilies, poppies, magnolias, cassias, peach and plumblossoms, and several kinds of minor flowers are painted in a freer fashion like the flower studies by

Yüan and Ming masters such as Wang Yüan, Shên Chou, Ch'ên Tao-fu, and T'ang Yin, and their followers. For the bamboo-paintings Kuan Tao-shêng has mostly served as a guide. To us these latter paintings are of the greatest interest, but among his contemporaries he was mostly esteemed for his formal flower-paintings in Sung style. They became very popular and were frequently imitated by younger painters, as pointed out by Yün Shou-p'ing in the following colophon:

"Nowadays the flower-painters all use the same boneless manner as I do; they have completely changed the common manner of dotting and painting with thick and heavy colours so as to satisfy the taste of the day. But if this manner is copied and continued for a while the stream will soon be overflowing, and therefore I am doing my best to bring out the light and refined manner of the Sung masters." In the rest of this colophon he praises some copies after Kuan Tao-shêng's pure and refined bamboo paintings made by Shao Mi and Wang Hui.

Most of Yün Shou-p'ing's flower-paintings are executed in colour, though the pigments are very light, sometimes almost transparent, applied with a brush which scarcely touches the paper, but he has also executed flowers and bamboos simply in ink, knowing well, as he said himself, that the ink may also contain the five colours – "which is far better than indulging in gorgeous hues". This may be observed in some of the flower studies included in the album published by Yamamoto Bunkadō, which furthermore are accompanied by notes referring to the motifs or the models. The first leaf represents a branch of a blossoming peach-tree; the inscription contains simply the words: "Jade cave, spring wind" – which probably refers to a legendary place where the most beautiful peach-trees bloom. The second represents magnolias (*yü-lan*) (Pl.420B) in the wind, painted after Shên Chou: "In the home of a Suchou collector I saw a scroll by Pai-shih wêng, which I imitated playfully". The third leaf represents two iris flowers with long leaves, and by

them the painter has noted the following advice: "One should apply the colours as one uses the ink, *i.e.* with ease; spread them out and move on quite naturally". The fourth shows a branch of hydrangea, and the flowers are characterized in the following imaginative strain: "These are the luxuriant flowers of the Sui gardens which have no perfume. They are delicately shaped like the full moon cut out in the house of clouds. They are like the tassels on the curtains of the Immortals; the fairies on the Jade Terrace are playing ball with them." The fifth represents a large poppy flower on a bending stalk, painted with supreme ease (Pl.420A); the thin petals of the open calyx seem to be quivering in the light, the large torn leaves are curving and swaying like wings. The sixth represents a huge lotus flower and fragments of a leaf executed in light washes: "I followed my ideas in spreading the colour, not aiming at accuracy but indicating quite carelessly the general effect". The seventh leaf is filled with a rock round which grow some tufts of grass, epidendrums, bamboos and chrysanthemums. The eighth represents a branch of cassia with the following poetic inscriptions; "The heavenly dew is pure; its drops are made without sound. But the place where it grows is high, and thus it is difficult to cut its branches, which are still hiding the moon." The ninth represents some stalks of chrysanthemum and has the following historical note: "It is difficult to paint chrysanthemums (in colours) but still more difficult to render them in ink. Wang Yüan of the Yüan period painted them with great refinement, Chou Ts'ao-ch'uang (at the end of the Yüan period) rendered them purely and beautifully; yet they did not equal T'ang Yin, who was most noble and free. In this picture I have followed T'ang Yin's manner, which is different from that of the Yüan masters." The tenth leaf shows some twigs of a blossoming plum-tree, accompanied by a short poem: "The spring wind has not touched the peach-trees and the pears as yet; it has but caused the snowy trunk (of a plum-tree) to cry its fragrance in the cold".

At the end of the album is a longer poem referring to the whole collection from which the following lines may be quoted:

"The flowers of ink transmit spring-times of old. The frosty brush still creates fresh verdure, though the wind is cold and blowing recklessly. The breath of a spirit has nourished these flowers; thus they have become like fairy ornaments in clouds ... Within these foot-square pictures I would retain for ever the breath of all the seasons."

The charm of Yün Shou-p'ing's flower-paintings is, indeed, something which cannot be transmitted by descriptions; it would require a poet like himself to do it justice. Their fugitive expression is most alluring when rendered with the least display of technical skill. His aim or method was to suggest rather than to describe; to paint with such ease and simplicity that the art would be forgotten for the living beauty of these delicate motifs. Such was the attitude which guided him in all his works and which he also expressed in his colophons, two of which may still be added here."

"In painting one should act as if seated cross-legged in loose garments when nobody is about. The creative power will then be held in the hand, and the breath of life will be spread all over the picture. One is not tied by the rules of the old artisans but steps beyond their manners and measures. Then one can freely play with the winds and the rains, spread out the verdant green and model the hills and the valleys with all their secret windings. But unless one possesses a style of one's own, one cannot reach the marvel of communicating with the unseen. Paintings (which are made in this way) may serve to benefit and enrich the spirit of men, and to mould their characters."

The spacing, the proper rendering of the empty parts, is a point of the greatest importance for the creation of pictures that make us feel the breath of life. Yün Nan-t'ien has emphasized this in several significant notes, such as the following:

"Painters of today pay particular attention to the parts of the pictures which are filled by the brush and ink, whereas the old painters paid closest

attention to the empty parts (not filled with the brush and ink). If you can see (understand) how the old masters brought out the empty parts in particular, then by concentrating your spirit you may enter the realm of art."

Like all the painters of the time he was unremitting in his studies of the old masters, but his sincerity and modesty made him realize that he never could reach to their level:

"One can learn how to use the brush and the ink, but not the moving power of heaven. One can grasp the compasses and squares, but not the breath of life. It is certainly not easy to seek for that which cannot be learned or grasped by means of things which can be learned or grasped. The old masters are far from me: I have to be satisfied with things that I can learn and grasp." Yet he was never really satisfied, but felt a constant urge to penetrate further into the realms of creative art and reveal more and more of the inner meaning of things. He had the ambition of a true artist and the reactions of a poet, and also to a remarkable extent the faculty of expressing himself with a gracefulness and ease that very few of the other painters could equal. No wonder that he became popular and that his flower-paintings in particular were imitated by scores of contemporary and later men, a fact which emphasizes his historical importance, though it has at the same time served to blur rather than to enhance the features of this attractive individual genius.

<div align="center">IV</div>

<div align="center">*Wang Yüan-ch'i*</div>

THE PLACE traditionally accorded to Wang Yüan-ch'i in the history of Chinese painting is that of the completer or consummator of the classic tradition in landscape-painting. He was the youngest of the Four Great Wang and as a grandson and pupil of Wang Shih-min, the natural successor to the leadership in the Lou-tung school. In addition to this he was a prominent theorist, the one who also transmitted Wang Shih-min's aesthetic ideas and technical principles best in writing, and held a commanding official position in the world of art as the leading expert and curator of the imperial collections. All this contributed to his wide range of influence and predestined him, so to speak, to keep within the fold of the Yüan masters and to transmit the principles of style well established since the days of Tung Ch'i-ch'ang. And it may be admitted that he did this particularly through his early works, which are no less faithful to the models of the Yüan period than Wang Shih-min's paintings, though it is evident that his attitude towards the models is not the same as that of his predecessors, and that it becomes more and more independent with the years. In our study of some of his works we shall find that he manifests a gradually growing tendency to break away from time-honoured traditions of design and brushwork and to consider the old problems in a new way.

It is this tendency rather than the faithfulness to well-known models that makes the study of Wang Yüan-ch'i's works most interesting and gives rise to the impression that he might with more reason be represented as the initiator of a new movement or style in landscape-painting than as a fulfiller or consummator of the old. But at the same time it should be observed that his ideas are more advanced than his paintings, or in other words that his artistic aims are not always successfully accomplished, which sometimes makes the pictures more interesting from a theoretical point of view than as specimens of

pictorial art. This may also have been one of the reasons why the painters who followed in his wake appropriated mainly the most traditional aspects of his art.

The biographical data and artistic career of Wang Yüan-ch'i are recorded in *Kuo-ch'ao hua-chêng lu* as follows: "Wang Yüan-ch'i, *tzŭ* Mao-ching, *hao* Lu-t'ai, grandson of Wang Shih-min, was born in T'ai-ts'ang (1642). He became a *chin shih* in 1670, and served first as a district magistrate; later he was promoted to the position of a censor and became a Han-lin member. The emperor, who admired his paintings, made him a *kung fêng*, and placed him in charge of the imperial collections of calligraphies and paintings. Then he was appointed vice-president of the Board of Revenue, served as a compiler of the *P'ei wên chai-shu-hua p'u*, and as the chief official in charge of the celebration of the emperor's sixtieth birthday. He died at the age of 70 (rather 73, *i.e.* 1715).

"As a boy he once painted a small landscape-scroll and pasted it on the wall of his study. Fêng-ch'ang, *i.e.* Shih-min, saw the picture, was greatly surprised, and asked: 'When did I paint this?' When further informed, he was much impressed, and remarked: 'The boy is certainly going to surpass me.' From time to time he then explained to the boy the Six Principles and the differences between old and modern painting. When the young man had passed the examination in the capital with success, Fêng-ch'ang (*i.e.* the grandfather) said: 'Now, since you have become a *chin shih* you should devote yourself to the art of painting and continue my work.'

"From that time he made great progress in his brushwork and reached the very limit of Huang Kung-wang's lightly coloured manner of painting. His works were mature but not sweet, fresh but not uncouth, light, yet substantial, rich in detail, yet clear, and filled to the very brim with a scholarly spirit. At the time Wang Hui from Yü-shan was most famous for his pure and elegant brush and known everywhere, even beyond the frontiers of China, but Wang Lu-t'ai was of such a high class

that he even surpassed this master. The great admiration bestowed on him by everybody was not without foundation.

"When Wang Chien from Lang-ya saw Wang Lu-t'ai's works, he said to Fêng-ch'ang: 'We two are, indeed, a head shorter than he.' Fêng-ch'ang answered: 'Among the four great masters of the Yüan dynasty Huang Kung-wang was the foremost. The one who grasped his spirit was Tung Ch'i-ch'ang, and I venture to say that I grasped something of his form (style), but my grandson seems to have grasped both the spirit and the form', to which Wang Chien agreed.

"The emperor K'ang-hsi often went to the South Library where Wang Yüan-ch'i served as a *kung fêng*, and ordered him to paint landscapes. There the emperor would lean over the table on which Wang Yüan-ch'i was painting, quite fascinated and unconscious of the passing of time. He bestowed a poem on the painter which contained the line: 'Your pictures should be shown to the people'; six characters which Yüan-ch'i carved on a small stone which he used as a seal in record of the imperial favour.

"In painting he always used paper from Hsüan-ch'êng, a double hair brush, and *ting yen* (top layer) ink. He often said: 'If any of these three things is missing, it is not possible for me to produce beauty of the old manner or effects of unrestrained freedom.' Someone brought to him a picture by Wang Shih-ku and asked his opinion about it. Wang Yüan-ch'i said: 'It is too mature.' Then the man brought a picture by Cha Shih-piao, and Yüan-ch'i said: 'It is too immature.' His own endeavour was not to be too mature, nor too immature. Once he wrote on a picture of Autumn Mountains on a Bright Day: 'Not on the old-fashioned manner nor on my hand (does its significance depend), yet it is not outside the old-fashioned manner nor outside my hand. The top of the brush should be like the *vajra* (diamond club)[1] which cuts off all bad habits.'

[1] Indra's weapon, also used by the Buddhist priesthood as a symbol of irresistible efficacy in prayer.

In reading these words one may realize how far he had reached.

"When living as an official in the capital he used at the beginning of winter to give each one of his subordinates a picture which could serve for the acquisition of a fur coat, because art-lovers were eagerly looking forward to these opportunities of acquiring pictures by the master. Most of his other works were made by imperial command; private people who came to acquire pictures from him had to be satisfied by his pupils' and assistants' works, to which he added his signature. Seven or eight out of every ten pictures (which pass under his name) are done in this way, and consequently critics who simply rely on the signature are usually deceived."

Chang Kêng then goes on to enumerate several pupils of Wang Yüan-ch'i, to wit: Hua K'un, *tzŭ* Tzŭ-kan, from Wu-hsi, a district governor; Chin Ming-chi, from Suchou; T'ang Tai, *tzŭ* Yü-tung, the Manchu official, court-painter and man of theory; Wang Ching-ming, *tzŭ* Tan-ssŭ, from Chia-ting, a prominent scholar and Han-lin member; Huang Ting, *tzŭ* Tsun-ku, the famous landscape-painter sometimes styled as a rival of Wang Hui, besides minor men such as Chao Hsiao; Wên I; Ts'ao P'ei-Yüan, *tzŭ* Hao-hsiu; Li Wei-hsien, *tzŭ* Chü-shan, a nephew of Wang, and Wang Yü, *tzŭ* Jih-ch'u, a paternal male third cousin of Wang Yüan-ch'i, who transmitted his master's teachings also in writing.

Wang Yüan-ch'i's surviving pictures may not be quite as numerous as the works of Wang Hui, yet they are more abundant than may be assumed by Western students who are not familiar with Eastern collections, because they have mostly remained in China and Japan, and only a small percentage have been made known through reproductions. The very high appreciation that the painter enjoyed in his life-time has hardly decreased with the years; he is still one of the favourites of the scholarly Chinese collectors, whereas relatively few Western connoisseurs have as yet recognized his artistic importance and hardly any leading museum has

started to collect his works. The largest supply of his pictures is still to be found in the former imperial collections, but good examples may also be seen in private possession in Japan and in Switzerland.[1]

Wang Yüan-ch'i's early pictures, which are dated in the seventies and eighties, are no less faithful imitations after Huang Kung-wang than the numerous paintings of the same kind by Wang Shih-min and Wang Hui, though they may perhaps show somewhat stronger pictorial accents and a less fluent brush than the works of his predecessors. One of the best examples of this early group is the picture in the Saito collection, dated 1679 and marked as in the manner of (Huang) Ta-chih[2] (Pl.421). It represents a mountain gorge with a broad stream that flows out from the innermost recesses of some mountains and follows a slow winding course through a valley until it is cut off by the lower edge of the picture. This quietly meandering stream has been skilfully utilized for the purpose of increasing the impression of depth; it opens the space between the mountains, whicht hus divide and recede instead of being crowded into a mass, as often is the case in pictures of this type. The spatial effect of the composition has been emphasized and the mountains stand out overwhelmingly grand, particularly if measured with the scale of the small buildings and bridges at their foot. Judging by the general character and the brushwork of this picture, Wang Yüan-ch'i has followed the great Yüan-master rather closely, as may be observed for instance, in the trees, though at the same time he emphasizes certain features of design and tone-values which contribute to bring out the effect of spatial grandeur.

The same may be said of the Mountain-landscape (formerly in the Yamamoto collection) which is dated 1687 and likewise indicated as in the manner

[1] The most significative appreciations of Wang Yüan-ch'i's art are to be found in the writings by J. P. Dubosc, to wit: "A New Approach to Chinese Painting", *Oriental Art*, vol.III, 2, and "Connaissance et Méconnaissance de la Peinture Chinoise", *Critique*, May 1952. An earlier appreciation of Wang Yüan-ch'i is included in Victoria Contag, *Die sechs berühmten Maler der Ch'ing Dynastie*, Leipzig 1940.

[2] Repr. in *Tōan*, p.54, and in *Ssŭ-Kang wu-yin*, pl.26.

of Huang Kung-wang.[1] The general scheme is much the same as in the previous example, the excellent spatial effect depending mainly on the broad river valley, but the brushwork seems to be a little stiffer and more tightening, the outlines of the cliffs are more accentuated, the general tone is deeper than in the picture of 1679. It may be said that the painter no longer seeks to imitate a definite model, but transposes it with individual freedom.

This relative independence in the transmission of the formal patterns as well as in the brushwork may also be observed in another picture of the same year (1687) representing a mountain pass between steep overgrown hills, from where the road leads down to a broad inlet of water with pavilions which are built on poles[2] (Pl.422A). It is painted with rich ink, gleaming dark against the vaporous mist that issues forth from the folds or crevices at the top.

In these and some other contemporary paintings Wang Yüan-ch'i is still clearly dependent on the Yüan models, but at the beginning of the following decade he makes a decisive effort to break away from the dependence on the Yüan models and to form a style of his own. This is illustrated by a number of important paintings dated between 1693 and 1696. The first of these is the picture of the Hua Mountain in Autumn in the Ku-kung collection[3] (Pl.422B). The squarely cut tower-like mountain is silhouetted against a field of white mist and built up of almost innumerable cubic blocks or lumps, strongly outlined by the dark growth of grass or small shrubs which makes them appear more or less free-standing. This manner of moulding and designing the rocks is quite different from the traditional manners which depend on tonal values and long softly flowing wrinkles; and Wang Yüan-ch'i seems to have developed it on the basis of actual observations. He tells us in several of his colophons how he tried to combine his studies of certain old masters with observations of nature, and it is evident that his interest in nature increased with the years as also his endeavour to render in his own way the essentials of what he had seen or learned.

In a picture which, according to the inscription, represents the Hou Mountain and was executed in 1694 "in the manner of Wang Mêng", the same way of moulding and constructing the mountains is combined with open spaces of water, which makes some of these rocky massifs stand out almost detached in their full cubic volumes, and serves to emphasize the receding planes of a deeply indented view (Pl.423).

The same problems occupy him in the River Landscape of 1696 (in the Ku-kung collection), which again is painted in the manner of Huang Kung-wang. It may at first sight look more traditional, but a closer analysis makes us realize how carefully the clumps, the rocky ledges and the dividing reaches of the river have been calculated so as to make the successive stages of the spatial extension clearly discernible. The picture represents a more advanced stage of landscape art, but the brushwork exhibits certain features such as the short horizontal strokes or dots used in drawing the trees and the hills which remind us of Ta-ch'ih's manner of painting (Pl.424). It is evident that Wang Yüan-ch'i (just like his grandfather) learned more from Huang Kung-wang than from any other old master, but he also realized the danger of being too closely tied by a formal model, as stated in the following colophons:

"I started by studying Ta-ch'ih; gradually I made some progress, and sought to penetrate to the very bottom of his art. Thus, when free from official duties, I often studied Tung and Chü with great care and in this way I grasped the root (of the matter) and need not trouble about the top. First the effect of general outlines should be fixed, then one should add colouring; but all must be penetrated by one breath of life, as the wind sweeps over the water and causes ripples to appear quite naturally. One cannot accomplish it by applying force or by being impatient about it."

[1] Ōmura, *Bunjin Gasen*, I, 10 (Yamamoto collection).
[2] *Ssǔ-wang wu-yün*, pl.27 (Yamamoto collection).
[3] *K.-k. shu-hua chi*, vol.XII.

In the following he gives a more complete description of his efforts to interpret Ta-ch'ih's art faithfully:

"The long handscrolls by the old masters were not lightly executed; months and years passed before they were completed. They took great pains with the work, but they also found pleasure in it. Once Ta-ch'ih painted a handscroll of the Fu-ch'un mountain on which he worked for seven years (before it was completed). It is evident that before he took up the brush, the spirit (of the scenery) joined with the heart (of the painter). The heart reflected the resonance of life; the brush could not but move when it should move, and stop when it should stop. He certainly did not strive for a display of skill and strange effects, and yet skill and strange effects are revealed beyond the brush and ink. After several hundred years the spirit is still luminous and brilliant . . ." He then tells how he saw the picture in the house of the president of the Board of Revenue and did a copy of it for a friend, with whom he often discussed painting and who used to watch him when working. 'It took me three or four years to finish this picture. My heart and thoughts are not equal to those of the old masters, but when I paint I never do it carelessly and it may be that in this scroll there is, after all, some slight smell of Ta-ch'ih's foot-sweat. This may cause a smile from you."

The smile is, however, not only luminous but also a striking expression of Wang Yüan-ch'i's humble attitude towards his ideal and his indefatigable efforts to grasp the spirit of Huang, and here may also be noted how he characterizes his own manner of working as slow, thoughtful and painstaking. It harmonizes perfectly with the impression that we receive from a study of his paintings. The new efforts and principles of design and representation which may be observed in these paintings are of this kind, revealing not only close observation but also clear thought and careful calculation rather than sudden flashes of inspiration like those so brilliantly manifested in the works of Yün Shou-p'ing. Wang Shih-min and Wu Li also expressed something of the same intellectual inclination, though their temperaments had a more romantic bent.

The analytical tendency served him even better in his theoretical and historical writings (to which we will return presently) than in his artistic activity, but it is interesting to note how it dominated his manner of working. A vivid description of this is attached to the biography in *Kuo-ch'ao hua-chêng lu*, where Chang Kêng repeats a story of his friend the Manchu scholar K'o-ta, whom Wang Yüan-ch'i once invited to his studio, where he could watch the painter's way of making a picture: "He started by spreading the paper, and then he cogitated for a long while. He took some light ink and drew some general outlines indicating in a summary way the woods and the valleys. Then he fixed the forms of the peaks and the stones, the terraces and the folds (of the mountains), the branches and trunks of the trees, but each time before he lifted the brush (to paint) he would think it over again and again. Thus the day was soon ended.

"Next day he invited me again to his house and took out the same scroll. He added some wrinkles (to the mountains). Then he took some reddish brown (ochre) colour, mixed it with a little yellow gum-resin (gamboge) and with this painted the mountains and stones. Thereupon he took a small flat iron loaded with hot coals, and with this he ironed and dried the picture. After that he went over the stones and the whole structure of the picture again, brushing it with dry ink. The leaves of the trees were dotted in a scattering manner, the woods on the mountains, the buildings, the bridges, ferries, streams, and beaches were brought out clearly. Next he took some green colour mixed with water and ink, and with this he washed the picture quite lightly and slowly, emphasizing lights and shadows and the relief. Then again he used the flat iron as before to dry the picture, and once more went over the contours and horizontal strokes, the coloured and the dotted spots from the lightest to the darkest parts, thus making the picture gradually denser. It took him half a month to finish the picture.

"At the beginning it was all in a nebulous state (*hun lun*), but gradually this was broken up, and then the scattered parts were brought together; finally the whole thing returned again to a nebulous state. The life-breath was boundless, the emptiness was filled with beauty, not a single stroke was carelessly done. This was the reason why he spent so many days on a work. The saying that the old painters used ten days for painting a watercourse and five days for a stone may not be an exaggeration."

It is rare indeed to find such a detailed and systematic description of an old painter's manner of working; it shows that Wang Yüan-ch'i was also considered remarkable in this respect, *i.e.* as *homme du métier*. The technical points reported in the quotation are clear enough to be understood without further comments, but still more important than these is the writer's insistence on the master's slow and gradual ways of painting, involving thorough preparation (mental and technical) and repeated periods of work on the same picture. The result of this became at times a somewhat distracting over-elaboration such as may be seen in the picture of the Hou mountain, mentioned above, but as time went by the painter tried more and more to systematize his designs and to give them a more structural aspect by reducing the details, and emphasizing the cubic volumes and planes.

This development was to some extent foreshadowed in the last picture mentioned above (dated 1697) and might be illustrated by several later examples "in the manner of" Huang Kung-wang (for instance the characteristic landscape in the Ueno collection)[1], but it seems more interesting to follow it through some pictures in which the Huang Kung-wang element is replaced by or combined with impressions gathered from Ni Tsan's works. The compositions of these pictures are relatively simple and uniform – they all represent river views framed by rocky ledges in the background and a few scraggy trees and a low pavilion in the foreground – but the rendering of these simple elements shows considerable variations. The picture in the Ku-kung collection, dated 1700,[2] is one of the best examples (*cf.* Pl.429, 430). The distance from the model is here not very great; Wang Yüan-ch'i may be said to have retained something of the airiness and refinement of the original. The design is spacious and the brushwork has a lighter touch than in the later pictures of this type. The Huang-Ni manner of painting with short horizontal and vertical brush-strokes is here beautifully applied.

In another similar view, undated but presumably painted four or five years later (in the Ueno collection)[3], the painter has emphasized the spaciousness of the vista by moving the ridge of the further bank farther away and inserting a rocky ledge between the foreground and the mountains of the background. The forms are firmly outlined with a stiff brush and modelled in relief against the wide stretches of quiet water. In the inscription the painter says: "Yün-lin's pictures may indeed be studied, but no one can really know them. I am now trying to represent his limitless views of peace and tranquillity, but nobody should say that I have entered his chamber." Wang Yüan-ch'i must have realized his own limitations; he saw that it was impossible to transmit faithfully the fugitive harmonies of Ni Tsan's art by faithfully transposing them into another key, but he could not help trying to do so.

The fundamental lines of his own artistic personality were so firmly set that he imposed himself involuntarily even in transmitting impressions of one of the most exquisite of the old painters. Most of his later imitations or transpositions of Ni Tsan show attempts to complete or develop his solitary river views so as to make them conform to the ideas of space-construction which form the central problem in the artistic activity of Wang Yüan-ch'i. Selecting some of these pictures in chronological

[1] *Yūchikusai*, pl.34.

[2] *K.-k. shu-hua chi*, vol.XLV.

[3] *Yuchikusai*, pl.36.

order, we may first consider two river views in the Dubosc collection in Lugano. The first is dated 1704, and in one of the inscriptions on this picture the painter says that he has tried to recapture the peaceful mood pervading the landscapes of Ni Tsan, and that he was inspired by a work by Wang Shih-min after Tung Ch'i-ch'ang (presumably in the manner of Ni Tsan). The view over the river is here divided into two sections by a rocky island in the shape of a truncated cone that rises in the middle distance between the solitary shore cliffs, with some thin trees and a low pavilion at the lower edge, and the mountain ridge in the background. The impression of depth is increased by the division of the composition into two portions; one might almost speak of two pictures in one, the upper one forming a continuation to the lower one (Pl.425).

The second picture, which is dated 1708, and according to the inscription painted in the manners of Huang and Ni, shows a more crowded composition in which the lower portion is filled with some large trees, a tall standing rock and low pavilions, and the rocky ledge in the middle distance is united by a curving promontory and a bridge with the mountain in the background[1] (Pl.426).

The third picture, which forms part of Dr. Vannotti's collection, is, according to the inscription, based on a work by Tung Ch'i-ch'ang, who, however, is here praised mainly as an expounder of Huang and Ni, and dated 1710 (Pl.427). It offers a more unified solution of the compositional ideas which we observed in the preceding pictures. In this case the central portion of the composition is not an open stretch of quiet water, but a continuous ridge with some off-shoots which connect the cliffs at the lower edge with the mountains at the horizon here placed at about the middle height of the picture. In other words the artist has given an approximation of the view as seen by a beholder somewhat below the horizon, or tried a kind of compromise between the traditional method of presenting the view as seen from above and a more realistic approach based on actual observation. This was not exactly new, some-

thing of the kind had been tried by certain masters in the Yüan and Ming periods, but not so systematically and successfully as in this painting and a few others by Wang Yüan-ch'i. He has taken a step further in the direction of representing objective space or extension in the unified and restricted sense that has been customary in Western art since the Renaissance. The scientific bent of Wang Yüan-ch'i's genius, his keen interest in observing the everchanging effects of nature and his systematic way of working led him in a direction parallel to that of certain modern European painters of the Cézanne school. But he was too firmly rooted in the traditional Chinese conception of space representation to go the whole length into the Western mode of perspective construction.

A closer analysis of Wang Yüan-ch'i's formal and technical innovations would be of considerable interest but it would carry us too far at this place. The pictures described above must suffice as illustrations of his endeavour to find new solutions for some of the fundamental problems. No less important for a proper understanding of his efforts to combine the principles of the old masters with his own observations of nature are some of his notes in the form of colophons or theoretical discussions. One of the most significative among the former is the following:[2] "The two Mis' manner of painting was of a very high class; their proper successor was Kao K'o-kung. He transmitted their spirit as well as their form. Other Yüan painters such as Fang Fanghu and Kuo Pi also possessed the elements of their art, but only in minor proportions. When, in the late spring and early summer of 1710, I was serving in the Summer Palace I used to look at the mountain peaks, observing how they appeared and disappeared in the morning brightness and evening glow. I

[1] The same influences are also evident in the large picture in the Musée Guimet, which furthermore is noteworthy as the only large example of the master's art in a public collection in Europe.

[2] Fifty-three of Wang Yüan-ch'i's colophons were collected under the title *Lu-t'ai t'i-hua kao*. They are reprinted in *Hua-hsüeh hsin-yin*, vol. VII.

studied the wonderful effects of transparency and tranquillity, and I realized that their true essence was caught in Mi Fei's ink-remains. In planning and executing such pictures one may indeed forget fatigue and old age. Many critics claim that he can be placed on a level with Tung Yüan and that even Huang Kung-wang and Wang Mêng were his inferiors, which is quite true."

Wang Yüan-ch'i has also given expression to his appreciation of painters like Mi Fei and Kao K'o-kung in (Pl.428) his excellent imitations after their works, which should be remembered as testimonials of the fact that he was not a doctrinarian who kept within the limits of a certain manner or set of principles, but a painter with wider views capable of using a manner entirely different from his own when he found it desirable. He looked to nature for a gauge or standard of appreciation also of the old masters' works; he realized that each master must follow his own way in expressing what he had felt or seen in nature, but that none could do it better than nature herself. She contained it all; the great masters' ways of painting and interpreting could all be found in nature, if one knew how to look for them, but not one was superior to nature's own transformations.

Thus it may be said that the study of the old masters also offered a clue or clues to a better understanding and interpretation of nature, but no inducement to slavish imitations. Wang Yüan-ch'i never became an eclectic to the same extent as Wang Hui and some other contemporaries. He preserved his artistic integrity and manifested his own ideas in painting as well as in writing with rare consistency all through his life. He was not a poet like Yün Nan-t'ien, nor a philosopher like Wu Li, but a thinker, a man of rare intellectual gifts who tried to find a reasonable explanation or solution to the problems of art and life: qualities which also made him an excellent official and a prominent expounder of the principles of painting.

His main achievement as a writer on art is the treatise known under the suggestive title *Yü-ch'uang*

man-pi, Scattered Notes at a Rainy Window, which contains a relatively condensed and clear summary of the theoretical ideas and technical principles that Wang Yüan-ch'i had absorbed during his apprenticeship in the studio of his grandfather. The historical importance of the essay is sufficient to warrant its inclusion at this place, and as the main points are clearly expressed, we can limit our explanatory remarks to a few words.

The introduction, in which the writer points out how certain schools of painting in the Ming period fell into the habit of continuous repetitions and copying, serves as a kind of background to the next section, which opens with the words: "The idea must be there before the brush; that is the essential secret in painting" – a statement that might serve as a general device for Wang Yüan-ch'i's artistic activity, which, as we have seen, was always based on thought and proper planning. The descriptive analysis of the painter's activity that follows refers to his mental as well as technical preparation and ends up in the usual praise of the old masters' ways of working in contrast to modern painters whose compositions are loose and whose brushwork is constricted.

A more specific idea is expressed by the term "dragon veins", a metaphor borrowed from old Chinese geomancy, where it was used to signify the life-carrying arteries in a landscape. Together with the spacing intervals they should form "the very source of strength and vitality of a picture". The idea is certainly suggestive and very useful in explaining the expressionistic features of certain masters like Wang Mêng, who drew his dragon veins "like winding snakes", or Wu Chên, who did them with straight brush-strokes, whereas Huang Kung-wang did not emphasize them to the same extent, and Ni Tsan "went beyond the common rules and manners of brushwork" – a scale of appreciation to which all the leading painters of the period might have subscribed.

The technical advice that follows refers to the systematic manner of working (so as to avoid haste

and confusion) and to the proper use of the five ink-tones and the colours, "which should supplement what is insufficient in brush and ink-work", a statement that one may find illustrated by some of Wang Yüan-ch'i's later paintings, in which bluish-green tones are often blended with the ink, and serve to emphasize the structural forms and the spatial values. Colourings should not be a kind of additional adornment (as often was the case in earlier Chinese paintings), but rather result from the transmission of the life-breath and serve to complete the design in a natural way: "Every element, light and shade, the clear and the obscure, the morning brightness and the evening dusk … should be observed with great care at all times".

No painter has pointed out more insistently than Wang Yüan-ch'i the necessity of a thorough and systematic training for the artist, involving study and observation as well as thought and application. He was the most learned and methodical and yet, perhaps, the most original and independent of the Four Great Wang. In summing up the general requirements that he considered most important in painting, he says that in his works the painter must combine reason and life-breath and make it interesting … "He should look for the strange in the common, for the needle in the floss of silk, for that which is produced by an interaction of the empty and the solid." It may be said that Wang Yüan-ch'i's method or programme was based on reason, but the aim of it was to enable the painter to reveal as much of the inner beauty or significance as he could realize in his own mind. "He should convey between the lines and in the ink that which others cannot give, and not give what others are able to do."

* * *

Scattered Notes at a Rainy Window[1]

The ancients have discussed the Six Principles in detail, but I fear that later students have adhered to ready-made opinions and not given expression to their own minds. In their uncertainty they have been guessing at their meaning, going in the wrong direction and getting worse. Now I am going to explain the general meaning of the principles of composition (plan and design, place and position), of brush and ink, and of colouring in accordance with the transmitted opinion of my grandfather, Fêng-ch'ang (Wang Shih-min), as I understand them, in order to make known both the sweet and the bitter. Later I may note down whatever I have grasped as the brush moves.

At the end of Ming times there were some bad habits and poor schools of painting; the Chê school was the worst among them. As to the great painters of the Wu and Yün-chien schools such as Wên Pi and Shên Chou and the great master Tung Ch'i-ch'ang, their works are much mixed up with fakes. One false thing led to another and gradually produced a stream of corrupt practices. The bad habits of the Yang-chou and the Nanking painters were hardly different from those of the Chê school. Those who desire to learn the proper use of brush and ink should be on their guard against them.

The idea must be there before the brush – that is the essential secret in painting. When the painter takes up the brush he must be absolutely quiet, undisturbed and at ease; rid of all vulgar emotions. Facing in silence the white scroll, he must concentrate his spirit and control his life-breath. He must look at the high and the low, examine right and left and the ways in and out of the scroll (composition). When he has a complete view in his mind, then he should dip the brush and let it suck the ink.

He must first settle the vital strength (life-effect), then draw the framework; then spread out the dense and the scattered portions, then make distinctions between the thick and the thin parts, turn them and change them, tap and rap until the west responds to east. Thus the bed of the stream will be ready for the water when it arrives. All parts will fit each other naturally, and the spirit of the brush will flow freely and without obstruction. If one's intentions are not

[1] Edit. *Mei-shu ts'ung-shu*, I, A.2; and *Hua-hsüeh hsin-yin*, vol.7.

definitely fixed, and one's thoughts rush towards profit and fame, seeking simply to please people, and if one introduces trees and stones one by one, accumulating them in heaps, twisting and shifting everything in the scroll without thought or taste, the brushwork will become vulgar.

Present-day people do not understand the real reason of painting but grasp only the formal resemblance. When the brush is fat and the ink is thick the work is said to be thoroughly rounded out, and when the brush is thin and the ink laid on in light washes it is said to be noble and free. When the colour is brilliant and the brushwork is delicate it is said to be bright and beautiful. People have no idea of how wrong they are. Shortly stated, the ancients built their compositions firmly, but their brushwork was free, whereas the compositions of modern painters are loose and their brushwork is constricted. If one pays proper attention to this, then sweetness, corruptness and vulgarity disappear by themselves without any effort.

Although the "dragon veins" ("the magnetic currents" of the scenery)[1], the spacing intervals (opening and closing) and the rising and falling (rhythm) form parts of the old methods in painting, they have not been properly recorded. Wang Shih-ku explained (these principles) and later students have followed them, but according to my opinion, students cannot finally grasp these things without combining theory with practice.

The "dragon veins" are the very source of strength and vitality in painting. They may be slanting or straight, complete or fragmentary, broken up or continuous, hidden or visible. They may be said to form the body or essentials of the picture. The spacing intervals follow from the top to the bottom, the principal and secondary ones in proper succession, sometimes they are closely tied together, sometimes spread out. The turning peaks, the winding roads, the forming clouds, the dividing water-currents, all have their origin in them. The rising and extending (elements of the composition) should reach from near to far, so that the front and the back

are clearly distinguished. Sometimes they may rise high and lofty, sometimes extend evenly. The inclining portions should support each other mutually; the top, the body and the feet of the mountains should be carefully balanced. These points can all be said to depend on practice. If one understands the "dragon veins" but does not properly render the open (k'ai) and the closed (ho), and the rising (ch'i) and falling (fu) (rhythm?), the result will certainly be cramped and lacking in strength. If one understands the rising and the falling, the open and the closed, but does not co-ordinate these elements with the "dragon veins", it may be said that one looks after the child but neglects the mother. The forcing and twisting of the "dragon veins" produce faults. If the opened and closed parts are cramped or too open, faults will result. If the risings and fallings are stiff or heavy, or incomplete and defective, it also produces faults. On the other hand, if the painting has spacing intervals (k'ai ho), each portion of it partakes of these intervals; and if the whole painting has rising and falling (movement), each part has it also, and it becomes still more wonderful by the connexion and correspondence of the parts within it. The excessive is controlled and the wanted is supplied, and the "dragon veins", whether slanting or straight, complete or fragmentary, hidden or visible, broken up or continuous, become bristling with life (in every part); only so can a true picture be done. If one understands and thoroughly penetrates all this, a small portion of nature becomes grand nature, and how then could the results be anything but wonderful?

Painters must above all pay attention to the breath of life and the outlines. It is not necessary to look for beautiful scenery or to hold fast to the ancient models. If one is able to give the spacing intervals (k'ai ho) and the risings and fallings (ch'i fu) in the proper way, and if, furthermore, the outlines and the breath of life are well combined, the "dragon veins" turn and bend with proper rhythm,

[1] Lung mo, see Giles, Dictionary, 8011; here evidently signifying the life-carrying lines or arteries of the landscape composition.

and wonderful landscapes will appear in accordance with the old methods. For painting trees and forests special methods exist.

Copying pictures is not so good as looking at pictures. When one comes across a true work by an old master, one should study it very closely. One should look for its main ideas, how it is composed, how one may move out of and into it, where it is slanting and where straight, how things are placed, how the brush is used, and how the ink is distributed. It certainly contains parts which are superior to one's own art; after some time one will quite naturally be in close harmony with it.

The old painters of the North and the South Sung periods were all divided according to clans (schools), and within each school the manner of applying the "dragon veins", the spacing intervals (openings and closings) and the risings and fallings were different, but the breath of life was expressed through all these points. Indeed, they ought to be studied with great attention, as for instance Tung Yüan and Chü-jan, whose style was absolutely complete and whose original life-breath was so strong and unrestrained that it seemed incomprehensible to the people. Then at the end of the Yüan dynasty appeared the four masters, who followed in their wake, i.e. Shan-ch'iao (Wang Mêng), who used "dragon veins" abundantly, drawing them like winding snakes, Chung-kuei (Wu Chên), who painted them with straight brush-strokes; each did them differently, and one must look closely to find out how in the work of each the dragon veins were connected. Huang Tzŭ-chiu painted them neither in a connecting nor in a disconnecting way; in using them he did not use and in not using he used them (i.e. "dragon veins"). If one compares him with the two masters mentioned above, one may observe how original he was. Ni Yün-lin was not stained by a grain of dust; there was dignity in his ease and quietness, refinement and beauty in his simple and abbreviated manner. He went beyond the common rules and manners of brushwork. He was the first of the four masters and belonged to the (i) class. My

grandfather Fêng-ch'ang, who had learned particularly from Ni and Huang, explained to me carefully in former years the essentials of their art, which I have noted down here respectfully as a guidance for connoisseurs.

In painting you should avoid smoothness, softness, hardness, heaviness and coagulation (too great solidity). Furthermore, avoid haste and confusion, avoid brilliant clearness and glossiness, avoid crowding and mixing things in disorder. You should not make a display of good brushwork, nor intentionally avoid awkward brushwork, but work leisurely without pressure (or haste). You should start from the light parts and proceed to the thick ones, preserve the original and outstanding, suppress the sweet and common, strengthen the delicate and the weak, and break up the stiff and the heavy. The brush should be applied without too much intention, yet not without intention, and then, even in turning the corners and edges, one is not the slave of the brush.

The use of the brush and the use of the ink complete each other mutually. The five manners of using the ink have all the same scope. To sum up: The breath and movement of life (Ch'i-yün shêng-tung) have all their origin in this (the brush-and-ink work).

To paint with colours is quite the same as to work with ink. The aim of using colours is to supplement what is insufficient in brush-and-ink work, they should serve to bring out the wonderful portions of this. But then men of today do not understand the meaning of it. In their pictures the colours are simply colours, and the brush and ink are simply brush and ink; they are not blended with the characteristics of the landscape and do not enter into the weave of the silk. One sees simply a blaze of red and green colours, which are enough to make one disgusted and satiated. If one does not aim particularly at colouring but rather strives for life-breath (ch'i), trying to stir it and to bring it out in the light and the shade, on the front and the back, the (effect of) colours will result from the life-breath. They

will not float about, nor seem congested, but complete the design quite naturally. One cannot accomplish these things in a hasty way; every element, light and shade, the clear and the obscure, the morning brightness and the evening dusk, the shape of the hills and the colour of the trees, should be observed with great care at the different hours of the day. The colours may be laid on lightly or in thick layers to suit the different parts, but this must be done according to practice and experience. There are no fixed rules for this.

It is very important that the painter should combine reason and life-breath in his work and make it interesting. If these three points are not accomplished, the picture will not become either of the refined, the wonderful, the divine or the unrestrained (*i*) class. Therefore one must look for the strange in the common, for the needle in the floss of silk, for that which is produced by an interaction of the empty and the solid. Painters who simply comply with the rules and express no ideas beyond the formulas, have ever since olden times been considered worthless fellows. When the student of painting has started on his career, he must keep on striving for gradual progress day by day. He must convey between the lines and in the ink that which the others cannot give, and not give what others are able to do. Only then can he obtain the secrets of the Sung and Yüan masters. And he should never be too satisfied with himself.

Followers of the Lou-tung School and other Famous Landscapists at the Beginning of the Ch'ien-lung era

Huang Ting, Wang Yü, T'ang-tai, Chang Tsung-ts'ang, Fang Shih-shu, Tung Pang-ta, Chien Wei-ch'êng, Kao Ch'i-p'ei, Li Shih-cho and others.

THE GREAT masters whose works we have studied in the preceding chapters had numerous followers, but no one of these rose to the level of Wang Hui or Wang Yüan-ch'i; nor did any of them equal Yün Shou-p'ing as a flower-painter. They followed in the wake of the leaders, faithfully as men of the brush, but rarely, if ever, as creative artists.

Nor would it be correct to try to reconstruct such local schools or groups as we have examined in the discussion of the preceding painters, because the influences of the greatest importance to the new generation were mostly of a generalizing kind and not confined to one predominant current of style or school. Wang Hui, who exercised the greatest influence, was after all an eclectic, his phenomenal faculty of reproducing styles and manners of various kinds was more impressive than his original creative genius, and he devoted most of his work and study to the transmitting of well tried patterns and principles of the old masters.

Wang Yüan-ch'i was more of a theorist and organizer and as such, greatly admired, but his new pictorial ideas were perhaps of too abstract a kind to be fully comprehended and put into practice by his followers. Their importance is more noticeable in the writings of some of the younger men such as Wang Yü and T'ang-tai than in their paintings.

The so-called Lou-tung school is consequently a generalizing term referring to a rather broad, though somewhat shallow flow of artistic thought and activity which was nourished by the sources of the Yüan painters, transmitted by Tung Ch'i-ch'ang, and conducted into new channels by Wang Yüan-ch'i.

The painters who traditionally are grouped in the so-called Lou-tung school and who were active during the first half of the eighteenth century are far too many to be completely recorded at this place; we can select only a few of the best-known whose works are easily accessible in reproduction and leave out those who are hardly more than names to us.

* * *

The oldest and most important of the Wang followers was Huang Ting, *tzŭ* Tsun-ku, *hao* Tu-wang-k'o and K'uang-t'ing, from Ch'ang-shu in Kiangsu (born 1660, died 1731), who sometimes was represented as a rival of his fellow-citizen Wang Hui. His pictures are still highly appreciated, though not placed in the top class. Chang Kêng says that he learned landscape-painting from Wang Yüan-ch'i but combined with these studies ideas borrowed from Wang Hui, which no doubt is correct. His brushwork was rich and vigorous and his copies after the old masters deceptively like the originals, particularly those made after Wang Mêng. Another contemporary writer, Shên Tê-ch'ien, has left a more intimate report about Huang Ting:[1] "There have been five famous painters in our time: Yün Shou-p'ing (original name Ko), from Wu-chin; Wu Yü-shan (family name) Li, and

[1] In a book called *Kuei-yü wên ch'ao*, quoted in *Kuo-ch'ao-hua shih*. The author was a great favourite of the emperor Ch'ien-lung. *Cf.* Giles, *Biogr. Dict.*[2] 1700.

Wang Lu-t'ai, Yüan-ch'i, from T'ai-ts'ang; Wang Shih-ku, Hui, from Ch'ang-shu, and last of all my friend Huang Ting from Ch'ang-shu. Wang Lu-t'ai was a *chin shih* and rose to the position of a vice-president, which made it easy for him to reach fame. The other four lived as hermits or common men, and though it was obviously more difficult for them to acquire fame, they did it in no less degree. Yün Shou-p'ing, Wang Hui and Wu Li were all highly praised by Wang Yüan-t'ing[1] and other men of importance; consequently their fame spread far and near. But when Huang Tsun-ku appeared, there were no such men to spread his fame, which was therefore the more hardly earned. He was a great traveller during most of his life, and wherever he saw strange or uncommon views he transformed them into paintings. Things of that kind were not accomplished by earlier men. The critics of Wu said: 'Shih-ku saw all the famous pictures of old and modern times, and his works were perfectly finished; he may indeed be called a great master. But Huang Tsun-ku saw all the mountains and rivers in the world [sic], and his paintings have the effect of life. He must likewise be called a great master.' The two men both came from Yü-shan (Ch'ang-shu) and consequently they are often discussed together. Tsun-ku called himself in his old age Ching-kou Lao-jên. He died in 1730 at the age of 71."

Most of Huang Ting's preserved works, of which a great number form part of the Ku-kung collection, are painted in rather close imitation of the Yüan masters, Ni Tsan, Huang Kung-wang, Ts'ao Chih-po, and Wang Mêng, though seldom as textual copies. They are in many cases quite effective with their strong and firm brushwork as well as by the abundant use of deep glossy ink, which the painter probably learned from Wang Mêng (Pl.431). The designs, too, particularly in some of the minor album-paintings (as may be seen for instance in *Shina Nanga*), are inspired by Wang Mêng's works and characterized by winding arteries or "dragon veins" (in the shape of paths and water courses) amidst an abundant growth on bulging mountains.

In his very large compositions such as the Snow-covered Peaks, in the Ku-kung collection (1729), or The Mountain Gorge here reproduced (formerly in private possession in Peking), which measures nearly ten feet in height, the details are so abundant and carefully elaborated that they become almost bewildering (Pl.432). Huang Ting was evidently an ambitious painter who did not hesitate to tackle problems which, strictly speaking, were beyond his powers, because they could not be solved simply by technical skill and good brushwork. Like most of the landscape-painters of Wang Yüan-ch'i's following, he possessed excellent principles and thorough theoretical knowledge, perhaps too much of it to make him free and strong as a creative painter.

Wang Yü, *tzŭ* Jih-ch'u, *hao* Tung-chuang, was personally as well as artistically closely attached to Wang Yüan-ch'i, his paternal uncle.[2] He did his best to follow in the footsteps of his relative and consequently devoted most of his time and endeavour as a student of painting to imitations after Huang Kung-wang, but in doing so he showed very little of the individual faculty of interpretation so characteristic of Wang Yüan-ch'i. His renderings of the Yüan master's designs are of a more indifferent kind, as may be seen in the two large mountain landscapes dated 1721 and 1722 respectively.[3] A more attractive work by the master is the album-leaf in the Musée Guimet representing a river view which, according to the inscription, was painted in 1688 in the manner of Wang Mêng (Pl.434).

Wang Yü's skill is usually praised as a result of his studies with Wang Yüan-ch'i, whereas his own talent is not rated very high. The most critical opinion about his activity as a painter seems to have been expressed by his wife, if we may believe the report

[1] Wang Shih-chêng (1634–1711), poet and high official. *Cf.* Giles, *op. cit.*, 2221.

[2] Wang Yü's relationship with Wang Yüan-ch'i has been variously defined; the closest definition seems to be: *Tsu ti, i.e.* paternal male cousin, given in *Chin-hua ou lu*, quoted in *Kao-ch'ao hua-shih*, vol. VIII.

[3] The former reproduced in *Shên-chou ta-kuan*, vol. I, the latter in *Sōgen*, p. 269.

in *Tsai-t'ing ts'ung kao*,[1] according to which the woman urged her husband to return to the occupation of the farmers: "They work hard", she said, "but they are able to support themselves, whereas painting may serve for amusing people, but it cannot serve as a support for a man. Students should hide their accomplishments. How could such an occupation equal work with the plough?" – A highly practical view which may have had some good justification, at least in the opinion of the vice-governor of the province, who composed a poem in praise of the prudent wife.

Wang Yü's fame with posterity is, as a matter of fact, less based on his painted works than on the theoretical treatise known as *Tung-chuang lun-hua* which he composed as a digest of the ideas and teachings that he had received during his apprenticeship with Wang Yüan-ch'i.

In the introduction he writes: "I served Master Lu-t'ai for three years and to some extent grasped his teachings. Yet until recently I was quite unable to apply all the knowledge I had already possessed in my work, because I had not reached 'the maturity which is beyond maturity'; there were some obstructions in my mind which prevented me from giving free and spontaneous flow to my ideas through the brush." He then goes on to tell how in the year 1732 he was laid up in bed and during the illness meditated quietly on the principles of painting that had been enunciated by his teacher, and how after he had recovered, he started painting again, and felt (to use his own words) "like a drunkard who awakens from his drunken sleep or like a dreamer who begins to regain his consciousness. My teacher had taken great pains in showing me the way, but only then did I grasp the true meaning of it all."

After some references to the correspondence between a man's character and the work that he produces with the brush, he draws the conclusion that "the most important point for scholars when they are painting is to be equal-minded and not to pay any special attention to connoisseurs, or to be

careless when working for the uninstructed. The progress of their studies will largely depend on this.

"Everybody knows that in painting there should be reason (right principles) as well as the breath of life, yet these two points are much neglected. The main point is that the mind and the character of the man should be developed; then the principles will be right (correctly applied) and the breath of life will be pure. Great ideas will then naturally issue from his breast and wonderful original effects will be produced by his brush. Such works may indeed become famous."

The demand for a combination of reason and life-breath in painting is well known from the writings of Wang Lu-t'ai; it must have been a fundamental tenet in the attitude and teachings of the master. In the following paragraphs Wang Yü returns repeatedly to the necessity of a proper mental preparation before the brush is grasped:

"Before the painter starts with the brush he should be in a happy mood and let his thought penetrate far. While he is working his pulse should be quiet and his soul concentrated, no matter whether he paints in the *kung-pi*, or the *hsieh-i* manner.

"The point of greatest importance for students of painting is to be open-minded and eager to learn. They must not become boastful as soon as they have made some slight progress. When they see works by other painters they should not try to expose their weak points. When they meet painters who are their superiors they should always ask their advice, and when they meet painters who are not their equals, they should turn a critical eye upon themselves."

Then he returns again to the necessity of waiting for the right moment before starting, of never doing it *invita Minerva*: "One should never start to paint before inspiration is aroused, be it through observations of clouds and streams or through contemplation of flowers and birds, or by strolling about and humming songs, or by burning incense, or by

[1] Quoted in *Kao-ch'ao hua-shih*, vol. VIII.

sipping tea; one must wait until something has been grasped in the heart and the inspiration has become overwhelming (itching for expression). Only then should one stretch the paper and start the brush. And as soon as the inspiration is exhausted, one should stop and not take up the work again until there is another moment of inspiration. Thus it will become quite naturally filled with the moving power of heaven and absolutely different from ordinary works (things of the dust) . . .

"The mind must be absolutely empty (like a cave) without a single speck of dust. Then the hills and valleys will issue from the very soul (of the man), sometimes blended and diffused, sometimes flowing easily, sometimes steep and vigorous, sometimes scattered and dispersed, and if one constantly keeps on thinking of them, the real appearance of the mountains and streams will become manifest at the tip of the brush. Such paintings could not but surpass the works of ordinary men.

"If the brushwork is firm and graceful and the ink (light, as if) flying and moving, there will be an overflow of original life. It will seem as if one stood face to face with the actual peaks and streams. Such is the power of real brushwork and ink-work. But it is necessary to realize this resonance of the spirit (shên yün) by constantly observing it in the mornings and the evenings, in the four seasons, in stormy and clear weather, in rain and snow, in mist and clouds, and in all other transformations of nature."

Wang Yü gives us a hint of the means that he himself used for reaching the state of equal-mindedness that he recommended so strongly to the painters. He refers to the practice of meditation in accordance with the Ch'an teachings which still constituted an important undercurrent in the life of the artists: "The practice of Ch'an teaches us that the worst deadlock may yet be resolved. The same may be said of the Six Principles in regard to a difficult situation in painting. One should not do things rashly or make unnecessary exertions, but keep the mind open and concentrate the thoughts in the eye; then, quite unexpectedly, things will become clear.

One picks up the work again without the least effort and the road to success is open."

The same psychological background and high regard for the proper mental attitude is expressed also in the following passage: "Purity and emptiness are two words which indicate the deepest secrets of the painters. Students who understand these marvellous points will be able to step out of the old ruts just as by one stroke of the Ch'an staff the whole emptiness is broken into pieces."

Wang Yü's historical remarks about the development of painting during the successive dynasties from T'ang to Ming do not contain much of particular interest, and we may also pass over his definition of the unrestrained spontaneous ink-painting, which at first sight looks "rough and confused", but at closer sight has "a limitless significance". The conclusive ideas are expressed in the following paragraphs:

"It is of the greatest importance in painting to know how to start and how to finish. The start should be quick like running away on horseback before the dust, but one must be able to draw the reins and make it (the horse) stop. Yet, when it stops, it should not have the appearance of stopping. The finishing should be like the returning of innumerable streams to the sea. The sea is ready to receive them all, they flow into it completely and yet it has not the appearance of being over-filled.

"The wonderful points in painting are not to be found in luxuriant beauty, but in refinement and strength. They do not depend on minute exactness, but on purity and ease. Because luxuriant beauty and minute exactness can be achieved by practice, whereas refinement and strength, purity and ease depend on the resonance of the life-breath and the character of the man. They cannot be forced."

* * *

T'ang-tai, *tzŭ* Yü-tung, *hao* Ching-yen and Mo-chuang, was also closely associated with Wang Yüan-ch'i and is counted among his pupils, but as an artist he was less capable than Wang Yü in trans-

mitting the master's teachings and ideals. He earned, however, great reputation and a social standing far above that of poor Wang Yü; his large paintings were considered the most perfect examples of the principles of landscape-painting that had been formulated by the great masters of the Sung and Yüan periods.[1] No one with a standing at court could entertain any doubts as to the genius of the Manager of the Imperial Household – T'ang-tai's official title – whose pictures were compared with the works of Fan K'uan and Wang Mêng, or other masters of the same class.

In the *Kuo-ch'ao yüan-hua lu* we are told that "the emperor K'ang-hsi considered him the foremost among painters (*hua-chuang-yüan*), and that later on the emperor Ch'ien-lung wrote a poem on a picture by T'ang-tai, called A Thousand Mountains at Sunset, in which he compared the painter with Fan K'uan, Ni Tsan and T'ang Ying". It is also reported that "when he entered the palace service he received personal advice from the emperor, which caused great progress in his manner of painting. Very few of his works passed into the collections of private people; those who possessed such works treasured them like pieces of precious jade."

A fair number of them may still be seen in the ex-imperial collections, most of them being very elaborate and faithful imitations after such famous masters of previous dynasties as Kuan T'ung, Fan K'uan, Hui Chung, Chao Mêng-fu, Huang Kung-wang, Wang Mêng and Shên Chou, etc., and even when they are not obvious or direct imitations after the patterns of the old masters, they are executed in a somewhat dry academic manner, revealing the brush of an imitator rather than that of an original master. Some of these pictures may possess historical interest as they reproduce more or less faithfully designs by old masters, but it would be a mistake to accept them as worthy substitutes for the lost originals[2] (Pl.433). Few pictures of the kind appear more depressingly empty because of the marked disproportion between their formal grandeur and the lack of life-breath. They are painted with the same

kind of indifferent skilfulness as a good artisan exhibits in ornamenting a screen or a sign-board, but this did not make them less esteemed at the Manchu court.

T'ang-tai who was a Manchu by birth, had also the ambition of appearing as a literary writer and theorist and composed as such a treatise on painting known as *hui-shih-fa-wei*. He repeats the fundamental principles which Wang Yüan-ch'i defined with the terms *lung-mo* ("dragon veins"), *k'ai-ho* (opening and closing), and *ch'i-fu* (rising and falling), and discusses their origin and meaning without adding anything essentially new. The same traditionalism prevails in his discussion of wrinkles and using colours which may be different in different pictures. When one is painting, and the inspiration rises one should observe the effects of the mountains and change the brush-manner accordingly. Kuo Hsi used mostly (in painting mountains) the unrolled hemp-fibre wrinkles, but when he came to corroded rocks, he painted them in whirls like clouds.

"Wang Mêng used long wrinkles, but in painting mountain ridges he used wrinkles like untied winding ropes. Chao Mêng-fu used 'lotus leaf-fibre wrinkles' but these are all transformations of the hemp-fibres . . ." Similar scholastic disquisitions about colouring, moss, trees and forests, distant mountains, mist and clouds, can hardly be said to add more interest to T'ang-tai's treatise. Like his paintings it leaves us with the impression that he was not a genius, nor an artist by nature; his great reputation as such was evidently (as often in similar cases) the result of influential protectors in high positions and the fact that he, as a Manchu, belonged

[1] A systematic account of T'ang-tai's *curriculum vitae* and his activity as a painter and theoretical writer is included in Dr. Roger H. Goepper's treatise called *T'ang-tai, ein Hofmaler der Ch'ing-Zeit*, which exists in mimeographed copies distributed by the Völkerkunde Museum in Munich, but not as yet in printed form. This volume was obtained only after my short discussion of T'ang-tai was in final form.

[2] Cf. *Li-tai*, vol.IV and V. *Ku-kung*, vol.XIV and *K.-k. shu-hua chi*, vols.VI, XIX, XX, XXI, etc. Other works by T'ang-tai in *Kokka*, 357, 376; *Sōgen*, p.284.

to the ruling clan, than of any outstanding individual gifts.

Wang Hui's enormous production would evidently not have been possible if he had not employed a number of able assistants. Some of them are known also through creations of their own; others have remained practically unknown. Among the former may here be mentioned Yang Chin and Wang Yün, both highly skilled professionals who did figure and flower-paintings just as skilfully as landscapes.[1] Yang Chin (1644–after 1726) has actually signed some paintings together with Wang Hui, as for instance the picture of the Yen Hsüeh Pavilion, on which Yün Shou-p'ing wrote a colophon in 1683,[2] whereas a landscape with A Pine-tree, Bamboo and a Blossoming Plum-tree (dated 1694) is signed not only by Wang Hui and Yang Chin but also by Wang Yün (1652–c.1735).[3] He was attached to the imperial Bureau of Painting (Hua Yüan) in the K'ang-hsi epoch, and enjoyed considerable reputation for his figure compositions in the manner of Ch'iu Ying and landscapes after the manner of Sung academicians such as Liu Sung-nien.[4] The picture in the Ku-kung collection representing a blossoming peach-tree, small bamboos and a mandarin duck, dated 1700 and signed conjointly by Wang Yün and Wang Hui, is a careful work in the manner of Lu Chih,[5] whereas Yang Chin's picture of a similar motif, i.e. a blossoming plum-tree, bamboos and a rock, dated 1712 (also in the same collection)[6], is painted with a lighter brush, more like that of Yün Shou-p'ing. Yang Chin was evidently a man of great technical proficiency able to vie with the greatest specialists of flower-painting, as is proved by the charming sketches of flowers and fruits in an album dated 1714 in the Hobart collection in Cambridge, Mass. Some of the famous younger flower-painters, active in the Ch'ien-lung reign, will be mentioned in a following chapter.

The legacy of the Lou-tung school was of course mainly directive in the field of landscape-painting; there it lived on through the Yung-chêng and first half of the Ch'ien-lung epoch, though gradually fading into more shadowy memories of great designs and abundant "dragon-veins", which no longer served as arteries of life. It included, however, several men of outstanding talent who should be remembered at this place.

Chang Tsung-ts'ang, tzǔ Mo-ts'un, hao Huang-ts'un, from Suchou (1688–1756), worked for some years with Huang Ting and was thus introduced to the methods and principles of the Wang school, though at the same time familiarized with the academy traditions of pre-Yüan times. His manner of painting is described in Kuo-ch'ao hua-chêng lu[7] as follows: "He painted in a somewhat heavy manner and put on the wrinkles of the mountains and stones with dry ink, which was accumulated in layers, using lighter ink for the trees, but this too was rubbed on dry, by which he suggested an atmosphere of life. The effect of his pictures is rather luxuriant." The same characterization is repeated by Ch'in Tsu-yung, who says that he piled up burnt ink on the trees, adding however the following true remarks:[8] "There was a little too much fine detail in his works and not enough of an enveloping atmosphere. The old masters' paintings, whether thick or light, were all filled with one breath of life, pure and deep, in a natural way. They did not use burnt ink to make them startling. But Huang-ts'un did not know this secret."

Chang Tsung-ts'ang's numerous landscapes in the Ku-kung collection, which mostly represent imposing mountain views with peaks behind peaks and layers upon layers, deeply fissured and richly clothed with shrubs and trees, are all painted with a strong, short brush and deep ink in the shadows. The general effect is often quite striking, though somewhat scattered or disjointed by the emphasis on the

[1] Both recorded in T'ung-yin lun-hua, I, 3, p.6 and II, 2, p.16.
[2] Shina Nanga Tai-kan, III.
[3] Shina Nanga, III, 12.
[4] Cf. Shên-chou T.-k. hsü pien, vol.V.
[5] Ku-kung, vol.XIX.
[6] K.-k. shu-hua chi, vol.XXVI.
[7] Vol.II, p.11.
[8] T'ung-yin lun-hua, I.3. p.5.

lights and shadows. In minor paintings after the Yüan masters, mostly Huang Kung-wang, Ni Tsan and Wang Mêng, he sometimes succeeds in transmitting a more immediate life-breath by a freer and easier handling of the brush and the ink-tones. Most remarkable in this respect is the illustration to Ou-yang Hsiu's dramatic *fu* poem known as The Autumn Dirge (Pl.435), in which the effect of the sudden storm, the whirling leaves, the bending trees, the battering rain and the men who seek shelter in and outside the pavilion are vividly rendered. The pictorial effects have been observed in nature, and the painter has modified his brushwork in accordance with the motif.[1]

Chang Tsung-ts'ang was at the end of his life particularly honoured by the emperor Ch'ien-lung, because when the emperor in 1751 travelled to the South, the painter had presented to the imperial art patron a series of sixteen views from the Wu district, which highly pleased the sovereign. He was ordered to serve in the palace and was three years later appointed to the post of a secretary in the Board of Revenue, but died shortly after at the age of 70.

Chang P'êng-ch'ung, *tzŭ* T'ien-fei, *hao* Nan-hua (1688–1745), should also be mentioned at this place. He is not so much known as a painter, owing to the scarcity of his works, but he was well known as a writer and sometimes called the "itinerant saint". He served in earlier years as a director of the crown prince's household. As a painter he followed the Yüan masters, though in a rather independent fashion. There are two hanging-scrolls by him (beside album-leaves) in the Ku-kung collection, both called Blue Peaks in a Clear Autumn,[2] though rather unequal. One is marked as an imitation after Wang Mêng and dated 1744; the other, which was painted the same year and dedicated to the emperor, is a more typical product of the Lou-tung school. Ch'in Tsu-yung praises his light brushwork and harmonious colouring and says that his art was absolutely free from vulgarity,[3] but in describing some of his larger pictures the writer adds: "The 'dragon

veins' are too forced and the spirit seems scattered, because he has not learned to control his temper" – a verdict probably meant as a criticism, but also pointing to the fact that the painter did not follow the beaten track exactly but made some attempts in other directions.

Fang Shih-shu, *tzŭ* Hsün-yüan, *hao* Huan-shan and Hsiao-shih Tao-jên (1692–1751), from Hsieh-hsien in Anhui, was also a pupil of Huang Ting. According to Chang Kêng,[4] "he used the brush in a clever fashion and aroused an impression of abundant life. At an early age he was already considered better than his teacher. He was indeed the kind of man who is seldom seen, and it was a great pity that he passed away in middle age. If he had lived some years longer, he might have shared the mat with the four Wang. His friend, the poet Min Yü-ching, said: 'Fang Shih-shu's early works did not seem to indicate such great progress as he has made nowadays. The real advance in art he made only after he was 40.'" His works are not very abundant, but some of them bear witness to unusual refinement and a very sensitive brush, as may be seen in the picture (from a private collection at Taiwan)[5] representing A Scholar's Study among Pine-trees, Cedars and Garden Rocks, dated 1746. It is painted after a model by Lu Kuang with a light and sensitive brush somewhat in the manner of Wên Chêng-ming's later works. The larger mountain landscapes (dated 1745 and 1746: reproduced in *Chung-kuo*, pp.142 and 144) may also be mentioned because of their pictorial atmosphere. The album pictures after Sung and Yüan masters in the Berlin Museum collection represent an earlier stage in his development. They are dated 1733 and painted in a broader manner with addition of colour (Pl.436). Here may be mentioned particularly the picture marked as an imitation after Chao Ta-nien which

[1] Cf. *Shên-chou*, vol.IX, and *Shina Nanga*, I, p.95.

[2] *K.-k. shu-hua chi*, vols.IX and XVI.

[3] *T'ung-yin lun-hua*, I, 3, p.13.

[4] *Kuo-ch'ao hua-chêng lu*, ii, 2, 1, 2.

[5] *Ōmura*, vol.I, p.1.

represents a leafless willow against a background of snowy mountains. According to the inscription: The day is cold and the crane is watching the first plum-blossoms.

Tung Pang-ta, *tzŭ* Fu-ts'un, *hao* Tung-shan (1699–1769), from Fu-yang in Chekiang, was a man of learning and prominent social standing, much appreciated by the emperor Ch'ien-lung as an expert in art and literature, who served in various high positions and finally was made president of the Board of Rites. He was also a member of the commission for the compilation of the imperial catalogues of paintings: *Shih-ch'ü pao-chi*, *Pi-tien chu-lin*, and *Hsi-ch'ing-ku-chien*.

As a painter he followed the Yüan masters (and may as such be placed among Wang Yüan-ch'i's pupils), but his great ideal was Tung Ch'i-ch'ang, whose footsteps guided him as a scholar and official even more than as a painter. All the critics are unanimous in praising his outstanding natural gifts, even when they do not express any particular admiration for his manner of painting. Chang Kêng, who wrote before Tung Pang-ta had reached the apogee of his career says:[1] "Tung Pang-ta, who passed his *chin shih* degree in 1733, is a Han-lin member and eminent in landscape-painting, which he learned from the Yüan masters. He uses a dry brush for making the outlines and wrinkles and brushes them in, in a free fashion. Recently he has also taken something from Tung Yüan and Chü-jan. His natural gifts are excellent and he is furthermore a great lover of antiquities . . . altogether a great man highly appreciated by the present emperor." Ch'in Tsü-yung gives a more critical characterization of his art:[2]

"Tung Pang-ta was thoroughly versed in the old styles; and the spirit resonance (*shên yün*) of his works was deep and far-reaching. He may be called the real heir of Tung Ch'i-ch'ang. But it is regrettable that he used a rather stumpy brush, and that his compositions of hills and valleys were made in a somewhat loose manner without sufficient concentration on the essentials."

Tung Pang-ta's landscape-paintings in the ex-imperial collections may be counted by the dozen. Few painters seem to have been more admired and collected by the emperor Ch'ien-lung, who also provided a great number of his pictures with colophons and poems.[3] According to the emperor's view, Tung Pang-ta represented the ideal combination of a scholarly connoisseur with that of a highly accomplished and versatile man of the brush, a combination which in his case was more complete than in the case of Tung Ch'i-ch'ang or Wang Hui, owing to his less marked individual genius. He imitated the manners or mannerisms of landscape-painters of the tenth century such as Ching Hao and Tung Yüan, as successfully as those of the Yüan masters; his rendering of Ching Hao's famous picture The Lu Mountain, dated 1747[4] (Pl.437), is thus from an historical point of view no less interesting than the excellent imitation after Lou Kuan's Mountain River, dated 1766, in the Musée Guimet, but neither of these imitations can be said to reawaken the significance or spirit of the originals after which they were made. Tung Pang-ta's contribution in cases like these was that of a formal imitator.

Something more of an individual artistic ambition may be discovered in some of his minor landscape-studies on album-leaves. But these, too, show considerable stylistic variations; thus one of the albums (in private possession in Japan) is made up of sketchy landscapes, trees and flowers painted in the easy, flowing manner of Tung Ch'i-ch'ang,[5] whereas another (in Chinese possession) consists of eight views of famous temple sites rendered with a rather dry brush in a very painstaking manner with addition of colour[6] (Pl.438). These pictures, which

[1] *Kuo-ch'ao-hua chêng lu*, II, 2.

[2] *T'ung-yin lun-hua*, I, 3, p.17.

[3] At least fifty-four items are listed under Tung Pang-ta's name in the catalogue of the former so-called National Museum, Peking, and some of them cover several pictures.

[4] *K.-k. shu-hua chi*, vol.XL.

[5] Cf. Ōmura, *Bunjin Gwasen*, I, 3–8, 12.

[6] Published by *Chung-hua Co.*, 1919 and 1929.

were done on imperial order and provided with the emperor's inscriptions, represent a kind of quasi-topographical landscape-painting which became popular in the Ch'ien-lung period, possibly under influence from Western painting. Tung Pang-ta's pictures of temple compounds in the mountains where the gullies are filled with rushing streams and the roads meander along steep slopes are evidently based on close observation of the actual sites, and represent realistic attempts along the lines recommended by Wang Yüan-ch'i. The connexion with the leading master of the Lou-tung school is noticeable in several of these pictures, though Tung Pang-ta's mode of composition is generally more traditional than Wang Yüan-ch'i's. All these landscapes are painted as if seen from above, which also gives rise to the impression that their hills and roads lead out of the pictures rather than into them, a device suitable to the topographical character of the pictures.

Tung Pang-ta's son Tung Kao, *tzŭ* Hsi-ching, *hao* Chê-lin (1740-1818), followed as a painter and official in the footsteps of his father, though with less success. He stood in great favour with the emperors Ch'ien-lung and Chia-ch'ing and rose to the position of a secretary in the Grand Council. His pictorial production was abundant, and most of it was absorbed into the imperial collections. Many of the pictures are records of actual landscapes, others simple variations on traditional patterns or studies of flowers, painted on album-leaves or fans, but there are also a number of larger pictures executed in the same smooth polished manner well fitted for photo-lithographic reproduction, as may be seen in various numbers of the *Li-tai ming-jên shu-hua*.[1]

Ch'ien Wei-ch'êng, *tzŭ* Tsung-p'an, *hao* Ch'a-shan and Chia-hsien (1720-1772), started as a flower-painter under the guidance of his grandmother, Ch'ên Shu, who was prominent in that field. In later years he devoted himself mainly to landscape-painting and became a prominent follower, if not rival, of Tung Pang-ta, likewise favoured by the emperor who considered him one of the greatest artists of the age and composed

poems on many of his pictures. He became a Han-lin member and made a brilliant official career, rising to the position of a vice-president of the Board of Works.

His early training as a flower-painter in a highly finished manner (illustrated by excellent specimens in the Ku-kung collection)[2] seems to have been decisive also for his later activity as a landscapist. His numerous handscrolls, hanging-scrolls and album-leaves representing river views and towering mountains are all distinguished by a kind of solidity and finish which endows them with a degree of formal perfection without inherent life. Some of them may actually be based on studies from nature, as for instance the views from the Summer Palace, others are variations on traditional motifs, and they may well stand comparison with Flemish drawings of the seventeenth century; but with all their obvious merits, they have no resonance from the world of the Immortals. What this means may be realized if we compare Ch'ien Wei-ch'êng's picture of the lofty Lu Shan[3] (Pl.439) with Shih-t'ao's rendering of the same motif, or his studies of the fantastic Huang Shan formations with Wu Li's picture from the same mountains. Ch'ien Wei-ch'êng has missed no details either in the pine-groves or in the temple compounds, even at the very top of the precipitous mountain, but he has never suggested the atmosphere of grandeur and mystery that envelops the mountain pictures by Shih-t'ao or Wu Li.

Practically all the landscape-painters mentioned above were for longer or shorter periods members of the imperial Bureau of Painting – a kind of Hua Yüan – and had their studios in Ju-i kuan, a spacious compound south of Chi-hsiang kuan within the palace precincts. The number of painters attached to

[1] More than 100 items, some consisting of albums of eight or ten leaves, by Tung Kao are listed in the catalogue of the former National Museum in Peking.

[2] Nearly a hundred pictures and seventy-two fans by Ch'ien Wei-chêng are listed in the catalogue of the former National Museum, Peking.

[3] *K.-k. shu-hua chi*, vol.XXX.

this institution was, as a matter of fact, much too large for a complete enumeration at this place. In the *Kuo-ch'ao yüan-hua lu* more than sixty names are mentioned, of which at least forty-two are also given in *Shih-ch'ü-pao chi*, the catalogues of the imperial collection; and in addition to these there were a number who painted by imperial command without being actually attached to the Bureau of Painting. But not a few of them were hardly more than skilled artisans, *i.e.* professional painters of slight individual importance classified together with jade-carvers and picture-mounters. We are told that the emperor was a frequent visitor in the palace studios, he loved to watch the painters and artisans at their work and occasionally took active part in their occupations. When a picture did not satisfy him, he gave his instructions for corrections or added a few strokes on it, which was considered a great honour by the painter thus corrected. He likewise made great efforts to enlarge and systematize the imperial collections of old paintings. All the most famous paintings that could be found in the country were brought or requisitioned, and catalogues were established under the guidance of the best experts. Two of them, the *Shih-ch'ü-pao chi* and *Pi-tien shu lin*, are still important sources of information regarding many famous specimens by old or contemporary painters, then included in the imperial collection.

The active interest of the imperial art-expert was, no doubt, an important encouragement for many of the painters, but it may be questioned whether it was conducive to the development of the artistic or creative element in painting. The official attitude was strictly historical (or archaeological); no fresh endeavours in new directions were expected from the painters attached to the Bureau of Painting, though the differences between the individual talents and their manners were in some cases quite marked, as we have noticed in discussing a few of the leading landscape-painters. They remained more or less within the very broad stream of the Lou-tung school or its confluents, in some cases combining with this elements of Sung academism, but none of them can be said to have stepped beyond the traditional manners or principles.

The same is also true of the emperor himself who in his activity as a painter, a calligraphist, and a poet was the most inveterate traditionalist, expressing his ambitious ideas and artistic reactions with fluent skill in forms and styles of somewhat ordinary traditional character. But this did not prevent the painters and experts in his surrounding from praising his paintings and writings as products of a divine genius. This was done, for instance, by Chang Kêng, the well-informed art-historian who opens his collection of painters' biographies with the following apotheosis of the emperor as a painter:

"His genius is a gift of heaven, his intelligence is all-embracing. He has searched into the origin of life. In his writings he explores the marvels of nature, but he also finds relaxation in art and is highly versed in painting landscapes, flowers, grass, epidendrum and bamboo. Once I respectfully beheld a branch of plum-blossom (by the emperor); it was painted with a straight pointed brush like writings in the *ts'ao* and *li-shu* styles, *i.e.* firm and elegant, vaporous and unrestrained; the inspiration of it was boundless . . ." Then he goes on to describe how the imperial artist surpassed all the greatest masters of the Ming and Yüan dynasties and how he improved by a few strokes those landscape-paintings which Chang Tsung-ts'ang presented to him in 1751, "things which cannot be done except by a genius", a genius, indeed, created by his imperial order, which found repercussion in the utterances of his devoted subjects, who were all obliged to pay tribute to official superiority.

The pictures by the emperor preserved in the former palace collections, of which half a dozen have been made known in reproductions, reflect close studies of some Yüan and Ming masters and a considerable mastery of the brush, but very little individual expression. The best ones are the small sketches of bare trees by a river-bank,[1] while the

[1] *Ku-kung*, vol.XV. *K.-k. shu-hua chi*, vol.XVII.

more elaborate ones are copies after earlier models, as for instance, The Sheep, painted after a work by the Ming emperor Hsüan Tsung.[1]

The cousin of the emperor, known as Yün-hsi, a grandson of the emperor Shun Chih, who was given the title Prince Shên, was more gifted as a painter. He painted large mountain landscapes in the styles of Wang Mêng and Huang Kung-wang in a rather bold manner without much refinement, but he is also said to have painted flowers in ink which were "beautiful and alive".

Still better known through his numerous works in the former palace collections is Hung Wu, a grandson of the emperor K'ang-hsi, also known as Ku-shan Pei-tzǔ. He was a poet and painter, and probably something of a bohemian, to judge by the *tzǔ* by which he called himself, *i.e.* Tsui-yü, the Foolish Drunkard.

According to the traditional appreciation of Hung Wu, repeated by Chang Kêng and other critics, he followed in his landscapes Tung Yüan and Huang Kung-wang, yet the fact that he applied and transformed with marked individual accents what he had learned from the old masters is more important than this dependence on the great traditional models of the Southern school. His compositions are evidently in many cases inspired by Huang or Wu Chên, but they are rendered in a rather free manner with an easily flowing sensitive brush, which endows his best paintings with more pictorial significance than we find in the works of other princely painters of the period[2] (Pl.440). In his flower-paintings Hung Wu followed more closely in the footsteps of Ch'ên Tao-fu and Lu Chih, the two most prominent specialists in this field of the Ming period.

Two of Ch'ien-lung's sons were also gifted poets and painters, *i.e.* Yung-jung, the sixth son of the emperor, also known as Prince Chih, whose rather refined and careful style is exemplified in a number of landscapes in the Ku-kung collection, and Yung-hsing, or Prince Ch'êng, the eleventh son of the emperor, who painted epidendrums, bamboos, and

landscapes in a free scholarly style, being more prominent as a poet and calligraphist than as a painter.

In spite of the traditionalism in style and brush-work prevailing among the painters active at court, there were, however, also exceptions, *i.e.* artists who worked independently and did not submit to the traditional academic principles. They detached themselves from the official current and approached to some extent the individualistic painters who, at the time, were active in Yangchou. Best known among these men was Li Shan, who served for some time at the Bureau of Painting, though he worked in a free, expressionistic manner, which connects him with some of the painters from Yangchou, his native town. Consequently he will be recorded in a succeeding chapter.

Kao Ch'i-p'ei, whose *tzǔ* was Wei-chih and *hao* Ch'ieh-yüan (1672–1732), was a more peculiar and detached case. He was a Manchu by birth, came from Mukden, and had no close connexion with any of the contemporary schools or centres of painting as far as we know, nor did he serve in the Hua Yüan. But he stood in great favour at court in the K'ang-hsi and Yung-chêng epochs and made a brilliant official career, rising to the position of a vice-president of the Board of Justice. He seems, however, to have devoted most of his time to painting, working in two quite different manners, a fact that reveals an unusual degree of virtuosity, which makes us realize that painting was to him more of a game, or an exhibition of skill, than a creative activity. But his works were, at least in part, quite original and aroused great admiration in wider circles, which is also enthusiastically voiced by Chang Kêng in *Kuo-ch'ao hua-chêng lu* (I, 3), where he writes:

"Kao Ch'i-p'ei's natural gifts were extraordinary; his conceptions were strange, and he expressed them

[1] *K.-k. shu-hua chi*, vol.I.

[2] No less than fifteen of Hung Wu's pictures from the former National Museum, Peking, are reproduced in *Li-tai ming-jên shu-hua*, and half a dozen in *K.-k. shu-hua chi*. Some of these are distinguished by finer pictorial qualities than the works by the leading court-painters.

in painting with great ease; he was highly appreciated everywhere ... People usually praise him simply for his finger-paintings; they have no idea of the beauty of his paintings with the brush. Since his finger-paintings met with so much success, and as he found it easier, with increasing years, to work with the fingers, he abandoned the brush completely, and consequently such works of his are very rare." Ch'in Tsu-yung repeats, as usual, the first part of Chang Kêng's characterization and adds the following description of a work by the artist:[1] "Once I saw a picture by him representing figures in a landscape. It was very confused and muddy and done with strength. The folds of the garments were made like writings in the ts'ao and chuan shu, each sleeve being folded up six or seven times. But the vital force was not disrupted and the movement of life was perfectly rendered. He had completely grasped the spirit of Wu Wei's art. It seems, however, strange that people simply praise his finger-paintings."

Judging by the still preserved works of Kao Ch'i-p'ei, one may feel inclined to accept the popular verdict as to the relative merits of his different kinds of paintings, not because the finger-paintings mark a very high standard of artistic perfection, but because of the somewhat crudely over-emphasized decorative stylization of the large landscapes painted in colour with the brush. They are rather pretentious compositions of academic type executed with technical skill, but with no suggestion of an inspiring life-breath. Among the most characteristic examples of this kind in the imperial collections may be mentioned Towers and Terraces on the Island of the Immortals, Greeting the Rising Sun,[2] White Eagle in a Pine-tree.[3] Some of these remind us of compositions by Chao Po-chü and other Sung academicians, transposed into more sonorous keys. But these were apparently greatly appreciated at the court.

The minor landscapes on album-leaves or hand-scrolls, which are executed (at least in part) with the brush, have a more intimate character, reflecting shifting moods or fugitive impressions in highly simplified but suggestive forms. An excellent series of such landscape-studies is contained in an album of twelve leaves belonging to the Museum of Asiatic Art in Amsterdam (cf. Fig.9). They represent certain characteristic aspects of rugged nature, freely composed from memory rather than painted after actual landscapes or models. The various elements of the motifs are known from many of his paintings, viz. spare trees on sharply cut rocky banks, fishing-boats faintly visible in the grey mist, returning sails on shore-less waters, birds descending to the reeds at dusk, small figures climbing steep paths that disappear in the narrow passes between the cliffs, and mountain ridges rising above the beds of woolly clouds, as if perceived from aeroplanes rather than by the eyes of an eighteenth-century painter, etc.

The pictorial beauty of the best among these studies of clouds and waters, split rocks and withered trees, depends mainly on the combination of light washes of spare ink and touches of a well-soaked brush (or finger nail) by which forms are suggested without being defined in detail. The painter has followed a borderline between realistic and imaginative ideas, making us realize that he was more of a technical virtuoso than of a genuine interpreter of actual nature.

Kao Ch'i-p'ei's genius as a landscape-painter also found expression in larger compositions executed with the fingers and the nails (Pl.441A). The ink in these pictures is applied in telling strokes and splashes which sometimes have a considerable expressionistic force. This may be observed in the very effective picture representing the Chiu-ju Mountain (in the former Abe collection),[4] which may be called Kao Ch'i-p'ei's masterpiece, and also in the somewhat smaller picture of A Solitary Pine-tree on a Cliff and Flying Geese, which reveal more poetic conceptions (Pl.441B).

[1] T'ung-yin lun-hua, II, vol.2, p.24.

[2] Li-tai, vols.III and II.

[3] Sōgen, p.272; a picture formerly in the collection of Chang Hsüeh-liang.

[4] The picture is dated 1708 and reproduced in Sōraikan, I, 57 and Ōmura, I, 10.

The comparison between Kao Ch'i-p'ei's finger-paintings and so-called grass-writing (ts'ao-shu) enunciated by Chang Kêng applies particularly to the figure-studies representing fantastic personages such as Chung K'uei, the demon-queller with his retinue of bats or imps, or Taoist fairies of more surprising than attractive appearance. In pictures of this kind he follows the same trend as Wu Wei in some of his rustic figures, though he insists still more than his predecessor on the grotesque features and renders them in a more muddy, though forceful manner – to quote Ch'in Tsu-yung.

K'ao Ch'i-p'ei's strange and striking paintings impressed many contemporaries and were imitated by both known and unknown painters. The most successful among the imitators was probably Fu Wên, tzŭ Tzŭ-lai, hao K'ai-t'ing, who came from Fêng-t'ien and also was a Manchu by birth. His finger-paintings representing rustic characters are done in a somewhat looser, more fluttering manner than Kao Ch'i-p'ei's, but have nevertheless a definite expressionistic character and an individual tone that makes them recognizable.[1]

The nephew of Kao Ch'i-p'ei, called Li Shih-cho, tzŭ Han-chang, hao Ku-chai, or Ch'ing-tsai Chü-shih and other appellations, was a more important painter. He came from Korea but passed most of his life in China and served as a court-painter during the early part of Ch'ien-lung's reign. Chang Kêng tells that "when young, he followed his father on a journey to Chiang-nan; there he met Wang Shih-ku and heard him discourse on painting ... His landscapes were beautiful, and his figure-paintings were, according to his own words, inspired by Wu Tao-tzŭ, whereas his flowers, birds and fruits were all painted in the hsieh-i manner which he had learned from his uncle's finger-paintings ... Both of them were great masters, though of different kinds, like Weng Mêng, the nephew, and Chao Mêng-fu, his uncle."[2]

The last remark seems true enough; the stylistic connexion between Kao Ch'i-p'ei and Li Shih-cho is not very close even though the younger master sometimes in his bird and flower-paintings uses a somewhat expressionistic and very spontaneous method. In the landscapes, which form the main part of his œuvre, he reveals a different artistic temperament and works in a more finished, though very sensitive manner. If this is based on studies of Wang Hui's landscapes, as claimed by Chang Kêng, it is evident that Li Shih-cho has transformed very freely what he may have learned from the famous master. Most of his paintings known to us represent mountain slopes with rushing streams and a few tall pine-trees, or gullies framed by precipitous cliffs and spare trees,[3] as in the view from the Tui Sung mountain,[4] i.e. views quite different from those which are most common in the works of the Lou-tung painters, and rendered with an undertone of romantic feeling usually accentuated by one or two figures who stand absorbed in contemplation of the views. Most expressive in this respect is the picture in a Japanese collection representing a man standing under a partly visible pine-tree looking out into hazy space, a composition which by its utter simplicity and absence of all limiting elements may be said to express "the infinity of heaven and earth".[5]

Li Shih-cho was evidently something of a nature poet. The motifs by which he expressed himself are distinguished by characteristics unlike those of most Chinese landscapes of the period. It may well be that they represent memories of youthful days spent in the Korean mountains. They are based on actual impressions of nature and rendered with a kind of sincerity which makes some of these simple views more attractive than the average traditional landscapes by T'ang-tai, Hung Wu, Chang Ts'ung-tsang, or the other famous court-painters about the middle of the century.

[1] For Fu Wên's finger-paintings see Ars Asiatica, vol.I; Musée Guimet, Paris, and Museum für Ostasiat. Kunst. Cologne.

[2] Kuo-ch'ao hua-chêng lu, I, vol.3.

[3] Among the best examples of this kind of paintings may be mentioned the Landscapes in the Cleveland Museum (Pl.442) and in the Hobart collection in Cambridge, Mass.; another picture of this type is reproduced in Sōgen, p.277.

[4] Reproduced in K.-k. shu-hua chi, vol.IX.

[5] Cf. Bijutsu Kenkyū, No.II.

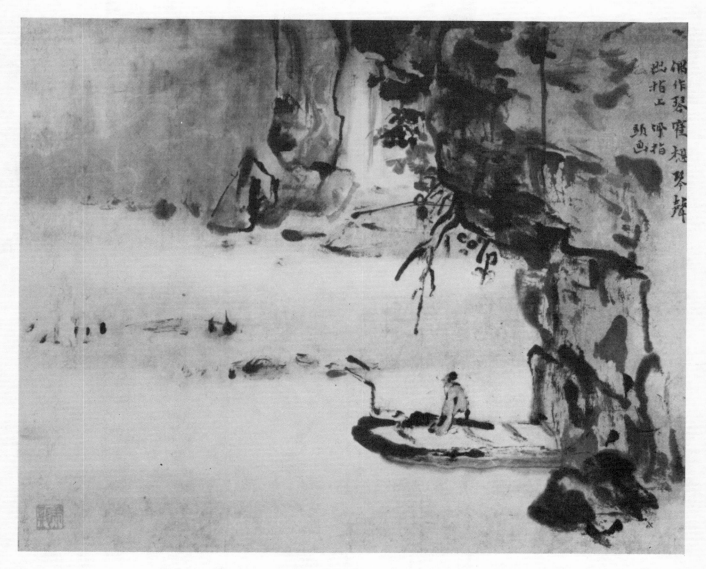

FIGURE 9. Kao Ch'i-pei, Entrance to a Cave. Album-leaf. Museum of East Asiatic Art, Amsterdam.

Westerners and Painters of Flowers and Animals at Court in the Ch'ien-lung era

Castiglione, Shên Ch'üan, Chiang T'ing-hsi, Tsou I-kuei, Ch'ien Tsai,

Chin Ting-piao, Ting Kuan-p'êng and others.

THE INFLUENCE from Western art which was noticeable in Chinese painting of the K'ang-hsi period (and earlier) increased considerably and became more definite in the reign of the emperor Ch'ien-lung, when the cultural relations between the Middle Kingdom and the leading European powers passed through a period of rapid advance. It was at the time represented mainly by several of the Jesuit missionaries, who brought with them from their homelands a good knowledge of the technical sides of painting and architecture (in particular), though none of them was a full-fledged artist by education or profession. Their pilgrimage to the Far East was not prompted by any kind of artistic ambition or curiosity, but by religious zeal; they came as representatives of the Catholic church, not as envoys of some art academy or kingly art-lover, and whatever they did or performed was expected to form a new cultural link or a step forward in the propagation of the Church.

Considering these circumstances, it is indeed a matter of surprise to note that some of these men won their greatest success not as representatives of a foreign religion but through their activities as painters, decorators, architects, mechanicians and instrument-makers, attracting as such far more attention and admiration than in their capacity of missionaries. The records of their employment by the emperor as artists and builders are relatively well known, owing to their own published accounts written for their superiors in Europe, and need not be repeated at this place, but a line or two from Père Attiret's letter of 1743, written at Yüan Ming Yüan, the Old Summer Palace, where they worked, may be quoted, because it offers some intimate glimpses of the activities of these missionary painters, who occupied somewhat extraordinary positions in the immediate surrounding of the emperor. Attiret, who himself was a gifted painter, and as such second only to Castiglione, wrote as follows:[1] "Of all the Europeans staying here (*i.e.* in Yüan Ming Yüan) it is only the painters and watchmakers who have access everywhere on account of their work. The rooms in which we paint are situated in one of the little palaces that I have mentioned. The emperor comes nearly every day to see how we are working, so it is scarcely possible to go away. We no longer go out to paint, unless the object to be represented is such that it cannot be transported; in that case we are taken under escort of eunuchs to the palace where it is situated. One must then walk very quickly and noiselessly on tiptoe, almost as if one were about to commit some heinous act."

The privilege of working under the personal supervision and guidance of the Son of Heaven and their manifest success in fulfilling the artistic ideas and requirements of the imperial master did not, however, give rise to any exaggerated self-esteem or personal ambitions on the part of the missionary painters. They did their work as *servi imperatoris* but at the same time to the glory of the church, which after all was the ultimate object of their presence in China. It was no secret that this and the future of their missions were ultimately dependent

[1] *Cf.* vol. XXVII of *Lettres édifiantes*, edit. 1749.

on the good will and personal favour of the emperor. His views in matters of religion were apparently fairly liberal or neutral, but it seemed to him evidently a rare advantage to have at his disposal skilful men, who could construct palaces and execute pictures of a kind that was adding to the glamorous fame of the princely residences in the Western world.

All these ambitions and disparate viewpoints, inspired by political, psychological, devotional and artistic ideas, coincided at this epoch of increasing material intercourse between the Far East and the West to open a road for the Jesuit painters in the Middle Kingdom and make their artistic products greatly appreciated, particularly by the emperor. They introduced a certain amount of new ideas, especially in the plastic modelling of the figures with light and shade and in the representation of space, but these were grafted on the traditional Chinese manners of pictorial representation, causing important modifications in the attitude of some of the contemporary artists, it is true, without ever removing them very far from the main high-road of traditional Chinese painting. The influence was of a limited kind, hardly more than an episode in the history of Chinese art, partly because these missionary painters could not fill the position of great creative masters and partly because their contacts with the general flow of contemporary indigenous painting was restricted by their position as the emperor's personal servants. They had little, if any, opportunity to do their work independently of such restrictions. In view of these circumstances they can hardly be said to demand much attention in a general history of Chinese painting; a native historian might well disregard them as an isolated side-issue or a temporary ripple on the surface of the broad stream of Chinese painting; yet these pictures should not be left out in a Western presentation of the subject in general, because they have gained considerable popularity among Western amateurs and served as important historical evidence of a somewhat experimental attempt to blend principles of Eastern and Western painting into a harmoniously combined form of representative art. This may not have proved as successful as was expected by its instigators, yet it must be admitted that nothing better of the kind has been attained in later times.

★ ★ ★

Among the European missionaries active in Peking in the Ch'ien-lung era were at least four who won some distinction as painters: Giuseppe Castiglione (Lang Shih-ning), Denis Attiret (Wang Chih-ch'êng), Ignatius Sichelbart (Ai Ch'i-mêng) and Giovanni Damascenus. Their artistic activity is recorded and pictures ascribed to the three first-named may still be seen, but it is only Castiglione who has won a well-established place in the history of Chinese painting;[1] he was able to assimilate at least in part the technical methods and artistic materials of the Chinese and thus won official recognition and appreciation. The emperors K'ang-hsi and Ch'ien-lung employed him constantly and considered his paintings as the very acme of pictorial art, and the latter, particularly, honoured him in many ways and made him one of the principal members of the imperial Bureau of Painting. No fewer than fifty-six of his pictures are enumerated in *Kuo-ch'ao yüan-hua lu* (after the imperial catalogue *Shih-ch'ü pao-chi*), and most of these have been reproduced in five albums published by the former Palace Museum.[2] Chinese critics considered him in particular as a very skilful painter of animals and flowers, but the emperor Ch'ien-lung praised him in one of his inscriptions as an unsurpassed portrait-painter, and he had many opportunities of representing the imperial countenance. It may also be noted that he took an active part in the planning of the European

[1] Lang Shih-ning was born in Milan 1688, arrived in Peking 1715 and died there 1766; his career in China has been discussed by various authorities: the most valuable information is found in P. Pelliot's article: "Les Conquêtes de l'Empereur de la Chine", *T'oung Pao*, 1921, and in M. Ishida's article: "A Biographical Study of Lang Shih-ning", in *Bijutsu Kenkyū*, vol.X, October 1932, where also all the earlier literature concerning the painter is quoted.

[2] *Lang Shih-ning hua*, vols.I–V, 1931–1935; an additional volume contains also some horse paintings by Ai Ch'i-mêng.

buildings with their adjoining gardens in the Old Summer Palace, Yüan Ming Yüan.

Lang Shih-ning (Castiglione) must evidently have had a considerable training as painter before he arrived in China; he was an able draughtsman and good colourist who knew how to represent all kinds of animals, birds, and flowers with great faithfulness to nature, but he did not have much of a chance to develop individual artistic ideas (if he actually conceived such), because his pictures were done on imperial command and meant to serve as historical documents rather than as works of art. He was also obliged to adopt as far as possible oriental implements, painting with the Chinese brush, ink, and colours, though he composed his pictures according to principles of Western art, *i.e.* with convincingly realistic space construction, and plastic modelling with light and shade. The landscapes may have caused the greatest difficulty to a man who had to satisfy Chinese requirements with foreign means and methods. They sometimes reveal a certain vacillation between Eastern and Western modes of representation (*cf.* Pl.443). When the scenery is limited to a single tree or a rock, these are rendered with the same insistence on plastic form as the animals, and there is no further spatial definition, but when it is more extensive, or continued through a long scroll, it is spread out in the Chinese fashion, more or less like a bird's-eye view. It should also be remembered that some of the very long or large pictures made to commemorate important events in the reign of the emperor Ch'ien-lung, such as the series of six scrolls illustrating his travels in various parts of the realm (belonging to the Musée Guimet), were not the individual work of Lang Shih-ning, but produced through the co-operation of several painters who worked under the guidance of the Italian, and whose names are recorded on one of these scrolls, *viz.* Chin K'un, Ting Kuan-p'êng, Ch'êng Chih-tao and Li Hui-lin. Lang Shih-ning's leading position in the imperial Bureau of Painting was probably due no less to his ability to organize the large supply of illustrative documents referring

to memorable events in the reign of Ch'ien-lung than to his technical skill in representing the most valuable horses, rarest animals and most brilliant birds with absolute fidelity and convincing illusion.

This was something that pleased his imperial patron more than it impressed the contemporary Chinese painters; it seemed to them more strange than attractive and with very little, if any, relation to their ideas about the art of painting. Lang Shih-ning had as a matter of fact no successors except among the foreign missionaries and among some of the native converts. His artistic skill was, however, quite sufficient to secure him a prominent place in the favour of the emperor. Ch'ien-lung employed him not only for painting portraits of his favourite horses and dogs, strange animals, such as white monkeys and antelopes, kingly eagles and hunting falcons, colourful peacocks and cranes (to mention only some examples from a long series of zoological motifs), but also for portraits of himself, his courtiers and soldiers. Lang Shih-ning represented the emperor in various situations, as for instance, receiving tribute horses from the Qazaks,[1] while seated on the porch of a pavilion surrounded by attendants, or inspecting horses out on pasture,[2] or studying antiquities in the garden of his Summer Palace,[3] *i.e.* in pictures which have a considerable interest as historical documents even if they do not rank very high as specimens of Chinese art.

It may also be recalled that Lang Shih-ning executed the drawings for two of the items in the series of sixteen illustrations of the "conquests", or victorious campaigns, of the emperor Ch'ien-lung, which have become famous through the engravings made of them in Paris on imperial command. They were intended to glorify the military expeditions of the emperor and served as gifts to various high officials and foreign potentates. Lang Shih-ning died before the series was complete. He was assisted in

[1] A famous scroll now in the Musée Guimet, Paris.

[2] *Tōsō*, p.422, a scroll from the imperial collection, now belonging to Mr. Chin K'ai-fan.

[3] Ku-kung, vol.II.

the preparation of these drawings (which probably were reduced copies of some larger pictures existing in the Hall of Purple Splendour, Tzǔ-kuang-ko, in Chung Hai)[1] by some of the other missionaries, like Sichelbarth, Attiret, and Damascenus, but their more or less dilettante drawings seem to have been rather freely arranged and corrected by the highly trained French artists who transferred them on to copper plates. It is consequently futile to draw any conclusions as to the artistic ability of these men from the famous engravings, which are excellent specimens of the bombastic style prevailing in French art of the period.

All these foreign missionaries who were occupied in artistic pursuits at the court of Ch'ien-lung became painters and builders from force of circumstance; their ultimate motives were, as said before, to strengthen the position of the Christian missions rather than to create great works of art, or to express individual inspirations. As painters they followed the same pseudo-Chinese manner as Castiglione and were appreciated for the same reasons. Ignatius Sichelbarth, whose Chinese name was Ai Ch'i-mêng (1708–1780), and Denis Attiret, who was called Wang Chih-ch'êng (1708–1768),[2] painted the imperial horses as well as birds and flowers, and, to judge by the pictures by the former still preserved in the ex-imperial collection, their works were somewhat simplified products of the same illustrative kind as Castiglione's pictures. But they all stood in great favour with their imperial patron and were placed on a level with, if not above, the Chinese painters who at the time were attached to the Bureau of Painting in Peking Palace. Ch'ien-lung may indeed have urged them to work in the Chinese fashion, but he must at the same time have been particularly attracted by the foreign elements in their art, which made these missionaries more interesting in his eyes than contemporary indigenous artists who might have produced better pictures of a similar type.

The opinion of the Chinese painters concerning the Western mode of painting has been well ex-pressed by Tsou I-kuei, the leading flower-painter, who was exactly contemporary with Lang Shih-ning and also active at the court, where he may have met the Italian or at least have become acquainted with his paintings. A short chapter in Tsou I-kuei's treatise *Hsiao-shan hua-p'u* is devoted to The Western Manner of Painting and contains the following remarks:

"The Westerners are skilled in geometry, and consequently there is not the slightest mistake in their way of rendering light and shade (*yin yang*) and distance (near and far). In their paintings all the figures, buildings, and trees cast shadows, and their brush and colours are entirely different from those of Chinese painters. Their views (scenery) stretch out from broad (in the foreground) to narrow (in the background) and are defined (mathematically measured). When they paint houses on a wall, people are tempted to walk into them. Students of painting may well take over one or two points from them to make their own paintings more attractive to the eye. But these painters have no brush-manner whatsoever; although they possess skill, they are simply artisans (*chiang*) and can consequently not be classified as painters (*i.e.* artists)."

Tsou I-kuei's pronouncement should not be too far generalized, even though it touches on certain fundamental differences of Eastern and Western art, because it is inspired by the somewhat simplified examples of European painting which at the time had become known in China, and which may be classified as artisans' rather than as artists' works. At the same time it is evident that he was greatly impressed by the scientific skill of the foreigners and also had an open eye for the advantages of their scientific knowledge when applied in painting. It was too obvious to be neglected or despised, and Tsou I-kuei just like some of the other flower and figure-painters, assimilated certain elements of it, particularly in their efforts to give more bodily

[1] *Cf.* the Appendix to the above quoted article by P. Pelliot in *T'oung Pao*, 1921.

[2] *Cf.* Pelliott, *op. cit.*, pp.189–192.

relief to objects than was customary in Chinese painting. How he did this will be described presently.

Among painters who apparently did not remain immune to the Western manner of painting may be mentioned in the first place Shên Ch'üan, *tzǔ* Hêng-chai, *hao* Nan-p'ing, from Wu-hsing in Chekiang, who, to judge by the dates of his pictures (1723–1776), was contemporary with Lang Shih-ning and in certain respects may be called a Chinese counter-part to the Italian. His works are characterized by the same kind of exact naturalism as Lang Shih-ning's animal and bird-paintings, though superior to them in the rendering of life and movement, not to speak of the brilliant execution in traditional Chinese *kung-pi* technique. But in spite of all these qualities, so fitting for a court painter, Shên Nan-p'in was never attached to the imperial Bureau of Painting; instead of that he was invited by a Japanese art-patron to Nagasaki, where he lived for three years producing a large amount of paintings and exerting a considerable influence on the local school of Japanese art. We are also told that he was liberally rewarded with gold, but "when he came back from Japan he distributed all the gold and silk which he had received there among his friends and relatives, and his own purse became empty again".[1] Chinese critics praise with good reason his brilliant colouring and his faculty of grasping the secrets of the many kinds of birds and animals which he represented. To mention some of them here individually seems hardly necessary, because they can be studied with ease in the many excellent reproductions in the Japanese publications mentioned in our Lists. Since Shên Nan-p'ing became so famous in Japan, most of his works went there and comparatively few have remained in China: not a single one is in the ex-imperial collections. Yet his art was of the kind that might well have served an imperial patron, colourful and decorative almost to excess, illus-trative and exact, with a touch of imaginative splendour, as for instance in the interpretation of the *fêng* birds, but perhaps had not enough of the flavour of foreign dilettantism and academic refinement to please the art critic on the throne.

Most of the flower and bird-painters of outstand-ing merit were, however, closely attached to the court as officials as well as in their quality of painters. The oldest and most influential among them was Chiang T'ing-hsi, *tzǔ* Yang-sun, *hao* Hsi-ku (1669–1732), who was already active in the K'ang-hsi and Yung-chêng reigns. He enjoyed the particular con-fidence of the emperors, was honoured with titles and high ranks, and held successively important posts in the government such as President of the Board of Revenue, and of the Board of War, Chief Examiner in the metropolitan examinations, Grand Tutor of the heir apparent, etc., and was finally (1729) made one of the first three Grand Councillors.[2] His name is thus even more famous in the political annals of the Middle Kingdom than in its art-history, yet he was generally hailed at the time (and also later) as the most brilliant of all the excellent painters of flowers and birds in China of the eighteenth century. Chang Kêng, who voices the official view of the time, writes[3] that Chiang "painted flowers and birds (living things) with an easy brush, sometimes strange, sometimes regular, doing them sometimes fugitively, sometimes elabor-ately, sometimes in colour, sometimes in ink only. A single picture of his may show this, yet be perfectly natural and harmonious, expressing spirit and movement of life ... He could well be placed at the side of the Yüan masters. Many of the scholars and officials who practised painting took him as their model." The writer then describes a fan-painting by the master representing a branch of chrysanthemum flowers, the petals were touched in lightly with thin washes of colour, but the pistils were dotted very carefully in *kung-pi* manner ... Every stroke in this was noble. "If he had not been a man of great knowledge and courage and wielded the brush of an Immortal, he could not have done it."

[1] *Cf. Hua yū lu* quoted in *Kuo-ch'ao hua-shih*, vol.12, 1, 9.

[2] Hummel, *Eminent Chinese of the Ch'ing Period*, vol.I, p.142.

[3] *Kuo ch'ao hua-chêng lu*, I, 3, p.7.

We are furthermore told that Chiang's name is found on many highly detailed coloured paintings which were not executed by himself but by an assistant called P'an.

Chang Kêng's reference to Chiang T'ing-hsi's faculty of combining various technical methods in his flower-paintings so as to obtain the most life-like and charming results, is no doubt significant not only as a characterization of the master's eclectic habits, but also as an indication of the point of view from which he was popularly most appreciated. This highly cultured courtier, scholar and official might indeed be called a perfect "gentleman technician" (if not gentleman-painter); he was as a matter of fact one of the last and most faithful representatives of the kind of bird and flower-painting that for nearly a thousand years had flourished under official protection at the imperial academies. And this may, indeed, have been of special importance at a time when flower-paintings of a Western type and the impressionistic *hsieh-i* studies were gaining the upper hand.

Among the best examples of Chiang T'ing-hsi's highly refined art may be mentioned the album of coloured fan-paintings after models by the emperor Hui Tsung published by the Chung-hua Co. 1932. They reflect an academic perfection that has rarely been surpassed, but the great majority of his abundant paintings are of larger size and reveal more of his feeling for the actual charm of Chinese gardens, those wonderful displays of horticultural and pictorial art which were then passing through their last period of florescence. He must have loved them; in his best pictures he has transmitted the radiance of the fruit-trees in blossom, the opulence of the magnolias and peonies, the elegance of the wisterias and the prowess of the tall chrysanthemums, with all the charm and distinction attaching to such models[1] (Pl.444).

Tsou I-kuei, *tzŭ* Yüan-pao, *hao* Hsiao-shan (1686–1766), was a little younger than Chiang T'ing-hsi and enjoyed his greatest reputation in the Ch'ien-lung era, but his official and artistic career was quite

similar to that of the older flower-painter. After he had passed his *chin shih* degree in 1727, he became a Han-lin member, a censor, a secretary in the Grand Council, and finally vice-president of the Board of Rites. Emperor Ch'ien-lung admired his flower-paintings immensely, describing them in several poetical colophons as absolutely unequalled, an admiration which is re-echoed by Chang Kêng, who uses many flowery adjectives about them and says that the painter was the only one in the field after Yün Shou-p'ing. But this redundant praise is sanely modified by Ch'in Tsu-yung, who writes:[2] "I have a few pictures by the artist in my collection, representing chrysanthemum flowers in colour. In painting these he first used thick powder for the petals and then washed them over with light colours. The powder made them stand out in relief on the silk. They are skilfully executed and beautiful, but after all rather stiff and deficient in elegant design. In his landscape-paintings the outlines and wrinkles are made carelessly and have no resonance of the life-breath. From this one may realize that the fame he enjoyed at the time is not to be depended upon."

The criticism is well founded. Tsou I-kuei's flower-paintings, which also abound in the former imperial collection, are more or less stylized in their formal designs, which may be attractive from a decorative point of view but hardly contribute to the living charm found in the flowers. His manner of painting is the opposite to that of the older painters; instead of reducing the material means to the utmost and with a few light touches of the brush creating an atmosphere or a suggestion of the fragrance of the flowers, he uses plenty of powder-colour, sometimes working the flowers in relief on the silk (as pointed out by Ch'in Tsu-yung), a manner which may have had its origin in his studies of Western painting, even though he never actually adopted the European technique. His endeavour

[1] The greater number of his pictures are still in the ex-imperial collections for which they were painted; a selection of these are reproduced in *Ku-kung shu-hua chi* and in *Ku-kung*.

[2] *T'ung-yin lun-hua*, I, 3, p.10.

was to create impressions of relief or objects standing free, without the use of modelling with shadows. The result became a kind of plastic stylization (mostly in bright colours) perfectly suitable for decorative purposes. Many of his larger compositions might serve admirably for screens or wall-panels just as somewhat later Japanese paintings of the same kind did. But one must not expect to find in them glimpses of the more intimate beauty or secret fragrance of the flowers (Pl.445).

Tsou I-kuei's treatise *Hsiao-chan hua p'u*, mentioned above, is mainly devoted to technical discussions of the flower motifs, their colouring and designs, but in the introduction he expresses some general ideas which may be quoted here: "The important point in painting flowers is to represent the shapes of the flowers according to nature and not to take them from one's masters. The works of the painters who devoted themselves to the copying of ready-made compositions have no life or flavour. Now the innumerable things in nature serve me as teachers, and their living force directs the movements of my brush. When one sees a flower or a bud, one should look into it and examine it most carefully, trying to understand why it is such; then its expression and appearance will become natural and full of life as if the Creator had worked through the painter.

"It is exactly the same as in figure-painting. . . . A deficient form has never as yet completely expressed the spirit. The flower-painters of today do not paint the covering petals completely or take account of their proper numbers, nor do they represent the young shoots properly; consequently their works are like mountains without 'dragon veins' or water without arteries," etc.

A radical change seems to have taken place in the attitude of the flower-painters since the previous generation. If we recall some of Yün Shou-p'ing's colophons in which he expresses his regret at not being able to represent things as lightly and immaterially as he would have liked to do, we at once realize that Tsou I-kuei's insistence on formal like-ness and completeness reveals a different attitude. Objective reality and decorative outwardness were gaining preponderance over the various forms of poetic or expressionistic pictorial interpretation which had dominated Chinese flower-painting (particularly since the Yüan period), a tendency nourished by the influence from Western art.

Less known nowadays, because his works are rare, but highly appreciated at the time was Ch'ien Tsai, *tzŭ* K'un-i, *hao* T'o-shih (1708–1793), grandson of Ch'ên Shu, the female painter of flowers and landscapes in the style of Wang Yüan-ch'i. In his case Ch'in Tsŭ-yung expresses no criticism, only praise:[1] "He was a man different from all others. . . . In painting epidendrum leaves he let the brush go quite freely; they were full of life and expression, and in painting stones he used the *fei pai* manner. His brush-strokes were vigorous, flowing and running without the least hesitation. He was quite free from common manners, started a style of his own and stood high above the dust." But his connexion with Hsü Wei and Ch'ên Tao-fu has also been pointed out by some critics. Ch'ien Tsai's small paintings of epidendrums, narcissi, fungi, pine-trees, and plum-blossoms are of a scholarly type, written down with a fluent brush in ink only. They are very simple without the least search for outward decorative effect but expressive through the life-imparting rhythm of the brush-strokes. The best among his works, for instance Epidendrums on a Rockery (in the Ku-kung collection),[2] may be placed on a level with paintings by Wang Ku-hsiang or Hsiang Shêng-mo, though the poetic undercurrent is less palpable.

Several other painters of flowers, grass, bamboos, trees and rockeries who were active in the K'ang-hsi and Ch'ien-lung periods might be mentioned, but we can do little more than record their names and refer to the Lists for an enumeration of their works;

[1] *T'ung-yin lun hua*, I, 3, I, 17.

[2] *K.-k. shu hua-chi*, vol.XV; another characteristic work by the painter representing Narcissi and Fungi is reproduced in *Li Tai*, vol.III.

Wang Wu, *tzŭ* Ch'in-chung (1632–1690), was something of a parallel to Hsiang Mo-lin, *i.e.* more famous as a collector and connoisseur than as a painter (Pl.446). Ma Yüan-yü, *tzŭ* Fu-hsi (active *c.*1690–1720), was a skilful imitator of Yün Shou-p'ing. Chang Jo-ai, *tzŭ* Ch'ing-luan (1713–1746), and his brother Chang Jo-ch'êng, *tzŭ* Ching-chien (1722–1770), sons of the well-known scholar and statesman Chang T'ing-yü, were both attached to the imperial Bureau of Painting and also prominent Hanlin members, serving as such in various official positions. A good number of their paintings, representing pine-trees, bamboo, plum-blossoms, narcissi and other flowers are to be seen in the ex-imperial collections, but they can hardly be said to reveal any marked individual characteristics.[1] Among their works are also mentioned snow-landscapes painted on the order of the emperor Ch'ien lung.

Yü Hsing, *tzŭ* Tsêng-san, was also greatly appreciated by the emperor and official circles; he was a close friend of the landscapist T'ang-tai. They were both remarkable for their technical skill and their lack of *chi yün*. Yü Hsing's minutely executed coloured pictures might serve as excellent illustrations in a treatise on garden-flowers, but they have little interest as specimens of pictorial art, and the same is true of his larger decorative compositions with colourful birds and flowers, pine-trees and stones. They remind us of similar compositions by Shên Nan-p'ing.

Chin T'ing-piao, *tzŭ* Shih-k'uei (active *c.*1720–1760), who also served as a court-painter in the Ch'ien-lung period, is better known, though perhaps less for his flowers, bamboos, and blossoming fruit-trees than for his figure compositions. He was evidently a very talented man who painted Buddhist and Taoist figures and scenes from peasants' lives with the same ease as flowers and traditional landscapes. Yet in spite of his great ease and productivity as a man of the brush, he seems to have studied nature rather closely and developed an individual kind of naïve realism which makes most of his figure-compositions entertaining as illustrations of actual

life and endows the studies of trees and flowers with the freshness of a fragrant spring. Among the former may be noted pictures representing Transporting Cranes in a Boat, Collecting Fungi in Snow, Dredging Mud, Collecting Orchids, Saluting a Stone (Pl.447), and several others of a similar kind which made him very popular. Chin T'ing-piao was a man from Chekiang and seems indeed as such to have been influenced by the traditions of the former Chê school in his landscapes, whereas the figures are more or less rustic descendants of Tai Chin's happy fishermen. Nor did he follow the more common academic traditions of Sung times in his flower-paintings or try to imitate the pictorial manner of Yün Shou-ping (then *en vogue* among flower-painters), but developed a style more akin to that of Lu Chih, the many-sided Ming painter who also reached his purest pictorial results in his studies of lilies and orchids (Pl.448).

* * *

Among the men who about the middle of the Ch'ien-lung reign represented figure-painting at the court beside Chin T'ing-piao may be mentioned Ting Kuan-p'êng, Hsü Yang, Shên Yüan, Chang T'ing-yen, Hsieh Sui, etc., names found not only in the *Kuo-ch'ao yüan-hua lu*, but also on many paintings in the ex-imperial collections. The two first-named are most abundantly represented, a fact which may be taken as a proof of their privileged position at the court. Their works are generally speaking of a somewhat simplified academic type and executed with more refinement of detail than decorative planning or coherence, mostly with colour in a careful *kung-pi* manner.[2] It is indeed significant that Ting Kuan-p'êng as well as Hsü Yang did free versions of the famous composition known as A Literary Meeting in the Western Garden, though probably neither of them had seen Li Kung-lin's original picture. Ting Kuan-p'êng, at least in one

[1] *Cf. K.-k. shu-hua chi*, vols.VII, VIII, XXXVI, and many paintings in the former National Museum, Peking.

[2] *K.-k. shu-hua chi*, vols.IV and XLI.

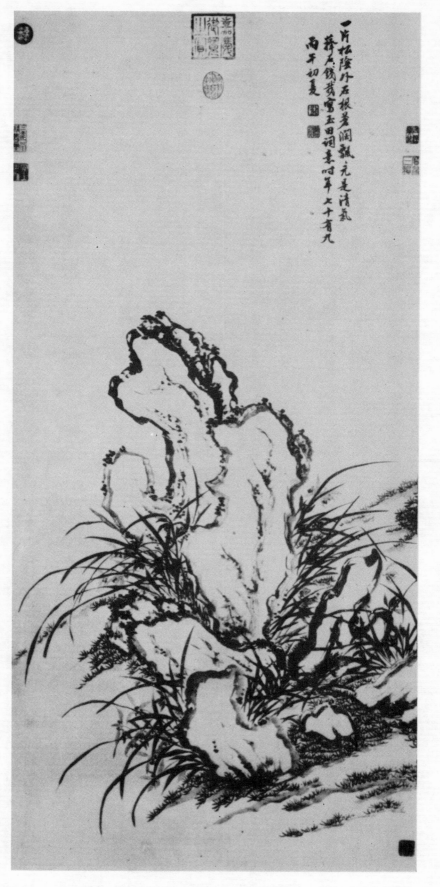

FIGURE 10. Ch'ien Tsai, Epidendrum and Bamboo by a Garden Stone.
Ku-kung shu-hua chi, vol.XV.

of his versions, followed Ch'iu Ying's transposition of the motif,[1] whereas Hsü Yang elaborated the composition with a larger garden in which the various figure groups were placed in closer conformity with the literary description.[2] T'ing Kuan-p'êng's particular interest in Li Kung-lin's art is also proved by the copy that he made of the master's handscroll representing the emperor Ming Huang playing polo (dated 1746).[3] Other paintings by the artist are based on earlier models, as for instance, the representation of Seven Poets Passing the T'ung-kuan Gate, after Han Huang.[4] It is executed with minute care in *kung pi* technique with addition of colour, but to what extent it actually corresponds to the original is more than we can tell. Ting Kuan-p'êng had evidently a leaning towards illustrative genre-painting and in this respect as well as in his more indifferent Buddhist paintings followed his namesake of the Ming period, Ting Yün-pêng, though he never rose above the level of a skilled imitator.

Hsü Yang was more varied in his choice of motifs and sought inspiration not only in the works of Northern Sung masters, but also in paintings of the South Sung and Ming periods. Reminiscences from Chao Po-chü, T'ang Yin and Ch'iu Ying may be observed in some of his landscapes with pavilions and figures,[5] but his most successful and harmonious paintings represent birds, geese among reeds or swallows around a blossoming pear-tree. As in the case of so many of these imitative painters, his individual sensitiveness was aroused by flowers and birds.

Hsieh Sui was another conservative traditionalist who composed illustrations to popular legends, for instance, the representation of The Great Yü Controlling the Flood,[6] a somewhat original composition in which a mass of vivid small figures are swarming in a rocky landscape of pre-T'ang type. Another of his pictures in the Ku-kung collection (dated 1777) represents an elaborate palatial building in snow and looks more like a copy of a Sung design.[7]

Chang T'ing-yen also specialized in palaces and figures, and his pictures seem to have been done mainly as recording documents. This is true of the palace view with men preparing the Mid-autumn Festival,[8] and also of the map-like picture which represents the battle at Wu-shih (a place between Aksu and Kashgar) just as neatly and orderly as if it were a cavalry parade for the entertainment of the emperor. The long descriptive text written by Ch'ien-lung himself is dated 1768.[9]

A more exact or positive fidelity to nature confers more historical interest on Shên Yüan's pictures from the imperial parks in Peking; they are truly entertaining in spite of their lack of artistic quality or pictorial significance. The two which are known to us in reproduction represent Ch'ien-lung's Pavilion for Playing the *Ch'in* (with a number of scholars forming the audience of the emperor) and An Imperial Skating Party on Pei Hai in Peking. The scenery in the former is a corner of a landscape-garden, which forms a harmonious background to the musical party in the pavilion[10] (Pl.449), whereas the other picture offers a bird's-eye view of Pei Hai on a winter day with the well-known Pagoda Island and the long marble bridge in the foreground.[11] Bare willows stand in rows like dark sentinels along the shores of a frozen lake where a great number of skaters are arranged in square groups as if prepared for some kind of competition. It is well known that such parties were held for the entertainment of the emperor, who used to watch the skaters from a two-storied pavilion standing near the shore. For anyone

[1] *K.-k. shu-hua chi*, vol.XXVIII.

[2] *Li Tai*, vol.VI.

[3] Scroll-reproduction by the Palace Museum.

[4] *K.-k. shu-hua chi*, vol.II.

[5] Cf. *K.-k. shu-hua chi*, vols.X and XIV, and *Li tai*, vols.III and V

[6] *K.-k. shu-hua chi*, vol.XXXVIII.

[7] *Ibid*. vol.XLI.

[8] *K.-k. shu-hua chi*, vol.XXXVIII.

[9] *Ku-kung*, vol.XLII.

[10] *K.-k. shu-hua chi*, vol.XXXV.

[11] *Ibid*. vol.XXXII.

who has retained some memories of Pei Hai as it sometimes could be seen thirty or forty years ago on bright winter days with its red pavilions and marble bridges reflected in the mirror-like ice under a luminous blue sky, a little picture like this contains an attraction quite independent of any marked artistic qualities. It is evocative of an atmosphere and of impressions which never will fade in the memory of friends of a Peking that once enchanted them, even though much of the old setting and harmonious beauty of the place have been replaced by modern improvements.

The Independent Masters in Yangchou and Elsewhere in the Ch'ien-lung reign.

Kao Fêng-han, Chin Nung, Chêng Hsieh, Wang Shih-shên, Li Fang-yin,

Li Shan, Huang Shên, Hua Yen, Lo P'ing and others.

THE OFFICIAL leadership in the art of painting after Ch'ien-lung's accession to the throne (1736) was more completely than ever before concentrated in the hands of the imperial artist, who devoted himself with inexhaustible energy to the study and collection of painting. In these occupations he was ably assisted by a number of prominent painters and experts who, as described in a preceding chapter, were members of the *Hua Yüan* (the Imperial Bureau of Painting) and naturally did their best to satisfy the imperial guide in their creative and selective work. Some of these painters have been introduced and characterized in previous chapters in which we also have had opportunity to note how closely they followed certain principles of style and manners of painting inherited from earlier epochs of academic prosperity. They were all to some extent influenced by the artistic ideals cultivated under the official protection of the *Hua Yüan* and thus implicitly, if not explicitly, engaged in propagating the kind of painting that could serve as a bulwark against any new, unbalanced or unprincipled movements in painting. There were many individual variations among these numerous artists but they were all rooted in the field of academic traditionalism.

This conservative movement was certainly prevalent in the time of Ch'ien-lung, yet not the only noticeable outflow of a new impetus or revival in painting which became evident at this epoch. There were also other movements which gradually found expression in the works of a number of creative masters who had no connexion with the *Hua Yüan*

and hardly any need for the "old masters" who were officially venerated and accepted as the proper guides in the art of painting. These painters may well be called independents, if this term is here used more or less in the same sense as it has had in later periods of Western art-history, *i.e.* as a designation of painters whose general and common characteristic has been their freedom from all kinds of traditional rules or officially imposed patterns of style.

The fundamental stylistic difference between the academicians, on the one hand, and the "independents" on the other, might indeed be compared – *mutatis mutandis* – with the well known opposition that existed in French painting of the nineteenth century between "les Académiciens" and "les Indépendants", but it must be remembered that the Chinese independents never formed anything like an organized group or school.[1] They were not inspired by any definite principles of style or

[1] The French terms quoted above, which should be more or less familiar to all who have followed the development of French painting during the latter part of the nineteenth century, are not used as historical definitions but merely for their general aesthetic implications. It should be recalled that, though "La Société des Artistes Indépendants" was founded in Paris only in 1884, a corresponding movement, based on independence of every kind of academic or official control of exhibitions and other similar manifestations, had existed for more than a generation under various forms such as "Le Salon des Réfusés" in 1863 (where Manet exhibited some of his most remarkable paintings) and as "La Société Anonyme des Artistes", which in 1874 held the famous exhibition in the rooms of the photographer Nadar, when these painters were called (mockingly) by an unknown journalist, "les Impressionists", a name which they thenceforth adopted as a sort of device or banderol. The Impressionists may thus be considered as proto-Indépendants, a relation that also confirms the rightness of our description of the Chinese "independents" as "impressionists" in their use of the brush.

theoretical ideas, nor by any conscious effort at opposition, but they may nevertheless be called independents, because they painted quite freely according to their hearts' desire, simply to express their individual ideas in accordance with their observations from nature. They had little use for historical traditions or principles, yet it should be noted that they were not simply queer or wayward freaks, detached from the psychological and historical background of Chinese painting; on the contrary, they were thoroughly Chinese in following a special line or current of free "impressionistic" painting, revealing in their best works flashes of individual genius and of the afterglow of indelible spiritual ideals which in former periods of pictorial florescence had produced some of the most brilliant leading lights in Chinese painting.

The painters who for reasons mentioned above may be classified as independents all followed – consciously or unconsciously – the path of introspective illumination which we in earlier chapters have described as the way of Ch'an or Tao. They practised meditation and sought unity with every form of sentient life in nature. Their paintings mirrored reflexes of this consciousness, giving individual glimpses or interpretations of the inner life or significance of things. They were not done according to established rules or precepts, but were spontaneous expressions of states of mind, records of visions or emotions, flashes of inspiration which could not be repeated or transmitted in traditional forms but had to be rendered each time afresh according to the mood of the moment.

It may not be necessary to dwell here on the fact that an artistic movement which included so many individual divergencies and varieties as the one described above, cannot be strictly limited in time and place or fully described as a local school which lasted for a generation. The material to be considered is rather complicated, and at times in fact startling, particularly when the pictures are done in the p'o-mo manner. To represent fully and appreciate this it would require a large number of characteristic

plates accompanied by sufficient text. This can no longer be effected in the present publication, since we have already come very close to the final number of illustrations. Yet here, too, something may be better than nothing and serve the purpose of rounding off our necessarily condensed presentation of the main currents of pictorial production in the Ch'ienlung reign. The aftermath of these movements after the close of the period, falls beyond the limit of the present publication.

The individualistic movement of ink-painting to which reference was made above has sometimes been ranged, if not identified, with the works of a group of painters known as The Eight Strange Masters of Yangchou. The identification is to some extent justified in so far as the said group includes some excellent representatives of ink-painting in a kind of p'o-mo manner, but not all the eight painters of the said group followed exactly the same path and, on the other hand, there were several good painters who are not commonly classified among the "Eight Strange Masters" yet followed the path of the individualists or "independents" with obvious success.

In order to obtain a general survey of the whole movement here under consideration we must turn not only to some of the Yangchou men but also to some other painters who had no personal connexion with the former except in so far as they followed parallel lines of highly independent ink-painting. Some of these were exactly contemporary with the men in Yangchou, others slightly older or younger, but hardly more than two or three of them have earned a fame equal to that of the "Eight Strange Masters".

The appellation of this group may easily cause the impression that they formed a homogeneous local school of a similar kind to what had existed (and still lingered) in a number of provincial towns such as Suchou, Hsin-an, Lou-tung, and other places where leading masters had given the impetus to certain currents of style and thus formed definite local schools. This was not the case in Yangchou, a town

with no special artistic or scholarly traditions and from which few painters had come. The attraction of Yangchou for some of the younger talents in the Ch'ien-lung period can hardly have been due to any marked scholarly or artistic traditions, but may rather have been the result of the material prosperity of this flourishing town in a beautiful situation near the Grand Canal, which at the time was the main artery of commercial transport. Some of the fortunes earned there by the salt-merchants and their likes were expended on costly gardens laid out by great artists (like Shih-t'ao). The emperors K'ang-hsi and Ch'ien-lung visited the place more than once, and nothing seems more natural than that it should also offer attraction and stimulation to painters of the independent type.

The following list of painters who worked there in the Ch'ien-lung reign may be useful as an introduction; it contains also some indications regarding the origin of these painters, their more or less independent positions, and their relations with the others of the group:

1. Chin Nung, *tzŭ* Shou-men, *hao* Tung-hsin, Ku-ch'üan, Lao-ting, Ssŭ-nung, and more than a dozen other fancy names. Born 1687 at Hang-chou, he started to paint only about the age of 50. Settled in Yangchou at mature age; died there 1764.

2. Chêng Hsieh, *tzŭ* K'o-jou, *hao* Pan-ch'iao. Born at Hsing-hua (Kiangsu) 1693. Spent most of his life in Yangchou; died there 1765.

3. Hua Yen, *tzŭ* Ch'in-yo, *hao* Hsin-lo shan-jên, Pai-shan Tao-jên, etc. Born 1682 at Ch'ang-t'ing, Fukien. Lived in Hangchou and later in Yangchou; died there *c.*1760.

4. Huang Shên, *tzŭ* Kung-mou, *hao* Ying-p'iao, Tung-hai-pu-i, etc. Born 1687 at Ning-hua, Fukien. Lived mostly in Yangchou; died *c.*1768.

5. Li Fang-ying, *tzŭ* Ch'in-chung, *hao* Ch'ing-chiang and Ch'iu-ch'ih. Born at T'ung-chou, Kiangsu 1695; lived mostly in Yangchou; died 1754.

6. Li Shan, *tzŭ* Tsung-yang, *hao* Fu-t'ang, Ao tao-

jên, etc. Born *c.*1670 at Yangchou; died after 1754.

7. Wang Shih-shên, *tzŭ* Chin-jên, *hao* Ch'ao-lin, Ch'i-tung-wai-shih. Born at Hsiu-ning, Anhui; active in Yangchou *c.*1730–1750.

8. Lo P'ing, *tzŭ* Tan-fu, *hao* Liang-fêng, Hua-chih-ssŭ sêng, etc. Born 1733 at Hsieh-hsien, Anhui. Lived mainly at Yangchou; died 1799.

The above-mentioned eight painters formed the nucleus of the group known as The Strange Masters of Yangchou, but this is sometimes enlarged with two more, making them ten instead of eight, namely:

Kao Hsiang, *tzŭ* Fêng-kang, *hao* Hsi-t'ang, Shan-lin-wai-shih and other names, who was a Yang-chou man, born *c.*1670, mentioned by the critics as a friend of Shih-t'ao and also of Chin Nung and Li Fang-ying. Another painter called Kao Fêng-han, *tzŭ* Hsi-yüan, *hao* Nan-tsun, Pan-t'ing, Kuei-yün-lao-jên, etc., who was born 1633 at Chiao-chou in Shantung, may also be added to the group, because of some mutual stylistic resemblances, particularly in the works that Kao Fêng-han did with the left hand.

Besides these men there were a number of younger painters who followed lines of expression-istic ink-painting similar to those of the Yangchou masters and consequently would merit to be studied in connexion with them, *e.g.* Chiang Chang, some-times called the rival of Huang Shên; Pien Shou-min (*tzŭ* I-kung), active at Huai-an and well known as a painter of geese; I Ping-shou (*tzŭ* Tzŭ-ssŭ), a Fukienese who served as governor of Yangchou until 1815; Shih Yüan, the donkey-painter, and several minor plum-blossom painters such as T'ung Yü and Wan Kang (*tzŭ* Wan-ch'üan) who all followed the current of the Independents in a more or less moderate way.

As may be noted in our preceding list the "Strange Masters of Yangchou" were all (with the exception of Lo P'ing) born in the last quarter of the seven-teenth century and active mainly during the first half of the eighteenth: most of them passed away

between 1750 and 1760. They were more or less related as representatives of an epoch and a stylistic movement, yet differed considerably in their individual temperaments and in their artistic training, which they had received at various places (mostly further south). The most conservative among them were still to some extent attached to earlier traditions of style, while others appear more detached and reached out towards the most exclusive modes of expressionism. We cannot, for reasons of space, study in detail each one of these ten or more painters, but must concentrate on the most important and mention the others in passing, starting with Kao Fêng-han who was, to begin with, a relatively conservative master.

He did not come from Yangchou or its neighbourhood and is usually not counted as one of the "Eight Strange Masters", but his work merged gradually into the same general stream of expressionistic ink-painting as that of the leading Yangchou men, and he became well known and appreciated, offering an abundant production in a definite individual style. He was born c.1683, passed the *hsiu tsai* examination in 1727, and was appointed to the position of a magistrate in Hsieh-hsien in Anhui, but shortly afterwards was censured and sent away. When, as the result of severe rheumatism, he lost the "feeling" (control) of his right hand, he started to paint and write with the left hand, which no doubt had some influence on the further development of the very free and splashy *p'o-mo* manner which may be observed in his later works, and called himself Hou Shang-tso-shêng (The Later Left-handed One) after a well-known Yüan scholar who also lost the use of his right hand.[1]

According to Chang Kêng's above quoted biographical account, "he painted landscapes in an unrestrained manner, not hooking on to the rules of other men, but expressing his own life-breath. He was particularly good in a kind of grass-writing which was supple and strong as if flying and moving. Very generous by nature he kept no money back for himself. His great passion was to collect ink-stones, of which he had more than a thousand. He carved inscriptions on them all and composed a book called *Yen-shih* (History of Ink-slabs).

"Once he came to my home province (Chekiang) and stayed with the president of the Board of Justice Fêng Ching-hsia, who was an old friend of his. When he was 61 years old, in 1743, he prepared his own epitaph."[2]

Ch'in Tsu-yung, who was a great admirer of the artist, described him in *T'ung-yin lun-hua* (III.1) as follows: "Fêng-han was a very original and wonderful man, quite free from the mannerism of common painters. Once I saw a small landscape by him; the brushwork in it was extremely free and sweeping. The picture showed the strong spirit of the North Sung masters combined with the quietness and ease of the Yüan masters. He did not adhere closely to the rules, yet he was not far removed from them."

The essential points of this somewhat terse characterization are, indeed, well taken; the critic gives full credit to the painter's individual originality and very free brushwork, yet emphasizes at the same time that he took over certain essential features of Sung and Yüan art. He was not a traditionalist, but he was familiar with the principles of classic painting.

This intermediary position in the general stream of evolution is quite well illustrated by one of Kao Fêng-han's early works, a fairly large hanging-scroll dated 1727, in the Abe collection in Ōsaka Museum, which represents a man cultivating his chrysanthemum garden in front of his cottage on a river-bank under some craggy pine-trees. The motif has an idyllic tone and is rendered in a spirit that may lead our thoughts to somewhat similar paintings by Wên Chêng-ming and T'ang Yin representing scholars occupied in their mountain gardens, but the pictorial execution of Kao Fêng-han's landscape is much softer and broader than in the paintings of the Ming period (Pl.450). While he

[1] *Kuo-chao hua-chêng-lu*, vol.II, 1.

[2] In which he dwelled on men's useless efforts to seek knowledge about death instead of being satisfied with life.

took over certain elements of earlier compositions, Kao Fêng-han has given them a new pictorial significance. He has not as yet detached himself completely from the general stream of landscape-painting or found entirely new forms for his creative ideas, yet he has entered upon a new line of pictorial expressionism which we shall find further developed in his later works.

The picture dated nine years later (1735), which represents a hermit, or a holy man, meditating in a mountain cave[1] is an important example of this development. The motif is not uncommon, but it has been transmitted in an individualized form that gives it new significance. It is painted in a very effective *p'o-mo* manner, partly with thin washes and partly with deep splashes of ink, which produce a flickering light that seems to become more and more intense the further we move into the interior of the cave. The source of the light is evidently not an outward phenomenon but an interior radiation of the spiritual enlightenment attained by the man in meditation (Pl.451). By a very sensitive use of light and shade the painter has tried to reveal the inner reality or meaning reflected in a motif of this kind, which naturally in all ages and stages of development has attracted the Ch'an philosophers among painters. We know it from the works of Mu-ch'i and Liang Kai as well as from paintings by K'un-ts'an and Tao-chi. Some of these are perhaps more important as works of art than Kao Fêng-han's picture, yet it may be questioned whether any of these famous masters have given a more appealing interpretation of the religious import of the motif.

It may not be necessary to dwell here on further examples of Kao Fêng-han's bold and vigorous brush; a certain number of them are noted in our List and several more could be added, because they are not uncommon. The majority of his pictures represent dry trees with gathering birds, or shrubs and rocks, generally painted with deep ink and a stiff brush, but he also did excellent flower-studies and garden-stones, sometimes with the addition of coloured moss and grass, which accentuates their decorative beauty and makes them more akin to works by Western "impressionists".

The foremost place among the Eight Strange Masters of Yangchou is usually accorded to Chin Nung. He was the most original and influential among these men, yet he can hardly be called the leader of the whole group, because he was not pre-eminently a painter but more of a philosopher, a writer, a poet, and a very remarkable calligrapher. He used his brush more in writing than in painting – sometimes filling all the empty space in a picture with inscriptions – and gradually developed a very clear-cut, strong and impressive calligraphic style, whereas his paintings often reflect an experimental state of execution, *i.e.* pictorial problems which could not be solved with the means at his disposal.

Chang Kêng, who may have known Chin Nung personally, wrote about him in *Kuo-ch'ao hua-chêng lu* (vol.II, 2, p.11) as follows: "He was a highly educated man, skilled in poetry and prose writing; his views were quite different from those of common men. He was also a very good connoisseur able to distinguish the true from the false in calligraphy and painting. He liked to travel but remained for the longest period in Yangchou.

"He did not start painting until he was over 50 years old, but as soon as he took to the brush, his works were mature and free from the bad manners of common painters. The reason for this was that he had seen so much of the old masters' works.

"To begin with he painted bamboo, following Wên T'ung in this, and called himself Chi-liu shan-min (The Long-tarrying Man of the Mountains). Then he started to paint plum-blossoms and in this followed Pai Yü-chan (the Sung painter Ko-ch'ang-keng), calling himself Hsi-yeh chü-shih. Then (again) he turned to horse-painting, in which, according to his own assurance, he grasped the manners of Ts'ao Pa and Han Kan, and far surpassed Chao Mêng-fu. Recently he has started to

[1] The picture was formerly in the Kuwana collection in Kyōto. *Cf. Nanju*, vol.9.

paint only Buddhist figures and he calls himself Hsin-ch'u-chia-an chu-fan seng (A small temple for one who is a monk at heart and feeds on rice gruel). These pictures are decorated with strange flowers and trees and executed in colours which cannot be found in the human world; they are all quite imaginary. When someone asked what these plants should be called, he said that they were of the kind that are called Pei-to[1] and Lung-k'o. He published his poems under the title *Tung-hsin shih-ch'ao*.

"He had no children; when his wife died he moved to Yangchou and returned no more to his native city" (*i.e.* Hangchou).

Chin Nung himself has also noted down some personal records regarding his later years in Yang-chou which convey vivid impressions of the growing importance of religious inspiration for his daily life and creative activity. He occupied himself at the time exclusively with Buddhist motifs, representing them in very free, quasi-realistic forms, probably with the intention of making them more appealing to common men. A few of the pictures are to occupy us presently, but it may be of interest to quote here first some extracts from the notes by the painter, he wrote: "Since my wife died I have lived alone and kept my body clean. I had formerly a dumb concubine but have sent her away. I have now come to Kuang-lin (Yangchou) and am stay-ing in a monastery, eating every day a vegetable soup which I do not find tasteless. I am occupied in copy-ing *sūtras* and in my leisure time I paint some pictures of Buddha.

"I am now a man of 70 and not looking for any blessings. My only wish is to continue to enjoy the quietness of the place and to contemplate the colour of the Chiang-nan mountains in front of the temple gates."

Chin Nung worked at this time more than ever "*ad majorem gloriam Dei*" and seems indeed to have been convinced that his pictures, if properly pre-pared, could become of spiritual value to believers. He writes: "I am now a man over 70 years old and harbour no longer any evil thoughts, though I still live in the dirty world. Every day I retire to my clean study for meditation. I wash my ten fingers at dawn and hold them over the burning incense before I grasp the brush and start to paint with reverence. I do it in deep earnest, so as not to leave the methods of the old masters. There are many devoted followers of Buddha in the world; I would like to present a picture to each one of them which could be of service to them in their daily worship."

This devotional spirit which made Chin Nung something of an apostle or pioneer of a highly individualized kind of religious art makes it easier for us to understand the aspirations and limitations of this somewhat unfinished genius. He was cer-tainly not one of the common crowd of skilled men of the brush, but highly imaginative, not to say mystical, more or less in the same way as Shih-t'ao, though not so far advanced as a painter. His in-fluence on some of the other men in the Yangchou group was probably based on his character and personality no less than on his artistic production.

In turning to his painted works it should be recalled that Chang Kêng divided these into three successive groups or classes, characterized by differ-ent motifs and manners of painting. During the first period, which probably corresponded mainly to his initial artistic activity in Hangchou, he specialized in plum-blossoms, bamboo, and epidendrums,[2] *i.e.* motifs particularly esteemed and cultivated by scholars and poets and which offered the best opportunities to men of their class to give free flow to their brush in a more or less individualized *hsieh-i* manner. The earliest dated plum-blossom paintings by Chin Nung, such as the picture in Musée Guimet (dated 1733), and the somewhat related picture in a Japanese collection (reproduced in *Shina Nanga*, vol.I, Pl.92), which represents twisting and twirling old branches strewn with white blossoms, are both remarkable for their intricate designs and the very sensitive rendering of the shivering blossoms, which

[1] *Pei-to* is the Chinese for *pattra* (palm), *Lung-k'o* is another tree mentioned in Buddhist legends.

[2] *Cf. Mei-shu ts'ung-shu*, I, 3, 2. (*Tung-hsin hua-fo t'i-chi.*)

make us recall some remarks by the painter as to the proper way of painting these harbingers of spring. He wrote: "The water in the ink-stone is turning into ice, the ink is half dried up, because the plum-trees must be painted on a cold evening; the trees then do not stand ruggedly. Their fragrance saturates one's sleeves. But do not show the picture to those who do not love the flowers."[1] It was only on such cold spring nights that the spark of returning life could be fully realized in the small white blossoms on the aged trees (Pl.452A).

In other notes Chin Nung refers to certain famous early painters of the Sung period, commonly considered as the greatest masters of plum-blossom painting and therefore often named as the best guides in this art (though authentic works by them were hardly known). It gives a hint about Chin Nung's veneration for the classic tradition, at least as a plum-blossom painter, in his early years: "In painting plum-blossom one must follow a certain style which should be 'thin' and not 'fat'. Yang Pu-chih, who was a pupil of the monk Hua-kuang, painted them like egrets standing on a cold beach, afraid of being seen too near. Seated here as a guest by the window I am imitating his manner for those who are able to understand it."

These notes indicate better than any descriptions Chin Nung's aim and method as a painter of plum-blossoms, his sensitiveness to their beauty, his endeavour to penetrate into their secrets, and his willingness to learn from the acknowledged masters of former epochs. As a painter he loved this motif more than any other of flowers or trees, and he painted it repeatedly during his whole life, but as far as may be concluded from the dated examples, the earlier ones are more attractive and alive than the later ones.

Chin Nung's bamboo-paintings are not as numerous as the plum-blossom pictures, but they are also remarkable for their distinctive individual character. They mostly represent bamboo branches, and the earliest dated example is of the year 1746, but there may be earlier ones among the undated specimens. One of the best examples is the typical picture in the Takashima collection in Kugenuma, (Pl.454B), which is dated 1750 and represents some exceedingly slender, almost thread-like, stems and branches which are weighted down by clusters of very large feather-like leaves. The opposition between the thinness of the branches and the thick and heavy leaves is emphasized in a way that is seldom seen in Chinese paintings and which can hardly be said to support Chang Kêng's statement that Chin Nung followed Wên T'ung as a bamboo-painter. If he did so at the very beginning, he must gradually have detached himself from the Sung model and formed a manner of his own also as a bamboo-painter.

There are, however, other bamboo-paintings by Chin Nung which may be said to contain more significant hints about his early studies, though they are difficult to date. The double album-leaf which once formed part of the Kuan Po-hêng collection in Peking is an interesting example of this kind. It represents a row of tall bamboo shoots combined with some thin twigs with large leaves. The two elements are not very closely united, but they have given the painter excellent opportunities to express with his brush, on the one hand, the energy and proud growth of the tall shoots and, on the other hand, the grace and suppleness of the elastic sprays and the long leaves. All these elements are rendered with perfect care and intimate feeling for their intrinsic character. The whole thing is a study rather than a finished painting, but as such highly indicative of the painter's approach to the motif (Pl.453A).

Chin Nung was something of an experimenter also in his bamboo-paintings, as can be seen in one of his later works (dated 1760), the so-called Bamboo after Wang Wei, which represents only sections of some pillar-like bamboo-stems, in a highly simplified study of the joints of the bamboo-plants (*Cf. Shina Nanga*, I, p.92).

The horse-paintings which are said to have formed another special group in the *œuvre* of Chin

[1] *Tung-hsin hsien-shêng chu, mei, fo, ma ti.*

Nung, are nowadays more seldom seen; only three of them are mentioned in our List. The most remarkable among these is the saddled horse in the former Abe collection (Ōsaka museum) which, according to the inscription (dated 1760), was painted "after Wei-yen", a statement which hardly can be taken literally, because no painter of pre-Sung date (such as Wei-yen) could have produced anything approaching this scraggy old mare. It is painted in a splashy *p'o-mo* manner which conceals rather than brings out its equine structure and distorts some essential parts, for instance the curving legs and the mane, which is ruffled over the animal's head. But it is nevertheless a horse rather than a mule, pitiful and as such "expressionistic", if this term is used in a more generalized sense (Pl.454A). The decorative effect of the picture is furthermore strengthened by the long lines of the inscription which form a striking vertical contrast to the heavy horse below, a co-ordination of the written and painted elements of the composition which is characteristic of Chin Nung.

Chin Nung's figure-paintings are with few exceptions[1] inspired by religious ideas or sentiments, though this may not be obvious at first sight, because the actual motif or inner meaning of the picture is often disguised or concealed in a quasi-profane exterior. His Arhats and Bodhisattvas are not celestial beings represented in accordance with the traditional formulas of Buddhist iconography, but quite ordinary earthly beings; and the Šakya-munis and Dharumas, of which he has painted several, are more or less individualized monks and hermits of a kind that the painter probably had contacted in the Ch'an monasteries in Hangchou and Yangchou. In painting these religious motifs Chin Nung did not lean on any predecessors; he composed them freely as individualistic interpretations of legendary characters or symbols of spiritual exaltation which he transmuted into quasi-realistic pictorial forms. The artistic effect or expressiveness of the pictures thus depends partly on their illustrative qualities and partly on their power to suggest introspective ideas or states of spiritual illumination developed through Ch'an practices.

Among pictures of this kind should be remembered various representations of the Meditating Bodhidharma, a motif which seems to have been particularly attractive to the painter and which he has rendered in several important pictures,[2] and also certain representations of single monks standing in meditation ensconced beneath tall trees of the *Bo* type (Pl.455A). They seem to have a connexion with the somewhat different traditional representations of Šakyamuni's meditation under the Bodhi-druma where he attained spiritual illumination, though it may also be noted that one of these pictures is inscribed with the title Wu-liang shou-fo (a reference to Amitābha?).[3] In another example of corresponding design the monk under the tree is sweeping fallen leaves with a large broom, which may refer to the legend about the broom handled by the Buddha.

It may not be possible to appreciate fully the meaning of pictures like these without some knowledge of the religious associations or legends that have inspired them, yet the artistic transposition is of a kind that opens a perspective of thoughts leading beyond the painted image.[4] He uses the tall, large-leafed *Bo*-trees as a sort of allusive symbol under which the human figures appear more significant than they would have been if placed under a pine-tree or a willow, making an appeal to the intuitive perception rather than to intellectual apprehension (Pl.455B).

In other paintings with religious subjects the conception is more illustrative or obvious; it raises no problems and we are attracted mainly by the pictorial treatment, which is quite original. One of them represents A Kneeling Man Worshipping a

[1] *Cf.* picture representing A Woman at a Spinning-wheel. *Chūgoku*, 8.

[2] *E.g.* paintings in the Yamaguchi collection. Ashiya: the Kitano collection, Kyōto; the H. C. Wêng collection, Scarsedale, N.Y.

[3] *Cf. Nanking Exhibition Catalogue*, 334.

[4] *Sōgen*, p.39, in a private Chinese collection.

Buddha Statue in a pavilion, while the other leaf of corresponding size shows a gateway in a low wall enclosing a humble dwelling or temple and a man who is stepping out through the gate. The compositions are quite simple, consisting mainly of some framing trees placed in front of plain walls, in the one case strengthened by a broad roofed gateway, while the other offers a view between latticed doors into the interior of a small room where the man is kneeling in adoration before the Buddha statuette. He is represented in full side-view, whereas the figure who is stepping through the gate is largely hidden by a tree (Pl.456A and B).

The compositional elements are spread out in flat planes which detach themselves, the one behind the other. This mode of composition makes them look quite different from ordinary Chinese pictures; the brush has not been used here as in writing or designing; the patterns are not indicated by lines but mainly by planes. As a consequence of this treatment the pictures may lead our thoughts to certain kinds of modern Western painting of the Matisse school, in spite of the fact that they are not executed with opaque pigments but simply with light washes of ink and water-colours. They represent something essentially new in the development of pictorial expressionism in China and are as such interesting though somewhat experimental phenomena. One cannot but ask what a painter like Chin Nung would have become if he had worked under other conditions and been in touch with movements of more recent date conducive to expressionistic painting? Would he have removed still further from the traditional methods of Chinese painting? Would he have detached himself from the dependence on the structural brushwork and attained greater success in a new kind of pictorial expressionism through the use of flat tonal values more or less corresponding to the so-called *mu-ku* manner? Questions of this kind must here be left open, yet they may be suggestive of certain significant parallels in the development of painting in the Far East and in Europe more than a hundred years later. They make us also realize that

Chin Nung was one of the very rare painters in China who actually was moved not only by new ideas but also by attempts at new pictorial modes of expression – modes, indeed, which if properly understood and continued would have opened up wider fields for the "independents" of Yangchou. To the critics of the time and the following generation he seemed, however, more strange than proficient, an opinion which is also echoed in Ch'in Tsu-yung's appreciation: "He was of a very independent nature with no regard for the old masters. As soon as one opens a picture of his, one feels a very strange and strong breath of life, which stirs up the thoughts of the beholder. If the old man had grasped the manner of Ni Tsan and Huang Kung-wang, he would have reached a place not below that of the Lou-tung painters. He certainly had the brush and ink of a great master. The old saying 'He had no predecessors and no successors', may well be applied to master Tung-hsin (Winter Heart)."

Ch'in Tsu-yung's well balanced concluding statement to his estimate of Chin Nung's importance as an artist and as a link in the long chain of development of Chinese painting is certainly right and well supported by our study of the painter's works. It is true that he himself often claimed to be a faithful follower of some of the old masters who were the recognized models in various fields of painting, but that did not prevent Chin Nung from following his individual road as a painter. This may not have been very clear-cut, because the advances that he sometimes made in new directions can hardly be said to have led to a complete or definite success. But the spirit of search and renewal, which is evident in his pictorial production, makes it more interesting.

Chin Nung's highly imaginative personality also found expression in numerous colophons written mainly on his own paintings and collected by a friend of his which were published under the title *Tung-hsin hsien-shêng t'i-chi* and divided into five sections devoted respectively to bamboo, plum-blossoms, horse-paintings, Buddhist pictures, and self-portraits. Some of these compositions are

highly fantastic and difficult of interpretation, others
more poetic, but there are also writings which throw
light on the deeply religious strain in his character as
witnessed by examples quoted above. They contain
reflexes of a somewhat wayward genius who ven-
tured upon the difficult art of using painting as a
means of expression for his quasi-spiritual inspiration.

Chin Nung was no doubt the most influential
personality among the Yangchou painters, but
around him gathered a number of lesser talents who
merit to be recorded, because they too – each
according to his gifts – contributed to make this
movement a very remarkable, not to say brilliant,
revival of the spirit of the "independents" and their
hsieh-i methods which now spread an afterglow
over Chinese painting.

Some of these lesser men followed Chin Nung
quite closely and were tied to him by personal
friendship, others stood more independently as
artists and transformed the stylistic influences re-
ceived from him according to their temperaments.
Among the former Chang Kêng mentions in par-
ticular Wang Shih-shên, Kao Hsiang and Li Fang-
yin, while the other group was formed by closely
related, though more independent painters includ-
ing Chêng Hsieh, Li Shan, Huang Shên, and Lo
P'ing and, to some extent, also Hua Yen. They are all
known through a certain number of original works,
partly described in our Lists and must, owing to the
lack of space, be mentioned here in a somewhat
abbreviated form.

Wang Shih-shên, who moved from Hsieh-hsien
in Anhui to Yangchou, was a good friend of Chin
Nung and more of a cultured amateur than of a
professional painter. Fifteen of his works are listed,
several of them dated between 1734 and 1751, but
he lived longer probably. Most of these pictures,
painted with a soft and sensitive brush and light
washes of ink, represent plum-blossoms and epi-
dendrums; yet he did also small landscapes such as
the Winter View painted, according to the inscrip-
tion, in 1740 for "a friend who sent him snow-water
for tea". The picture (reproduced in *Shên-chou ta*

kuan, No.6) is not of a very impressive kind, but it
is inscribed and surrounded by a dozen encomiums
(one by Chin Nung) reflecting the atmosphere of
friendship and mutual admiration that existed at this
last stronghold of aesthetic enjoyment in China. It
radiates likewise from his paintings of plum-
blossoms and epidendrums which are very simple,
almost transparently light, but with the quality of
lyric improvisations which transmit the living
charm of the motifs (Pl.452B).

Kao Hsiang, who is commonly appended as the
ninth member of the Yangchou group, was actually
a native of the place; the dates of his life are not
known, but since he was a personal friend of Shih-
t'ao, he may have been a little older than the men
mentioned above. Ch'in Tsu-yung praises his extra-
ordinary natural gifts, his brilliant copies, and his
"lightly painted plum-blossoms", an appreciation
furthermore substantiated by such expressions as:
"He grasped the heart-impressions of Chin Nung"
(*i.e.* as a painter of plum-blossoms), but in his "land-
scapes he followed Hung-jên's simple and detached
manner", and as he also "assimilated Shih-t'ao's free
manner, his brushwork was transcendent, free from
the dust of the world".[1] He may, indeed, have
been a more gifted painter than Wang Shih-shên
yet the plum-blossoms by the two men are much
alike; they are expressive of a similar spirit in closely
related manners, a condition also illustrated by their
co-operation in painting together the four panels for
a screen decorated with plum-trees.[2] Kao Hsiang's
landscape sketches (for instance in the album now in
the Shanghai museum) reveal greater variations of
style with influences from the Yüan traditions of
landscape-painting.[3]

Li Fang-ying is placed by the old critics on a still
higher level. He came from T'ung-chou in Kiangsu
and spent a number of years as an official in Anhui,
but retired to Yangchou and died there 1754 as a
poor man. Chang Kêng, who was well familiar

[1] *Tung-yin lun-hua*, III, 1, p.4.
[2] *Nanga Taisei*, vol.III, p.111.
[3] *Gems*, III, Pl.14.

with his art, characterizes it quite pertinently as follows: "He paints pine-trees, bamboos, plum-blossoms and epidendrums quite recklessly in a criss-cross manner without adhering to any rules or measures. His brush-idea (style) is half-way between (the styles of) Hsü Wei and Chu-han(?). In the Yung-chêng period he was appointed to the position of a magistrate in Ho-fei (Anhui). He was a benevolent official and much liked by the people. When he retired he was poor and old, and there was no one to support him. So he devoted himself more than ever to painting in order to earn his daily bread."[1]

Ch'in Tsu-yung emphasizes likewise his reckless manner of painting ("without regard to rules and squares") and mentions a large picture by the artist representing a plum-tree in blossom which was "vigorous and old-fashioned; the ink was dripping-dropping, reminding one of ruffled hair and tattered clothes, but the dominating impression of the blossoms was harmonious and quiet. The spirit of the picture was hidden in the fragrance of the slender twigs"[2] (cf. Fig.11).

The references to Li Fang-ying's recklessly free, not to say wild, manner of painting, which are repeated by the critics quoted above, are indeed pertinent and fully supported by the painter's preserved works, but still more important from an historical viewpoint is Chang Kêng's statement that Li Fang-yin might be characterized as standing half-way between Hsü Wei and a painter called Chu-han (whose identity escapes us). The reference to Hsü Wei, the well-known expressionist of the six-teenth century, and the inference that he belonged to the same stylistic current, though a typical Yang-chou painter of the eighteenth century, is a remark-able evidence of the fact that this connexion, or continuity of style, was well known to the leading art-historian of the Ch'ien-lung period. This well founded remark is one more confirmation of our own view that the Yangchou "independents" formed a revival of the kind of pictorial art or ex-pressionism that had deep roots in the Chinese

genius, but could not appear in full bloom or adequate form except at certain moments or critical times of spiritual revolt, when the creative forces were sufficiently aroused by individual search for the independence and freedom necessary for the art that may be called "idea-writing" (hsieh-i).

Li Shan was also a typical member of this group. He was actually born in Yangchou (about 1670) and passed most of his life there except when he served as a magistrate in another place. As a painter he followed lines parallel to those of Li Fang-ying and is characterized by the critics in terms similar to those used for the other Li. He too had an historical guide or path-opener of the Ming period, if we may believe Chang Kêng who wrote with reference to Li Shan: "In his flower and bird-paintings he followed Lin Liang and worked in a very free and quick manner like a runaway horse, quite inde-pendent of all rules but nevertheless obtaining the effects of nature." Ch'in Tsu-yung expresses a more critical opinion about Li Shan in writing as follows: "He was a man of considerable skill, but after all not quite satisfying, because his brushwork was reck-less; he could not free himself from an air of vulgar audacity and traditional bad habits. In that kind of work only Chin Nung reached the old masters. As to the others (of the Yangchou group) they may have been wonderful, but they could not help being wild." The verdict may well be accepted as right, particularly from the points of view prevailing in official art circles. Some of these painters carried the hsieh-i manner to such a degree of reckless freedom that their compositions seem to be written down in the wildest ts'ao-shu (grass-script) with little struc-ture or coherence. Li Shan excelled in pictures of lotuses, pumpkins, and climbing plants, often with insects and butterflies, quivering with momentary life (Pl.458). The best among them are the smallest, i.e. album-leaves with beetles and flowers; in the larger pictures of trees and climbers the composi-tions are lacking in structure and such expressional

[1] Kuo-chao hua-chêng-lu, II, 1, p.17.

[2] T'ung-yin-lun-hua, III, 1, p.11.

elements as would transform the decorations into works of art.

Chêng Hsieh, commonly called by his *hao* Pan-ch'iao, was one of the most gifted men of the brush among the Yangchou painters. He was born 1693 at Hsing-hua, a place quite close to Yangchou, and passed his *chin shih* degree in 1736. Later in life he served as a magistrate in Wei-hsien (Shantung), but retired because of illness and died 1765. He is praised by the biographers as a poet, an excellent calligrapher, and an unsurpassed painter of bamboo and epidendrum (Pl.457A). "He painted the epidendrum leaves most wonderfully, moving the brush in long slanting strokes as in writing *ts'ao shu*. Sometimes the leaves were many, yet they did not seem confused, at other times only a few, yet not seemingly scattered. He was quite free from the bad habits of the time and surpassed all others in beauty and strength", etc. Ch'in Tsu-yung repeats practically the same encomium, emphasizing "the emotional quality of his brush, which he waved according to his impulses, expressing himself without the least restraint, but he did not master an art depending on careful deliberations".

No better characterization of Chêng Hsieh's individual temperament and expressionistic manner of working could be given than in the last remark by Ch'in Tsu-yung. It makes us realize that the rhythm of his brush was the immediate repercussion of the movements of his heart and the pulse of his inspiration, discernible in his writings as well as in his paintings. He painted his tufts of epidendrum in the crevices of the rocks and the tall bamboo-stems with their spare branches and scattered leaves in the same style, alive with the same spirit as the pictorial calligraphy by which the compositions were completed. There was no longer any dividing line between the two elements of composition, as may be seen in the beautiful three-panelled bamboo screen in the Takashima collection, painted with an ease that "holds nothing in reserve" and united in a composition that seems perfect though perhaps unbalanced from a formal viewpoint (Pl.453B).

Two of the most gifted representatives of the Yangchou group, Huang Shên and Hua Yen, came from Fukien and contributed effectively to make this broad current of expressionistic ink-painting popular in wide circles. They were both very productive (more so than appears from our Lists) and excelled in painting entertaining, sometimes humorous, illustrations to human and animal life rather than poetic transcriptions of plum-blossoms and epidendrums.

The biographical records about Huang Shên are mainly derived from the notes, or *Wên-chi*, by Wang I-shan, which have been reported by various authors. He wrote:[1] "Huang Shên, *shan-jên*, settled in Yangchou eight years ago; I met him there when I went to Yangchou to see a doctor. His paintings as well as his poems possessed an interest beyond the subject-matter. After the death of his father, when living alone with his mother, he took up painting in order to make a living, but the mother said to him with tears in her eyes:[2] 'You are doing this to earn your living, but I have heard that without immersing oneself in books and acquiring the spirit of a scholar, one can only reach the skill of an artisan; that would not enable you to distinguish yourself and comfort the departed spirit of your father'. But the boy simply kept on harder.

"At the age of 18 he went to live in a Buddhist temple. There he painted in daytime and read at night in the light from lamps placed before the Buddha statues, which made the mother rejoice.

"He made the acquaintance of many prominent people. He became a very skilful painter, a good poet and a writer of *ts'ao-shu*. When travelling to Kiangsi he passed through Kiangsu and Chekiang, and as the people of Yangchou offered him hospitality, he settled there 1727."[3]

Huang Shên's characteristics as a painter are well described by Ch'in Tsu-yung in the following

[1] *Cf. Kuo-chao hua-chêng-lu*, II, 2, p.6.

[2] *Cf. Tung-yin lun-hua*, I, 3, p.13.

[3] Quoted in *Kuo-chao hua-shih*, vol.11, p.15, from Wang I-shan's *Wên chi*.

words:[1] "In his landscapes he followed both Ni and Huang, but he also studied Wu Chên thoroughly. He became much appreciated. I have seen both small and large pictures by him; they are painted in a rough and vigorous manner and filled with an air of extraordinary boldness . . . but his figures have a too extravagant appearance; they are lacking in refined beauty and harmonious ease. He answered to the old saying: 'When the brush runs too far it hurts the *yün*' (the spirit-resonance)."

Refinement and beauty are, indeed, the last things that one should look for in Huang Shên's quite abundant works. They are often coarse, painted in an apparently careless fashion, though filled with life-movement and *ch'i-yün*. It matters little what they represent, whether they are called fishermen or wood-cutters, Taoist immortals or gods of longevity, poets or philosophers like Mêng Chiao, Li Po or Su Tung-p'o,[2] they are all characterized as strange and ungainly appearances from a world quite detached from that of ordinary human beings. The brilliant brushwork, which often shows combinations of ink and light colours used in washes, makes them live: fugitive shadows as it were, fixed on the paper on the brink of disappearing (Pl.459). When Huang Shên paints flowers and birds he sometimes reminds us of Pa-ta shan-jên, for instance in the picture of A Heron and Lotus in the Nagao collection in Aki,[3] but his brush is lighter; it seems to move over the paper like the faint soughing of an evening breeze (Pl.460A). His limitations become more evident in his larger compositions representing several figures or landscapes,[4] as pointed out by Ch'in Tsu-yung, but in his minor landscape-sketches such as the album-leaves in the Saito collection[5] he sometimes obtains pictorial impressions similar to those of Chin Nung, though rendered in a more fugitive manner.

Closely akin to Huang Shên as painters, though less well known because their works are not so abundant, were Chiang Chang, *tzŭ* T'ieh-ch'in, and Shih Yüan. The former was born in Tan-yang (Kiangsu), but lived in Yangchou and painted all kinds of animals and unwieldy figures, sometimes executed with the finger rather than with the brush, which makes them akin to Kao Ch'i-p'ei's figure-paintings, though they are still more sketchy. He is said to have founded the "Chiang school", which thus became a tributary to the leading Yangchou current (Fig.11).

Shih Yüan was a native of Yangchou and specialized in painting donkeys. He used to keep a number of such animals at his home, and became known as Shih, the Donkey-man (Shih Lü-êrh). His surpassing skill in this speciality is illustrated by a picture in the National Museum in Stockholm representing Two Men Riding on Donkeys accompanied by a servant-boy. It was painted, according to the inscription, in 1744, and is as such a telling example of donkey characterization executed with reducing brush-strokes.

Hua Yên, better known under his *hao* Hsin-lo shan-jên, passed the greater part of his life in Yangchou and is generally counted among the "Eight Strange Masters" of this place, but he was by temperament and style somewhat different from the other men of this group, his production being very large and varied. His connexion with the old Cheki-ang school may have been of some importance for the development of the quick-witted, and often humorous realism that found expression in his representations of animal and bird-life (*cf*. Fig.12), and also in many illustrative scenes of village-life in the South. He returned to the shores of the West Lake towards the end of his life and died there (about 1762) 80 years old.

Chang Kêng, who may have known Hua Yên personally, praises him as an excellent painter of figures, landscapes, flowers, birds, animals, vegetables and insects, free from the bad habits of the

[1] In *Tung-yin-lun-hua*, III, 1, p.4.

[2] Series of such pictures by Huang Shên are reproduced in *Shina Nanga*, i, pp.101–106; ii, 1, 6, 11. and iii, 1, 5, 8; others in *Kokka* 216; *Sōraikan*, p.65, etc.

[3] *Nanju*, vol.13.

[4] *Ibid*. vol.25.

[5] *Tōan*, pp.58, 59.

time and guided by close studies of the old masters'
works; "He did not seek for vulgar beauty and was
to our age as welcome as the sound of footsteps to
one who is lost in a mountain hollow. His paintings
of animals were particularly good, but in his land-
scapes he was inclined to leave out too much, which
was a mistake."

This somewhat qualified approval points on the
one hand to Hua Yen's studies of certain old masters
and the high estimate of his studies of animals, birds
and flowers, but also (with some criticism of the
painter's sketchy or abbreviating manner) to his
defects as a landscape-painter. As an example of his
studies of the early masters may be mentioned a
picture called Green Mountains and White Clouds
which is executed in the contourless *mo-ku* manner
after an original by Chang Sêng-yu.[1] It shows the
painter's attachment to classic models of a type that
was congenial to his fluent style and sensitive brush-
work. Studies of this kind did not prevent him
from using a typical *p'o-mo* technique in other
landscape-studies, as may be observed in the picture
in the Chang Hsüeh-liang collection.[2] Landscapes of
this latter type are not uncommon among the
master's works and make us realize that the very
fluent, not to say impressionistic, brushwork was by
no means a weakness, even though it did not
correspond to the taste of Chang Kêng.

Ch'in Tsu-yung gives a better estimate of it when
writing: "Hua Yen's brush-manner was exceedingly
free; he covered ('broke up') even the empty parts
and produced effects of life with the tip of his brush.
He revealed a new phase of art with wonderful
skill. I have seen more than twenty pictures by him,
and there was not a single one among them which
did not reveal something new and surprising; they
all seemed so natural. He could, indeed, be placed at
the side of Yün Nan-tien; he surpassed by far the
common painters and was 'like the sound of foot-
steps in a mountain hollow'."

Hua Yen's production was so rich and varied that
it cannot be properly described in a page or two;
we can only indicate some typical examples pub-

lished in various albums; they include human
figures as well as animals, birds, and insects, etc., all
rendered with humour and imagination.[3] To these
may be added the double album-leaf (formerly in
private possession in Peking) which shows three old
men seated on a terrace under a large tree, who
evidently have enjoyed their wine, but nevertheless
are expecting more of it, as explained by the in-
scription: "Bringing wine from the East Garden,
getting drunk in the West Garden", and by the
activity of the two boys who are unloading some
barrels from a boat (Pl.461).

The lonely horse may serve to illustrate Hua Yen's
faculty of animal characterization. It stands under a
projecting cliff with a doleful expression on its
raised head; the inscription says: "When autumn
comes, the longing for far-away places is aroused;
the neighing of the horse breaks the silence of the
valley". Like so many of Hua Yen's animals it is not
an ordinary quadruped but a sentient being with
thoughts and imagination, humanized by the
painter's sympathy. The same is true of so many of
his minor renderings of birds and animals in
momentary positions (Pl.462).

The picture in the former Abe collection (in
Ōsaka Museum) which, according to the inscrip-
tion, was painted in 1755, when the painter was 74
(Western reckoning 73) years old, is an illustration
to Ou-yang Hsiu's famous prose-poem, "An
Autumn Dirge". The old philosopher is seated in
the pavilion (which his servant-boy is entering)
listening to the autumn storm which shakes the
trees and makes their leaves whirl about in the air
(Pl.463). "On it came, at first like the sighing of a
gentle zephyr, gradually deepening into the splash
of waves upon a surf-beaten shore . . ." It can
hardly be claimed that the artist has succeeded in
depicting the grand sweep of Ou-yang Hsiu's

[1] *Sōgen*, p.308.

[2] *Ibid.* p.314.

[3] Various series of album-paintings by Hua Yên have been pub-
lished by the Chung Hua, the Yu Chêng and other companies
mentioned in the Lists.

description of the approach of autumn; yet he has transmitted its tone and atmosphere into a "silent poem", less monumental than the text, but alive with the same swift and poignant rhythm, which he has transmitted quite spontaneously. The appeal of the picture is thus truly individualistic; it makes us realize the meaning of Ch'in Tsu-yung's statement, quoted above, to the effect that there was not a single work by Hua Yen which did not reveal something new and surprising.

Lo P'ing, better known under his *hao* Lo Liang-fêng, was the youngest of the "Strange Masters"; he was born in Hsieh-hsien, Anhui, but seems to have settled, while still young, in Yangchou where be became a devoted friend and pupil of Chin Nung. He continued his activity until the very end of the century (1799) and was altogether a highly gifted creative personality representing, so to speak, a final epitome of the artistic ideals and typical endeavours of the Yangchou masters. As a painter and a student of Ch'an he followed very closely in the footsteps of his older friend and teacher Chin Nung, who presented him with a self-portrait on which he wrote the following dedication:[1]

"I present this to Lo P'ing, who studied poetry with me and was a very successful pupil (entered my chambers). As a painter he started by copying my wild plum-blossoms, afterwards imitating my figure and horse-paintings as well as my strange trees and rockeries. He is a very able man of the brush who paints (such things) without the least mistake." Ch'in Tsu-yung confirms this in writing about Lo P'ing as follows:[2] "His brush was strong and easy-flowing and his thoughts profound; he grasped the very spirit of Chin Nung's art. His paintings of plum-blossoms, epidendrums, and bamboos in ink are all wonderful and of very original effect, and his figure-paintings, Buddhist images are likewise very strange. Yet he never offended against the truth (of nature) but produced noble things in ink with great ease. No common artist could reach his level."

Some of his large figure-paintings may indeed seem rather sloppy, or fantastic, though not quite in the same sense as Chin Nung's or Huang Shên's Immortals, but others are more like portraits of ancient models. The eighteen Arhats in the album published by the Chung Hua Co. are almost grotesque, and the same is true of the fat monk meditating in a cave (reproduced in *Shina Nanga*, I, p.114), while the Taoist patron of medicine, known as Yao Wang (in the Yamaguchi collection in Ashiya), whom he has represented seated on a stool under two sturdy bamboos, is characterized, not without a grain of salt, as a hoary old man sunk in deep thought. They all contain reflections of a peculiar mind attuned by Ch'an meditation, but are as works of art less interesting than his pictures of epidendrum, bamboos and creeping plants, in which Lo P'ing's excellent brush-manner prevails. Good examples of these may be seen in the National Museum in Stockholm. One of them, which represents some tall stems of bamboo, is dated 1775 and signed: "Liang-fêng, the Taoist who in a former life was a monk in the Hua-chih temple", while the other and more important picture, called Creeping Grape-vine is dated 1771 and provided with a lengthy inscription in which the artist tells that his picture was inspired by a work of the monk-painter Wên Jih-kuan (of the Sung period) and furthermore reproduces a colophon by his teacher Chin Nung (Tung-hsin), written originally on Wên Jih-kuan's picture, in which he said: "When Wên, the monk, was drunk, he slept in the house of a courtesan. Then he painted some grape-vines in ink which made him famous in an evil age. He handled the strange leaves and the extravagant climbers like mere trifles and made them form together what seems like the tattered robe of a monk." To which the painter adds: "I threw away my brush and laughed. But people think that my grapes are like 'precious pearls in a bowl of jade' and consider me a Wên Jih-kuan. Why not, as I in a former life was a disciple of Buddha in the Hua-chih temple?"

Chin Nung's colophon as well as Lo P'ing's note

[1] *T'ung-yin lun-hua*, III, 1, p.10

[2] *T'ung-yin lun-hua*, I, 3, p.17.

are characteristic expressions of the mental attitude of these men, their search for the strange and mysterious, their way of dwelling in a realm of imagination detached from the dust of common cares. They were, indeed, creative artists by nature who revealed in their works glimpses of the unseen, but their visions may have been somewhat tattered and beclouded by the bohemian habits and dissolute spirit of the age. The undercurrent of spiritual inspiration was no longer the same as in the great creative ages of the Sung and Yüan dynasties. It had lost its glow, though occasionally and for a while it flashed up in brilliant individual efforts.

<p style="text-align:center">★ ★ ★</p>

Painters like the members of the Yangchou group might well – under more favourable conditions, in another age – have reached higher levels of creative art, because they were men of genius and devotion who, in spite of their rather free transformations of the pictorial symbols, formed a continuation or revival of one of the most potent currents within the general flow of Chinese ink-painting.

Lo P'ing may consequently here serve as a concluding figure in the sequence of more or less kindred painters we have studied. After him there was no one who employed the same principles of style and technique with equal success, no painter who actually followed in the footsteps of the above-mentioned artists and gave expression to that distinctive life-breath, or spirit of independence, which characterized these so-called strange masters of Yangchou.

This does not mean that the art of painting fell into complete decay after the end of the Ch'ien-lung period, or that there were no talented men worthy of our attention in the Chia-ching and Tao-kuang reigns. Several such artists could easily be

mentioned, but, whatever merits might be assigned to them, they had no connexion with the Yang-chou school of expressionistic ink-painting. They followed other roads and were mostly dependent on more exacting popular methods introduced by leading academicians of the Ming period such as Wên Chêng-ming. T'ang Yin and Ch'iu Ying. A further discussion of the various currents and tributaries of the widely spread though shallow flow of painting after the close of the Ch'ien-lung period would lead us beyond the limits of the present publication and hardly enhance our appreciation of Chinese painting as a whole.

Stylistically, then, as well as historically, the Yangchou masters constitute the last stage in the long gallery of creative painters on whom we have turned a critical eye, and whose works have been the objects of our attention from volume to volume. They form the end, though they still contributed new elements of interest to the continuous flow of artistic production. It would hardly be correct to place them on the same level as their most eminent predecessors of the Ming and Yüan periods, yet their best works and some of the records referring to Chin Nung's and Lo P'ing's creative endeavours indicate that they followed a well-worn path, were rooted in the same spiritual soil, and drew their inspiration from the same sources as so many of their famous predecessors. These sources or undercurrents, sometimes visible, sometimes hidden under a dry surface, have been occupying us time and again under various names, whether as Buddhist, Taoist, or Divinely Hierarchical; they need not be further discussed at this place. It should only be emphasized that whenever they met with men of genius who were attuned to their essential elements, they showed themselves able to raise the level of painting to that of spiritual, and therefore relatively permanent, reality.

Index to Chinese Names and Terms

VOLUME IV

An Ch'i 安岐, 35, 36, 49, 80, 81

An Lu-t'sun 安麓村 (see An Ch'i)

An-tao 安道, *t.* of Wang Li, 95

An-ting College (Hu-chou) 安定書院, 27

Ch'a Shih-piao 查士標, 72 (see Ching lists)

Ch'an (Buddhism) 禪, 11, 13, 98 ff., 108 195

Chang Ch'ien 張乾, 137

Chang Ch'ou 張丑, 18, 55, 69, 83 (*cf.* Index in Vol.II)

Chang Chün Collection (Taipeh) 張羣, 49

Chang Fang-ju 張芳汝, 99 (see Yüan lists)

Chang Fêng-i 張鳳翼, 190

Chang Fu 張復, 139 (see Ming lists)

Chang Hui 張翬, 137 (see Ming lists)

Chang I 張益, 123

Chang I-shang 張義上, *cf.* Chang Shun-tzǔ, 71

Chang Kêng 張庚, 96

Chang Kuo-lao 張果老, Taoist, 34

Chang Ling 張靈, 193, 207 (see Ming lists)

Chang Lu 張路, 134 ff. (see Ming lists)

Chang-o 張娥, the moon fairy, 203

Chang Sêng-yu 張僧繇, 76, 164

Chang Shên 張紳, 50, 51 (see Yüan lists)

Chang Shih-ch'êng 張士誠, 93

Chang Shun-tzǔ 張舜咨, 71 (see Yüan lists)

Chang Ta-ch'ien Collection 張大千, 64, 77, 123, 233

Chang Tsao 張璪, (*cf.* Index in Vol. II)

Chang Ts'ung-yü Collection 張蔥玉, 25, 71, 81

Chang Wên-chung 張文忠, 174

Chang Wu 張渥, 36 (see Yüan lists)

Chang Yen-fu 張彥輔, 50 (see Yüan lists)

Chang Yu 張祐, 225 (see Ming lists)

Chang Yu-shêng 張有聲 (Chinese painter mentioned by Sesshū), 117

Chang Yü 張羽, 112

Chang Yü 張雨, 47

Chang-yü 漳餘, *h.* of Yo Tai, 189

Chang Yüan-pien 張元忭, 227

Ch'ang-ch'ang shih 悵悵詩, 195

Chao Ch'ang 趙昌, 28, 30, 32, 217 (*cf.* Index in Vol. II)

Chao Chün 昭君, 216

Chao Fei-yen 趙飛燕, 169

Chao Fêng 趙鳳, 26

Chao Lien 趙廉, 113

Chao Lin 趙麟, 24, 26 (see Yüan lists)

Chao Mêng-chien 趙孟堅, 6, 23 (*cf.* Index in Vol.II)

Chao Mêng-fu 趙孟頫, 3, 12, 17 ff., 37, 54, 76, 153, 180 (see Yüan lists)

Chao Mêng-yü 趙孟籲, 24 (see Yüan lists)

Chao Po-chü 趙伯駒, 30 ff., 115, 153, 180, 210, 216 (*cf.* Index in Vol. II)

Chao Shu-ju Collection 趙叔孺, 114

Chao Ta-nien 趙大年, 84, 153

Chao Tso 趙左, 172

Chao Yung 趙雍, 24, 37, 76 (see Yüan lists)

Chao Yüan 趙原 (or 元), 83, 93, 94, 111, 125 (see Yüan lists)

Chê-school 浙派, 117, 128 ff.

Chên-ch'i-shêng 貞期生, *h.* of Chang Wu, 36

Chên-hsien-shêng 真閒生, *h.* of Chang Wu, 36

chên shu 真書, formal style of calligraphy, 51

Chên-tsê chi 震澤集, 151

Ch'ên Chi 陳繼, 148

Ch'ên Chien-chai 陳簡齋, 75

Ch'ên Chung-jên 陳仲仁, 27 (see Yüan lists)

Ch'ên-hao 宸濠, 194

Ch'ên Hsi-chiang 陳西江, 179

Ch'ên Hsien-chang 陳獻章, 103 (see Ming lists)

Ch'ên Hui 陳撝, 113

Ch'ên, J. D., Collection (Hongkong) 陳仁濤, 22, 119

Ch'ên Ju-yen 陳汝言, 91, 93, 112, 125

Ch'ên Kuo 陳栝, 220 (see Ming lists)

Ch'ên Lin 陳琳, 26, 96 (see Yüan lists)

Ch'ên Liu 陳澑, 224

Ch'ên Lu 陳錄, 102 ff. (see Ming lists)

Ch'ên Mêng-hsien 陳孟賢, 148

Ch'ên Pao-ch'ên Collection (Peking) 陳寶琛, 70

Ch'ên Shun 陳淳, 165, 219 (see Ming lists)

Ch'ên To 陳鐸, 171

Ch'ên Tzǔ-ho 陳子和, 142 (see Ming lists)

Ch'ên Yu-liang 陳友涼 72

Ch'ên Yüan 陳遠, 112 (see Ming lists)

Ch'ên Yüan-lung 陳元龍, 102

Chêng-chung 徵仲, t. of Wên Chêng-ming, 172

Chêng Ho 鄭和, 105

Chêng Kuang-wên 鄭廣文, 23

Chêng-po 貞伯, t. of Li Ying-chêng, 165

Chêng Po-yüan (pupil of Chu Hao-ku), 9

Chêng Ssǔ-hsiao 6, 23 (cf. Index in Vol. II)

Chêng Tê-k'un Collection (Cambridge) 鄭德坤, 231

Chêng Tien-hsien 鄭顛仙, 139 (see Ming lists)

Ch'êng Chêng-k'uei 程正揆, 176

Ch'êng-chü 檉居, h. of Tu Chin, 144

Ch'êng Min-chêng 程敏政, 194 ff.

Ch'êng-tien Monastery 承天寺 (Suchou), 99

Ch'êng-tsu 成祖, Emperor Yung-lo, 112

Ch'êng-tsung 成宗, Emperor, 18

Chi-chung chi 汲仲集, 30

Chi-hsiang 繼相, t. of Liu Shih-ju, 225

Chi-hung 季宏, t. of Lu Kuang, 72

Chi-kuang 吉光 (mythical animal), 226

Chi Li 計禮, 143

Chi-li-tzǔ 機里子, h. of Chang Shun-tzǔ, 71

Chi Pên 季本, 227

Chi-shan (Shansi Prov.) 稷山, 9

ch'i 氣, 73

Ch'i River 淇水, 40

Ch'i-nan 啓南, t. of Shên Chou, 148

Ch'i-sou 畸叟, h. of Wang Li, 95

Ch'i-wêng 奇翁, h. of Wang Li, 95

ch'i-yün 氣韻, 21, 26, 34, 149, 68, 72, 120

Chia-hsing (Chekiang) 嘉興, 73

Chia-hsi Palace 嘉熙殿, 71

Chia-shan (Chekiang) 嘉善, 127

Chia Yün-lao 賈耘老, 48

Chiang Ch'ien 蔣乾, 171 (see Ming lists)

Chiang-hsia School 江夏派, 137

Chiang Ku-sun Collection (Taipeh) 蔣穀孫, 153

Chiang-ning fu-chih 江寧府志, 137

Chiang-shan (Chekiang Prov.) 江山, 12

Chiang Shao-shu 姜紹書, 149

Chiang Sung 蔣嵩, 134 ff., 171 (see Ming lists)

Chiang-ts'un hsiao-hsia lu 江村銷夏錄, 61 (cf. Bibliography)

Chiang Tzǔ-ch'êng 蔣子成, 113 (see Ming lists)

Chiang Tzǔ-ya, 姜子牙, 130

Chiang Yin 姜隱, 215 (see Ming lists)

Chiang-yin (Kiangsu) 江陰, 121

Ch'iao Chung-shan 喬仲山, 39

chieh-hua 界畫, 37, 115

Ch'ien Fên 錢芬, 74

Ch'ien Fên 錢棻, 47

Ch'ien-fu 潛夫, t. of Li Chu, 137

Ch'ien Hsüan 錢選, 17, 29 ff., 38 (see Yüan lists)

chien-k'o 劍客, 59

Ch'ien Ku 錢穀, 98, 191 (cf. Ming lists)

Ch'ien-lung 乾隆, Emperor, 35, 61, 69

Ch'ien-t'ang 錢塘, 40, 115, 128

Ch'ien-t'ang River 錢塘江, 54

Chih-chêng 至正 (era, 1341–67), 12, 59, 61

Chih-hsin Mountain (near Suchou) 支硎山 221

Chih-kung t'u 職貢圖, 209

Chih-yüan 至元, era (1335–1340), 59, 98

Chih Yung (calligrapher), 62

Ch'ih-wêng 癡翁, h. of Shih Chung, 63, 166

Chin-ku Garden 金谷, 214

Chin Ta-shou 金大受, 11

Ch'in Kao 琴高, 116

Ch'in-li 欽禮, t. of Chung Li, 137

Ch'in-tz'ǔ I-ch'iao t'u-shu 欽賜一樵圖書 (seal of Chu Tuan), 144

Ch'in-yü shan-jên 秦餘山人, h. of Yo Tai, 189

Ching-an 靜菴, h. of Tai Chin, 128

Ching-chao 景昭, t. of Pien Wên-chin, 113

Ching-chung 敬仲, t. of K'o Chiu-ssǔ, 49

Ching Hao 荆浩, 23, 83

Ching-hsi tao-jên 井西道人, h. of Huang Kung-wang, 59

Ching-k'ou (Kiangsu) 京口, 57

Ch'ing Huan (follower of Ch'iu Ying), 215

Ching-ming chü-shih 淨名居士, h. of Ni Tsan, 80

Ch'ing-ch'i 清溪, h. of Chu Lang, 189

Ch'ing-ho shu-hua fang 清河書畫舫, 59

Ch'ing-k'uang 清狂, h. of Kuo Hsü, 141

ch'ing-lü shan-shui 青綠山水, 211

Ch'ing-pi ko 清閟閣, 49, 80

Ch'ing-po Pavilion (Suchou) 清白軒, 126

Ch'ing-shih 馨室, h. of Ch'ien Ku, 191

Ch'ing-t'êng 青藤, h. of Hsü Wei, 227

Ch'ing-t'êng t'ang 青藤堂, 231

Chiu-fêng 九峯, h. of Hsü Lin, 145

Chiu-hsien 酒仙, h. of Ch'ên Tzŭ-ho, 142

Chiu-lung shan-jên 九龍山人, h. of Wang Fu, 118

Ch'iu Chu 仇珠, 215 (see Ming lists: Ch'iu Shih)

Ch'iu-o 秋葊, t. of Shên Chao, 208

Ch'iu-shui 秋水, h. of Ch'ên Ju-yen, 93

Ch'iu Ying 仇英, 116, 208, 211

Ch'iu-yüeh 秋月, t. of Yen Hui, 12

Cho-chêng yüan 拙政園, garden in Suchou, 190

Cho-kêng lu 輟耕錄, 20, 67

Chou Ch'ên 周臣, 138, 193, 205 (see Ming lists)

Chou Chi-hung 周季宏, 123

Chou Chih-mien 周之冕, 224

Chou Fang 周昉, 209

Chou Hung-sun Collection 周鴻蓀, 28

Chou Kung-chin 周公謹, 22

Chou Mao-shu 周茂叔, 134 (cf. Chou Tun-i)

Chou Po-ch'i Chu-fu-chün mu-chih ming 周伯琦朱府君墓誌銘, 77

chou shu 籀書, seal characters, 51

Chou T'ien-ch'iu 周天球, flower painter (orchids, etc.), 61, 62

Chou-tso 周佐, t. of Chiang Yin, 215

Chou Tun-i 周敦頤 (t. Mao-shu), 134

Chou Wei 周位, 112 (see Ming lists)

Chou Wên-ching 周文靖, 116, 128, 133 ff. (see Ming lists)

Chou Wên-chü 周文矩, 203 (see Index in Vol. II)

Chou Yung 周用, 165 (see Ming lists)

Chu-hao lao-jên 竹鶴老人, h. of Ho Ch'êng, 121

Chu Hao-ku, painter of Temple Fresco in Museum at Toronto, 9

Chu Hsi 朱熹, 108

Chu I-tsun 朱彝尊, 228

Chu K'ai 朱凱, 175

Chu-ko Liang 諸葛亮, 146

Chu Lang 朱朗, 189 (see Ming lists)

Chu Mai-ch'ên 朱買臣, 115

Chu Nan-yung 朱南雍, 171 (see Ming lists)

Chu-p'u hsiang-lu 竹譜詳錄, 39

Chu-shih chi-lüeh 祝氏集略, 204

Chu Tê-jun 朱德潤, 77 (see Yüan lists)

Chu Tuan 朱端, 141 ff. (see Ming lists)

Chu Yüan-chang 朱元章, 104

Chu Yün-ming 祝允明, 194, 204

Chü-Jan 巨然, 27, 53, 62

Chü-nan 燁南, t. of Tu Chin, 144

Ch'u-hsien 樗仙, h. of Hsieh Shih-ch'ên, 167

Chuan-Shu 篆書, 50

Chuang Lin 莊麟, 71 (see Yüan lists)

Chuang-tzŭ 莊子, 47

Chung-chao 仲昭, t. of Hsia Ch'ang, 122

Chung-chien 仲謙, t. of Ch'ên Hui, 113

Chung-hsien 仲賢, t. of Liu Kuan-tao, 35

Chung-kuei 仲圭, t. of Wu Chên, 73

Chung K'uei 鍾馗, the Demon Queller, 14, 26, 186

Chung Li 鍾禮, 137, 139 (see Ming lists)

Chung-mu 仲穆, t. of Chao Yung, 24

Chung-pin 仲賓, t. of Li K'an, 39

Chung-shan 仲山, h. of Wang Wên, 170

Chung-shu shêng 中書省, "central chancellery", 77

Chung-wên 仲溫, t. of Sung K'o, 50

Chung Yu 鍾繇, 173

Ch'ü Chieh 居節, 190 (see Ming lists)

Ch'ü-pao Gate (Nanking) 聚寶門, 166

chüan 卷, passim

Chüeh-yin 覺隱, h. of Pên-ch'êng, 98

Chün-tzŭ 君子, 38, 185

Êrh-ya 爾雅, 41

Fa-hai ssŭ 法海寺, temple near Peking, 112

Fan K'uan 范寬, 23, 195

fan-t'ou-ts'un 攀頭皴, 74, 82

Fang-hu 方壺, h. of Fang Ts'ung-i, 188

Fang Jo Collection 方若, 216

Fang-shan lao-jên 房山老人, h. of Kao K'o-kung, 54

Fang Ts'ung-i 方從義, 59 (see Yüan-lists)

Fang-yai 方崖, 50 (see Yüan lists)

fei pai 飛白, 144

fên-shu 分書, official style of calligraphy, 51

Fêng bird 鳳, 142

Fêng Chi 馮箎, 126

Fêng-ch'iu 鳳丘, h. of Yu Ch'in, 215

Fêng-hua (Chekiang) 奉化, 138

Fêng-hua hsien-chih 奉化縣志, 138

Fêng-t'ien tien 奉天殿, 112

Fu-ch'ing 服卿, *t.* of Chou Chih-mien, 224

Fu-ch'un shan 富春山, 57 ff.

Fu-ch'un Shan-chü t'u 富春山居圖, 60 ff.

Fu-yang 復陽, *t.* of Chang Fu, 62, 139

Hai-yen (Chekiang) 海鹽, 145

Hai-yün 海雲, *h.* of Wang Chao, 141

Han Hsin 韓信, 206

Han Kan 韓幹, 19 ff. (*cf.* Index in Vol. II)

Han-lin College 翰林院, 18, 111

Han-shan 寒山 (Buddhist hermit), 13, 141

Hang-chou 杭州, 1, 17

Ho Ch'êng 何澄, 121, 171 (see Ming lists)

Hou Mou-kung 侯懋功, 191 (see Ming lists)

Hsi-chai tao-jên 息齋道人, *h.* of Li K'an, 39

Hsi-chin chü-shih 西金居士, *h.* of Chin Ta-shou, 11

Hsi-chou 西洲, 200

Hsi-hsia, 11

hsi-mo 戲墨, 46, 75

Hsi-wang-mu 西王母, 210, 215

Hsia Ch'ang 夏昶, 38, 51, 122, 125, 143 (see Ming lists)

Hsia Kuei, 34, 52, 130, 138 (*cf.* Index in Vol. II)

Hsia K'uei 夏葵, 138 (see Ming lists)

Hsia Ming-yüan 夏明遠, 37

Hsia Wên-yen 夏文彥, 27

Hsiang-ling hsien (Shansi) 祥陵縣, 9

Hsiang Shêng-mo 項聖謨, 233

Hsiang Yüan-pien 項元汴, 186, 232 (see Ming lists)

Hsiao Hsieh-lü 蕭協律, 40 (*cf.* Hsiao Yüeh)

Hsiao-hsien 小仙, *h.* of Wu Wei, 135

Hsiao I 蕭繹, 213

hsiao k'ai 小楷, style of calligraphy, 18

Hsiao-tsung 孝宗, Emperor Hung-chih, 135

Hsiao Tung-t'ing 小洞庭, garden of Liu Chüeh, 125

Hsiao Yüeh 蕭悅, 41 (*cf.* Hsiao Hsieh-lü)

Hsieh An 謝安, 141

Hsieh Huan 謝環, 114, 128 (see Ming lists)

hsieh-i 寫意, 142, 176, 219

Hsieh Shih-ch'ên 謝時臣, 89, 138, 167 ff., 189 (see Ming lists)

Hsien-chang 憲章, *t.* of Ch'ên Lu, 102 ff.

Hsien-chou 僊周, *t.* or *h.* of Wu I-hsien, 138

hsien-jên 仙人, 141

hsien-liang 賢良, 148

Hsien-tsung 憲宗, Emperor Ch'êng-hua, 134 (see Ming lists)

Hsien-yü Shu 鮮于樞, 40 (see Yüan lists)

Hsien-yü Po-chi 鮮于伯機 (*i.e.* Hsien-yü Shu), 40

Hsin-yu chêng shih 辛酉徵士 (seal of Chu Tuan), 144

Hsing-chih 行之, *t.* of Chou Yung, 165

Hsing-hua ssŭ (temple near Chi-shan, Shansi) 興化寺, 9

Hsing-kuo, Duke of 興國公, *i.e.* Wên T'ien-hsiang, 173

Hsing T'ung 邢侗, 163 (see Ming lists)

Hsiu-ch'êng 休承, *t.* of Wên Chia, 186

Hsiu-ning (Anhui) 休寧, 141

hsiu ts'ai 秀才, 71, 145

Hsü Chên-ch'ing 徐禎卿, 173

Hsü-ch'ien pai-yün i-kao 許謙白雲遺稿, 29

Hsü Ching 徐經, (fellow examination candidate to T'ang Yin), 明史, 194

Hsü Hai 徐海, 227

Hsü Hsi 徐熙, 217 (see Index in Vol. II)

Hsü Hsiao-p'u Collection (Taipeh) 徐小圃, 56

Hsü Lin 徐霖, 141 ff. (see Ming lists)

Hsü Pên 徐賁, 72, 87, 93, 112, 125

Hsü Shih-ch'ang Collection 徐世昌, 213

Hsü Ta 徐達, 104

Hsü Tao-ning 許道寧, 45

Hsü Wei 徐渭, 169, 231 (see Ming lists)

Hsü Wên-ch'ang chi 徐文長集, 169

Hsüan ch'ing 懸馨, 192

Hsüan-tê 宣德, Emperor Hsüan-tsung, 112

Hsüan-tsung 宣宗, Emperor Hsüan-tê, 113, 128 (see Ming lists)

Hsüan-tsung 玄宗, T'ang Emperor, 34

Hsüeh-ch'uang 雪窗, *h.* of P'u-ming, 99

Hsüeh-hu 雪湖, *h.* of Liu Shih-ju, 225

Hsüeh-ko shan-jên 雪個山人, *h.* of an unidentified person, 216

Hsüeh Ying 薛英, 126

Hu Ch'ang-ju 胡長孺, 30

Hu Ching 胡敬, 61

Hu-chou (Chekiang Prov.) 湖州, 17, 24, 30, 186

Hu Ta-hai 胡大海, 101

Hu Tsung-hsien 胡宗憲, 227

Hu Wei-yung 胡惟庸, 85

Hua-chu 畫塵, 175

Hua chuang-yüan 畫狀元, 135

Hua-lin chü-shih 華林居士, *h.* of Sun Chih, 190

Hua-lun 畫論, 6

Hua-p'u 花譜, 223

Hua-shan 華山, 19 ff. 117

Hua-shih hui-yao 畫史會要, 27, 29, 59, 72

Hua-t'ing (Kiangsu) 華亭, 69

Hua yen 畫眼, 140

Hua-yüan 畫院, 111

Huang Chien 黃潛, 70

Huang Ch'üan 黃筌, 27, 28, 218 (*cf.* Index in Vol. II)

Huang-ho shan ch'iao 黃鶴山樵, *h.* of Wang Mêng, 85

Huang-hua shan-jên 黃華山人, *h.* of Wang T'ing-yün, 39

Huang Kung-wang 黃公望, 22, 23, 26, 53, 54, 59, 63, 65 ff., 152 (see Yüan lists)

Huang, L. T., Collection (formerly of Yenching University), 168

Huang Shên 黃慎, 189

Huang T'ing-chien 黃庭堅, 44, 148 (*cf.* Index in Vol. II)

Hui-Ch'ung 惠崇, 153

Hui-hua kuan (Peking) 繪畫館, 22, 33, 34, 49, 64

Hui-ti 惠帝, Emperor, 109

Hui-tsung 徽宗, 111

Hung-wu 洪武, Emperor, 50, 94, 111

I-ch'iao 一樵, *h.* of Chu Tuan, 143

I-ching 易經, 59, 148

I-ch'ing 一清, *t.* of Wang Ch'ien, 226

I-chou ming-hua lu 益州名畫錄, 87

I-fêng 一峯, *h.* of Huang Kung-wang, 59

I-shu ch'uan-t'ung 藝術傳統, 63

I K'uan 兒寬, 115

I-mên 夷門, *h.* of Hou Mou-kung, 191

I-ming 以明, *t.* of Shih Jui, 115

I-mo 遺墨, 47

i-p'in 逸品, 165

I-shan 以善, *t.* of Lin Liang, 142

I-yüan chih yen 藝苑卮言, 120, 151, 167

Jên-chih tien 仁智殿, 111 ff.

Jên-hung 仁宏, *t.* of Kuo Hsü, 141

Jên Jên-fa 任仁發, 17, 29 ff. (see Yüan lists)

Jên-tsung 仁宗, Emperor, 18, 36

Jo-shui 若水, *t.* of Wang Yüan, 27, 28

ju 儒, 102

Ju-hai Yin-kung 如海因公, 83

Ju-ho 汝和, *t.* of Chi Li, 143

Ju-yin chü-shih 如隱居士, *h.* of Ch'ên Lu, 102

K'ai-fêng 開封, 1, 113

k'ai shu 楷書, style of calligraphy, 122

k'ai shu 楷書, 173

Kao Ch'i 高啓, 112

Kao Jan-hui 高然暉, 57 (see Yüan lists)

Kao K'o-kung 高克恭, 3, 27, 38, 54 ff. (see Yüan lists)

Kao Shih-ch'i 高士奇, 35, 61, 63

Kao-shih t'u 高士圖, 202

Kêng-chih t'u 耕織圖, 35

Ko Chêng-ch'i 葛徵奇, 176

K'o-chêng 克正, *t.* of Chu Tuan, 143

K'o Ch'ien 柯謙, 39

K'o Chiu-ssŭ 柯九思, 26, 38, 46, 121, 123 ff. (see Yüan lists)

Ku An 顧安, 38, 123 (see Yüan lists)

Ku-an 穀菴, *h.* of Yao-shou, 46, 127

Ku Hung-chung 顧閎中, 203 (see Index in Vol. II)

Ku K'ai-chih 顧愷之, 164

Ku-k'uang 古狂, *h.* of Tu Chin, 144

Ku-kung Collection 故宮, 13, 22, 32, 46, 48, 49, 50, 51, 55, 64, 66, 69, 70 ff.

Ku Ning-yüan 顧凝遠, 165

Ku-su (Suchou) 姑蘇, 205

Ku Ying, obscure painter mentioned only in *Nanga Taisei*, 98

Ku-yün ch'u-shih 孤雲處士, *h.* of Wang Chên-p'êng, 36

K'uai-yüan 快園, 149

K'uai-yüan-sou 快園叟, *h.* of Hsü Lin, 145

Kuan Fu-jên 管夫人 (see Kuan Tao-shêng)

Kuan-hsiu 貫休, 12 (*cf.* Index in Vol. II)

Kuan Tao-shêng 管道昇, 24 ff. (see Yüan lists)

Kuan-ti miao (T'ai-ts'ang) 關帝廟, 216

Kuan T'ung 關仝, 23, 130

Kuan-yin 觀音, 15, 123

Kuang-fu ssŭ (Suchou) 光禧寺, 157

Kuang-shêng ssŭ 廣勝寺, temple in Chao-ch'êng 趙城, (Shansi Prov.) 9; *cf.* Ming-ying wang tien 明應王殿

K'uei-chang ko 奎章閣, 49

K'un-shan (Kiangsu) 崑山, 122, 137

kung (degree) 貢, 173

Kung-fêng 供奉, 112, 113

Kung-fu 公甫, *t.* of Ch'ên Hsien-chang, 103

Kung pi 工筆, 20, 28, 30, 131, 166, 177

Kung-shou 公綬, *t.* of Yao Shou, 127

Kung-su 恭肅, posth. title of Chou Yung, 165

Kung-sun Ch'ing 公孫, 47

Kuo-chih t'ang chi 括志堂集, 121

Kuo Ch'un 郭純, 113

Kuo Chung-shu 郭忠恕, 37

Kuo Hsi 郭熙, 23, 45, 68, 117 (*cf.* Index in Vol. II)

Kuo Hsü 郭詡, 141 (see Ming lists)

Kuo Jo-hsü 郭若虛, 87 (*cf.* Index in Vol. II)

Kuo Pao-ch'ang Collection 郭葆昌, 213

Kuo Pi 郭畀, 57 (see Yüan lists)

Kuo Shou-ching 郭守敬, 2

Kuo-tzǔ chien 國子監, 3

Kuo Tzǔ-hsing 郭子興, 104

Kuo Wên-t'ung 郭文通, 113 (see Kuo Ch'un)

Lan-chên ts'ao-t'ang chi 懶眞草堂集, 94

lan hua 蘭畫, 24

Lan-t'ing 蘭亭, 210

Li Chao-tao 李昭道, 77

Li Ch'êng 李成, 45, 67, 77

Li-chi 履吉, *t.* of Wang Ch'ung, 189

Li Chu 李著, 137 (see Ming lists)

Li Ch'ung-ssǔ 李充嗣, 174

Li Fang-ying 李方膺, 189

Li Hêng 李亨, 98 (see Yüan lists)

Li Jih-hua 李日華, 50, 60, 68 (see Ming lists)

Li K'an 李衎, 38 ff. (see Yüan lists)

Li K'ang 李康, 28 (see Yüan lists)

Li Kung-lin 李公麟, 30

Li Lung-mien 李龍眠, 19, 22, 31, 173 (*cf.* Index in Vol. II)

Li Po 李白, 41, 77

Li P'o 李頗, 41 ff.

Li Shan 李鱓, 189

Li Shê 李涉, 141

Li Shêng 李昇, 85 (*cf.* Index in Vol. II)

Li Shih-hsing 李士行, 38, 45 (see Yüan lists)

li shu 隸書, style of calligraphy, 28, 51

li shu 隸書, 173 (together with *k'ai shu*)

Li Ssǔ-hsün 李思訓, 77, 115

Li T'ang 李唐, 116, 172 (*cf.* Index in Vol. II)

Li T'ieh-kuai 李鐵拐 (Taoist Immortal), 13

Li Tsai 李在, 116 (see Ming lists)

Li Tung-yang 李東陽, 150

li wei 禮闈 (examination), 195

Li Ying-chêng 李應禎, 165, 173

Liang Ch'u 梁儲, 194

Liang K'ai 梁楷, 202 (see Index in Vol. II)

Liang Shih-chêng 梁詩正, 61

Lieh-ch'ao shih-chi 列朝詩集, 191

Lien Ch'üan Collection (Hangchou) 廉泉, 102

Lin Han 林翰, 90

Lin Liang 林良, 141 ff. (see Ming lists)

Liu Chüeh 劉珏, 125 ff., 155 (see Ming lists)

Liu Chün 劉俊, 141 (see Ming lists)

Liu Hai-hsien 劉海蟾 (Taoist Immortal), 13

Liu Hai-su 劉海粟, 72, 126

Liu-i 六一, *t.* of Chang Yen-fu, 50

Liu-ju chü-shih 六如居士, *h.* of T'ang Yin, 193 ff.

Liu Kuan tai-chih chi 柳貫待制集, 54

Liu Kuan-tao 劉貫道, 17, 29 ff. (see Yüan lists)

Liu Pei 劉備, 146

Liu Shih-ju 劉世儒, 225 (see Ming lists)

Liu Sung-nien 劉松年, 35, 180, 197

Liu Tao-ch'un 劉道醇, 217

Liu-yen chai erh-pi 六研齋二筆, 119

Liu Yung 劉庸, 25

Lo Chên-yü Collection 羅振玉, 33

Lo Chia-lun Collection (Taipeh) 羅家倫, 82

Lou Ch'ih (Ch'ou) 樓璹, 35

lo-ch'ing 螺青, 68

Lo-han 羅漢 (*cf.* Arhat), 131

Lou Kuan 樓觀, 125 (*cf.* Index in Vol. II)

Lu An-tao 陸安道, 189

Lu Chih 陸治, 95, 189, 221 (*cf.* Ming lists)

Lu-chih 祿之, *t.* of Wang Ku-hsiang, 213

Lu-ch'un 魯純, *h.* of Ma Yüan, 70

Lu-fu 魯夫, *h.* of Wu Wei, 135

Lu Hsin-chung, 11 (*cf.* Index in Vol. II)

Lu Hsüeh-shih 陸學士, 50

Lu-kuan tao-jên 鹿冠道人, *h.* of Tu Ch'iung, 125

Lu Kuang 陸廣, 59, 72, 119

Lu Lêng-ch'ieh, 12 (*cf.* Index in Vol. II)

Lu Shih-tao 陸師道, 189 (see Ming lists)

Lu Ta 魯達, 10

Lu Tzǔ-chuan 陸子傳, 180 ff.

Lu-wang 魯望, *t.* of Yü Hsi-lien, 172

Lu Yu 陸遊, 148
Lu Yü 陸羽, 95
lung-mo 龍脉, 92
Lung-p'ing, Duke of (*i.e.* Chang Yu) 隆平侯, 225
Lü Chi 呂紀, 141 ff., 217 (see Ming lists)

Ma Ho-chih 馬和之, 202 (see Index in Vol. II)
Ma Lin 馬麟, 145 (see Index in Vol. II)
Ma Shou-hua Collection (Taipeh) 馬壽華, 72
Ma Yüan 馬遠, 43, 52, 116 ff., 130 (*cf.* Index in Vol. II)
Ma Yüan 馬琬, 34, 70 (see Yüan lists)
mei-hua 梅花 (plum-blossom), 101 ff.
Mei-hua p'u 梅花譜, 226
Mei-hua tao-jên 梅花道人, *h.* of Wu Chên, 46, 47, 73
Mei-hua wu-chu 梅花屋主, *h.* of Wang Mien, 101
Mei-shu ts'ung-shu 美術叢書, 39, 47
Mêng Chiao 孟郊, 167
Mêng-chin 夢晉, *t.* of Chang Ling, 207
Mêng-hsüeh 孟學, *t.* of T'ao Ch'êng, 220
Mêng-tuan 孟端, *t.* of Wang Fu, 118
Mi-chai 密齋, 120
Mi Fei (Fu) 米芾, 18, 53, 70
Mi Yu-jên 米友仁, 18
miao-p'in 妙品, 165
Ming-hsüan 明鉉, *t.* of Wei Chiu-ting, 27
Ming-hua lu 明畫錄, 138 ff.
Ming-shan ts'ang 名山藏, 128, 142, 175
Ming shih 明史, 95, 119
Ming-wên pieh-chi 明文別紀, 171
Ming-ying wang (local deity) 明應王, 9
Ming-ying wang tien 明應王殿 (Pavilion in the Kuang-shêng ssŭ, Chao-ch'êng, Shansi Prov.), 9
Mo-chu p'u 墨竹譜, 44
Mo-hu 墨湖, *h.* of Li Chu, 137
mo-ku 沒骨, 218
Mo-lin 墨林, *h.* of Hsiang Yüan-pien, 232
Mo pao 墨寶, 230
Mo Shih-lung 莫是龍, 69
Mo-yüan hui-kuan 墨緣彙觀, 22, 23, 28, 82 (*cf.* Bibliography in Vol. II)
Mu-ch'i 牧谿, 58
Mu-chih 牧之, *t.* of Wang Ch'ien, 123, 225

Nan-ching chih 南京志, 145
Nan-kung 南宮, *h.* of Sung K'o, 50
Nan-yüeh shan-jên 南越山人, *h.* of Chung Li, 137

Nêng-p'in 能品, 131, 165, 209
Ni Tsan 倪瓚, 23, 38, 80 ff. 74 ff., 81, 97 ff., 103, 123, 125, 140, 144 ff., 173, 181, 189
Ni Tuan 倪端, 116 (see Ming lists)
Ni Yü 倪迂 (*cf.* Ni Tsan), 80
Ning, Prince 寧王 (see Ch'ên-hao), 174
Ning Ch'i 甯戚, 115
Ning-po 11
Nü-chi Mountain 女几山, 198

Pa-huan tao-jên 八還道人, *h.* of Ch'ien Fên, 47
Pa-ling 霸陵, 195
Pa-ta shan-jên 八大山人, 142 ff.
pai-miao 白描, 36, 37
P'ang Lai-ch'ên Collection 龐萊臣, 89, 90
P'ang Yüan-chi Collection 龐元濟, 28, 64, 81, 197
Pao-chieh shan 寶界山, 170
Pao-shan-tzŭ 包山子, *h.* of Lu Chih, 221
Pao-shêng 葆生, *h.* of Wên Po-jên, 187
P'ao-an 匏菴, *h.* of Wu K'uan, 173
Pei-kuo-shêng 北郭生, 93
Pei-shan 北山, *h.* of Kuo Pi, 57
P'ei K'uan 裴寬, 22
P'ei-wên-chai shu-hua p'u 佩文齋書畫譜, 67, 77, 95
Pên-ch'êng 本誠, 98 (see Yüan lists)
P'êng-fei 鵬飛, *h.* of Hsü Wei, 227
P'êng Li, 彭禮, 150
P'êng-mei 朋梅, *t.* of Wang Chên-p'êng, 36
P'êng Nien 彭年, 190, 212, 213 (see Ming lists)
pi-i 筆意, 44, 86
p'i-ma-ts'un 皮麻皴, 88
Pien-ts'ai 辨才, 213
Pien Wên-chin 邊文進, 113, 114, 218 (see Ming lists)
Ping-hu tao-jên 冰壺道人, *h.* of Wang Ch'ien, 225
P'ing-shan 平山, *h.* of Chang Lu, 139
Po Chü-i 白居易, 148
Po-hu 伯虎, *t.* of T'ang Yin, 193
Po-i 伯益, *t.* of Yü Ch'ien, 123
Po Tzŭ-t'ing 柏子庭, 99 (see Yüan lists)
Po-yang 白陽, *h.* of Ch'ên Shun, 219
Po-yen Pu-hua 伯顏不花, 71 (see Yüan lists)
p'o-mo 潑墨, 56, 72, 82, 98, 175
P'u-an 樸庵, *h.* of Kuo Ch'un, 113
P'u-ming 普明, 99 (see Yüan lists)
P'u-shan lun-hua 浦山論畫, 95
P'u-t'ien (Fukien) 莆田, 133

San-chiao t'ang 三教堂, school established by Huang Kung-wang in Suchou, 59

San-ch'iao 三橋, h. of Wên P'êng, 186

San-shan 三山, h. of Chou Wên-ching, 133

San-sung 三松, h. of Chiang Sung, 139

san-tsai 三彩, 214

San-yüan 三原, 150

Shan-ch'ang 善長, t. of Chao Yüan, 83, 94

Shan-ku 山谷, h. of Huang T'ing-chien, 40

Shan-ku tao-jên 山谷道人, 156

Shan-yin (Chekiang) 山陰, 227

Shang-chih 尚之, 213

Shang-ch'ing-kung 上清宮, Taoist monastery on Lung-hu shan, Kiangsi, 42

Shang Hsi 商喜, 114 (see Ming lists)

Shang-ku 商谷, h. of Chü Chieh, 190

Shang-kuan Po-ta 上官伯達, 113

Shao Fu-ying Collection (Peking) 邵福瀛, 101

Shao-hsing 紹興, 172, 225

Shao-ku 少谷, h. of Chou Chih-mien, 224

Shên Chao 沈昭, 208

Shên Chên 沈貞 (see Shên Chên-chi), 152 (see Ming lists)

Shên Chên-chi 沈貞吉 (see Shên Chên), 148

Shên Ch'êng 沈澄, 148

Shên Chou 沈周, 49, 70 ff., 125, 148 ff., 152 (see Ming lists)

Shên Hao 沈顥, 84

Shên Hêng-chi 沈恒吉, 148

Shên Hsi-yüan 沈希遠, 112

Shên Jui-lin Collection 沈瑞麟, 199

Shên Ming-ch'ên 沈明臣, 227

shên-p'in 神品, 165

Shên Ssǔ-tan 沈思贊, 133

Shêng Chu 盛著, 112.

Shêng Mou 盛懋, 50, 73, 76, 112 (see Yüan lists)

Shih-an 士安, original name of Kao K'o-kung, 54

Shih-chai 石齋, h. of Ch'ên Hsien-chang, 103

Shih-chên 士貞, t. of Chü Chieh, 190

Shih-chou 十洲, h. of Ch'iu Ying, 209

Shih Chung 史忠, 138, 166 (see Ming lists)

Shih Ch'ung 石崇, 214

Shih-chü pao-chi 石渠寶笈, 61

Shih-fu 實父, t. of Ch'iu Ying, 209

Shih-hsing 士行, t. of Chang Shên, 51

Shih Jui 石銳, 115 (see Ming lists)

Shih-k'uei 師夔, t. of Shang Shun-tzǔ, 71

Shih-mên 石門, t. of Sung Hsü, 172

Shih-t'ao 石濤, 180

Shih-tê 拾得 (Buddhist hermit), 13, 141

Shih-t'ien 石田, h. of Shên Chou, 149, 162

Shih-tsu, Emperor 世祖 (cf. Kubilai Khan), 18

Shih-tsung, Emperor Chia-ching 世宗, 227

Shih-tzǔ-lin 獅子林, garden in Suchou, 83, 125

Shih-ying 士英, t. of Wu Wei, 135

Shu-hou 叔厚, t. of Chang Wu, 36

Shu-ming 叔明, t. of Wang Mêng, 85

Shu-pao 叔寶, t. of Ch'ien Ku, 191

Shu-p'ing 叔平, t. of Lu Chih, 221

Shu-shih hui-yao 書史會要, 18

Shu-ta 叔達, t. of Sun Chih, 190

Shui-hu chuan 水滸傳, 10

Shui-li shu 水利書, 33

Shun-ch'ing 舜卿, t. of Chou Ch'ên, 205

Shun-chü 舜舉, t. of Ch'ien Hsüan, 29, 30

Ssǔ-chung 思忠, t. of Hsieh Shih-ch'ên, 167

Ssǔ-ma Kuang 司馬光, 182

Ssǔ wan 四萬, 188

Ssǔ-yu chai ts'ung-shuo 四友齋叢說, 69

Su-chou 蘇州, 83, 164 ff.

Su Han-ch'ên 蘇漢臣, 37, (cf. Index in Vol. II)

Su Shih 蘇軾 (Su Tung-p'o), 18, 42, 43, 120, 148, 157 (cf. Index in Vol. II)

Sun Chih 孫枝, 190 (see Ming lists)

Sun Chün-tsê 孫君澤, 34 (see Yüan lists)

Sun-fêng 巽峯, h. of Ch'ien Hsüan, 29

Sun Ta-ya 孫大雅, 82

Sung Hsü 宋旭, 172

Sung-hsüeh tao-jên 松雪道人, h. of Chao Mêng-fu, 18

Sung K'o 宋克, 38, 50 (see Yüan lists)

Sung Lien 宋濂, 70

Sung Lo 宋犖, 187

Sung Mou-chin 宋懋晉, 172

Sung-t'ien 松田, 99 (see Yüan lists)

Ta-ch'ih 大癡, h. of Huang Kung-wang, 59

Ta-Fo ssǔ 大佛寺, temple in Chêng-ting, 113

Ta-t'ung (Shansi) 大同, 54

tai-chao 待詔, 9, 24, 111 ff., 135

Tai Chin 戴進, 116, 128, 155 (see Ming lists)

Tai Piao-yüan 戴表元, 59

T'ai Chien-shan 泰兼喜 (i.e. T'ai Pu-hua), 101

T'ai Pu-hua 泰不花, 101 (see Yüan lists)

T'ai-shêng 太聲, t. of Ch'ên To, 172

T'ai-ting 泰定 (i.e. Temur Khan), 5

T'ai-ts'ang (Kiangsu) 太倉, 137, 209

T'ai-tsu 太祖, Emperor Hung-wu, 111

Tan-ch'iu 丹邱, h. of K'o Chiu-ssǔ, 49

Tan-hsien 澹軒, h. of Wang Yüan, 27

Tan-lin 丹林, h. of Chao Yüan, 94

Tan-t'u (Kiangsu) 丹徒, 144

Tan-yu 澹游, h. of Wang Man-ch'ing, 39

T'an Chih-jui 檀芝瑞, 50 (see Yüan lists)

T'ang Hou 湯垕 (or 厚), 6

T'ang Ti 唐棣, 59, 70 (see Yüan lists)

T'ang Wên-jui 湯文瑞, 151

T'ang Yin 唐寅, 116, 175, 193 (see Ming lists)

Tao-fu 道復, t. of Ch'ên Shun, 219

Tao-tê ching, 道德經, 4

Tao-yüan 道元, t. of Pên-ch'êng, 98

T'ao Ch'êng 陶成, 220 (see Ming lists)

T'ao-hua an 桃花庵, 204

T'ao-hua wu 桃花塢, 195

T'ao Tsung-i 陶宗儀, 86

T'ao Wên-chien 陶文簡, 228

T'ao Yüan-ming 陶淵明, 31, 160, 181

T'ao Yüan-tsao 陶元藻, 228

Tê-ch'êng 德承, t. of Wên Po-jên, 187

Tê-ch'u 德初, t. of Wang Chao, 141

Têng Wên-yüan 鄧文原, 46

Têng Wên-yüan Pa-hsi chi 鄧文原巴西集, 46

Ti P'ing-tzǔ Collection 狄平子, 37, 49, 95, 89

t'i-pa (colophon) 題跋, 147, 160

T'ieh-mei 鐵梅, 156

T'ien-chieh temple (Nanking) 天界寺, 112

T'ien-ch'ih 天池, h. of Hsü Wei, 227

T'ien-ch'ih 天馳, t. of Chang Lu, 139

T'ien-hsi 天錫, t. of Kuo Pi, 57

T'ien-li 天歷, era, 49, 72

T'ien-yu 天游, h. of Lu Kuang, 72, 97

Ting-chih 定之, t. of Ku An, 48

T'ing-chih 廷直, t. of Shih Chung, 166

T'ing-chih 廷直, t. of Wang Ê, 138

T'ing-hsün 庭循, t. of Hsieh Huan, 114

T'ing-mei 廷美, t. of Liu Chüeh, 125

T'ing-wei 廷偉, t. of Liu Chün, 141

ts'a-pi 擦筆, 176, 197

Ts'ang-ch'un 藏春, h. of Wang Ch'ien, 226

ts'ang-ku 蒼古, 72

Ts'ang-yen 蒼巖, t. of Po-yen pu-hua, 71

Ts'ao Chih-po 曹知白, 59, 69

Ts'ao Chung-yüan 曹仲元, 15

Ts'ao Pa 曹霸, 20

Ts'ao Pu-hsing 曹不興, 164 (see Index in Vol. II)

ts'ao shu 草書 ("grass characters"), 51

Tsê-min 澤民, t. of Chu Tê-jun, 77

Tsêng, Hsien-ch'i (Chinese American expert in Boston), 159

Tsêng Yu-ho 曾幼荷, 195

Tso-chuan 左傳, 148

Tso T'ai-chung 左太仲, (see Tso Ssǔ), 118

Tsou Chih-lin 鄒之麟, 62

Tsou Fu-lei 鄒復雷, 100 (see Yüan lists)

Tsu-hsüan 祖玄, monk-name of Sung Hsü, 172

Tsu-wêng 卒翁, 99 (cf. Index in Vol. II)

ts'un-fa 皴法, 68, 88

tsung 宗 (school), 96

Tsung Ping 宗炳, 86 (cf. Index in Vol. II)

Ts'ung-lung 從龍, t. or h. of an unidentified person, 181

ts'ung-shu 叢書, 108

Tu Chin 杜堇, 141 ff. (see Ming lists)

Tu Ch'iung 杜瓊, 125 ff., 153, 165 (see Ming lists)

Tu-ch'ü 杜曲, 195

Tu Fu 杜甫, 213

Tu-ling Nei-shih 杜陵內史, h. of Ch'iu Chu, 215

Tu-lo yüan 獨樂園, 182

Tu Mu 都穆, 149, 165

Tu Ta-shou 杜大綬, 233 (see Ming lists)

Tu Yüan-ching t'an-ts'uan 都元敬談纂, 91

T'u-hua chien-wên chih 圖畫見聞志, 87

T'u-hui pao-chien 圖繪寶鑑, 26, 34, 63, 73, 102 (cf. Bibliography in Vol. II, p.7)

Tuan Fang Collection 端方, 30

Tun-huang 敦煌, 9, 15

Tung Ch'i-ch'ang 董其昌, 23, 24, 55, 60, 62, 69, 82, 140

Tung-po 東伯, t. of Yo Tai, 189

Tung-t'ing Island 洞庭, 187

Tung-ts'un 東邨, h. of Chou Ch'ên, 205

Tung Yüan 董源, 23, 53, 60, 67, 69, 151

T'ung-hsüan 同玄, 90

Tzŭ-ang 子昻. *t.* of Chao Mêng-fu, 18, 46

Tzŭ-chao 子昭, *t.* of Shêng Mou, 76

Tzŭ-chêng 子正, *t.* of Ch'ên Kuo, 220

Tzŭ-chien 子健, *t.* of Chiang Ch'ien, 171

Tzŭ-ching 子京, *t.* of Hsiang Yüan-pien, 232

Tzŭ-chiu 子久, *t.* of Huang Kung-wang, 60

Tzŭ-ch'iu 子求, *t.* of Yu Ch'iu, 215

Tzŭ-ch'uan 子傳, *t.* of Lu Shih-tao, 189

Tzŭ-hua 子華, *t.* of T'ang Ti, 72

tzŭ-jan 自然, 45

Tzŭ-jên 子仁, *t.* of Hsü Lin, 145

Tzŭ-lang 子朗, *t.* of Chu Lang, 189

Tzŭ-ming 子明, *t.* of Jên Jên-fa, 33, 60

Tzŭ-tsai chü-shih 自在居士, *h.* of Hsia Ch'ang, 122

Tzŭ-yü 子裕, *t.* of Wang Wên, 170

Tz'ŭ-wêng 次翁, *t.* of Wu Wei, 135

Wan-an 完菴, *h.* of Liu Chüeh, 125

Wang Ao 王鏊, 151

Wang, C. C. Collection (New York) 王季銓, 23

Wang Chao 汪肇, 141 ff. (see Ming lists)

Wang Chên 王振, Eunuch, routed by Mongols, 1450

Wang Chên-p'êng 王振鵬, 29 ff., 115 (see Yüan lists)

Wang Ch'ien 王謙, 123, 226 (see Ming lists)

Wang Ch'ien 王乾, 225 (see Ming lists)

Wang Chih 王直, 227

Wang Chih-têng 王穉登, 62, 125, 176, 219

Wang Chin-ch'ing 王晉卿, 90 (see Wan Shên, Index in Vol. II)

Wang Chün-lu 王君祿, 179

Wang Ch'ung 王寵, 189 ff., 212 (see Ming lists)

Wang Ê 王諤, 134 ff. (see Ming lists)

Wang Fêng 王逢, 78

Wang Fu 王紱, 38, 51, 114, 118, 121 ff., 153 (see Ming lists)

Wang Hsi-chih 王羲之, 18, 31, 77, 146, 213

Wang Hsiang-ch'üan Collection 王湘泉, 180

Wang Hui 王翬, 62

Wang K'o-yü 王珂玉, 162

Wang Ku-hsiang 王穀祥, 179, 189, 213 (see Ming lists)

Wang Kuo-ch'i 王國器, 25

Wang Li 王履, 93, 95 (*cf.* Ming lists)

Wang Liang-ch'ên 王良臣, 98 (see Yüan lists)

Wang Man-ch'ing 王曼慶, 39 (*cf.* Index in Vol. II)

Wang Mêng 王蒙, 30, 72 ff., 85 ff., 178

Wang Mien 王冕, 69, 100 (see Yüan lists)

Wang Nien yün-ch'i lou 往年雲起樓, 62

Wang Pin 王賓, 20

Wang Shih-chên 王世貞, 133, 149

Wang Shih-min 王時敏, 62, 79

Wang Shou-jên 王守仁, 141

Wang Shu 王恕, 150

Wang Ta 王達, 119

Wang T'ing-yün 王庭筠, 39 (*cf.* Index in Vol. II)

Wang Tzŭ-ch'ing 王子慶, 40

Wang Wei 王維, 19, 23, 40, 62

Wang Wên 王問, 170 (see Ming lists)

Wang Yang-ming 王陽明, 108

Wang Yen-sou 王嚴叟, 100 (*cf.* Index in Vol. II)

Wang Yüan 王淵, 27, 28, 98, 153 (see Yüan lists)

Wang Yüan-ch'i 王原祁, 77

Wei River 渭川, 40

Wei-chi 惟吉, *t.* of Shang Hsi, 114

Wei-chien 惟健, *t.* of Chang Ch'ien, 137

Wei Chiu-ting 衛九鼎, 27 (see Yüan lists)

Wei-kung 魏公, posthumous title of Chao Mêng-fu 18

Wei-yün 惟允, *t.* of Ch'ên Ju-yen, 91, 93

Wên-chao 文昭, *t.* of Chuang Lin, 71

Wên Chêng-ming 文徵明, 119, 144, 149, 172 ff., 186, 212 (see Ming lists)

Wên Chia 文嘉, 177, 186 (see Ming lists)

Wên Chia hsing-lüeh 文嘉行略, 174

Wên-chin 文進, *t.* of Tai Chin, 128

Wên-ch'ing 文清, *t.* of Hsü Wei, 227

Wên-chu 文羔, *t.* of Chang Hui, 137

Wên-hua tien 文華殿, 112

Wên-jên 文人, 157

Wên-jên hua 文人畫, 92, 169, 170, 186, 212

Wên Lin 文林, 149, 165

Wên-min 文敏, posthumous appellation of Chao Mêng-fu, 18

Wên P'êng 文彭, 62, 177, 186 (see Ming lists)

Wên P'êng 文彭, 61 ff.

Wên Pi 文璧, original name of Wên Chêng-ming, 140

Wên-pi 文璧, *t.* of Ma Yüan, 70

Wên Po-jên 文伯仁, 145, 186-7 (see Ming lists)

Wên-shui 文水, *h.* of Wên Chia, 186

Wen T'ien-hsiang 文天祥, 2, 18, 141b

Wên Ts'ung-ch'ang 文從昌, 187 (see Ming lists)

Wên Ts'ung-chien 文從簡, 187

Wên Ts'ung-chung 文從忠, 187

Wên Ts'ung-lung 文從龍, 187

Wên T'ung 文同, 39, 42, 120 (cf. Index in Vol. II)

Wên-t'ung 文通, t. of Kuo Ch'un, 113

Wên Wang 文王, Chou Emperor, 130

Wên-yüan ko 文淵閣, 111

Wêng, H. C., Collection, Scarsdale, N.Y. 翁, 154 ff.

Wo-chih lou 臥凝樓, 166

Wu School 吳派, 147 ff.

Wu-ch'ang (Hupei) 吳昌, 135, 137, 164

Wu Chên 吳鎮, 22, 25, 30, 38, 46, 73, 172

Wu-ch'i chi 梧準集, 46

Wu Ching-an 吳靜安, 63

Wu Ch'iung-ch'ing (same as Wu Chih-chu) 吳囧卿, 62

Wu-chün tan-ch'ing chih 吳郡丹青志, 164 ff., 172

Wu-fêng 五峯, h. of Wên Po-jên, 187

Wu-hsi (Kiangsu) 無錫, 80, 118

Wu-hsien (Suchou) 吳縣, 147 ff.

Wu-hsing (Chekiang) 吳興, 25, 30, 71, 85

Wu-hsing 吳興, Eight Scholars of, 八士, 29

Wu I 吳奕, 175

Wu I-hsien 吳亦僊, 138 (see Ming lists)

Wu K'o-wên 武克溫, 209

Wu K'uan 吳寬, 149, 165 (see Ming lists)

Wu Li 吳歷, 62, 64

Wu-mên ssŭ chieh 吳門四傑 (Four Worthies of Suchou), 93

Wu-shêng shih-shih, 無聲詩史 80, 91, 100, 101 ff., 122, 141, 149

Wu Ta-chêng Collection (Suchou) 吳大澂, 161

Wu Tao-tzŭ 吳道子, 12, 15, 24, 136

Wu-tsung 武宗, Emperor, 18, 145

Wu Wei 吳偉, 134 ff. (see Ming lists)

Wu Wên-hsing (see Wu Ch'iung-ch'ing) 202

Wu-ying tien 武英殿, 11, 113

Wu-yü 無隅, t. of Fang Ts'ung-i, 58

Ya-i shan-jên 雅宜山人, h. of Wang Ch'ung, 189

Yang Chi 楊基, 112

Yangchou, Strange Masters of, 232

Yang Hsiung 提雄, 95, 227

Yang Hsün-chi 楊循吉, 125

Yang Kuei-fei 楊貴妃, 30, 169

Yang Wei-chên 楊維楨, 23, 51 (see Yüan lists)

Yang Wên-hsiang 楊文襄, 174

Yao Shih, colophon writer on Kêng-chih t'u, 35

Yao Shou 姚綬, 125, 166

Yao Yen-ch'ing 姚彥卿, 77 (see Yüan lists)

Yeh-lü Ch'u-ts'ai 耶律楚材, 2

Yeh-lü Hsi-liang 耶律希亮, 2

Yen-an 研菴, h. of Shêng Mao-hua, 28

Yen-ching 燕京, 1

Yen-ching 彥敬, t. of Kao K'o-kung, 54, 57

Yen-chou t'i-pa 弇州題跋, 133

Yen-hsia chu-jên 煙霞主人, h. of Wang Liang-ch'ên, 98

Yen Hui 顏輝, 12 ff. (see Yüan lists)

Yen Li-pên, 30

Yen-shang 延賞, t. of Hou Mou-kung, 191

Yen-tsê 彥澤, t. of Ho Ch'êng, 121

Yin-t'o-lo 因陀羅, 99 (cf. Index in Vol. II)

yin-yang hsün-shu 陰陽訓術, soothsayer, 133

Ying-tsung 英宗, Emperor, 18

Yo Chêng 岳正, 143 (see Ming lists)

Yo Tai 岳岱, 189 (see Ming lists)

Yu Ch'iu 尤求, 215 (see Ming lists)

Yu-shih 友石, h. of Wang Fu, 118

Yu-shih 酉室, h. of Wang Ku-hsiang, 224

Yu-wên 幼文, t. of Hsü Pên, 93

Yu-yüan 又元, t. of Ts'ao Chih-po, 69

Yung-chia (Chekiang) 永嘉, 38

Yung-chia 用嘉, t. of Tu Ch'iung, 36, 125

Yung-lo 永樂, Emperor, 105 ff.

Yung-lo Ta-tien 永樂大典, 108

Yung-t'ien 用田, 99 (see Yüan lists)

Yü Chi 虞集, 19

Yü-chien 玉澗, 58 (cf. Index in Vol. II)

Yü-chien tsun-wên 玉劍尊聞, 137

Yü Ch'ien 虞謙, 123

Yü-ch'uang man-pi 雨窗漫筆, 92

Yü-ch'üan shan-jên 玉泉山人, h. of Tai Chin, 128

Yü-fêng 玉峯, h. of Hsia Ch'ang, 122

Yü Hsi-lien 喻希連, 172 (see Ming lists)

Yü-shan tsao-t'ang ya-chi 玉山草堂雅集, 71

Yü-t'an 玉潭, h. of Ch'ien Hsüan, 29

Yü Yin 余寅, 227

Yüan-chang 元章, t. of Wang Mien, 100

Yüan-chên 元鎮, t. of Ni Tsan, 80

Yüan-chou 元洲, h. of Lu Shih-tao, 189

Yüan-po 原博, t. of Wu K'uan, 165, 173

Yüan Shun-ch'u Collection 袁巽初, 178
Yüan T'ai-ch'u 袁太初, 141
Yüeh-hua chien-wên 越畫見聞, 228
Yüeh-shan 月山, *h.* of Jên Jên-fa, 33
Yün-hsi 雲西, *h.* of Ts'ao Chih-po, 69
Yün-hu hsien-jên 雲湖仙人, *h.* of T'ao Ch'êng, 220-1

Yün-lin-tzǔ 雲林子, *h.* of Ni Tsan, 80
Yün-mên shan-ch'iao 雲門山樵, *h.* of Chang Shên, 51
Yün Shou-p'ing 惲壽平, 51
Yün-tung chi 雲東集, 127
Yün-tung i-shih 雲東逸史, 127
Yün-wên 允文, *t.* of Chao Fêng, 26

VOLUME V

An-chieh 安節, *t.* of Wang Kai, 135
An-chu hsing-jên 菴住行人, *h.* of K'un-ts'an, 144
Anhui, 46
Ao tao-jên 懊道人, *h.* of Li Shan, 237

Ch'a-shan 茶山, *h.* of Ch'ien Wei-ch'êng, 220
Ch'a Shih-piao 查士標, 114, 117, 147
Ch'ai-chang-jên 柴丈人, *h.* of Kung Hsien, 128
Ch'an (Buddhism) 禪, 4, 5, 11, 14, 16, 68, 83, 139, 236, 238
Chang Ch'ang-po collection 張昌伯, 134
Chang Ch'ung 張狪, 61, 62 (see Ming lists)
Chang Chün 張羣, 146
Chang Fêng 張風 or 飄, 138 ff. (see Ch'ing lists)
Chang-hou 章侯, *t.* of Ch'ên Hung-shou, 63
Chang Hsiu-yü 張修羽, 99
Chang Hsüan 張萱, 60
Chang Hsüeh-liang collection 張學良, 223 ff.
Chang Hung 張宏, 26 ff., 30 (see Ming lists)
Chang Jui-t'u 張瑞圖, 47, 51, 55 (see Ming lists)
Chang Kêng 張庚, 30, 32, 36, 39, 63, 86, 87 ff., 96 ff., 128, 142, 149, 159
Chang Ku 章谷, 127 (see Ch'ing lists)
Chang Ling 張靈, 3

Chang P'êng-ch'ung 張鵬翀, 218 (see Ch'ing lists)
Chang Sêng-yu 張僧繇, 6, 20, 37, 61, 62, 164, 174, 198 (*cf.* Index in vol.II)
Chang Shan-tzǔ 張善孖, 166 (brother of Chang Ta-ch'ien
Chang Shêng 章聲, 127 (see Ch'ing lists)
Chang Ta-ch'ien collection, 張大千, 9, 134, 166
Chang Ts'ai 章采, 127 (see Ch'ing lists)
Chang Tsao 張璪, 12
Chang Tsung-ts'ang 張宗蒼, 212, 217 (see Ch'ing lists)
Chang Tu-hsing 張篤行, 85
Chang Yao-hsing 張瑤星, 144, 148
Chang Ying-hua collection 張英華, 39
Chang Yü 張雨, 181 (see Yüan lists)
Chang Yüan 張沅, 171
Chang Yüan-chü 張元舉, 3 (see Ming lists)
Ch'ang, Prince 昌王, 81
Ch'ang-chou fu chih 常州府志, 85
Ch'ang-hêng 長蘅, *t.* of Li Liu-fang, 46
Ch'ang-kung 昌公, *t.* of Fang I-chih, 138
Ch'ang-kung 長公, *t.* of Chang Jui-t'u, 47
Chao Ch'ang 趙昌, 16
Chao Ch'êng 趙澄, 176 (see Ch'ing lists)
Chao Chih 趙芝, 77
Chao-ch'ing 兆清, *t.* of Lin T'ai-hêng, 74

Chao Hsiao 趙曉, 202

Chao Kan 趙幹, 14 (cf. Index in vol.II)

Chao Ling-chün 趙靈均, 30

Chao Ling-jang 趙令穰, 39 (see Index in vol.II)

Chao Mêng-chien 趙孟堅, 71

Chao Mêng-fu 趙孟頫, 4, 6, 38, 42, 59, 76, 179

Chao Pei 趙備, 70, 74, 76 (see Ming lists)

Chao Po-chü 趙伯駒, 4, 14, 223

Chao Po-su 趙伯驌, 14 (cf. Index in vol.II)

Chao Ta-nien 趙大年, 6, 9, 15, 129, 178, 218 (cf. Index in vol.II)

Chao-tai ts'ung-shu 昭代叢書, 188

Chao Tso 趙左, 17 ff., 173 (see Ming lists)

Chao Wên-shu 趙文俶, 70, 73

Chao Yüan 趙原 (or 元), 181

Ch'ao-lin 巢林, *h.* of Wang Shih-shên, 237

Chê School 浙派, 1, 36

Chê-lin 鷓林, *h.* of Tung Kao, 220

Chên-chih 振之, *t.* of Wu Chên 吳振, 22

Chên-hsiang Fo k'ung-ssŭ-hai 眞香佛空四海, 141

Chên-yen lao-jên 枕煙老人, *h.* of Wên Ts'ung-chien, 30

Ch'ên Chi-ju 陳繼儒, 2, 4, 10 ff., 23, 43, 96 (see Ming lists)

Ch'ên Chia-yen 陳嘉言, 78 ff. (see Ming lists)

Ch'ên Hsien 陳賢, 68-9 (see Ming lists)

Ch'ên Hung-shou 陳洪綬, 63, 65 ff., 70, 73, 93 (see Ming lists)

Ch'ên Lo 陳裸, 26 ff. (see Ming lists)

Ch'ên Mei 陳枚, (see Ch'ing lists)

Ch'ên Pao-ch'ên (collection), Peking 陳寶琛, 100

Ch'ên Shu 陳書, 220 (see Ch'ing lists)

Ch'ên Shun 陳淳, 102

Ch'ên Tao-fu 陳道復, 3, 56, 76

Ch'ên Ting 陳鼎, 149 ff., 159

Ch'ên Tsan 陳瓚, original name of Ch'ên Lo

Ch'ên Ts'an 陳粲, 3

Ch'ên T'ung-fu 陳同父, 130

Ch'ên Yüan-su 陳元素, 3, 48 (see Ming lists)

Chêng Chung 鄭重, 62 (see Ming lists)

Chêng Hsieh 鄭燮, 235, 246 (see Ch'ing lists)

Chêng Ping-shan 鄭秉珊, 149

Chêng-shu 正叔, *t.* of Yün Shou-p'ing, 193

Chêng Wu-chang 鄭午昌, 166

Ch'êng, Prince 成親王 (see Yung-hsing) 222

Ch'êng Chêng-k'uei 程正揆, 110, 142

Ch'êng Ch'i 程棨, 90 (see Yüan lists)

Ch'êng Chia-sui 程嘉燧, 45 (see Ming lists)

Ch'êng-chiang 誠將, *t.* of Ch'ên Lo, 28

Ch'êng Hsien 程憲, 76

Ch'êng-hsin-t'ang paper 澄心堂紙, 135

Ch'êng-hsüeh 澄雪, Monk-name of Hu Ching, 71

Ch'êng Shêng 程勝, 76

Ch'êng shih mo-yüan 程氏墨苑, 75, 89

Ch'êng Sui 程邃, 117, 121 (see Ch'ing lists)

Chêng Tê-k'un collection, Cambridge 鄭德坤, 53, 115, 129

Chi-ch'ên 吉臣, *t.* of Lêng Mei, 91

Chi-ch'i 繼起, 143

Chi-hsiang kung 吉祥宮, 220

Chi-liu shan-min 稽畱山民, *h.* of Chin Nung, 239

Chi-wên 吉文, *t.* of Lü Huan-ch'êng, 126

ch'i (originality) 奇, 27

Ch'i 氣, 196

Ch'i Chai-chia 祁豸佳, 109 (see Ch'ing lists)

ch'i-fu 起伏, 209

Ch'i-hsiai chih 齊諧志, 143

Ch'i-jo 螭若, *t.* of Huang Tao-chou, 51

Ch'i-tung wai-shih 溪東外史, *h.* of Wang Shih-shên, 237

Ch'i-yün 氣韻, 16, 102, 105, 117, 184

ch'i-yün shêng-tung 氣韻生動, 4, 43, 125, 210

Chia-ch'ing 嘉慶, Emperor, 220

Chia-ho (Chia-hsing) 嘉禾, 196

Chia-hsien 稼軒, *h.* of Ch'ien Wei-ch'êng, 220

Chia-hsing (Chekiang) 嘉興, 18, 38, 40, 71

Chia-ting 嘉定, 40 ff.

Chiang school 蔣派, 247

Chiang Chang 蔣璋, 237, 247 (see Ch'ing lists)

Chiang Kuan-tao 江貫道, 105

Chiang Mêng-p'ing collection 蔣孟蘋, 189

Chiang-nan t'ung-chih 江南通志, 96, 193

Chiang Po-shih 姜白石, 41

Chiang-shang wai-shih 江上外史, *h.* of Tan Chung-kuang, 123

Chiang Shao-shu 姜紹書, 88

Chiang T'ao 江韜 (see Hung-jên)

Chiang T'ing-hsi 蔣廷錫, 86, 225 (see Ch'ing lists)

Chiang Ts'an 江參, 106 (see Index in vol.II)

Chiang-tung pu-i 江東布衣, *h.* of Ch'êng Sui, 121

Chiao Ping-chên 焦秉貞, 67 ff., 86, 89, 90 ff. (see Ch'ing lists)

Ch'iao-ch'iao 巧巧, h. of Hsüeh Wu, 72

Chieh-ch'iu 介邱, t. of K'un-ts'an, 144

Chieh-k'an 介龕, h. of Ko Chêng-ch'i, 40

Chieh-sou 蜨叟, h. of Lan Ying, 36

Chieh-tzu-yüan hua-chuan 介子園畫傳, 135 ff.

Ch'ieh-yüan 且園, h. of Kao Ch'i-pei, 222

Chien-an 劍菴, h. of Huang Ying-shên, 86

Chien-chiang 漸江, t. of Hung-jên, 116

ch'ien 乾, 172

Ch'ien Ch'ien-i 錢謙益, 157, 187

Ch'ien ku 錢穀, 3

Ch'ien-li 千里, t. of Chêng Chung, 62

Ch'ien-lung (Emperor) 乾隆, 7, 50, 81, 82 ff.

Ch'ien-t'ang 錢塘, 36, 64

Ch'ien Wei-chêng 錢維城, 212, 220 (see Ch'ing lists)

Chih, Prince 質親王 (see Yung-jung), 222

chih-hou 祇侯, 82, 85

Chih-hsiang 止祥, t. of Ch'i Chai-chia, 109

ch'ih (unbalanced emotions) 癡, 27

Ch'ih-mu 尺木, t. of Hsiao Yün-ts'ung, 114

Chin-an 勁庵, 168

Chin Chün-ming 金俊明, 113 (see Ch'ing lists)

Chin-jên 近人, t. of Wang Shih-shên, 237

Chin-ling pa-chia 金陵八家 (see Eight Masters of Nanking), 128 ff.

Chin-ling p'ai 金陵派, 173

Chin Ming-chi 金明吉, 202

Chin Nung 金農, 235, 237, 239 ff (see Ch'ing lists)

Ch'in-ch'uan chih 琴川志, 184

Ch'in-huai River 秦淮河, 72, 130

Ch'in Tsu-yung 秦祖永, 110, 146, 159, 217, 223 (see Ch'ing lists)

Ching-chiang, Prince 靖江王, Ming 明 prince, ancestor of Shih-t'ao 石濤, painter, 157

Ch'ing-hui hua-po 清暉畫跋, 183

Ch'ing-hui tsêng-yen 清暉贈言, 183

Ching Hao 荊浩, 9, 35, 37, 57, 58, 133, 174 (cf. Index in vol.II)

Ching-i 敬一, t. of Huang Ying-shên, 86

Ch'ing-kou lao-jên 淨垢老人, h. of Huang Ting, 213

Ching-yen 靜巖, h. of T'ang-tai, 215

Ch'ing-ch'i i-kao 青溪遺稿, 111, 142

Ch'ing-ch'i tao-jên 青溪道人, h. of Ch'êng Chêng-k'uei 110

Ch'ing-chiang 晴江, h. of Li Fang-ying, 237

Ch'ing-chu 青主, t. of Fu Shan, 139

Ch'ing-hsia 青霞, h. of Ku Ning-yü'an, 42

Ch'ing-hsiang ch'ên-jên 清湘陳人, h. of Tao-chi, 160 ff.

Ch'ing-hsiang yeh-jên 清湘野人, h. of Tao-chi, 159

Ch'ing-hui 清暉, h. of Wang Hui, 176

Ch'ing-hui ko 清暉閣, 176

Ch'ing-liang shan 清涼山, 131

Ch'ing-tsai chü-shih 清在居士, h. of Li Shih-cho, 224

Ch'ing-wei t'ing 青微亭, 12

Ch'ing-yüan monastery 青原山堂, 139

Ch'ing-yün 晴雲, 180

Chio-ssŭ 覺斯, t. of Wang To, 56

Chiu-i 九疑, h. of Li Jih-hǔa, 40

Ch'iu-ch'ih 秋池, h. of Li Fang-ying, 237

Ch'iu-chung 虬仲, t. of Li Fang-ying, 237

Ch'iu-fu 秋甫, t. of Kao Yang, 77

Ch'iu K'ai-ming 裘雲明, 169

Ch'iu-shui 秋水, h. of Mo Shih-lung, 11

Ch'iu Ying 仇英, 3, 15, 64, 91 (see Ming lists)

Ch'iu-yo 秋岳, t. of Hua Yen, 237

Ch'iu Yüeh-chü 裘曰菊, 152

Cho-chin River 濯錦江, 18

Cho-jan 卓然, t. of Mang K'u-li, 87

Chou Ch'ên 周臣, 3, 29

Chou Chih-mien 周之冕, 3, 70, 77 (see Ming lists)

Chou Ching-wên 周景文, h. of 周忠介, 67

Chou Fang 周昉, 64–5 (see Index in vol.II)

Chou Hung-sun (collection) 周鴻蓀, 139

Chou Liang-kung 周亮工, 109, 130, 138, 142, 147 (see Ch'ing lists)

Chou Lung 周龍, 68 (see Ming lists)

chou-shu 籀書, 197

Chou T'ien-ch'iu 周天球, 73, 76 (see Ming lists)

Chou Ts'ao-ch'uang 周草窗, 199

Chou Tsu-hsin 周祚新, 74

Chou Yung 周用, 3

Chu Fei 朱苐, 179

Chu Hao-nien 朱鶴年, 163 (see Ch'ing-lists)

Chu-hsü 竹嶼, h. of Wu Chên 吳振, 22

Chu I-tsun 朱彝尊, 92, 187

Chu Jo-chi 朱若極, secular name of Tao-chi, 157

Chu-ko Liang 諸葛亮, 111

Chu K'uang-ting 諸匡鼎, 193

Chu Kuei 朱圭, 91

Chu-lan hua-ying 竹嬾畫滕, 40, 42

Chu Lu 朱鷺, 3, 74 (see Ming lists)

Chu Lu-shêng 朱盧生, 165

Chu Lun-han 朱淪瀚, 84 (see Ch'ing lists)

Chu Shêng 諸昇, 136, 137 (see Ch'ing lists)

chu-shêng 諸生, 141

Chu-shih 竹史, *h.* of Wu Hung, 130

Chu Ta 朱耷 (see Pa-ta shan-jên, see Ch'ing-lists)

Chu-tzŭ 竹子, 73

Chu-yüan 竹園, 21

Chü-jan 巨然, 4, 9, 37, 97, 174 (*cf.* Index in vol.II)

Ch'u (Hunan, Hupei) 楚, 96

Ch'u Sui-liang 稽遂良, 16

ch'uan-shên 傳神, 68

chuan-shu 篆書, seal characters, 197, 223

Chuang Chiung-shêng 莊冏生, 85 (see Ch'ing lists)

Chuang-tzŭ 莊子, 76

Chung-chao 仲詔, *t.* of Mi Wan-chung, 55

Chung-ch'u 仲初, *t.* of Wang Chien-chang, 49

Chung-fang 仲方, *t.* of Ku Chêng-i, 17

Chung Hsing 鍾惺, 3, 129 (see Ming lists)

Chung Hua Book Co. 中華書局, 6, 12, 163

Chung K'uei 鍾馗, the Demon Queller, 84 ff., 224

Chung-shu 仲書, *t.* of Ku Ming, 86

Chung-shun 仲醇, *t.* of Ch'ên Chi-ju, 11

Chung-sung 鍾松, *h.* of Hu Ching, 71

Chung-tuan 忠端, posthumous title of Huang Tao-chou, 51

Chung-t'ung 仲通, *t.* of Kuan Chiu-ssŭ, 35

Chung Yu 鍾繇, 48, 74

Ch'ung-chêng, Emperor 崇禎, 36

Chü-shan 巨山, *t.* of Li Wei-hsien, 119

Ch'ü-shan 瞿山, *h.* of Mei Ch'ing, 119

Chüeh-lang 覺浪, 143

chün (embarrassed) 窘, 193

Chün-kung 駿公, *t.* of Wu Wei-yeh, 112

Chün-shih 君實, *t.* of Li Jih-hua, 40

Chün-tu 君度, *t.* of Chang Hung, 30

Êrh-chan 二瞻, *t.* of Ch'a Shih-piao, 117

Êrh-shui 二水, *h.* of Chang Jui-t'u, 47

Fa Jo-chên 法若真, 121 (see Ch'ing lists)

Fan Ch'i 樊圻, 128 (see Ch'ing lists)

Fan K'uan 范寬, 58, 105, 174 (*cf.* Index in vol.II)

Fan-niu 飯牛, *t.* of Lo Mu, 125

Fang Ai-hsien 方艾賢, 98

Fang I-chih 方以智, 138 ff. (see Ch'ing lists)

Fang-lu 方魯, *t.* of Tsou Chê, 128

Fang Shih-shu 方士庶, 212 ff., 218 (see Ch'ing lists)

Fang Ta-yu 方大猷, 113 (see Ch'ing lists)

Fang Ts'ung-i 方從義, 38, 179

fei-pai 飛白, 197

Fei-tun lu collection, 肥遯廬, 147

Fêng bird 鳳, 15

fêng-ch'ang 奉常, 97, 201, 208

Fêng Chin-po 馮金伯, 142

Fêng-hsin mountain 奉新山, 149

Fêng-kang 鳳岡, *t.* of Kao Hsiang, 237

Fêng-o Mountain 鳳阿山, 186

Fo-yin 佛印, 63

fu 賦, 135, 141

Fu, Prince 福王, 51ff

Fu-ch'un shan-chü t'u 富春山居圖, 8, 178, 188, 204

Fukien, painters of, 51 ff.

Fu Pao-shih 傅抱石, 149, 158

Fu-po 浮白, *h.* of Pien Wên-yü, 33

Fu Shan 傅山, 138 ff. (see Ch'ing lists)

Fu-t'ang 復堂, *h.* of Li Shan, 237

Fu-ts'un 孚存, *t.* of Tung Pang-ta, 219

Fu Wên 傅雯, 224 (see Ch'ing lists)

Han-chang 漢章, *t.* of Li Shih-cho, 224

Han-ju 漢儒, *t.* of Fa Jo-chên, 121

Han Kan 韓幹, 239

Han-lin College 翰林院, 219 ff.

Han-shan 寒山 (Buddhist hermit), 19

Han T'an 韓菼, 177

Hang-chou 杭州, 26

Hao-hsiu 浩修, *t.* of Ts'ao P'ei-yüan, 202

Hao-shêng-kuan 毫生館, 60

Ho-chien 鶴澗, *h.* of Chang Hung, 30

Ho Kuan-wu collection, Hongkong, 140 (same as *T'ien-ch'i shu-wu ts'ang-hua*)

Ho-lin ssŭ 鶴林寺, 21

ho-shang 和尙, 156

Ho-ssŭ 何思, *t.* of Kuan Chiu-ssŭ, 35

Ho-yang 河陽, 113

Ho-ying-tzŭ 鶴影子, *h.* of Hsü I, 74

Hou-ming 後明, *h.* of Mo Shih-lung, 11

Hou Mou-kung 侯懋功, 3

Hou Shang-tso-shêng 後尙左生, *h.* of Kao Fêng-han, 238

Hsi-chiang school 西江派, 174

hsi-ching (short cut) 蹊徑, 15

Hsi-ching 西京, *t.* of Tung Kao, 220

Hsi-ch'ing ta-chien 西清大鑑, 219

Hsi-hu (West Lake) 西湖, 158

Hsi-san 希三, *t.* of Ch'ên Hsien, 68

Hsi-t'ang 西唐, *h.* of Kao Hsiang, 237

Hsi Tsung, Emperor 熹宗, 48

Hsi-yeh chü-shih 昔耶居士, *h.* of Chin Nung, 239

Hsi-yüan 西園, *t.* of Kao Fêng-han, 237

Hsia Ch'ang 夏昶, 58

Hsia Kuei, 14

Hsia-kung 治公, *t.* of Fan Ch'i, 128

Hsia Sên 夏森, *t.* Mao Lin, 76

Hsia-tsun-chê 瞎尊者, monk name of Tao-chi, 159

Hsia-tsun-chê chuan 瞎尊者傳, 157, 159

Hsiang-fu 祥符, 168

Hsiang-kuang mo-hsi 香光墨戲, 9

Hsiang-lan 湘蘭, *h.* of Ma Shou-chên, 71

Hsiang-lin 橡林, 74, 109

Hsiang-nan 湘南, *t.* of Chao Pei, 74

Hsiang-shan wêng 香山翁, *h.* of Yün Hsiang, 34

Hsiang Shêng-mo 項聖謨, 35 ff., 38 ff., 70, 231 (see Ming lists)

Hsiang-ts'ao-t'ang chi 香草堂集, 128

Hsiang-yen 香燕, 65

Hsiang Yüan-pien 項元汴, 38

Hsiao and Hsiang (rivers) 瀟湘, 9, 118

Hsiao Chao 蕭照, 178 (see index to Vol.II)

Hsiao-shih tao-jên 小獅道人, *h.* of Fang Shih-shu, 218

Hsiao-shu 孝叙, 72

Hsiao Yün-ts'ung 蕭雲從, 114 ff. (see Ch'ing lists)

Hsieh Ho 謝赫, 44

Hsieh Hsüan 謝玄, 61

hsieh-i 寫意, 30, 50, 140, 154, 169, 197

Hsieh-kung 歇公, *h.* of Hsü I, 74, 129

Hsieh Ling-yün 謝靈運, 177

Hsieh San-hsiu 謝三秀, 77

Hsieh Shih-ch'ên 謝時臣, 57

Hsieh Sun 謝蓀, 128 (see Ch'ing lists)

Hsieh Tao-ling 謝道齡, 77

Hsien-ch'ing 獻卿, *t.* of Hu ching, 71

Hsin-an, Masters of 新安, 114, 116, 173 ff.

Hsin-ch'u-chia-nu-chu-fan sêng 心出家盦粥飯僧, *h.* of Chin Nung, 239

Hsin-lo shan-jên 新羅山人, *h.* of Hua Yen, 237 ff., 247

Hsing-i 行一, 76

hsing-shu 行書, 4, 52, 55, 56, 170

Hsing T'ung 邢侗, 55

hsiu-ts'ai (degree) 秀才, 11

Hsiu-wên 休文, *t.* of Kuei ch'ang-shih, 74

Hsiung-nu 匈奴, 21

Hsü Ch'ung-ssŭ 徐崇嗣, 194, 197

Hsü Hsi 徐熙, 198

Hsü I 許儀, 70 (see Ming lists)

Hsü-po 盧白, *h.* of Kuan Chiu-ssŭ, 35

Hsü-shan-ch'iao 胥山樵, *h.* of Hsiang Shêng-mo, 38 ff

Hsü Tao-ning 許道寧, 56, 58, 178 (*cf.* Index in vol.II)

Hsü Tzŭ-shan 徐紫珊, 185

Hsü Wei 徐渭, 2, 43, 194

Hsüan-ch'êng 宣城, 119

Hsüan-tsai 玄宰, *t.* of Tung Ch'i-ch'ang, 4, 89

Hsüan Wên-chün 宣文君, 65

Hsüan-yüan 遁遠, *t.* of Fang Shih-shu, 218

Hsüeh-chiang t'u 雪江圖, 182

Hsüeh-chü 雪居, *h.* of Sun K'o-hung, 19

Hsüeh-ko 雪個, *h.* of Chu Ta, 149

Hsüeh-lao-jên 雪老人, 190

Hsüeh-lu 雪廬, *h.* of Mei Ch'ing, 119

Hsüeh Su-su 薛素素 (see Hsüeh Wu)

Hsüeh Wu 薛五, 70 ff. (see Ming lists)

Hsün-chih 遜之, *t.* of Wang Shih-min, 95

Hu Chêng-yen 胡正言, 75 ff. (see Ming lists)

Hu Ching 胡靖, 70, 71 (see Ming lists)

Hu Ts'ao 胡慥, 128 (see Ch'ing lists)

Hu Tsung-chih 胡宗智, 76

Hu Ying-lin 胡應麟, 72

Hu Yüeh-ts'ung 胡曰從 (see Hu Chêng-yen)

Hua-ch'an-shih sui-pi 畫禪室隨筆, 13

Hua-chih-ssŭ sêng 花之寺僧, *h.* of Lo P'ing, 237

Hua Chuang-yüan 畫狀元, 216

Hua-chung chiu-yu (The Nine Friends in Painting) 畫中九友, 46

Hua-ch'üan 畫筌, 124 ff.

Hua-chüeh 畫訣, 134

Hua-fa yao-lu 畫法要錄, 43

Hua-hsüeh hsin-yin 畫學心印, 13, 108, 177

Hua-kuang 華光, 241

Hua K'un 華鯤, 202

Hua-lun 畫論, 173

Hua-shih hui-yao 畫史會要, 18

Hua-shuo 畫說, 13

Hua-t'ing (Kiangsu) 華亭, 11, 19
Hua-t'ing school 華亭派, 17 ff.
Hua-yen 畫眼, 13
Hua Yen 華嵒, 235, 237 (see Ch'ing lists)
Hua-yin 畫引, text by Ku Ning-yüan, 5 ff.
Hua-yu lu 畫友錄, 21
Hua-yü-lu 畫語錄, 171
Hua-yüan 畫院, 82
Huai-su 懷素, 48
Huan-shan 環山, h. of Fang Shih-shu, 218
Huang Ch'üan 黃筌, 198
Huang Ho-ch'ing 黃河清, 75
Huang I-pin 黃一彬, 75
Huang Ju-yüeh 黃汝耀, 75
Huang Kung-wang 黃公望, 4, 6, 10, 35, 37, 45 ff., 96 ff.
Huang Lin 黃鏻, 75
Huang-po sect 黃檗宗, 68
Huang-shan 黃山, 52, 158, 163, 220
Huang-shan hsüeh-lao-jên 黃山雪老人, 190
Huang Shên 黃慎, 235, 237 (see Ch'ing lists)
Huang-shih 黃石, h. of Fa Jo-chên, 121
Huang Tao-chou 黃道周, 47, 51 ff., 70 (see Ming lists)
Huang-ti 黃帝, 157 ff.
Huang Ting 黃鼎, 212 (see Ch'ing lists)
Huang T'ing-chien 黃庭堅, 41
Huang-ts'un 篁村, h. of Chang Tsung-ts'ang, 217
Huang Tzŭ-li 黃子立, 75
Huang Ying-shên 黃應諶, 86 (see Ch'ing lists)
Huang Yüan-chi 黃元吉, 75
Hui-ch'ih 悔遲, h. of Ch'ên Hung-shou, 63
Hui-chou 徽州, 163
Hui-ch'ung 惠崇, 98, 109 (see Index in vol.II)
Hui-hua kuan, Peking 繪畫館, 18, 112
Hui-kung 會公, t. of Fan Ch'i, 128
Hui-shih fa-wei 繪事發微, 216
hun-lun 混淪, 205
Hung-chih 弘智, monastic name of Fang I-chih, 138
Hung-jên 弘仁, 114, 115, 147 (see Ch'ing lists)
Hung-pao 鴻寶, h. of Ni Yüan-lu, 52
Hung Wu 弘旿, 222 (see Ch'ing lists)

i, all-pervading unity 一, 172
i (spontaneity) 逸, 27, 140
I-an 易菴, h. of Hsiang Shêng-mo, 38
I-ching 易經, 51

I-fêng 一峯, 9
I-hua 一畫, 170
I-kung 頤公, t. of Pien Shou-min, 237
i-p'in 逸品, 111, 117, 134, 140
I Ping-shou 伊秉綬, 237 (see Ch'ing lists)

Jên-wu 人屋, h. of Chu Ta, 149
Jih-ch'u 日初, t. of Wang Yü, 202, 213
Jih-kuan 日觀, 249 (cf. Index in vol.II)
Jih-wei 日爲, t. of Lu Wei, 126
Ju-i kuan 如意館, 220
Jui, Prince (Durgan) 睿親王, 79
Jun-ch'ing 潤卿, t. of Hsüeh Wu, 72
Jun-chou 潤州, 124
Jun-fu 潤甫, t. of Pien Wên-yü, 33
Jun-niang 潤娘, h. of Hsüeh Wu, 72
Jung-mu 榮木, t. of Yeh Hsin, 128

k'ai-ho 開合, 209
k'ai-shu 楷書, 4, 56
K'ai-t'ing 凱亭, h. of Fu Wên, 224
K'ang Hsi, Emperor 康熙, 79 ff., 82 ff., 173 ff.
Kao Ch'i-p'ei 高其佩, 84, 212, 222 (see Ch'ing lists)
Kao Fêng-han 高鳳翰, 235, 237 ff. (see Ch'ing lists)
Kao Fu 高阜, 130
Kao Hsiang 高翔, 237 (see Ch'ing lists)
Kao K'o-kung 高克恭, 6, 12, 38, 61, 99, 179, 206
Kao Shih-ch'i 高士奇, 65
Kao Ts'ên 高岑, 128-9 (see Ch'ing lists)
Kao Yang 高陽, 70, 76, 77 (see Ming lists)
Kao Yu 高友, 76
kao-yüan 高遠, 134
Kêng-chih t'u 耕織圖, 90
Kêng-tzŭ shu-hua p'ing 庚子書畫評, 101
Kêng-yen Cottage 耕煙閣, 179
Kêng-yen wai-shih 耕煙外史, h. of Wang Hui, 175
Kiangsi 江西, 123 ff.
Kiangsu 江蘇, 123 ff.
Ko Chêng-ch'i 葛徵奇, 35, 40 (see Ming lists)
Ko-shan-lü 個山驢, h. of Chu Ta, 149
Ko-wêng 葛翁, 165
k'o (carving) 刻, 27
K'o Chiu-ssŭ 柯九思, 154
k'o-hua 刻畫, 15, 44, 198
K'o-jou 克柔, t. of Chêng Hsieh, 237
K'o ta 克大, 204

K'o-t'ing 恪庭, *t.* of Shên Tsung-ching, 126

Kou-ch'ü shan 句曲山, 31

Kou tao-jên 垢道人, *h.* of Ch'êng Sui, 121

Ku-chai 穀齋, *h.* of Li Shih-cho, 224

Ku Chêng-i 顧正誼, 14, 17 ff. (see Ming lists)

Ku Chien-lung 顧見龍, 86 (see Ch'ing lists)

Ku Ch'ing-ên 顧慶恩, 3

Ku-ch'üan 古泉, *h.* of Chin Nung, 237

Ku Fu-chên 顧符稹, 94 (see Ch'ing lists)

Ku K'ai-chih 顧愷之, 174 (see Index in vol.II)

Ku-kung collection 故宮, 18, 23 ff., 27 ff., 71 ff., 84 ff., 188

Ku Ming 顧銘, 86 ff.

Ku Ning-yüan 顧凝遠, 3, 14, 35 ff., 42 (see Ming lists)

Ku Ping 顧炳, 75 (see Ming lists)

Ku-shan pei-tzǔ 固山貝子 (see Hung Wu), 222

Ku Ta-shên 顧大申, 113

Ku-yü 古愚, *h.* of Chang Ku, 127

K'u-kua ho-shang 苦瓜和尚, *h.* of Tao-chi, 159

Kua-ch'ou 瓜疇, *h.* of Shao Mi, 32

Kuan Chiu-ssü 關九思, 35 ff. (see Ming lists)

Kuan-hsiu 貫休, 59

Kuan Mien-chün collection, Shanghai 關冕鈞, 64

Kuan Ssü 關思 (*cf.* Kuan Chiu-ssü)

Kuan Tao-shêng 管道昇, 69

Kuan T'ung 關仝, 9, 42, 56 ff., 93 (*cf.* Index in vol.II)

kuan-yao 官窯, 13

Kuan-yin 觀音, 23 ff.

K'uang-t'ing 曠亭, *h.* of Huang Ting, 212

Kuei, Prince 桂王, 82

Kuei Ch'ang-shih 歸昌世, 70, 74 (see Ming lists)

Kuei-ch'ü-lai 歸去來, 65

Kuei-yü wên-ch'ao 歸愚文鈔, 212

Kuei-yün lao-jên 歸雲老人, *h.* of Kao Fêng-han, 237

k'un 坤, 172

K'un-ts'an 髡殘, 111, 112, 138, 142 ff. (see Ch'ing lists)

Kung, Prince 恭親王, 101

kung-fêng 供奉, 63, 82, 91

Kung Hsien 龔賢, 111, 128 (see Ch'ing lists)

Kung-mou 恭懋, *t.* of Huang Shên, 237

Kung Pên-ang 宮本昂, 50

kung-pi 工筆, 31, 49, 51, 60, 62, 115

K'ung-chang 孔彰, *t.* of Hsiang Shêng-mo, 38 ff., 71 ff.

K'ung-chang 孔彰, *t.* of Ch'ên Chia-yen, 70

K'ung Sung 孔嵩, 77

K'ung Tung-t'ang 孔東塘, 128

Kuo-ch'ao hua-chêng lu 國朝畫徵錄, 30, 36, 39, 57, 63, 67, 84 ff., 96

Kuo-ch'ao hua-shih 國朝畫史, 85 ff., 101, 119, 132, 142, 177

Kuo-ch'ao yüan-hua lu 國朝院畫錄, 82-3

Kuo Chung-shu 郭忠恕, 6, 115, 154, 178 (*cf.* Index in vol.II)

Kuo Hsi 郭熙, 38, 93, 124

Kuo Pi 郭畀, 206

lan-hua 蘭畫, 93

Lan Ying 藍瑛, 26, 35 ff., 173 (see Ming lists)

Lang Chang-jên 浪杖人, 144

Lao-ch'ü fan-fu 老瞿凡父, *h.* of Mei Ch'ing, 119

Lao-lien 老蓮, *h.* of Ch'ên Hung-shou, 63

Lao-ting 老丁, *h.* of Chin Nung, 237

Lêng Mei 冷枚, 86, 91 (see Ch'ing lists)

Li Chao-tao 李昭道, 133 (*cf.* Index in vol.II)

Li Ch'êng 李成, 6, 10, 96, 174 (*cf.* Index in vol.II)

Li Fang-ying 李方膺, 235, 237 (see Ch'ing lists)

Li Ho 李賀, 42

Li Jih-hua 李日華, 14, 35 ff., 40, 42, 65

Li Kung-lin 李公麟, 62, 64, 92 (*cf.* Index in vol.II)

Li Liu-fang 李流芳, 3, 34, 45, 50 (see Ming lists)

Li Lung-mien 李龍眠, 6, 59, 178

Li Ma-tou 利瑪竇 (see Ricci, Matteo)

Li Po 李白, 247

Li-pu 吏部, 4

Li Sao 離騷, 114

Li Shan 李鱓, 235, 237, 245 (see Ch'ing lists)

Li-shang 荔裳, *t.* of Sung Wan, 93

Li Shih-cho 李世倬, 84, 212, 234 (see Ch'ing lists)

Li Shih-ta 李士達, 26 ff. (see Ming lists)

li-shu 隸書, 96, 127, 169, 170

Li Sung-an 李松庵, 156

Li Ssǔ-hsün 李思訓, 14, 61, 175 (*cf.* Index in vol.II)

Li-tai ming-jên hua-p'u 歷代名人畫譜, 75

Li T'ang 李唐, 36

Li Tou 李斗, Author of *Yang-chou hua-fang lu* 揚州畫舫錄, 158

Li Tzǔ-ch'êng 李自成, 52, 79 ff.

Li Wei-hsien 李為憲, 202

Li Yü 李漁, 136

Li-yüan 櫟園, *h.* of Chou Liang-kung, 144

Liang-fêng 兩峯, *h.* of Lo P'ing, 237

Liang K'ai 梁楷, 239

Liao-fa 了法, 172

Lieh-ch'ao Shih-chi 列朝詩集, 46

Lien-chou 廉州, *h.* of Wang Chien, 104-5

Lien Ch'üan collection (Hangchou) 廉泉, 50

Lin-chi 臨濟, 14

Lin Lang-an 林朗庵, modern collector, 166

Lin Liang 林良, 57, 194

Lin T'ai-hêng 林台衡, 74 (see Ming lists)

Ling-ching 靈境, 33

Ling-nan school 嶺南派, 70

Ling-yen ssŭ 靈巖寺, 143

Ling Yün-han 凌雲翰, 76

Liu 劉, Family name of K'un-ts'an, 138

Liu-ch'i wai-chuan 留溪外傳, 157

Liu-ch'iu (islands) 琉球, 71

Liu Chüeh 劉珏, 3

Liu Hai-su 劉海粟, 8

Liu Kuan-tao 劉貫道, 72

Liu Sung-nien 劉松年, 15, 178

Liu Tsung-yüan 柳宗元, 11

Liu-yen-chai pi-chi 六研齋筆記, 40, 65

Liu Yü-hsi 劉禹錫, 86

Liu Yüan 劉源, 86 (see Ch'ing lists)

Lo Chên-yü collection 羅振玉, 162

Lo Chia-lun collection 羅家倫, Taipeh, 133

lo-han 羅漢, 59

Lo Liang-fêng 羅兩峯 (see Lo P'ing)

Lo Mu 羅牧, 125, 173 (see Ch'ing lists)

Lo P'ing 羅聘, 235, 237 (see Ch'ing lists)

Lou Ch'ou 樓璹, 91

Lou Kuan 樓觀, 173

Lou-kuan 婁關, 143a

Lou-tung 婁東, 184

Lou-tung school 婁東派, 109, 212

Lu-ch'ai 鹿柴, *h.* of Wang Kai, 135

Lu-ch'i 鹿起, *h.* of Fang I-chih 138

Lu Chih 陸治, 3, 64, 76

Lu-ch'ih 陸癡 (see Lu Wei), 126

Lu Hung-i 盧鴻一, 178

Lu Kuang 陸廣, 196 (see Yüan lists)

Lu-shan 廬山, 50, 163, 220

Lu Tai 魯岱, 155

Lu-t'ai 麓臺, *h.* of Wang Yüan-ch'i, 207

Lu-t'ai t'i-hua kao 麓臺題畫稿, 206

Lu T'an-wei 陸探微, 66 ff, 174 (see Index in vol. II)

Lu Wei 陸㬇, 128 (see Ch'ing lists)

luan (bird) 鸞, 15

Lun-yü 論語, 172

lung-mo 龍脉, 209

Lung-shan 龍山, 14

Lung-yu 龍友, *t.* of Yang Wên-ts'ung, 53

Lü Chi 呂紀, 77

Lü Huan-ch'êng 呂煥成, 126 (see Ch'ing lists)

Lü-wu-lü 驢屋驢, *h.* of Chu Ta, 149

Ma-chü 駒馬, 14

Ma Ku 麻姑, 62

Ma Shou-chên 馬守貞, 70, 71 (see Ming lists)

Ma Yüan 馬遠, 12, 16, 44, 153

Ma Yüan 馬琬, 14

Mang K'u-li 莽鵠立, 67 ff., 87

Mao-ching 茂京, *t.* of Wang Yüan-ch'i, 201

Mao-lin 茂林, *t.* of Hsia Sên, 76

Mao-shan 茅山, 31, 123

Mei-ch'ih 梅癡, *h.* of Mei Ch'ing, 119

Mei Ch'ing 梅清, 114, 118 ff., 158 (see Ch'ing lists)

Mei-ho 梅壑, *h.* of Ch'a Shih-piao, 117

mei-hua 梅花, 73

Mei-hua ku-na 梅花古衲, *h.* of Hung-jên, 116

Mei-kung 眉公, *h.* of Ch'ên Chi-ju, 11

Mei-shu ts'ung-shu 美術叢書, 13

Mei-ts'un 梅邨, *h.* of Wu Wei-yeh, 112

Mêng Ch'ang-chün 孟嘗君, 160

Mêng-yang 孟陽, *t.* of Ch'êng chia-sui, 45

Mêng Yung-kuang 孟永光, 85 ff. (see Ch'ing lists)

Mi-chih 密之, *h.* of Fang I-chih, 138

Mi Fei (Fu) 米芾, 5, 6, 37, 41, 55 (*cf.* Index in vol.II)

Mi Wan-chung 米萬鍾, 54 ff. (see Ming lists)

Mi Yu-jên 米友仁, 6, 9, 61 (see Index in vol.II)

miao-p'in 妙品, 30, 126

Min (Fukien) 閩, 96

Min Yü-ching 閔玉井, 218

Ming-chih 明之, *t.* of Sung Mou-chin, 22

Ming-hua lu 明畫錄, 22, 29, 61, 66, 71 ff.

Ming Shih 明史, 3, 5, 52 ff.

Mo-ching hua-po 墨井畫跋, 188

Mo-ching tao-jên 墨井道人, *h.* of Wu Li, 184 ff.

Mo-chuang 默莊, *h.* of T'ang-tai, 215

mo-hsi, cf. hsi-mo 墨戲, 9

mo-ku 沒骨, 74, 129,197 (see Index in vol.II)

Mo-kung 默公, 187

Mo Shih-lung 莫是龍, 2, 3, 5, 10 ff. (see Ming lists)

Mo-ts'un 默存, *t.* of Chang Tsung-ts'ang, 217

Mu-an (Mokuan) 木菴, 68

Mu-ch'i 牧谿, 148, 239 (*cf.* Index in vol.II)

Mu-ch'ien 穆倩, *t.* of Ch'êng Sui, 121

mu-tan (tree peonies) 牡丹, 198

Nan-Ch'ang 南昌, 90, 125

Nan-chi 南季, *t.* of Shên Tsung-ching, 126

Nan-hua 南華, *h.* of Chang P'êng-ch'ing, 218

Nanking 南京, 128

Nan-t'ien 南田, *h.* of Yün Shou-p'ing, 193

Nan-tsun 南邨, *h.* of Kao Fêng-han, 237

Nan-yü 南羽, *t.* of Ting Yün-p'êng, 59

Nan-yüeh 南越, 160

nêng-p'in 能品, 66–7, 184

Ni-an 霓菴, *h.* of Shih Sê, 84

Ni-ku lu 妮古錄, 13

Ni Tsan 倪瓚, 4, 6, 35, 45, 99 (see Yüan lists)

Ni Ying 倪瑛, 76, 77

Ni Yüan-lu 倪元璐, 47 ff., 51 ff., 70 (see Ming lists)

Nien-an 念菴, *h.* of Shêng Mao-hua, 28

Nien-shao 年少, *t.* of Wan Shou-ch'i, 66

Ning-tu 寧都, 125

nun (timidity) 嫩, 27

Nü Fan 女範, 75

Ou-hsiang kuan 甌香館, 193

Ou-hsiang kuan hua-po 甌香館畫跋, 201

Ou-yang Hsiu 歐陽修, 248

pa-fên 八分, 96, 127, 164, 170

Pa-ta shan-jên 八大山人, *h.* of Chu Ta, 2, 38, 138, 145, 149 ff.

pai-miao 白描, 59, 60, 61, 66, 86, 102

Pai-sha tao-jên 白沙道人, *h.* of Hua Yen, 237

pan (stiffness) 板, 27

Pan-ch'iao 板橋, *h.* of Chêng Hsieh, 237

Pan-ch'ien 半千, *t.* of Kung Hsien, 128

Pan-t'ing *h.* of Kao Fêng-han, 237

Pan-yüan 半園, 190

P'ang Lai-ch'ên collection 龐萊臣, 100

P'ang Yüan-chi collection 龐元濟, 113

Pao-ên ssŭ 報恩寺, 143 ff.

Pao-kuo ssŭ 報國寺, 52

Pao Nai-an collection 鮑耐菴, 66

Pao-yen-t'ang pi-chi 寶顏堂秘笈, 13

Pei-hai 北海, *h.* of Ts'ui Tzŭ-chung, 60

P'ei-wên-chai shu-hua p'u 佩文齋書畫譜, 39, 52

Pên-ch'u 本初, *t.* of Yün Hsiang, 34

Pi-lo ts'ao-t'ang 薜蘿草堂, 130

Pi-shui 碧水, *h.* of Ch'ên Hsien, 68

Pi-tien chu-lin 秘殿珠林, 219 ff.

pien-hua (transformations) 變化, 198

Pien Shou-min 邊壽民, 237 (see Ch'ing lists)

Pien Wei-ch'i 邊維騏 (see Pien Shou-min)

Pien Wên-chin 邊文進, 77

Pien Wên-yü 卞文瑜, 26 ff., 34, 45 (see Ch'ing lists)

p'ing-yüan 平遠, 134

Po Êrh-tu 博爾都, 158

Po-hao-an 白毫菴, 47

Po-hsüeh hung-tz'u 博學鴻詞, 121

Po-min 白民, *t.* of Chu Lu, 74

Po-shih 白室, *h.* of Ch'ên Lo, 28

Po-wên 伯文, *t.* of Wan Kuo-chên, 70

Po-yün wai-shih 白雲外史, *h.* of Yün Shou-p'ing, 193

p'o 坡, 134

P'o-ch'ên 波臣, *t.* of Tsêng Ch'ing, 66

p'o-mo 潑墨, 9, 38, 236

P'u-an wên-ch'ao 樸菴文鈔, 185

San-chia an 三家菴, 144

Sao-yeh lou 掃葉樓, 132

Sê-ju 瑟如, *t.* of Ku Fu-chên, 94

Sê-lu 嗇廬, *h.* of Fu Shan, 139

Sêng-mi 僧彌, *t.* of Shao Mi, 32

Shan-hai ching 山海經, 143

Shan-hai kuan 山海關, 79

shan-jên 山人, 177, 246

Shan-lin wai-shih 山林外史, *h.* of Kao Hsiang, 237

Shan-shui ch'ing-hui 山水清暉, 177

Shan-ts'ai 善才, 190

Shantung 山東, passim

Shang-chi 上吉 or 尚吉, *t.* of Yü Chih-ting, 91

Shang-lin 上林, passim

Shao Ch'ang-hêng 邵長蘅, 149 ff.

Shao Hou-fu collection 邵厚夫, 101

Shao Mi 邵彌, 26 ff., 32, 45, 67 (see Ming lists)

Shên, Prince 慎郡王 (see Yün Hsi) 222

Shên-chai 慎齋, *h.* of Yü Chih-ting, 91

Shên Chou 沈周, 2, 3, 11, 36, 76, 100

Shên Hsiang 沈襄, 77

Shên Hsin-yu 沈心友, 136

shên-i (spiritual and unrestrained) 神逸, 192

Shên I-tsai 沈伊在, 108, 177

Shên Shih 沈碩, 77

Shên Shih-ch'ung 沈士充, 17 ff., 22

Shên Tê-ch'ien 沈德潛, 212

Shên Tsun-tê 沈存德, 76, 77

Shên Tsung-ching 沈宗敬, 126 (see Ch'ing lists)

shên-yüan 深遠, 134

shên-yün 神韻, 20, 125

shêng (incompleteness) 生, 27

Shêng-chou tao-shih 昇州道士, *h.* of Chang Fêng, 140

Shêng-hua chü-shih 聖華居士, *h.* of Ting Yün-p'êng, 59

Shêng Mao-hua 盛茂燁, 26 ff.

Shêng Mao-yeh 盛茂曄, (*i.e.* Shêng Mao-hua)

shih 勢, 21

Shih-chai 石齋, *h.* of Huang Tao-chou, 51

Shih-ch'i 石溪, *t.* of K'un-ts'an, 111, 144 ff.

Shih-chou Island 十洲, 187

Shih-chu-chai shu-hua p'u 十竹齋書畫譜, 73 ff.

Shih-chü pao-chi 石渠寶笈, 219 ff.

Shih-fêng 獅峯, *h.* of Shên Tsung-ching, 126

Shih K'o-fa 史可法, 79 ff.

Shih-ku 石谷, *t.* of Wang Hui, 175

Shih-kung 石公, *t.* of Hu Ts'ao, 128

Shih Lü-êrh 施驢兒, 247 (see Shih Yüan)

Shih Sê 碩塞, 84 (see Ch'ing lists)

Shih Shang-po 施尚白, 139

Shih Shih-ch'i shih-chi hui-pien 釋石溪事蹟彙編, 142

shih-ta-fu 士大夫, gentlemen painters, 3, 14

Shih-tao-jên 石道人, *h.* of K'un-ts'an, 113a

Shih-t'ao 石濤, 2, 38, 119, 138 ff., 156 (*cf.* Tao-chi)

Shih-t'ao shang-jên nien-p'u 石濤上人年譜, 157

Shih-tê 拾得 (Buddhist hermit), 19

Shih-t'ou-t'o 石頭陀, *h.* of Lan Ying, 36

Shih Tsu 世祖, Emperor Shun Chih, 82 (see Ch'ing lists)

Shih-tzŭ-lin 獅子林, 117, 186

Shih Yüan 施原, 237 (see Ch'ing lists)

Shou-mên 壽門, *t.* of Chin Nung, 237

Shu-ching 書經, 51

Shu-fa 書筏, 124

Shu-hua chin-t'ang 書畫金湯, 13 ff.

Shu-hua shih 書畫史, 13

Shu-lo 叔裸, *t.* of Ch'ên-lo, 28

Shu-nien 書年, *h.* of Chu Ta, 149

Shui-hsing (the planet Mercury) 水星, 48

Shui-kung 帨公, 122

Shun Chih, Emperor 順治, 82, 84 ff. (*cf.* Shih Tsu)

shuo-fa 說法, 190

Ssŭ-nung 司農, *h.* of Chin Nung, 237

Ssŭ-po 思白, *h.* of Tŭng Ch'i-ch'ang, 4

Su-ch'ing 素卿, *t.* of Hsüeh Wu, 72

Su-chou 蘇州, 3, 25 ff.

Su Shih (Su Tung-p'o 蘇軾, 41, 63, 74, 118–9, 123, 169

Su-sung p'ai 蘇松派, 3, 17 ff.

Sui-shan-ch'iao 邃山樵, *h.* of Lu Wei, 126

Sun I, 孫逸, 114 (see Ch'ing lists)

Sun K'o-hung 孫克弘, 3, 17 ff., 76 (see Ming lists)

Sun Ta-kung 孫轄公, 23, 149

Sung-ch'ao 松巢, *h.* of Ku Fu-chên, 94

Sung-chiang 松江, 17, 25, 40, 173

Sung-chiang chih 松江志, 18, 20, 23

Sung Hsü 宋旭, 18 (see Ming lists)

Sung Lo 宋犖, 117, 126

Sung Mou-chin 宋懋晉, 20 (see Ming lists)

Sung Wan 宋琬 (荔裳), 清 dynasty man, 93

Sung-yüan 松園, *h.* of Ch'êng Chia-sui, 45

Ta-fêng 大風, *t.* of Chang Fêng, 140

Ta-shih 大士 (*i.e.* Kuan-yin), 59

Ta-ti-tzŭ 大滌子, *h.* of Tao-chi, 159

tai-chao 待詔, 63, 82

Tai Chin 戴進, 36, 68

Tai Ming-shuo 戴明說, 54 ff., 84, 85 (see Ch'ing lists)

t'ai-ch'ang 太常, 96, 97

T'ai-hang shan 太行山, 124, 157

T'ai-hsüan 太玄, *h.* of Ch'ên Hsian, 68

T'ai-hu rock 太湖石, 52, 53, 91

T'ai-ts'ang school 太倉派, 95, 109

T'ai Tsung, Emperor 太宗, 79

Tan-an 淡菴, *h.* of Chuang Chiung-shêng, 85

Tan Chung-kuang 笪重光, 123 ff., 127, 179 (see Ch'ing lists)

Tan-kung 澹公, 151

T'ien-jang 蒐壤, *h.* of K'un-ts'an, 138, 142 ff.

Tan-ssŭ 丹思, *t.* of Wang Ching-ming, 202

Tan-t'ai 丹臺, 61

T'an Chih-i 譚志伊, 3

Tʻan-yüan 檀園, h. of Li Liu-fang, 46

Tʻan Yüan-chʻun 譚元春, 129

Tʻang, Prince 唐王, 51 ff.

Tʻang-liu-ju hua-pʻu 唐六如畫譜, 75

Tʻang Pin 湯斌, 86

Tʻang-tai 唐岱, 86, 202, 212 (see Chʻing lists)

Tʻang Tsu-hsiang 湯祖祥, 86

Tʻang Yin 唐寅, 3, 11, 64, 66, 75–6, 196

Tao-chʻang 道塲, 190

Tao-chi 道濟, 156 (see Shih-tʻao) (see Chʻing lists)

Tao-fu 道復, 54

Tao-hsin 道昕, 130

Tao-mo 道默, t. of Tai Ming-shuo, 57

Tao-mu 道母, t. of Tsʻui Tzŭ-chung, 64

Tao-shêng 道生, original name of Yün Hsiang, 34

Tʻao Wang-ling 陶望齡, 4

Tʻao Yüan-ming 陶淵明, 65

Ti Pʻing-tzŭ collection 狄平子, 86

tʻi-pa 題跋, 97

Tiao Kuang-yin 刁光胤, 77 (*cf.* Index in vol.II)

Tʻieh-chʻin 鐵琴, t. of Chiang Chang, 247

Tʻien-fei 天飛 or 天扉, t. of Chang Pʻêng-chʻung, 218

Tʻien-shu 田叔, t. of Lan Ying, 36

Tʻien-tʻai shan 天台山, 158

Ting-chiu 定九, t. of Chʻên Ting, 159

Ting Kao 丁皋, 137

ting-yen (ink) 頂烟, 201b

Ting Yün-pʻêng 丁雲鵬, 49, 59, 70, 73 (see Ming lists)

Tʻing-han 廷韓, t. of Mo Shih-lung, 11

Tʻing-lin 亭林, h. of Ku Chêng-i, 17

To-lo pʻo 墮騾坡, 12

Tsai-hsin 在辛, t. of Tan Chung-kuang, 123

Tsʻai-shih 采石, 114

Tsʻai Tao-hsien 蔡道憲, 69

Tsʻan-tao-jên 殘道人, h. of Kʻun-tsʻan, 144

tsʻang (vigour) 蒼, 27

Tsʻao Chih-po 曹知白, 6, 38, 45, 117, 179 (see Yüan lists)

Tsao Ku-an 曹顧菴, 110

Tsʻao Pa 曹霸, 159

Tsʻao Pʻei-yüan 曹培源, 202

tsʻao shu 草書, "grass characters", 52, 55, 56, 189, 223

Tsʻao Tsʻao 曹操, 21

Tsêng Chʻing 曾鯨, 66 ff. (see Ming lists)

Tsêng Shên 曾參, 60

Tso Ssŭ 左思, poet of the 3rd century A.D., 121

Tsou Chê 鄒喆, 128–9 (see Chʻing lists)

Tsou Ti-kuang 鄒迪光, 22 (see Ming lists)

Tsou Tien 鄒典, 129

Tsui-wêng-ting chi 醉翁亭記, 185

Tsui-yü 醉迂, h. of Hung Wu, 222

Tsʻui Tzŭ-chung 崔子忠, 63 (see Ming lists)

Tsun-ku 尊古, t. of Huang Ting, 202, 212

tsʻun-fa 皴法, 15, 16, 98

tsung-chiang 宗匠, professional artists, 3

Tsung-pʻan 宗盤, t. of Chʻien Wei-chʻêng, 220

Tsung-yang 宗揚, t. of Li Shan, 237

Tu Chün 杜濬, 111

Tu Fu 杜甫, 68

Tu-hua lu 讀畫錄, 129, 139, 142, 176

Tu-wang-kʻo 獨往客, h. of Huang Ting, 212

Tʻu-hui pao-chien 圖繪寶鑑, 35, 105

Tʻu-nan 圖南, h. of Chang Chʻung, 61

Tuan Fang collection 端方, 50

Tuan-jung 端容, t. of Chao Wên-shu, 73

Tuan-po 端伯, t. of Chʻêng Chêng-kʻuei, 110

Tun-fu 遯夫, t. of Lo Pʻing, 237

Tung Chʻi-chʻang 董其昌, 1 ff., 22, 39 ff., 45, 53, 89, 95 ff., 174, 206 (see Ming lists)

Tung-chuang 東莊, h. of Wang Yü, 213

Tung-chuang lun-hua 東莊論畫, 213

Tung-hai pu-i 東海布衣, h. of Huang Shên, 237

Tung-hsin 冬心, h. of Chin Nung, 237, 243

Tung-hsin hsien-shêng chu-mei-fo-ma tʻi 冬心先生竹梅佛馬題, 240 ff.

Tung-hsin hsien-shêng tʻi-chi 冬心先生題集, 240, 243

Tung-hsin hua-fo tʻi-chi 冬心畫佛題記, 240, 243

Tung-hsin shih-chʻao 冬心詩鈔, 240

Tung Kao 董誥, 220 ff. (see Chʻing lists)

Tung-lin Society 東林黨, 159

Tung Pang-ta 董邦達, 212 ff. (see Chʻing lists)

Tung-shan 東山, h. of Tung Pang-ta, 219

Tung-shê 東余, 12

Tung-tʻing Lake 涷庭湖, 157

Tung-tʻing island 洞庭, 92

Tung-yang 東陽, 68

Tung Yüan 董源, 4, 6 ff., 9 ff., 37, 97, 174 (*cf.* Index in vol.II)

Tʻung-ya 通雅, 139

Tʻung-yin lun-hua, 桐陰論畫, 33, 34, 36, 52, 54, 113, 121, 176

Tʻung Yü, 237

Tzŭ-chên 子眞, *t.* of Chang Ts'ai, 127

Tzŭ-chü 子居, *t.* of Shên Shih-ch'ung, 22

Tzŭ-hao 子鶴, *t.* of Chang Shêng, 127

Tzŭ-hsüan 紫玄, 35

Tzŭ-kan 子干, *t.* of Hua K'un, 202

Tzŭ-lai 紫來, *t.* of Fu Wên, 224

Tzŭ-shao 子詔, *t.* of Hsü I, 74

Tzŭ-ssŭ 組似, *t.* of I Ping-shou, 237

Tzŭ-t'ao-hsien tsa-chui 紫桃軒雜綴, 40

Tzŭ-yü 子羽, *t.* of Chang Ch'ung, 61

tz'ŭ 詞, 141

Tz'u-chih 慈治, 122

Wan Kang 萬岡, 237 (see Ch'ing lists)

Wan Kuo-chên 萬國楨, 70 (see Ming lists)

Wan Shou-ch'i 萬壽祺, 66 (see Ch'ing lists)

Wang Ch'i 王蓍, 26 ff. (see Ming lists)

Wang, C.C. collection, New York 王季銓, 165

Wang Chien 王鑑, 45, 95 ff., 164

Wang Chien-chang 王建章, 47, 49 (see Ming lists)

Wang Chih-jui 汪之瑞, 114, 119 (see Ch'ing lists)

Wang Chih-têng 王穉登, 29

Wang Chin-ch'ing 王晉卿, 15

Wang Ching-ming 王敬銘, 202 (see Ch'ing lists)

Wang-ch'uan 輞川, *t.* of Wan Kang, 237

Wang Fêng-ch'ang shu-hua t'i-po 王奉常書畫題跋, 98, 102

Wang Fu 王紱, 105, 179

Wang Hêng 王衡, 95

Wang Hsi-chih 王羲之, 48, 52, 74

Wang Hsi-chüeh 王錫爵, 95 ff.

Wang Hsia 王洽, 9, 15 ff. (*cf.* Index in vol.II)

Wang Hsiang-ch'üan collection 王湘泉, 153

Wang Hsien-chih 王獻之, 52 (*cf.* Index in vol.II)

Wang Hui 王翬, 8, 97, 102, 109, 175, 213 (see Ch'ing lists)

Wang I-shan 王巳山, Author of *Wên chi*, 246

Wang Kai 王概, 135 (see Ch'ing lists)

Wang Ku-hsiang 王穀祥, 3, 76, 231

Wang Mêng 王蒙, 4, 6, 37, 98, 189 ff. (see Yüan lists)

Wang San-tê 王三德, 75

Wang Shih 王蓍, 137

Wang Shih-chên 王世貞, 84, 213

Wang Shih-lu 王士祿, 84

Wang Shih-min 王時敏, 45, 67-8, 95 ff. (see Ch'ing lists)

Wang Shih-shên 汪士愼, 235, 237, 244 (see Ch'ing lists)

Wang Shih-yüan collection, 汪士元, 61

Wang To 王鐸, 54, 56 ff., 111, 129 (see Ming lists)

Wang Tsuan 王撰, 97 (see Ch'ing lists)

Wang Wei 王維, 6, 14, 174 ff. (*cf.* Index in vol.II)

Wang Wei-lieh 王維烈, 70 (see Ming lists)

Wang Wên 王問, 76

Wang Yü 王昱, 202, 212, 213 (see Ch'ing lists)

Wang Yüan 王淵, 156-7

Wang Yüan-ch'i 王原祁, 86 ff., 91, 97, 102, 109, 185, 200, 202, 213 (see Ch'ing lists)

Wang Yün 王雲, 86, 127 (see Ch'ing lists)

Wang Yün-an 王蘊菴, 135

Wei-chih 韋之, *t.* of Kao Ch'i-p'ei, 222

Wei Chih-huang 魏之璜, 73, 76 (see Ming lists)

Wei Chih-k'o 魏之克, 73, 76 (see Ming lists)

Wei Chung-hsien 魏忠賢, 4, 48

Wei K'o 魏克, 77

Wei-ning 未凝, *t.* of Wang San-tê, 75

Wei-shêng 蔚生, *t.* of Kao Ts'ên, 128

Wei-shui-hsien jih-chi 味水軒日記, 40

Wei Ta 韋達, Son of 宣文君

Wei Yen 韋偃, 242 (see Index in vol.II)

Wên-chêng 文正, posthumous title of Ni Yüan-lu, 52

Wên Chêng-ming 文徵明, 3, 5, 26, 30, 36, 39, 41, 73, 174, 238

Wên Chia 文嘉, 3, 30

Wên-chung 文中, *t.* of Wu Pin, 49

Wên-hsiu 文休, *t.* of Kuei Ch'ang-shih, 74

Wên I 溫儀, 185, 202

Wên-jên 文人, 22, 28

wên-jên hua 文人畫, 10, 14

Wên-k'o-kung 文恪公, posthumous title of Wu Na, 184

Wên-min 文敏 (Genius of Literature), posthumous title of Tung Ch'i-ch'ang, 5

Wên-pi 文璧, *t.* of Ma Yüan 馬琬, 17

Wên Pi 文璧, original name of Wên Chêng-ming, 208

Wên Po-jên 文伯仁, 3

wên-shih ming-chia 文士名家, 3

Wên Shu 文淑, 3, 30 (see Ming lists)

Wên-su kung 文肅公, posthumous title of Wang Hsi-chüeh, 95-6

Wên-t'ao 文濤, *t.* of Yüan Chiang, 93

Wên Ts'ung-chien 文從簡, 30, 73 (see Ming lists)

Wên-tu 文度, *t.* of Chao Tso, 20

Wên T'ung 文同, 74

Wu-school 吳派, 26 ff.

Wu Chên 吳鎮, 7, 37, 74 (see Yüan lists)

Wu Chên 吳振, 22 (see Ming lists)

Wu-ch'i 無奇, *t.* of Ko Chêng-ch'i, 40

Wu-ching 無競, *t.* of Wang Wei-lieh, 70

Wu Ch'ing-ch'ing 吳清卿, 178

Wu-chün tan-ch'ing chih 吳郡丹青志, 29, 72

Wu-hsien chih 吳縣志, 27 ff.

Wu Hung 吳宏, 128, 130 (see Ch'ing lists)

Wu-jui 無瑞, *t.* of Wang Chih-jui, 119

Wu-k'o 無可, *t,* of Fang I-chih, 138

Wu-liang-shou fo (title) 無量壽佛, 242

Wu Li 吳歷, 184 ff. (see Ch'ing lists)

Wu-lü 屋驢, *h.* of Chu Ta, 149

Wu Mei-ts'un wên-ch'i 吳梅邨文集, 96

Wu-mên tao-jên 無悶道人, *h.* of Hsiao Yün-ts'ung, 114

Wu Na 吳訥, 184

Wu Pin 吳彬, 47, 49, 51, 77 (see Ming lists)

Wu San-kuei 吳三桂, 79 ff.

Wu-shêng shih-shih 無聲詩史, 4, 19, 21, 27, 36, 45, 52 ff., 61 ff., 88 ff., 95 ff.

Wu Shih-kuan 吳士冠, 76 ff.

Wu Tao-tzŭ 吳道子, 14, 59, 64, 92, 174 (*cf.* Index in vol.II)

Wu Wei 吳偉, 68, 85

Wu Wei-yeh 吳偉業, 32, 45, 96, 105, 110, 112 ff., 187 (see Ch'ing lists)

ya (dumb) 啞, 150

Yang Chin 楊晉, 217 (see Ch'ing lists)

Yang-chou 揚州, 81

Yang-chou hua-yüan lu 揚州畫苑錄, 124b

Yang-chou pa-kuai 揚州八怪 (Eight Strange Masters of Yangchou), 236 ff.

Yang Pu-chih 楊補之, 241 (see Index in vol.II)

Yang-shan 陽山, 7

Yang Shêng 楊昇, 6, 20 (*cf.* Index in vol.II)

Yang Tz'ŭ-kung 楊次公, 77

Yang Wên-tsung 楊文驄, 45, 47, 51, 53 ff. (see Ming lists)

Yang Yin-pei collection (Peking) 楊蔭北, 187, 195

Yao-ti 藥地, *h.* of Fang I-chih, 138

Yao Wang 藥王, 249

Yeh Hêng-chai 葉恒齋, 101

Yeh Hsin 葉欣, 128 (see Ch'ing lists)

Yeh-so 野所, 148

Yen-k'o 煙客, *h.* of Wang Shih-min, 95

Yen-k'o 彥可, *t.* of Wên Ts'ung-chien, 30

Yen Li-pên, 61 (*cf.* Index in vol.II)

Yen-lo 嚴犖, *h.* of Tai Ming-shuo, 57

Yen-shih 硯史, 238

Yen-t'ien 硯田, *h.* of Wang Chien-chang, 49

Yen-tsai 言在, *t.* of Chang Ku, 127

Yen Wên-kuei 燕文貴, 6, 56, 58, 178 (*cf.* Index in vol.II)

yin-yang 陰陽, 172, 175

Yin-yüan 隱元, 68

Ying-p'iao 瘦瓢, *h.* of Huang Shên, 237

Ying Yü-chien 瑩玉澗, 148 (see Index in vol.II)

Yo Tai 岳岱, 3

Yu-ch'i shan 幽棲山, 143

Yu-hsin 又新, *t.* of Chou Tsu-hsin, 74

Yu-huai-t'ang wên-chi 有懷堂文集, 177

Yu-shih 友石, *h.* of Mi Wan-chung, 55

Yu-sui 由桜, ming of Pa-ta shan-jên, 149

Yu-yüan 幼元, *t.* of Huang Tao-chou, 51

Yüan-ch'ên 遠塵, 172

Yüan-chi 原濟, *i.e.* Tao-chi

Yung-hsing 永瑆, 222 (see Ch'ing lists)

Yung-jung 永瑢, 222 (see Ch'ing lists)

Yü, Prince 裕, see Shih Sê, 84

Yü Chih-ting 禹之鼎, 92 (see Ch'ing lists)

Yü Ch'iu-shêng 虞邱生, *t.* of Chang Yüan (張沅), 171

Yü-ch'uang man-pi 雨窗漫筆, 207

Yü-ju 玉汝, *t.* of Ni Yü'an-lu, 52

yü-lan (magnolia) 玉蘭, 198

Yü-shan 漁山, *t.* of Wu Li, 175, 184 ff.

Yü-shan school 虞山派, 109

Yü Shih-nan 虞世南, 16

Yü-ts'ung 玉驄, *t.* of Chuang Chiung-shêng, 85

Yü-tung 毓東, *t.* of T'ang-tai, 202, 215

Yüan (completeness) 圓, 27

Yüan-chao 圓照, *t.* of Wang Chien, 104

Yüan Chiang 袁江, 93 (see Ch'ing lists)

Yüan Chung-tao 袁中道, 4

Yüan-kung 淵公 or 遠公, *t.* of Mei Ch'ing, 119

Yüan T'ing 阮亭, 94

Yüan-tu 遠度, *t.* of Wu Hung, 128, 130

Yüan T'ung 元同, 142

Yüan Yao 袁耀 (see Ch'ing lists)

Yüeh (Chekiang) 越, 124

Yüeh-hsin 月心, *t.* of Mêng Yung-kuang, 85

Yüeh-ts'ung 曰從, *t.* of Hu Chêng-yen, 76, 77

yün 韻, 22, 27

Yün-an 雲菴, *h.* of Lo Mu, 125

Yün-ch'ao 雲巢, *h.* of Ku Fu-chên, 94

Yün-ch'êng 雲程, *t.* of Ku Chien-lung, 86

Yün-ch'i wai-shih 雲溪外史, *h.* of Yün Shou-p'ing, 193

Yün-chien (Sung-chiang) 雲間, 3, 22, 23, 54

Yün-chih 允執, *t.* of Sun K'o-hung, 19

Yün-ch'ing 雲卿, *t.* of Mo Shih-lung, 11

Yün-fêng 雲峯, 189

Yün Hsi 允禧, 222 (see Ch'ing lists)

Yün Hsiang 惲向, 26 ff., 34 ff., 113 (see Ming lists)

Yün Ko, 惲格, see Yün Shou-p'ing

Yün-lü 雲侶, *h.* of Kao Yang, 77

Yün-mên 雲門, 14

Yün Shou-p'ing 惲壽平, 71 ff., 124, 181, 192 (see Ch'ing lists)

Index to Japanese Names and Terms

Abe Collection (Ōsaka Museum), IV, 24, 94, 120, 153 ff., 200, 204, 220, 230; V, 20, 29, 34, 35, 52, 54, 120, 122–3, 141, 154, 165 ff., 223 ff.
Asano Collection, IV, 98

Bijutsu Kenkyū, IV, 19, 55

Chion-in (Kyōto), IV, 214
Chion-ji (Kyōto), IV, 13
Chō Densu, IV, 13

Daitoku-ji (Kyōto), IV, 11 ff.
Dharuma, V, 242

Fujii Collection (Kyōto), IV, 176–7, 216; V, 70

Gokoku-ji Collection, IV, 138

Hakone Museum, IV, 115
Hakubundō Co., Ōsaka, IV, 159
Hara, K, Collection, IV, 145–6
Harada, G., Collection, Ōsaka, IV, 155
Hashimoto Collection, Takatsuki, IV, 137; V, 50 ff., 112, 166 ff.
Hayashi Collection, IV, 152, 169
Hikkōen, IV, 25 ff.
Hiyoshi Collection, IV, 185
Honda Collection, Tōkyō, V, 118
Horikawa Collection, V, 56
Hōshaku-ji (Yamazaki Prov.), IV, 12

Ichinei (i.e. Issan), IV, 11
Inoue Collection, Tōkyō, IV, 116, 134, 226
Issan (priest), IV, 12
Iwasaki Collection, V, 37

Jurakusha, Tōkyō, V, 153 ff.

Kanayama Collection, Ettsu, V, 60
Kanō School of Painting, IV, 13, 141
Kanō Motonobu, IV, 13
Kanō Tanyū, IV, 13
Kawahara Collection, Kurume, IV, 165
Kawai Collection, Kyōto, IV, 190
Kawanishi Collection, IV, 25–6
Kawasaki Collection, IV, 13
Kennin-ji (Kyōto), IV, 12; V, 29
Kikuchi Collection, Tōkyō, IV, 230; V, 45, 190
Kitano Collection, Kyōto, V, 243
Kokka, IV, 12, 28 ff., 50, 115, 119, 137, 139, 159 ff., 187, 215; V, 22, 37, 70, 85, 112, 162
Konchi-in (Kyōto), IV, 56
Kundaikan Sayūchōki, IV, 50, 56, 99
Kurokawa Institute, Ashiya, V, 21
Kuwana Collection, Kyōto, V, 37 ff., 119, 128, 238
Kyōto Museum, IV, 16, 137

Maeda Collection, Tōkyō, IV, 138
Magoshi Collection, IV, 28
Mampuku-ji, Uji, V, 70
Maruyama Collection (Ōsaka), IV, 12; V, 133
Masaki Collection, Tōkyō, V, 111
Matsudaira Collection, IV, 141
Matsui, T., Collection, V, 188
Morita Collection, Owari, V, 139
Moriya, Dr. T., IV, 24
Motoyama Collection, IV, 126, 176
Murayama Collection, IV, 33
Mutō Collection, IV, 98

Nagao Collection, Aki, V, 246
Nakamura Collection, Owari, V, 128
Nanzen-ji, Kyōto, IV, 139, 184; V, 70
Nezu Collection (Tōkyō), IV, 32, 35; V, 35
Nishi Hongan-ji (Kyōto), IV, 25

Obata Collection, Tōkyō, IV, 227
Ogawa Collection, Kyōto, IV, 116; V, 196
Ōmura, V, 7, 102 ff., 141, 178 ff., 218 ff.
Osen Keishan, IV, 19
Ōtsuki Collection, V, 28

Prince Matsukata, Tōkyō, IV, 19
Prince Sanjō Collection, V, 37

Ryūko-in (Daitoku-ji, Kyōto), IV, 12

Saitō Collection, IV, 55, 153, 178, 213; V, 37, 39, 108,
 126, 188, 202, 246
Sakuragi Collection, V, 166, 167
Sawahara, S., Collection, V, 118
Seikadō (Iwasaki) Collection, IV, 35, 165 ff.; V, 22,
 28 ff., 70
Seiryō-ji (Kyōto), IV, 12
Sesshū, IV, 55, 116
Shimada, Dr., IV, 55
Shimbi Shōin, V, 50
Shinosaki Collection, Tōkyō, IV, 136; V, 38, 51
Sho, Marquis, Collection, V, 128
Shōman Ryudō Gekiseki, V, 50
Sogawa Collection, Takamatsu, V, 34

Sokoku-ji (Yamato), IV, 141
Sōraikan, V, 165, 186
Soyeshima Collection, V, 72
Sumitomo Collection (Ōiso), IV, 55, 114, 229, 230;
 V, 29, 49, 117, 145, 153, 160, 165 ff.

Takamatsu Collection, V, 74
Takami Collection, Nagasaki, V, 70
Takashima Collection, Kugenuma, IV, 229; V, 108,
 241, 246
Tanaka, Viscount M., IV, 120
Tani Shinichi, IV, 19
Tokaian Collection (Kyōto), IV, 12
Tōkyō Art Academy, IV, 35
Tomioka Collection, V, 39
Tomita, K., IV, 166; V, 157, 169
Tōyō Bijutsu Taikan, IV, 13

Ueno Collection, IV, 65, 179, 197; V, 98 ff., 186 ff., 205
Uji, V, 70

Wakimoto, S., IV, 55

Yamaguchi Collection, Ashiya, IV, 184; V, 243, 249
Yamamoto, T., Collection (TōkyX), IV, 71, 92, 119,
 176 ff., 197, 204; V, 37, 106, 147, 178 ff.
Yamanouchi, Visc., Collection, V, 51
Yonezawa, Y., IV, 115; V, 47
Yōtoku-in (Daitoku-ji), IV, 35
Yūrinkan (Kyōto), IV, 76, 193; V, 133

Index to Western Names and Terms

Académiciens, Les, V, 235
Academy of Painting (Hua-yüan), IV, 111 ff., 128, 134 ff., 140; V, 82
Acunha, Portuguese name of Wu Li, V, 186
Amida Buddha, V, 147
Amoy, IV, 106
Arhats, IV, 11 ff., 35, 204; V, 51, 69, 242, 249
Ars Asiatica, V, 224
Art Institute, Chicago, IV, 88 122–3, 137–8

Bachhofer, L., IV, 8
Backhouse, E., V, 79
Bamboo-painting, IV, 17, 22 ff., 38, 39 ff., 120 ff., 183 ff.; V, 57, 74, 136, 241, 245
Berlin Museum (Museum of Far Eastern Art, Berlin), IV, 123, 136, 140; V, 129, 218
Bird and flower-painting, V, 75 ff.
Bland, V, 79
Blue and green manner of landscape-painting, IV, 31
Bodhidharma, V, 12, 84, 242
Bodhisattvas, IV, 15; V, 69, 242
Boneless manner, V, 20
Boston Museum (Museum of Fine Arts, Boston, Mass.), IV, 12, 15, 16, 26, 36, 37, 94, 136, 143, 144, 166, 200, 206, 214, 215, 216; V, 9, 23, 28, 37, 47, 86, 167, 169
Boundary-painting, cf. chieh-hua
British Museum, IV, 19, 113, 160, 175; V, 66, 92, 93
Buck, Pearl S., IV, 10
Burmese, V, 81
Cahill, J., Collection, Washington, IV, 170; V, 21
Calligraphy, V, 5, 170
Caro, Frank (New York), see Loo, C. T. Successor, IV, 25; V, 133
Cézanne, P., V, 155, 206
Chicago Art Institute, IV, 177, 210, 214, 220
Christian Mission, IV, 5 ff.

Cincinnati Art Museum, IV, 32, 49, 90–1
Cleveland Museum, IV, 145; V, 154, 160, 224
Confucian scholars, IV, 106 ff.
Confucius, IV, 47, 107–8; V, 172
Contag, Victoria, V, 99, 149, 157, 159, 202
Couplet, P., V, 186

Deva, Buddhist heavenly being, IV, 16
Dragon-veins (lung-mo), IV, 90, 92, 154, 178; V, 207, 209 ff., 213, 216, 217–8
Dry brush, V, 7, 8, 21, 110
Dubosc, J. P., Lugano, IV, 153, 154, 161, 183 ff.; V, 11, 33, 64, 85, 100, 107, 112, 202, 205–6
Durgan, V, 79
Duyvendak, J. J. L., IV, 105

Ecke, G., V, 29
Edwards, R., IV, 33
Eight Masters of Nanking, V, 128 ff.
Eight Scholars of Wu-hsing, IV, 29
Eight Strange Masters of Yangchou (Yang-chou pa-kuai), V, 236 ff.
Eleuthes, V, 81
Epidendrum-paintings, V, 70 ff., 73 ff., 136, 161, 244
Ericson, E., Collection, New York, IV, 182, 184; V, 48 ff., 180
Eumorfopoulos Collection, British Museum, London, IV, 113
European influence, V, 174
Expressionism, IV, 53; V, 21, 121, 138, 155, 242, 243

Fan-paintings, IV, 192
Figure Painters, V, 59 ff.
Finger-painting, V, 223
Fitzgerald, V, 82

Flower-painting, V, 70, 193, 197 ff.
Fogg Museum, Cambridge, Mass., IV, 9, 33, 45, 121, 189, 226
Four Famous Talents of Suchou, IV, 173, 194
Four Masters of Chia-ting, V, 45
Four Worthies of Suchou (*Wu-mên ssŭ chieh*), IV, 93, 112
Franke, Herbert, V, 149, 150
Franke, Otto, V, 90
Freer Gallery, Washington, IV, 21, 25, 32, 35, 48, 50, 65, 76, 78, 94, 98, 100, 121, 123, 132, 139, 161, 191, 220, 222; V, 23, 62, 91, 92, 121, 178
Fresco, IV, 8
Fuller Art Museum, Seattle, V, 37

Giles, Herbert A., IV, 2, 3, 48; V, 43, 48
Goepper, Roger H., V, 216, 235
Goodrich, L. C., IV, 106
Gustaf VI Adolphus, King of Sweden, V, 9, 31, 34

Hariti, IV, 36, 37
Henke, F. G., IV, 109
Herron Art Museum, Indianapolis, IV, 197
Hobart Collection, Cambridge, Mass., V, 217, 224
Hochstadter, W. (New York), V, 8, 29, 64, 112, 133
Honolulu Academy of Arts, IV, 95, 183, 199; V, 60, 65, 72, 134
Hoyt Collection, Cambridge, IV, 221
Hummel, A. W., V, 48

Idea (*i*) writing (painting), IV, 50; V, 208
Impressionism, V, 117, 236
Independents, V, 235 ff.
India Antiqua, IV, 8 ff.
Indianapolis, Museum, V, 71
Individualists, V, 125, 140
Indra, V, 201
Ink-play, IV, 38, 46, 85, 94, 162, 211; V, 47, *cf. hsi-mo*
Intimist, V, 45 ff.

Jenghis Khan, IV, 1 ff.
Jenne, J., V, 89
Jesuit Missionaries, IV, 107 ff.; V, 95, 184 ff
Jesuit Order, V, 185
Juniper-trees, IV, 184 ff.
Jurchen, IV, 106

Karakorum, IV, 104
Khanbalic, IV, 2, 4 ff.
Kingfisher, V, 153
Kubilai Khan, IV, 2, 3 ff., 16, 18 ff.
Kurth, Julius, V, 136

Laufer, B., V, 88, 89
Lily Collection (Indianapolis), IV, 36, 45; V, 73
Lippe-Biesterfeld, E. A. Prinz zu, IV, 39; V, 131
London Exhibition, 1935-6, V, 141
Loo, C. T. (Paris), IV, 9, 14, 46; V, 9
Loo, C. T., Successor (New York), IV, 23, 82, 93, 120, 156, 159, 186, 197; V, 20
Lorrain, Claude, V, 168
Los Angeles County Museum, V, 115, 132
Lotus-flowers, V, 72
Lucalongo, Pietro da, IV, 4

Macao, IV, 106; V, 186, 191
MacGowan, V, 79
Mahāyāna Buddhism, IV, 14
Manchu Household Collection, IV, 36, 66, 76, 78, 81, 83, 223
Manet, E., V, 235
Mañjušrī, a Bodhisattva, IV, 15
March, B., IV, 144
Marco Polo, IV, 2, 3, 5 ff.
Matisse, H., V, 243
Mencius, V, 171, 172
Metropolitan Museum, New York, IV, 22, 31
Monte Corvino, Giovanni da, IV, 4
Monumenta Serica, V, 29
Moon-fairy, *see* Chang-o
Moule, A. C., IV, 3, 4
Mukden, V, 79, 222
Musée Guimet, Paris, IV, 176, 191, 233; V, 163, 213, 219, 224, 240
Museum für Ostasiatische Kunst, Köln, IV, 167; V, 224
Museum für Völkerkunde, Munich, V, 216

National Museum, Peking, IV, 36, 210; V, 86, 219 ff.
National Museum, Stockholm, IV, 10, 25, 119, 136 ff. 200, 206, 216, 230, 231; V, 20, 37 ff., 68, 72, 74 ff., 94, 102, 112, 116 ff., 131, 154, 162, 198, 247 ff.
National Museum, Tōkyō, IV, 116, 141, 142 ff.; V, 56, 179

Nelson Gallery, Kansas City, IV, 9 ff., 35, 44, 50, 76, 123, 154, 184, 216, 220; V, 60, 87, 92, 93

Nicolao, Giovanni, V, 89

Nine Friends in Painting, V, 32; cf. Hua-chung chiu-yu

Niva, Giacomo, V, 89

Northern School, V, 14, 173

Ogodai, IV, 1, 4

Old Masters, V, 10, 105, 199

Oriental Art, IV, 193, 195

Ostasiatische Zeitschrift, IV, 193; V, 186

Paine, Robert T., Jr., V, 75

Palace Museum, Peking, IV, 14, 19 ff., 50, 210; V, 164

Paradise of Maitreya (Toronto Museum), IV, 9

Pelliot, P., IV, 113; V, 88, 90

Petrucci, Raphael, V, 136

Philadelphia Museum, IV, 9 ff.

Piacentini Collection, Tōkyō, IV, 160, 174, 184; V, 120

Pine-trees, V, 52 ff., 120

Playing with ink, cf. hsi-mo, V, 9

Plum-blossoms, Paintings of, IV, 99 ff., 225 ff.; V, 137, 240

Pointillist manner, V, 31, 130

Pordenone, Odorigo da, IV, 5

Portrait-painting, V, 66 ff.

Portuguese Settlements in China, IV, 106

Princeton University Collection, V, 74

Printing in the Ming period, IV, 107

Prunelé, P. de, V, 186

Quails, V, 152

Realism, IV, 14–15, 52

Red Cliff, V, 118

Revue des Arts Asiatiques, IV, 9

Ricci, Matteo, IV, 107; V, 67, 88

Rococo style, V, 92

Rubrucke, William de, IV, 5

Šākyamuni Buddha, IV, 16; V, 242

Salon des Réfusés, V, 235

Samantabhadra, a Bodhisattva, IV, 15

Satin, V, 120

Seligman, Mrs B. Z., Collection, London, IV, 202

Shanghai Museum, IV, 45, 89, 145, 177, 203, 224 ff.; V, 244

Sickman, L., IV, 9

Signorelli, Lucca, IV, 10

Simon Xavier, Christian name of Wu Li, V, 186

Six Principles, V, 44, 177, 201, 208, 215

Société Anonyme des Artistes, V, 235

Société des Artistes Indépendants, V, 235

Southern School, IV, 53 ff., 70 ff., 148; V, 6, 14, 45, 95 ff., 174

Speiser, W., IV, 167, 193

St. Louis City Art Museum, IV, 123

Strange Masters of Yangchou, IV, 232

Tanguts, IV, 1

Taoism, V, 83, 123, 236

Taoist Figures, IV, 12 ff., 141, 210

Tejaprabha, a Bodhisattva, IV, 15

Temur Khan, cf. T'ai-ting

Ten Talents, IV, 93

Tibetans, V, 81

Toronto Museum, IV, 8 ff.

T'oung Pao, V, 89

Tului, IV, 1

Tura, Cosimo, IV, 10

Tushita Heaven, V, 190

University Museum (Philadelphia), IV, 9

Vajra, V, 201

Van Gogh, V., IV, 67

Vanotti, Dr. F., Collection, Lugano, IV, 161, 180 ff.; V, 112, 206

Verbiest, Ferdinand, V, 90

Vimalakīrti, V, 59

Voretzsch Collection, IV, 49

Waley, V, 19

Wall-paintings, IV, 8 ff., 36, 112, 216

Weller, Friedrich, V, 149

White, W. C., IV, 8, 39

Wierx, Anton, V, 89

Wrinkles, cf. ts'un-fa, V, 17, 216